THE ARCHER KING

ROBIN OF THE WOOD

&

THE MAID MAERIN

by
Reyna Thera Lorele

BLUE ARROW BOOKS
PACIFIC PALISADES, CA

acknowledgments

Heartfelt gratitude to my beloved, Gary Chase, for trying to understand when I disappear into my office to write, to my parents Enid and Dick Katahn for reading first drafts and more, to editor and friend Dona Haywood, and to Carl Haywood. Special thanks to Lynne Bernfield. For past support and encouragement, thanks to Jo Andersen, John Coinman, Patricia Lipman, Peggy Raess, and the former members of Elkgrove Circle and Circle of the Willoweavers. Any mistakes remaining in the text are my own.

The Archer King: Robin of the Wood and the Maid Maerin

by Reyna Thera Lorele

Published by Blue Arrow Books, POB 1669, Pacific Palisades, CA 90272

ISBN 0-9625803-3-3
Library of Congress Catalog Card Number TBA

Publisher's Cataloging in Publication Data
Lorele, Reyna Thera
The Archer King: Robin of the Wood and the Maid Maerin/by Reyna Thera Lorele—
First Edition.
Includes bibliography.
1. Fiction
2. Robin Hood
3. Myths, legends, folklore of Britain

Cover design by TBA

First Edition (month) 1999.
10 9 8 7 6 5 4 3 2 1

Printed and bound in the United States of America.
Text is printed on recycled paper.

TABLE OF CONTENTS

AUTHOR'S NOTE AND BIBLIOGRAPHY

TO BE INCLUDED

PROLOGUE

It was a heat-chased August. Even the wind seemed to run from the scorching sun. It fled the open fields, gusted under the limp leaves of the trees, sighed into the eaves of the stables and storehouses, and curled up to hide under the drooping feathers of the nestling doves in the dovecote.

Tempers flared in the overheated kitchen attached to the Great Hall. The spit-boys quarreled with each other and the master cook boxed the ears of the serf who was slow to take out the morning's slops, which were already beginning to rot and stink.

In the main courtyard, young knights-to-be were sweating like oxen at the plough in their leather tunics and helmets, their sweaty palms slipping on the hilts of their heavy swords. Their practice was sullied with even more name-calling and cursing than usual, and of a more serious tone than usual, until the swordplay degenerated into a fist-fight. Not to be outdone, the younger boys abandoned their wooden swords and soon were scrabbling around on the dusty ground like fighting ferrets.

Towering over them all, Ranulf fitz Warin, Baron of Derby, barked out commands and reprimands, grabbed boys by the nape of the neck to separate them, propelled them out of range of the goat and sheep dung that speckled the yard, and cursed as he wiped the sweat from his brow.

But when his seven-year-old daughter rushed into the fray with a slat of kindling as her sword, a grin cracked his weathered, sun-burned face. Some of the boys caught sight of her and laughed, and the tension in the air lessened.

Her kindling knocked out of her grubby little fist, Maerin hurled herself at the legs of her much taller opponent. He tumbled backwards to the ground. The other boys hooted. He reddened and tried to shake her off without hurting her, but she had latched on with all four limbs and would not let go until her father came and lifted her away.

"Get ye gone, then, lads, that's enough for today," bellowed fitz Warin. "And you, Maerin, back to your nurse, there's a good girl," and he kissed her on the nose.

Her protests were drowned out by the boys' gleeful shouts as they threw off

their stifling leather armor. They scampered through the gate in the wooden palisade and down the path between the fields of ripening grain to the glade at the southern edge of the estate, where a murky greenish-brown river coiled, boasting a short waterfall and a good-sized swimming hole at its foot.

Fitz Warin disappeared into the gloom of the castle keep in search of something to drink besides well-water. Unseen, Maerin darted after the boys at a safe distance, hiding behind tree trunks if anyone glanced her way. The smell of honeysuckle drooping on the vine sweetened the air, strong enough to taste, and as she passed a bushy clump of it, she plucked a promising blossom and sucked the tiny drop of juice from the end. Sweat trickled down her back and dampened her underarms until she was a sticky mass of discomfort, but the thought of the cool water ahead led her on. If her nurse Elgitha knew where she was going, there would be fuss and bother enough to rouse the whole keep. But Elgitha had fallen asleep with a wet cloth draped over her face, saying the heat made her 'squamous,' and leaving her charge happily to her own devices.

Maerin could hear the boys thrashing through the underbrush like boars, then their shouts of exultation as they reached the river. She peered at them from behind a bush as they threw off their clothes and splashed naked into the water, laughing and yelling. Otter-quick, she stripped and charged down the bank into their midst.

The cool river water soothed her limbs and filled her ears. Her tousled hair billowed above her. As she lurched upward for air, a whooping shout burst around her, and the boys were splashing her and she was splashing them back. Then, as if with one mind, the boys plunged toward the opposite bank and the heavy tree branch that overhung the water. Maerin swam hard after them, but to her frustration she could not keep up. When at last she clambered up the far bank and sat down to catch her breath, they were already diving and jumping in twos and threes from the branch.

One of the boys flopped down beside her and said, "You swim like a fish!"

The praise made her feel warm inside and she looked up with a tentative smile. The boy's blue-grey eyes were friendly.

"You're new here," she said. "I'm Maerin."

He nodded. "Robert is my given name. Our estate is called Loxley. I will be a knight someday." He puffed out his wiry chest a bit, then deflated and hesitated as if he would have said more, but had changed his mind. He picked up a stick and began poking holes with it in the moist earth of the river bank.

She wondered what it was he didn't say. He looked to be perhaps eleven summers, old to begin training as a knight. She had seen the clothes he threw off on the other shore. They were slightly shabby and his hair, now streaming with

river water, was long and unkempt. He clearly came from a poor family and would be lucky merely to be someone's squire someday, but she dimly knew if she said as much, he might not look on her so kindly as before.

"What a strange mark," she ventured, and reached out to touch a small birthmark on his inner left thigh, an unusual crescent shape.

Robert drew back, frowning, then jumped to his feet and dove into the river, swimming forcefully away under the water.

Maerin pouted. No one wanted to play with her. If only she were a boy. She could have been a knight. A better knight than that ragamuffin of Loxley would ever be! She grimaced, foul-tempered. Perhaps the heat was making her squamous too.

Robert came up for air by the waterfall. He tilted his head back to drink. The cool water calmed the restless stirring in his loins he so often felt these days, and at the least provocation. Silly girl! Whatever made her reach out to touch him? She was nothing but a baby. She didn't know what she was doing. He took another mouthful and spit the water in an upward stream through his teeth, seeing how high he could make the fountain of spittle go. Some of the other boys joined in, and then they were spitting at each other and wrestling under water.

Left alone, Maerin slid back into the river with a sigh and struck out towards the other bank to retrieve her clothes. She was halfway across before she noticed that the bush that held her clothing was north of her rather than south. In her frustration, she had forgotten to swim upstream against the current. She changed direction now and paddled harder, but she was nearing the south end of the swimming hole. The river grew swifter here and she heard the gurgling of the rapids beyond. Her father had forbidden her ever to play near the river, saying it was too dangerous for little girls. It had claimed lives before.

She heard a shout from somewhere but could not spare attention for it. There were already several boulders poking up through the water on either side of her, and a few yards away, the white curl of the rapids. A low whine came from her throat. She heard another shout, much closer. Her shoulder bumped sharply into a submerged rock, knocking her under the surface. She swallowed water, flailing her arms, seeking purchase. Then a wiry arm was around her neck and Maerin and Robert both swirled into the rapids, Maerin choking and kicking, Robert cursing and struggling to drag her toward the bank.

Dimly Maerin heard the yelling of the other boys. Her lungs ached, and her shoulder too. Buffeted by rocks for twenty yards or so, they finally slammed into a rough slab of stone that lay near the bank and managed to scramble up it to safety. They lay gasping for breath until Robert was able to demand angrily, "Why didn't you go limp?"

"I couldn't breathe! You were choking me," she lied, for it was the water that had been choking her. She had simply panicked and now she was ashamed.

"You shouldn't be here anyway! We are not nursemaids," he accused.

"Please don't tell my father!" she begged. "I—I'll let you ride my pony!" It was the only bribe she could think of quickly.

"I wouldn't tell your father anyway. If he can't keep a better rein on his daughter, it isn't for me to do it."

She bristled at this, but his tone was eager when he said, "I should like to ride your pony just the same. Anything's better than my old nag."

"He's small but he's fast," Maerin said in Starfoot's defense.

"Tomorrow morning? For the hunt?" He held out his hand to help her to her feet just as several of the other boys appeared, searching for them. They clapped him on the back like he was a hero.

Maerin supposed he might have saved her life. She ought to thank him, but she was too angry about getting herself into trouble. "Anyone who tells my father I was here will find toadstools in their stew!" she declared.

They laughed, but Robert said, "We have better things to do than tell tales on little girls," and he walked off with his friends, ignoring her. Somehow she knew he spoke so for her sake, to distract them and protect her.

She found her clothes, dressed and circled through the glade, picking wildflowers here and there as if that had been the sole purpose of her walk from the outset. Then she sashayed through the wooden gate of the bailey, across the hard-packed earth littered with straw and dung, into the grey stone keep and up to her chamber to rouse with a nosegay old Elgitha, who still dozed sweatily ignorant of Maerin's exploits.

In the morning, Baron fitz Warin complimented his daughter's generosity in allowing that poor boy from Loxley to ride her pony.

<p style="text-align:center">⌘</p>

It was past moonset. The whole castle slept, except in the old converted stable that served as the boys' dormitory, where Robert, listening to the steady breathing of the others, pulled his bed covers stealthily back and got to his feet on top of his straw-filled pallet. He swallowed the grunt that rose in his throat as he heaved himself up over the sill of the high narrow window above his bed, that had once served as ventilation for horses. He slithered out and dropped to the ground below, where he crouched, waiting in the chill autumn air until he was sure the sentries had not seen him.

The earth was cold on his bare feet as he made his way to the neighboring stable and slipped inside the door. He held his breath as horses snuffled and shifted, smelling his presence. The stable boys and grooms slept on, oblivious. He let out

his breath slowly and made for the corner of an empty stall, where he had discovered a hidden trapdoor by chance one day while mucking out the stable, for he worked to help pay for his training. He had explored the secret passage within but briefly, fearing discovery, not wanting to share his find. He only knew the tunnel led in the general direction of the castle keep.

Tonight he would find where it led or be damned.

Palms sweating despite the cold, he brushed away the concealing straw and lifted the trapdoor, easing himself down into the cavity below, closing the door over his head. He swallowed hard. It was black as death. This must be how it felt to be in a tomb or a grave. Why had he not prepared by bringing a rushlight? He forced himself to creep forward through the musty blackness, feeling his way, stair by stair downwards, then along the narrow tunnel, brushing away cobwebs and phantom spiders, until his foot bumped against something.

He groped downward with his hands, felt damp, soiled stone stairs. He breathed a sigh of relief and climbed upward until he reached a dead end. He cautiously felt the stone before him. There was no door. Above him, however, he felt wood. He pushed upward. Nothing moved. He bent his head and shoved with his shoulder. A creaking that seemed as loud as the trumpets on Judgment Day heralded the raising of the trapdoor. He hesitated, spine tingling, then pushed it all the way open and heaved himself over the edge into a greyer darkness. He froze on the floor, muscles taut, listening, trying not to think about what would happen if he were caught thieving in the night.

But for the snoring of men hearth-side in the Great Hall, their hounds asleep beside them, all was still. He edged along the wall, trying to imagine himself silent as shadows. His stomach growled once so loudly, he thought it would wake the dead, but even the dogs slumbered on.

He walked through the kitchen, his bare feet noiseless on the uneven stone floor. The slop-girl was sound asleep by the hearth where embers glowed dimly red, with only a ratty shawl wrapped around her thin shoulders. The spit-boys were curled asleep in a box of rushes by the arched passage leading to the bailey.

Robert inched toward the pantry. A faint scuffling sound came from within and he stopped, shoulders tensing. A dim light shone through the crack at the bottom of the doorsill. He swore under his breath. The cook was known to be wakeful and often checked his stores in the middle of the night against the suspected thievery of his underlings. The cook was also known, however, for his loud bark and little bite. He might cuff his charges once or twice if they pilfered a bit of bread, but if nothing of real value was taken, he did not trouble his master about it.

Robert thought of turning back, hating all the trouble he'd gone to for noth-

ing. It wasn't that the Baron did not feed his charges well. It was just that Robert was always hungry no matter how much he ate. A twisting in his belly decided him. With luck, he might have time to grab a biscuit left over from the evening meal, or a fistful of currants, and make his escape before the cook could box his ears or even get a good look at his face.

He swung the door open fully expecting an assault of bellows and slaps from the red-faced cook. Instead, on the pantry's stepladder stood Maerin, her dark hair escaping wildly from her thick braids, the light from her candle guttering in the flow of air from the open door. Her deep blue-green eyes were wide with the fear of discovery and one hand was frozen in the act of lifting one of those coveted biscuits from a covered basket on a shelf.

"Oh, it's only you!" she piped.

"Shhhh!" He slipped the rest of the way inside and shut the door carefully.

"If you tell the cook or my father that you saw me here, I shall shoot you in the bum with an arrow!" she declared in a fierce whisper.

He knew she could make good her threat. Even with her small bow and arrows, she was a better shot than a good many of the boys, and her skill had earned her a grudging respect. He grinned. "I will carry your secret to the grave, milady. Would you do me the honor of allowing a humble knight to share your repast?"

She gave him a quizzical look at this flowery speech.

He grabbed a biscuit and bit into it hungrily.

"Oh, wait, it's better with butter!" The child-sized knife she used at table for her meat was stuck at a jaunty angle in a tub of fresh-churned butter on the shelf below. She grabbed the handle and smeared a glob of creamy butter on his biscuit, then slathered one for herself and began to devour it.

They ate in companionable silence, she spreading dollops of butter for him until he had finished three biscuits in quick succession. He belched loudly and happily.

"Shhhh! You'll wake the cook!" she said, her eyes glittering with mischief, crumbs clinging to the corners of her smiling, butter-smeared mouth.

Seeing that impish smile, he felt an odd lurching in his chest, and on impulse, he leaned over and kissed her lightly on her soft, pink lips.

Now whatever had possessed him to do that? As surprise registered on her face, he felt himself blushing and turned away to inspect the crocks and baskets on an upper shelf.

"Currants!" He pulled out a triumphant handful and began tossing them one after another up in the air, his head tilted back as if he were drinking from a waterfall, catching the sweet morsels in his mouth.

She held out a sticky hand and he dropped some into her palm. She tossed them up and opened her mouth. Currants rained down on the floor around her. He laughed and she looked at him darkly, but when she saw his eyes held no malice, she giggled. He offered her another handful. She tossed them up one at a time, practicing until she caught one in her mouth.

"Bravo!" Robert praised her, adding through a mouthful, "I'll wager the slop-girl is the one will have a sore bum, once the cook finds all this missing."

Maerin shook her head, held up a hand meaningfully, and smeared her palm over the tub of butter to make the top look even and untouched.

"I see you are a practiced thief," he said.

She stuck her tongue out at him.

"Such a face! Slippery as a greased pig—and just as fat!" he teased.

Her lips puckered in a frown. Then she reached out her buttered palm and wiped it on his face. She laughed aloud at his look of astonishment. He reached for the butter tub. With a cry, she leaped off the stepladder to bound away, but he grabbed her by a braid and smeared butter in her hair and down her face. Outraged, she flung a biscuit at him, bouncing it squarely off his chin. It stung, but he only chuckled and cheerfully upended the whole basket on her head. The crusty biscuits spattered to the floor at her feet. She growled, raising clenched fists.

"Hush," he said, grabbing her wrists, "you'll wake the cook!"

"Piss on the cook!" she hissed, kicking his shins.

He yelped with pain and wrapped his arms around her so she could not flail at him. "That's enough now. I don't want to hit you. You're only a girl!"

With a wail, she sunk her teeth into his arm. He let out a rasping yell. In a flash they were rolling about on the floor, squashing fallen biscuits and currants, smacking and kicking one another and grunting like angry geese.

It was thus the cook found them, having been summoned by the frightened slop-girl, who said there were demons in the pantry, for she had heard them screaming.

Reported to Maerin's father, Robert's punishment for stealing was a birch cane whipping in front of the other boys. The shame of having to bare his back publicly and the regret of having been caught would have scraped away the sharper edges of his pride, had he not benefitted by a new respect from his peers for having dared to sneak into the kitchen, and all of them wanted to know how he had gotten past the dogs.

Maerin's punishment seemed by far the worse to her, for her father said she was becoming unruly and must not be allowed to play with a pack of boys anymore, but must be taken in hand by her nursemaid, with a governess to be hired as well, and she would be taught to be a lady like her blessed mother had been

before her death. No fit of temper or begging or even pretended docility on Maerin's part would cause him to change his mind, and over the winter the younger boys graduated from wooden swords to metal ones without her. Several times Robert snuck away from his chores to teach her what he had learned in some hidden corner of the bailey, but Maerin's governess, alert as a hungry crow, soon found them out and put a stop to their meetings.

Still, learning to be a lady proved not to be the worst thing that could happen to Maerin. In spring, her father was wounded in the arm during sword practice with one of his best students. It seemed a superficial cut at first, but he would not keep still long enough to heal properly, and argued with all who would have him rest, saying he had promised to train these boys into knights and squires and train them he would, and besides, he could not abide lying about like an invalid.

The wound festered, the festering spread, and when at last he succumbed to the notion of fetching a leech, it was too late to do anything but cut off the limb. His screams were no less muffled for the large jug of whiskey he drank to dull the pain, and Maerin screaming and pounding on his chamber door drove him and the doctor half-mad, until she was carried away by her nurse Elgitha. But the amputation did not stop the spread of gangrene to Ranulf fitz Warin's heart.

His funeral was honored by the presence of every noble in Derby, as well as by the boys who would soon scatter to lodge and train elsewhere. Maerin, swathed in a cumbersome black gown, walked tearless beside the casket, having cried herself out already. Now she seemed sunk in some kind of trance and had to be guided along the muddy track to the churchyard by Elgitha and her father's burly brother Reginald, whom she had never met before. They had both learned only that morning from her father's will that her uncle was to take Maerin in as his ward.

Fitz Warin was scarcely cold in the ground before Maerin discovered Reginald's idea of taking her in was to send her at once to a convent to be raised.

Dry-eyed and miserable, she said good-bye to Elgitha, who clucked and fussed over her and burst into tears. Maerin ignored her governess, whom she had disliked on principle from the start. Chin quivering, she raised a hand in farewell to the boys as they saddled and mounted their horses in the courtyard, with Robert looking a finer sight than he felt on the new gelding he had received as a gift from his father at Yule.

But as he reached the gate, he turned sharply in his saddle and called out, "I'll come and get you, Maerin, as soon as I am able!" as if he were a proper knight and she, his lady fair, were being sent to prison, which indeed, she felt she was.

That impulsive promise often rose up in her mind, and the memory of Robert's laughing blue-grey eyes, as she journeyed with a maid and two of her uncle's retainers south through England and across the Channel to the Norman convent of Fontevraud. Often she thought of that promise of freedom as she lay upon her thin pallet in the sleeping chamber with a dozen other little girls, after another long day of grieving for her father and chafing at the thousand and one new rules that made her life a torment. But as the months passed and she discovered ways to obey some rules without thinking and bend others without getting caught, she thought on Robert's promise less and less, until it faded from her mind like some childish dream, and in the way of children, he forgot having made it.

⌘

1-THE RETURN

COLD MOON DARK, 1191

Robert, heir to the lands of Loxley, returned to England from the Holy Crusade in a state of wretchedness that would prove over time to have deeply affected his mind.

He returned without his King, Richard the Lion Heart, whom he had followed into battle inspired by many a Christian sermon promising glory, riches from the spoils of war and an eternal place in Heaven. Yet of glory there had been little, of riches less still, and as for Heaven, that promise also remained to be kept, but Robert was by now somewhat disenchanted with the accepted means of getting there.

He had as companion no Norman-Saxon nobleman or eager youth for squire, but a tall, brawny, red-maned mercenary with a Gaelic burr in his speech and skin so freckled from years of fighting in desert climes that he looked ruddy as a fox.

As weapon Robert wore no proper English sword, but a sharp Moorish dagger and a stolen scimitar, which luckily proved just as deadly as his broadsword, or he would never have escaped the Holy Land with his life. His polished helmet, chain mail and finely woven woolen cloaks, gifts from his father and dearly bought, had long since been exchanged for dirty rags, and he had counted himself lucky to get them from the wracked bodies of fellow soldiers who had died in battle, or of starvation, or of illness, or of some mad quarrel with a companion-in-arms.

His mount was no muscled warhorse adorned with embroidered footcloth and plumed headpiece, but an old, patched rowboat that miraculously made it across the Strait of Dover from Calais in a rainstorm.

His once-smooth young face was roughly bearded, tanned and hollow-cheeked, his emaciated body showed here and there the white jagged ghosts of old wounds, his dark hair was shaggy and untrimmed, and underneath his dark brows, his blue-grey eyes had lost their sparkle.

For he had fared the worst in trading his bright, high spirits for worn and weary bitter ones. He had tasted of cruel killing and pillage, rape and

plunder, the razing of whole towns and cities and despoiling of women and children unarmed, he had smelled rotting bodies and blood clotting in the hot sun of the Holy Land, heard the clang of metal against metal and the ripping of flesh as swords sought to sever limbs, the rushing of great boulders plummeting through the air, the crunching of bone beneath them, the hiss of boiling oil burning bare flesh and turning chain mail into cauldrons, the screams of the dying above fierce war-cries, and all in the name of the Lord Jesus, called the Christ. It sickened his heart.

Yet during the weeks of arduous travel across the sea, across Europe, and across winter's treacherous Channel, Robert had felt the pall cruel experience had hung over his heart lifting slightly with each mile that he drew closer to home, to his father's Hall, and the people he had known and cherished since birth. The sight of the white cliffs of his homeland sent a rush of relief and exhilaration through him.

Now he plunged over the side of the boat, swayed to his knees and fell length-wise upon the shore. Will Scarlok clambered after him, shifted uneasily from foot to foot, then knelt and crossed himself, peering out of the corner of his eye to see what Robert would do next. At last Will sighed, closed his eyes, and settled himself to the bit of prayer he remembered, a good half of a Hail Mary, until he felt a cold hand on his shoulder.

"Let's go," said Loxley.

"I thought you were praying."

"I was," lied Robert, who didn't like to admit he had passed out. "But I'm wet and cold and hungry, and damned if I wouldn't pray better with a full belly."

Will agreed wholeheartedly. He lumbered to his feet and followed Robert, who was already picking his way through the rocks, searching for a path that might lead to the top of the cliffs, which loomed under roiling, menacing clouds and intimations of thunder. An icy rain began to fall, making their way dangerously slick. By the time they struggled to the top, sliding and scrabbling through the mud and wet crumbling rock, it was nightfall. Before them lay gentle rolling meadows cloaked with yellowed grasses and clumps of bare trees standing sentinel by swollen streams. The only landmark in the distance was an ancient Roman lighthouse, a ruined monolith illuminated briefly in flashes of lightning.

Robert and Will splashed onward, already soaked to the bone, until they saw a light flickering ahead. They slogged toward it, and came to a mud-daubed hut whose surrounding stubbled fields made a shabby pretense of being a farm.

When they knocked, the light was put out, and a butcher's knife was thrust out the doorway uncomfortably close to Robert's neck.

"Hold, there, stranger! Is this any way to greet poor travellers, who seek only a crust of bread and a bed for the night?"

"Be on your way," snarled a man's voice. The door slammed shut.

"We can pay."

The door opened a crack.

"I have no money with me now, but—"

The door shut again.

Will put his hand on the hilt of his sword and darted a questioning look at Robert.

"No," Robert said. "If our own countrymen will not toss a crumb to one of Richard's men, I'll not steal it."

"You were not so particular in the Holy Land," Will reminded him.

"The Holy Land?" uttered the voice behind the door. "Thou'rt Crusaders?"

"We were."

The door opened fully and a scruffy fellow of perhaps thirty summers and looking forty bade them enter. His eyes narrowed suspiciously. These Crusaders were dressed like beggars, yet one of them spoke like a nobleman.

The hut stank of smoke, mold and sweat. The embers of a fire glimmered erratically in the hearth. Over it hung a black cast-iron cauldron. The peasant poked at the fire and added a few twigs. The resulting glow revealed one chair, a rough-hewn table, and a pallet of straw where a woman huddled with four scrawny, shivering children, one of them but a babe at her drooping breast.

"We've no bread, but you may share our soup," offered the peasant.

"*Grand merci,*" said Robert in thanks.

The soup was a thin gruel of roots and bark. With every bite Robert took, he felt he was leading this pitiful family one step closer to their deaths, but his body, starved for days, demanded he eat. No one spoke. The steady rain was punctuated by thunder and the hollow scraping of wooden spoons against wooden bowls. The mother shared hers with the children, for there were not enough bowls for everyone.

"A rabbit or a squirrel would have made a better stew," commented Will. "Have you had no luck in hunting?"

The peasant snorted. "You've been away some while, haven't you? Hunting's called poaching, for the likes of us, and the greenwood is called forest, and no longer free to roam in, and it seems the deer have royal blood

that only a King may spill it."

The woman tried to shush her husband, but he went on, "Shall I get a squirrel for our supper and lose my hands, or my eyes? We dare not even gather twigs for our fire without leave. And the Church would have us tithe!"

Robert frowned. "But when King Henry died, his widow, Queen Aliènor, revoked the forest laws."

"'Tis their son has brought them back."

"Not Richard."

"Nay, not Richard. The younger, John Lackland, who styles himself King while his brother's away. But say you King Richard returns?" asked the peasant, eyes hopeful.

Robert shook his head. "I hear he lays siege once more to Jerusalem."

The peasant bit his lip, not daring to ask why they were not at Richard's side.

The rising wind battered the roof viciously, and he muttered, "The Wild Hunt is abroad tonight. 'Tis no night to be walkin' without. Ye may stay by the hearth, if ye will't."

Though the straw that covered the earthen floor was dirty with old chicken droppings and lice, it was drier and softer than the bare ground outside. Gratefully, Robert and Will settled in for the night, covered only with their damp, ragged clothes, while the wind blew through chinks in the rough plank walls, and the roof leaked intermittently on their heads.

Will cursed. "We should have prayed for the rain to stop."

"We could always go back to Outremer. It never rained on us there."

Will growled, Robert laughed grimly, and they both turned over in the straw and chased their sleep.

2-ROBERT BECOMES A HERO AND A VILLAIN ALL AT ONCE
COLD MOON WAXING, 1191

ill sat on a rock with a makeshift fishing line, watching as Robert plunged his hand into the nearby stream, then drew it out, empty. They had eaten little but tree bark since the night spent in the peasant hut. At least the morning sun was faintly shining through a thin veil of gauzy clouds for the first time since their return to England.

Robert's hand flashed into the water and came up empty again. He swore and stood, muttering, "Bears do it. Why can't I?"

"They aren't biting today either," Will replied, casting his fishing line aside. "Let's walk on. That peasant said there's a town."

"Go ahead. I'll catch up." Robert glowered at the water.

"What, and let you eat all that fish by yourself?"

Robert laughed. "Come, let's break our fast."

They drank their fill of the icy stream, then tramped northward through the wood, along a trail that was probably used more by deer than by men.

"Would that we'd spot a deer," Robert wished aloud, "and had bow and arrow with which to kill it."

"And a fire to cook it over."

"And warm our hands as well."

"If it were summer—"

"If wishes were horses," Robert said, "we'd ride to Loxley Keep."

"If I had a horse, I wouldn't know whether to ride it or roast it."

At last they came to the village, a collection of tawdry huts with smoke rising out of the smokeholes, and several wattle and daub cottages boasting a bakery shop, which was closed, and a saddler's. The ringing of a blacksmith's hammer filled the air. They soon found the one inn. The landlord seemed a nervous fellow, yet generous enough, for he let the travellers muck out the stables in exchange for a meal.

Soon they were stuffing themselves with flat brown barley bread, boiled potatoes and turnips, roasted hens, baked apples and tankards of ale, and the red-haired serving maid cheerfully kept their trenchers filled without being bidden. When at last Robert leaned back in his chair, licking the grease off his fingers, the maid took it as a signal to clear the table.

"My, but you were hungry, weren't you?" she dimpled. "It does me good to see a man go at his meat so. They say how a man eats is how a man loves." She gave him a wink and a smile and disappeared into the kitchen.

Robert's mouth slackened and his eyes widened. The ale ran dizzily through his head, the food warmed his belly, the heat from the fire seemed to lap at his boots and rise up to his groin, and without realizing it, he ran his fingers through his beard as if to comb it. Then every other thought drained away, and he was there again, in the Holy Land, with Richard's army, ransacking the city.

Robert burst into a Pagan shrine in search of plunder, only to find a veiled woman standing before a vessel of flame, two live serpents twining around her arms. He stumbled backwards at the sight, but she did not flinch

from his drawn and bloody sword. She said in broken English that she would give him a great gift if he would spare the shrine of her Lady. He knew he could take her and it would be no gift, and well she knew it, too. The screams of women in the streets were proof that other soldiers had not hesitated. But something in her tone, in her steadfast manner, and the fact that she called her Pagan mistress 'the Lady,' as he might pray to the Virgin Mary, made him lower his sword.

She coiled her snakes into lidded baskets, which were intricately woven with unfamiliar designs, and she began to dance for him, her movements quick as a flicker of flame, then sensuous as water. His sword soon fell forgotten to the tiled mosaic floor, and one by one her veils were wreathed around it. The love-making she offered him seemed to touch and heal his soul.

He stayed three days and nights with her, while the rest of the army, besotted, set fire to the streets. When it was over and he stumbled out to seek his commanding officer, her shrine was one of the few buildings miraculously spared. If only he could have gone home again directly from her arms instead of back into battle.

He pushed those thoughts away and stood, slightly swaying. Perhaps this pretty, round-limbed maid had pinched her rosy cheeks to redden them for his sake. As if drawn by a fishing line, he followed her.

Will grunted and put his feet on the table, settling down to doze in his chair, satiated and no longer caring in the least what Loxley did.

"I cannot take long away from my tasks," protested the maid, wriggling playfully as she allowed Robert to press her against the wall outside the kitchen and smother her breasts with kisses. She was warm and soft and smelled of woodsmoke and baking bread. "This won't take long, I promise!" he said, looking up at her, a mischievous glint lighting his eyes.

Laughing, she led him around the side of the inn, whispering, "I'll go first and you follow but quickly a moment after." She darted through the rain across the yard to the stable, as if on some errand from her mistress.

They found their trysting place on some hay in an empty stall and were pleasantly undiscovered for a good thirty minutes despite an inordinate amount of giggles and groans escaping their busy lips. The maid's cries of pleasure fed him almost as well as the meal he had just eaten.

Afterwards, his face nuzzled against her pungent softness, he began drifting off to sleep when he heard shouts coming from the inn.

"You stay three nights, eat like a hog, pay not a penny, and now you want our money? You thieving scoundrel, you'll get nothing from me!" the landlord bellowed. The landlady shrieked, "No! No!" Then came a low threat-

ening voice, the words indistinguishable, and then the woman wailing.

Robert fumbled with his clothes, barely managing to straighten them in time to grab his scimitar before a shifty-eyed man in a blue cloak strode into the stable to the tune of jingling coins, making for his horse in the next stall.

"Halt, thief! A knight of the Cross commands you!" Robert shouted, stumbling out of the hay, but the thief was quick-witted, drew his own sword and leaped forward to attack. Robert parried several blows, the stable rang with the sound of steel on steel, and the two men circled each other, their feet sliding and scuffling in the straw.

"Hand over the money and I'll let you go with your life," said Robert generously enough.

"You dare to interfere with the law? You'll be hanged!" hissed the man.

"The law is it, that steals?" Robert scoffed.

"It's the Earl of Maidstone's fief here, you filthy beggar!" said the scoundrel. "This money is his, and Prince John's."

"Yes, and the sword I hold is the right hand of God, and I am the Pope!" Robert swung his sword again.

Then a curse in Gaelic assailed his ears. The thief blanched and Robert grinned, for Will stood in the doorway, wakened from his nap by his hosts' screaming. His eyes, bloodshot from ale and months of deprivation, lent a manic glare to his fiery features. The blade of his dagger was clenched between his teeth, distorting his incoherent muttering, and his scimitar was raised with both hands above his head as if to split the thief in two from gullet to gut.

With a lunge, Robert knocked the distracted robber's sword from his hand and let the tip of his own scimitar sting the man's throat. "The money," Robert demanded.

"Prince John will hear of this!" gasped the man.

"At that, he may hear of it from me. If, as you say, you are merely collecting the Prince's taxes, I'm sure when he hears of the percentage you've been stealing, he will be most displeased."

The thief gawked. Robert poked the man's cloak open with his sword and, seeing a large pouch, cut it from the man's belt. It fell to the ground with a short but satisfying jangle.

"Now get out and be grateful Robert of Loxley has the mercy not to take the cloak off your thieving back or the blood from your thieving heart."

The man backed toward his horse's stall. He reached for the reins. Will brandished his scimitar in a circle above his head and growled.

"I think he means for you to give us your horse as well," Robert interpreted.

"Evil spawn of the Devil!" The thief let go the reins of his horse and ran out of the stable. Will lowered his scimitar and took the dagger from his mouth.

"Getting the horse into the bargain was good thinking," Robert said as he hefted the money pouch.

"I have walked across most of Europe and my patience is wearing thin. As are my boots," Will added with a Gaelic burr. He patted the mare's neck.

Robert sheathed his scimitar and stretched out his arm to the serving maid, who had been hiding. Her eyes shone with excitement and fear, for she had not known what manner of man she lay with, only that he seemed young enough for pleasure and might give her a penny or two into the bargain. Now, with the look of that moneybag, she might have several.

In the kitchen, they found the landlord pacing the floor, and the landlady grinding her teeth and counting the money in a small tin box, an accounting which took but a moment.

"We shall have to sell the cow," she said mournfully to her husband.

"Keep the cow and buy another," Robert said, plopping the moneybag on the table, "for that is the end of the thief."

"Aye, thieves, that's what they are, the lot of them!" spat the landlord. But the landlady looked at the money bag with horror. "You have taken the Earl's taxes?"

The smile on Robert's face slowly dissolved. The landlady crossed herself. "Merciful Lady, we are doomed!"

"The man was no thief?" Robert said.

"You shouldna have started this, Robert," Will murmured in his ear.

"Aye, a thief right enough," said the landlord, "but the Earl's thief."

Will murmured, "Perhaps you should have taken the thieving blood from the man's heart after all. A fine bit of poetry, that. You even obliged him by telling the bastard your name."

Robert gave him a dirty look.

"Our eyes will be put out!" moaned the landlady.

"Not yours," Robert said, and shook his head to throw off the shudder that snaked up his spine to his own eyes. "But I am a nobleman. He should not have spoken to me as he did," he decided aloud, "no matter whose taxes he was collecting. Take back the money that is yours. The rest will go with me to Maidstone. My father will make up the balance when I get to Loxley. All will be well," he said, with more confidence than he felt.

By the time he and Will rode out of the town, with Will on a newly purchased mule, having lost the privilege of riding the mare to Robert with a coin toss, word had spread of their exploits with the tax collector, and the villagers had turned out in force to ogle them as they rode by. At the look of hunger in their eyes, Robert reached into the taxman's pouch and scattered a handful of coins to the crowd. Well did he know such hunger. "Here is a return from your Earl of Maidstone!" he shouted.

A cheer went up. Urchins leaped forward to catch the coins, hobbling old dames scrabbled to their knees to pick the money out of the frozen mud, and the able-bodied followed the two men to the edge of town shouting, "À Loxley! À Loxley!"

But Will said again, "You shouldna have started this, friend."

Robert snorted. "Maidstone will likely reward us when he hears how his servant has been stealing from him. If we spur our mounts, we'll be at Maidstone's keep before the cock crows."

"As long as your cock does not crow again first," grumbled Will. "If we had not lingered after our meal, none of this would have happened."

"Yes, and you would be walking."

Will fell silent for a moment. Then he said, "The Earl will cut off your hands and hang us both."

"Then go. Go back to Scotland. Nothing binds you."

Will growled. They both knew Will had nothing to go back to. They knew further what bound him. "I'm no coward," he said.

"We'll return the money," Robert said, "and the horse. Then we'll make for Loxley, and all will be well."

"You are a simpleton. We should make for Loxley at once."

Ignoring his friend's dark looks, Robert launched into a supremely unChristian ditty he had picked up on the Crusaders' ship, having to do with a mermaid and certain features of her supple tail. So he ignored his own forebodings as well.

3-A DETOUR OF ANOTHER COLOR

he road led into woodland. The trees grew thick and the shadows bred by the setting sun melded into a single sheet of greyish blue twilight enfolding the land. They had not ridden far when they

found their way blocked by a mounted knight in full battle gear, his face hidden by the deepening darkness.

Robert called a greeting. The stranger lowered his lance, as if to charge. Robert gaped.

"Maidstone, or his taxman. Throw him back his money," Will said.

But before Robert could pull the pouches from his tunic, before he could offer a word of explanation, the knight let out a yell and spurred his warhorse, and a chorus of shouts erupted behind them. They turned to see four more knights charging up the road, swinging maces and axes for which their swords were no match.

Robert and Will urged their mounts off the road, Will spanking the rear of his mule with his scimitar. The knights gave chase.

Robert drew his sword and lopped off tree branches behind him. A branch fell onto one of their pursuers, knocking him from his horse and leaving him unconscious, but the others were gaining on them. They charged through a particularly painful cluster of thornbushes and leafless vines as thick as pythons, and saw a slash of blackness loom in the ground before them. Their mounts leaped the gully, Will's mule barely able to clamber up the far bank. Behind them, a harsh whinny and the clanking of mail told the story of a horse that had reared and thrown its rider.

Then their mounts pulled up short in a narrow cul-de-sac defined by a sheer rocky cliff four times the height of a man. Above the trees, a scrap of rising moon cast enough silvery light to show there was no escape except back the way they had come, a way which was blocked by their pursuers.

There was no room for anyone to fight mounted, and Robert swung off his horse. Will followed suit. Without waiting for their opponents to dismount, Robert charged forward, his Crusaders' instincts taking over, and he slashed at a horse's foreleg while its rider's mace got tangled in the branches and vines overhead. The ruined steed went down with a shriek, but the rider fell clear of the thrashing beast and managed to draw his sword before Robert rushed in.

He heard Will's grunts and the clashing of swords to his right. Robert was forced backwards by his heavier opponent. "Who are you?" Robert hissed under his breath. "If you seek to rob us, know we have nothing."

"Liar! You've a moneybag meant for me and Prince John." The Earl of Maidstone lunged, his sword slashing.

"An honest mistake," Robert began, still parrying the Earl's blows.

"A mistake you'll die for." The Earl redoubled his efforts. Robert's back

was at the crumbling cliff. Some part of his mind vaguely noted that it was good English limestone. He slid his dagger out of its sheath, ducked down and jabbed at the man's unprotected knees, then surged upwards, bringing his scimitar up with all his might under the man's left shoulder. Screaming with pain, the Earl staggered backwards, blood spurting out of the socket where his arm had been. He sank to the ground and lay still.

Robert ran to help Will, whirling his scimitar overhead, then swinging downward and slicing through a knight's chain mail headpiece at the neck. The head lolled sickeningly sideways, then the body followed, even as Will finished off the other man.

Robert went to put the screaming horse out of its misery. The other horses had bolted, to Will's chagrin.

They heard a groan. The Earl was still alive. Will strode over and cut his throat with the cool practicality of a professional mercenary before Robert could stop him.

"That was the Earl of Maidstone, you madman!"

Will was already wiping the blood from his sword with dry leaves. He paused, then shrugged. "And?"

"And there was no need to kill the bloody bastard!"

"He'd have happily killed you."

Though it was true, the bile in Robert's stomach rose to his throat. He had thought to put an end to killing. He had come home to farm his father's estate in peace, something he had once thought would be hell on earth. But no, he had found hell elsewhere. And now it seemed he'd brought it back with him to England. "We could have taken him to Maidstone, with the tax money. He might have lived."

Will scowled. "Sometimes I fear for your sanity, Robert. You saw how well he waited for explanations. He'd have thanked you with a dagger in your back."

These words found their mark. Much as he hated it, Robert knew it was true. He tightened his jaw and went to his horse. As for the tax money, he dared not show himself to the authorities in his present state, ragged, dirty and fresh from the scene of the Earl's death. He would take the money to his father, who would know best how to present their case to Prince John.

They rode back toward the main road, but Robert was far from singing. "Out of the skillet into the cauldron," he muttered.

By dawn of the next day, they reached London and lost themselves in the crowds there.

⌘

4-John lackland on the throne of the lion heart

Prince John sat in state on his brother's throne as if testing it out to see if it would fit his buttocks. In fact, the throne seemed somewhat too large for him, in spirit as well as in physical size, for Richard seemed to have inherited, along with the throne, the better part of the wit, the brawn and the forthright brazenness that their father, King Henry II, and their mother, Queen Aliènor of Aquitaine, had had between them to bequeath. Yet the inevitable comparisons with his elder brother were not entirely fair to John, and he chafed against them.

He was of average build for his twenty-four years, well-proportioned, even, by some accounts, handsome, though his limp hair was an unruly mass of brown, his eyes glittered as if with an uncommon fever, and when he spoke, he waved his jewelled hands about to emphasize his words, giving the impression of a child continually besieged by gnats.

On either side of him stood his advisers, with solemn faces. The most dour was Walter of Coutances, who had been named Chancellor of England when King Richard's first choice, William Longchamp, had been chased out of the country by an angry clergy. William's exile delighted Prince John, for it served his purposes perfectly.

The second was Hugh of Nonant, the Bishop of Coventry, who had fueled the flames of discontent by having had a great deal to say about Longchamp, much of it false and none of it pleasant.

The third, and perhaps the most ominous, was a knighted nobleman named Pierre de Beauvais. He was dressed flamboyantly in the style of the Parisian court, but his most distinguishing feature was a thin scar across the bridge of his nose. His presence so close to John indicated nothing, however, to a certain politically ignorant tax collector who now kneeled before the throne.

"So one of our brother's valiant Crusaders has scuttled back from the Holy Land?" said John with a smirk, fluttering a hand moth-like in the air.

"Yes, Sire, he spoke of the Cross, Sire, and called himself of Loxley," said the taxman, ducking his head several times, for being in the presence of the Prince was rare and intimidating, and made him want to bow overmuch. His eyes darted toward the Earl of Maidstone's steward, who, in order to secure the safety of his own neck, had brought the taxman here to tell his tale in person.

"And this Crusader stole from you our tax money? Right religious of him," John laughed. Every courtier in the hall followed suit except Walter of Coutances.

The tax collector bobbed his head in affirmation.

"Then you must go collect these taxes again, and you must stop travelling on this business by yourself. Why did he go by himself?"

The steward turned on the taxman. "Why did you go by yourself, fool? Did I not give you strict orders?" In truth, he had never given any orders on the subject, strict or otherwise.

"I never had no trouble before, your lordship," the taxman pleaded with the Prince. "The villagers are not armed. But this Crusader's sword, milord! Curved like a reaper's scythe, as if Death itself had appeared to stalk me! And his companion—red as the Devil, Sire, I swear it!" The man's eyes bugged out in terror, though of the Prince rather more than of the Devil at the moment.

"I see," said Prince John coldly. "The Devil took our taxes and killed our loyal subject, the Earl of Maidstone. A tall tale. Perhaps you are guilty of stealing the money yourself."

"N-nay, my liege!" The man could barely protest from fear.

John's lips curled. "I shall decide within a fortnight who shall receive the fief of Maidstone. In the meantime, have a brace of your master's remaining knights go with this taxman on his rounds."

"Milord," the steward bowed.

The Prince dismissed Maidstone's men with several flicks of his wrist, and they bowed their way out of the hall. "Loxley, Loxley. . . where is that?" John muttered.

"I believe it lies in the middle shires, Sire, northwest of Nottingham," answered his own steward.

"Nottingham lies north of Leicester and east of Derby, milord," said Walter of Coutances.

"I know that! I own it!" snapped John. "So this Loxley is really Sir

Reginald's problem."

"It would seem so, Sire," said Hugh of Nonant.

"Well and good. He bought his office from my brother with gold. Now let him pay me with his toil. See to it."

"At once, Sire." The steward bowed and hurried off to find a scribe for the message to Nottingham.

"Let us retire. I shall see no more of my subjects today. I'm thirsty. Do we have any more Bordeaux or have I drunk it all? Say I shall not be reduced to English ale!" John began to laugh but choked on his laughter, his eyes transfixed upon the far end of the Great Hall.

Everyone turned to see a woman sweeping toward them unannounced, pushing aside courtiers and armed soldiers by her mere presence. She was dressed in a sumptuous red velvet gown with swooping sleeves, and her hair and throat were hidden by the finest silken wimple, white as a swan's wing, yet barely whiter than her skin. She was crowned by a circlet of gold studded with tiny emeralds. Though she had given birth eight times and was past her prime, she retained the vitality of youth, and the faint lines about her eyes and lips, far from appearing to age her, were but the gentle signs of a flirtatious and laughing nature that she used to her advantage with the wiliness of a pirate.

She sailed toward the throne like a small, proud ship, then paused, and with nothing but an eloquent silence, dismissed everyone in the court save the cluster of men about the throne.

"Mother!" gasped the Prince. "I thought you were at Fontevraud!"

"John," replied Queen Aliènor sternly, "what is that you're sitting on?"

He popped up out of the throne like an arrow shot from a bow.

Now the Queen stepped lightly toward Pierre de Beauvais, holding out her hand. "So we meet again, Monsieur."

Beauvais knelt hastily and kissed her hand, but as he let go, she slapped his face with it, though almost playfully, and she said, smiling, "Get out." He flushed, straightened, bowed, and quit the hall.

The Queen dismissed the Bishop Hugh of Nonant with a cold stare, but Walter she motioned to stay. Then she heaved a sigh and began pacing, and her clear voice carried to John with the undulating rhythm of a snake, now uncoiling closer, preparing to strike, now slithering away again as if to gather its forces. "John, John, John, you really do amaze me."

The Prince knew better than to take this as praise.

She went on, "Do you truly imagine Philippe of France is a good ally?"

"I—I don't know what you mean, Mother."

"Do not trifle with me, my little angel, I know very well that you are conspiring with him. Now, where do you suppose Monsieur de Beauvais got that scar on his nose? From your own brother, Richard! At the Parisian court! Which is where I myself have seen him, and not so long ago!"

"Richard, in Paris?" John exclaimed, horrified.

"No, you idiot, Beauvais!"

"Madame, if I may speak," began Walter of Coutances.

"You know all about it, of course?" she cut him off. Far from being offended, Walter bowed and his eyes gleamed. At last John would get his comeuppance for his scheming, and for ignoring Walter's counsel. The Queen turned back to John and softened her tone. "Philippe only seeks to use you for his own ends, my child."

"Why should I not use him for mine?" demanded John.

"Oh, indeed, dear boy, why should you not? But for the fact that you are incapable! He is far too clever for you. When will you learn?"

"Learn to outsmart him or learn I am not clever, Mother?" asked John bitterly.

She clapped her hands and said, "Now you've got the way of it! Choose either one, John, but choose, for Heaven's sake, and choose quickly! Yet I caution you, be sure to choose my side."

"Your side is Richard's side and never mine! You have no faith in me! You never have."

"You have given me little enough cause for faith. Oh, John, my youngest, so easily swayed. First the pawn of your father and now of Philippe. Has Beauvais informed you that Richard's subjects across the Channel remain loyal to him? I thought not. More to the point, they will not rise against Richard in his absence, for that he has taken the Cross. They are superstitious. They believe it would mean bad luck." She wound up this portion of her snake-speech near her son. She leaned toward him and stroked his hair.

He steeled himself not to recoil. With one word, one look, his diminutive mother could make him feel five years old again and caught stealing the honey.

"My poor little one," she said. "The leavings of a royal family with too many sons can be so disappointing. But Nottingham and Derby, Cornwall and Devon, Dorset and Somerset—your brother was generous to give so much to you."

John squirmed at this reminder of what he owed Richard. As if a few shires could bribe him to relinquish his dreams of being King! Was he not as much of a man as his father, or Richard? More of a man, if rumors of Richard's

tastes in bed-partners were true. Why should John not be King? Did not the same royal blood run in his veins? If only his brother would die in the Holy Land. Often he had prayed for it. Then it would be a simple matter to dispose of their little nephew Arthur, Richard's named heir, who stood between John and the throne.

His mother was soothingly saying the opposite. "Dear John, you will never have the Aquitaine or the crown of England. And this silly idea of Philippe's, to steal back the Vexin—tell me, were you going to send him arms? Soldiers? Money?"

"The Vexin is not my concern."

She left off petting him and said, sharp as an adder's bite, "He will never get it back while I live!"

"Then why hasn't your precious Richard married Philippe's sister Alys as he was supposed to? The Vexin was her dowry, not his fief, not unless he married her. He always gets his way!"

Aliènor tried to hide her disgust at this petulant outburst. John had ever been Henry's creature, and look what kind of man her husband had made of him! And mainly because Henry had refused to see his own days of glory were past, and had pitted his sons against himself and each other, while he had clung to the throne like a splinter in the sea of time. And chased after every female in the shire, until even his own noble vassals hid their wives and daughters from him. All to prove he could still measure six inches! She had ignored his dalliances like a true queen. Besides, had she not had lovers of her own? But then Henry had forgotten discretion and flaunted that harlot Rosamunde in public.

Aliènor stifled the twin stabs of humiliation and fury she felt even now, after so many years. She must think of the present. Her beloved Aquitaine was at stake. So John was the imp Henry had made him. It was too late to mend that. But Richard—Richard had always been hers, and despite his faults, he was the one who would keep the kingdom together and strengthen it. And Walter of Coutances would help them, perhaps better than Longchamp would have done.

"Leave us now, please," she said to Coutances. "I would consult with you privately later." He bowed, and when she was alone with her youngest son, she told him, as if explaining matters to a child, "We have the Vexin; why should you help Philippe get it back? And now Richard has a very useful new wife from Spain. Why should his broken engagement bother you? Do you wish to marry Alys yourself? What good would that do you? As I said, we already have the Vexin. And don't tell me you're in love with her. Her head is

full of nonsense. Though I suppose that would serve you well enough. I have
heard you are not so particular about what a woman has between her ears as
long as she gives you what's between her legs."

"You're just jealous of her!"

Aliènor colored slightly, but chose to ignore this sally. No one had ever
proven that Henry had counted Alys among his conquests.

"Everyone still calls me 'Lackland,'" John was complaining.

"Let them call you what they will! You may lay a coin upon it!"

He sat down heavily upon the throne and hung his head.

Aliènor sighed and walked toward a window overhung with a tapestry
to keep out the cold. "Yule is fast upon us, John. Soon the peasants will be
clamoring at the gates for their joints of meat and kegs of ale. Why have your
servants neglected to decorate the hall? Ah, but I forget already: this is not
your hall and these are not your servants. They are Richard's. John, I want
you to send Beauvais away. I want you to go to one of your own castles, leave
London to Coutances, and stop this foolish plotting with Philippe. Do I
have your word?"

He stared at the straw-covered stone floor and eventually nodded.

"That's better, darling."

But as she left the hall, he mumbled, quietly, so she could not hear, "I
wish you had died in father's prison."

⌘

5-The Humble Beginnings of a Noble Marriage

Cold Moon, 1191, Normandy

ugustin de Coucy, his elegant brow furrowed with concentrated fury, paced wordlessly from antechamber to bedchamber and back again in the small apartment afforded him by his elder brother Edouard's sense of duty. His heavy broadsword banged against his thigh as he walked and annoyed him so much that he wrenched the heavy leather belt from his waist and flung it and the sword to the bare stone floor.

His squire René, indentured to Augustin since childhood, hastily retrieved the sword and leaned it against the wall. Coucy, poised now like a hungry greyhound before a tapestry depicting a hunt, tore the tapestry from the wall, flung it down and stomped away into the bedchamber.

René suppressed the quivering he always felt when Coucy was in one of his rages. But this particular fury was expected. René himself had been sent to hire the *jongleur* who penned the lines of love Coucy had memorized and recited as if they were his own to the fair Isabeau, who played with Coucy as if he were but a clever toy wooden engine on wheels, and she held the string.

Coucy strode back into the room and pointed at his swordbelt. René clasped it again around his master's waist.

"I must have the means, René."

"Yes, milord."

"The means to joust in Poitiers."

"Yes, milord!" At last his master was making some sense.

Augustin went to the hearth and gripped the edge of the stone mantel with both hands, his black eyes, made blacker with anger, fixed on the fire as if on the scrying ball of a sorceror. "I will win horses, I will win suits of mail, I will hire a score of knights to ride beside me into the courtyard of Isabeau's father's castle, and I will win her, by her favor or by force!" He swept an arm across the mantel, knocking a candelabra, a platter of apples and a holly wreath in clattering disarray to the floor. "My horse!" he roared.

"At once, milord!" René hurried after his master down the winding staircase that led to the ground floor of the keep. If only his master did not break so many things—indeed, if only he did not require such fine and costly things, and if only he would not gamble so much in an effort to get them— he would not be in so much debt, and then perhaps Isabeau would look more kindly upon him. But one did not mention such facts to a hot-blood like Augustin de Coucy and remain long unbloodied oneself.

René was not surprised to see which road they took: not, of course, to Isabeau so soon, which would be showing too much adoration, which would give her too much pleasure in her power over him, and with whom Augustin could not hope to get any real satisfaction of the kind he needed when he was frustrated, when he was obsessed with a rich and sought-after young noblewoman, and when he himself was landless and had supposedly been destined for the clergy, for all that he was completely unsuited for it.

The afternoon sun slanted faintly through the trees along the road to Vernon. The aging Comte de Vernon had been missing for almost a year, another casualty of the Crusade. His wife was no longer exactly young, but was blessed with something in her eyes and manner that lured men, and since her taste in lovers ran from the lean to the husky, dark to fair, tall to short, quick-witted to positively cretinous, everyone knew, though none spoke of it, that on any given night, a noble as handsome as Coucy stood a good chance of tumbling her into her curtained bed, provided he got there before someone else did.

René looked forward to an evening trading tales with the pages and squires in the Great Hall while Coucy parlayed a repeat of his poetic *amours* for Isabeau into the amply more receptive ears and bosom of Madame la Comtesse.

She received Augustin as usual in her private reception hall, a chamber that was cosier than the Great Hall, more pleasantly decorated, and which had the added advantage of a hidden passageway that led directly to her bedroom.

Coucy delivered his lines, knelt and kissed her small white hand, and gazed up at her charming face with appropriately feigned devotion.

The Comtesse let her lips part moistly. She enjoyed the play of love more than love itself, having loved once passionately and lost cruelly, and been forced to marry the Comte. No fool to think Augustin truly cared for her, she appreciated his gallant demeanor, his smooth young face and sensuous lips, despite or perhaps because of their tendency to pout, his long black hair, his dextrous hands, and above all, his firm thighs between her own soft

ones. Now she beckoned, took up a three-pronged candelabra and led him to the tapestry of a maiden and a unicorn which hid a small wooden door.

Augustin, knowing from experience where the key was kept, leaned over to kiss her neck, wrapped his teeth around the long, thin, gold chain and drew the key out from between her breasts.

Much smiling in the dark passageway, her finger to his lips to hush a chuckle, the swift rustle of her silk gown against the walls—the gown he knew he would soon be pulling off her scented skin—Augustin could barely wait for the bed and considered taking her on the floor of the corridor. But he let himself be led and was rewarded.

The only light came from the candelabra, which she placed far enough from the bed to let the shadows keep secret any bodily imperfections brought on by aging or the caprices of Nature. They lay there afterwards several times, Augustin having the stamina of youth, and the Comtesse having a contented smile on her face.

Then she heard the door open. She sat up and threw the bedclothes across Coucy's body to hide him. "Marie! Have you no ears? I told you to leave me for the night." But instead of the familiar form of her maidservant, a man stood in the doorway. The glow of candlelight revealed a bearded face, sunken eyes and stooped shoulders enmeshed in chain mail. Roughened hands held a battered helmet.

"My husband!" said the Comtesse, loudly. "By Our Lady, I thought you long dead!"

Augustin stiffened. His sword was on the floor halfway across the room. He felt the Comtesse jump out of bed. "*Mon Dieu*, how you have startled me!" she exclaimed to her husband. "Come, you look half-starved. I'll rouse the cook."

"An ecstatic welcome from my wife after such a long absence," said the Comte sarcastically. "And what's this? A sword? By the Christ, woman, have you a lover in your bed?"

Augustin rolled out of the blankets onto the floor so that the bed was between him and the Comte, and not a moment too soon, for the latter's sword slashed at the mattress. Unarmed and naked, Augustin ran for the door. The Comte howled and gave chase. Augustin looked for his sword, whirled in time to see it in the hands of his assailant, and felt the tip, which had been aimed at his back, cut into his right shoulder with a nasty ripping sound. Augustin gasped, and the Comte shouted with rage as he shifted to stand between his prey and the door. "By God's eyes, it's young Coucy! I know your puppy face!"

"Spare him, milord! We truly believed you dead!" cried the Comtesse, but the sword flashed again in the candlelight and Coucy ran for the far corner of the room.

"Yes, run, swine! Adulterer! Coward! I'll spit you like the he-goat you are!" shouted the Comte.

Augustin felt chill fear surge into hot rage at being called a coward. He looked around wildly for a weapon. His gaze landed on a low wooden cabinet. He threw himself toward it, jerked open the carved doors and pulled out the chamber-pot. He dropped onto all fours and rolled aside just as the Comte's sword split the air above him and crashed into the cabinet. Wood splintered. The smelly contents of the pot splashed around him. The Comte grunted as he strove to pull the heavy blade free of the wood. Coucy leaped to his feet and smashed the man over the head with the chamber-pot. The Comte moaned, let go the sword and sank to the floor unconscious.

"Quick, before he wakes!" The Comtesse shoved his clothing into Coucy's arms. She saw his wound, leaking blood down his chest, and reached out half in wonder, half-concerned, to touch it.

He heard clanking beyond the door, knights roused by their lord's shouts. Augustin pushed the Comtesse away, tugged his sword free of the cabinet and ran for the secret passage.

"A kiss! A last kiss, my love!" the Comtesse cried.

Coucy looked back at her in dismay. He had almost been killed, and still she wanted him to play the gallant? The door opened. Crackling torches chased shadows about the room. Without a word or a kiss, he turned and made for the maiden and the unicorn.

René, lounging in the Great Hall with the chickens, the squires, and several drunken knights, had been one of the first to witness the unexpected return of the Comte de Vernon, escorted by a raggle-taggle band of hired mercenaries. René had tried to slip away to warn Coucy but as he had never been anywhere else in the castle, he had no idea where to go. He heard shouts above, but could not find the source of them. So he hurried to the stables for their horses, trusting to Coucy's wits, which had always proved sharp in similar situations.

Sure enough, having escaped through the secret passage, dressing haphazardly in his headlong rush, Coucy appeared in the courtyard, leaped upon his bay, and took to the road with René galloping at his heels.

Augustin expected the dawn to bring a challenge from the Comte for a duel to the death, and René got little sleep that night, what with sharpening Coucy's broadsword, polishing his helmet and checking his chain mail and

the trappings of his warhorse. But the message that came to Coucy's chamber in the morning was from the Comtesse.

Coucy tore open the sealed parchment and read, "My friend, my husband died an hour ago. I warned my servants to guard their tongues or they would lose them, but you know how well the poor keep the secrets of the rich. Take heed for your safety. And don't come to see me."

Within days, it seemed all Normandy had heard the gossip.

Chafing at the necessity, Augustin went to his brother and asked for help. For the sake of the family name, Edouard de Coucy cajoled and bribed the *seigneur* to whom the Comte was subject, and Augustin was let go with a stern reprimand for his hasty actions and lack of discretion. He was reminded that the honor of the lady in question had been tainted, and that this was a crime against chivalry. There the matter was dropped. After all, men were frequently killed in duels, and to bring a nobleman before the law for such a minor brawl was almost a crime in itself.

But Augustin found he was no longer welcomed with the same congeniality by his friends, not because he had killed a man, or even because he had been caught in bed with the man's wife, but because he had been stark naked at the time of the 'duel' and his weapon had been a chamber-pot. He became an object of ridicule. The smiles that greeted him on every side were full of amusement instead of acceptance.

Then his brother refused him the money to go to the tournament in Poitiers, and he was forced to stay at home and brood over his misfortunes.

Worst of all, Isabeau would not see him. He rode to her father's castle a dozen times only to be turned away. He once caught a glimpse of her watching him from a diamond-paned window. She quickly stepped back and disappeared from view, but not before Augustin saw the look in her eyes, and it was rich with scorn.

His outbursts of temper became so great that every servant on the Coucy estate dreaded his approach. Even René took to hiding to avoid becoming the object of his master's misspent wrath.

One night as he sat staring into the fire in his apartment, trying to drink himself senseless, his brother summoned him to the hall, welcoming him with his usual lack of warmth. With a sardonic smile on his pockmarked face, he said, "You must go away for awhile, Augustin. Since you have already been sent away from the monastery, I think we must accept that you will never become a priest. I will write letters of introduction to some of my acquaintances in England. If you are well out of sight, everyone in Normandy will forget about you in a fortnight. Some other juicy bit of scandal will

garner their attention. Besides, I grow weary of your temper tantrums and of watching my servants skulk about. Don't glare at me! I'm offering to help you. Money, Augustin, for your journey. And I advise you not to gamble it away. It will be the last you'll get from me. I can't support your follies forever."

"I won't need your support," Augustin blurted. "I'll marry the Comtesse."

Edouard laughed. "Is that what you've been plotting? As if she'd have you. Besides, she's in mourning."

"I'll wait."

"You've never waited for anything in your life."

Augustin almost mentioned how long he had courted Isabeau, but since he hadn't won her, it would only make him look more ridiculous. "Perhaps you intend to marry the Comtesse yourself."

"Perhaps. Since my wife died, I have no one to comfort me on cold nights. I could certainly use the Comtesse's money. And I have no heirs."

"Other than me."

"You? You lose the allowance I give you at dice, you sleep with noble-women without a thought to their safety. Why not bed peasant girls? That's what they're for. But no, you're irrational as a woman, hotheaded, greedy, without wisdom and without method. Father was right. You'll never amount to anything. I'll leave you nothing when I go, my fine, handsome brother. Absolutely nothing." Edouard licked his lips as if savoring his words.

For once taking his cue from his brother's coldness, Augustin left the room without an outburst. The next day he rode to see the Comtesse. He was refused admittance, but bullied his way into the Great Hall, where she sat stitching embroidery with her ladies. She said severely, "You shouldn't have come."

"I must speak with you alone."

"Impossible."

"Don't be absurd."

A smile tugged at her lips. She dismissed her servants.

Augustin tried to remember the gallantries that had once come to his lips so easily. He wanted to ask for wine, but did not wish to presume upon her reluctant hospitality. His hands were shaking and he rested them on his swordbelt, then fell to his knees and swore he had missed her, he thought of her every day, he grieved for any suffering he had caused her, and though it was in poor taste to say it, how lovely she looked in black.

"Suffering?" she said with a smile. "Indeed, you are my champion. You know I never loved him."

"But I love you. Marry me."

The smile froze on her lips.

"Of course you are in mourning," he hastened to say. "We would have to wait. But if you give me your promise now, in secret, I will wait for you with joy in my heart as long as I must."

"Shall I wed my husband's murderer? How people would talk!" She chuckled. "It would almost be worth it! They'd have to bandage their tongues, they'd be so sore from wagging! But Augustin, you and I have no true love for each other, I have no love for marriage, and we would be quite miserable together. I think I shall enjoy very much being well-to-do and unbound by wedding vows."

"And I am poor," he said sharply.

"Yes, that is quite unattractive in a spouse. And you have a dreadful reputation." She laughed.

"That will change. People will forget."

"But you will not change. No, dear Augustin. You are a gambler and a womanizer, and I've heard tales of your temper. For my own part, I've shared many pleasurable hours with you, and believe me, I will treasure those memories almost as much as my gold. You are the perfect lover. And you would be a horror of a husband."

"You filthy whore!" he spat.

She didn't flinch. "Don't say things you'll regret, my love. I've never seen you in such a foul mood and I advise you not to show it in future to prospective brides, especially rich ones. But since you are my champion, I am in your debt, and since it is courteous for ladies to shower their loyal knights with favors, and since I think to wear my sleeve upon your lance as a token would not excite you overmuch. . . ." She rose and went to the doorway, where she beckoned and murmured something to someone. A short time later, her servant Marie entered with a curtsey and a velvet purse, the latter of which she handed to her mistress, then left the hall.

"Take this, Augustin, and use it as well as you know how, or if possible, better. Now, it's unseemly for you to be here." She kissed him on the cheek as he weighed the pouch in his hand. It was satisfyingly heavy. Then she whispered coquettishly in his ear, "Promise me you'll never come back."

"Never," he vowed, and kissed the purse before tucking it into his belt. He bowed, and the two former lovers smiled at each other in complete understanding.

For the first time in his life that he could remember, Augustin felt grateful to a woman. It was such an unusual feeling that he quickly dismissed it.

He returned home to face his brother's scorn.

"Would she have you?" asked Edouard, examining Augustin's face. "Ah. I thought not."

"Good luck with her," Augustin said, enjoying the secret knowledge that his brother's suit, if he chose to make it, would also be rejected. "I would like to go to England."

"I'm glad to see you have temporarily come to your senses." His brother wrote letters of introduction to two petty nobles and an abbot, gave him a somewhat less generous purse than that of the Comtesse, and bid him *adieu*.

That night, Augustin put his affairs in order by sending messages to his debtors saying that his brother had kindly agreed to honor his debts, a lie which he relished almost as much as the wine he was drinking. The next morning, in much-lightened spirits, albeit with a hangover, he set off for England amid flurries of snow with the two purses, his bay horse and a gelding, his sword, two daggers, one for fighting and one for his meat, a coat of mail, three changes of clothing, and René.

6-LOXLEY KEEP
COLD MOON FULL, 1191

With plodding determination, Robert and Will made their way north to the midlands. London lay far behind them. A sense of shame filled Robert whenever he thought of how his father would react to the tale of the stolen taxes. He had thought the Crusades had changed him; he had imagined his father would be proud. Then he had behaved like an impetuous stripling. Well, he would pay the price, he thought grimly.

His horse emerged from a copse of winter's leafless beeches into a stubbled field, under a late afternoon sun half-obscured by clouds. Beyond was a rounded tor covered with trees. A spasm of Robert's old enthusiasm gripped him and he shouted, "There it is! Puck's Hill! The first to gain the ridge shall have the other's mount!" He spurred his horse to a lurching gallop.

Will Scarlok dug his heels into his mule's haunches and gave futile chase. He heard Robert's shout of victory as he reached the top of the hill.

But instead of plunging down the other side, Robert reined in his mount with a harsh jerk. Anticipation drained from his face as he gazed at the sight below him. It was as if some terrible painter had drawn a curving line from

the base of Puck's Hill in a wide, jagged oval encompassing the whole of the glen. Then this painter had colored the valley black with his brush. The gentle, rolling pastures, once green with tender shoots in spring, golden with grain in late summer, brown in autumn or white with January snow, had become a sea of scorched earth.

At the far side of the wasted valley, atop another hill, rose the craggy ruins of an old Saxon tower, now a burned-out shell, even to the gnarled and blackened trunks of the dead trees beside it.

Loxley Keep.

The mare whinnied and stretched her muzzle down to nibble at the few dried tufts of last summer's grass still waving like a taunt above the ruins. Robert slid off her back, dropped the reins, and took a few staggering steps toward the keep with a look of such pale horror on his face that Will, riding up beside him, felt his own heart clench.

Then with a scream like a battle cry, Robert threw himself upon his horse again and whipped her furiously down the hill.

Will followed more slowly across the dead land, reined in his mule outside the keep and waited, assuming rightly his friend's need for solitude.

Robert picked his way through the ruins, kicking the rubble, searching for some clue, his thoughts in chaos. What disaster had befallen his home? Had his father quarreled with some powerful baron? Why? Could his father have escaped, alive? He must have. Robert could only picture him as hearty and robust as he was the day Robert left for Outremer.

He peered half-blindly through the gaping rents in the stone walls at the clouded sky, the ravaged earth. Faces flickered through his mind: the blacksmith, sweat pouring down his brow, with his stained hands, who had forged Robert a small sword when he was five. Ugly Annie, his wet-nurse, who had raised and coddled him after his mother's death. The miller by the beck, hands dusty with new-milled barley flour, and the miller's son, who had dreamed of becoming Robert's squire but was too young.

They could not all be dead. They had abandoned the wreckage of their home, that was all, and who could blame them? But where had they gone?

His booted foot knocked against something. It rolled unevenly away with a dull clatter that echoed hollow-sounding against the stones. He bent down to pick it up. It was a battered and fire-blackened silver chalice. Filigreed spirals of Celtic knotwork twined around the rim, studded at intervals with knobs of colored glass now smudged by ash. Two of the glass gems were missing, shattered or fallen away, no doubt in the heat of the fire.

How well he knew this chalice. His father had drunk from it at table

every night. Even now, he could see the serving girl filling it with red wine, see his father nodding and lifting the cup, toasting visitors, toasting the sunset, toasting his son.

A charred bone under a fallen timber caught his eye. He felt his veins filling with the familiar chill recognition of death. Gritting his teeth, he heaved the beam away, revealing the skeletal remains of a hand, and upon it, melted and misshapen but recognizable by its size and the stone within, his father's ring.

Robert heard himself groan as if the sound came from someone else's throat, felt a wrenching in his chest as if his heart would stop. He quelled the impulse to scream, to run; he knew this vision of death would go with him. He fell to his knees, digging through the debris, shoving away charred beams and fallen stones, searching for his father's bones as if the strength of his shock and grief could clothe them in flesh and bring them back to life again.

He found nothing else he could recognize as human. He picked up his father's ring and the chalice and cradled them in shaking hands.

An aching of unshed tears burned his guts and lungs and throat until he thought he would choke. He had never felt such anguish, through war, prison, starvation or in the face of a dozen other deadly threats and losses. Not even when his mother had died, for he had been too much of a babe to know her well, and besides, his nurse Annie had been there.

But this was a desecration of all he had truly loved, without knowing how much he loved it until it was gone from him. What a fool he had been.

He would never make peace with his father. He hadn't even planned what he would say. He had assumed the words would flow freely when the time came and everything would be forgiven. Now it was too late. There was no forgiveness. There was nothing left, not even to bury. And Loxley—how would he rebuild it? He was practically penniless.

Except for the stolen taxes.

While he crouched in the ruins, his mind spinning, darkness fell. The clouds lifted and the full moon rose, bathing him in mournful light. At last, almost against his will, he reached some kind of miserable peace, a hopeless peace, a surrender to despair, and an owning of it.

He heard a skittering sound. Inches above his head, a mouse scurried along a collapsed beam. Something yet lived here, he thought. Nature implacable, unperturbed. Vermin, of course. They always survived.

Then something else flew after the mouse and lodged forcefully in the beam, whacking the little creature's head off in a stroke. Robert's eyes widened. It was a large meat cleaver, very near his own tender neck, and after it

came scrabbling a shrunken man in dirty rags more tattered than his own, who pounced on the mouse and began tearing at its raw, furry flesh with his teeth.

Aghast, Robert recognized the man's thin shoulders and jutting brow in the moonlight. "Cedric!"

"What?! Who goes there?" Cedric stumbled backwards and looked wildly up from his mouse.

"Do you not know me?"

"Oh, may God have mercy, a ghost!" Cedric crossed himself. "By all the saints, leave me in peace!" Then curiosity got the better of him. "Are you not the ghost of his lordship's son, young Robert who died in the Holy Land?"

"I'm no ghost. It's you who have a ghoulish look about you. Eating raw mice. Have you gone mad?"

"Y-you're not dead?"

"Not yet, by some miracle. If I yet believed in miracles. I feared *you* were dead."

Cedric crossed himself again with a trembling hand. "I was spared, God forgive me. I ran, I hid, but the others. . . ." He shook his head as if to shake the memory away.

Robert forced out the words, "Tell me."

"Milord, I barely escaped. Your father, may he rest in peace. . . he tried to stop them. I don't know why they burned Loxley. The Church wanted it, but your father would not sell. Why would anyone ruin good land? It must have been mercenaries, for they bore no standard. We had no warning. It was Samhain, milord, All Hallows' Eve. They took brands from our own bonfires for the burning, and they slew us with swords, serfs and freedmen, women and children, right where we danced! And now it's said your father worshipped the Devil and was a traitor to the Crown, that he slaughtered his people and burned his own lands in a fit of demonic possession! Though the Sheriff's seal be upon it, God knows it's a lie! But if I were to come forward to speak the truth, I'd be hanged, sure enough. The Church owns Loxley now. I've heard they'll build a monastery here come spring."

Robert was speechless. Even as he had been making his way toward France, holding the thought of home like a beacon before his darkened heart, his father had been murdered. Now the Church owned Loxley? For a monastery? And a Sheriff's seal upon it? "What Sheriff?"

"Nottingham," answered Cedric. "There's a new Sheriff there, Sir Reginald by name." Having told his gruesome tale, he was eyeing his mouse and licking his lips. Loyalty won out over instinct. "You have surely travelled

far, milord, and must be starving." He offered his master the mouse.

But before Robert could refuse, Cedric yelped. Will had slipped inside the ruins with his scimitar drawn. The moonlight glowed around his tall, pale, muscled form like an eerie halo, and his curved scimitar gleamed dully like the scythe of some Pagan God of the Dead.

Robert summoned what remained of his wits. "Peace, my friend. This is our old cook, Cedric. Never was there a knight more skilled with a sword than Cedric is with a meat cleaver. Come," he added to Cedric, for a vague sense of being lord of the manor descended on him, though the manor was gone, "we have bread and cheese, food fit for a man, not an owl."

"I obey you, my liege," said Cedric, "and my mouth fairly watering with the joy of obedience!"

Yet he trusted not to Fate, and pocketed the mouse for later.

7-THE SHERIFF OF NOTTINGHAM SHOWS BOTH HIS FACES
YULE, 1191

Nestled in the midlands among endless miles of woodland lay a thick wad of cottages and huts, ploughed fields and fallow, with a St. Mary's Church, several hundred souls of poor, and a rutted lane which led to a gate in a high embankment enclosing a town, which boasted shops and more cottages, narrow twisting streets, some cobbled and some raw with mud and sewage, more souls less poverty-stricken, and another small chapel where the nobles prayed, by the square where the market was held on Saturdays.

The gates of the walled town were locked at night and guarded always by sentries. During a siege, if there were warning enough, the poor took refuge within the town walls along with their livestock, and if these walls were breached, the people would surge inside the castle walls, if they could make it before the iron gates cranked shut.

The fortress, looming high on a cliff, had three moats and baileys, and castle within castle, for the later additions in the Norman style crowded around an ancient Saxon keep built hundreds of years earlier. The Great Hall was in

the newer section, and here Sir Reginald, Knight of the Realm and High Sheriff of Nottingham, with the erect posture of a soldier who had served King Henry II, sat upon a large wooden throne covered with ancient, cracked leather and silver studs. The chair itself stood upon a stone daïs at the far end of the hall. His steward Aelfric and other courtiers had to stand on the rush-covered floor, and supplicants bowed low before him, all of which pomp and ceremony made the Sheriff seem more imposing than even his great height demanded.

For Reginald was a big man, made as if born to wear armor, his arms thick and powerful for wielding axe and mace, his shoulders strong from bearing the weight of chain mail. He was dressed as always for battle, with a long mail coat over a calf-length blue robe, yet his expression seemed incongruously mild, and his manner surprisingly sophisticated for a soldier in a fortress so far from London. His face was cleanshaven in the Norman fashion. His hair was fair, streaked with grey that attested to his fifty summers, but his eyes were a piercing, lively blue. He spoke both Saxon and Norman with equal ease, having striven to better himself, and having succeeded. He held his iron helmet in his lap like a sceptre.

The narrow windows of the hall were covered with tapestries in an effort to keep out the winter cold. For light and heat, huge candelabras burned scores of candles day in and day out. The fire in the immense hearth blazed hot. Above the hearth, boughs of holly showed their berries bright red among shiny, spiny green leaves, along with fragrant boughs of pine and balsam fir, and dried pomegranates. High above the floor a narrow gallery ran along three sides of the hall, and this too was festooned with garlands of blue-berried juniper and cedar, their Yule cheer masking the gloom beyond the short-columned arches, for the gallery was poorly lit.

Still, with so many assembled for the holidays, there was an air of gaiety in the hall. A colorful assortment of ladies, knights, townsfolk, villagers, serving maids pouring mulled wine, pages delivering messages, hunting dogs, and a stray chicken or two revolved about one another like eddies in a pool. Some half a dozen noblewomen and their ladies dotted the gallery, chatting quietly, delicately sniffing linen handkerchiefs dipped in rose or lavender water, and watching the activity below.

In a corner near the entrance to the kitchen sat a Benedictine monk at a wooden table. The top of his head, shaved in a tonsure, bobbed like a featureless face as he bent over his quill and ink, carefully inscribing a parchment and seeming oblivious to the goings-on around him.

Slightly apart from everyone, leaning against the wall by the hearth,

was a handsome young man with elegant, dark features, dressed in the height of court fashion. He had no interest in the audiences held by the Sheriff, the petty woes of the villagers being the order of the day, and he kept his eyes on the monk as if the words that good man wrote were the tallyings of his own life, soon to be presented to St. Peter at the pearly gates.

"I never stole no chickens, milord," babbled a beggar who grovelled before the throne.

The Sheriff beckoned to Aelfric and asked for a small knife, with which he began pruning his fingernails while he pondered what the sentence should be. "The stocks for two days and nights. Bread and water." He nodded at the guard.

The unfortunate beggar moaned at the thought of the stocks, where he would suffer cold and abuse from the villagers, but at least his hands would not be cut off for stealing; the good Sheriff was merciful because it was Christmas. "God have mercy on you, and bless you, milord!" he cried. A few puffs of tell-tale feathers flew off his rags as he was dragged away.

A page bustled by him toward the throne and said a few words to Aelfric, who in turn whispered them to the Sheriff. Years of practice at hiding his emotions served Reginald well now. He had never thought this particular little problem would ever cross his threshold again. Well, since it had, he'd best be done with it quickly.

"Show him in at once," he said, examining his fingernails in the candle-light.

The page bowed and hurried out.

"Brother Denys, I think you'd better rest your hand," said the Sheriff, nodding toward the main doors. The monk and his shadow, the young nobleman by the hearth, turned their gazes, as did everyone else in the hall.

A lean, dishevelled and dirty young man entered, followed by a tall figure with a beard and bushy hair almost as red as the holly-berries. A herald announced, "Sir Robert of Loxley."

With Will Scarlok beside him, Robert strode forward until he stood before the Sheriff. He bowed. The Sheriff noted in a glance Loxley's hodge-podge of worn clothing and mail, his lack of weapons, his hollow face, his body that had clearly missed too many meals, and yet the slight swagger in his walk. Reginald quickly assessed him: impudent, poor, hungry, hot-headed. "Robert of Loxley. What good fortune."

"I am glad you count it so, milord Sheriff," Robert said. "May I speak freely?"

The Sheriff inclined his head in the affirmative.

"I have come to reclaim my lands of Loxley."

Reginald frowned and shaved off another tiny sliver of fingernail. "Those lands are forever forfeit. But have you proof of your name? I thought you were dead."

Robert felt the blood rush to his face. "Or wished it so."

The ladies gasped at his audacity and a hush fell in the hall as everyone waited to see what Sir Reginald would do.

The Sheriff sighed as if with regret. "This is a bad business. You know, I received a letter from London about you. I thought perhaps someone had mistaken your identity. Since they were correct, I'm surprised you would dare show your face in my court."

"I would have shown it sooner, but for thieves in Sherwood Forest who stole our mounts," Robert said ruefully. "We were forced to walk to Nottingham." The travellers' provisions had also been stolen. Even now, the smell of spiced, mulled wine in the hall and roasting meat from the kitchen made Robert's mouth water and his stomach clench, but he refused to show his hunger.

Reginald pursed his lips and assumed a philosophic air. "Thieves, is it? How fitting. Are you sure you know what thievery is? Or did you merely have a difference of opinion with one of the Earl of Maidstone's tax collectors? You did not steal from him at all, did you? He gave you the money because he felt sorry for you in your pitiful state." His voice had grown ominous; the hush in the hall deepened.

"Indeed it was a misunderstanding, Sir Sheriff, one which I shall explain in due course. But I am more concerned with a higher class of thieves. My lands of Loxley have been stolen from me. I have been told the Church holds title to them now. Wrongfully."

Reginald's eyes narrowed and he pointed with his knife. "You are an insolent whelp. Prince John suggests I have you flogged."

Robert laughed.

The Sheriff laughed too and said, "I think we can forego flogging, don't you? After all, you are of noble blood. It is true you killed the Earl of Maidstone." It was a statement, not a question. Will made as if to object, but Robert stayed him. Reginald observed, "The Earl was not one of John's staunchest allies. Merely repay the money you took, and a fine, and all will be forgotten."

Robert said, "I cannot repay it, for I have lost it to thieves. Return to me my lands of Loxley and I will repay at the harvest, if not this year, then the year after."

Sir Reginald frowned. "I'm afraid that's quite impossible."

"Anything is clearly possible with your seal upon it!" Robert said contemptuously, and a wave of shocked murmurs echoed through the hall.

The Sheriff felt a flicker of anger. "Your father was a heretic. Lands—"

"That's a lie!"

"—lands purged of Witchcraft are always forfeit to the Church. I am flattered at your faith in my omnipotence, but the Church is a harsh mistress."

"Indeed, She is one I'll not lie with any longer if She does not return what is rightfully mine!" Robert declared.

At these blasphemous words, Brother Denys colored and crossed himself, and the shocked whispers in the hall grew into exclamations of outrage.

"Loxley was stolen and my father murdered. By whose hand, Sir Sheriff? Surely you know."

"He died by his own hand, raving like the moon-mad."

"Never! He was struck down and I shall have vengeance!"

Reginald laughed heartily. "Then you shall fight with the minions of Hell, a battle I should like to see engaged, from a safe distance, of course."

This idea made the monk quite anxious; he crossed himself several times, to the silent amusement of the nobleman by the hearth.

"My father was no Devil worshipper!" Robert insisted.

Sir Reginald said, "I heard he himself lit a bonfire every May Eve and danced around it with his peasants."

"Since when is that Satanic?"

"The Church frowns on these things."

"The Church be damned!"

Shouts went up from the courtiers.

"Blasphemy!" bellowed the High Sheriff.

Robert's rage was tinged with fear and shame. He had spoken the words without thinking, and for all his current embitterment against the Church, he was surprised to hear such a curse from his own lips. But he called over the din, "Only one thing remains unclear to me, Sir Reginald. If the Church got Loxley, what did you get?"

The Sheriff leaped to his feet. "You dare accuse me?" He drew his sword.

Seeing this, the castle guards drew their swords as well, and rushed to support him, though Robert and Will were weaponless. Above the screams of the ladies and the yelling of the men, Reginald could barely be heard commanding, "Enough! Hold!"

Reginald pushed through the thicket of his soldiers' blades and said

softly to Robert's grime-streaked face, "First, you young madman, blaspheme no more in this house or it is you who will be damned, and I will send you on your way to Hell the quicker. Men have been hung for less. Second, I am not responsible for your father's death and I will not suffer another such accusation to pass your lips. I warn you, Robert, formerly of Loxley, you are on the threshold. Your lands are forfeit. That is the law. As for Prince John's taxes, you will bring the money to me within a fortnight or you will come under the full punishment the law can mete. Is that clear?" He stepped back and touched Robert's hands meaningfully with the tip of his sword, as if he would cut them off. "Do not tempt me. I am lenient for that you were a soldier of Christ and a nobleman. Now get out of my sight." He turned and walked back to his throne.

Robert lunged after the Sheriff, but Will restrained him. With a shudder, Robert pushed Will aside, but he held himself in check, gave an abrupt, exaggerated bow and strode out of the hall with his friend.

Reginald scowled. The nobleman by the hearth broke the silence. "Who is this Loxley anyway? He looks like a commoner."

"Ah, Coucy, stop hiding behind the ladies, and come and play chess with me. I shall give no more audiences today." The Sheriff dismissed the court and the people swept away in a babble of delighted gossip.

Reginald went to a side table painted with a checkered board and sat down on the bench before it. "Brother Denys, lay aside your present work and write a letter for me to your Bishop of York."

Coucy frowned at the delay in the monk's scribing, but he went to sit opposite the Sheriff, who was saying, "Write to the Bishop that Loxley, the son, is alive. He has no money and I doubt he shall prove dangerous, but he wants his land back and he may have friends. It would be good if he were to find help from such friends lacking …. Ah, Queen's pawn, a typical start. You have so little imagination, Augustin."

⌘

8-ON THE MANY USES OF A STURDY WALKING STICK

*W*hen I get Loxley back, Robert told himself, I will clear my father's name, and my own, and rebuild the keep. The fields will yield their barley and rye; the mill will grind the corn. Peace will be mine again, as it was before, when I did not want it.

The Great North Road led them into Sherwood Forest, an infinity of alder and oak, blackthorn and yew, apple, ivy and mistletoe, and of every other tree and shrub once sacred to the Celts. To penetrate the cacophany of growth was as much a challenge for fox as for mortal man. Yet here a man might hunt rabbit or deer if he could not buy bread, and if he could avoid the King's foresters, he might well live to eat what he killed.

Day gave way to a drizzling grey twilight, and the wood on either side of the road seemed even more full of gloom and evil portent than usual.

"These woods are haunted," Cedric whined. "And ripe with thieves and murderers who will cut your throat for a penny."

"Then lucky we are to have no more pennies," Robert said. "Let's have no more talk of ghosts and thieves either, now."

"You shouldna have started this, Robert," Will said in a foreboding refrain. "You'll hang," he added with a definitive air.

"Oh, and where will you be?"

"Anywhere is better than here. A biting wind instead of a hearth fire, eating tree bark instead of roasted meat. Better they had killed me at Acre, along with the heathen. A quick death, with a good thrust to the innards, not a long slow starving them out. But no, I had to make my escape, and you had to help me, you bastard." He shook his head and trudged on beside Robert, who forebore to make an apology. Cedric followed them, beating his arms against his body in the struggle to stay warm. His stomach growled miserably, but he had long since eaten his mouse.

The further they went into Sherwood, the more ancient the trees, the higher they towered above, and the less undergrowth blanketed the ground. Knights could have joisted in the open spaces, covered by a canopy of tree

limbs. The wind sighed through the leafless branches, clacking them together with a hollow sound like empty gourds. Even when the wind was still, the trees creaked in the cold. Cedric started at every sound and whispered prayers to every saint he could name.

Robert gave up trying to calm his servant's nerves. He paused a moment, leaning upon the thick oak staff he had made of a broken branch, and surveyed the landscape. Then he nodded to his companions. "This way." They turned onto a deer track that led through a mat of dead leaves and broken twigs. The trail lost and found itself a dozen times, but Robert insisted it was the shortcut to Chesterfield. He only hoped his uncle still lived there. "He'll lend us horses and weapons—"

"Let him lend us money to repay Prince John," Will said.

Robert spat on the frozen ground. "And if I do repay the Prince? What of Loxley? Shall I beg the Church to return my own land? The Crusades have taught me well how likely Mother Church is to give up any of Her riches."

"But what will you do?"

Robert was silent. What else did he know but fighting? Would he hire himself out as a mercenary? He could almost see the blood spurting down his sword again, see the maggots swarming in the decaying bodies of the dead, smell the spoiling flesh, strong enough to taste. A soldier again, he would smell and taste and live it again, until it was his turn to die. What if his uncle and aunt were dead? What if they too had been turned out by the Church, for their kinship to his father? To whom could he turn? Who would give him shelter once they knew his name? Worse, whom would he endanger by asking for help? Even if his uncle still lived, surely Robert would do him a better turn by avoiding him.

He was no longer sure where he should go. He only knew he could not go back the way he had come, nor could he stay here in Sherwood.

Night fell. The three men built a fire and huddled together for warmth. The waning moon rose, barely visible through the trees, and under its baleful-seeming light, they took turns keeping watch while the others tried to sleep.

Dawn came with an aching slowness unmoved by Cedric's prayers, bringing more drizzle which soon turned into a hard rain bordering on sleet. In the morning light, everything looked different than Robert remembered it from years ago. Unsure of his destination, he was now unsure of the path that led to it. Impatient, grumbling, hungry, wet and cold, they took up the trail again, until they heard rushing water over the rain. Robert pushed ahead, knocked aside a curtain of vines with his staff and saw before him a turbulent

river swollen into a torrent from the downpour. He lay flat on the bank and lowered his head until he could lap with his tongue at the freezing water, his teeth aching with the cold. Will and Cedric joined him.

Then Will sat back on his heels and said for the tenth time that morning, "Robert, we are certainly—"

"Lost. All right, I admit it. Are you content?"

"Far from it."

"We must keep moving or we will freeze to death." Robert stood.

"We should have stayed on the Great North Road," Will grumbled.

Robert did not deny it.

They made their way downhill beside the river until they reached a place where the water dropped away in a crashing halo of spray and grey mist. To their joy, a few man-lengths this side of the waterfall, an enormous fallen oak spanned the river.

Robert stumbled and slid down the steep, muddy hillside to what he prayed would be a better path, made for men instead of deer, and leading where food might be waiting. He did not stop to think how he would pay for it, only envisioned roasted chickens blackened and dripping with fat, a whole goat turning on a spit, basted with rosemary, ale and honey, mashed turnips and parsnips steaming and buttery, lamb stew in thick brown broth with golden carrots and soft, pearly onions, juicy pasties stuffed with beef and chunks of potato, spiced with nutmeg and clove and thyme, platters of luscious grapes and dates and cheeses, and he saw himself eating out of each dish, a bite of one and a bite of the next and then the one after, and all the way around an enormous table to begin again with roasted chicken.

He swallowed a mouthful of saliva and wished his mind would stop taunting him with fantasies. At the moment, he would have eaten vulture meat. Had he not been forced to eat it more than once, starving in the Holy Land?

The fallen oak rested several feet above the water and sure enough, it was wide and worn on the top from years of many feet crossing it. On either end of it stretched a decent path.

Dizzy with hunger and panting from the descent, Robert waved to his friends and started across. Beneath him, the water rushed over the falls into a roiling froth in a rocky pool below, then pounded down the hill past boulders and fallen branches that only served to make the water churn more viciously instead of blocking its way. Robert breathed in the sweet, damp mist as if it were fresh cream. It seeped into his lungs and his skin like a tonic. Midway across the bridge, he thought he heard a voice, as if the river's rum-

bling made words. He chalked it up to weariness, though it was said that sleeping out under a full or waning moon could make one moon-mad. Perhaps he was losing his mind and hearing the river's spirit calling to him.

Then he saw the very mundane source of the voice. On the far bank, a burly black-bearded peasant in a soiled tunic, with a stout staff in his right hand and his eyes on his rag-bound feet, climbed upon the log-bridge.

Robert called out to him.

The man stopped his tuneless singing and looked up. "Give way!" he shouted and advanced a few paces.

Robert advanced a step or two himself. "We have come farther than you in crossing this bridge. Go back and wait your turn."

"Not bloody likely," snarled the peasant, his craggy face rough with hard living behind his black beard.

A swirling pressure rose to Robert's head, made of anger, hunger, exhaustion, and pride. Other men and events had taken control of his destiny and shaken him about like a field mouse in the sharp talons of a swift and ravenous owl. He had lost his father, his lands, his favorite sword, his title, his most recent horse, his last bottle of wine and crust of bread. He was losing his faith as well. All he had left was himself, and now he felt as if his very soul were being lifted from the firm earth and shaken about ferociously like a dying rodent in the jaws of Fate. With frustrated clarity of vision, he knew he must lose no more ground.

The man facing him was a good six inches taller than he, and as brawny and broad a man as Robert had ever beheld, with the single exception of King Richard the Lion Heart. But Robert hefted his walking staff in both hands and declared, "Give way freely or against your will, but give way you shall."

"Three against one? Brave man!" The stranger took another step toward Robert.

Robert motioned to his friends to stand back. "I fight alone. And when I win, you'll carry us one by one across the river upon your back."

"When I win, you shall swim for your life, you pasty-faced maggot!" With that, Black-beard lifted a horn that hung around his neck and blew loudly upon it three times, as if to announce a hunt. Then he raised his staff and advanced.

Robert waited until the last possible moment, then swung his staff high and met that of his opponent with a resounding crash. The blow shuddered through his arm and into his chest. He danced backward and parried several more of the giant's blows, his bones vibrating with the force of them, then

managed to smash the stranger in the thigh. But Black-beard stood fast and Robert was barely able to fend off another heavy blow toward his own un-protected head. Next he aimed for the stranger's belly, but the blow rebounded as if the man's stomach were a metal shield. Black-beard merely laughed.

So it went for a good half hour, the two men scrambling backwards and forwards on the foot-bridge, taking turns in gaining ground. Though Black-beard was stronger, Robert was faster, and he dodged blows and dished out many that did little damage but annoyed the big man until he roared.

"At least your shouts are more melodious than your singing," gasped Robert, managing to smack his opponent a glancing blow in the shoulder.

"Oh, is it so?" snarled the bear-like stranger, and he began at once to sing, terribly off-key, "Beggarman, nobleman, yeoman, priest, give me your money that I may feast, give me your horse that I may ride, the last to say nay was the last that died." He swung his staff toward Robert's head.

Robert ducked, feinted, and stomped on his opponent's foot. The singing turned to a loud yelp. Robert laughed and the fight went on without further musical accompaniment.

Will and Cedric watched from the river bank, Cedric calling out encouragement to his master, Will shaking his head. But then above the roaring of the river, they heard a shuffling in the woods and found themselves surrounded by half a dozen men, the same thieves who had robbed them on their way to Nottingham.

Will stiffened, preparing to fight with his bare hands, but the outlaws were watching the battle on the bridge and did little more than keep a disdainful eye on Will and Cedric, weaponless and outnumbered as they were.

"On, John!" shouted one of the thieves.

"Give him a drink, John! He's looking parched!"

"Aye, give the mucky bastard a bath!"

Robert was distracted by their shouts for but a moment, yet this was all John needed to ram him harshly in the chest with the blunt end of his staff and knock him off the bridge into the freezing torrent. It carried him over the falls in a flash. John laughed and the robbers cheered.

Will charged down the hill to Robert's aid, followed by Cedric wailing his master's name, and then by the thieves, who enjoyed this sport almost as much as the fight itself.

Robert's flailing arms and legs kicked free of the foam once or twice, and John himself hurried to shove his staff into the water, that his former opponent might take hold and drag himself to shore, but the river ran faster than any of them, and Robert was swept out of sight.

9-AN ODD FISH IS CAUGHT BY A GIANT HAND

Robert's shouts were torn out of his lungs as the river dragged him over the falls. His body smashed into the churning pool below. Freezing water and foam filled his ears, nose and mouth. The torrent carried him downstream. He struck out with his arms and legs, seeking purchase, fingers scrabbling at slippery boulders as they sped by. His head banged into a rock. Brain reeling, he vaguely felt his limbs bruising against more boulders. He was flooded with cold. A heavy thrumming sound filled his ears, accompanied by a strange whistling, like the high death cry of the raven, or the trilling of water sprites. This was no man singing out of tune, but the eerie lure of the Otherworld. Beneath the whitewater was green, then black. He was spinning downward into the abyss. His heart pounded with death panic, even as a corner of his mind saw the irony of being defeated, not by Saracen steel, Greek fire, famine, forced marches, desert heat and thirst, imprisonment or hanging, but by a scruffy Saxon peasant with a wooden stick.

He protested soundlessly, water filling his throat, and made a last prayer to the Merciful Lady.

A giant hand cupped his body in sharp bony fingers and lifted him out of the rapids. An oval patch of grey appeared vaguely above him, pierced at the edges with black lines. Cracks in an egg? He blinked as he struggled for breath, choking on water. Was it God held him in His palm, breaking open the sky and lifting him to Heaven? Yes, there were the heavens, swirling into focus, the bare trees alongside the river tracing the edges of the sky with their branches.

Shouting blurred over the pounding spray, "Grab hold and crawl, you numbwit!"

Robert realized he was caught in the branches of a birch which had fallen partway across the river in some recent storm. He turned his head and peered groggily toward the bank. A man in a black hooded robe was leaning on the bottom end of the tree trunk, which was balanced over another fallen tree on the shore.

"I won't hold this forever, man! Move!" the hooded stranger yelled.

Sputtering and shaking, Robert began crawling toward safety. The stranger helped him to the ground where he crouched, spitting up water. The man slapped him on the back, threw a sleet-dampened woolen blanket over him, then pulled out a leather flask and handed it to Robert, who drank the brandy deeply and gratefully, sat back in the mud and let the spirits warm him while he watched the world around him slowly spin to a halt.

Then he eyed his benefactor. The man's reddish-black beard curled down his chest like the ruff of a black lion, his dark eyes were keen, and under the folds of his robe, he appeared to have the muscles of a bull. He reminded Robert of statues of gryphons and gargoyles adorning the great new cathedrals in France, he was that ugly and yet enthralling.

Robert said, "Thank you."

The stranger nodded.

"I am indebted to you."

The stranger nodded again, with a look in his eyes as if to say that debt must be repaid.

"And what brings you to this river on such a foul day?" Robert asked.

"Fishing."

Robert raised an eyebrow at the joke. "What manner of monk are you?"

"Benedictine."

"That is no Benedictine robe you wear."

"Yet I am what I say I am."

"You may be the Devil Himself and I am still most grateful to you."

The monk smiled.

Robert said, "Yet I hope I don't owe you eternity in Hell in exchange for my life."

"Would you jump back in the river if that were so?"

Robert laughed.

"A gold coin would serve me better," said the monk, his hairy lips spreading in a grin.

"It would serve me well too, but everything I owned has been stolen."

"Yes, there are many outlaws in these woods. I find my poverty protects me better than swords," the monk added with an air of piety that seemed somehow false.

Robert spat on the ground. "There are outlaws in the towns as well, and worse ones in the churches. But I beg your pardon if I offend your faith, since you've saved my life." Robert took another swig of brandy and handed back the flask. "Well, we are both freezing. I'll be on my way. Walking will warm me, and if God grant I get your gold piece, I will bring it to you.

Where will I find you?"

"I am but a poor hermit, yet I have a hearth close by where you can warm yourself first and dry your clothes. I have bread."

"Not every hermit is so generous. I thank you once more."

"Come, then." His benefactor rose and set off through the woods, following no path that Robert could see. He hurried after and was hard pressed to keep up. The sleeting rain stung at his face, but the speed of their journey began to warm him. To his relief, it was not long before they reached the mouth of a small cave.

The monk ducked inside. He lit a torch and quickly brought the fire in the rude hearth from embers to a blaze, making the place almost cheerful and lighting it well enough so that Robert could examine his surroundings. The monk's bed was a pallet in a corner. There was a bench with an assortment of wooden bowls and cooking pots, mortar and pestle, flasks and phials. Against the bench leaned a longbow with a sackful of arrows nestled beside it. Several ropes had been strung near the hearth, tied at either end to piles of rocks. Dried plants of various kinds hung from the ropes. By the stone wall crouched a small wooden table and a chair. On the table were a bowl of apples and a loaf of bread.

The monk waved to the chair, bidding Robert sit and strip off his clothes, which Robert did at once with cold-numbed fingers, for they weighed upon him heavily, wet and cold.

The stranger hung them before the fire among the dried plants. At his touch, the ropes bobbed in silhouette before the dancing flames, which hissed and sparked.

Robert stared into the fire feeling as if he could not take another step. When his clothes were dry, however, he must go. Will and Cedric would surely be waiting, searching for him. He imagined he saw them by the river, calling his name. He imagined their worried faces in the fire, and squirrels and bats among the herbs, and the smiles of leering outlaws mingling with the empty eyesockets of the thousands of dead at Acre, and the shapes of vultures swooping down upon them, and owls with golden eyes shooting out of the fiery antlers of a stag.

He realized the monk had taken another woolen blanket and was rubbing him dry, limb for limb and lovingly, even to every toe on his feet, yet his body felt like cold lead. He sat there weak as a lamb and let the man tend him. The last thing he was aware of was being lifted from the chair in the monk's strong arms and being laid onto the pallet, where he finished his fall into a raging fever.

10-PENANCE
HARVEST MOON WAXING, 1192

ven from a distance, the abbey at Fontevraud in the broad valley of the Loire was impressive. Peeking above its thick outer walls was an array of unusual domes and stone-roofed turrets that proclaimed a town unto itself, boasting separate buildings for nuns, monks and fallen women, as well as a hospital, a leper colony, several chapels and a church, the kitchen and refectory, gardens, stables and more.

At noon on this perfect autumn day, with the air crisp and the sky blue and the leaves of the trees golden as the sun, Sir Reginald of Nottingham rode in state through the main entrance of the abbey into the large courtyard. He and his entourage were welcomed serenely by the prioress and the Sheriff was led to a pleasant room in the visitors' hostel. He was duly wined and dined with abundant fare served on silver plate, a gleaming reminder of the riches of the Order and a far cry from the original charter, which called for, among other things, poverty.

He slept that night on a goose down pallet and embroidered white linens made fragrant with lavender brought from the warmer climes of the continent. The morning brought mass and a hearty breakfast of warm breads, fresh-churned butter and cheeses, a lengthy and somewhat monotonous tour of the grounds with a stiff-mannered monk, followed by a lavish luncheon, followed by several hours of rest, and all this on the excuse that the abbess was too pressed to meet with him as yet, and worse, his ward was in seclusion doing penance for some infraction of the convent's Rule.

Reginald scowled inwardly at this evidence that his ward still behaved like a postulant to the Order, but he endured the delay with a pretense of good humor. Let these conniving women think they could toy with him. He would not be swayed from his purpose. Besides, the food was excellent.

The second day he went hunting in the surrounding forest with his men and brought down a buck with practiced ease. He offered it to the abbey's kitchens in a false gesture of goodwill.

At last, late in the morning of the third day, he was led by a silent nun past the cloisters and the domed abbey church, along a colonnade to a se-

cluded office. The nun announced him and stood by the door as he entered the chamber.

The abbess was seated at an ornately carved and highly polished wooden table covered with parchments. She rose and came toward him with a faint smile. She was younger than he had expected from the tone of her letters and her high station, though it was hard to tell her age for certain with the habit revealing only her hands and face. He bowed, though not too deeply, and was irritated that she did not return the bow, but held out her hand for him to kiss the ring, as if she were an archbishop. Perhaps a flock of unmanned monks was willing to be subservient to a woman, but the Sheriff was not. He took her hand but did not kiss it, only bowed over it again briefly.

"I trust my ward is now ready for her journey to her homeland," he said in the local dialect, seating himself in the chair the abbess indicated.

"How well you speak the language of our country, Monsieur. We are honored that you chose to come for her in person," said the abbess as she glided back to her desk.

"There is no one alive who could care more for her best interests."

"Do you think so?" asked the abbess. "There are many here who have come to love her and to know her well. We have shared in her joys and sorrows, her struggles, her triumphs. Those who love from afar often love with their imaginations, or perhaps with their memories, rather than with their hearts. One might say they love their own thoughts after a time, perhaps more so than the original source of their devotion."

"And is this how you feel about your love of God, far away in His Heaven?"

"God is everywhere, Monsieur," the abbess replied calmly.

Touché. Sir Reginald smiled. "You contradict the heart of chivalry and the *chansons* of the troubadours with such sentiments about earthly loves. I'm surprised to hear it from a woman of Aquitaine, be she nun or blushing maid. How many knights have risked their lives for their ladies, loving them from afar and never knowing them, shall we say, intimately?" He wondered if his reference to carnal knowledge would offend the abbess, but he was sorry to see that she remained completely in control of herself.

"I have often had cause to question the kind of love that requires bloodshed and often death to prove its constancy," said the abbess, who had come as a widow to Fontevraud.

Reginald abandoned the flowery repartee. "I have come in person to ensure that this time my ward will not delay her journey back to England."

"We will miss her."

Reginald chuckled. "You will miss the fantasy you have cherished for so long of getting your hands on her dowry."

"No, *Monsieur*. You wrong us. It is true that we have many rich noblewomen here who forsake the world to join our Order. We receive many dowries and widows' fortunes, and as you no doubt know, we benefit greatly from the charity of Queen Aliènor of Aquitaine, may Our Lady reward her generosity in Heaven. Your ward's inheritance is ample enough, but it is of small consequence to us, who value her soul. She has turned into a beautiful woman in the nine years since you last saw her." The abbess emphasized the 'nine years.' She gestured to the nun who waited by the door. The nun slipped outside.

"What infraction of your Rule was my ward punished for?" Reginald asked.

"That is between her and her confessor, *Monsieur*."

"Surely she has not dallied with a man!"

The abbess said coldly, "Her purity is unsullied. Any more than that, she must tell you herself, if she so chooses."

"Do you play chess, *Madame l'abbesse*?" asked Reginald, thinking she had the mind for it.

"I have little time for such worldly pursuits." She smiled.

"What a pity," he murmured.

A rustling at the door bade Sir Reginald turn.

She wore the dress he had sent her last Yule, an emerald green robe with wide embroidered sleeves over an under-gown of pale green silk. Her dark curls were mostly hidden, he saw with distaste, by a stiff white linen wimple covered with a gauzy white veil, crowned with a plain circlet of brass, a fashion affected by Queen Aliènor to hide her aging chin, and adopted, to their detriment, in Reginald's opinion, by noblewomen in several countries seeking to emulate the Queen. Of course, the Queen's circlet would be gold, no doubt.

The girl's face was screened modestly by the veil, yet Reginald noted with approval that the scrawny urchin he had sent to Fontevraud for her upbringing had grown well into womanhood, with round, swaying hips, swelling breasts, and the barest curve of a belly beneath the green silk gown. Her pale fingers tapered delicately, unadorned by rings, and the tight sleeves of her under-gown showed to good effect her graceful arms. The alluring form curtseyed deeply to the abbess and then to Sir Reginald.

The abbess said, "Lift your veil, my dear, that your uncle may see you."

The white hands swept up gracefully and drew back the veil.

Reginald rose, his mouth slackening in surprise. "Maerin! How lovely you are!"

Her features were a mix of her Celt and Saxon forebears, with perhaps a bit of the fey in her elfin chin and dark hair, a stray strand of which had escaped her wimple. Her high forehead bespoke a clever mind. Her eyebrows arched gently, darkly setting off stunning blue-green eyes flecked with hazel. Her cheeks rounded prettily towards the chin that was perhaps a bit more narrow than the current fashion but which looked charming on her, especially when her soft rosy lips parted and she said in a melodious voice, "Hello, Uncle."

Reginald took both her hands in his.

She did not return his smile. Her clear eyes observed him coolly and he had the uncomfortable sensation that his soul was being probed and perhaps found wanting. But she was respectful enough on the surface, and pretty, and that was all that mattered. Let her save her warmth for her husband. "I trust you received the travelling clothes I sent you."

"Yes, thank you, Uncle. Though the cloak does not really suit me. I do not like crimson. It is too gaudy for me."

"*Mariane,*" warned the abbess gently.

"Small matter!" said Reginald, clapping his hands together. "We shall have a dozen seamstresses to prepare your trousseau and your wedding gown. You may have everything designed to your taste." So she did not care for crimson—well enough; it was the most expensive of dyes.

"You are most generous," she said.

"Not at all!"

A brief lift to her eyebrows made Reginald suspect that she agreed with him, that she knew his generosity was based on his expectation of reward. For of the several nobles Reginald had entertained for his ward's hand, he had chosen the one who promised him the largest portion of Maerin's dowry as soon as the marriage was consummated. Yet Reginald was certain there was no way Maerin could know this. Well, surely she could not expect otherwise. He deserved some recompense for caring for her all these years, and he needed the money. The harvests had not been bountiful in the past several seasons and his estates often cost more than they brought in. And then there were the taxes, ever-increasing, and bribes, and all the other accoutrements of owning a high office in England. So Maerin was perceptive; that was not always a flaw in a woman as long as she knew her place, and what maiden had illusions about the motives for noble unions? "I regret that your intended was unable to join us here at Fontevraud," he said. "I am sure you are

eager to meet your betrothed."

"You will find that one of the things your ward has learned with us is patience, Sir Reginald," interjected the abbess, adding with a laugh, "and believe me, it was not her easiest subject! Music, Latin, geometry, astronomy, ethics, logic, needlework, archery, riding—all her lessons came to her quite naturally. But it is often so with the things of the world. It is the inner qualities, the virtues of heart and soul, that are so much more difficult to achieve. Do you not agree, Sir Reginald?"

He bowed slightly, not caring in the least and wishing the irritating creature would stop pontificating.

The abbess stood and held out her arms to Maerin. "Come to me, my child, and kiss me *adieu*."

"I will leave you to say your good-byes," Reginald said. "We depart at once," he added firmly to Maerin as he left the room.

Maerin knelt before the abbess with head bowed, and kissed her ring.

The abbess bade her rise and said, "Did you find your solitude enlightening?"

"Yes, Reverend Mother."

"Good."

Maerin looked up, but the abbess held up a hand. "We will speak no more about it."

Maerin hesitated, then said, "Will you not change your mind and keep me?"

"Dear one! I know your words arise from your piety and dedication instead of your old intractability. It has given me great joy to see you transformed from an obstinate *sauvage* who preferred toy swords, climbing trees, and swimming—nude, if I recall!—into an intelligent young woman devoted to Our Lady. Yet I think there remains in your nature that which would revel in the world if you were but introduced to it. And who knows but that your religious devotion might inspire others to a more profound worship? It is time for you to challenge your spirit, to meet your fate and fortune. Your duty now extends beyond these walls."

"But, Reverend Mother, I have prayed and prayed—"

Once more, the abbess held up a silencing hand. "The peace you have finally found here … carry it with you in your heart. Adversity and joy are the weft of life, and this peace is the warp. Make of your life a fine tapestry, my darling. Remember to write me, remember your prayers …." Her voice trailed off as she saw the color rise in Maerin's face. The abbess abandoned her somewhat impersonal religious counsel and spoke more to the point.

"Even if I believed your fate lay here, which I do not, your uncle will not change his mind and he will not postpone marriage a second time. You are already seventeen. You know that most women are married much younger. Your uncle has kindly consented to a long engagement, but only because you have been so sheltered from the world here. You were lucky your first fiancé died in jousting. It gave you a reprieve, did it not?"

A mischievous smile briefly brightened Maerin's face.

The abbess continued, "I hear he was a rascal. This Augustin de Coucy I do not know, though I believe he has a very rich and powerful cousin in Picardy, who in fact challenges the throne of France from time to time. You will be allied, though distantly, with a powerful house."

"God's House is the most powerful and it is the only one I care about!"

The abbess smiled at the girl's fervor. "Who knows? You may find marriage to your taste. I myself rebelled at first, but then I learned to love my husband. If you do not … well, with any luck your future spouse will be a bold and adventurous knight who will not be much at home!" The abbess laughed. "Then you will be charged with defending your manor, and be a warrior, like Matilda of Boulogne or our own Aliènor." She took Maerin's hand and pressed a hard object into her palm. "Take this, in remembrance of the Lady who travels with you. Now go, your guardian awaits you."

Maerin opened her hand. Nestled in her palm was a small cross carved of ivory attached to a rosary of tiny ivory beads, each engraved with a perfect rose. Maerin's eyes filled with tears. She pressed the holy keepsake to her lips, and unable even to murmur thanks through the storm of emotions that besieged her, she fled from the chamber.

The abbess sighed heavily, shook her head, and returned to her desk, where, after a moment's consideration, she reached for a blank piece of parchment and her quill. She had been vacillating about this for weeks, as if afraid of the answer she might receive. For whatever the reply, she had no power to change Sir Reginald's purpose. Nonetheless, she began to write a letter to a sister convent in Normandy. Perhaps the abbess there would have knowledge of the character and bearing of this Augustin de Coucy. Perhaps it would be good news and comfort her heart.

⌘

11-MAERIN'S SOUL REVEALED YET RE-
MAINING UNSEEN
HARVEST MOON WANING, 1192

They arrived in Nottingham on a wet, windy day, and Augustin de Coucy's first glimpse of his fiancée was of a cloaked, mud-spattered creature whose cheeks were rosy red from cold, not blushes, and who offered Coucy, not a dainty hand to kiss, but only a frank, serious stare. Then she was swept into the spindly arms of her lady-in-waiting, Elgitha, once her childhood nurse, now middle-aged and prematurely grey, and fairly shrieking with amazement and delight at how her duckling had grown into a swan.

Upon feeling the swan's forehead, however, Elgitha called for buckets of hot water and herbal tisanes, and bundled her up the winding stairs to her bedchamber, from whence the swan did not swim forth for some time, being sick with a fever. Maerin was cosseted with the best doctors and Elgitha's bitter brews, but her recovery was slow, her dreams were like hallucinations, and she cried out for the Abbess in her sleep.

Meanwhile, Coucy fidgeted and Reginald was gruff, for if she died unwed, the dowry would go to the Church after all, and neither of them would benefit.

It was two days before All Souls' Day, and the servants were furtively crossing themselves and scattering cloves about the doorways to keep evil spirits from entering when Maerin finally made her first public appearance at the annual banquet offered for the guilds, to celebrate the season, and this year, her belated betrothal as well. The local nobles made a respectable showing, and the peasants outside the castle wall rejoiced in their portions of meat and ale, a charity performed always on holy days, and doubled this night because of the marriage banns.

A small army of servants bore down on the Great Hall bearing huge trays piled with tureens of soups both sweet and tart, platters of figs stuffed with boiled eggs, mutton stewed with figs and apricots, roast boar, venison braised with honey, whole poached fish seasoned with rose petals, pheasant with herbs, and an endless array of vegetable dishes.

Maerin hardly tasted the food, her throat still raw from her illness.

Her uncle and Coucy, seated on either side of her at the high table, spoke more to the guests than to Maerin, yet knights and ladies and guildsmen gazed at her and smiled and lifted their cups to toast her until she began to feel like some ornament or portrait, meant to be admired, but considered to have no powers of speech. At first she found this infuriating, but soon discovered it was soothing, for meals at the abbey had been conducted in silence except for the quiet reading of the Holy Scriptures. So here also, she was not required to speak, but could lose herself in contemplation.

Talk in this English court, however, veered far from religious themes. The fine points of hawking and gossip about people unknown to her being the order of the day, she closed her mind to the conversation, finding it by turns boring or offensive.

She had plenty of time to steal sidelong glances at her fiancé. He was what some would call dashing, she supposed, well-dressed, handsome, and carrying himself proudly. Yet there was something subtle about the look in his black eyes that suggested more the fox in the henhouse than the upright knight about to be united with a lady fair. Naturally he wanted her money; that was the way of the world. But she prayed there was more to him than that. She would not be quick to judge, she told herself, as if hearing the voice of the abbess in her mind.

Between the pheasant and the salad course, she dabbled her greasy fingers in a silver bowl filled with water and slices of lemon. Coucy put his hands into the bowl as well, and their fingers gently touching, he began to stroke her fingers clean. She felt a pleasant tingling go up her arm, which surprised her, but she knew she should not allow such familiarity so soon, and in public. It was unseemly for him to have tried it. She stiffened and withdrew her hands.

He was rewarded for his boldness by the sight of her blushing.

By now, the company had drunk a great deal of wine and port, cider and ale, so when a *jongleur* appeared and began to sing a bawdy song, to the shouts and laughter of the guests, Maerin excused herself, saying her recent illness had made her weak.

In the morning, she went to mass and confession, and spent the day in prayer, for she wished to prepare herself for All Souls' Day. It was not until nightfall, therefore, that Coucy had a chance to see her, let alone woo her again. Not that he need woo her, for the contracts had been signed, but he had always enjoyed the chase.

The two were left in privacy in a chamber on the third floor of the

central keep. Elgitha sat sewing outside the door, within earshot.

"Would that it were spring and we could sit in the garden," sighed Maerin, standing before a high, narrow window and imagining the bare thorns of the rosebushes and the dying herbs in the walk beyond. The curtain wall was a shadow looming against the night sky, the crenellations blotting out stars in an even patchwork, like the ghostly teeth of some otherworldly beast. "Already I long for a breath of spring, and winter has barely begun."

"Were we in that spring garden, I would pluck you a budding rose to match the color of your lovely lips, and snowdrops to match the whiteness of your skin." Coucy bowed gracefully.

Maerin didn't notice. "Yet whiteness of skin cannot compare to purity of the soul," she said softly.

He held back a snicker. "Most assuredly."

She went to a chair. At once he came to sit beside her on a low backless bench covered with red velvet cushions. He gazed up at her prepared to say more pretty things, but she did not spare him a glance, only sat with her hands resting in her lap like the folded wings of obedient birds. She felt his eyes upon her and looked over at him at last, and now the bird's wings twisted uncomfortably as if they would take flight, but could not. He smiled, amused at her shyness, and felt a growing hardness between his thighs. It would be a pleasure to take such a modest, unworldly thing and make her open to him, make her cry out, to feel her soft body writhe beneath him.

"You do not speak," he said in his gliding Norman accent, making a show of concern. "You are tired, perhaps?"

"No, *Monsieur.*" She hesitated, at a loss for conversation, then asked, "Shall I tell you the legend of the garden?"

"Please do," replied Augustin, stretching out his legs and reaching for one of the goblets of wine that sat on an inlaid table beside them.

Having heard this tale more than once as a child, Maerin had told it a hundred times to the other girls at the convent, late at night when they were meant to be sleeping. It had never failed to bring chills to their spines and romantic tears to their eyes. She took a deep breath and began. "When this part of the castle was first built generations ago, there was not even a village here, much less a town as you see today. All around lay the wild woods. The lord of the castle planted the garden inside the battlements for his wife when she was carrying their first child, for he did not like her to roam outside the castle walls. It was said she was of Faerie blood, and her husband had stolen her, and feared the Faerie Folk would steal her or her child back to them.

"Soon after the first roses bloomed in the garden, their child was born a

daughter. The father swore at the girl's birth; he had begged God for a son and heir. But several years passed and no son was given to him. Then his wife died, some say of illness, some say of loneliness, some say of longing for her freedom. In his grief and anger, the earl swore revenge on his dead wife's people, whom he believed had cursed him. He fought with every earl and thane who clung to Pagan ways, and in truth, the hand of God was with him, for he suffered not even a scratch no matter how many battles he fought, or how fiercely.

"Meanwhile, his child grew into a maiden. Her name was Aelfleda. Her nurse and her maidservants weaned her on stories of her mother and eerie tales of the Faerie Folk. Her head filled with this nonsense, she vowed to find her supposed kin. One night, when her father was away fighting as usual, she dressed herself in peasant rags, stole out of the castle and foolishly went to the wood, knowing it was Beltane, the eve of the May rites of the Old Gods. True to the tales, she smelled the bonfires burning and, following her nose, came to a great fire hidden in a clearing in the wood. There were scores of people there, peasants and villagers, and if the tales are to be believed, pixies from the hills. They welcomed her as if she were one of them, and perhaps indeed she was, for she danced for hours without tiring, and leaped the bonfire with them, shouting out her cares and sorrows and loneliness, leaving them behind her, for burning in the flames.

"Among the revellers was a handsome young man from a nearby village, a peasant farmer's son. In the heat of the fire, of youth, of the dancing and the passion of May, the two fell into each others' arms and sinned together in the wood."

Augustin smiled. Maerin colored and wished she had not chosen to tell this tale, but now that she had begun, it was too late. "In the morning, in the clear light of day, the young maiden begged the lad to marry her before a Christian priest, and so give sanctity to their union. He loved her so well, he agreed. She bade him come for her in seven days' time and ask the lord of the castle for the hand of Aelfleda. Then she hurried home.

"Her father returned the next day from his warring, and she told him a nobleman was coming to ask for her hand. She promised her father a grandson to be his heir, but she dared not say she had already met her lover, or where, or that she had already let the seeds of that grandson be sown in her, for she desperately feared her father's wrath.

"Her father, who had spared little enough attention for his daughter in the past, said he was content to marry her off to the first nobleman who appeared. Grateful and also terrified, the princess summoned a tailor in se-

cret and caused a noble suit of clothing to be made, with the tailor working night and day to finish it. She wrapped the clothes in a sack of burlap and sent them to her lover in the hands of a loyal page, who memorized a message begging the farmer's son to say he was of noble blood, and schooling him as to all the things he should say to support his claim, that he came on foot because he had lost his horse and his purse to brigands, that his retinue had fled in fear.

"Then she waited, watching by this very window when it rained, pacing up and down in the garden when the sun shone, so pale and worrisome her ladies feared she was ill.

"But as if her words of brigands had somehow foretold it, the page was murdered by outlaws in Sherwood Forest, and the noble clothes made garments for thieves.

"On the seventh day, as he had promised, the farmer's son arrived, freshly bathed and in his best garments, and asked to speak to the lord of the castle. He was led into the Great Hall, and bowing before the earl, he asked for the hand of Aelfleda. The earl, seeing the lad swordless, in his scuffed boots and peasant's tunic, roared at his impudence, and called his daughter to him. The serf saw to his utter dismay that his darling was no scullery maid or serving wench, as she had pretended to be on May Eve, but a noblewoman dressed in silk and lace.

"But you are a princess!" exclaimed the lad in shock. "You did not tell me so by the Beltane fires!"

"Enraged at the boy's presumption, and his Paganry, and at his daughter's wantonness, the father wasted not a breath, but ordered the lad to be put to death. At once, a guard struck the serf's head off with his sword, and the bleeding corpse was dragged away in a trail of red, the head rolling across the floor, eyes frozen wide with horror, and Aelfleda screaming.

"The earl ordered the serf's handsome head to be stuck on a pike in the garden just outside these walls." Maerin turned her gaze toward the high, narrow window. "There it stayed while the four winds and the sun and the rains wore at it, and the birds and the insects tore at it. But the maiden Aelfleda did not live long enough to see the skull emerge from the flesh, for as soon as she returned to her chamber after the murder of her lover, she slit open her veins from elbow to wrist and bled to death in her bath."

Maerin paused for effect, then finished the tale. "On finding his daughter dead, her skin stained with her own blood, her long hair floating upon the water above her bloated body, the earl believed himself to be truly cursed. He gave up his warring and became a penitent, wandering in rags toward the

Holy Land, begging for his bread. This keep fell to ruins for three generations, until a new lord was brave enough to claim it, and paid three holy hermits three gold coins each to sprinkle it with holy water and exorcise the demons. Still, it is said that a ghost comes to this garden at midnight on the eve of a day when some injustice will be done. They say it is the ghost of Aelfleda, bleeding and weeping eternally for her lover, giving warning to those who will suffer as she did."

"A gruesome tale," said Coucy, thinking this was hardly the sort of preliminary flirtation he was used to with women.

"I thought I saw her once when I was a child," said Maerin with a trance-like air of foreboding. "She was dressed in white and was dripping red blood."

"You were an impressionable girl."

"I closed my eyes in terror and when I opened them again, she was gone." Maerin looked down at her hands resting in her lap. "But the next day, just as legend would have it, a terrible injustice occurred. I was sent away to the convent at Fontevraud, and my life and my dowry were given into the hands of my uncle, for my father was dead."

Coucy choked on his wine. A mischievous smile played upon Maerin's lips. Seeing it, Coucy recovered himself, laughed and complimented her storytelling, bizarre though it was. Heartened by his laughter, she said, "Tell me something of yourself, of your family. I know so little about you."

"There is little to tell. My mother and father died of illness. My elder brother inherited the estate." Seeing Maerin was not satisfied with this answer, Augustin began to relate several of his adventures in tournaments, embroidering his exploits to make a richer story.

She listened politely, saying, "Oh," and "Ah," in the appropriate places, then asked who taught him his battle skills, and if not his father, why not? And if his father had not financed the upkeep of his horses and squire, then who? And then she remarked how generous his brother was.

Coucy frowned, remembering the vile argument that had preceded his brother paying him off to leave the estate. "Tell me of your life in the abbey," he said, to get her prying mind off his affairs.

She told him of the daily cycle of prayers, the studying, the Rule of the Order, the endless quiet, her memories then prompting her to speak more intimately, pushing away the thought that she was talking too much. "I used to feel I was buried alive in a huge grave filled with ghosts wearing habits. I kept trying to run away but I was always caught. How I was made to pray in penance! And scrub floors and suffer the birch cane! I finally gave up trying

to escape. I still slipped away, though, at times, late at night, but I'd always return to my bed by morning. I'd climb over the wall by the refectory, where the thickest vines grew. I'd run through the woods pretending I was a deer, or that I was one of the King's foresters, scouring the woods for poachers." Maerin smiled as she remembered her secret pleasures, little realizing that to one who had risked his life in jousts and sleeping with other men's wives, her adventures sounded silly, and worse, unwomanly.

She continued, lost in her thoughts, trusting Coucy's silence to mean interest. "One night, I came to the strangest place, deep in the forests by Fontevraud. Enormous stones were piled upon each other like runes cast by giants, and the moon shone upon them—it was full that night—and the shadows and light made patterns like doorways, as if the stones were sentinels guarding the entrance to another world. I was drawn to them and frightened at the same time. I wanted to run away but I couldn't. My legs felt rooted to the spot, as if I were under a spell or enchantment. I began to say my rosary and then … then I heard a voice … a Lady's voice. She spoke to me and Her voice was so beautiful it brought tears to my eyes. And the things She said … that was the night I gave my soul to the Virgin Mary and vowed to serve Her with my life!"

Maerin barely realized she spoke aloud. Now her own ardor woke her from her trance of memory, and a wave of embarrassment washed over her. She had never spoken of the episode in the woods to anyone, not even to the abbess, who had simply remarked a change in Maerin's behavior with relief and approval. Well, if she could not confide in her future husband, to whom could she speak truly of her heart? Let her know now whether or not he was a man of understanding. To break the silence in the chamber, Maerin added, "I never went back. I was afraid She wouldn't be there."

But Coucy was staring into his wine cup and seemed not to have noticed that she had stopped talking.

"I fear I'm boring you," she said loudly, rising to her feet.

"Not at all," he said, looking up at her as if he too were waking from a dream, for at mention of Fontevraud, he had thought of Isabeau, and Maerin's soft voice had lulled him into the distant landscape of Normandy and his own memories.

"I hate people who lie!" Maerin fled to the window. Ashamed doubly for having revealed her childhood secrets as well as for this impetuous outburst, she nonetheless stubbornly sought Biblical support for the latter, and quoted, "'Thou shalt not steal, nor deal falsely, nor lie to one another.'"

Coucy snorted. "Quite honestly, I have never been obsessed with reli-

gion and I don't find your Christian fervor to be the greatest of your charms."

"I have not set out to charm you," Maerin replied, flustered.

"But why not? We are to be married. Is it not better to charm me than otherwise?"

"It's hardly necessary, is it? I am nothing more than a cow or a sack of grain, to be bartered to the highest bidder. And you, it seems, have already bought me."

He was amused at her fit of anger and her prettily flushed face. His eyes narrowed to slits as the heat in his groin rose. He smiled. "Believe me, milady, you are nothing like a cow."

"Oh, yes, I am exactly like a cow! A well-dressed one, covered with baubles and smelling of rosewater, a prize cow on market day!"

Coucy laughed, but she did not soften or laugh with him. She was a prickly thing despite those rosy lips and delicate hands. Had she ever been alone in a room with a man? Clearly those stupid nuns hadn't taught her how to treat a suitor, much less her betrothed. "Please understand me, Maerin. I find you so irresistibly charming, the comparison to a cow—"

"Oh, you retreat to 'charming' again. I see you have a limited palette when it comes to painting a portrait of your feelings for me." She was being ridiculous and she knew it; he could hardly have had time to come to know her. But awareness of her own fault only made her more angry. She turned to stare out the window again.

Coucy's face clouded. He finished his wine, then took her goblet and drained it as well. He was unused to such bristling from a woman, unused to his well-schooled advances being spurned in this manner. Even Isabeau, the she-devil, had always led him closer step by step, day by day, though always keeping him just far enough at bay so that he could not claim her.

Isabeau. He didn't want to think of her. He had a fiancée now, an attractive one too. He would think of Maerin instead.

He got up and went to her, grabbed her by the shoulders, swung her around to face him, and kissed her firmly on the lips. She gasped and struggled briefly in his arms, and he kissed her harder. She stopped struggling and he thought with pleasure that she was giving in to him, when he felt her kick him hard in the shins. Surprised and in some pain, he held her tighter, drove his tongue into her mouth and watched with excitement as her eyes widened in shock. Her muffled moans grew louder, her struggling more desperate, and he almost had to dance to avoid her kicking feet. He wanted to laugh at her clumsiness, he wanted to squeeze her breasts and grind his hips against hers, but he resisted the temptation to go too far, even as the swelling in his

loins grew more urgent. Time enough to take her after the wedding. At last he would have a woman of worth who could not refuse him.

Just then she bit down on his tongue, wound her foot around his ankle, shoved him with all her weight and knocked him sprawling to the cold stone floor.

"Elgitha!" she screamed and ran to the door, then swirled back to face him. "You're a fiend! A pig! I'll never marry you!" And she spat and cursed him in three languages in a manner hardly fitting for a lady. Coucy laughed, wiping the blood from his mouth.

Elgitha ran into the hall, a worried expression on her face. "What is it, milady?"

"I was merely testing my future bride," Coucy said, getting to his feet and straightening his tunic over the bulge in his crotch. "I admire you, my betrothed, for protecting your virtue, as becomes your station. And I can see now that you are much more than merely charming. I have always liked women of spirit!" He strode past the two women and out the door, grinning his fox's grin.

Maerin sank to the floor at Elgitha's feet and told in fits and starts how he had forced her.

"There, there, dear one," Elgitha said, petting Maerin's brow. "You'll get used to it."

"Get used to it?! Never!" Her eyes filled with tears. "I'll never marry that cur!"

"It was naughty of him to woo you so roughly," Elgitha crooned. "There, now, my duckling, come to your chamber and I'll give you a nice salt bath."

"Salt!"

Elgitha babbled, "Never you mind about the salt, I'm as good a Christian as anybody. But there's nothing better soothing to the heart than salt water, unless it be fresh rosewater, but it's not that time of year," she said, helping Maerin to her feet. "You'll get used to him, milady. Mind, you're to be married and soon he'll have the right."

Elgitha's words chilled her and her stomach turned. No, she could never marry this Norman fox. She would speak to her uncle. She would take a hot salt bath tonight to calm her and cleanse away the feeling of defilement that clung to her mouth and breasts, and she would speak to her uncle in the morning. She would give him her dowry, all of it, and she would ride south and sail across the Channel. She could be back in Fontevraud before a fortnight was out, and there she would take the veil and fulfill her promise to the Lady.

12-THE HANGED MAN
HUNTERS' MOON, 1192

"Don't be absurd," Reginald chuckled, but stopped in mid-laugh at the sight of the misery on his young ward's face. Of course he could not take her request seriously, but he didn't want to cause her undue pain. He cleared his throat and motioned to his valet to continue dressing him.

Maerin had hoped to have a moment alone with her uncle, but he insisted they talk while he was being dressed, for he was planning to tour his nearby estates and would be gone until nightfall. She thought her heart would burst if she had to wait all day to speak with him, so while the valet adjusted the folds of his surcoat, she begged him to take her dowry and set her free. Now his mocking laughter burned inside her like a brand.

"Maerin," he said, "even were I to agree to your impetuous offer, Fontevraud will not have you penniless. But I will not go back on my word. Your marriage contract has been signed."

"I have not signed it!"

"Your signature is not required," he said, shrugging his chain mail into place. "You are legally betrothed. I'll not fight a war with the Coucys over you, as if you were Helen of Troy. You are lovely, but not that lovely, my dear. And believe me, Fontevraud would not join in that war."

Maerin faltered, not knowing what argument to pursue. "I ... I cannot marry him, Uncle. He is ... I could never love him."

"This is marriage, not love! What did that witless abbess teach you? I should never have sent you to the land of the troubadours."

Maerin flinched at hearing her beloved abbess spoken of so rudely.

"I'm losing my patience with you, Maerin. You have delayed your marriage long enough. It's unnatural. I've a mind to marry you off at the next full moon."

"Oh, no, please, Uncle!"

"You'll do as you're told. Now," he waved his valet away, "Coucy is going with me today. You may join us if you wish."

She took a deep breath and said coldly, "No, thank you." She was going to stalk off to her chamber when she thought better of it. Forcing herself to sound obedient, she curtseyed to her guardian and said, "I can see I have been in error, Uncle. I bow to your wishes. Only do not make me wed at the next full moon. My gown is not ready."

He chucked her under the chin and said, "That's better." Leave it to a woman to think of nothing but her gown! He cursed his dead brother for saddling him with the girl, but reminded himself somewhat guiltily that without her, he would not stand to become quite so wealthy, and without having to wed some wealthy bitch himself. Women: heaven to bed, purgatory to wed.

Alone in her chamber, Maerin paced, stopping now and then to gaze through the stained glass window. The light of the grey dawn weakly illuminated the diamond-shaped panes of pale green, gold and white, which cast not even a faintly colored glow upon the stone floor this gloomy day.

If the abbess knew of her troubles, surely the Merciful Virgin would move her to take Maerin as a postulant, with or without her dowry. But what if her uncle was right and Fontevraud would not have her?

Maerin began pacing again, then stopped at the foot of her bed. She shuddered, remembering how Reginald had laughed at the liberties Coucy had taken, saying such behavior was ill-advised but hardly surprising in a hot-blooded young man about to wed a pretty lass. Reginald had smiled and said, "Of course he is eager."

She kicked the bedpost. If that Norman fiend thought he could mount her like a stallion on a prize mare! With no mark of tenderness or even pity for her virgin state! She would tear out his eyes in their marriage bed!

She threw herself onto the bearskin that covered the fine linen bedclothes and stroked the rough-furred head down to the bared jaws, her fingers tracing each of the sharp teeth. She imagined those jaws biting into Coucy's neck, imagined the blood spurting. She shivered at her own monstrous thoughts, sat up, wrapped the skin around her and rocked back and forth for a moment, then threw off the skin and ran to her writing table.

She would not be defeated before she even tried. She would not let Reginald frighten her, despite his massive size and being High Sheriff and her legal guardian. If she ever set eyes on the contract that made her Coucy's betrothed, she would throw it in the fire! In the meantime, she would send a letter at once to the abbess.

⌘

In the hills, below the seamless grey of a clouded sky, the last clumps of

purple heather set off the brown of dying gorse. The fields were picked clean, the refuse ready for burning, the smell of smoke for preserving meat filled the air. The serfs bowed their heads to Reginald respectfully enough; he was a better master than some.

But he was not pleased with the year's harvest. The seasonal butchering of farm animals meant more cured meat for winter, but less stock for breeding in spring. There had been too many lean years in a row. The rumble in his stomach seemed more than the result of a tardy supper, but rather a warning of hungry months ahead. It was all he could do to make a show of forbidding the poor to build bonfires and celebrate All Hallows' Eve in the old way instead of going to mass. Most would likely do both, the mass first, and then to the high hills and groves to ask for blessings from older Gods, and Reginald would pretend to turn a blind eye upon it, as usual. With the harvest being this poor, he had half a mind to join them. He dismissed the thought with a shudder. It could be used against him, if he were seen at a Pagan revel.

By the time Reginald, Coucy, his squire René and their retinue of soldiers finished their survey, evening was falling, and the full moon was escaping its cocoon of clouds, rising fragile and light as the eye on a butterfly's wing, reminding Reginald of the Greeks' belief that butterflies were really dead souls flying to the next world. He shivered. Yes, tonight he would lock himself in his keep and pretend not to see the burning tors, for the peasants were fearful of winter, and tonight the fires would flame hot.

The outskirts of Nottingham were dark and mean; no serf could afford candles here, but ahead, pinpoints of light glowed at the doorways and windows of the distant cottages that clung to the town walls.

The first hut they came to was a wretched affair, held together as if by desperation, in lieu of good wooden pegs and strong boards. An old crone lived within, a widow with no sons. She was rumored to have a propensity for prophecy. On impulse, despite his hunger, Reginald motioned to his men to halt. He dismounted, took a torch from Aelfric and knocked upon the door himself with a mailed fist. There was no answer. He opened the door and went inside, calling to his tenant.

Coucy appeared in the doorway behind him, an impatient shadow. "What is it?"

"I wonder where she's got to."

"God save me!" breathed a voice. "Who goes there? What do you in my house?"

The light from the torch revealed a girl of perhaps fifteen summers

crouching in the shadows by a dying hearth. The ragged brown shawl around her head could not completely cover her wild blonde curls, and her full lips were half-open as she gaped at them. Her slender hands, reddened by work but shapely nonetheless, held the shawl clasped over her bosom. She peered into the men's faces with large, fearful blue eyes.

"Rather what are you doing in my house, girl? I am Sir Reginald, High Sheriff of Nottingham. Where is the old woman who lives here?"

The lass looked as if she wanted to bolt. Instead she bowed her head, hastened to stand and curtsey, and said, "My aunt, milord Sheriff. She is dead. I came to nurse her. But it was too late. She was too ill." Her voice lifted as if she were pleading.

"And you are …?"

"Her niece, milord. Dulcie is my name." Her hands were trembling.

"Dulcie," said Reginald, softening his tone. What a sweet way to warm his bed for a night. It had been some time since he'd had a new woman. How had she kept out of his sight? Would he take her here? She would keep his mind off the bonfires on the hills. But Coucy would want a turn. Reginald did not wish to share. "Did you know your name comes from the Latin, Dulcie? It means 'sweet.' And where are you from?"

She bowed her head. "Loughborough, milord."

"In Leicester."

She nodded.

Coucy was staring at her as if she were a ghost. The blonde hair, the blue eyes—he had half-expected her to say her name was Isabeau. But no, the resemblance was superficial; it was only because of the dim light. Still, the wench was alluring enough in her own right.

Reginald made himself comfortable in the one chair. "And when will you return to your family, Dulcie?" he asked.

"I've no family now, milord."

"What a shame. Where will you go?"

"I know not, milord, unless I might stay here, an it please you, milord. My aunt said I might, begging your pardon, milord."

"And how will you make your rent?"

"I hope to raise chickens, milord, and sell the eggs, and perhaps I—"

"Very good, you may stay."

"Oh, thank you, milord!" She knelt hastily before him in gratitude.

"And how is it that a lovely thing like you has no husband?"

Dulcie said nothing, but swallowed hard.

"I suppose you're pretty enough to be choosy. You must marry a strong

young man who will work hard for me and give you a dozen sons! Tell me, can you read the cards, as your aunt used to do?"

"Cards, milord?" Dulcie answered reluctantly.

"Don't be afraid. Do you know the Tarot, Dulcie?"

"No, milord," she lied, crossing herself. "I'm a Christian." In truth, she had read the cards many times, Christian though she was, and her skill was known well enough in Leicester. Alas, one unhappy foretelling to a tavernkeeper had been the cause of her swift departure from that shire. The prediction had indeed come true: the tavernkeeper's son had run off to become a wandering minstrel instead of staying to work for his father. The tavernkeeper, in his rage at his son, turned that rage against Dulcie and called her 'Witch,' and though he garnered little support from anyone else in the district, many of whom had benefitted from Dulcie's second sight, she had thought it best to go away for a time, and had taken refuge with her aunt Lisbeth in Nottingham. She had determined never to read the cards again for anyone, hoping to forestall disaster. Then Lisbeth had fallen ill and died, something neither of them had foreseen. Dulcie had feared someone would accuse her of cursing her own aunt, but luckily, no one in Nottingham knew of Dulcie's past, and no one much cared about the unsurprising death of an old widowed peasant woman.

But now Dulcie shuddered at the High Sheriff's questions. She desperately needed his good wishes. If she were turned away from here, she had nowhere to go. She must be docile, she must be respectful, but above all, she must reveal nothing.

"Where did she keep her cards?" Reginald persisted.

"I don't know of any cards, milord."

"Coucy, look for the old woman's cards."

Augustin tore his eyes away from the girl and began rummaging through the pitiful furnishings in the hut. He quickly found the cards under the thin pallet that served as a bed.

"Ah, there are so many lumps in that poor mattress, you probably never felt the cards," said Reginald, taking the worn deck. "Have you ever slept on a featherbed, sweet Dulcie?"

Dulcie shook her head.

"We shall have to see what might be done about that, eh?" Reginald began laying the cards out at random on the wooden table. Dulcie felt queasy hearing his sly offer of a bed, seeing his thick, hairy fingers on the cards. He was defiling them. Only the owner should touch them. And the owner was dead.

He said, "Coucy, do you know the Tarot?"

Coucy shrugged. "It's a game, for women and children."

"Not at all. It is an art, though some say a black one. They say these arts run in families. Look at the cards, Dulcie. What do you think they mean?"

The familiar faded figures on the cards stared up at her. "I—I don't know, milord!"

He watched her keenly as she answered. Years of sitting in judgment on thieves and other outlaws had made him a sharp observer of others, and a flash of intuition told him she was lying. He swept up the cards, thrust the deck toward her, and with a cruel sense of his power over her, he commanded her to read the cards for him or leave Nottingham.

She turned white. Tense silence held the room. Shaking, she took the cards, shuffled them, dropped them willy-nilly to the floor with a gasp, hurried to scrape them up again, shuffled more carefully and presented them to Reginald to cut. She began laying out the Celtic cross. She whispered as she went, "The Fool covers you, the Seven of Swords crosses you, the Hierophant is below you, the Seven of Wands is behind you, Justice—" she hesitated, then said, "—Justice, reversed, is above you, the Hanged Man, reversed, is before you." Even as she laid out four more cards in a line alongside the cross, she felt herself slipping into the trance; it embraced her like a loving mother; it had missed her. Then the cards were but doorways into another realm and the images took her through.

Reginald's thrill of power turned into a thrill of fear. Why did he flirt with the hidden arts in this way? It always made him nervous. And yet, he longed to know what the future might bring, even as he dreaded it, and hated it that Fate might play a stronger hand than his own.

As if from a distance, Dulcie heard herself say, "The dragon powers of earth and sea are at work. Nations struggle, and through them, and because of them, the lesser forces are swayed. You seek answers but your faith is in halves, half in jest, half in your own power. Watch where you tread, man of power, for there is a greater power than your own. You have secret dealings with the Church."

Reginald let out a gasp.

She said, "You see it as a game. But a man will come to challenge you for whom it is no game."

"Is it Prince John? Or the King?" Reginald breathed.

"Treachery!" she hissed.

"From whom?" Was it Coucy? He was a wily, untrustworthy creature. Would Reginald have to fight the man for his promised portion of Maerin's

dowry? Then, with foreboding, he thought of the Bishop of York. Yes, the girl mentioned the Church, and the Bishop's movements were often suspect, as Reginald knew only too well. But so far, the Bishop seemed to be no threat. "Whose treachery, Dulcie?"

"Yours, Nottingham," she proclaimed hoarsely, feeling as if the noose already gripped her throat.

Reginald leaped to his feet. "You lie! Wretched bitch! You said you could not read the cards! You are full of lies! I should have you tried for Witchcraft!"

Before she knew what she was doing, she flung herself to the floor, clawing at his feet and weeping. "I beg you, milord, have mercy! I only say what the cards say, milord. I know it could not be true! Forgive me! The cards are sometimes wrong! They have fallen falsely today! It has been too long since I've touched them. These are not mine, but my aunt's. They do not serve me. I can read them no longer. I have put them aside! I am a good Christian! Milord, have mercy!"

Reginald's face was purple with rage. He kicked her in the side hard enough to make her cry out and fall backward with pain, then strode out of the hut.

She felt hands on her shoulders. "Get up. He will not harm you. I will see to it." Coucy lifted her up and gazed long and searchingly into her tear-filled eyes. His look both frightened and warmed her, his touch and his kind words made her dizzy with fear and yearning for safety. He was handsome, too. Did she dare trust him? She had heard the Sheriff call him 'Coucy.' He was promised to the Sheriff's ward, then. She had heard the banns announced.

His lips parted and she thought he was about to bend forward and kiss her, but instead he said again, "He will not harm you." Then he left.

She sank down into the chair, her mind reeling, and closed her eyes. A few more wretched sobs escaped her. The embers hissed once, as if to say they would soon go out completely. She should feed the fire, though there was nothing to cook over it tonight. She had thought she would steal into the woods after mass to celebrate Samhain with some of the other villagers, and perhaps a scrap of roast meat would be given her for her supper. But now she dared not be seen near a Pagan bonfire, not after the Sheriff's accusation of Witchcraft. She would go to bed and let the thin blankets, her shawl and her clothes suffice to warm her through the cold night.

She would leave this place in the morning. She would run. But where?

If only she could read the cards for herself, she mourned, but that she had always been unable to do.

✵

Reginald barely heard Coucy's horse catching up with him, so fierce and tangled were his thoughts. How dare she! He was not treacherous! He invariably did what was most just and most expedient, given complicated circumstances. He chose what was good for as many as possible, as long as it was also good for him. No one expected otherwise. How else had he come to be High Sheriff? How else had he become a knight, with land and rank, when his elder brother had inherited the family's estate? Reginald had won his position through hard work and valour in war, and he was not about to lose it through anyone's ill dealings, least of all his own! He was not such a fool as that!

The image of that card, of the Fool traipsing toward the precipice, aroused his fears almost as much as the Hanged Man. Who was the Fool? Surely not himself! Perhaps Prince John, with all his scheming for the throne. Or the Bishop, as crafty a man as he had ever met. Reginald reviewed his dealings with York. What of that nasty business with old Loxley, that should have long been laid to rest? Damn the man's get!

But it was not his responsibility! The father was already dead and the son was believed dead when Reginald set his seal to the parchment that made Loxley's lands over to the Church. He did not know precisely how the father had died and he did not wish to know. It was not his affair and he could not be blamed.

The girl Dulcie was a demon or a halfwit. She should know not to insult her betters. He berated himself for stopping at the hut in the first place and tempting Fate.

They rode up to the gates of the town in silence, Coucy for once not being so brash as to press his case concerning the girl when the Sheriff was in such a foul mood.

But Sir Reginald's mood worsened considerably before the night was through, for when he entered the Great Hall, he found a message awaiting him from London. Prince John was coming, before the winter was out, though the letter did not say exactly when. The expensive tastes of the Prince and his many retainers would stretch the resources of the shire to the breaking point. Worse, the Prince's letter said he was most anxious to hear if the thief Robert of Loxley had been captured and the stolen taxes repaid, for it had been many months, the letter caustically pointed out, since this matter had been brought before the Sheriff and the Prince's patience was not Job's.

Loxley! To think of him twice in the space of an hour seemed an evil portent. Like a louse squirming in his hair, evading the fingernails, plaguing

him with a resolute itch. He would have to send men to search for the vagrant Crusader or for some evidence of his death.

Then again, he could feign finding the latter and be done with the matter once and for all. Loxley had last been seen disappearing into Sherwood Forest months ago, and likely was dead anyway.

⌘

Early the next morning, Dulcie was awakened by banging on the door. The soldiers had come! She lay in bed paralyzed with fear, unable even to whimper, praying against all odds that they would think her gone, that they would go away themselves, that somehow she could escape. Why had she not run during the night? Better to be torn apart by wild animals in Sherwood than tortured in the Sheriff's prison and hung as a Witch in the market square!

The banging continued, then the door was thrust open. She heard the clomping of booted feet. She was too frightened even to turn her head and see her captor. She shut her eyes and waited for harsh hands to drag her from her bed, a harsh voice to curse her, a soldier to beat her, rape her perhaps, then take her to prison.

A voice said, "You sleep. Pardon. I have wake you."

There was a pause. Dulcie dared to open her eyes.

"Ah, it is good morning. My master, Augustin de Coucy, has sent you these. You are Dulcie? I am sorry, my language of your country is not good."

Dulcie saw a brown-eyed, brown-haired man in a squire's livery placing a loaf of bread upon the table, on top of the scattering of Tarot cards that still lay there. In his other fist he held a large burlap sack, which wriggled.

Dulcie sat up.

Puffs of air came from the man's mouth as he spoke, for the room was November cold. "My lord tells me you must not have to be fear, he speaks for your safety. He brings you these."

She looked at the bread and her mouth watered. If she accepted, what would Coucy expect in return? Ah, but could he not take whatever he wanted anyway? And if she refused, what protection could she expect in the future? She found her voice. "Grammercy, sir."

René bowed several times, abashed. Now he saw why his master, who was not the generous sort, bestowed such relative riches on a peasant girl. She was stunning. Indeed, she was as fair as Isabeau, despite her ragged clothes. Yet she had a sweetness about her, an innocence, that Isabeau had long ago shed, probably coming out of the womb. "Where do you wish these?" He awkwardly hoisted the wriggling bag.

"What is it?"

He grinned shyly. He opened the bag, upended it, and out onto the floor toppled two hens, squawking and pecking at one another and flapping about the room in their joyful new freedom.

René laughed at the surprise on Dulcie's face as she exclaimed, "Laying hens!" Coucy had not forgotten! She jumped out of bed fully clothed, as she wore every rag she owned for warmth at night in winter. Laughing with delight, she began chasing the chickens out of the hut to the coop behind it, which was only slightly poorer and smaller than her own dwelling. René helped her, removing his heavy woolen cloak and swinging it like a Spanish bullfighter, and the two of them giggled and shouted while the hens clucked and skittered across the hard-packed dirt yard.

When the chickens were safely penned, Dulcie pushed her tousled golden hair back from her face and breathlessly thanked René. Her cheeks were rosy with exertion and her blue eyes sparkled with pleasure.

He blushed. Wishing he had seen her first and that his master never had, he politely bid Dulcie *adieu* and went to report his small mission accomplished to Coucy.

13-AN EMERALD BROOCH
YULE, 1192

n agony of time passed for Maerin as she awaited a reply from Fontevraud. Her only solace was that her uncle held to his original promise of a long engagement.

So she delayed and dawdled in choosing fabric for the bridal gown, fussed over the style and the headgear, and played the flighty maiden, as if an unfinished dress would mean an unfinished wedding. She insisted upon complicated embroidery for her linens and endless yards of trim for every bliaut in her trousseau. In these expenses her uncle indulged her, thinking he had trapped his prey at last in a dainty net of Nottingham lace.

Maerin took care never to be alone with Coucy, insisting that Elgitha be her constant chaperone. For Coucy's part, he restrained himself and seemed determined, if not to win her favor, then at least to allow for her modesty. Little did she know that René, his squire, had steeled himself to counsel his moody master.

Early one snowy evening as Coucy was pulling on his boots before the

fire in his bedchamber, resenting the need to attend a feast in honor of some visiting baron and comparing the English winter to the frigidity of his bride-to-be, René cleared his throat and said, "Milord, if I may be so bold, have not colder hearts than hers been won by kind words and charming gestures?"

"They are lost on Maerin. She is ice."

"She is convent-raised and has no experience of love. She is perhaps frightened. But flies will come to honey."

"Yes, yes, and to rotting meat! And a mouse will come to cheese! I have done all I can to charm her. She will come to her husband, whether she likes it or not."

Undaunted, René ventured to counsel quiet words and gifts of pretty trifles, small gallantries that did not beg reward. He hoped to sweeten his master's engagement and at the same time curb his interest in Dulcie.

Coucy cuffed his squire and swore he needed no advice on how to handle women, but he did soften his behavior toward Maerin. Why worry over her when he could lavish his attentions on pretty Dulcie, who knew well enough how to appreciate it? So René's advice did not have the result he'd intended, and he could do nothing but watch, saddened and silent, while Coucy wooed Dulcie as if she were landed gentry.

That Coucy was absent from the castle more often was a relief to Maerin. She knew nothing of his visits to the honey-haired card-reader on the outskirts of town, for she did not listen to servants' gossip, and Elgitha never tattled of such things to her innocent mistress.

But at last came the bustle of Yuletide, maids and pages scurrying to deck the hall with sweet-smelling evergreens and the bright red holly-berry, snow piled high on the ground and on the battlements, snow turning to mud under the hooves of horses and mules and bleating goats in the streets of the town, new snow falling in a leaden sky, and with it, a letter came from Fontevraud. Maerin snatched it from the messenger's hand, sent him to the kitchen to be warmed and fed, and hurried upstairs, where she bolted the door to her chamber and tore open the red waxen seal.

She held back a gutteral cry as she read the words, "My dearest *Mariane*, I received your letter with joy and read it with increasing distress. I am sorry to hear that your fiancé is lacking in the tender graces, but this is not unusual among men, I fear. As to your relinquishing your dowry and coming to us, I wish it could be so. I have prayed over the question at length, and this is the guidance God still gives me. Your place is in the world. You must pray to be relieved of your willfulness. Some good may yet come to you of this marriage. But do not expect sainthood of a mere husband. Even my own hus-

band, whose memory I cherish, was far from perfect. But consider marriage to be grist for the mill of your own striving for perfection. Trust in the Lord and pray for the Virgin's mercy. Write me soon and tell me how you fare. God be with you. Your Mother in Christ, *Madame l'Abbesse de Fontevraud.*"

Maerin flung the letter into the hearthfire, then burned her fingers in quickly retrieving it to read it again, seeking to wring some comfort out of the abbess's closing words.

Why couldn't she believe God was guiding her? Was it as her uncle said, that because she thought to renounce her dowry, the abbess refused her? She could not bear to believe that. Yet Fontevraud was a rich abbey that catered to rich noblewomen, except for the very poor or fallen women. Maerin cursed the fate that made her neither of these. Better to be a harlot, she thought, than marry a man she despised!

In horror at her own shocking thoughts, she crossed herself and hastened to the corner of her chamber where she kept a small altar to the Virgin. She lit yet another candle before the white-robed statue with the blue mantle draped around the serene and tender face, knelt on the bare stone floor, took out her treasured ivory rosary and began fervently to pray.

Her face was pale when she appeared in the Great Hall that evening, but she insisted she was well when Reginald inquired after her health. She requested, however, to go to Derby, near her birthplace, to hear a special Yuletide mass. She had resisted going to church as a small child, far preferring to run free outdoors, but she had grown used to it at Fontevraud.

Now she attended mass daily at St. Mary's in Nottingham's market square, but she had fond memories, dimmed by time, of the multicolored kaleidoscope of light falling through the stained glass windows at Derby's chapel, the sharply pungent smell of frankincense and myrrh, and the calm gestures of the old priest. She wondered if he were still alive. Perhaps in taking communion from his hand, she would feel closer to her Lady, who seemed to have deserted her.

Reginald said, "A trip to Derby? Splendid idea! Coucy and I will accompany you." He did not notice her frown. He was in excellent spirits, for a corpse had been found that day badly decomposing in a hollow near the river Trent. He had chosen not to inquire into the death too closely, but had pretended to recognize as Loxley's a brass image of a saint found on a chain around the corpse's neck. He took a sip of wine and added, "I deserve a rest from my labors, now that Loxley's remains have been discovered."

Maerin started. "Loxley?" It had been years since she had heard that name. Images rippled into her mind, of a boy's laughing face, of blue-grey

eyes the color of clouds on a rain-swept spring day, then the river, the sun-light of her youth, and the taste of honeysuckle melting on her tongue like butter. "Was he not a petty nobleman who lived beyond Sherwood Forest?"

"This is his son. Or was. A thief and a wastrel. Of course, his father was a Satanist. Blood will out."

Maerin's already pallid face whitened to the color of her linen wimple. Her hand went to her cheek. "A Satanist! But that's impossible!"

"What could you know of such matters, my dear?" Reginald smiled indulgently. "The convent sheltered you from the wicked ways of the world. Why, Maerin, you truly look unwell. Perhaps you should take supper in your chamber."

"No, no, it's just … I … " She did not want to say that she once knew Robert of Loxley. A thief? A Satanist?! And he had kissed her once. She re-membered that. Had such evil been so close to her? Close enough to touch? It sickened her. She could not believe it. She shoved her chair back awk-wardly and rose to her feet. A page ran to catch the chair before it fell over. "You are right, Uncle. I think I will not take supper at all this evening." She hurried off to her chamber with Elgitha clucking at her heels.

She prayed long before her altar, scarcely could fall asleep, and woke in the night from fragmented dreams to find herself crying, thinking of Robert of Loxley, dead. But it was so long ago that she had known him. Why was she crying? And for whom? Could she have known him at all, if his blood was so tainted? No, she cried for her lost innocence, her freedom, her father, more so than the lively boy she had once known, whose body now rotted in a common grave in unhallowed ground. She vowed to pay for a mass to be said at Derby for Robert, and one for his father also. Perhaps it was wrong of her. They had died outlawed, excommunicate. But surely the Blessed Virgin Mary Whose mercy embraced all the living would intercede with Her Son on their behalf, for the sake of whatever good these two men might have done in their lives. Surely even the most tarnished of souls must have some silver beneath the black, even if, in the case of Robert, it was only that he had once saved her from drowning.

In the morning, hollow-eyed, she prepared for her journey to Derby. The forced company of her guardian and Coucy was a sore disappointment to Maerin, but she hid her feelings. Well-cloaked against the cold and guarded against outlaws by a retinue of knights, they rode through the southern edge of Sherwood Forest on a clear, crisp day, with the sun striking rainbows off the snow. Reginald complimented Maerin on her riding skill, not noticing how carefully she watched the road and the wood and the fallow fields as

they passed, and not remarking how frequently she asked for the names of tiny hamlets and other landmarks along the way.

"I seem to remember hearing of a sister convent of Fontevraud near here," she observed after a time.

"Nuneaton," replied Reginald. "Yes, it lies to the southwest. Ah, look, a hare! Would that I had the dogs with me!"

They stayed in Derby's best inn. Coucy excused himself from the evening meal, saying he had friends in the town. Maerin kept to her room, with Elgitha.

The old priest was dead, but the mass next day was comforting none-theless and Maerin felt briefly at peace in the chapel. She begged the Lady for guidance, but receiving no reply other than the promptings of her own heart, she could not see herself bending to the fate prescribed to her by others.

Before she left, she paid for masses for the souls of the two Loxleys, and one for her own father as well, letting her uncle think she only sought the latter.

She journeyed back to Nottingham with faint hope in her breast that she would somehow be released from her marriage contract. She decided to put more effort into her devotions, that the Mother of God might hear her prayers, and to that end she began to rise before dawn each day to pray, as she had been taught to do at Fontevraud, and her last deed every night was to kneel once more before the statue of the Virgin on her private altar and tell her ivory beads.

On Christmas Eve, Maerin offered embroidered cushions and other gifts she had fashioned herself to her uncle, her servants and, somewhat grudg-ingly, to Coucy. But Reginald surprised her with a fine black mare and the trappings for it in gold and scarlet, saying she was a good enough rider to deserve her own horse. The gift pleased her more than Reginald knew, for reasons he did not suspect, while the obvious delight in her face made him smile. They went together arm in arm to the feast, almost as if they cared for one another.

The Great Hall was packed with nobles and the high clergy of the shire, while from outside the castle drifted the faint shouts and laughter of the poorer folk celebrating. It was a merrier table than usual that night.

It was past one in the morning before Maerin left the Hall with Elgitha at her side. They were followed by Coucy, who stopped Maerin on the curv-ing staircase, bowed and presented her with a magnificent emerald brooch. The rectangular silver setting held a large square jewel in the center. He was quite gallant in offering it, saying it had once belonged to his mother. She

found her heart warming slightly toward him, for that he would give her a gift with such sentiment attached. Perhaps the seeming falseness of his charm was just his manner, she thought. Perhaps there was sincerity in his heart. Perhaps he could learn to treat her gently. Perhaps it was up to her to school him in the art.

That night the brooch graced her bedside table, for all that she had been taught at the convent that thinking too much on created things was a sin. She went to sleep in a muddle of pleasant confusion caused by too much mulled wine and too many sweets, while unbidden thoughts of Coucy's handsome face and dark eyes hovered above her like spirits and slipped into her dreams.

14-ROBERT JOURNEYS INTO A bILL
full moon, yuletide, 1192

Robert hung inside a fever. The sky spun and his flesh prickled. The heat of his borrowed mare and the speed of travel kept his thighs and chest warm, yet an icy wind bit into his bare face and hands. The tang of approaching snowfall filled his nostrils. The frozen ground rang hard under the horses' hooves. The trees cast spiny shadows into the moonlight, writhing like lost spirits. Branches beckoned with black fingers, and he dreamed he followed the God Herne on the Wild Hunt, gathering up the souls of the dead, for they rode in haste, in darkness, on a path both secret and sacred.

Though he urged his mare onward, still he lagged behind his companion, the strange monk who had saved him from drowning, whose silhouette against the rump of the rising moon showed his black robe fluttering behind him like a Witch's cloak, as if he rode the wind and no mere beast.

They sped out of the woods onto a low rolling plain. The moon sailed into a sea of clouds and the snow began to fall, large soft flakes the size of a baby's palm. The first flakes melted into meandering, ice-edged brooks where bare trees huddled together like so many morris-dancers exhausted after a long and tiring celebration. The thick grasses, already bowed under heavy frost, hunched lower beneath the gathering snow.

They did not take the way that led to the Giants' Dance. Why in the name of the Lady did they turn away from Stonehenge? Had he not learned

what was required, and quicker than any pupil before him? He spurred his mount mightily and shouted a question at the mad monk, but the wind tore his words away. Robert swallowed his vexation, then wished he had something with which to swallow it. He had fasted now for three days and nights, and the rumbling in his gut often seemed louder than the pounding of his horse's hooves. The waves of hunger ebbed quickly, however, as in a fever one is weak for food, but cannot stomach it.

At length two rows of massive stone sentinels loomed out of the night, and between them, the avenue which led to Avebury, even more ancient than Stonehenge. Yet the monk charged across and did not follow the lane. Bewildered and annoyed, Robert charged after.

The moon soared free of the tangle of clouds, her face shining creamy and round as a huge white cherry. Then the stars came down from the sky and danced upon the dark earth and the earth rose up like a great wave in the sea.

Robert reined in his horse, his heart pounding at the sight of the world turned upside down. Then he realized a gigantic hill loomed before him in the moon's bright, snow-reflected glow. It was surely several hundred feet in diameter and as tall as twenty men or more. It was perfectly round, miraculously free of snow or frost, and covered with short, dead winter grasses. Around it curved a frozen moat, silted with new snow. Not stars, but blue flickering flames like the ghosts of fireflies swirled upon its crest.

Faerie lights, Robert thought with a shudder of excitement and fear, for despite his year's training, he had never quite believed such things were real.

The dancing lights swirled into a spiral which slowly unwound down the slope, finally resolving into a wavering line at the base of the hill. Robert spurred the mare onward, but only caught up with the monk's horse, for its rider was already hurrying toward the hill on foot. They were late. That was why they had not taken the ritual avenue of Avebury.

Robert dismounted and ran after. When he reached the hill, he saw the blue lights were torches, held by black-robed figures whose faces were hooded and hidden. The smell of burning pitch was strong. These were no eerie messengers from the Underworld or phantoms of fantasy, but real flames, and held by men. Were they Druids, like his teacher?

Robert looked about in vain for a sign of the man. How like him to disappear unexpectedly and with no further instruction! Another test for the student. Well, Robert would master it, as he had the others.

A low moaning sound arose, like the wind crying a coming storm. Yet by now the clouds had evaporated, the stars shone hard as diamonds in the

coal-black sky, and the moon picked out each snow-dappled clump of grass and twisting tree on the plain as if they were sweets dusted with silver sugar.

The moaning grew louder; the men were singing. Robert thought he made out words, but of a foreign tongue. The men began walking in single file moonwise, widdershins, around the hill.

Robert felt his gut clench and then loosen. If this were a Faerie mound, these men clearly meant to enter it. This would be a greater magic than any he'd yet been taught. With a whispered prayer to the Lady, he joined the solemn procession. The chanting rose into a wail, the men picked up their pace until they began to run, whirling and sliding on the ice, waving their torches, sparks of blue flame darting around their heads, puffs of snow leaping like powdered lightning at their feet, and he was dancing between them, falling behind and then leaping forward, shouting words he had never heard before, knowing nothing of their meaning, yet feeling their ancient resonance at the base of his spine, crawling up his back, tickling from his neck to the crown of his head, and he was hot from the dancing and the torches, yet shivering in the snow and the silver moon.

Three times they circled the hill and then the chanting grew muffled and the flames before him began to be eaten by the earth. He was the last to enter the mound, yet he saw not a flicker of light from the many torches that had gone before. A faint whispering spoke of rustling robes which quickly faded to nothingness. Behind him, with a squealing sound of roots tangling together and clods of earth crumbling, the opening behind him grew shut, by magic or hallucination, by rockslide or unseen hands, blocking out the last sheen of moonlight, so no unbidden soul could enter.

A musty smell hovered in the still air. His vision was black. He could not see his hand in front of his face. He was alone. The chilling sweat dried on his prickly skin.

Perhaps he had died of fever and dreamed the past year and a day. Perhaps only now was his spirit conscious again, and it was in the tomb. So, did the spirit live beyond the grave, but imprisoned? A Hell perhaps worse than that of the Christians' devising.

He took a deep breath and rubbed his cold hands together for warmth. If this were death, it was a chilly one! He chuckled to himself and the sound was swallowed by the dark.

No, he lived still, and he would not fail his teacher. Or himself. He reached out into emptiness and took one step forward, then another.

The sides of the earthen passageway were soon close enough to brush both of his shoulders as he pressed ahead, making a swishing sound, which

was the only sound beyond his heartbeat and his breath. Within a few paces his palms came abruptly to a wall, but he felt about and found the emptiness to his left. He walked into it.

The passage curved slightly to the right, then left and yet left again, then twisted sharply left once more and downward, until Robert lost all sense of direction. He reassured himself that the labyrinth was long and full of air, yet he felt short of breath. His palms rubbed knobs of stone in the earthen walls, polished perhaps by hundreds of black-robed bodies over hundreds of years to a smoothness like fine ivory. He caressed the stones as if a tender touch would make the Earth Mother merciful, but the walls crowded in on him just the same, and the chill, close air seemed to be Death's breath on his neck.

With a shudder, he reminded himself that he had walked with Death as his companion many times since the fatal day he had joined the Third Crusade. But tonight's battle was with inhuman forces, and also a battle within him, and nowhere to strike with a sword.

He lost track of time as he wound around in the earth on the way of the Old Ones, knowing there was only one path in, and one path out, and to get out, he would have to go all the way in.

He rounded another corner and saw a glow ahead. He breathed deeply, half-relieved, half-wondering what test or danger lay ahead. He saw the flickering of a torch. He drew closer. A robed and hooded figure held the torch, pointed a heavy broadsword at him and challenged, "Who comes?"

"Robert of Loxley." His voice was hoarse.

"Why hast thou come?"

Several answers spun through his head, some of them insolent, for the labyrinth had shaken him. But he knew he must answer from the heart. He said, "To know the Mysteries of death and rebirth."

"In whose name?" demanded the hooded figure.

"In the names of the Lord and the Lady." He winced inwardly, for he should have said that immediately.

"Who speaks for you?" came the harsh voice.

"Cal of Copmanhurst."

The sword lowered. "You must give me that which you cherish the most or you will never pass out of this labyrinth."

Robert hesitated. He had lost all he had cherished. What could he possibly give here? Even the clothes he wore were borrowed. "It must be my life itself, then," he said with an air of careless bravado.

"Why so?" came the surprising retort.

He shook his head. Was not one's own life the thing every creature cherished above all else? Damn these Druids, with their riddles within riddles and poems made of symbols! Yet if he could pass this test, he would be one of them.

"What makes your life so valuable?" sneered the challenger.

Robert snorted a laugh. With a spark of mischief, he said, "That is what I have come here to find out."

The Druid was silent for a moment. "Then pay me for passage, impudent one."

He offered the few coins he carried in a pouch on his belt.

"These have no value here," said the hooded one, "but give them to me, and your clothing, and your dagger; all you carry."

Muttering against highway robbery under his breath, Robert handed over the dagger, hilt first, then stripped and gave the Druid his clothes, then paused before he ripped free the thong around his neck that held the protective amulet Cal had given him. He handed this over as well. The Druid nodded and beckoned, but when Robert stepped forward, the torch was snuffed out, the hooded figure disappeared and abysmal darkness returned.

A hiss escaped Robert's lips. Was there a secret passage the Druid had taken? And was he meant to search for it? Or had this encounter been simply a vision? The loss of his clothing was real enough! Goosebumps rippling across his naked flesh, he felt along the walls. They were solid, but for the one way that led onward. He followed it.

Time passed and no further vision came to challenge him. His thoughts began to wander and plague him. Images of tombs and catacombs, dungeons and torture chambers fled one another through his mind, crevices in caves where men fell to their deaths, the oubliettes of France, where a man might find his vertical grave, with a heavy stone tumbled into place over his head, and the condemned, forgotten, unable to move, starving to death standing in his own wastes.

Had he been lured here by his trust in his teacher, who secretly might practice human sacrifice? He might wander forever in this place, around and about and down to nothingness, locked in the hill. A dozen old wives' tales came back to him, of how the Sidhe lured unsuspecting mortals to their deaths, of the Druids and sacrificial blood, of garroting and drowning—above all, of burying alive. He tasted the soil in his mouth as if it stopped his lungs. He struggled for breath. The vast silence would drown the screams he choked back in his throat, but he knew they would escape him if he came upon a dead end in the labyrinth.

Christian promise of Heaven, threat of Hell, Druid songs of rebirth, regeneration, reincarnation, all philosophy and faith became dust in his mouth, worthless echoes of silence in his ears. What was religion but the grasping at straws of the doomed, the desperate struggle to give meaning to the meaningless? Who knew what lay beyond the grave? Only the dead.

Yes, the corn would be cut down and grow again in the spring from its own seed, but was the spirit of the grain truly the same as before? The doe gave birth in her season, but whose spirit was the fawn's?

One day his own breath would stop, his heart would clutch, his stomach twist and his bowels loosen. His soul would seep out of his body, his skin and muscle and bones would shrivel and dry in the vast twisting darkness, changed, crushed to dust, invisible, gone forever, and he would not know himself as Robert, as a man, a son, friend or lover, warrior or priest. Who would he be? How? And where?

The universe gaped before him in all the ghastliness of its utter indifference. He shoved the walls with his palms as he passed between them, as if he could keep them from bearing down upon him and crushing him into the void. He was sweating with cold, nauseous, hands shaking. He began to run, forcing himself sideways past the narrowing walls of this convoluted tomb.

The sound of his own hoarse gasping and his pounding heart stopped him in his tracks. With a blush of shame invisible in the darkness, he cursed himself. Frightening himself with his own gruesome thoughts like a child afraid of the night! Running like a coward fleeing from battle!

As if he could run from Death.

No, Death walked forever arm in arm with Life, like a wedded couple, for better or worse.

He forced himself to slow his breath, to concentrate on the cool air entering his lungs and the heat of it as he breathed out, each breath steadying him a trifle more, as Cal had taught him. He touched his bare skin. Its chill masked the warmth within, the vital blood pulsing in his wrists, his temples. He was alive now. As his heart slowed, the panic passed.

Whatever his destiny, he would go forward to meet it. He had chosen this path and he would follow it to its end, and if the end in this labyrinth was Death, then it would simply come sooner rather than later. That was the choice he had made, the risk he had dared a year ago, when he had recovered from near-drowning and illness to find a Druid had saved his life. In thanks and payment, he had agreed to apprentice himself, promising a year and a day. Where else could he go, after all? No doubt Will and Cedric had given him up for dead, any road.

Now his apprenticeship was fulfilled, and this was the final challenge, the attempt to master the Mysteries, and it was a gift to and from his teacher, to himself, to the Lord and the Lady.

If he survived this night.

He walked on.

A minute later, or an hour, or a breath, the passage widened into a cavern. In the center was a gaping hole in the ground. From that hole came a fiery glow which threw the walls of the cavern into faint relief. Beyond the pit hung a wavering wall of spiders' webs, glistening gold in the light. A teeming colony of white spiders clung to the webs and crawled blindly about.

Something tickled his hands. Robert hissed and shook off several spiders, drawing back from the wall. The jaws of a squirrel leered after him, and the glaring empty eyesockets of a man's skull, the tusks of a boar, the fangs of a wolf, and he saw with a shock that the stones, smooth as ivory, that bound the earthen walls together, that he had caressed so gently in passing when he first came into the hill, were in fact the skulls and bones of the dead, both human and animal.

He stumbled backwards, off-balance, and spun around to keep from falling into the pit, and it was only then that he saw another opening in the wall. It was a long steep passage that led directly up to the sky. The full moon commanded it, shooting rays of silver light toward him like welcoming arms, bidding him leave that deathly place, promising freedom and life.

He had triumphed! He was free! He had made his way to the end and found the way out! He staggered toward the tunnel, gratefully breathing in the fresh air. Just as he was about to set foot in the passageway, he halted. What awaited him outside? The vast plain. The celestial moonlight. His borrowed horse. And little else.

Would he still turn from the darkness, the pit? Still run from fear, strive to escape the unknown rather than confront it?

There rose a whisper, a moan, then unearthly screams, as though every ghoulish spectre of every nightmare since the dawn of time had found eternal misery in the pit behind him, and above this terrible wailing he heard a screeching, shrill and wild, calling his name, again and again, like a dirge, an accusation or the perilous grieving of a lost soul.

He laughed and spun around. "To the fiery gates of Hell, then!" he shouted, leaping forward and throwing himself into the burning pit.

⌘

15-WHAT HE FINDS THERE

Robert's yell blended with the screams below him. The fall lasted only seconds, but his heart was pounding by the time he landed, not in a vat of Hell's burning pitch stoked by demons with forked tails, but in a gossamer white net, woven like a spider's web of fine, strong threads.

Robert scanned his surroundings as he caught his breath. The vast cavern swirled with smoke, of incense, of juniper, of torches burning. To his right, a massive hearth hewn out of the stone wall blazed with fire which cast grotesque shadows across the crystalled ceiling. Near the hearth slouched three musicians, their eyes glazed in trance, sweat pouring down their faces. The screaming hushed to a sigh, then a low laugh, like the joy a mother feels through the pains of her labor when the child is come. Above it he heard monotonous chanting, the skirling of a wooden flute; below it, the beating of a drum, the kind banned by the Church, for it cried men's minds to ecstasy and made their bodies and spirits dance. The dry hollow sound of two sticks knocking together punctuated the hypnotic melody.

In the middle of the stone floor squatted a fat black cauldron. Blue fire leaped out of it. Before it stood two robed, hooded figures, one in black, the other in white. Beyond them, in a circle near the far wall, were a group of men in black robes and women in white, each holding a white candle and chanting ancient words as they glided in and out of some intricately patterned dance.

Robert scrambled free of the net and went toward the cauldron. The two Druids threw back their hoods. The man was his teacher Cal, who met Robert's eyes with a solemn, impenetrable gaze. The white-robed one was a tiny old crone with a face like a crumpled handkerchief, so lined and wrinkled it was, yet the skin was not white as linen, but brown as the earth. Surely she was one of the Old Ones, Robert thought.

She drew a curved knife from her belt and held it up to Robert's throat.

"Kneel," she commanded.

He obeyed.

The dancers swayed forward, forming a circle around Robert and the

priest and priestess who challenged him. The old Druidess flashed her knife downward, the blade so sharp and quick Robert felt no pain. Drops of blood pearled in a crescent along his bare shoulder. Cal held a large silver chalice below the wound while the crone pressed nine drops of Robert's blood into the cup. Then she pricked her own left forefinger and Cal's as well, and drops of blood from both of them she pressed into the cup.

Cal took a skin of red wine from his belt and filled the chalice to the brim.

With an odd, lilting accent, the crone said to Robert, "The world thou hast known is no longer thine. Dost thou renounce thy old life?"

"I do."

"Then say how thou art Mine."

A trembling tore through Robert's body, and not from the cold. Beyond this, there was no return. In the past year, his ideas about the world had been set on end. With this rite, he would topple them over. He would abandon the Christian faith for which he had once fought, for which he had risked his life. He would abandon his old identity, his claims to titles or land, everything he had imagined himself to be. With a shiver of fear and yet exultation, it seemed to him that he had waited for this moment all his life, without knowing he so waited. He had sought glory in the eyes of men and adventure in foreign lands. Now he would dedicate himself to another glory.

Despite the excitement and trepidation surging through him, his voice was steady. "By land and sea and sky, my heart and soul and every sinew in my body belong to the Gracious Lady and Her blessed consort, the Horned One, to do Their will until Time stand still and Earth be done. As a snake sheds its skin, I freely renounce my old life, in which I was known as Robert of Loxley. From this time forward and forever, let me be known as Robin."

"Then Robin thou art!" The priestess held the chalice high and poured half its contents over his head. The mingled wine and blood ran down his face and shoulders while she chanted, "East, South, West, North, here I come to call you forth! Air, Fire, Water and Earth, this body bless, this soul rebirth."

She handed the cup to him. "Drink deep and never thirst, Robin."

He drank and gave it back to her, saying, "Drink deep and never thirst, Grandmother." She drank and passed it to Cal, who also drank, then poured the last few drops in the fiery cauldron and said, "For the Lord and the Lady."

The chanting and the music ended. Smiling, the crone took Robin's face in her hands and kissed him on both cheeks, bidding him rise. She said,

"Your choice of names is a good one, Robin. The woodland has need of such as you, the more so since John Lackland brought back the forest laws Queen Aliénor revoked. But we will speak of doings in the world of men later. Come, you must be chilled."

They dressed him in a black woolen robe and tied a thick cord around his waist, hanging on it a curved dagger in its sheath. They gave him black leather boots, supple and warm, lined with rabbit fur. Over his head, the Druidess draped a black hood with a cowl that rested loosely about his neck. She patted his cheeks in a grandmotherly way and said, "Now you look a proper Druid."

The other men and women crowded eagerly forward to congratulate and embrace him, one by one, until he was spinning among them, tossed from one smiling face and warm pair of arms to the next. He soon took advantage of this hearty welcome to embrace the prettier women somewhat more fondly than the rest, his body sorely reminding him that it had been a year and a day since he had lain with a woman, and he fervently hoped that part of his training was about to end.

They broke their fast with dried venison, cheese, apples, dates and Çervoise, a beer made from honey, barley and other plants known only to the Druids, with a strength that made the blood in Robin's veins flow hotter still.

But he feared he drank too much, for when everyone had eaten their fill, Cal put a heavy hand on Robin's shoulder and said, "Now for the final challenge, puppy." Cal grinned, for he saw by the look in his pupil's eyes that Robin had thought the testing done for the night. "Find the way out," Cal said.

Robin looked toward the spider-web net and the hole above it. Without a ladder, there would be no climbing out that way. Unless he could take off his boots and grip the rough rock walls with his toes. But no, the roof of the cavern curved too widely. He would have to crawl upside down like a spider! Now there was a magic he'd enjoy learning!

Cal barked a laugh. "You're thinking too much, imp. You have tasted the blood of the Old Ones. You must prove their knowledge is yours. If you fail now, your other skills will avail you nothing, for we will bury you in this labyrinth and your flesh will rot and your bones crumble to dust three times over before ever your soul sees the light of rebirth."

Robin smiled and said distinctly, "I'll bury you first."

Cal laughed.

Robin forced himself to concentrate. He inhaled deeply, his head swim-

ming from the Çervoise. With his breath, he drank in the smell of stone, of crystals, of frankincense and myrrh, deer's-tongue herb and rose petals, juniper and cedar burning in the hearth. He stood and walked toward the cave wall, sidled alongside it for a few paces, changed direction once or twice, stopped and closed his eyes, sending his awareness out to touch the stone. He felt the grain of it, where it waxed strong and where it gave, he felt the hum of the earth beneath his leather-booted feet, felt it singing in his veins. With a sudden knowing, he found the place he sought.

He almost unsheathed his new dagger, unconsecrated though it was, but decided against it. The power comes from within, he reminded himself, not from the tool in the hand or the word in the mouth. Yet unbidden words of power came flooding into him nonetheless, and he spoke them aloud and tapped the wall three times, as casually to the outward eye as if he tapped at the door of his beloved's chamber, and she was expecting him.

The secret stone door swung open on hidden hinges. Behind him, the Druids sighed. He could feel their approval caressing his shoulders. The doorway revealed a long, jagged, black crevice, old as time, and he led the others through it, through the darkness, out of the hill and onto the plain.

Winter's wind struck him full in the face. Dawn was breaking after the longest night of the year. The sun gleamed red as embers on the horizon, and as the others filed out behind him onto the ruby-sparked snow, tears came to his eyes, both from the biting cold and from hot joy, for on this Solstice morning, he knew he was reborn.

16-Ɔеrсιfυl νιrGιn
nеw wolf Ɔoon, 1192-1193

he fine black mare with the gold and scarlet trappings and her attractive rider soon became a common sight in Nottingham and the surrounding countryside. Accompanied by Elgitha and two men-at-arms for protection, Maerin stopped at every church and chapel in the shire to light a candle to the Virgin, and if she went further and further afield each time she rode out of the castle, Reginald did not chide her, for to it he attributed rightly the rosiness in her cheeks. In this way, she learned the lay of the land and the people.

He gave her a modest allowance, thinking she would spend it on rib-

bons and baubles in the market, but instead she gave alms wherever she could. Here, beyond convent walls, it seemed to Maerin that money served mainly to stimulate men's greed; the more they had, the more they wanted, and not always to use, but to store up against Death. She would not worship such idols as false security, she told herself. She would use her own small means for a greater goal. She had dedicated herself to the Lady and she had not forgotten her promise, even though it sometimes seemed that the Lady had abandoned her. Perhaps it was a test. The Virgin tempered her soul as a blade of steel was tempered in fire and water.

She was often seen leaning over her horse's mane to toss a penny to a beggar in a crossroads or buying bread to give to the poor in the tumbledown huts outside the town gates. She even gave alms to lepers, who were generally shunned. She was especially generous in tithing to the Church, and the priests always welcomed her, some blessing her money, others blessing her generous heart.

Gossip of her benevolence spread quickly and far, and those who were the objects of her charity began to think of her as the incarnation of their own Merciful Virgin, though of course they never spoke such blasphemy aloud.

But as winter progressed, nasty weather sometimes kept Maerin from her rounds. She would have ventured out even in a snowstorm, for that was when the poor needed her most, but Reginald, concerned for her health and safety, forbade it and would hear no argument, so she was confined restlessly within walls. She practiced her aim with bow and arrow in the courtyard, but in truly rough weather, she was reduced to embroidering indoors and planning meals with the cook.

Once the holidays were over, the latter was a simple enough task, for the niceties of court life were few in this backwater so far from London, visitors were fewer still, and there were no noblewomen with whom she could while away the bleak hours. Not that Maerin was much for frivolous chatter. The nuns who had raised her had frowned upon girls forming special friendships, and Maerin had long since learned that for her, confiding in God and the Mother who bore Him was enough. Yet she often found herself, in the long hours of that winter, praying selfishly for an early spring.

One blustery evening as sleet hammered the layer of fallen snow outside and slickened it to sheets of ice, Maerin sat stitching at her embroidery with Coucy and Elgitha on either side of her like a fox and a watchdog facing off at the henhouse. Conversation was lagging when a page entered with a letter for Augustin. Delighted at the interruption and hoping for news that

would ease the tedium of the winter night, the women urged Augustin to share the contents of the letter with them.

Frowning, Augustin tore open the waxen impression of his brother's seal. "Augustin," he read aloud, "I write to inform you of the joyous occasion of my betrothal to Isabeau … "

His voice trailed away. Maerin watched her fiancé's face drain white and his hands begin to shake. He read the rest silently, his jaw visibly clenching and unclenching. Then he lurched to his feet, crumpled the letter, threw it on the floor and stormed out of the room. Maerin and Elgitha gazed after him in dismay.

Over Elgitha's faint protests, Maerin picked up the letter, smoothed it in her lap and read, "It seems I was able to persuade her where others could not. I tell you this only to forestall any dark connivances you may be planning with regard to her or to our deceased father's estate. I will soon have not one heir—my beautiful wife—but two, for I intend to get a son upon her as quickly as possible, and you will be even less likely to be able to force a claim should anything happen to me. Do not come for the wedding. Edouard."

So things were not as well between Augustin and his brother as she had been led to believe, thought Maerin. Was this burst of bad temper brought on by the loss of inheritance or by his brother's meanness? How greedy was Augustin? How loyal? How would she ever come to know this man? He never spoke of his family, his interests. He exchanged with her only the shallowest of pleasantries and flirtations. She could never lead their conversation to questions of philosophy or religion, not even music or art. He seemed to know little of such things, and worse, cared less.

And now, when he was most in need of the friendship and comfort a good wife might provide, he rushed out of the chamber like a mad dog. She sighed, crumpled the parchment and left it on the floor again, with Elgitha crossing herself in shame for their snooping.

⌘

Coucy galloped through the bludgeoning wind to the edge of town, left René and the horses badly sheltered from the sleet in a grove of leafless trees and, gaining the hut through drifts of snow, shoved open the door without knocking.

Dulcie was sitting by the fire, combing her freshly washed hair with a forked twig. She blanched at the sight of him, his glowering eyes, his sleet-wet and wind-tossed cloak, his muddy boots and the sword swinging at his hip.

In the few weeks since she had met him, he had only talked with her or

sat watching her as she sewed; he had stroked her hair and even kissed her hand, then her cheek, and only rarely, her lips. He had wooed her as if she were a lady, but unpredictably, gentle one day, moody the next, appearing at odd times or not at all as his whims moved him. She had been confused by him, but grateful for his apparent and unexpected respect for her.

Now he said not a word, but pulled her roughly to her feet and shoved her down onto the bed.

Stunned, she let out a cry, but did not protest or resist. She reasoned dimly that if she gave in, he would continue to protect her. Had he not kept her from the Sheriff's wrath? And he had brought her gifts, not just the chickens, but other tokens of food, a good kettle for the fire where her aunt's had long since needed mending, a new leather bucket. Had she not known the gifts he gave must come at a price and that someday he would demand payment?

Coucy's lips were hot and insistent, and his hands upon her bosom and then under her skirt sent surges of pleasure through her. Indeed, she had often fancied herself in his arms, though not quite like this. She sighed with a strange mixture of resignation and excitement.

He groaned, and sucking, bit her breast. So her maidenhead was taken without tenderness, yet she had not expected better from life.

It was over quickly and he asked for wine, but she had none. He gruffly said she should have it for him when he came to see her. He was already adjusting his clothes, which in his urgency he had not bothered to tear all the way off. She wondered if he would give her the coins to buy the wine or if she must buy it herself from her meagre store of pennies.

Coucy sat up. He had thought taking the peasant girl would satisfy him, but she had not resisted him, neither daring to lash him with as sharp a tongue as Maerin's, thereby serving his craving for a fight, nor toying with him coolly, teasing and flirting with him, as Isabeau always had. As Isabeau now did with his despised brother.

Hearing the little movements Dulcie made in the bed, straightening the thin blanket, dabbing at the bloody cleft between her legs in silence, only fed his rage. It was as if her very timidity accused him of cruelty, of failure. Was he not a fine enough lover for her then? The bitch. She was just an ignorant peasant. She gave in to him because she had little choice, not because he had won her. True, she was grateful to him. And beautiful. Though in a few years she would be used up, coarsened by hard work and few comforts. But what did that matter to him? All women were the same, venomous and two-faced. Dulcie was simply too stupid and too poor to have a hold

upon him and to enjoy using it to twist his soul.

She reached out a hesitant hand to touch his shoulder, where his tunic had come awry to reveal the reminder of yet another humiliation: the scar the Comte de Vernon had given him in their duel.

Coucy shoved Dulcie's hand away and got to his feet, adjusting his cloak. He would go to the Triple Horseshoe. The ale they bought from the castle brewery in the caves of the castle cliff was the best in the shire. True, he could drink for free in the Great Hall, but damned if he would play another infernal game of chess with the Sheriff, and damned twice if he'd sit watching Maerin embroider, and settle for kissing the back of her hand at bedtime. At the tavern he could gamble, and it was worth a copper penny or two on the chance that the Triple Horseshoe's daughter would take him into her bed this night. Now there was a girl who knew how to play the games of love, of the hunt, of passion and conquest.

Dulcie watched Coucy go without daring to protest. A small voice within her warned that she should leave Nottingham at once, but where would she go, a lone young woman? What if her reputation followed her? Was it not doubly ruined now, in Leicester for reading the Tarot, in Nottingham for becoming a nobleman's whore? What if Coucy himself grew angry at her for running away, and followed her, denounced her as a Witch or killed her?

She wondered what had angered him so, what had made him come to her so roughly. What had she done wrong? She racked her brain trying to find the answer. The wine—she must be sure to get wine for him, first thing on the morrow. Or was his fury to do with the maid Maerin? It was said Maerin resisted the match.

Dulcie felt no jealousy toward her rival, nor blame. Who would not fear to have Coucy nearby every day as a wife must? And yet, he had saved Dulcie from the Sheriff. Did she not owe him her loyalty? He had been kind to her before and would be once more.

She rose and poured water from the new leather bucket into the sturdy iron cauldron and swung the latter over the hearth, blowing on the embers and rekindling the fire, which had burned low during the encounter on the bed. When the water was warm, she cleaned herself carefully. There was not much blood. It had only hurt for a moment.

He had said she should have wine waiting for him. That meant he would come to her again, she thought, and shuddered with sharp pleasure.

⌘

That night Maerin did not sleep well. Halfway through her disturbed dreaming, she realized she was actually concerned for her future husband. She rose

before dawn to pray to the Virgin Mary in thanks for opening her heart.

The temperature dropped again during the day and the clouds opened their hearts as well, until fresh snow covered the world, as pure and clean as Maerin felt her soul to be. She spent the day supervising in the kitchen, calmly embroidering, giving alms at the gate and playing backgammon with Elgitha.

Augustin stayed in his chamber and when Maerin sought to speak with him, René, a strained look on his sleep-deprived face, said apologetically that his master was resting and had commanded not to be disturbed. Maerin took it that Augustin was upset about his brother.

When Coucy appeared for the evening meal, having imbibed quite as much willow bark tea that day for his headache as he had the ale which had caused it the night before, Maerin was wearing the brooch he had given her. She allowed him to kiss her hand and then held his hand warmly and inquired after his well-being. Surprised at her tenderness, Augustin lied that he was in excellent spirits.

They sat down at table, Maerin solicitous, Augustin evasive, but at last, having drunk the hair of the dog that bit him, he revealed that he had loved a woman once who had scorned him, and this same woman was now marrying his brother. He lied that he no longer felt any love for the girl; it was only the shock of the news that had caught him offguard. He did not speak of his hatred for Edouard, which sibling rivalry would surely chill Maerin's heart, or of his rage that the income from their father's estate was denied him forever.

Touched that he suffered for a lost love rather than a lost fortune, Maerin warmed to him even more.

They spent the evening *en famille* in the Great Hall, with Reginald and Elgitha in attendance, as well as the steward Aelfric and the captain of the guard, Anhold, with everyone taking turns telling stories of war and romance, myth and magic. When Maerin was ready to retire, saying she had not slept well the night before for worrying over him, Coucy kissed her hand and then made bold to kiss her on the lips. She allowed it, her thoughts and her limbs in a haze of bemused tingling.

Reginald smiled at this sign of a truce between the two betrothed.

Coucy was wise enough not to press his advantage further. Maerin glowed with appreciation for his chivalry.

When she reached her chamber, she realized she had left her embroidery in the Great Hall, where her uncle and Coucy had settled down to play chess. The embroidery was intended for a sachet for Elgitha's birthday two

days hence, and knowing the hall would be bustling the next morning with courtiers, supplicants and other business for the Sheriff, Maerin made her way back downstairs to retrieve her needlework, planning to finish it on arising.

At the bottom of the stairs, she heard loud voices. Reginald was harshly berating someone for something; she could not quite make out his words. Drawn into the scene almost against her will, she hovered near the open door, hidden in shadows.

She saw her uncle fling a handful of coins at Coucy. They scattered among the rushes and herbs strewn on the floor.

Reginald shouted, "This is the last time you'll get any money from me, you snivelling wastrel! Next time, take back from Maerin that damned emerald brooch you won at dice in Derby and use that to pay your gambling debts. I'll have you banned from every tavern in the shire if you prey upon my good will like this again. Do not forget who is Sheriff here! I could have you flogged!"

Augustin, on his knees picking up the money from the floor and looking for all the world like a beggar in the street instead of a dashing nobleman, vowed he'd repay the loan as soon as he saw his marriage bed and the dowry that went with it. He spat, "It is your doing, old man! You let that prudish, cock-teasing wench of yours delay in surrendering what is legally mine. I have minced about her like a whipped mongrel these past weeks and I've little taste for it. Tonight she favors me out of pity, but I have fucked as many whores as she has said Hail Marys in waiting to ply her cunt. You have sold me ice, not a woman!"

Pale-faced, heart pounding, Maerin hardly heard Reginald's rumbling reply. To hear herself spoken of so viciously, in so crude a fashion! And the emerald brooch she had treasured had never belonged to Coucy's mother. He had lied and she had believed him like an innocent. This was what came of doting on baubles and riches. She was ashamed and humiliated.

Coucy was hissing, "When I bed her, she'll see her whipped mongrel turn mastiff fast enough."

Forsaking her embroidery, Maerin slipped away unseen to her chamber and spent a sleepless night in prayer.

As if the Merciful Virgin had finally heard her, the morning was as clear as May, the sky cloudless and the sun embracing the snow until it began to melt. Maerin sent a message to her uncle professing a desire to go to mass at the chapel in Ripley, where she wished to give alms, and promising to be back by nightfall. These excursions being habitual with her, Reginald barely

gave it a thought as he assented. Before the sun topped the battlements, Maerin and Elgitha were riding out through the iron gates. Their lack of an escort puzzled the gatekeeper for half a second, until his attention was captured by the weightier matter of having stepped in some horse droppings.

The two women cantered away from the castle and through the town, heading northwest. Once out of sight of Nottingham, they frantically urged their mounts southward through snowy vales and wooded copses, where long fingers of ice stretched down from the trees as if pointing the way to the darker reaches of Sherwood, and they feared to be set upon by outlaws or haunts at every turn. Day became terrifying night before they reached the double convent at Nuneaton, where Maerin begged audience of the abbess to give her refuge there, offering the ill-gotten emerald brooch and her bright black mare as the only dowry she possessed.

17-HELPLESS KING

Sunlight slunk in through the high narrow windows as if loathe to discover the object it revealed, the contorted figure of Prince John lying in bed draped with a woman, with a splitting ache in his royal head and a fermenting in his gut due to an overindulgence in food and wine the night before. His whole body throbbed and he was sure if he got up, he would vomit.

The pain and dizziness were made worse by the shouts of men who apparently had not slept a wink during the night and who were now carousing in the courtyard, trying their still-drunken hands at unseating a straw-stuffed, raggedy-legged, helmeted chain mail effigy on a wooden horse. Their curses and laughter and the clanking of metal upon metal were like blows to John's head, but they were soon overshadowed by a more vicious pounding, and much nearer. He sat up in bed with a start as if to ward off the sword. The hasty movement caused a drumming in his brain in syncopation to what he now perceived was knocking on the door, which opened slightly.

His steward stepped in, hesitant as the winter sun, carrying a sealed scroll. "Beg pardon, Your Highness."

John groaned and sank back upon the goosedown pillows. "Go away."

"It's from the Queen, Your Highness."

John groaned again. "Then read it to me."

"Sire," the steward protested feebly.

John cursed. Of course the fool should not be allowed to read a message from the Queen Mother. At least the fool knew it. God's eyes, how his head ached! "Send me the Bishop of Coventry and be quick about it."

"Yes, Your Highness."

John blearily looked at his bedpartner. He couldn't remember her name, although her breasts were familiar. He elbowed her in the ribs to wake her, and with a word, sent her packing.

The Bishop soon arrived, himself much the worse for the past night's festivities. With red-rimmed eyes and a scratchy voice, he began to decipher the flowing script of the Queen Mother's hand. "My dearest son—"

"The hag!"

Hugh coughed and continued. "—let no one's eyes but your own read this letter." Hugh looked up expectantly. John waved a hand and bade him keep reading.

Hiding a smile, Hugh read, "I write you in haste and in earnest on behalf of your beloved brother, Richard, King of England, Duke of Aquitaine, Normandy and Poitiers, Count of Anjou. I have received word that he is being held prisoner for ransom by Duke Leopold V in Austria." Hugh raised his eyes to share a shocked look with Prince John, then read on eagerly. The tone of the Queen's letter abruptly changed from lofty to familiar. "Because of his quarrel with Philippe—you know what happened when they took Acre—Richard always acts first and lets his advisors pick up the pieces after. At any rate, Richard dared not journey home from the Holy Land by way of France. He sailed the Adriatic and then—horrifying news—he was ship-wrecked."

John sat up, eyes wide.

"Through God's grace he was saved."

John groaned, held his head, and lay back down.

"He was forced, however, to travel through Austria, and because of that unfortunate incident with the Austrian standard in the Holy Land—believe me, if I had been there, none of it would have happened. I should have gone. I remember when I accompanied Louis on Crusade, I and my noble ladies. We fought as well as the men, and inspired them as much as possible to behavior befitting knights of the Cross, no easy task with soldiers. But then they also had Louis to emulate. He was such a saint—an insufferable quality in a husband. That's why I divorced him. Your brother is different. He has that terrible temper. Of course it takes a bold man to be King.

"But I am distraught and must get more to the point. I have gone with-

out sleep since I heard the news. It is almost dawn and this must go to you at once. In short, your brother was kidnapped, or so we have been told. The ransom is ridiculously high. Duke Leopold has got some absurd notion that we are richer than we are. We are not the Pope, after all! When I ransomed William Marshal years ago, I was able to pay out of my own purse. How tongues did wag! Your father was terribly jealous. But I cannot afford Richard's outrageous ransom on my own. We are negotiating for a reasonable compromise."

John smirked. He was sure that was not all his mother was negotiating, but what manipulations and intrigues she would set into motion were beyond him to imagine.

Hugh read on, "I have heard rumors that the Emperor Henry VI has offered to buy Richard! We shall have to outmaneuver him. This is of the utmost urgency, John. We must be swift to gather our resources. I expect you to contribute what you can from your own estates as a loyal subject and loving brother of King Richard. I have already instructed Walter of Coutances to take a goodly portion of the royal treasury of England, which I'm sure I need not remind you is Richard's. Now, for another matter. Rumors continue to reach me concerning you and Philippe of France. I pray these rumors are untrue. I pray you are wise enough to know that a pretense to your brother's throne could bring ruin to England and disaster upon your head; in fact, you might lose the latter entirely."

Hugh looked up. John sneered. Hugh went back to the letter. "The only one who will benefit is Philippe. My son, because you were wrenched from the bosom of your loving mother at a tender age, it has never been my place to forbid you anything—"

"Hah!" cackled John.

"—but know that there are many who may yet do so, not with the protective words of a loving mother, but with swords, or worse, a dagger in the back from one who calls you 'friend.' Beware those who offer to serve you but who use you for their own purposes. I most singularly do not care for that fawning viper, Hugh of Nonant."

Hugh reddened. John snatched the letter out of his hand and read silently to himself. "You were never one to choose your associates wisely. Do not forget those who have been generous to you. I await your reply. Your loving mother, Aliènor, by the wrath of God Queen of France and Queen of England."

Curse the woman! John crumpled the letter and wished he could crush his mother so easily.

So his dear brother Richard was a prisoner. Nothing could have served his own purposes better, unless it were his dear brother's death. Even the pain in John's head seemed to be receding. "Does Beauvais know of my brother's kidnapping?"

Hugh spread his hands helplessly.

John shouted for his steward to fetch Beauvais, shouted for his servants, who rushed in and began to dress the royal body and succour the royal headache with raw egg and cayenne.

It was Beauvais who pointed out that they had not received any proof of Richard's kidnapping, only hearsay. Was his brother truly still alive? What about that shipwreck? Had not many men drowned? Was the prisoner in Austria an imposter? Was there indeed a prisoner at all? Perhaps this was merely a scheme of Leopold's to drain the coffers of his enemies.

Several hurried conferences and several couriers to Paris later, John Lackland declared Richard dead and claimed the English throne. He would show his mother 'bold.'

18-THE HUNTERS AND THE HUNTED
WOLF MOON WAXING, 1193

In Sherwood Forest, several yards from the Great North Road, three men lay behind a low rise in the earth. Dry brown leaves and broken twigs showed here and there through the pristine snow like curling brown embroidery upon a linen sheet. Icicles hung gleaming in the sun amid a tangle of bare black branches and the sky was as pale a shade of blue as the inside of a robin's egg. Someone with a poetic turn of mind would have found it a world enchanted.

But John Nailor was of a pragmatic nature. He leaned against a tree trunk in his ragged cloak, his eyes closed against the beauty of the day, and soft snores emanated from time to time from his open mouth, for he and his men had waited for hours in vain for good hunting, they had long since eaten their meagre lunch of stale bread stolen from the tavern called The Green Man, and John had learned early in childhood that sleeping stilled hunger pains and cold, except when one dreamed of feasting by a fire, which unfortunately was a recurring nightmare of sorts of John's, in that he always woke to find it wasn't true.

He smacked his lips a little in his sleep.

His companions sighed insomniac and nestled deeper into their own thin blankets, their bows strung and ready.

From his perch in the trees, their lookout watched the sun lowering in the sky, a raven swooping by with a hoarse cawing, and the empty, rutted road. Then his eyebrows twitched and he gave a birdcall himself.

Harald, a grubby lad of perhaps sixteen summers, nudged John's foot. John gurgled and woke. The three men on the ground huddled forward and peeked over the crest of the slope. Sure enough, a stranger soon appeared, heading north. He wore the black robe of a cleric, with the hood pulled forward snugly to keep the chill from his face and neck. A sack of arrows, a sheathed sword and a dagger hung on the thick cord that wound around his waist and an unstrung longbow rested across his shoulders. As he came closer they saw his robe was new and his boots were of good leather. They smiled in a wolfish leer, for the condition of his clothes bespoke a full money pouch.

Soon they could hear his footsteps swishing in the snow. He was near enough and unwitting. They leaped from their hiding place with a shout and fell upon him.

He drew steel, but too late. He was outnumbered and soon unarmed, knocked to the ground and held there with menacing threats, his own sword pointed at his belly in John's right hand, John's foot resting none too gently on his chest and John's lips spread in a grin through his thick brown beard.

"Your money or your life!" demanded John.

The monk sighed and muttered, "I have no money."

John laughed. "A monk with no money? A pig without a snout! Not bloody likely." He nodded to Much, who searched their captive and found an empty purse and not a crumb of food.

"Strip him," John growled, disappointed.

"Wait," the monk said. "Let me fight you for my clothes. It's a cold day. The exercise will warm me."

"You'll need the warming once you're naked as a new-shorn sheep," said John. The outlaws laughed. "What say, lads? Shall we have a bit of sport? Never let it be said that John Nailor is not the fairest of thieves. You'll beat my best swordsman or you'll give us your blood this day along with your clothes." He handed the monk his sword.

"And if I win, I go free," declared the stranger, clambering to his feet and gripping his sword in both hands.

John agreed, sure the monk would lose, for he seemed none too broad in the chest. John whistled and down from the tree dropped the lookout,

who quickly sized up his hooded opponent and advanced, expressionless, his scimitar hissing as he twirled it in the air.

At the sight, the monk lowered his own sword, swayed slightly, then tossed his weapon on the ground and threw back his hood.

"Coward!" spat John.

The lookout lunged toward the monk, threw his arms around him, and they hugged one another like dancing bears, pounding each other on the back and laughing.

"By God that died on a tree, I thought you were dead!" said the lookout.

"I thought I was too! And when I found I lived, I was sure I'd never see you again," said Robin. "Will Scarlok! But how is it you're in the company of thieves?"

Will replied, "Better thieves free in the forest than an honest soldier hung on a gibbet."

"Spoken honestly. And Cedric? Has my old cook turned thief as well?"

Will hesitated. "Dead, of a fever." He did not add that the old man had plunged into the icy river to try to save his master, had taken ill and died raving.

Robin's face clouded at the news of the man's death. "He was old. Now he rests." He bent down to pick up his sword, perhaps to hide the sorrow in his face, then straightened and spun and leaped savagely at John. The point of his sword was at John's throat before the thief could take another breath. "You and I have a score to settle," Robin said.

Light dawned in John's eyes as he recognized his opponent from the footbridge, a year past. "And here we gave you a fighting chance! We could have taken your boots and your robe and left you to freeze."

"That is so. Yet now you must win the right to go free of me, and I will not fight you with the quarterstaff again, for I don't like losing!"

John bared his teeth in a smile. "I see you carry bow and arrow."

"Excellent." Robin lifted his sword from John's neck. "And when I win, you shall carry me on your back to my destination."

John spat on the ground. "When you lose, you'll run naked through the forest with your hair braided like a girl's. We'll chase you right through the gates of Nottingham!"

Much and Harald laughed.

"But in fairness," John said, "since we are striving to be fair, I warn you I am the fairest marksman in all of Sherwood."

"Until today," smiled Robin, stringing his bow.

Much quickly fashioned a leafless wreath from vines and hung it on the trunk of a birch fourscore yards away. John shot three arrows. Each one found its mark inside the circle, good shots, but Robin matched him arrow for arrow.

Then Robin shrugged. "This is hardly a worthy target." He walked over to a hazel tree and cut a branch no thicker than his finger. From it he shaved the bark with a small curved knife he carried, and as he trimmed it he hummed an odd little tune to himself. He sharpened one end of the branch, strode past the birch tree twice as far into the wood, kissed the wand and stuck it into the ground before the black trunk of a dead tree.

"This shall be our target," called Robin.

Much and Harald stared, mouths agape. John took a deep breath, licked his lips and nodded. He fitted arrow to bow and began to take aim, squinted, steadied his hands, lowered his bow, blinked, aimed again, furrowed his brow and finally loosed his shaft. It whistled through the air and lodged with a faint thump in the dead tree, only an inch from the hazel wand. Much and Harald whooped with delight.

"A fine shot," said Robin, impressed in spite of himself.

John stood back and nodded.

Robin slid an arrow out of his pouch, kissed it, winked at John and barely notched it to his bow before he let it fly. Another thwocking sound was heard. Much and Harald ran to judge the shots.

"He split the wand!" came Much's disbelieving shout.

Mouths open, John and Will went to see for themselves. Robin's arrow was lodged in the dead tree trunk, with the arrow's feathers resting in the split hazel wand like a bird's wing caught in a fork.

Robin leaned on his bow and listened to their surprised, distant murmurings. They turned to stare at him and he acted for all the world as if this were no more than he'd expected. But to himself he muttered, "Thanks be to the Lord and Lady, for it's too damn cold to be bare-assed in Sherwood."

The outlaws plucked the arrows from the tree and made their way back to Robin. John said, "With that kind of shooting, I've a mind to ask you to join us."

"I thank you, but I'm no outlaw."

"But you are, my friend," said Will. "or were. The High Sheriff of Nottingham made you so, for you never returned the taxes you stole."

"We stole!"

"But then he declared you dead, and as I've said, I was sorry to hear it."

Robin's eyes narrowed with a glimmer of amusement. "Fitting enough.

Dead to the Sheriff or outlawed, it's of no force. So be it. I have no more money now than I did then, so well enough I shall not be expected to pay it back!"

"Stay with us and you'll get some, and none shall have it from you," said John. "But if you're to join us, we must have proper introductions, for we are as courteous thieves as we are fair."

"It did not seem so when last we met," observed Robin.

John laughed. "I am John Nailor of Hathersage. I killed a deer and would not let my sovereign lord take my balls in payment for it. This jackanapes is Harald, who was a shoemaker's apprentice before he learned our trade, and he learned it stealing leather to make shoes for his family. And Much here may not look like much, but he can slip through narrow windows quick as a weasel."

"Much?" said Robin, peering more closely at the skinny lad. "An unusual name. You bided by Loxley once. I know you."

"No! Never!" Much's face drained pale.

"I swear that you did. At the mill."

"I was never there!" Much's hands began to shake. "I'm no Devil worshipper!"

"I never said you were. No man or woman of Loxley ever worshipped the Christians' Devil."

"Aye, that's the truth," Much said warily.

"And your father and mother? Your sisters?"

Much ducked his head and his lower lip trembled.

Robin looked away. "I had thought to spare you hardship in your youth. Perhaps if I had taken you with me as squire to Jerusalem, as you wished, you would have been spared the sight of Loxley burning."

At last Much recognized him and went down on one knee. "Master!"

"I am no one's master now but my own. Get up." He took Much's arm and pulled him to his feet.

"Well, Loxley, don't be expecting me to go down on one knee," said John. "There are no nobles among us. But it looks to me like you gave up your title to join some monastery. So what do we call you? Brother Wolf?"

"I'm no longer of Loxley and I'm no monk, I assure you. I am of the wood, that is all, and my name is Robin now."

Will stiffened and Harald's eyes went wide. Much took a step backward and crossed himself.

Robin said, "But I go to Loxley even now, for the last time, to lay to rest the spirit of my murdered father."

"Then lay it to rest and come back to join us," urged John in a strained voice. Much tugged at John's sleeve and shook his head, but John cuffed him on the ear and called him a fuddle-pated piss-pot.

"I doubt my path will lead me back here," said Robin, wryly noting his former serf's nervousness, "but night is falling and I'd be obliged to you for a fire and shelter until dawn."

The thought of having Robin obliged to him made John Nailor the happiest he had been in a good long while. All his life, he had heard stories of Robin of the Wood or Robin Goodfellow, sometimes known as Puck, sometimes called the Hooded Man, or by many other names, and wild tales they were, of mischievous wood sprites, goblins, boggles, demons and Gods, and though he had never met a wood sprite before and had even at times doubted their existence, it couldn't hurt to offer hospitality to a man who called himself by such a name. Whether this Robin was mortal man or something wyrd, he silently thanked St. Brighid, patron saint of brigands, that he had not made this particular fellow run naked through the greenwood in winter.

John extended a hand. Robin shook it as the others looked on in varying degrees of dismay, and so Robin left the main road and walked into the uncharted woods with the outlaws, thinking he would be sharing their hearth for only a single night.

19-OF A CRONE, A STRANGER AND A HARE OR TWO

Through thicket and vale they plunged ever deeper into the wood. The sun had dropped low and its light was falling weakly through a haze of clouds just above the horizon before they came to a narrow ravine, a cleft in the earth so well concealed that Robin himself did not see it until he almost stumbled into it. John led the men down a steep, barely discernible path, passing ledges in the rocky cliffs where the mouths of a dozen small caves gaped. Lower down, a brook, too fast-running and sheltered from the wind to have turned to ice as yet, trickled from within the rock into a wide, natural basin of rugged rocks. John said they called it Brighid's Well, though it was not a proper well, but a wild-flowing pool feeding a stream that slid over stones and the exposed roots of trees lining its banks,

following the length of the narrow, wooded valley. The men followed the stream into the heart of the ravine.

Robin smelled smoke before he saw it, a faint wisp of grey angling up into the darkening sky. A secluded clearing in the trees opened before them. In the center, an ancient oak spread its heavy limbs. A rude lean-to rested at the edge of the open space. Before it a welcome fire burned in the fading light, and above the fire rested a great black cauldron on a tripod of iron. A handful of men milling about the fire looked suspiciously at the newcomer.

"This be Robin," said John, "as fair a marksman with bow and arrow as ever I laid eyes on."

"Has he any money?" said a short, stocky man with his left arm in a sling.

"Shut up, Stub," said John.

A heavyset woman in a brown bliaut and a worn cloak draped over her greying hair emerged from the lean-to with a knife in one hand and a bunch of sorry-looking carrots and parsnips in the other.

John said, "My mother, Priscilla Nailor."

"Prim," corrected the crone, giving Robin a penetrating look.

It seemed to Robin that despite her elderly appearance, she was not entirely past her prime. Energy seemed to crackle out of her grey eyes and her movements were deft and steady. He bowed to her.

"Oh, a fancy man, and another mouth to feed," grumbled Stub.

"He won his supper," said Will, "and he is my friend, so watch your tongue or I'll cut it out." The frayed tension of what appeared to be an old quarrel filled the air.

"It's a fine bow," ventured Harald, eyeing Robin's weapon admiringly. "Will you teach me to shoot?"

"I'll not be here long enough. But will not John teach you? He is almost a match for me," Robin smiled.

Prim pursed her lips at this boasting and went to the fire, where she began to cut the parsnips into chunks. The outlaws huddled around, shivering and watching.

Robin went closer and looked into the pot. "Have you no meat for the stew, Good Mother?"

John said, "We've had little luck hunting in these woods."

"They're enchanted." Much shivered.

"Easier to take a man's purse on the Great North Road," said Stub.

John said, "We've become hunters and trappers by necessity, not by trade. We were farmers and shepherds."

"Shoemakers," said Harald.

"Millers," offered Much.

"Not royalty," said Stub with a sneer at Robin.

Will objected, "I was reckoned a good enough hunter before I came to Sherwood. I caught a rabbit in a trap here only last week."

"You caught its chewed-off leg," objected Stub.

"Fed us for a week, it did!" John laughed.

"So you have little skill for hunting," said Robin, "yet none of you is skilled enough at thievery to pay the baker for bread, the butcher for meat, or even the piper for a song to feed your poor pathetic spirits!" He laughed.

Stub snarled and put his hand on his knife. John stayed him with a frown. Prim peered at Robin out of the corner of her eye.

Robin said, "I can get you meat. Which one of you walks most quietly in the wood?"

"I do!" said Harald eagerly.

"You do not, you're a galumphing ass. In the morning, you can take Will," John said.

"I'll take him now." Before John could protest, Robin nodded to Will and they were heading out of the clearing toward the steep path on the face of the cliff, leaving the others watching hungrily after them, and John wondering if this Robin Goodfellow would return or if he were already up to some mischief, stealing away his best man. But he did not want to cross him by trying to stop him, or else, if the Faerie tales were true, bad luck would be his master the rest of his days.

Stub spoke John's fears for him. "What's that cockscomb up to? You never should have brought him to our hideaway."

"Shut up, Stub."

Prim took John aside. "I'd say that's a Druid's hood your new friend wears. Didn't you call him 'Robin'?"

"I did." Seeing the look on her face, John added, "I trust him."

Prim raised a skeptical eyebrow and went back to stirring her broth.

<center>⌘</center>

Robin walked swiftly through the snow, pausing often, sniffing the wind, changing direction from time to time in a wandering fashion that seemed to have no purpose. Will kept one eye open for signs in the landscape to mark their path home and kept his other eye on the setting sun, all the while wondering at his old friend's mysterious air and his new skill with the longbow.

Robin stopped by a gnarled yew tree. Just ahead of him the ground dipped, and in the shelter of the hillock, some last bits of drying foliage

poked above the snow. A large white hare was feeding there.

Will pulled an arrow from his quiver. At the movement the hare looked up. Robin stayed Will's hand with a flick of a finger behind his back. The men stood motionless. Robin's eyes glittered and his lips moved silently. The hare froze its gaze upon him.

Slowly, as if stroking a lady's cheek, Robin drew forth one of his arrows. Just as slowly he nocked it and let it fly. It struck the hare neatly in the head and the creature fell without a cry.

"Well done," Will said ruefully, thinking the hare had been his if Robin hadn't stopped him.

Robin went to retrieve his arrow, wiping the blood in the snow, then put his hands over the hare's death-wide eyes for a moment and muttered something under his breath that Will couldn't quite hear. Then Robin took up the hare by the legs and led them further into the forest.

<p style="text-align:center">⌘</p>

The fire cast a warm glow in the darkness, the more cheerful for what was about to be cooked over it. While Prim skinned and cut up the rabbits, John Nailor approached carrying a blanket which he unrolled at Robin's feet. It held three objects, a sword, a cup and a staff.

Robin recognized them as the scimitar he had brought back from the Holy Land, stolen by these same thieves on his way to Nottingham to confront the Sheriff many moons ago. He picked up the battered silver chalice that had been his father's, and the walking staff he had used in fighting John on the footbridge. Robin nodded. Harald and Much watched this silent transaction with awe, but Stub had a scowl on his face.

When the stew was ready, the men hunkered down and wolfed their food without a word, but Robin sprinkled a bit of his upon the ground, murmuring something as he did so.

Her own wooden bowl in hand, Prim sidled close to the young stranger in his Druid's hood and sat beside him. Between mouthfuls of thick rabbit stew, she asked, "How is it you find meat where others find none?"

"I once shot three arrows at a roadside cross and it gave me magic." He winked and wiped gravy from his mouth with his sleeve.

"A pretty superstition. If only it were true, more men would be better hunters."

Robin relented. "I studied the ways of the woodlands with a hermit near Copmanhurst."

"Not old Cal the Necromancer?" said Prim with a start of surprise, almost dropping her bowl.

Robin felt somehow that it would take a great shock to make this stolid lady astonished. That he had just given her such a shock both pleased and worried him. "Is that what you call him?" he replied warily.

"Well, if it really is Cal! He and I learned of herbs together, off his old granny. But he would never go by what others told him. He had to make his own way. I used to tease him to the ends of the earth over his foul concoctions. Has he got any the less foolish? I thought he was dead!"

"So you know herb lore and healing?"

"As well as I might," Prim answered tersely, regaining her composure.

"Then you are a Witch," he said quietly.

"By our Lady, the very idea!" Prim crossed herself and looked around the fire to make sure no one else had heard his words. "I only know a few herbs for healing women's troubles, a few more herbs for their taste. I would never study Witchery."

"And Cal is no sorcerer."

"Oh, no; no indeed, *Robin*," she replied pointedly, and the two eyed each other over their stew.

20-DEATH HONORED
WOLF MOON FULL, 1193

The next morning, after they broke their fast with a porridge so thin it barely deserved the name, Robin begged his leave of the outlaws. Will offered to join him in his quest, then Harald asked if he might go too, and while Robin told him no, Much looked on as if he were torn between fear and longing, for Loxley had once been his home also and he had his own ghosts to lay to rest.

"We might as well all go," grumbled John, his brows knitting together at the thought of his men following this Robin away through the wood.

But Stub said, "I'll go nowhere out of Sherwood and the rest of you are daft to think of it. We've all got prices on our heads." He did not seem pleased that Robin agreed with him.

In the end, Robin left with only Will at his side. Stub crouched by the fire and growled, "We've seen the last of them, I'll wager," and John kicked him in the buttocks for speaking his own thoughts aloud again.

⌘

"The Carmelites tried to build a monastery at Loxley, paying rent to the Benedictines, who own it now," said Will as they made their way toward the Great North Road. "But they failed. The rumor is that evil spirits linger there, hauntings and sickness. Five monks died, all in one month, from some unknown plague."

"Carmelites? The mendicant friars? No wonder. They never bathe," said Robin sarcastically.

Will laughed. "They called in a bishop to perform an exorcism, but even then, they claim the crops would not grow, the milk turned sour in the cows, and the monks were forced to abandon the place. Perhaps you'll do them a good turn by laying your father's spirit to rest."

Robin frowned and halted briefly in his tracks. "Be that as it may, I have vowed to do it and I owe it to my father." Then he grinned. "I hope you are not afraid of haunts."

"I've no fear of demons. My sword protects me," Will replied with a cocky air.

"Well spoken for a soldier. I, too, am protected."

Will had the idea that Robin was not referring to swords at the moment. That mysterious air he had noticed while hunting the day before hovered about his old friend like a persistent mist that the sun strove in vain to burn away. Will decided he preferred not to know too many details of the time they had spent apart. Robin had not spoken of it except to say he had been rescued from the river and a raging fever by a holy hermit, and had repaid his life-debt by staying with the monk and serving him for a year and a day.

The sky was overcast, the air was icy and they saw no other travellers. The day wore on and the forest with it, and after awhile neither man wasted breath on talk.

By sunset, however, the clouds began to break, and the snow-covered hills and meadows northwest of Sherwood turned into a sea of gold under the sun's rays. There being no cover in the fields, the two men waited for true nightfall before leaving the shelter of the wood.

They pressed on in the darkness at Robin's behest, for the moon was rising full that night, the best time to finish the work he had begun secretly at moon-dark.

An hour or two before midnight they reached Puck's Hill. Some of the oaks upon the hill had been cut down, no doubt to rebuild the stables and other outbuildings of the keep, but many of the great trees had been spared.

Beneath one of these, in the windbreak of an outcropping of rock, Robin

and Will built a fire to warm their hands while they ate a meagre meal, a handful of nuts, bark tea. Robin had not spared time for hunting as they had travelled and seemed not to notice the lack of food, but Will's stomach rumbled in the familiar protest he had grown used to in the past months.

They sat pensive, gazing into the flames, until Robin began to speak, as if talking to himself, or explaining himself to himself, making peace with his own heart. "My father and I did not always agree, but only now do I begin to understand him. Too late. He tithed and attended mass, but he was of the country, not the town. He bent one knee to the Christian Church, but danced on the holy days of an older faith. He celebrated the coming of summer, the harvest, the death and rebirth of the sun. His peasants demanded it. They would not plough the fields and sow the corn if the Elder Gods and Goddesses were not honored, for they believed it would blight the crops.

"My father fought as a soldier for King Henry when he could not afford to pay another to take his place, but he never loved battle. He served well enough to be awarded a small estate, but he was never knighted. I was unlike him. I spilled from my mother's womb screaming for adventure. Even as a child, I dreamed of escaping our paltry holding and the boring, back-breaking labor of a farm to become a brave and honored knight. I begged and worried at my father so much that at last he gathered the money to send me to Derby to study jousting and swordplay, the crossbow and all the other business of killing men, with an old sergeant of his, a knight called fitz Warin. This man had no sons, so he fostered a herd of boys from noble families. He was a burly man, gruff and harsh, but with a tender streak he showed to his little daughter."

Robin laughed softly, lost in his memories. "She used to play with us boys when she was very young, with her little bow and arrows and a dull-edged dagger. We made fun of her until she put us to shame, for she was quick and had a good aim, and she soon learned how to beat the life out of anyone who taunted her. She didn't scratch at their eyes like a girl; she'd wrestle them down into the mud, howling like a moonstruck wolf. But then the serving women took the girl in hand and started to make a lady out of her." In his mind he saw her as clearly as the flames in the fire before him. She was peering out of a high tower window, a skinny moppet with unruly dark hair cut short like a boy's but now forced into ringlets, wearing an elegant dress, clutching a distaff, all awkwardness and painful shyness, when before she had been daring and outspoken, and her face was blotchy-red with anger as she watched the boys jousting below. Then her face shifted. He saw her older, paler, her clothing drab as a nun's, and forbidding grey walls

surrounded her. Her eyes were sad, her mouth unsmiling. What vision was this?

Then he remembered she had been sent to some convent to be raised. Robin shook his head free of the unsought image. "Her father died and she was sent away," he said. "I and the other boys went to train at another court, larger and more lively. There were troubadours every night, a brace of sons intriguing for inheritance, and two daughters ripe for wooing. Rivalries developed. Our mock fighting at times grew serious, but that was all part of the training. I was never wounded badly enough to knock any sense into me. I suppose I thought myself invincible. By the time I was strong enough to wield a man-sized sword, it took but a few fiery sermons to incite me. I was knighted along with a crowd of other half-baked soldiers and peasants and I went crusading with *Coeur-de-Lion*. Jerusalem had fallen to the infidels and we were going to save it, or so I thought." Robin spat on the ground as if the memory left a vile taste in his mouth, and Will spat also, like a pact.

"I rode home before we set sail, to bid my father good-bye, vain in my new knighthood and hoping for his pride in me. He lost his temper. He forbade me to go, in a rare attempt to fetter me. I laughed in his face. He said, 'To hunt the deer is noble. To hunt men is not.' I said, 'A deer has no defense against a man but fleetness of foot, and my arrows are fleeter than any deer. What contest is that? A man fights another man evenly matched, with wits and courage and muscle, with lance and battle-axe and sword.'

"He said, 'You have not hunted boar enough if you think beasts are no match for a man. But enough of this madness. Think you I do not know the taste of war? Glad I am that I shall taste no more of it! We hunt animals that we may eat. Will you eat the bodies of the men you kill? Will you drink their blood, as you are told to drink the blood of Christ in the Church?'" He smiled without humor. "I shouted that he knew nothing of the world, and my father shouted that he did not know my world and did not wish to know it. I said that he shamed me, I was sorry to call him 'Father.' I stormed away to make myself ready for the voyage, and so we parted, with never another word spoken between us."

The fire crackled and hissed. Will fed it another broken branch and stirred the coals.

After a time Robin said, "I only wish he still lived, that I might tell him he was right. But what of you, Will? I never asked how you came to be in *Outremer*. You do not seem of a religious bent."

Will snorted. "I never liked being inside four walls to pray. I'd rather be in the wood or the fields where I can see what's coming at me."

"But one need not cross the sea to find work for a good sword."

Will hesitated. "I started as a slave. I never knew my father or mother. Poor wretches, I think they were slaves themselves, slaughtered in some bloody clan feud in the Highlands. I was stolen from my home as a babe. I grew up strong, I was big, and I soon made money for my owner who would bet on me at wrestling. Och, he was a bastard. If ever I lost, which was rare enough, he would whip me 'til I bled like a river. One summer I managed to escape with a band of *Rroma*—gypsies, you call them. I killed the man my master sent after me. So, with a price on my head, I made my way south to England with the *Rroma*, who cared little for the laws of other men. But steady money lured me. I hired myself out as a mercenary. I went wherever the money was best. A baron took me on as part of his troops and off we went to the Holy Land on Crusade.

"Now, there was enough blood and plunder to satisfy any warrior. But before long, my pay was late and food was running low, and one tires of killing unarmed women and children anyway, there's no challenge in it … and you know the rest." Will's teeth flashed in a brief smile.

It was after the taking of Acre. As the Crusaders made their way along the coast to Arsuf and Jaffa, ever closer to Jerusalem, harried constantly by Turkish cavalry, Robin and a handful of other men had been charged with finding deserters and bringing them back for punishment. But a fierce raid by the Turks had scattered their small force, and Robin, wounded badly and left for dead, had finally regained consciousness enough to crawl toward a scraggly line of palms that he thought might give some shelter from the relentless sun. There he had found Will, a deserter, himself starving and sun-burned and half-mad from thirst and hunger. Will bound Robin's wounds and guarded him through an incoherent day and night of fever. He also took a share of Robin's provisions, and through the grace of some water, a crust of bread and some bandages, a friendship was forged.

On the second night, when it was dark and safe enough to leave their hiding place, Robin had thought it wiser to travel away from the fighting rather than toward it, something he had wanted to do for some time but had lacked the opportunity. He could not bear the idea that he might be branded a coward, a deserter. But how could he take this man who had probably saved his life back to imprisonment or hanging? It would not be nobly done. He was grateful for the excuse. The two of them began to make their way home.

Now Robin said, "Well-met, Will Scarlok."

They watched the fire in silence for a time, until the moon was at

midheaven. Then Robin stood. "Wait here. I'll return before dawn."

"I'll come and watch your back," Will offered.

"I am not afraid of ghosts, as I said, or of Carmelite monks," Robin grinned. "This is something I must do alone, my friend."

Will was far from disappointed. Haunted ruins were not his preference for a night's work. He grunted and folded his arms across his chest, settling back to wait by the fire.

Robin strung his bow and slung it over his shoulder, took up his staff and left the circle of firelight. He walked down the hill and across the wasted fields, feeling himself a ghost in a dead world, until he came to the stream that flowed through the valley, blissfully clear and cold. He drew his father's silver chalice out from his deerskin pouch and filled the goblet with water. Then he carried it toward the ruins of the keep. He passed five graves in the moonlight, mounds of moldering soil with wooden crosses already weathered and tilted. Let the dead lie in peace, he told himself; they did not steal my father's land.

At the keep were signs of new masonry, walls unfinished, a broken hoe, an abandoned wooden bowl, everything topped with dustings of snow. He plunged his staff into the rubble. He spoke a single word, or perhaps not a word but a syllable or a sound that seemed to rise out of him like a wave, and he passed his hand over the staff. The unschooled eye might not have seen the blue flame that now danced about the top of the staff, but to Robin the flame was clear and the shadows of the craggy ruined walls danced also, like tortured giants, in the blue glow.

Robin set his bow on the ground beside him. He dipped his fingers in the chalice and flicked drops of water in a circle around him. He took his dagger, and the designs he drew with it in the east and south, west and north, above and below him glowed blue, and when he was done, a circle of blue flame surrounded him, punctuated by stars.

There were watchers in the night who saw those flames and drew closer: not men, but squirrels and mice, hiding in the crevices of fallen stones as an owl glided over, hooting, its golden eyes gleaming.

Robin knelt and took from his deerskin pouch a circle of black serge cloth the size of his hand. On this he placed various herbs and resins, among them rosemary and myrrh, bark and needle of cedar and pine, and lastly, the hair of a dog and a butterfly's wing, for these were known to the ancients as psychopomps, guides to the souls of the dead. He crumbled these all together with his fingers. Then he took out a poppet made of cornhusks, the figure of a man, with eyes painted to look closed as if in sleep. He cradled the

poppet in his hands, crooning to it, as if it were an anxious child and he lulled it. His own eyes took on the look of trance, his heartbeat slowed, and when he began to feel as if the earth blew strength from its heart into his, he sent it from his heart into the heart of the poppet.

He murmured, "I name you Hugh of Loxley. In spirit and flesh, thou art he." He kissed the poppet and felt a thickening in his throat, as if this really were his father and his final kiss good-bye. He placed the poppet on the crushed herbs, then tied the cloth into a little bag with black thread.

"By Air, by Fire, by Water, by Earth, by the powers of Nature, my words be heard." He cupped the bundle in his hands and blew on it, then passed it unharmed through the blue flame of his staff, sprinkled it with water from the chalice and touched it to the stones of what was once the keep's floor. "Great Herne, Lord of the Hunt, carry my father's spirit safely to the Underworld, where he may await rebirth. Carry my words to him: until we may meet again, my father, in this world or beyond, hear my heart. Accept my offering to your spirit. Fare thee well—no! There is more. Grant me your forgiveness, Father. I—" His throat caught. He could speak no more. But he thought, "I didn't know. I didn't understand."

He tied the black bundle to his finest arrow, adorned with the black feathers of a raven. He stood, nocked the arrow to his bow and shot it over a ruined wall toward the full moon. He cried out, "Go freely from this world, Hugh of Loxley, to whatever good awaits you!" He lifted his arms above his head, his voice rising in an ancient chant, his fingers stretched wide. The blue flame dipped horizontal to the ground in a gust of wind. There was a sharp cry—perhaps the owl had caught its prey?—and a flash of golden light shot out from the staff.

Robin crouched on the ground and pressed his forehead to the cold stone floor. He noticed he was shaking, trembling with power. He felt as strong as ten men. He found himself whispering, "I vow that your death shall be avenged, Father." And the face of Sir Reginald of Nottingham leaped into his mind as if commanded to come.

<div align="center">⌘</div>

In the morning, not far from the ruins of Loxley, in a sparsely wooded vale, one of the King's rabbits lay dead with an arrow through its breast. A young boy of perhaps nine winters found it, and hunger overcoming his confusion and superstitious fear at the odd black bundle attached to it, he buried the bundle hastily at the foot of the nearest tree, hid the arrow and the rabbit in his shirt and ran home to his widowed mother, where they rejoiced at having something substantial to eat for a change.

The boy kept the bundle and the arrow secret from his mother, for he knew they would upset her. He said the rabbit was a gift from a forester for running an errand for the man. Otherwise she would chastise him for stealing or begging and would send him to give the rabbit back. He silently begged God's forgiveness for the lie.

As the days passed with no perceptible harm coming to him or his mother from the eating of the mysterious rabbit, other than the wearing off of the magical feeling of their stomachs being full, he forgot both the lie and the black bundle.

But the arrow he saved as a treasure, hidden in the straw of his bed, and he often took it out and looked at it and dreamed about it, wishing someday he might have a bow large enough and himself be grown enough to shoot it.

21-the scourge of the forest

By dawn, Robin and Will had regained the stillness of Sherwood. But the strength Robin had felt at the end of his midnight ritual seemed to have drained away. Now that his vow to honor his father was fulfilled, another vow had arisen out of it, yet how to honor this one?

He halted in his tracks to watch a flock of birds soar southwest. He narrowed his eyes to study the changing formations they made as they flew. He shook his head, walked on, then stopped to slide a hand down the trunk of a birch. The bark only made his palms itch. He trudged on, then stopped again, listening to the wind, sniffing at the air.

Will watched this odd behavior with some suspicion, but Robin, lost in thought, did not notice. So the birds flew south and west, he was thinking. What of it? One could say they beckoned him back to the outlaws' nest or beyond to Cal's hermitage, or across the Channel. His skill did not lie with augury. Today he could read no omens in bird flight, feel no one's fate in the bark of trees, hear no messages whispered in the wind, only a soft and to him, meaningless clicking of bare branches swaying against each other in the morning breeze.

In the hopes his friend would move more quickly against the biting chill, Will asked, "Where go you now?"

"Well. . . and where do you go?"

"I thought I'd go where you go."

"Well enough. Only I ... don't know where I'm going."

"It's cold here," said Will, glancing beyond the trees toward the wan sun rising. It shed little warmth.

"I'm hungry," suggested Robin.

"There's little enough to eat at Brighid's Well."

Robin nodded and left the path to wander through the trees, poking here and there in the snow with his staff, and finally kneeling down and digging up some sort of root, which he scraped clean with his dagger and broke in half. Will chewed his portion grimly. It was slightly bitter, but edible.

"And how do you like the life of an English outlaw?" Robin asked. "Better than an English soldier?"

Will shrugged. "We could go to Normandy or France. They don't know us there. Hire ourselves out as mercenaries."

"Soldiering has lost its lure for me. But I dreamed night before last, strangely, of Constantinople. Or was it Heaven?"

They grinned at each other.

"The sun," said Will.

"The women," smiled Robin.

"The gold."

"But there's one thing I must do before we go. Sir Reginald of Nottingham."

"What of him?"

Robin paused, then appeared to change the subject. "Venison would go well with this, roasted on a spit." And he smiled a most unsettling smile and ripped a chunk of the root off with his teeth.

For the sake of the venison, they found and followed a deer trail, while the sun travelled higher in the sky and the void in their stomachs gnawed at them. When Robin saw the stag, the creature was very close, yet almost hidden among the trees, lifting his head and gazing straight at him with moist velvety black eyes, his king's crown of antlers like golden branches seeking the sun, his coat an astonishing creamy white, like goat's milk or the snow at his feet, which was itself a pale mimicry of the ruff of dazzling white at his throat. Hypnotized by his beauty, Robin reached slowly for an arrow.

He didn't even hear Will asking, "What is it?" for Will saw nothing through the trees and snow.

The stag stood motionless, watching. Robin took aim. The proud creature tossed his head, turned majestically and trotted away westward, disappearing into a hollow between the hills.

Robin lowered his bow and arrow with a dazed expression. Only now did he wonder that a stag would still have antlers in dead of winter. A white stag.

He took off after the beast, Will at his heels, hissing, "What? What is it?" They reached the hollow and now both of them saw the stag, poised as if waiting for them.

The creature turned and trotted deeper into the wood. They followed for an hour and more, over hillocks and across frozen brooks, slipping on boulders covered with lichens and snow, dodging thornbushes and vines hanging like snakes from the branches, the tree trunks crowding closer and closer together, thick and old as the hills. Fallen trees often blocked their way, but the stag leaped them effortlessly. The two men clambered over to find the stag waiting, half-hidden, then turning and bounding away. Robin moved so swiftly and with such ease that Will lagged further and further behind, until, slowed by a fallen oak, he lost sight of his friend entirely.

He called Robin's name, scanning the dense wood. He heard no reply, saw no movement, as if even squirrels or birds could not penetrate this primeval place. He dared not push on in the wrong direction. He would have to trust Robin's newly acquired sense of the woodland, and hope he returned before nightfall. Reluctantly, Will began to clear away snow and dead leaves. He dragged over a dead branch and began chopping it up to build a fire. He planned to hunt for more of those roots or even a hare, but did not go too far from his fire. Not that he truly believed these woods were haunted, he told himself. It was only that he did not know them well, and would not risk losing Robin again.

Robin ran, panting and sweating, almost as fleet as the deer, mindless now of the thorns that grabbed at his robe or the sharp stones that threatened to pierce the soles of his leather boots. At times, he was close enough to see jets of steam spout into the frigid air from the white stag's nostrils, to see his wide black eyes roll wildly as he charged over a ridge and disappeared into a rising mist.

Then came the breathy, horn-like cry of a doe calling for her mate, "Hhh-e-rr-nnn! Hhh-e-rr-nnn!" An answering cry filled the air.

Robin topped the ridge and checked his flight, for he saw through the layer of mist below the white stag, alone, pawing at the edge of a frozen pond with his sharp hooves. The ice cracked and the stag leaned his head down to lap up the cold water. Then he lifted his dripping muzzle and trumpeted again, and the forest came alive with deer. Young stags and does and fawns appeared through the mist from every direction, brushing past Robin as if he

were but a tree. They gathered near the white stag, licked the water at the edge of the pond, searched out the last dried growth of foliage under the snow, rubbed against tree trunks and nibbled curiously at the bark, and swarmed so close that Robin could see their nostrils twitch as they smelled his man-smell.

Robin stood breathless at the sight. A doe paused as she stepped delicately by him, her ears pricked forward as if she could hear his heart beating. Her nostrils twitched wetly. He held himself as still as he could. She came closer and nosed at his hand, then licked the salty sweat from his palm, her soft, warm tongue a benediction. Yet with this benediction, he seemed to hear a warning, though he could not have said from whence came the voice. "Take the blood of the white stag and you shall die with him."

The stag let out a soft ululating cry. In an instant, pounding hooves like thunder, swishing snow and dead leaves like rain swept the wintry glade empty of deer. The white stag had vanished like a wraith.

Carefully, Robin made his way down the slope to the mist-swirled pond. He knelt and stuck his tongue into the freezing water and lapped it up like a beast, then sat back on his haunches and felt a nameless power surge through him once more, as it had during the night.

He threw back his head and let out the wild stag's cry.

⌘

The crackle of the fire masked the snap of a twig under Robin's boot, but Will was watching the shadows and had his scimitar in hand by the time Robin's form was revealed by firelight.

Robin ignored the flash of his friend's steel and dumped the body of an aged doe onto the ground. He set about deftly skinning the pelt and slicing off meat for roasting, storing the rest packed in snow.

Will assumed the white one had escaped and said nothing to shame his friend. When the venison was cooked, they devoured their meal silently, but for Robin throwing a strip of meat into the fire and murmuring, "For Herne."

A shiver ran through Will at the name of that ancient ruler of the wood, leader of the Wild Hunt, but whether Robin said it because he followed the old faith or because he wished merely to appease the Elder God in this enchanted forest, he did not say, and Will forebore to ask, perhaps because he feared the answer.

In the morning, as they scrambled back over the fallen tree trunks and slippery ice-coated rocks toward the Great North Road, Robin knew where he would spend the winter, at least. Avenging his father's death might take a different form than he had expected. He had envisioned righteously angry

noblemen at his side, storming the castle at Nottingham; Fate had sent him a scraggly band of thieves. He would not argue with Her who held the strands of Life in Her hands. Who knew what web She designed to weave?

Except for the grumblings of Stub, Robin's return was welcome and the remains of the doe more welcome still. As Prim and the men ate, Robin told John he would like to winter with them. John clapped him on the shoulder and bade him stay as long as he liked. Robin rubbed his sore shoulder and thanked him.

Harald immediately began pestering Robin for lessons in archery, and Robin and John spent the rest of the day competing to teach him all they knew of the art.

The following day, Robin, in an unusual burst of modesty, asked for instruction from John with the quarterstaff, and when the other men tired of watching and cheering on their favorite, they took up their staves as well. So, without planning it, Robin began training his 'troops' without fanfare, and without revealing his goals.

The short winter days were filled with these contests and the endless quest for food, which remained scarce and consisted more frequently of nuts and tubers than meat, despite Robin's skills. The men longed for bread made of grain instead of ground acorns, and for fruits and vegetables, dried or preserved, whatever the season might allow to a farmer. Their patched rags they gladly would have traded for warmer clothing, but as they had nothing valuable to trade, the only way to get these goods was to steal them or steal money for them, and John and Stub were eager to go hunting of men as before.

Robin joined them in their scheming, but interfered at the moment of truth, for when they waylaid a peddler or merchant, tradesman or craftsman, Robin insisted they take tribute only, instead of robbing them blind. John, not wishing to cross his Robin of the Wood, went along with this somewhat disappointing approach, and so one day they took three pieces of silver instead of six, and another day they took two bolts of cloth instead of ten, but at least it was the best thick wool for their cloaks.

Once they managed to hold at bay six knights riding down the Great North Road with two noble ladies, but though he took the knights' weapons and money, Robin declared no harm must come to the women, giving no reason but that he would not offend the Lady.

"It's a hell of a time to suddenly become religious!" swore John, his thick fingers already wrapped around one frightened woman's amber necklace. The argument that followed ended when Robin aimed an arrow at John's

chest, an infamy for which John did not forgive him for a month. The lady, however, remembered it with surprised gratitude every time she wore the necklace thereafter, and it made a pretty tale to tell on a cold winter night, of the dashing brigand who triumphed over armoured knights yet protected their womenfolk.

Robin made up for his regrettable lapses as a thief in general, however, by the alacrity with which he specifically robbed the clergy, who were forced to part with every coin and jewel, from their purses to their rings of office to their great gold crosses and rosaries, and sometimes even their sumptuous robes. Rumor spread through the shires of Nottingham and Derby, then into Lincoln, Leicester and York, that a Robin Goodfellow held sway in Sherwood, no mere outlaw, but a *puca*, and it was said that only the brave or the poor dared venture through there.

Of course this chatter was disregarded by more rational souls, especially by religious men of the cloth, who trusted in their God and Jesus to guide their footsteps, and would not be turned aside by fear of mortal man or Faerie tales. As a result of their laudable faith, the plundering that winter grew slowly better for the motley band by Brighid's Well, and whatever bread and blankets they could not steal, the outlaws paid for with stolen coins. The tradespeople in the towns were happy for the extra business and did not trouble to ask from whence these strangers hailed or where they got their gold.

From time to time, in villages and towns near Sherwood, Lincoln, even as far as Herne's Fell north of Fountains Abbey in York, in every hamlet and estate where one of the outlaws had kin of blood or spirit, peasants and blacksmiths, millers and innkeepers, widows and farmers opened their doors in the darkness before dawn to a quiet knocking, and seeing no one, stumbled bleary-eyed upon parcels that proved to be the haunch or shoulder or other choice portion of a fresh-killed deer, a hare or a brace of quail, and upon the parcel the bow and arrow sigil of Robin of the Wood. And if here and there a baker found a loaf of bread missing, or a cobbler discovered a length of shoe leather gone, they considered it a good enough trade, and hid the meat to feast upon it secretly, away from the prying eyes of local nobles or clergymen who would betray them to the King's law.

Meanwhile, the bandits' numbers grew. A serf did not like being beaten by his master and ran away. A serving girl who did not like her liege lord getting her with child against her will took refuge in the wood. An artisan whose noble clients neglected to pay him was turned out of his home, and sought a new one, as did a slave woman from Outremer, escaping her new

master. Other outlaws also came, some rogues by choice and some by chance. They lost a few, however, to illness, to the swords and crossbows of knights they preyed upon, or to fights among themselves, for desperate men in their anger sometimes made a comrade-in-arms into a foe.

Nor was Robin immune to dissension.

On a windy day in March, he and half a dozen of the outlaws waylaid three monks in a cart returning from a pilgrimage to Canterbury. The monks stood quaking in the road, with little to offer in the way of booty besides the cart itself, for they belonged to an Order which still kept to its charter of poverty.

When a monk refused to surrender his rosary, Stub, thwarted in his greed, lost his temper and plunged his knife into the man's chest. He stumbled back gurgling and fell to the ground, limbs twitching in death. The other monks screamed for God's mercy. That same instant, the grey goose feathers of an arrow's shaft blossomed in Stub's heart, and the string of Robin's bow was trembling. Stub crumpled with a grunt, his eyes wide.

His features expressionless, Robin told the terrified monks to pick up their dead brother's body and go in peace, and to take Stub's body as well and claim whatever reward there might be for him. The other outlaws watched, stunned.

Robin hid his disgust, in Stub and in himself. Had he not seen enough of murder as a Crusader? If he had to kill to save his own life, he would do so without hesitation or regret, but he had reacted without thinking to Stub's vicious attack. Damned if Robin's own temper wasn't as bad as that of the man he had killed. Stub had not offered himself up for a sacrifice like some charm-beguiled rabbit.

The truth was, Robin had grown to detest the man, returning Stub's disfavor in kind. He had never planned to kill him. He had acted on instinct. But how could he excuse or defend the unnecessary killing of a worthless fool on sacred ground? For all of Sherwood was sacred to him.

Robin told the others to go back to Brighid's Well without him, and spent the night alone among the oaks, scrying in the flames of a fire made from juniper wood and hawthorn, seeking to make amends to the balance of natural and unseen Powers in Sherwood. But though he prayed and chanted and slowed his breath until a passerby, had there been one, would have thought he did not breathe at all, no answer came to him from the flicking tongues of flame other than echoes of words he had heard once before, "Never may you take the blood of the white stag; it is forbidden you."

It seemed little enough sacrifice, for he would never choose to kill the

mythic beast, and he somehow felt dissatisfied, as if he owed more. But then, he had not consciously chosen to kill Stub either.

With a sense of foreboding, he returned to Brighid's Well the next morning and sat by the communal fire to break his fast. The others greeted him warily, avoiding his solemn gaze. Finally Robin said, "To kill the clergy is foolish. The Church is like a tree bearing fruit of golden coins and rich jewels. If we pull it up by its roots, it will bear no more and we will have no harvest."

But Prim thought, "It is more like a weed, with roots spreading deeper and farther than men can see, choking the old, good growth," but she said nothing.

Meanwhile, tales of that day's deed bubbled and frothed through the countryside like well-brewed mead pouring out of the vat. News of this latest exploit reached Nottingham, and gossips remarked, crossing themselves, that Sherwood's *puca* meted out his own justice.

Annoyed that this scourge of the forest was gaining popular approval, the Sheriff saw he must remind the people who was responsible for justice in his shire, and that it was no robber peasant masquerading as a will o' the wisp. He put out a warrant for the arrest of one 'Robin in a hood, an Outlaw,' offering a reward of no less than fifty marks.

But since few knew what Robin looked like, his face being mostly hidden in his dark cowled hood, and since few people wished to enter the unmapped depths of the forest to seek such a fearsome wolf's-head and claim the reward, and since Brighid's Well was so secret a place, Robin and his men survived the winter in Sherwood undisturbed.

22-A KING'S RANSOM

While Robin and his men were building their reputations on misdeed and hearsay, other rumors were flying fast and free through Europe, to wit, that Richard the Lion Heart was imprisoned in the castle Dürnstein on the Danube, that Richard was imprisoned at Regensburg, that he had escaped, that he had been executed, that he had drowned, that he had gone mad and renounced his title. At last, the Lion Heart, of sound mind and body, was found at Ochsenfurt by two Cistercian abbots, emissaries sent by Coutances in England.

Richard's beloved brother John, having declared him dead and claimed

the throne, rallied an army of reasonably loyal followers who were eager to fight those who believed the Lion Heart lived. Their armies writhed across England, laying sieges to castles, laying waste to the surrounding land and earning the continuing hatred and mistrust of the common people. Fields that would have fed them if properly ploughed and sown were trampled under horses' hooves or simply burned to impoverish their overlords, while grove after grove of healthy trees were cut down to build mangonels and battering rams and siege towers, until a stubble of tree stumps edged the forests like a badly-shaved chin on the face of the earth.

Queen Aliènor was heartened when the Pope excommunicated Leopold, Richard's first abductor, but she was grim when the Pope stopped short of her goal, for he did not excommunicate Emperor Henry VI, who had bought her son from Leopold for the staggering sum of a hundred thousand marks.

Richard was tried in a court created by his enemies, for the crime of allowing the Austrian standard to be thrown down at Acre and other offenses of royal pride and malice. The Lion Heart spoke so nobly and eloquently in his own defense, however, that he miraculously won his case against his enemy judges. But to buy his freedom, he was forced to agree to pay the Emperor the hundred thousand marks of his ransom.

Richard was a generous man. He threw a woman into the bargain, promising a niece in marriage to none other than Leopold. He was also forced to pledge his lands and fealty to the Emperor, although he received his lands back as a fief. This last left a bitter taste in Richard's mouth, but those who knew him well doubted he would ever honor the obligation, forced out of him under duress.

Richard, accompanied by the Cistercian abbots, was sent to a castle in the mountains west of Speyer, for his captors moved him about frequently in order to confuse any who might seek to free the prisoner through force of arms. While waiting for his ransom money to arrive, Richard bided his time, composing ballads, playing practical jokes on his guards and keeping them so well-soused with wine and ale that he became a thorn in the side of the Emperor.

In secret, the exiled Longchamp slipped back into England to raise money for his King. With the help of Aliènor and the justiciars of England, enormous taxes were levied. A quarter of income and a quarter of the worth of moveable property were demanded, but the amount of money raised was not enough. Now the Cistercians were made to surrender their wool crop to the Crown, and monks of every denomination scurried either to hide or to offer up their plentiful silver and gold plate, for the Church's riches also were

demanded for the King's ransom. Although many grumbled, many also deemed it worthwhile to save the Lion Heart and bring him back to England to knock some sense into his brother's head, or preferably to remove that head from that body and save everyone a great deal of misery.

With the sure knowledge that the Lion Heart lived, his loyal barons grew bolder and their armies drove John's forces back to his castles at Windsor and Tickhill. The beleaguered prince parlayed a truce, and handed over many of his lands to none other than his mother. He was allowed to keep only Tickhill and Nottingham, and he retreated to the latter to lick his wounds, where he was welcomed with much false warmth and pageantry by the High Sheriff.

At meat the first night, perhaps in an attempt to salve his pride, John asked what had become of the outlawed Robert of Loxley, who had stolen his taxes so many moons before. After being assured by the Sheriff that Loxley was dead, a well-meaning local baron declared, "It's that Robin in the Hood I'm concerned about. Just last week I had to cut off a man's hands for eating venison, and his son vowing it was enchantment." He guffawed, mimicking the boy, "'We know not how the venison come to our table, milord, but it must be Robin o' Wood left it for us, and we could not anger the Faerie Folk by refusing to eat it!' I cut out his lying tongue."

"Silly nonsense invented by poachers," pronounced Reginald.

"Magical venison! What next? Shall we carry a charmed haunch instead of a rabbit's foot around our necks?" scoffed the skeptical Coucy, swimming deeply in his cups and in a foul temper since Maerin had run away, God alone knew where.

A few uneasy titters rippled among the diners at Coucy's strange idea.

The canon of St. Mary's said, "I pray you, let us not speak of such Pagan practices."

"Paganry or Faerie stories, I do not hold with either," announced the baron piously, "but it's true that men of the cloth are no longer safe to ride the Great North Road for fear of the Hooded Man."

"Not so," Reginald protested.

"Yet I have heard he never troubles women," ventured the baron's wife coyly. "And it was his own man he killed, it is said, in punishment for killing the monk. Which bespeaks a nobility of character most surprising in—"

"God's eyes! How can we expect to hold a kingdom when our own sheriffs cannot even keep our royal forests free of petty thieves?" bellowed John in a fit of fury the like of which his retainers had rarely seen before. Evidently this talk of Robin was the last straw for a man who carried the

weight of such a resounding defeat in war so newly laid upon his shoulders.

"When spring is upon us, milord, we shall easily apprehend him. For now, the roads are in poor condition and the forest is thick and wild," Reginald began. "My best men have already—"

"Get us the head of this miscreant, and spare us excuses!" John stormed off to his chambers to rant and rave, and then to dictate a coded message to Philippe of France, offering to continue their partnership off the battlefield. For if there was one quality which John possessed that in a greater man with higher ideals would have proven sterling, it was his tenacity.

The following morning, by decree of the High Sheriff, the reward for one 'Robin Wood, a Hooded Outlaw' was raised to seventy-five marks, dead or alive.

23-A TINKER'S METTLE
ҺAWTҺORN MOON NEW, 1193

poor fellow is a tinker," thought Tom Cabbage, whiling away the hours with a mix of self-pity and self-approval, "who wanders the land, staying a few nights here and another there in exchange for a meal and a penny and a piece of a cold hard floor on which to rest his weary head. But a stout man is a tinker, who pounds out metal, picks over other folks' trash, and walks in sun and rain, snow and sleet, making ends meet."

A poor, stout fellow was the tinker Tom Cabbage, of unknown parentage, who had been called Cabbage because he was born with hair so curly and tousled no comb could be got through it. The other orphans called him Cabbage-head and the name stuck. To add to the effect, his eyes were an eerie, washed-out green. He had a pug nose and a beard the color of last week's overcooked meat. His clothes were much-mended but well-mended, for he was as skilled with a needle as he was with a hammer, and he wore over his floppy trousers a stained leather apron that bespoke his craft.

It was a late afternoon at the end of March, and wide patches of soiled snow still lay in hollows of frozen mud by the side of the Great North Road. These patches Tom struck with his crabtree staff, sending up spurts of icy white as he trudged along, puffs of cold air jetting steam from his mouth as he whistled, his sack of tools swaying against his muscled back. He let out a tweedling tootle of pleasure when the town of Nottingham came into view.

He was heading for the castle, where he might find a richer clientele and a better bed of straw than usual, but it was almost dark already, and harrowing cold, and a long steep climb to the castle. A glimpse of a glow through the crack in a leather-covered window and a burble of laughter and talk within turned his feet off the main road and into the Triple Horseshoe.

"I can't say as seventy-five marks reward isn't tempting just the same," a man was saying as he lifted his tankard to drink.

"Go on with you! You'd never catch 'im!" said another.

Talk ceased as the stranger Tom quickly closed the door behind him and stamped the mud and snow off his boots. He called for a pint and a bowl of hot stew, and flipped a penny onto the table when he sat down, to show he could pay.

In his trade, it didn't do to be retiring, so while the silence lingered, he announced, "I be Tom Tinker, come to mend your kettles and pans. Tell your women and your masters, for I'll stay but a sevennight and be on my way. And I do good work."

This speech was met with a nodding of heads and a grunt or two. Encouraged, Tom asked, "What's this I hear of seventy-five marks' reward?"

Dead silence returned. Tom frowned. "I be a stranger to these parts, and hungry for news as well as for bread. But if you'll not tell the tale, then bring me my dinner and I'll speak no more."

This subtle declaration of neutrality loosened the tongues of the locals. "'Tis the reward the High Sheriff of Nottingham offers for the outlaw Robin in the Hood, seventy-five marks, dead or alive."

Tom whistled, for seventy-five marks was a grand sum. "Robin in a Hood, you say? Never heard of him. What's his crime?"

"He's a will o' the wisp."

"A *puca*."

Tom Cabbage laughed. "A reward for a boggle? Is the High Sheriff mad?"

Now the folk began to argue. "Nay, Robin's a thief right enough."

"More like a murderer."

"Psshaw! The one he killed was a thief as well."

"Killin' is killin'."

"Robin'll be killed soon enough if he don't stay offen the Great North Road."

"Nay, he's too swift and cunning. They'll never catch him."

"Well, he never did me harm," said the landlord quietly. "I was passing through Sherwood with my sister Bessie from Sheffield, and he and his band appeared." Everyone listened attentively, though they had heard this story

many times before. "Right out of the trees they come, like wood sprites, and covered with branches and bits of leaf and vine. It was only us two against more'n ten o' them, and Robin Hood there big as life, his face all shadowy under a black hood. He coulda stolen the shirt offen me, but he took nothing, for he saw my Bessie was afeared of him, and he spoke so calm to her like he was gentlin' a frighted mare."

"They say he himself can turn into a horse," someone said in a hush.

The first man said, "That's as may be, but seventy-five marks is still a tempting lump to put in my pocket."

"Hah! You've already got a lump in your pocket, and it gets bigger every time I walk by!" chortled the landlord's daughter Bertha, entering from the kitchen and slapping the man playfully on the side of the head with one hand while setting before the tinker a tin tray with a bowl of stew, a loaf of bread and a slab of fresh-churned butter. Tom dug in to his dinner as the men guffawed at her joke and eyed her appreciatively, for she was a fetching wench with a flashing eye and a proud air.

But Tom was thinking how seventy-five marks would practically make a nobleman out of him, at least for a time. He could rest until full summer—nay, with seventy-five marks, he could rest next winter too, and not be roaming the countryside with toes and fingers freezing, seeking pennies as if bobbing for apples on All Hallow's Eve.

"And what does this Robin look like?" he asked casually, his mouth full of stew.

At first no one seemed willing to answer, but then Bertha said in an awed voice, "None has ever seed him, 'ceptin' those whose money he has stolen. And even then, as my father has said, his face is hidden by a black hood. But some swear his eyes burn red as coals, like the Devil's, and you will know him for certain by the fact that he is hung like a stallion, should you care to get that close to him to find out!" She let out a peal of laughter, and the locals laughed heartily with her.

"How do you know how well he's hung, Bertha my girl?" teased one fellow, but she only smiled, tossed her head and sailed out of the room.

Tom said nothing more of Robin, but ate his meal, nodded goodnight amiably to all, and made his way in darkness to the castle. He stated his business at the gate. Surprise registered on the gate-keeper's face, but he called for Anhold, the captain of the guard, who showed Tom at once into the presence of the High Sheriff.

"If'n it's seventy-five marks for one Robin Hood, I'm your man," said Tom without preamble.

Reginald could barely mask his delight, for no one in the shire would go against the Hooded Man. Clearly it took a stranger who didn't know enough to be afraid and whose loyalties had not been swayed by gifts of venison.

A good night's sleep in the straw in the castle stable, and in the morning, Tom Cabbage was on his way, armed with a warrant for Robin Hood's arrest, a few pennies in advance to buy provisions, and a vague description of the places the man usually showed his hand in robbing wayfarers.

As Tom walked toward Sherwood, he felt the eyes of the townsfolk upon him, for word had gotten out quickly as to his mission. No one greeted him or wished him good fortune. Instead they gazed on him with the peculiar closed expression which only a peasant can give, and indeed must learn young, a gaze quiet as the earth, cold as the stone, closed as the grave.

Tom shrugged away his uneasiness and vowed he'd settle in London before he'd ever stay in Nottingham, once he'd done his business here.

He walked along the Great North Road into the forest, thinking to be waylaid soon by the thief himself. He spent three days and nights searching in vain. He even left the main road and followed streams and byways. He was always cold and grew tired. This hunting of men was hard work. But no harder than being a tinker, he told himself.

When he ran out of food and the clouds overhead began to dump snow on him, he decided to make for Lincoln to rest and buy bread. Lincoln was closer than Nottingham, and besides, he dared not show his face in the latter without his prize.

By midmorning he reached the Roman gate of Lincoln and found an inn called The Green Man, where he called for ale and a meal. At that time of day, the tavern was empty but for the landlord and one other customer, a forester, lean, dark-haired, dressed in brown, with a longbow slung across his back, a quarterstaff resting beside him, a hunting horn and a sword at his hip, and a loaf of brown bread before him.

When Tom finished his bread and cheese and stewed cabbage, the landlord brought out a pot that needed mending. Tom puffed out his chest under his leather apron and said, "I am no longer a mender of pots but a breaker of heads. Or rather, I mend the Sheriff of Nottingham's pot, a big one called Robin of the Hood. I have the warrant for his arrest here in my toolbag. Hast ever seen the knave?"

"I have," offered the forester, "and an evil bastard he is, too."

The landlord disappeared into the kitchen with his broken pot as if he feared the very mention of the name Robin.

Tom asked, "How may I know him, then? I've heard only that he wears a black hood, and none has seen his face."

"Oh, I've seen it. He is fair-skinned as a maid, with hair the color of corn, and when he turns sideways, he disappears."

"He is thin and weak, then? I will break him in halves like a loaf of stale bread."

The forester rose from his stool and came over to Tom. "In fact, he is as burly and thick as a two-hundred-year oak, and as tall. But he is a wood sprite. He dives in and out of mortal sight like an otter in a brook. You'll be hard-pressed to catch him, the rascal, and even if you did, he'd likely trick you out of your warrant and be away into the hollow hills before you could spit."

"I'll catch him and smite him 'til he begs me to stop."

The forester cracked a smile. "Brave words! I'd like to see it. I've fought this Robin three times and never bested him. He steals the deer from under our noses and thumbs his own nose at us. But perhaps I can help you catch him. I know his haunts."

"I need no help from you," Tom replied, suddenly surly. He wished he'd said nothing, for he didn't want to share the reward.

As if reading Tom's mind, the forester said, "It would be reward enough for me to see him hanged. But such talk is thirsty work. Let me fill your cup and we'll plan his capture." He called for the landlord. "Your best ale, and be quick about it!" He scratched his cheek with one finger, brushed his shoulder as if to brush away a crumb and winked at the tinker.

The landlord soon reappeared with two tankards of ale, and the forester said, "Keep them filled."

Tom was flattered at this attention from the forester, who normally would treat a lowly tinker no better than a dog. He drained his tankard.

"But tell me, Tinker, you are not a Lincoln man."

Tom nodded and began to tell of his travels, with the forester chiming in to say he'd also been to this or that shire, and when it was, and a humorous tale or two of his doings there, and in between each of their tales, he toasted the tinker's health, and before long, they were singing a merry May song together like old comrades.

But when the song was done, Tom mumbled, "Ah, the May, she's a long time in coming. That's why I need the money. I shall rest in winter like it was summer, that I shall." And he lowered his lips toward his cup and dozed off.

The forester waited until the tinker's snoring was even. Then he quietly opened the tinker's tool sack and withdrew the warrant. He lifted the tinker's

purse as well, then left a coin on the table for his own share of the ale, and soundlessly stole out of The Green Man.

Tom's dreams were disturbed by the landlord shaking his shoulder. "Here, now, pay up and be off with you. I've got respectable people coming in for their supper."

"Wha—? Where—? The forester—he's takin' me into the wood."

"He's taken you, all right. Now pay up."

"He's paying for my ale, you wretch. You heard him yourself!"

"Him, pay for you? Hah! He left a bloody hour ago. Now pay me or you'll work it off in my kitchen."

Tom cursed and reached for his money, but it was gone. He plunged his hand into his tool sack, but found no warrant. "That fiend has stolen my money and my warrant, to get the reward himself! I'll report him to the High Sheriff!"

"You do that. He'll put you in irons for giving away your secrets to Robin of the Wood." The landlord chuckled, for he had enjoyed the whole play. Robin and his friends frequented his tavern and paid well, so when with casual Druid signs, a finger on the cheek, a hand brushed against a shoulder in a certain way, Robin had signalled to him to add a dollop of a harder brew to the tinker's ale, the landlord had been happy to comply.

"But he—but I—but that—" The tinker reddened as he realized the forester was no forester. He grabbed his tool sack and his quarterstaff. "I'll kill that wolf's-head myself, and wait for no hangman!"

"Not so fast. You haven't paid me." The landlord seized the tool sack and wrested it away. "These shall be payment, for I'll sell them."

"I've been robbed by you both! I'll catch this Robin Hood, for now I know his face. Keep my tools, you bastard! I'll be back for them, and after I break this thief's neck, I'll be tinker again, and the Sheriff be damned for sending me on the trail of a trickster!" The tinker ran out of the inn waving his crabtree staff, and the landlord laughed so hard his eyes were watering.

Meanwhile, Robin had taken off for Sherwood, blithely congratulating himself for doing good mischief that day and strengthening his new reputation. "I make a damn fine *puca* for an old Crusader!" he told himself.

As soon as he was safely running among the trees, he began making up his own words to go with the tune he and the tinker had sung.

The Sheriff and the Tinker Man
Have drunk unto despair, oh,
And cannot find young Robin Wood

Who hunts the buck and hare, oh!
Heel and toe, and a hey nonny oh,
We were up and dancing long before the day, oh,
To welcome in the summer,
To welcome in the Maaaaaay, oh!
Summer is a-comin' in,
And winter's gone away, oh!

After a few more rousing verses at the expense of foresters, kings and princes, he decided it would be wise to pull out the warrant and read it to see what new crimes he had lately been accused of, but the words blurred together like nonsense for the ale he had drunk and the less-than-precise penmanship of the castle scribe. After some hazy deliberation, he drew on the parchment with dirt a banishing pentagram, a five-pointed star in a circle, and he buried the warrant at the base of an alder tree so as to bury the Sheriff's will against him and to call protection to himself. Then he bounded away like a stag through the trees.

Yet even a stag must rest. The drowsiness stealing into his limbs and head made him feel he was running through cold honey. He shrugged. By now he felt as at home anywhere in the forest as he once had in his father's keep. He crawled into a dense thicket, wrapped himself in his cloak, and fell promptly asleep.

Tom Cabbage, however, was plunging through the wood scarcely thinking of where he was going, led by his gut instinct and his crabtree staff. His temper was still so hot, he had to bite his tongue to keep from shouting when he came upon a leather-clad foot sticking out of a clump of bushes. He crept closer. The foot was attached to a leg encased in brown, above the leg were the rumpled folds of a brown cloak, and above that was the face of the scoundrel Robin in peaceful slumber.

With a yowl, the tinker raised his staff and swung, but Robin woke in time to roll aside. The staff smashed into the half-frozen ground. Robin dizzily grabbed his own staff, regretting the ale he had drunk.

"Turn sideways, fiend, and disappear!" challenged Tom.

Robin grimaced. His joke had gone against him, and the buried warrant had not yet had time to work its magic.

The men exchanged several blows before Tom slammed his staff into Robin's right hand and his own staff flew into the brush. Tom pressed his advantage, beating him about the ribs and shoulders, and then swung his staff toward Robin's knees for a crippling blow. Robin dodged and fumbled

at his belt for his horn, finally letting loose with three short blasts and pray-
ing his friends were near enough to hear him. Then he swung himself up on
a tree limb and tried to kick the tinker in the head. Tom ducked, the branch
broke, and Robin slammed to the ground.

"The Sheriff's reward!" Tom yelled, raising his staff for a final blow. But
a hare dashed by his feet, distracting him, a light wind blew up from the
south, tumbling his hair into his eyes, and then Tom found himself staring
into the freckled face of a red-haired giant, and beside him, two other men,
one a lad, and the other a burly fellow leaning on a quarterstaff even stouter
than Tom's own.

Robin somersaulted away from the tinker and rolled to a halt at John
Nailor's feet, then flipped himself upright and leaned back against a tree,
panting and grinning.

Tom hissed, "Stand back, strangers. This outlaw is mine."

Will said, "Far be it from us to interfere. We were just passing by, hunt-
ing. Have you seen a hare?"

John elbowed Robin in the side. "It's a cryin' out loud for shame that
you've not bettered your skill with the quarterstaff, Robin."

"And it's cryin' inside for pain with your elbow in my ribs," Robin re-
torted, cuffing his friend amiably.

"Were bow and arrow the contest, Robin would best you all!" cried
Harald, who hated to see his hero beaten.

Tom's face was draining of color. These men were Robin's friends. He
was outnumbered. He cursed the night he first heard of that seventy-five
marks reward. He would die here in the greenwood, and the wild beasts
would feast on his flesh, and no one in all the world would miss him.

Already John was hefting his oak staff. Will was easing his scimitar out
of its sheath. Tom backed away, raising his staff defensively.

"Now, now, friends, what say we let him go with his life?" Robin asked.
"I tricked the poor bloody bastard, but not well enough, and it's my own
damn fault he gave me a beating. How say you, Tinker? Shall we go our
separate ways and forget this day?"

"Nay, let's fight it out," Tom muttered after a moment's pause. "My life
is worth nothing with no money, no tools and no warrant. The Sheriff'll
have my head, an' he sees my mug in Nottingham again."

"Then keep out of Nottingham. You'd be safe here in Sherwood, for he
never shows his face here. I hear he's afraid of *pucas*."

The outlaws laughed.

"You've a way with a staff, Tinker. I'd like to see you and little John go at

it someday. But I'd surely rather have you fighting for us than against us. What say you? Join us and you'll have a share of the plunder, whether great or small, a dry place in a cave to rest your bones at night, all the water you can drink and a price on your head."

"Come now, Robin, don't paint it so pretty," Will said.

Tom Cabbage considered his lack of options for a moment, scratched his head, and said the wages sounded fair enough.

"Good! And may Sir Reginald's money come to us both in due time!" Robin said, clasping Tom's hand.

24-ROBIN ENCOUNTERS SOMEONE ELSE'S TRUE LOVE
HAWTHORN MOON WAXING, 1193

o there, Anne! Do not ride so far ahead, my girl! We are entering the forest now and you must stay close by."

"Yes, Father." Anne slowed her jennet from a canter to a walk to allow her father and mother and the four men-at-arms to catch up with her.

Her mother had fretted at having such a small guard to protect them on their way to Nottingham, but their holding at Snaith was not so rich that they could afford more, and her father had said they had little enough to steal should robbers come upon them.

"It is not only thievery I fear," her mother said, the color rising in her cheeks.

Her father grumbled, "There is nought to be done. I must go to Nottingham on business. Perhaps you should stay behind."

Then Anne had protested, for she hadn't seen her cousins in ages, and then her mother had confessed she did desire some of the famous Nottingham lace for Anne's trousseau. Anne's eyes brightened.

"And if Anne should see her cousins, that trousseau might find its intended use the sooner," chuckled her father, for his nephew Ralf was a promising young man. He tousled his daughter's silky red hair. As usual, he could deny her nothing. So it was decided that the family would travel together just as they had planned in the first place. Still, Anne's father took the precaution of being well-armed, along with his men.

Unknown to him, Anne had secreted a dagger in her boot and another in her belt under the light blue cloak she wore to keep out the chill of fading winter. She had decided not to bring her best necklace, the one with the garnets, though it would have been a pleasure to show it off in front of her cousin Agnes, who would ooh and aah with mixed delight and envy, and Ralf, who might give her another of those burning looks he had shot her way during their last visit.

Any road, she had already decided that if she had to give up a few baubles to a highwayman, she would let them go and hex him as he took them, but any more of what was hers she was not prepared to give, and if any outlaw dared lay a hand upon her, she would cut it off.

Despite these precautions, the travellers were not three hours into Sherwood before they were set upon by thieves. Two of their guard were killed before ever they saw their attackers. The horses were rearing and whinnying, her mother was screaming, and Anne had all she could do to control her little horse, who skittered nervously down the road only to be stopped by a robber chasing her full speed on foot. He caught the jennet's bridle and wrenched Anne out of the saddle and into his filthy, stinking arms despite her fists flailing at his face.

"Now here's a pretty!" he said, his breath noxious with rotting teeth and old garlic. He wrenched the gown from her bosom and pawed her bare breasts with one hand while with the other he hiked up her skirts, crushing her lips with his and forcing his tongue into her mouth, his bristly beard scraping against her smooth cheek.

Gagging, she reached for the dagger in her belt but he was too quick for her, and caught her wrist as she tried to bring the blade up into his gut.

"Bitch!" he snarled, squeezing her wrist so hard her fingers grew numb.

"I curse you nine times nine!" she screamed.

He slapped her in the face until her brain reeled. She dropped the dagger and sagged to a heap on the ground, but even as she thought she might lose consciousness, she tried to wrap her numb fingers around the knife in her boot.

He ripped his pants open, then grunted and instead of flinging himself down and pressing his vile body against hers, he slumped over sideways, blood leaking from his lips.

Her eyes took in the arrow in his neck, and then heavy arms were around her, lifting her up from the road, and she was screaming and kicking to get free, and a voice cursed in Gaelic when her booted foot made sharp contact with a shin.

Then the husky voice was saying in her ear, "I dinna mean you any harm, girl! Hush now, you're safe, it's my arrow in the bastard's neck!"

She quieted slightly and he let her go. She spun around to get a look at him as she backed away.

"I was only tryin' to help you to your feet!" Will Scarlok swirled his green cloak from his shoulders and wrapped it around her, covering her naked breasts.

Under her direct gaze, he blushed and looked down at the ground, but not before he noticed how well his green cloak set off her red hair, so like his own, and how her pale skin was flushed, and she was not only a beautiful young lady of perhaps sixteen summers, but stoic as a soldier. She did not succumb to tears before him, but bent down to retrieve her dagger. He offered to guide her back to her people.

Without a word, she started down the road, then whirled on her heel and said, "You have saved my honor and perhaps my life." Her color heightened even more.

For Will, that was thanks enough. He caught up with her in one long stride and as they walked, they cast furtive glances at one another. By the time they reached her parents, they were very much liking what they saw.

The other bandits had either fled or been slain by Robin, John and their men. Anne's mother was tearfully reunited with her daughter. Anne's father thanked the strangers who had come to their rescue, not recognizing them for the thieves they were. "How may I reward you for your gallantry?"

John was eyeing the gold ring on the man's hand, but Robin had a keener eye for how things stood already between Will and the young maid. He thought Will might prefer some other reward than money. He waved John back and said with a bow, "Think not of payment. We are at your service. Sherwood is a dangerous place in these times. The safety of upright people is reward in itself."

John rolled his eyes heavenward at this pretty speech.

"Where are you bound, sir?" inquired Robin politely.

"To Nottingham, sir."

If Robin blanched, his black hood hid it. "We are going your way ourselves," he lied, and so the outlaws escorted Anne, her parents and their two surviving men-at-arms through Sherwood, with the sad burden of their dead draped over one of the horses.

At last Nottingham castle loomed in the distance on its cliff, above broad fields waiting to soften under the sun for seed. Robin gazed at the stronghold as if he could see the Sheriff pacing within. Will disrupted his

reverie by murmuring, "We must offer to meet them on their way back. They'll need an escort."

"Who's stopping you?" Robin asked, quelling the urge to chuckle.

On the appointed day, Will met Anne and her family on the outskirts of Sherwood with a gaggle of armed thieves in stolen livery and chain mail, and on their best behavior.

After that, Will Scarlok travelled often to the keep at Snaith. He scaled the poorly guarded wooden palisade, swung up the ivy that clung to the stone of the keep and climbed into Anne's window. He confessed his current occupation early on, for he could not bear to lie to someone as forthright as she, and rather than greeting the news with a storm of tears, she merely said she had suspected as much, but she had heard good word of the Hooded Outlaw, and if Will ran with him, at least he was better than other thieves.

Will told her he hoped someday to clear his name and marry her. She swore to wait faithfully for that day, and wait she did, disdaining other suitors, even her cousin Ralf, to her parents' dismay. In the meantime, love would have its way. Only through Will's practiced stealth and Anne's knowledge of herbs to prevent conception was their love-making kept secret.

Robin watched this courtship with amusement, for he had never imagined Will in love, but he also felt envious, until Will generously invited him along to Snaith, saying the keep was rife with pretty serving girls, all of whom spoke highly of a certain Robin of the Wood.

As they walked towards the keep, Robin's mind was filled with fantasies of what and whom the night might bring him.

The girl must be buxom, he thought, or else slender, and her hair would be braided, twined like two snakes, dark as a raven's wing, or golden as ripening wheat, or red as a copper kettle, though brown tresses were also lovely, especially when they curled invitingly over soft shoulders or hung straight as a burnished waterfall down a woman's back. And her skin, would it be fair or tanned from the sun? Any road, her thighs would be soft. Or firm. And her hands would be delicate and gentle as a high-born lady's, or strong and knowing from hard work; and then, if there were a lilt in her voice or a capricious smile, so much the better.

It happened there was a maidservant who filled enough of these requirements to satisfy Robin, and he did his utmost to satisfy her. He did not sleep much that night, to his great pleasure, and he woke with the first birdsong feeling a sense of well-being that would not let him lie still. Unable to rouse his companion from her slumbers, he brushed the straw from his tangled hair, dressed quickly in the dark, slipped out of the stable, tossed the watch-

dog a bone he had kept reserved for the purpose, climbed the wooden pali-
sade and dropped down to the ground below.

He broke into an easy trot that soon took him into his domain. The
wood was damp and chilly, for the day before had been blessed with an icy
rain. But with the night's passions well-spent and the sun newly rising and
shining to make the glades in the forest gleam, Robin's step was light and he
felt his whole body was smiling. He wound through the wood in search of
nothing in particular, trusting that sooner or later his feet would find their
way home, when he heard a voice singing and the slow, squelchy plodding of
feet upon a muddy path.

Eager for some mischief, Robin darted through the underbrush toward
the voice. He hid behind a chestnut tree and waited.

Soon his victim came into view, slight, small, and clearly impoverished,
Robin saw with a frown. The young man dragged his feet as if they were
bound with heavy chains. Over his shoulder he carried a battered harp with
several strings missing. His cap was squashed and worn awry on a thatch of
golden-brown hair that straggled raggedly long and unkempt at the back of
his neck. His brown tunic, though made of fine linen, was torn in several
places, as were his black woolen cloak and hosen, which were spattered with
mud. Several days' short growth of untended beard besmirched his young
face, and his downturned lips and round brown eyes reddened from crying
added to his doleful expression. Even the dandyish curling toes of his leather
shoes were sagging as if they too were saddened by the dirge-like tones of his
song.

> A-weary, weary, weary,
> A wanderer am I.
> My footsteps leave no traces
> In the forest where I'll die.
> I've seen it in the wind,
> 'Tis the end, 'tis the end,
> For I have lost my true love,
> Her heart will not unbend.

These tragic words he repeated again and again with minor variations in
pitch or rhythm as if he were working out just how miserable he could make
it sound.

Robin smothered a chuckle at the singer's studied pathos, and began to
sing along with the man, a beat or two after him and as out of tune as he

could manage. The singer stopped and looked around, confused.

Robin emerged from his hiding place. "These woods are my estate, Minstrel, and your music trespasses upon my happy soul. I order you to sing a merrier tune or your life is forfeit."

"Then take my life, for it is worthless to me."

"Worthless to me, too, I'm sorry to say, for it seems you haven't a penny. But pay me with a glad song and I'll let you pass by safely."

"God knows, I have no glad songs either. Do not mock me, for my heart is broken and will bear no further blows," said the minstrel, somewhat melodramatically, Robin thought.

"Perhaps I should deal you a different kind of blow altogether, one that might knock a better humour into your head," said Robin, twirling his walking stick.

"Aye, with any luck, perhaps you'll kill me," and the minstrel slung his harp to the ground and stood waiting for the death blow.

Robin scowled. "There's no pleasure in fighting a man who won't fight back. Tell me your troubles. Perhaps I can cheer you."

"There is no cheer for me, nor any hope. It would take a miracle from Jesus the Christ Himself."

"Jesus, I think, does not often roam through Sherwood these days," said Robin with an impish grin. "But perhaps Puck, the wood sprite, son of the Faerie King, will hear your tale and take a liking to you. Perhaps he listens even now. You know these woods are enchanted. But first, tell me your name, O Miserable One."

"I am called Allan o' Dale, for my home is in the dales and glens, and so it is the ruin of me." Allan sat heavily down on a fallen log. "I fell in love with a princess—not really a princess, but so she seems to me. Her beauty is so great the world can scarcely contain it. Her eyes are like a calm lake reflecting the sky, her hair is the color of the morning sun on ripening flax, her skin is as smooth and sweet as fresh cream."

Robin nodded solemnly at these rhapsodies and sat down beside Allan, who went on, "I love her with all my soul and I was sure she loved me. But I am only a minstrel, with no lands or wealth, the son of a commoner, a tavernkeeper. When my lady's father discovered our love, he threw me into his dungeon. I never saw her lovely face or heard the sweet music of her voice again. I was a month in that prison, starved and beaten. Then I was thrown into their filthy moat, to drown or swim to safety as I might. I suppose that was her father's mercy. He could have hanged me. Would that he had, for now she is pledged to a doddering old Norman knight who will bear her

away to the continent forever. I'm done out of my love and I've no way to win her, nothing to offer. Nothing but a song, my heart, my body and soul, which are everything in the world, and yet nothing."

"A sad tale," acknowledged Robin. "But take comfort elsewhere! You'll find a score of willing lasses in Doncaster alone."

"Another lass?! Nay, my love burns too fiercely! What is a mere candle to the raging bonfire my Aelflin has lit within me? Only the deep pools of her eyes can quench my thirst, only the cool seas of her love are vast enough to hold the sweet fountains of my desires."

Robin laughed. "First it's bonfires and then it's oceans. I know not the name of this strange fever, for I've never been stricken with it."

"It is true love, my friend."

"Then perhaps Prim can heal you of it. Come with me, Miserable. You have met your Puck!" He got to his feet and started off southward through the trees.

Allan stood and called out, "I do not wish to be cured! To die of true love unconsummated is an honorable death!" Nevertheless, with no other prospects in sight and nowhere else to go, Allan grabbed his harp and ran after Robin. "But tell me your name, for I cannot call you Puck."

"On the contrary, Puck will do well for me. Or you may call me Robin."

Allan halted in his tracks. "R-Robin of the Wood?"

"Perhaps."

"The Hooded—" Allan swallowed hard. "—Man?"

Robin doffed his hood.

"I've heard tales of you."

"Then perhaps you will make them into a song," said Robin blithely. "Just now you were ready to die for love, and now I offer you both life and love. Are you afraid?" He grinned, walked on and disappeared behind an oak. Allan hesitated, then hurried after.

By the time they reached Brighid's Well, the air was charged with metallic tapping from the smithy, the chopping of wood, a baby whining. The leftovers of the morning's hot porridge were still in the cauldron, and Allan was soon gobbling a portion and telling his tale of woe once more to anyone who would listen.

John took Robin aside. "You brought him here without a blindfold? What if he's a spy, the Sheriff's man?"

"He has an honest face."

"Hah! Minstrels are the tallest tale-tellers in the world, and can play an honest face or an evil one as well as any Judas!"

"Then we will find him out soon enough. Rest easy, little John."

John spat on the ground and stomped away.

Robin went to sit by Prim, who was busily plucking feathers from a brace of quail. "How are you with philters and love spells, Good Mother?"

"Depends on what kind of love you seek," she answered coolly. "You seem to have no trouble getting what you want, Robin." She knew where he had passed the night and could tell by his mood that he had passed it well.

"Perhaps my wants are changing!" he said in a cheerful lie.

"Then perhaps your methods will change as well."

"I ask on the part of Miserable there, not for myself."

Prim tossed a bare bird onto a tin platter and began plucking another. "There are some things that hold so much magic in them already, it is dangerous to toy with them. Love is one of these." And she would say no more.

Allan was ending his story by saying his Aelflin would be wed in the church at Harrogate that very Friday.

"In a church?" whistled Harald.

"They must've bribed someone well for that," commented Tom, for the Church had abhorred marriage and called it sin for centuries; those who wished to marry had always used Pagan rites. Only lately had the Church eased its stern lack of regard for matrimony, and some thought it was gold that did the easing.

Allan said, "In a church or in a grove, if she weds another I will die, if not from sorrow, then by my own hand." He mourned that he had no knife, being neither knight nor hunter but a maker of songs, and he asked the outlaws if he could borrow a knife for the purpose of plunging it into himself come Friday.

Robin laughed. "Leave death to come in its own time, Miserable. Who knows what magic we may work between now and then?"

⌘

The church at Harrogate was a decrepit affair, having been hastily built of timbers beside an ancient crossroads where three lanes met, where once passersby had spilled drops of water or pinches of grain as offerings to the Triple Goddess Cerridwen, asking for safe passage or some other boon. Now the peasants paid tithes to the Church instead, but having little enough with which to tithe, the congregation was generally lax and small.

The old canon of Harrogate was therefore pleased when on Friday morning, as he struggled with the key that unlocked the doors of the church, a bearded minstrel dressed in scarlet appeared and said, "Let me help you, Father, for we must hasten to prepare for the wedding today. There is a wed-

ding, is there not? I have come to play the music."

Gratefully the canon handed the minstrel the key. "Thank you, my son, for my eyes are growing weak. Indeed there is a wedding, and music will be welcome, so long as it is seemly."

"Indeed, I play most seemly at weddings and save the bawdy tunes for the feast after!" said Robin, stroking his false beard and winking.

The canon looked slightly aghast.

Robin lied, "I am Bernard de Ventadour. Have you not heard of me? My name and my songs are known throughout the world. I have played for Aliènor of Aquitaine, in her Courts of Love. It is said my music ignites fiercest passion in the faintest of hearts."

"May God grant that our passion be for Jesus Christ's suffering!" He crossed himself. "Ah, but do my eyes fail me again or does the wedding party approach?"

Along the lane came a fat cleric in purple robes astride a chestnut stallion. The Bishop of York had been pressed into officiating at the wedding by the Norman knight, to whom he owed a favor. Beside him rode his retainers, two monks. Behind them rode the knight with his squire. Behind them on one horse came a plump man and, arms around his waist, a slender blonde girl in a pale green gown. As they approached and dismounted in the churchyard, Robin could see the maid was pale and trembling and her nose and lake-blue eyes were swollen and red from crying.

Robin strode to the altar in the musty church and unslung from his shoulder Allan's harp, freshly strung. As the wedding party filed in, he began to pluck and sing a lament in the *langue d'oc*, the courtly language of love from the continent.

> In a garden by a fountain
> Of water clear and gravel white
> Sat a king's daughter, hand on her cheek,
> Sighing, remembering her gentle lover.
> "Ai, Count Gui, my friend!
> Your love is my only solace and joy.
>
> "Count Gui, my love, what evil destiny!
> My father has given me to an old man,
> In this house he has imprisoned me.
> Neither evening nor morning may I go out without him.
> Ai, Count Gui, my friend!

Your love is my only solace and joy."

Her cruel husband, hearing her complaint,
Entered the garden and lashed her with a strap.
So long did he beat her, she lay cut and bloodied
And nearly dead at his feet.
"Ai, Count Gui, my friend!
Your love is my only solace and joy."

Her evil husband, his wretched act ended,
Repented and feared he had acted in folly.
For, as one of his followers told him,
She was a king's daughter.
"Ai, Count Gui, my friend!
Your love is my only solace and joy."

The lovely lady rose from her swoon
Crying to God to hear her true heart,
"Sweet God beloved, you who have formed me,
Show me, my God, that you have not forgotten me.
Bring my love back to me before this evening.
Ai, Count Gui, my friend!
Your love is my only solace and joy."

Our Lord heard her well,
And sent her lover, who carried her away.
Sitting beneath a leafy tree,
They shared so much love
They shed tears of ecstasy.
"Ai, Count Gui, my friend!
Your love is my only solace and joy."

During this performance, the white-haired Norman knight first gave Robin
dour looks, then harsher ones, then began muttering threats to silence him,
but Robin ignored him. The canon and the father, who did not understand
the *langue d'oc*, tried to shush the knight. The Bishop, panting and red-faced
from the exertion of getting down from his horse and waddling into the
chapel, was conferring with his retainers and his leather-bound Bible, and
paid no attention to the music.

But Aelflin recognized the song as one her beloved Allan, whom her father claimed had deserted her, often used to sing. Trembling, she turned her wan gaze on the minstrel. Robin winked. She paled even more, searching his face. Not recognizing him, she turned away and shuddered.

Several stragglers entered the church and sat in rows in the hard pews near the front. The groom and the Bishop took their places at the altar. The father pulled his stumbling daughter up the aisle, but Robin intercepted them with a smile. "I think I must perform a roundelay, for the bride does not look bright and willing. Tell me, Aelflin, could you love a poor harper?"

"How dare you speak to my daughter so?" demanded the father.

Tears leaped into Aelflin's eyes. She whispered, "How do you know my name? You have stolen his harp! What have you done to him?"

"Tell me if your love is true or if you like gold and land better," said Robin.

"Before God, I love only Allan!" she said.

"Throw this lout into the road!" commanded her father.

The knight's squire hastened to obey, but the members of the congregation drew swords and crossbows which they had hidden in their clothes, and quickly surrounded the father, the knight and the Bishop.

"Sinners!" cried the canon.

"Brigands!" spluttered the Bishop.

Allan threw back the hood that hid his face and hurried to his sweetheart's side, crying, "Aelflin! My love!"

"Allan!" She gasped and swooned in his arms.

"You!" bellowed the father, recognizing the harper.

The Norman knight turned on the father. "You swore she was a virgin!"

"And so she is!" shouted Allan angrily.

"How now, Robin Goodfellow, I see we have a nice fat pheasant in our snare!" John eyed the Bishop's golden chains and jewelled rings, and was ready to forgive Robin for this silly escapade.

"Robin?" the Bishop wheezed.

"Your Grace." Robin bowed.

"Robin of the Wood?!" exclaimed Aelflin's father, sinking to the floor and pissing his pants.

"How dare you interrupt this holy rite?" demanded the Bishop.

Robin said, "If a lady weds against her will, there is nothing holy about it. But I wonder at your presence here. Have you forgotten how St. Augustine called marriage a sin?"

"I shall not argue theology with a thief!" said the Bishop, folding his

arms across his chest.

Robin laughed. "Thievery is indeed our trade, Your Grace, though not our religion." Robin turned to the knight. "You may keep your horse and mail, but we must steal away the bride."

The knight held his head high and pointed at Allan. "I relinquish all claim to the girl. If she tarnished her virtue with so base a creature as this outlaw, I shall have nothing to do with her." He motioned to his squire and the two strode haughtily out of the church. Will followed, nose in the air, mimicking them to perfection, while the outlaws laughed.

"My money! My land!" moaned the father as he knelt on the floor in a puddle.

Robin reached into his money pouch and tossed him a few coins. "Take this to feed your mean spirit and may it serve you better than you have served your daughter." He nodded to two of the outlaws and they dragged the father out before he could finish scraping up the coins.

By this time Allan had revived Aelflin with soothing words and kisses, cradling her in his arms.

Robin said, "Ah, the lady returns to us. I see roses blooming in her cheeks. Now we shall have a wedding!"

"I shall never wed these two," the Bishop declared.

"Then by Our Lady, I will," said Robin, moving to take the Bishop's place at the altar.

"You would not dare sully this church!"

"You are right, milord Bishop. It would be a travesty. We'll go to the greenwood and have a wedding there that will make the saints hike up their robes and dance in Heaven."

"Blasphemy!" gasped the Bishop.

But Aelflin once more turned pale and whispered in Allan's ear, and he announced, "She wants a Christian wedding and will not have me any other way. She has gone against her father's wishes and fears to wed without Christ's blessing."

The Bishop nodded self-righteously.

"See how much your Aelflin loves you," Robin muttered to Allan.

The unhappy couple stood squirming, eyes downcast. Robin wished he had kept silent. Seeing the poor girl standing there, shaking like a leaf, one minute doomed to wed a grandfather, the next saved, and now threatened with what she imagined was sin and disgrace, he took pity on her.

"Very well, then, Bishop, you shall perform your task." He lifted his dagger to the red-faced Bishop's throat, but the girl cried out to see the holy

man treated roughly, and she whimpered, "Oh, this was not at all what I had hoped my wedding day would be," and she wrung her hands.

"She hath very little spine," murmured Tom Cabbage to Will.

"Aye, but it's not her spine Allan's interested in," Will replied, remarking, "Allan's a fool."

John, in a hurry to get his hands on the Bishop's gold, said, "I know of a friar, pious, but not overly so. If we offer him a wedding feast, I think he'll agree to perform the ceremony." He nodded gruffly at the grateful Aelflin.

Robin said, "Be it so. John, you'll show the way. Will, come with us. Allan, take the girl to safety in the wood."

Allan and Tom hustled Aelflin out of the church.

Without the maiden's eyes upon him, Robin grabbed the Bishop's gold medallion and yanked it away from his neck, breaking the thick gold chain. John lifted the Bishop's rings. They bound and gagged him and his monks, and the poor canon of Harrogate as well, though they apologized to him for the inconvenience. Then they went away rejoicing, for they had not expected so much reward for their efforts that day.

But trussed to the altar with humiliation and hatred in his eyes, the Bishop watched them go and cursed the day Robin was born, for he was sure the latter was no *puca* but a man born of sinful woman like any other. As he waited for rescue, his stomach soon grumbling empty and his bladder painfully full, the Bishop swore he himself was become Robin's greatest enemy.

⌘

25-OUR LADY OF THE FOUNTAINS
BLESSES ROBIN WITH WATER THROUGH
THE OFFICES OF A GOODLY FRIAR

Fountains Abbey was so called because it had been built to enclose a spring and holy well once sacred to Britain's Goddess of the Land, Brigantia, who was at other times and places known as Brighid or Brede, which meant 'the High One,' also called Pillar of Fire, Fiery Arrow, Bride of the White Hills, Mother of the Moon and Triple Muse, whose father was the Dagda, whose primeval cauldron in the earth fed all and was never empty, whose consort was also the Dagda, the quintessential, eternal male force, and whose son was also the Dagda. In other words, She was the Mother of God. Her gifts were healing waters and holy fire, and also the blending of the two that could transform both, and the magic that could harness their essence to forge earth's metal into cups and swords, torcs and crowns, as well as the magic that forged the fire of the spirit and the love of the heart into words of power. Hence She was the matron Goddess of poets, whose province was Truth.

The Christians, unable to transfer Her worship entirely to Mary, took Brighid to their bosom, squeezing Her thereunto so tightly, they diminished Her powers, called Her 'virgin,' and canonized Her as a mere saint.

The place was now peopled by monks instead of Her holy priestesses. It lay not far from Harrogate, a few hours' brisk walk for sturdy men, but the outlaws took their time reaching their goal, for the chivalrous saving of damsels was thirsty work. When the road brought them to the Inn of the Pilgrim, they stopped to buy a loaf of barley bread, a round of cheese, two roasted hens and two jugs of ale, which they took into the woods away from prying eyes.

In a clearing among the brambles, with the distant spires of Fountains Abbey peeping through the tops of the trees, they ate and boasted to one another about their exploits that day. Will mimicked again the haughty Norman knight's departure, to the applause of his friends. Encouraged, he

soon was acting out the entire episode, from Robin's singing and Aelflin's swooning to her father's pissing himself, and the Bishop's bulging eyes as he was bound and gagged, until Robin and John were fairly choking on their chicken with laughter.

This performance made Will even more thirsty. He and John polished off the rest of the ale. Warmed by food, drink and good humour, lulled by the buzzing of insects and the buttery rays of the April sun glinting through passing clouds in the cool air and sparkling on remnants of snow, with the rosy buds of newly-forming hawthorn blossoms nodding fragrantly above them, the two began drifting off to sleep. Words could not rouse them. Robin kicked their booted feet, but they muttered and drowsed on.

Robin shook his head at their snores and decided to fetch Fountains' friar himself. He took off through the woods. Before long he came to a river as wide as four men were tall, and deep enough to reach a man's thighs. With a sigh, Robin was about to strip off his clothes and wade through the icy snow-melt when he heard a smacking sound. The smacking was followed by a murmuring, as if a cat purred contentedly on the lap of its mistress. This gentle sound was followed by a loud ungentle belch.

Robin slipped through the brush along the river bank and soon caught sight of a mountain of a man dressed in the burlap sacking of a penitent friar. His face was round, with sturdy jaws and a high curving forehead above which rode the circlet of brown thatch that was his tonsure. His bald spot shone in the sun like the spangled cap of a dancing Arabian *houri*. At his waist he wore an oversized leather belt that sported both dagger and rosary. A steel helmet and a massive sword lay on the ground beside him. He was leaning against a tree trunk beside a patch of snow, with his knees bent and his legs splayed as if his copious stomach had pushed his thighs imperiously aside in order to droop down more effectively toward the earth. He seemed oblivious to the cool air, for his friar's skirts were tucked up above his knees, revealing thick, naked, hairy calves and leather sandals on his feet.

In one beefy hand he held a meat pie and in the other, a large leather jug, and with a rhythmic slurp and glug, he took turns imbibing the two, intent as a juggler. He devoured the first pie and then a second in four enormous bites apiece.

Robin decided this gluttonous creature was far from being the model of a wandering penitent beggar, and by the look of his sword and helmet, he might well have stolen his feast. Likely he was a mercenary soldier, disguised as a friar to grub for charity. It clearly fell to Robin to teach the scum a lesson. He grinned. His morning of mischief had gone well, the day was far from

over, and he was discovering in himself a strong liking for the role of Puck.

The soldier tipped the jug once more to his lips and gurgled, eyes raised heavenward with a look of beatific contentment. He drank so long and with such single-minded concentration that Robin crept closer to him unnoticed, and when at last the giant lowered the bottle, he started at the sight of Robin standing beside him in his Druid's hood, holding his scimitar in his hand.

Robin smiled. "Seeing your face sets my heart to rest, fat man, for you drank so long and steadily, I feared your snout was stuck in the jug like a pig's in the trough."

"What manner of evil comest soundlessly on the wind, to taunt a holy man? Get thee back to thy haunts and pixies, malicious spirit!" He held up the crucifix on his rosary as if to frighten off a vampire and belched prolifically.

"But I have need of you. Serve me well and I'll set you free unscathed. Serve me badly and I'll haunt you for a year and a day."

The man's brown eyes narrowed in his fat face. "Get thee back to Hell from whence thou comest, and may the Devil spare thee one lash of his barbed whip for leaving me in peace!"

"I'll go and gladly, but to Fountains Abbey, not to Hell. Unfortunately, there's a river in my way. But you're so fat, the icy water will be a balm to you. Carry me across." He raised his scimitar meaningfully.

"Thou rude and vile creature! But for that I am a pious and holy friar, and for that you have so foully drawn your sword before ever I had a chance to draw mine, I would run you through like a capon on a spit! Yet in Christian charity I must humbly bow to your service. May Saint Brighid have mercy on you, and may Christ in His Holiness shower you with the Grace of the Dove!" His voice rose to a sonorous bellow and he raised his arms beseechingly toward the sky. "May you be inspired to forsake your evil ways, and be led not only to the abbey, but to God!"

"You turn a pretty phrase," commented Robin.

"Sheathe your sword, my wayward son. I am your servant."

Robin did not sheathe his sword, however, but gestured with it, so the mercenary tucked his skirts up higher into his leather belt to keep them from getting wet, and lifted Robin onto his back. The soldier waded into the river, gasping as the frigid water inched up his calves to his knees and then his thighs and the delicate parts between them, while Robin laughed and whacked the man's buttocks with the flat of his scimitar.

The soldier stooped, gave a great heave and tossed Robin full force into the river, shouting, "Get thee behind me, Satan!"

Freezing water filled Robin's nose and throat. He floundered and splut-tered and splashed, seeking his footing on the uneven, sludgy riverbed, re-membering that other dunking at the hands of little John that had almost proved his death. The mercenary, meanwhile, strode back to the bank for his sword and helmet.

Enraged at this treatment, especially since he more or less deserved it, Robin found his feet and struggled back to shore with his sword in his fist. Dripping and already shivering with cold, he roared a wordless challenge and crossed swords with the soldier.

The man was skilled, strong as an ox, and nimble despite his size. Robin soon realized grimly that most of his opponent's bulk was not fat but pure muscle, and when the tip of his sword tore the friar's habit and glanced off chain mail underneath, he knew for certain this man was more warrior than penitent, despite the burlap robe. He rued the ale he'd drunk earlier, for it made his reflexes slower and his head spin. The minutes stretched into an hour. The clanging of their swords slowed, their howls of rage softened into exhausted grunts, the earth was churned up with snow into mud, and nei-ther man gained an advantage.

Robin shifted his sword from hand to hand as if to show off his skill, but in truth he was trying to give his sword arm a rest. Finally the men paused in wordless agreement to catch their breaths, panting and staring at each other, sweat pouring down their faces and bodies despite the cold.

Robin gasped, "I must admit, I've rarely met a better swordsman."

"I think perhaps I have met my match in you, for all that you're the size of a fly," grumbled the mercenary grudgingly, leaning upon his sword and wheezing.

"By your fighting, I'd say you were a Templar."

"Nay, but I fought my share as a soldier before I took the Cross as my shield. Only last autumn did I return from Outremer," he panted.

"A fellow Crusader then."

The mercenary gave Robin's scimitar a measuring look. "So that is where you honed your skills. I might have guessed."

"I know one who could best us both, though with staff and not sword."

"I am glad he is not here."

"Aye, you have the luck of the Lady today."

"That is fitting. We are near Her holy spring. I keep it for Her and She rewards me with Her protection. You can never best me here."

"But we are also near the greenwood and the Lord of the Hunt protects me."

The soldier squinted at Robin. "It seems a shame for the Lady of the Fountains and the Lord of the Hunt to battle one another through us. Are they not consorts?"

Robin raised an eyebrow at this unexpected bit of Pagan knowledge coming from a Crusader. "I fear we do them dishonor," Robin agreed.

"Yet our own honor demands we fight until one of us wins."

"A tricky riddle. But I can solve it." Robin brought his horn to his lips, blew a signal as loudly as he could and hoped Will and John had wakened from their ill-timed nap. With reinforcements, he would have the advantage and the soldier would surrender. Yet he vowed inwardly to let the man go.

The soldier, however, hearing the horn, grew suspicious and put his fingers to his lips, whistling shrilly. Robin groaned. What manner of mercenary monks would now come to their brother's aid?

Will and John, roused from their sleep, raced to the river calling Robin's name. At the same time, six mastiffs came barreling into sight on the opposite bank and hurled themselves into the water, snarling as they swam. The soldier urged them onward with bloody epithets. They gained the shore and bounded toward Robin with teeth bared.

Will and John let arrows fly, but the huge hounds leaped up and caught the arrows in their massive jaws, crunching them into bits, drooling and growling, never slowing their pace. Robin ran for the nearest tree, for he would not bloody his sword on dogs that caught arrows in their teeth. It smacked of sorcery. This mercenary was indeed much more than he appeared to be. Robin grabbed a low-hanging branch, but before he could swing himself up, a black mastiff sank his jaws into Robin's booted heel hard enough to pierce the leather. Robin swore, managed to shake himself free and clambered up into the oak, hearing John shout, "Friar Tuck! Call off your dogs! Tuck, it's me, John Nailor!"

"John? John of Hathersage? Do mine eyes deceive me?" Friar Tuck called to his dogs at once, and soon they wound around his ankles whuffling and panting, while John introduced him to Will and Robin.

"What strange company you now keep, John," commented Tuck.

Robin jumped down from the tree. "Then it is you I came to see today, to enlist your aid."

"Get across the river on your own two legs, *puca*, whether you be friend to John or no."

"My mistake. You've taught me a lesson today, when I had sought to teach you one. If you are a friend to John, you are a friend to me." Robin extended a hand and the friar gruffly shook it. "John did not tell us his holy

friar is also a swordsman."

"Swordsman, yes, and better with the quarterstaff," John said. "This is the man who was good enough to school me in the art, before he took his vows and left our village. But Robin and Will were Crusaders like yourself, Friar Tuck."

"Yes, Crusaders become wood sprites, and come to enlist the aid of a Christian friar? I count it odd."

John quickly told of Allan and Aelflin, while Robin sat down and pulled off his left boot to see what damage the dog had done, for the stinging in his heel proclaimed a wound. Sure enough, there were toothmarks in the skin, deep enough to have drawn a few drops of blood. With a wry grin, Robin shook his head and put his boot back on. "I hope your hound is not rabid; he looks it."

The black mastiff sat on his haunches licking his frothy chops as if fully enjoying the taste of Robin's blood. Robin approached the beast, crouched down, spoke to him softly, tousled his drooping black ears and enormous head, then abruptly batted him over onto his side and wrestled with him while the dog's tail wagged ferociously. The other five dogs frisked about them like puppies and Robin looked more like a boy of ten than a holy warrior or Druid priest.

"So, Friar Tuck, will you help the poor lass?" Will asked.

Robin rolled to his feet and brushed the mud and stray twigs from his clothes. "Say you do not scorn matrimony, like so many of your brothers."

"I've priested over many a handfasting," Tuck replied, "and many a leaping and twirling I have led around the churchyard on the holy days, while the priest frowned. Yet the common folk, inspired by the word of Our Lord, insist upon dancing their devotion, feasting and making merry with or without me, which last, of course, I could not allow. It is my sworn duty to lead sinners to God. But they'll not allow a wedding in the chapel at Fountains Abbey. No, to the greenwood we must go, and a hop over the broom and a song, and they'll be wed."

"We will feast you well in the meantime," promised Robin.

"Done!" said Tuck.

The outlaws waited at the river while the friar swiftly returned his dogs to the abbey where they rightly belonged. Then he gathered the essentials: a Bible, a sack of bread, cheese, apples and wine in case he got hungry along the way, and rejoined the outlaws.

But before they had travelled a mile, the black mastiff came charging after them with the rope that had held him trailing behind, and it was not

the friar he bounded toward to have his head scratched, but Robin. From then on the dog would scarcely let Robin out of his sight, and nothing Friar Tuck did could tempt him back to his first master.

The following day, by a bonfire and a bower dotted with primrose blossoms and violets, John called out the marriage banns not three times, but three times three for good measure, and Aelflin was wed to her minstrel. With her proper 'Christian' ceremony behind her and a flagon or so of wine inside her, Aelflin joined in the dancing and singing, hiking up her skirts like any peasant, as she and Allan twirled about the great oak in the center of the clearing, and she was rosy-cheeked, laughing and glistening with sweat when she herself drew her new husband away from the fire and the bawdy jokes of the other men and women, into the privacy of the enfolding night.

26-THE GREEN MIST

The hour grew late, the bonfire died down and some of the revellers fell to snoring by the warm coals, but Robin was wakeful, and tossed a log on the fire from time to time to keep it alive, his thoughts flickering and changing like the dance of the flames.

He tried to imagine a woman looking at him with the love Aelflin poured out upon Allan, tried vainly to imagine being so devoted as Allan. What was lacking in himself? He adored women. All of them, he smirked to himself. He had always thought more on war and glory than on the wedding he had assumed would one day simply happen to him, much as Spring and the other seasons had simply seemed to happen. Now, of course, he knew better. There were holy rites for the seasons, from blessing the fields with lovemaking at Beltane to culling and purifying the herds at Samhain. The people of the land acted in harmony with the spirits of the corn, the trees, the beasts, the sun and moon. Would the grain grow without someone to tend the fields and charge them with magic? Perhaps some would grow wild, but not as well, not to be relied upon, not enough to keep a village from starvation.

Such were his escapades with women, he thought. Wild seeds sown by the wind. But what harvest?

Perhaps he was not the kind of man who could cling to one woman, but seeing Allan with Aelflin, the joy in their faces, the contentment they seemed to share merely sitting side by side, he rather wished he were.

Ruefully, he poked the coals and added another chunk of wood to the fire. The light danced reflected in the brown eyes of the black dog, who lay with his head between his paws, watching Robin as if privy to his thoughts and full of understanding.

Beside the dog, Prim stared into the flames as if seeking visions and prophecy. John Nailor and Tom Cabbage swapped tall tales that grew ever more implausible, and Much and Harald listened agape, believing every word.

Will, without his lady Anne present to keep his hands busy, was whittling sticks down to nubbins, and Tuck said the results would make fine spears for Faeries, and he must burn them or beware facing an army of angry critturs in the morning, that would poke his bum with those Faerie spears until he got out of bed.

Much made the sign of the Cross and exclaimed, "Speak not of the Faerie folk! They may be listening!"

Robin chuckled and Much shivered, unsure whether his former master was still completely human.

Prim cleared her throat. "So, Much, you've such a fear of Faeries, boggles and boggarts, *pucas* and pixies that you dare not speak of them? It's true, they are mischancy and mischiefy, difficult to do with, though I myself have never seen much of them, except mayhap a boggle or so, nothing worth telling of." She darted a mocking glance at Robin and he inclined his head regally.

Much swallowed the lump rising in his throat, but the others grinned, for Prim's voice held the sing-song of a storyteller. "Now I could tell you tales like as my old granny told me when I was but a knobby brat. She was old, Granny was, nigh a hundred year—"

"Oho! Already she stretches the truth!" claimed Tuck with a laugh.

"Whether a hundred year or no, she knew a lot about the times that were. Mind, I could not say that all the tales be true, but Granny said they were, and believed them herself. Any road, I but tell them as I heard them, that's all I can do."

Prim reached for one of Will's Faerie spears and turned it about in her hand as she spoke. "In those times folk were much like now. Instead of doing their work of the weekdays and smoking their pipes of a Sabbath, in peace and comfort, they were always bothering their heads about something, or the Church was doing it for them." Prim looked pointedly at Friar Tuck. "The priests were always at them about their souls, and what with Hell and the boggarts, their minds were never easy.

"Folks had ideas of their own and ways of their own, as they'd kept years and years and hundreds of years, since the time before there was the Church,

when they had given things to the boggles and *pucas* and such, to keep them friendly. Granny said the boggles had once been thought on a good deal more. At dark every night, folk would bear lights in their hands around their houses, saying words to keep off the nasty ones, and they'd smear blood on the doorsill to scare away the horrors, and they'd put bread and salt on the flat stones set up by the lane to get a good harvest, and they'd spill water in the four corners of the fields when they wanted rain, and they thought a good deal on the sun, for they saw he touched the earth and made things grow. They made nigh everything into great boggles or gods, like, and they were always giving them things, or saying prayers, to ask them for special goodies or to keep them from doing evil."

Much listened with a rapt look on his face, a combination of fear and fascination.

"Well, that's a long time gone," continued Prim, "but not all forgotten. Some folk believe it still, and say old prayers or spells on the sly. So there are, so to say, two Churches, the one with the priests and candles and all that, the other just a lot of old ways, kept up unbeknown and hidden amid the folk; and in the old days, Granny said, they thought more of the old spells than of the service in the Church. But as time went on, the two got sort of mixed up, and some of the folk couldn't have said if the things they did were for one or the other.

"At Yule, in the churches, there were grand services, with candles and flags and what-not, and in the cottages, there were candles and cakes, but the priests never knew how many of the folk were only waking the dying year, spilling the wine on the doorsill at first cock-crow to bring good luck in the new year. Some of the folk would do the old heathen ways and sing hymns betimes, with never a thought of the strangeness of it.

"But many kept to the old ways altogether, though they did it hidden." Again, Prim shot a glance at Robin. "After harvest-time, they thought the earth grew tired and they sang hushie-bye songs in the fields in the autumn evenings, to help the earth go to sleep. They thought she would sleep through the winter, and that the boggles and such had nothing to do but mischief, for they'd nought to see to in the fields. So they were feared on the long dark winter days and nights, as unseen things, ready and waiting for a chance to play their tricks.

"As the winter went by, it came time to wake the earth from her sleeping and set the boggles to work caring for the growing things and bringing the harvest. The folk went to every field and lifted a bit of turf from the soil, and said strange words they could scarce understand themselves, the same

words as had been said for hundreds of years. And every morning at the first
dawn, they stood on the doorsill, with salt and bread in their hands, watch-
ing and waiting for the green mist, that rose from the fields and told the
earth to wake again. Then the life would come to the trees and the plants,
and the seeds would burst with the beginning of spring.

"I'll tell of one family my Granny knew well, that had done all that,
year after year, for every generation since time remembered. It was winter, a
hundred and thirty years ago, a troublous bad winter, with sickness and hun-
ger, and the daughter, a ramping young maid, had grown white and waffling
like a bag of bones, instead of being the prettiest lass in the village as she'd
been before. Day after day she grew whiter and weaker, 'til she couldn't stand
on her feet any more than a newborn babe. She only lay at the window,
watching and watching the winter creep away. 'Oh, Mother,' she kept saying
over and over, 'if I could only wake the spring with thee again, maybe the
green mist would make me strong and well, like the trees and the flowers,
and the corn in the fields.'

"The mother would comfort her, and promise she'd come again to the
waking, and grow strong and straight as ever. But day after day, she got whiter
and wanner, 'til she looked like a snowflake fading in the sun. And day after
day the winter crept by, and the waking of the spring was almost there. The
poor maid had got so weak and sick that she knew she couldn't walk to the
fields with the rest. But she wasn't giving up for all that, and her mother
swore she'd lift the lass to the doorsill at the coming of the green mist, so she
might toss out the bread and salt of the earth with her own poor thin hands.
The days went by, and the folk were going of early morns to lift the turf in
the fields, and the coming of the green mist was looked for every dawning.

"One evening, the lass, lying with her eyes fixed on the little garden,
said to her mother, 'If the green mist don't come in the dawning, I cannot
wait for it longer. The soil is calling me, and the seeds are bursting as will
bloom over my head; I know it well, Mother, and yet, if I could only see the
spring wake once again! I swear I'd ask no more than to live as long as one of
them cowslips as come every year by the gate, and to die with the first of 'em,
when the summer's in.'

"The mother whisht the maid in fear, for the boggles and such were
always near at hand, and could hear all that was said. They were never alone,
the folk then, with things they couldn't see and things they couldn't hear,
always around.

"Well, the dawn of the next day brought the green mist. It came from
the soil and wrapped itself around everything, green as the grass in summer

sunshine, sweet-smelling as the herbs of spring, and the lass was carried to the doorsill, where she crumbled the bread and salt onto the earth with her own hands, and said the strange old words of welcoming to the new spring. She looked to the gate where the cowslips grew, and then was taken back to her bed by the window, where she slept like a baby, and dreamed of summer and flowers and happiness.

"Whether it was the green mist that did it, I know not, but from that day, she grew stronger and prettier than ever, and by the time the cowslips were budding, she was running about and laughing like a very sunbeam in the old cottage. But Granny told she was always so white and wan, she looked like a will-o'-th'-wyke flitting about, and on cold days she'd sit shaking over the fire and she'd look nigh dead. But when the sun came out, she'd dance and sing in the light, and stretch out her arms to it as if she only lived in the warmness of it. By and by the cowslips burst their buds, and came in flower, and the maid, so strange and beautiful, would kneel every morning by the cowslips, and water and tend them, and dance to them in the sunshine, while the mother would stand begging her to leave them, and cried that she'd have them pulled up by the roots and thrown away. But the lass only looked strange at her, and said, soft and low, 'If thee aren't tired o' me, Mother, never pick one o' them flowers. They'll fade of theirselves soon enough— aye, soon enough, thou knows.'

"And the mother would go back to the cottage and grieve over her work, but she never said nought of her trouble to the neighbors, for they would think her mad, or pitiful.

"One day a lad of the village stopped at the gate to chat with the lass, and by and by, while they were gossiping, he picked a cowslip and gave it to her, smiling and thinking what a pretty maid she was. The lass went strange and white, and laid a hand over her heart. She looked at the flower, and at the lad, and all around at the green trees, the sprouting grass, the yellow blooms, and up at the golden shining sun itself, and all at once, shrinking as if the light she'd loved so much were burning her, she ran into the house, without a spoken word, only a sort of cry, like a dumb beast in pain, and the cowslip catched close against her heart.

"She never spoke again, but lay on the bed, staring at the flower in her hand and fading as it faded all through the day. And at the dawning there lay on the bed a wrinkled, white, shrunken dead thing, with in its hand a shrivelled cowslip, and the mother covered it over, and thought of the beautiful joyful maid dancing like a bird in the sunshine by the golden nodding blossoms, only the day gone by. The boggles had heard her and had granted her

wish. She had bloomed with the cowslips and had faded with the first. And my Granny told as how it was all as true as death."

In the ensuing silence, the fire crackled and hissed.

"What think you, Much? Do you dare a wish for the boggles to hear?" asked Tuck jovially.

Much peered at Robin, clearly fearing the least little thing he might say awry might endanger him with this man some called Puck.

Robin, seeing the boy all a-jaw, winked and wiggled his eyebrows at him, and in a flash, Much was up and running into the dark wood. Everyone laughed roundly at poor Much.

"Someone fetch him," Robin said, wiping the laugh-tears from his eyes. "If I go to reason with him, he'll have none of me."

So Will and Tuck went after the lad, and with much cajoling and calming words, and Will advising him that the right gift would make any *puca* beholden, they managed to convince Much to creep back to the fire and present Robin with an arrow of Much's own fletching, which offering Robin gravely took, and swore to be a friend to the boy forever.

Thus did Much come to be on good terms with a mischievous *puca*.

27-SPIRITS OF FIRE
HAWTHORN MOON WANING, 1193

But if there were any who went to the fields to turn the turf that year, they waited and watched in vain for the green mist. Or perhaps no one went to look for it, and that was why it did not come, and so Spring's promise was broken by a return to bad weather, and the cowslips and primroses froze in their budding.

Perhaps it was because of this, or perhaps it was the wedding of Allan and Aelflin that put it in Prim's mind, or else she had been stewing over it all winter, but one cold evening soon after the ceremony, Prim sat Robin down by the great oak, out of earshot of anyone else, and said, "The people here follow your example now. You are master in all but name. But have you given a thought for where you lead them?"

"To the Great North Road, to fill their bellies and their purses!" Robin said with a grin.

"It is not enough!"

Robin frowned and looked away. He gave a low whistle and called, "Balor!" The black mastiff left off begging at the communal cooking fire, loped over and laid his massive head in Robin's lap to be petted. Prim waited. Robin ruffled the dog's ears for a moment, enjoying the warmth of his fur on his cold hands. "What do you want of me, Prim?"

She pursed her lips. "In your thieving—"

"Not thieving! Taking tribute, for the Green Man, for the Lord of the Hunt and the Lady."

"Call it what you will, you rob the clergy more than any others. But if you lead people to scoff at the Christian faith, what will you do for their souls?"

"I do not scoff at the faith. I only defy those who abuse its power. But I am not a Crusader anymore, either for Jesus the Christ or for the Gods who came before Him. People's souls are their own affair."

"Yes, and your vengeance for your father, that is your own affair, yet you bend the men to serve you in your will just the same."

Robin eyed her sharply. "Their will happens to run with mine, that is all, like the many currents in a wide river." He leaned back against the tree with a display of nonchalance he did not feel, for Prim was after something. He wished she'd get to the point. With the glimmer of a smile he asked, "Shall we convince Friar Tuck to stay on, then, and be priest to thieves?"

"Pah! Your Tuck may stay or go as he pleases. He is more Dionysus than friar, and he does not concern me. But the Roman Catholic Church, that does concern me. The Christians build their chapels over the holy places of the Old Ones, they twist the old rites into Christian Holy Days, twist the Elder Gods and Goddesses into their saints and martyrs, or worse, their demons and devils, and twist the common folk along with them into their new religion, away from all that has protected us and served us in the past. They are twisting and choking the power that flows through the leys of the land. I hear the earth crying out in my dreams, the cold drags on, Spring is held at bay by Winter like a wounded hound against a rabid boar, and the spirits of the people starve, for the Church perversely calls every pleasure sin and every hardship noble." Prim leaned forward. "If you would truly lead, Robin, and if you would deserve the name you have chosen, if you truly desire the loyalty of these people and of the peasants in their passion, so that none will turn against you and all will abide by your word, there is one rite you must observe."

Robin's heart began pounding so hard he thought it might stop beating. He knew the rite of which she surely spoke and it was not to be under-

taken lightly. He did not know how to answer. But he belonged now to the greenwood. He knew that much. Again, in his mind's eye, he saw the white stag at the pond, pawing the ice-encrusted waters with his hooves, lifting his magnificent head to call to his herd, and then the doe was licking Robin's hand again, soft and gentle and wet, and her limpid black eyes became the eyes of a woman in love.

He found himself laughing at the image. The black dog perked up his ears. "And do you wish to play the part of the Maiden for this rite, pretty Prim?"

She chuckled, the tension swiftly leaving her face. "Wouldn't I love it, my downy duckling? But it wouldn't do. We must find someone, somehow."

"Shall we proclaim it in Nottingham? Wanted: one virgin."

"Laugh as you like. I will think of something. Not just any young girl will do. This is no dalliance with an ignorant serving wench in a poorly guarded keep," Prim added with a knowing look. "She must have some love of the wood, some power of the spirit, some link with the Goddess of the Moon and Sea. Provided you are willing. Provided you wish to do more than slaughter the odd deer, pilfer the odd purse, and pester the Church and the High Sheriff."

"Good Mother Prim, how long has this plot been brewing in the crucible of your cunning mind?"

"It's your mind and heart you must search. What are you willing to do for the land, Robin of the Wood? How will you live up to the legacy of that name you took for your own? Now that you have had your fill of crusading, what will you do with that fiery spirit of yours?"

He made no answer, but his limbs flushed with heat, as if her words had summoned it. He closed his eyes and drank in the night air, suddenly hungering for its coolness. He hadn't thought his path would lead to this crossroads, not even when he'd drunk those few drops of the blood of the Old Ones. This was too much an honor, and too much a sacrifice. He was not selfless enough for this! And what if the Elder Gods would not accept him? There would be a challenge, a test, and if he failed, it would mean his death. He could not die leaving his father unavenged! He would have to say no.

Yes, there was his excuse, and a good one, and already he knew he would despise himself if he hid behind it.

Suppose he did attempt the rite. If he succeeded, revenge for his father would come easier, for people would rally around him.

But by the eye of the God, this was not some casual charm or spell to undertake for his own ends. If he did not go pure in heart to this rite, his

death would be certain, and that death would be wasted, for the sacrifice would serve no one.

He felt as if the walls of the labyrinth in the hollow hill at Silbury were crowding down on him once more. How could he feel this bone-gripping panic? Had he not faced Death and won, the night of his initiation? Perhaps that was but the first battle in the war to conquer fear. He turned his eyes inward and upward, and slowed his breathing so that the panic, the terror of that cold suffocation, would subside.

Breathing, he was alive. Controlling his breath, he would someday command his own life, and death. So Cal had taught him.

He heard Prim's aging bones creak as she rose, and he watched through his lowered lashes as she walked toward her cave in the cliff, leaving him to gaze at the reflection of his motives in the mirror of her words, and not altogether liking what he saw there.

28-A MASS OF CONSPIRATORS

During the night, a storm charged across the sky ripping the air with claws of lightning and lashing the wind-tossed trees with sleet and hail. The outlaws took shelter in their cliff dwellings and thanked their Gods, whether Christian, Pagan or merely gold, that they had warm clothes again, and blankets, and a dry place to lay their heads.

The Bishop of York, safely rescued, sat at meat with the Sheriff of Nottingham. Prince John had the High Seat, with Hugh of Nonant beside him. Due to the Prince's presence, every meal must needs be a celebration. Knights of the realm and their ladies were arrayed at two long trestle tables, below the salt cellars sat a contingent of the shire's wealthier townsfolk, and Reginald laid a more sumptuous table than was his habit.

Coucy's attention was drawn from his own wine cup as he marvelled at the sight of the Bishop devouring a duck.

York's face was as round as the Harvest Moon, but this moon had three red chins which jiggled every time his jaws widened to engulf another drumstick. His thin nose resembled a pigeon's beak, his darting black eyes were slits half-buried in rolls of fat, and his pudgy fingers dripped with glittering rings and duck grease, for the Holy Bishop ate with his hands like any other man.

He was dressed in great pomp and circumstance, for he had just conducted a special mass for the Prince. His enormous bulk was exaggerated by a heavy robe of purple velvet trimmed with fur. The high silken mitre upon his head was embroidered with real gold threads, and the thick golden chain around his neck held the glowing medallion of his office, for he had long ago caused several to be made, and John Nailor had stolen only one at Harrogate.

Of luxurious robes he also owned several, and of castles and estates that had once belonged to noblemen, more than several, and his coffers were overflowing with tithes to the Church in coin and jewels.

For when he was younger, York had heard the call of gold rather than the call of God. He had manipulated and bribed his way to his present powerful station, and he considered it an achievement worthy of merit, that lesser men could not have attained. But for all his gluttony and greed, he knew his Scripture and believed devoutly in his own interpretations of it, and his eyes were sharp and his mind sharper still, especially whenever he saw a way to benefit himself, for the greater glory of God, of course.

Freed from his bonds at Harrogate's church by a passing peasant, the Bishop had been in a terrible temper, and on his belated arrival at Nottingham, he interrupted the Sheriff's game of chess to rail against the lack of safety in Sherwood and the far-reaching arm of one Robin in the Wood.

Sir Reginald said, "Indeed, Your Grace, I have already taken steps to capture the thief. There is a substantial reward offered."

"A reward? It will take an army! I shall speak to Prince John."

"Nonsense."

The Bishop flushed on hearing his views dismissed in so casual a fashion, and Reginald hastened to repair the damage, for the Bishop did not forgive easily. "Your Grace, the affront to your person is unpardonable. This wolf's-head will be caught and hanged. But it were best not to distract the Prince at the moment, for he is busy with matters of state, which loom larger than any thief no matter how invidious. It is my duty as Sheriff to address this problem, and so it shall be done. Please, allow my servants to attend you and we will speak of this further, after you have rested and recovered from your ordeal."

With a calculating mind, the Bishop agreed for the time being. Reginald would be indebted to him for his silence. If the thief were not captured, the Bishop could still go to Prince John.

Now his tiny, pursed lips wrapped rosily around a bone and sucked the marrow out. He swallowed, tossed the well-gnawed bone onto the rush-covered floor with the rest, belched in tandem with a rumble of thunder out of

doors, and reached for his chalice of wine.

Reginald took this opportunity to bring up the subject of Maerin, whose whereabouts had finally been discovered.

The Bishop coughed, wetted his greasy fingers in the silver finger bowl, and replied, "Getting your ward out of Nuneaton should have been a simple task, but there are unexpected obstacles. These double monasteries which house both monks and nuns were granted autonomy in the seventh century, by the Pope himself, mind you. While the Scriptures surely do not support this outrage, that brother monks should bend a knee to any female abbess, the current Pope stands firm on this issue. Tradition, you see. It is my contention, however—and I have put it to the Papal Legate in no uncertain terms, I assure you—that the abbess of Nuneaton has no jurisdiction over secular matters. The betrothal between your ward and Monsieur de Coucy is legal and must be upheld. I think the Pope will quickly tire of this matter. Marriage contracts between persons with no royal blood are hardly worthy of his consideration. A few more letters written to the appropriate parties, and all will be well. But in weather like this, you know how difficult it is to get a message to Rome. The spring is late in coming this year."

"If it were up to us," put in the Prince, "we would not bow to Rome for anything. Did we not throw off the yoke of her legions centuries ago? Now it is time to throw off her other yoke."

No one, not even the Bishop, dared contradict the Prince, who turned away to pinch a serving maid as if what he had said were casual conversation instead of heresy.

Reginald said quickly, "Surely we will have Maerin back in time for the wedding at the harvest."

"You intend the marriage for August? An unholy time," pronounced the Bishop. "A Pagan tradition that must be obliterated."

"Not by my accounting," growled Coucy. "As soon as we've taken her, I'll have her, May or August, holy or unholy, trousseau or no! She can wear a nun's habit for a wedding frock for all I care."

"Now, now, my friend," Reginald laughed, shrugging at the appalled Bishop as if to apologize for the folly of youth.

The Bishop leaned over to Reginald and murmured, "This is to be your heir?"

Reginald replied with a shake of his head, "No, never. I shall designate the firstborn son of his union with Maerin."

"It strikes us, Sir Reginald," observed the Prince loudly, "that you never married yourself."

"I prefer to lead a holy life," joked the Sheriff. In fact, his concern was for living his own life as comfortably as possible, and he had no interest in leaving legacies or continuing his family name, though he supposed a few bastards with his features ploughed the land in Nottinghamshire and Derby.

"You are wise," nodded the Bishop. "The Bible warns us that females are sinkholes of corruption and bestiality, more poisonous than adders."

"On the contrary," the Prince objected mildly. "Females, Your Grace, are savories to be enjoyed like tonight's meat." And he grabbed a spiced leg of mutton and sank his teeth into the flesh.

The Bishop shook his head with a sad expression. "Your Highness, I fear you compromise your soul. I would be remiss in my duty if I did not tell you so."

Prince John's eyes narrowed slightly. "Your concern for us is noted, Your Grace."

Reginald smiled as blandly as he could manage and turned the topic to hunting. To his relief, the Prince soon rose and put an end to everyone's obligatory presence at the feast by taking his leave, and if a certain serving maid disappeared shortly thereafter, it was nothing but her obligation, and if a wink and a leer from some of the more observant knights followed her, no one gave it much thought except Reginald, who sighed and counted up how many more bastards would doubtless be born in his castle come next winter and how long he would have to support them until they could be put to work.

As the other guests retired for the night, Reginald led the Bishop and Coucy a roundabout way into the old inner keep, where he kept a small, private study. There the men lowered themselves onto cushioned benches as the storm settled into a steady drumming of sleet outside the windows.

A servant offered them cups of hot mulled wine and withdrew. The Bishop spoke first. "Now for that villainous wolf's-head who styles himself a Robin of the Wood. What reward have you offered for his capture?"

"It stands at seventy-five marks."

"You must double it."

Reginald's lips thinned into a pretense of a smile. How dare the man tell him his business! "Your Grace is naturally upset after the events of the day. But as High Sheriff and a soldier, I must not allow my emotions to sway my good judgment. I have increased the reward for Robin Wood several times already. Few dare venture through Sherwood in order to claim it. Men have gone after him often enough, and have come back empty-handed—in fact, emptier-handed than when they went in. Horses and weapons stolen,

good soldiers wounded or killed. This thief has rallied a band of followers to support him in his infamy, and he knows every byway and hiding place in the woodland better than I know my own bedchamber. As a soldier, my tactics are to let it rest until the weather is gentler and such wolves come further out of their dens."

"Bah! You'd let him grow fatter and stronger, after my honor—nay, the honor of Holy Mother Church!—has been sullied and scorned by that impudent filth?" The Bishop's jowls shook with outrage.

"I myself will go after him, with forty of my best fighting men, when the time is right."

"Forty men to capture a single thief?" scoffed Coucy. "I could take him alone, with but my sword and dagger."

"Excellent! Then you may lead my soldiers instead of me," said Reginald, amused at how Coucy's bravery increased in direct proportion to how much wine he had drunk.

"Agreed!" said Coucy.

"Nay, this Robin is too sly," said the Bishop. "He must be cornered in his lair and I know just the man to do it. Even now he sits in chains in your dungeon waiting for his neck to be collared by a noose."

Reginald reflected upon his current prisoners, dismissing them one by one from his mind. Then he set his cup down so hurriedly that the wine sloshed out. "Not Guy of Gysborne!" His skin crawled at mere thought of the man.

"What better than a fiend to trap a fiend?" said the Bishop.

"No! The cost to me in capturing Gysborne was enormously high, in money and in men. I cannot risk letting him go. Besides, Gysborne is a cold-blooded murderer. This Robin Wood is nothing but a brigand and shall be dealt with accordingly."

"You fool! A brigand is precisely what he is! He is a follower of the old Goddess Brigantia, and of other evil Heathen powers. Do you not see the threat he poses? A murderer kills at most a dozen or two dozen men in his lifetime. What is that to you or me? But the Hooded Man could be the ruin of us all! He has taken the name of one of the old Gods, do you not see? Tales of his doings spread like molten metal poured out of the blacksmith's forge, and that metal makes a mighty sword on which to impale us! He incites the peasants against us, against the Church, against the forest laws! We cannot have our power usurped. Let alone the losses in gold! He and his men laugh at us. Christian clergymen as objects of ridicule! It's unsufferable! Ah, you think I exaggerate. Very well, hide your smile behind your wine cup, but I

tell you, the peasants chafe against tithing and taxing now, and with a Robin
of the Wood to lead them, who knows what damage might be done? Will
you wait until he and his followers steal this very castle from under your
nose? Will you sit there watching your sword gather dust, guzzling your wine,
while the downfall of the kingdom lurks behind the trees in Sherwood, in
your domain, waiting only for the right moment to pounce?"

"What's to prevent Gysborne from disappearing into the wood, or even
joining Robin Hood and his band of thieves?" Coucy pointed out, not so
soused as to have no sense remaining.

"Simple. You shall hang another in Gysborne's place. Only disguise him
well and the people will never know. And Gysborne you will disguise also,
and set spies on him to watch his every move. Promise him a huge reward,
one that he cannot refuse. Tell him he'll not go free or be paid until he brings
you Robin's head wrapped in his own Hood. And when he brings the brigand's
head for ransom, you will have Gysborne skewered on the spot. Then all
your Pagans, thieves and murderers are taken care of in one blow. Yes, set
your cutthroats after your cutpurses; let them do the work of your soldiers."
The Bishop nodded, satisfied, and reached for his wine.

Reginald felt as if his bones were filled with ice, but he forced his ex-
pression to remain mild. He stood and began to stroll back and forth, as if
thinking it through, hiding his agitation. "You exaggerate the danger of this
wolf's-head. And if I were to let such a man as Gysborne go free, the people
would have my head! And rightly so. He is infamous in seven shires for his
abominations." Reginald paused by the narrow window that gave out upon
the castle courtyard and he shivered as if it were open to the freezing gale
beyond the walls. He himself had seen the remains of some of Gysborne's
victims and was plagued with nightmares for a week. He, who had seen
horrors in war that had made lesser men weep! "No, Your Grace, Guy of
Gysborne is a Devil-driven plague upon us and he'll be hanged." He turned
back to face the others. "The reward for the Hooded Man will be increased
in the morning. A hundred marks. But it will never be paid out, I assure you,
for I will catch him myself—with your help, Coucy—come spring."

The Bishop scowled and vowed inwardly to advise Prince John of the
Sheriff's unwarranted softness.

Yet Reginald knew how far he could trust the Bishop, and that night,
alone and sleepless in his bed, his mind twisting along the remembered cor-
ridors of their conversation, Reginald decided he must have an alternate plan,
if Prince John confronted him. He would keep Gysborne alive in the dun-
geon for a time, just in case.

29-OF A CRONE, AN OWL AND A MAID
OAK MOON NEW, 1193

ay dawned, drained of color. Each twig and dead leaf and brittle sprig of brown grass was encased in a clear sheath of ice. Primroses that had bloomed too soon were bruised and flattened by the weight of round white hailstones which rolled underfoot.

Robin looked for the sun at the top of the cliff, his eyes gritty and a drumming in his head from lack of sleep, for his thoughts during the night had run in circles ever faster like a dog chasing its tail. He finally gave up trying to make a decision, sat up and meditated, letting breath and prayer wipe his mind blank as fresh vellum, waiting to see what God and Goddess might write upon it.

Now he rubbed his eyes with the palms of his hands as if to wipe away doubt. At his feet, Balor gazed up at him, eager for the signal to walk on.

For a brief moment the clouds relinquished their grip on the hills and a wafer of pale rosy light streaked across the sky. The sight did not cheer him.

The Oak Moon had begun, yet the land was still clutched in the frozen fist of winter. Prim had spoken rightly; there was no true sign of spring, neither the return of Robin Redbreast nor the warming rains that would seep into thawing earth and rise again as the sap in the trees. Of course the spring would come again eventually, whether he aided it or no. But how strong and fertile a spring? And when? And how well would it bring the summer in, and the harvest following?

The clouds lowered once more and the sunlight was lost to view. Robin hunched his thick cloak around his neck and shoulders for warmth and patted Balor on the head. Below, Prim emerged from her cave and started down the steep, rocky path. The way was slick, but her step was sure and nimble despite her age. She disappeared among the tree trunks in the ravine.

He heard her before he saw her. He said, "If you called up last night's storm, Mother Prim, you overstated your point." The grim look on his face belied his teasing words.

"If I had a skill for weather-working, I'd have called up sunshine, Robin."

They both looked down into the ravine, glossy with ice. He asked, "When shall we begin our working, then?"

Prim noticed he did not flinch. "Come to me in ten nights' time. The moon will be nearing its full."

"Beltane."

"Of course. Meantime, prepare yourself." She walked away, back into the ravine, and busied herself with her morning tasks as if nothing unusual were afoot.

Robin's idea of preparing himself was to sleep long hours, eat heartily, go hunting, and sleep some more, little knowing as he dreamed strangely of nothing that Prim watched him out of the corner of her eye with amusement. But on the seventh day, he began to fast, and took himself into the woods to meditate instead of hunt, and his voice grew hoarse from chanting in the silence.

Prim prepared herself in other ways. When she cooked the evening meal that first night, she took, so subtly that no one noticed, a portion of raw squirrel meat, which she wrapped in dried leaves and slipped into her pocket.

She ate with the others in the largest cave, which most of the outlaws shared as their home. Then, yawning broadly, she pretended to go off to her own cave to sleep. Once outside, however, she climbed out of the ravine and trudged eastward through the wood, coming at last to a place where she had gathered mushrooms once of an early autumn evening, had heard the hooting of a horned owl on a branch, and seen by the coloring that the bird was a young female.

At the time, she had wondered what dark omen this owl might portend, but now she thought the omen might be dark, perhaps, for the owl herself, or perhaps, someday, for Robin, but now was a time of increase, of strengthening, of taking what had gone awry in the world and setting it on its true path again, and the owl had called to her then so she would know where to find the creature now. She only hoped the bird still made her nest in the hollow in the oak, and that she had not yet found her mate.

Near the base of the tree, Prim unwrapped the squirrel meat and laid it upon the snow. Then she walked some twenty paces away, sat down and leaned against a tree trunk. She untied the thin white cord she always wore around her waist, hidden under her overtunic, and knotted it into a circle. Then she waited in the windless night, with the clouds hanging heavy above her black as the anvil of Wayland the Smith, and she began crooning to herself, and to the Moon Goddess Brighid, Maiden Protector of Animals, Mother of All Children, Maker of Marriages, Warrior Queen of the Hunt,

while behind the clouds, the silver sliver of Her crescent sank behind the hills. On and on she sang, of this sinking of the new moon, hidden, of the cold in her bones and the cold comfort of the ground on which she sat, the cruelty that had outlawed her son, of the loyalties and love that made her choose to be fugitive with him, of the love therefore of a mother for her son, of the love of a woman for her man, who gave her the seed for the son, of the love of the moon and the sea for the land and the sun, of roots of trees taking life from that land and leafing into bud, and of primrose and crocus, beetle and vole, stag and boar, of oak and ash and thorn, of May and midwinter, and she sang it in the Old Tongue until the song died away of its own accord, and still she waited.

Without a sound to announce its flight, the great horned owl landed on a bare branch of the oak near the hollow that was her nest. Her sleek white feathers were speckled with brown and black, like soil under a thin blanket of snow. Her eyes in the darkness were hollows above the whiteness of her wings. Her head swivelled from left to right as she searched the wood for signs of life.

Prim sighed softly, letting the owl hear her breath, and she wove her white cord about her fingers, and played cat's cradle again and again, half-mindedly, watching the bird.

The owl swooped down, grabbed the squirrel meat with her sharp talons and flew up to her nest to eat. As Prim had guessed, the bird was starving in this long harsh winter, and owls would eat dead meat if they could not find it on the run.

Satisfied, Prim untied the knot, bound her cord once more around her waist and went home.

This ritual the old woman repeated every night for eight more nights, and each time the owl came home sooner from bad hunting, and each time Prim sat a little closer to her offering of meat, and played cat's cradle as she watched the owl seize her dinner.

The owl had no mate; there were no hatchlings in the nest.

On the ninth night, a clear night, with the pregnant moon floating high and cold among the stars, Prim stood close to the oak, toying with her cord, when the owl dropped down with her talons stretched toward her easy prize. In a flash, Prim grabbed the bird's neck with one hand and looped the cord about the creature's legs, quickly twisting the string and winding one end around her wrist. The owl screeched and tried to claw and tear at her with her sharp beak. She was strong and challenged Prim's muscles to hold her tight.

"There, there, lovely, hush, now, I'll not hurt you. There, now. A bit of a pinch is all." Prim plucked one feather from each wing and one from her tail. "I thank you, Maiden. May your hunting be good. May you find your mate." The creature's golden eyes glittered like stained glass in the light of the moon as Prim released her and she soared into the air.

That night Prim put ointment on her hands to soothe the burning of the wounds the owl had given her, and then she slept soundly, quite pleased with herself.

The next morning early, as he had been bidden, Robin came to her cave, the black dog at his heels. Prim gave him a long, narrow deerhide pouch and told him to wear it around his neck, warning him not to open it or seek to know what was inside. He was intensely curious, but knew better than to meddle with the old woman's spells, though he sniffed at the pouch and shook it near his ear when she wasn't watching. He smirked at himself: it made no sound and smelled redolently of deerhide.

Prim pointed at a large, bulky leather pack. "Carry this."

He crouched down and shouldered the burden with a grunt, but he would not question her as to what was inside here either, for she had a mischievous gleam in her eye and was clearly enjoying ordering him to his tasks with such mystery.

He followed her down the path to the great oak with the black dog trotting after. A dozen or so outlaws were gathered around the tree, breaking their fast.

"Keep Balor for me, would you?" Robin said, convincing the dog with some difficulty to sit beside Will.

"We'll return tomorrow," Prim told them.

John looked suspiciously at his mother, who had a peculiar preening expression on her face.

"Where do you go?" Will asked.

"Can I go with you?" Harald piped.

Robin shook his head and answered, "Wherever we go is our affair, and what we do there will do harm to none. We'll rejoin you here at the rising of the sun."

This rhyming speech unnerved Much, for it was just the sort of thing a *puca* would say. He quickly offered Robin a hunk of bread from his own breakfast, but Prim waved it away, saying Robin was fasting. Robin grinned and winked at Much, and followed Prim out of the shadow of the cliff.

They walked for the better part of the morning, Robin's muscles straining under the weight of the pack, until they reached a snowy vale among low

forested hills. A small spring gurgled in the rocks, and a thin brook ran out from the ice-capped pool, still flowing as if it were so small, winter had overlooked it. Nearby stood a lichen-covered gray rock, twice the height of a man, with a shape suggesting hunched shoulders and a short fringe of icicles hanging along the ridged top like the hair above a wide-mouthed face.

Robin slung the pack down and helped Prim open it and pull out a heavy cloth-wrapped object which proved to be an ancient cast iron cauldron big enough to boil a baby lamb.

"A little soon for the sacrifice," muttered Robin, but Prim said, "Help me set it on this tripod," and when that was done, she said, "Gather me wood and build me a fire," and then, when that was done, "Fetch me water from the spring," and she handed him a wooden bucket which had been tucked inside the cauldron along with various pouches and packets. After he had fetched several buckets of ice and water and dumped them into the cauldron, she said, "Build a shelter under that stand of birch trees." While he did so, binding branches together with vines, she melted the ice in the cauldron over the flames.

Meanwhile, Will sat poking the communal fire with a stick, hardly hearing his friends' idle conversation. The more he thought on the sight of that old crone trudging away with Robin behind her, carrying a pack full of odd bulges, the more troubled he became. Why would Robin go off with her? Why could no one go with them?

Ever since Robin had returned as if from the dead, Will had seen changes in his old comrade that disturbed him. First, the name, although for an outlaw to take another name was common enough. But there was the way Robin murmured over a kill, for example, and the way he dropped little tidbits from his meals on the ground, usually when he thought he was unobserved, and he murmured over those too. And there was the way he insisted the men use every part of a dead beast, from eating the flesh and tanning the hides, to saving the very sinew, and making glue and powders from the hooves and what-not. Robin himself worked the days away at a hundred tasks no nobleman of Loxley would have condescended to in times past. And any newcomer with a skill to share at tanning or chandlery or, by the saints' knees, even soap-making, was hailed like a hero knight of the Crusades!

Yes, that was another thing that rubbed Will's brain to rawness: where Robin had once been eager for battle against the infidel, now he seemed twice as eager against the Church, though less bloodthirsty. It was true he had lost his land and his father to the Church, but surely that was the fault of a few evil clergymen, not every sheep in the Christian fold.

Most unusual and disquieting of all was that three nights ago, Will had said he was slipping away to Snaith and Robin had refused to join him. Was he ill? Was he bewitched? And what did the old woman have to do with it, with her herbs and her odd ways?

Will pondered his friend's sad condition as the sun travelled toward its zenith, while the other men spoke of how it was the eve of Beltane, and if they would or would not light a bonfire, and some said it was devilish, and others argued it was not, and another pointed out the lack of young lasses to sport with, for though some women had joined them, most were married already or too old to play the May Queen, and besides, they had not cut a Maypole. Someone suggested they do so now, but someone else suggested it would be more fruitful to go hunting, and then an argument began about the importance of dancing at the May.

This talk of the Pagan holy day aroused Will's nervousness even more. Sure there was no harm in dancing around a Maypole, but still, there were old ways and spirits and enchantments that gathered in the very air at such times, and especially in wild places like the greenwood, which was just where Robin was, and abruptly Will stood up and announced, "I'm going after Robin."

"Let it lie," said John. "We were told to stay here."

"Are we free men or no? I take orders from no one. What good can come of him and an old woman spending a night alone in the wood? I don't like it, them going off like that. It makes no sense. You, Tuck, will you join me? You've a good sword arm and you've lingered here long enough without earning your keep."

John said, "Robin can take care of himself. And I'd bet a crown on my mother if any beast should threaten her, animal or human! Besides, you cannot follow a *puca* about if he doesn't want you to. He'll just turn invisible."

Some of the men nodded sagely as John went on in a flurry of words, "God knows what they're up to, my mother and that Robin, it's none of my affair and I don't want to know." He stood and stalked off.

"Robin is no *puca*," called Will to John's back. "He's a man like you or me. Who is with me?"

Harald Sparrow said he was game for danger and would do anything to serve Robin, though his actions gave his words the lie, for Robin had distinctly told him not to budge.

"And you, Much? Are you fearing night demons? Faerie lights?" taunted Will, and aroused Much's pride, so that he agreed to go also.

Tuck lurched to his feet, buckled on his sword and began stuffing left-

over barley bread into the folds of his robe.

Having learned from Robin how to track as well as wolves, the four men were not far from Brighid's Well when they picked up the threads of Robin's and Prim's trail, for Robin had not bothered to try to conceal it. But it was the drum that led them at the last.

<div align="center">⌘</div>

Prim prepared a potion. Three cupfuls Robin drank, while she chanted and sang and beat upon a drum, an ancient frame of wood with deerhide stretched across it, streaked black with grime and age and use.

The steady thrumming locked itself to Robin's pulse, then commanded it, slowing it, then lifting it higher until it begged for release. He rose, threw off his cloak and began to stamp his feet, stretching out his arms to East and West, then raised them up as if calling the sun. His blood raced hot. He tore off his tunic. He whirled in and out of daylight and the shadow of the stone. The drum pulsed in his bones with the pulse of the greenwood, singing to him, urging him on. His thoughts swirled away until all that was left was sensation.

At last he stood naked, but for the deerhide pouch around his neck, red in the last glow of the cold day. The sun hovered on the horizon, beckoning. His skin tingled and he wanted to chase that brilliant gleaming towards its setting. He lifted his head and sniffed the air as if tasting it.

Prim draped over him the untanned hide of a deer, with the fur still bristling on it and the head of the beast resting upon his own head, as if he had two faces. She washed his body with another potion, thick with grease and burning to the touch. Warmth coursed through him. He let her move his arms and legs slightly as she worked, himself standing loose and relaxed, as if the wind moved him like the limbs of a tree.

He could feel the twittering of birds vibrating in his heart, he saw the swift darting of a mouse in a hollow log a league away, he heard the whispers of men's dreams. The air spoke to him of the tang of fresh grasses and crystal water. The face above the hunched shoulders of the stone grimaced and grinned and shuddered.

He shook his head. The wind stirred the hair on his chest and thighs, on the deer-hide covering his back. The woman's hands were rubbing his calves now, and his hooves, with the acrid-smelling ointment of deer-fat and herbs, and mud made of dirt and melted snow. She rubbed his forelegs and shoulders, neck and forehead and antlers, massaging him until he tingled and his fur stood on end.

Color fled from the world; everything gleamed white and black and

shades of grey. He snuffed the air again, and his own smell was of earth and
deer and wildness, and before him, woman-smell, this round-limbed being
draped in cloth to cover her unprotected skin, with her flat face and flat
muzzle that opened and made strange sounds that took ages to crawl through
the air into his ears and then his brain and become words he could somehow
understand.

She unwrapped from a linen cloth a knife with a handle of deer antler
and a double-edged blade of obsidian. She offered it to him and said, "Bring
me the blood of the white stag."

Robin quivered, arched his neck, let out the keening cry of the Horned
One calling his herd, and ran.

Prim watched after, making the sign of the Earth across her heart, for
Robin was deeper in trance than she had ever seen anyone go, and she could
only hope and pray that he came back alive and whole in body and mind.
But he had agreed to the sacrifice. If he died, it was his choice, and was it not
a good death, to go at the time of one's own choosing? Yet her eyes pricked
with tears. She had grown fond of the rascal.

She turned back to the fire and picked up her drum.

⌘

The full Oak Moon touched every twig and stone with light and shadow,
glistening on ice and snow, revealing his silvery way moment by moment.
He jogged through the underbrush, scarcely feeling the cold. Delicately he
sidestepped thorn and dead branch, making no sound. He did not hurry, for
he had already run through his excitement and now his breath came heavy.
He crossed an old deer trail and its twisting reminded him of the secret place.

A wolf howled far away and he stopped, lifted his head, eyes wide, sniff-
ing, but the breeze brought him no wolf-scent, so he moved on. He paused,
nibbled at the frozen bark of a tree. He longed for tender juicy baby leaves,
for spring. He bent down and licked the snow, for his tongue was dry. Then
he moved onward, nimbly, light as a shadow.

He came to a long clearing that stretched to either side beyond his
vision, and he shuddered to a halt among the trees, ears pricked, listening.
Silence. He made his way to the edge. He sniffed at month-old horse drop-
pings, ghosts of man-odors, sweat and sour leather and the cut wood of carts,
stinging metal smell, man-made, which brought him the recognition of Road.
Then he bolted across and into the wood beyond, where he shook off his
remembrance of words and other man-created things and went deeper, de-
lighting in his new shape.

Clustered by the pond, sleeping half-hidden in rocky clefts, he found

them, soft and tender dappled-coated fawns nestling in their mother's warmth, the does' inviting smell making his loins race at the same time his man's mouth filled with saliva and the remembered tastes of blood and venison.

The snow lay thickly here upon the ground, lying in drifts vivid in the moonlight that fell straight as arrows between the great trees. Then, almost close enough to touch, he saw the white stag etched briefly against the moon.

The deer-man reared up on his hind legs and leaped. The stag reared up also, slashing with its hooves, cutting the deer-man's chest and thighs, sending him careening backwards until he landed on the ground. He rolled quickly onto all fours, scattering snow. The stag trumpeted a warning. Rustling branches marked the startled flight of the herd. The deer-man ached to run after them, but he knew he must fight to win them. Ignoring his bleeding and bruises, he ran after the white stag.

Hooves rang against rocks and dead branches, struck silver and diamonds from the moonlit snow and ice. The stag was only as far ahead as the stone's throw of a child. Under his breath, under his thoughts, the deer-man prayed wordlessly to Herne for swiftness and sure-footedness. He remembered magic; he touched the deerskin pouch around his neck and whispers in the wind ran with him. He heard the baying of the bitch-hounds of the Moon Goddess. His skin was deer-scent, his blood was the sap of the oak, his heart's pounding was the wing-beat of the owl. He took flight, a bird of prey sweeping over the earth, fast as the Morrigan, inexorable Fate, death gripped in his hand, obsidian.

He shouted in exultation and jumped off an outcropping of rock, sliding down a hill, gaining on the stag. Sweat ran down the small of his back, dried mud cracked on his skin as his muscles stretched. He screamed with the joy of the hunt.

The white stag plunged up a steep rocky slope, faltered and floundered in a drift that reached as high as his haunches. The deer-man howled and sprang upon those stumbling legs. The stag's eyes rolled back in his head and he toppled over.

They tumbled partway down the slope together. The stag struggled to regain his footing, nostrils flaring, breath coming in surging gasps as the deer-man dug his fingers into the furry ruff around the beast's neck and flung his legs over his back, grunting, urging him up the hill.

They gained the crest and the deer-man laughed. The stag's body quivered with fury and fear as he reared again and again, tossing his head, trying to throw his rider and spear him with the sharp tines of his antlers. The deer-man clung to him, panting hard, hearing his breath in the wind, hearing the

ghost-hounds baying, his own heartbeat, and the stag's heart, a drumbeat, and the singing of a woman by a cauldron, reminding him of his purpose.

The stag stretched his muzzle forward and trumpeted. The sound penetrated Robin's soul and it said, "Betrayer!"

With a jolt, he remembered his humanness, and that to kill the white stag was forbidden him.

Yet to serve the earth, the people of the land, to serve the Lady, kill he must. How else could he triumph and be Her King? Prim's words echoed in his mind, "Bring me the blood of the white stag."

The moment spun like a hinged crossroads before him, splaying out arms like a wheel, splaying out choices.

With a cry of anguish and a quick downward thrust, he slashed his knife across the white stag's flank. Blood pearled out of the wound and smeared against his thigh, mingling with his own blood from the wounds the stag had given him. He wiped his thigh with his palm and brought it to his lips, licking the sweet blessed wetness. Power surged into his veins.

He whispered, "You will never die by my hand, my Lord," and he slid off the white stag's back and let him bound away to freedom.

He lay sprawled breathless in the snow. The black sky assailed him, the stars sang like the souls of the dead, but then the voices of the living began to join in, and they were galloping toward him, fox and rabbit, deer and wolf, ferret and bear and boar, and everything hoofed or clawed or horned or feathered or furred. They swept him into their embrace and carried him up over the snowy ridge, beyond the vale and the sacred pool, tearing through a league of trees, through a gleaming world where every root and branch, every stone and snowflake and grain of soil lunged toward him and through him and made him and tore him to pieces again, and the heat of his body inflamed the night and the wild creatures fawned upon him.

He saw on the far tors the ghosts of ancient bonfires burning pale gold in the past, and the Lord of Misrule and the Abbot of Unreason danced chaos in and out of the sparks, and many-limbed Gods and Goddesses in wheels of fire bore down upon the world to create it and uncreate it, and floating above them all, the shining disc of the moon.

He heard lovers' cries of passion, cries of mothers giving birth, and the pounding of a drum, on and on, which called him to the cauldron.

At the edge of the circle of firelight, the wild animals drew back. Robin walked alone to where Prim waited. He lifted his hands, spreading them, empty. The deer hide fell open.

She saw the blood on his thighs, his hands, his lips. She shuddered. She

had expected a fine rack of antlers, a magnificent drooping white carcass, and from it, a bucket of blood for making life. Where was the sacrifice? What had happened on the hunt? Robin's eyes held secrets she could not read. She mourned the dying land, and prayed the Lord and the Lady would guide them in their makeshift rites.

⌘

On a westward hill, the men wriggled through the snow until they could peer over the crest of the ridge. Golden firelight in the moonlit vale revealed a huge cauldron steaming over the coals, and beside it, two smaller cauldrons on three-legged trivets, steam curdling out of them. The leering face of the Celtic stone loomed behind Robin, behind Prim as she hovered over the fire, her long hair unbound. A whiff of pungent smoke drifted their way.

"Naked as the King of the May," commented Tuck.

"What's she doing?" whispered Harald.

"We shouldn't have come here," whined Much.

"He's bleeding!" Will put his hand on his sword's hilt.

"Whisshht!" Tuck shushed them.

Prim went to fill the bucket with icy water from the spring. She set it before Robin and appeared to be muttering something to him. He crouched and held the obsidian blade in the palm of his left hand, squeezed until it cut him and drops of blood leaked out of his fist into the bucket.

Will swallowed hard, Harald's eyes were frozen wide, Much whimpered and Tuck crossed himself, yet he was nodding as if he understood.

Prim took a damp rag and wiped the blood from Robin's face, rinsing the rag in the bucket, wiping his wounds. He groaned as she washed him, the pain starting to seep into his consciousness. He shook his head, sniffed the air. Man-smell. He tasted it. Then he heard the heartbeats of four humans on the hill, but his tongue still belonged to the wild and he could not form words to warn his High Priestess.

Prim bound up his hand, then went to one of the small cauldrons. She ladled out liquid into a small vessel, carried the vessel to Robin and poured a stream of warm, pungent oil upon his head. The warmth felt golden, melting along his crown of antlers, forming a crown of gold, filling his head with light. As she anointed his chest and hands, she began to chant. The words floated up the hill.

Thou art a stag of seven tines.
Thou art a wild flood on a plain.
Thou art a wind on the sea.

Thou art a shining tear of the sun.
Thou art a hawk on a cliff.
Thou art a healer among herbs.
Thou art a boar for valor.
Thou art a salmon in a pool.
Thou art a mist on a mountain.
Thou art a wave of the sea.
Thou art a roar of the sea.
Thou art a spear waging battle.
Thou art a God who shapes fire for a head.
Who is calling in the mountain?
Who seeks peace without fear seven times?
Who sings enchantments for arrows?
Who knows the secrets of the stones?
Thou art a stag of seven tines.

She went to the second small cauldron and from it ladled hot red wine mulled with herbs into a large silver chalice, cooled it with a bit of pure spring water, and gave it to Robin. He drained the cup. His limbs relaxed. She wrapped a blanket around him and led him toward the hut he had built, where she bade him lie down on the pallet of pine boughs and hides she had prepared for him.

She said, "Rest now, and dream of your best beloved, She who comes to you as the sacred Queen of Night, who honors you with Her mouth, who opens to your love, whose juices are the rain, the Spring Maiden whose footprints blossom with white flowers."

He breathed in the blessing of her words, closed his eyes and promptly fell asleep.

As soon as Robin's breath was deep and rhythmic, Prim took the three owl feathers from the pouch about his neck and went back to the fire. She lifted the bucket of water, now slippery with blood and mud, ointments and sweat, and poured it into the broth in the great cauldron.

Then she began invoking Goddess in a low song, "Brighid, Brighid, High One, Pillar of Fire, O Lady, come"

As she chanted, one by one she held up to the full moon the man-shaped root of the mandrake, a vial of dragon's-blood oil, a handful of white willow and one of cinquefoil, cassia, angelica and several other herbs, and finally the whole of a dried red rose. One by one she dropped each ingredient into the cauldron.

She bowed her head a moment as if in thanks, then held up the three owl feathers to the moon before slipping them into the cauldron, crooning, "Come to me, my pretty maid, come to claim your own. Light and dark, inflame my art, feather, blood and bone."

A snowy horned owl swooped across the face of the moon and down to Prim, her wide wings beating the air about her, tossing Prim's long grey hair back from her face. The bird of prey perched on her arm as if trained to it like a falcon, and gazed at her with harsh golden eyes. Prim grasped the feathered creature about the breast and lowered her slowly into the cauldron. The bird screeched but did not struggle, and the vapor rose and enfolded her. The light feathery horns on the owl's head were the last to disappear into the broth. The steam swirled and gathered, changed shape evanescent, and grew thick as a fog that cloaked the old crone invisible, and then the watchers on the hill, caught in the grip of this strange magic, heard her voice, "Praise to the Maiden! Praise to the Bride! Welcome to our sacred circle! Thou art Goddess. Thou art the land. Wilt Thou take Robin as Thy consort? As we love the Earth, Our Mother, go to him!"

There came forth from the mist a maiden with tawny golden hair reaching almost to her knees, a snow-white body covered with freckles like golden dust, breasts like new apples, a tiny rosy mouth pursed as if to kiss a lover, and her feet were the sharp, yellow talons of an enormous owl.

As if with one voice and one body, Harald and Much howled and hurled themselves back the way they had come, but Will drew his sword and charged down the hill, despite Tuck shouting a warning after him.

The creature of the cauldron was gliding toward the hut where Robin slept. In moments, Will was behind her, but Prim threw herself between him and the creature with her hands raised and a look of the otherworlds in her eyes.

"Kill me," she cried hoarsely, "but leave them to their love-making!"

"Love-making?!" he shouted, but some power in her hands, her eyes or her voice seemed to paralyze him, and then Tuck was locking his steely arms around him from behind and wrestling him to his knees. Pain shot through his shoulders as Tuck wrenched his arms back. Will shouted, "No!" as the creature glided into the hut.

Prim was on the ground beside him then, her arms outstretched, but she dared not touch him, for his fear of her. She hissed, "Do not interfere with things you do not understand!"

"Witch! Succubus! You deal with demons!" accused Will hoarsely. "You betray him!"

"Ignorant fool! Appearances deceive you. Do you know nothing of the Sacred Marriage? Your own Anne would honor it. Has she told you nothing? Be sure, before you accuse Witchcraft, you've some idea what it is! By our Lord and Lady, kill me, if you must kill, Will Scarlok. If you are so driven to kill everything you fear, like the men who trained you to war, and may the land take my blood-gift for Her strength—but wait! Listen!"

⌘

Robin came awake to a maiden's touch. He smiled faintly, but his smile turned to a gasp as she stroked him hungrily from his feet to his thighs, kneading his muscles. She leaned down and nibbled his skin gently with her tiny sharp teeth, then stroked his chest and his shoulders, licked his belly down to his groin and cupped him in her slender hands, breathing hot upon him.

The cool light of the setting moon shot bands of ivory through the chinks in the branches he had used to build the shelter, criss-crossing her silvery body, light and dark, light and dark, like the sun through the palm fronds in the courtyards of the conquered ones in the Holy Land, and he was hot, as he had been in the desert, hot and thirsty and feverish with desire.

She wrapped her arms around him, her flesh soft and tingling with warmth as she gave him to drink from her mouth, her body light as a feather as she lay across him, as if her bones were hollow, and her hair swirled across him like a veil of silk, and her eyes gleamed golden. She smelled of herbs and ointments and woodsmoke. He buried his face in her bosom and tasted her taut nipples. His hands drifted along the inside of her arms and she shivered with pleasure. He found the small of her back and then the soft mound between her thighs. She spread her legs, wrapped them around his waist, and guided him inside her, cooing and whimpering, rising into shrieks of ecstasy. He groaned.

Their cries penetrated the night.

"He's dying!" gasped Harald, trembling and clinging to a tree.

"It's the Witch! She's murdering him!" gabbled Much.

"Priscilla Nailor, a Witch! Who would have suspected? She was always so nice to me."

"Fatten you up and eat you," offered Much, barely able to speak through his fear.

A fluttering scream pierced the night as the owl woman reached her first climax.

Harald straightened and drew his dagger. "Will and Tuck are braver than we! We must go to their aid!"

"Oh, God!" said Much, and fell over puking into the snow.

But when Harald plummeted down the hill yelling, his dagger wagging in the air, he saw Will, Tuck and Prim talking earnestly by the fire and he halted in mid-yell. Silence now, except for Robin's voice, murmuring urgent and hoarse.

"You have no dagger sharp enough to cut through this magic, boy," Tuck said.

Harald hesitated. "But Robin?"

Tuck laughed and Will, looking pale, shook his head as if bewildered.

"Sit down, Harald," said Prim. "Have a cup of tea."

"Uh … no, thank you."

Tuck chortled and Prim's eyes flickered with amusement. She and Tuck launched back into their conversation, of holy powers and the ways of the Wicca, how Jesus on the cross was like Wodan on the World Tree, how the Maypole was the same and yet also the opposite, and how the union of men and women could bring divine power into the wood. It made Harald's head spin. Seeing Will drink some tea with no ill effects, however, he finally accepted a cupful himself. It tasted like chamomile, and soon he was drowsing by the fire and thinking every word Prim said made perfect sense. Yet in the morning, he could not remember a word that was spoken.

<p style="text-align:center">⌘</p>

Morning sunlight sifted across Robin's eyelids, buttery and sweet. He opened them.

He was alone. Dust danced in stripes of gold across his body. His head felt clear as spring water. He sniffed the air and smelled rain in it. Then he smiled, thinking perhaps it was the smell of sex on his skin. Yet the woman or Goddess who had lain with him seemed nothing more than a dream or hallucination. Well, who knew what Prim put in her potions? He had certainly drunk enough of them the day before to knock any man out of his wits.

Then with a chill, he remembered the night's hunt. He had done that which was forbidden him. Yet he had not broken the spirit of the warning. He had tried to walk the narrowest road, between the worlds, to serve them both, and in so doing, he may have failed them both and failed his truest test. But he had given of his own blood as well as the white stag's, and had not the Lady come to him, accepted him?

Well, done was done, and no going back. Time would tell if this fruit would ripen.

He threw off the hides and blankets and crawled out of the shelter, then stood up naked in the cool air, refreshed by it. He yawned, stretched, scratched

his crotch, then saw Prim sitting at a nearby tree trunk, playing cat's cradle with a cord and watching him with a knowing air.

He laughed. "Did you sit there the night through? And who were you dreaming of, pretty Prim?"

She stood up and tied the cord around her waist. "I have better things to do than listen to your moans and groans. I only came back this morning to make you some tea."

"Ha! You sat gossiping by the fire with Will and Tuck, Harald and Much."

She raised an eyebrow. "There you're wrong, Robin. Poor Much never came to until this morning." They both laughed. "The lads have taken him home. I suspect he will never let me cook for him again. And how are you feeling this fine day?"

"Mother Prim," Robin said, catching her about the waist and twirling her around and around the clearing, "you are a very good Witch!"

30-JUNIPER BECOMES AN OUTLAW
OAK MOON WANING, 1193

ordecai! Run!" his mother screamed. Behind her, burned into his vision, their hut collapsed in flames against the night. The neighbors were pointing at her, shaking their fists, yelling, "The Jewess cast the evil eye on my cottage and now my hens won't lay!"

"My cow's blighted these three weeks! She'll give no milk!"

"Burn the Witch! Kill her!"

Miriam was running, her cloak on fire, but armed men in chain mail grabbed her and threw her to the ground, stamping out her burning cloak even as they kicked her in the side. Mordecai bit back a scream, hiding behind the woodpile. His heart was pounding. He had to save her. But what could he do?

"Let the Witch burn!" cried the villagers.

A soldier snarled, "She'll hang after she confesses to the priests." He jerked Miriam to her feet.

Another soldier spat in her face and said, "Too bad we can't send her across the Channel. She'd be burned alive at the stake, good and proper."

"Ruining the livelihood of good Christians. It's Hell she'll burn in. We'll take her to Nottingham. They say the High Sheriff has French torturers.

They'll treat her as she deserves."

"I've an idea of how to treat her right now!" leered another soldier, hitching up his tunic and loosening his trousers.

"Wait!" cried a farmer. "The Jewess will have treasure buried in the floor of her hut!"

"Fetch water!"

The villagers left Miriam to the soldiers and scurried to save the supposed treasure.

Mordecai wrapped his thin hands around a log and crept forward. His mother saw him before anyone else. She shook her head and her eyes pleaded with him as a soldier pawed underneath her patched skirt. "Run, Mordecai!"

So he ran. Two soldiers chased him, but Mordecai knew the wood well. He often scavenged game from other people's illegal traps by moonlight, and gathered twigs for fuel when he could not be seen trespassing. He was light and fast and small for his nine years, having starved for most of them, and he darted through thickets and crawled through briars while thorns tore at his already ragged clothes and tender skin, until he heard his pursuers trip heavily and fall, cursing the darkness.

Mordecai ran beyond the tiny hamlet that had been his home, past the desolation that was old, haunted Loxley Keep, to the top of Puck's Hill and down again, until there was silence behind him and pain tore through his lungs and he could not breathe. He splashed through a brook, chilling his bare feet, then stumbled over a rock and fell. Gasping, he tried to stand, but dizzily slumped to the ground again. He bit his tongue, trying to hold back tears, but soon gave himself up to crying wretchedly, feeling he shamed the memory of his father with his tears. His father. He could barely picture him. His mother had spoken of him from time to time with a look of such love and bitterness and sorrow combined that it had frightened him.

Beneath the half-closed eye of the waning moon, he sobbed himself to sleep. He dreamed fitfully of flames, whimpering like a wounded animal until his own cries woke him. His first thought was of his mother. She would surely die. They had no relatives left, no one to turn to for help. What would he do? How could he save her? What would become of him? He lay paralyzed with shock, listening for wild animals or soldiers who might come upon him and tear him apart.

Just before dawn, the birds broke into song as if life were beautiful. Mordecai could not imagine why they were so happy. They must be happy, else why would they be singing? Perhaps they were happy simply because it was another day. He could not imagine ever feeling that way again.

He dozed off and it seemed in his dreaming that one night was a thousand years to a bird, every hour was a hundred thousand tiny heartbeats of a bird. This was the long cold death of birds, the fluttering bird-soul of night. Food was sleeping. A chill was on the land and the river rushed on and on and on. Each crack of a twig bespoke a hunter's paw. Danger lurked in the darkness and all creatures lost themselves in the formless chaos in God's closed and sleeping eyes. The world had ended.

Then suddenly the darkness seemed one shade lighter. All things began to reform. The birds burst joyfully into song after their thousand years of night. The black sky seeped into vivid blue. Dawn broke. Birds fluttered down to Mordecai, red-breasted robins, blue-winged bluebirds and singing larks, and they carried him up into the blue sky where clouds lingered like sheep grazing, and for a moment he was at peace.

Then he woke. Memory flooded back, and with it, the horror of the night before. The sun slanted through the tree trunks, but he could not feel any warmth in it. The air was fresh and smelled of Spring, but it held no promise for him. He lay on his pallet of earth, praying, wondering if the God of his people, of whom he understood very little, would hear him and send a miracle. A few more tears leaked out of his puffy, sore eyes. He pulled his treasured arrow out of his tunic and turned it over and over in his hands, wishing he were a grown man, an archer, who could have killed the soldiers and saved his mother. He hated himself. He had failed her. He was ashamed.

And he was cold. He tucked away his talisman, scrambled to his feet, and started wandering through the trees, with no idea where to go. There were terrible outlaws in the woods, he knew, more vicious than wild beasts. He set his lower lip firmly so it would not tremble.

But then he remembered there was one outlaw of whom some men spoke with awe and respect, and others with fear, or laughter. Many tales were told of his cleverness, his fairness, his cruelty or kindness, depending on who did the telling. But whatever his true nature, he was an enemy of the Sheriff of Nottingham, the Sheriff who would torture and hang his mother.

Now Mordecai walked with a purpose, to find the Hooded Man. But what if the outlaw slit his throat for pleasure, or else ignored him entirely, for Mordecai was so clearly poor and not worth bothering about?

Robin and his companions, however, made it their business to bother about everyone who wandered into their domain, and because they were always nosing about in the woods, hunting or gathering or searching for some hapless prior or taxman to whom they might give a lesson in Christian charity, it was only a matter of two or three days before they came upon

Mordecai, who was by then quite faint from hunger, having only found a few young dandelion leaves and some tiny unripe berries to stuff into his ravenous mouth.

He was in the act of stuffing those bitter berries when a rustling warned him he had company. The rustling was done on purpose, for the outlaws had learned to be as silent as the earth herself when they chose.

Mordecai looked up from his lunch to see himself surrounded by out-landish men wearing tunics and hosen, or breeches brown as tree trunks, with budding twigs tied to their shoulders and heads, and faces daubed with mud for camouflage. One of them wore a black hood, thrown back to reveal blue-grey eyes and a chin bristling with several days' growth of beard.

"Methinks we have here a pixie," said Will to Tom, nodding toward Mordecai.

"It's a spirit, a ghost," declared Friar Tuck, playfully besmirching a few Latin phrases and drawing crosses in the air, as if to banish evil.

"Do you think it has got any money?" asked John.

"Nay, I think not, it looks the pauper to me," Allan replied.

"Shall we poke in its pockets just the same?" said Will.

"Yes, let's." They started for the boy.

Gulping, Mordecai whipped out the arrow he carried in his tunic and thrust it in front of him as if it were a dagger.

Robin waved the men back. "Time for thieving anon, my friends. Tell me, *puca*, why do you walk the woods alone? Do you not know this forest is dangerous full of outlaws?" The outlaws laughed.

Mordecai found his voice and said bravely, "It's an outlaw I seek, the Hooded Robin Wood."

"The bounty hunters are getting younger," observed Will.

"Do you serve the Sheriff of Nottingham, little boggle?" asked Tuck.

"Never! It's Robin Hood I would serve."

"Ho, Robin, you have a camp follower!" teased Allan.

The boy's mouth dropped open. "Y-you're Robin in the Hood?"

"I am."

"Can you prove it?" he asked, wide-eyed.

The men laughed.

"An excellent question." Smiling, Robin strolled over to the boy, then darted out his hand and caught the black-feathered arrow out of Mordecai's grubby palm.

The lad jumped up to grab it back, torn between fear and anger at his precious keepsake being stolen from him. "Give that back! It's mine!"

"By Our Lady, I say it's mine!" said Robin, keeping the arrow well out of the boy's reach.

"It's mine, I found it, and you'll not have it!" bleated the boy.

Robin gripped him by the front of his tunic and lifted him one-handed into the air, where he kicked furiously and helplessly. "Tell me, little *puca*, did you find it near a keep called Loxley?"

Mordecai's eyes grew moon-round at Robin's ability to see into the past. "Aye, it was in a dead rabbit!"

"And did it have a small bundle attached to it? Black?"

The boy nodded, gulping back his fear.

"What happened to that bundle, boy?"

"I buried it, your … your Lordship," Mordecai stuttered, for he knew not how to address such a powerful mage.

"Hah, hear that, Robin? He thinks you're royalty!" said John.

Robin lowered Mordecai to the ground. "And what became of the rabbit?"

Mordecai said, abashed, "We ate it, your Worship."

"Good lad! You did well." Robin clapped him on the shoulder. "What is your name, boy?"

Mordecai cast about wildly for an answer. If he told his Hebrew name, the friendly hand on his shoulder would be whisked away and he would be kicked and beaten, or even killed, and there'd be no help for his mother either. His eyes lit on a small tree and he blurted its name, "Juniper."

"A fine name," said Robin. "Did you know that juniper brings love? But perhaps she who named you knows."

At mention of his mother, the boy's lower lip trembled and he could not hold back the tears.

"This blubbery boy is something of a half-wit, I think," murmured Tuck, for he had noticed the boy's hesitation in saying his own name.

"Nay, I think there's a tale here. Tell us, Juniper," said Allan, always on the look-out for a story to steal for a song.

"It's m-m-my mother. She's prisoner in Sheriff's castle at Nottingham. She's never a Witch! Never! It's a lie!"

The men stiffened. Robin knelt before the boy and plied him with questions. Juniper's protests that his mother was no Witch only seemed what anyone would say to protect a loved one. Hearing the whole story, Robin stood and said, "We must be quick." Whether a Witch or no, if she were a Witch accused, she might already be dead, but he did not say so in front of Juniper.

"You're not thinking we're going to storm Nottingham castle?" Will said.

"No. We will have to play the trickster," Robin said.

Tuck said, "I've an idea of how to go about it. But we must go in disguise."

Robin handed Juniper the arrow, lifted him up on his shoulders and broke into a run. The others ran after them with such speed it seemed to Juniper that they had sprouted wings on their feet. A flock of flightless birds, the men raced to Brighid's Well.

31-A WITCH ACCUSED

P rim stirred the cauldron with a vile expression on her face, her eyes on Juniper, who sat wolfing down soup with Friar Tuck beside him and Aelflin handing the boy more bread.

Prim said to Robin in a low voice, "She'll be in terrible pain. I've heard how Nottingham treats Witches. Our Lady have mercy on her."

Robin nodded. England's law called for starvation and sleep deprivation to break the will of Witches, and hanging instead of burning alive at the stake, but how many held to the letter of the law? Nottingham had a jailer from Germany and French clerics who called torture the work of their God and an art.

Prim set her spoon aside and beckoned Robin to follow her to her cave, where she dug among pouches of dried herbs and amber bottles of liquid, mixed several together in a flask of brandy and handed it to Robin. "This for the pain. It will taste foul, but get it down her gullet, all of it. If I can set eyes on her, I'll know what I can do for her. If anything. If she's still alive. And by every God and Goddess I wish you were not going there after her, Robin."

He hoped she only spoke out of love for him and was not foretelling doom in prophecy.

⌘

A brisk wind blew from the northeast, whipping people's tunics and skirts around their bodies and their hair into their faces, so they barely noticed the two strangers walking along the lane that wound uphill to Nottingham town. A portly monk with his arms stretched behind him held one end of a long cloth-wrapped bundle, and at the other end of the bundle struggled a slighter

man, his head bowed under his dark hood. Fighting the wind, they crossed the bridge over the moat and entered the walled town, then trudged through the streets to the castle. At the iron gates, the first monk asked the guards for admittance.

"What's your business?" said Anhold, a stern, helmeted soldier whose cloak bore the insignia of the captain of the guard.

"A Witch possessed."

"In that bundle?"

"In your dungeon, man! We have come at the Bishop's request to cast out the sulphurous demon that defiles the Witch's body and soul." He did not say which Bishop.

"What's in the sacking?" the captain demanded.

"Our instruments," replied the fat monk.

"Open it."

The two monks exchanged looks, then laid their burden flat on the ground and pulled back the brown cloth a few inches.

"Look inside, my son," said the second monk in a sepulchral voice.

"Empty it," the captain said.

The two monks knelt and pulled out leather packets of various sizes, which they untied. One held twenty long thin needles. "For boring under the fingernails and toenails," said the fat monk. Next they pulled out awls and tongs, "for boring into the ears and placing red hot coals upon the eyes," said the monk, and Anhold's face blanched considerably. While the smaller monk kept pulling out evil-looking implements, the fatter monk rifled the sacking open enough to reveal a sturdy silver cross almost the size of a man. "A big cross for a big devil!" he exclaimed. "They say this succubus bears the scales of a dragon, with eyes of flame, a horned head, jaws of a lion, tongue of a serpent, the ass of an ass, breath like the stench of a thousand farts of a dog—"

"All right, enough! On your way!" The captain signalled two soldiers, who grappled with the creaking wheel that turned the massive ropes that opened the gate. The two monks hastily put away their tools, lifted their burden and trudged through the stone archway and under the sharp iron spikes as the gate lifted. Murmuring their mission when confronted by guards, they went through the courtyard and into the castle proper, through an echoing corridor bare of tapestries or ornament, and down spiralling steps into the black dungeons. Here the smell of fresh and drying blood and burnt flesh lingered horribly in the air, mingled with the stench of excrement and vomit. The two monks fought down nausea.

Some cells were gated with iron, others had thick wooden doors so that the groans and suffering of those within were muffled. They came to the cell that held the Witch. A soldier stood on guard in front of the oaken door.

"*Pascule verboscum,*" intoned the first monk. "Let us in, my son, and leave us to do the work of God alone. Fear not for us, we need no earthly protection. We have the protection of a Higher Power," and he looked devoutly heavenward.

Relieved, for listening to the screams of the damned was not the fancy of this particular guard, he let them in, placed a single torch in a sconce on the cell wall, which cast off the darkness but poorly, and shut the door behind them with a heavy thud.

"*Pascule verboscum?*" murmured Robin.

Tuck crossed himself.

The two men searched the shadows.

"Miriam?" Robin said. There was no answer. "Miriam, I am a friend to you, a friend to your son." Robin pulled back his hood to reveal his face.

A wail arose. "I con'hesss, I con'hesss. Ny sson knows nothing. I did it all, all you sssay. Kill ne nowww, hlease. Why is there always nore to con'hess? Whyyyy? Whyyyyy?" Her voice thinned to a moan.

As Tuck reached for the torch, Robin walked toward the keening voice. He saw a silhouette, then a disheveled wad of stringy hair, a pale blob of a face, a heap of rags that covered flesh. Her wail turned to weeping.

He choked out the words, "We are here to free you."

"Chains?" asked Tuck.

Robin felt at her swollen ankles and wrists; they were securely chained. He drew back at the sound of her indrawn breath, as if his gentle touch had caused her unbearable pain.

"May the iron be old and rusted," Robin muttered, drawing his sword from beneath his robe. He hacked at the chains attached to the floor and the wall until they broke. She screamed with fear at every blow. No doubt the guard thought the torture had begun again. Robin put his arms around her waist to lift her. She cried out.

Tuck brought the torch closer to her face. Her eyes were pinpoints of terror. They saw the burnt flesh of her cheeks and forehead, the branded skin festering under her matted hair. Her lips had been slit and were swollen blue and purple beneath the blood that flowed anew from her speaking. The swelling and distention of her bare toes, her feet, her fingers and arms, showed where her bones were broken.

Robin whispered, "Do not be afraid. Your son has sent us to aid you."

"Ny sssonn," Miriam hissed with putrid breath, her tongue carefully avoiding her lips. The men saw that her teeth had been ripped out, leaving ragged and bloody gums.

Robin forced himself to speak quietly instead of screaming at the sight of her who had once perhaps been beautiful, who had once lain in the arms of her husband, who had borne a son and fed him at her breast, who had cooked and sewn, lit candles and prayed, harvested fruit, reached out to embrace. "Don't talk. Your son is safe. I am called Robin. Here, drink this if you can. It will burn your mouth, but it will ease your pain," and he fed her Prim's concoction. She spluttered and gagged and swallowed as best she could, and he murmured comforting phrases, "It's all right, we will care for you. All will be well."

He looked at Friar Tuck, who shook his head and whispered in his ear, "We should kill her now, Robin."

"No! We must try to save her! Prim can, if any mortal can. Broken bones heal. Prim has magic …."

Their faces pale and dripping with sweat, they looked down at the great silver cross.

⌘

Friar Tuck led the way. Behind his back he held the long bundle. Holding the foot of it was Robin, his face hooded once more.

"*Benedicite,*" Tuck muttered to the guards at the drawbridge as the gate creaked open to let them pass.

"Just a minute, you." The captain of the guard grabbed Robin's shoulder, halting the little procession. "You were not about your business long."

"The Witch died," murmured Robin. "God be praised."

Anhold threw back the sack and saw the bare end of the cross. He grunted and was about to let them pass when a tiny trickle of blood crept down the silver.

Anhold's hand moved to his sword.

"The blood of Our Savior!" exclaimed Robin.

The captain's eyes narrowed.

"It's a miracle! God be praised! The Witch confessed before she died, by the grace of God, and now the blood of Christ anoints the Holy Cross! Touch it and be blessed," Robin urged. "Drink it and gain eternal life! Here! Let us give you a taste of the holy blood!"

"A miracle!" echoed Tuck, inwardly cursing. Robin, in his horror and fury, was going too far.

Robin laid his end of the cross on the ground and in the same move-

ment, slid his dagger out from his boot and thrust it up toward the captain's abdomen, but Anhold moved to draw his sword and Robin's blade plunged into his thigh instead of his belly. He screamed.

"Run, Tuck!" yelled Robin, wrenching back his dagger, but Tuck was already running, dragging his burden across the drawbridge toward the village as Robin drew the broadsword from beneath his robe. The groaning captain urged on the soldiers who churned out of the gate behind him. Robin cut off one man's sword-hand. Weapon and hand clattered onto the wooden planks and into the muddy, algae-encrusted moat, followed by another soldier's head. Blood splattered the bridge. Robin crouched down while a third soldier's sword swept past his shoulder, and with a shove, Robin toppled the man into the moat as well. He spun, fighting, half-walking, half-crawling, edging further and further from the castle gate, holding his assailants at bay, giving Tuck a chance to flee, but the shouting had roused the soldiers in the castle barracks. More armed men were rushing onto the drawbridge. Robin's sword flashed in the sunlight like the wings of a dragonfly, beating back the bristling swords of his opponents.

Then the soldiers faltered, eyes wide, gagging in fear. Robin dared not spare a glance behind him, but then a spectre loomed up beside him as if risen from a grave in the muddy bank of the moat, a giant in chain mail holding a curved sword, arms covered with trailing green vines, green leaves sprouting from torso and legs, vines woven around his helmet, with flaming red hair and beard and bright freckled skin smeared with the black mud of the earth.

"The Green Man!" cried one soldier, and he collapsed from fright at the sight of the Pagan God come to life before him.

Will roared as he fell upon the amazed and terrified soldiers, and together, spectre and Robin, they beat off their foes and made good their escape.

⌘

In a clearing in the wood near the Great North Road, Prim, Tom and John stood grim-faced and silent as Tuck pulled back the sacking from the silver cross. When Will and Robin caught up with them, Prim was kneeling beside Miriam's broken body, which sagged upon the cross like a mockery of the crucifixion, not glorified in white, blue and gold paint, and a dab of bright red where the blood was said to have flowed, with noble suffering in uplifted eyes, but instead blackened with fire, mud-brown with dried blood, limp wreckage, the body of a dying woman, unwilling sacrifice to the Christ.

She was mercifully unconscious from Prim's potion. Fresh blood stained

the silver, running down her legs.

"It's the movement," Tuck said. "It has opened her wounds again."

White-faced, the men stood motionless, awkward.

"Can you help her?" breathed Robin.

"She's beyond saving," Prim said tersely. Her eyes were hard beneath a glisten of tears. "She's lost too much blood. Her wounds are already infected. Can't you smell the gangrene? You should have ended it there."

Friar Tuck began mumbling in broken Latin; no one heard clearly what he said.

Robin swallowed hard. Setting his jaw, he drew his dagger, so recently wet with the blood of men who had beat her, raped her, imprisoned and starved her. He bent over her broken body and whispered in her unconscious ear, "Your son is safe. Go with Goddess," and he slit her throat.

The woman jerked involuntarily one last time.

Robin dropped his bloody dagger, dragged himself to his feet and stumbled away, over a rise, out of sight of the others. He slumped to the ground while his stomach wrenched out his nausea.

How he wanted vengeance upon her torturers! How he hated the Sheriff, hated the Church, and worst of all, hated himself, for his arrogance in thinking he could save her. Prolonging her suffering. He was a fool, a monster!

At least she had been unconscious at the last. Perhaps the trip from Nottingham to Sherwood had been painless for her despite all. But he would never know. He should never have risked it. Not to mention Tuck's life, smuggling her out of there. And Will's.

And beneath his fury and loathing, disgust and compassion, lay the sure knowledge that her fate would be his also, if ever he were caught. "Ah, Gods, but they must catch me first," he groaned, and vomited again.

By the time he made his way back to the others, they were already digging her grave. They buried her in the greenwood, calling upon the powers of Earth and Air, Fire and Water, and the Lord and the Lady to guide her on her way, free of this world. They covered the grave with last autumn's leaves and twigs so none would see it, and they planted beside it an acorn that had escaped the notice of foraging squirrels, that from her death, new life might grow.

"Go in peace," said Tuck. "Whatever your faith in this life, Christian, Wiccan, Druid or some other, your soul is made of the One Divine Power that moves all powers." And instead of a cross, he drew a five-pointed star in the air above the secret grave.

⌘

Juniper ran to greet them, his eyes searching eagerly for his mother. "Where is she?" Juniper cried. The men's faces were closed, the usual noise and bustle of the camp seemed muffled.

Robin bowed his head. "She ... we ... I was too late. I'm sorry."

"No! She's not! She's not dead!"

"I'm sorry. We tried."

"No! Why are you lying to me? Where is she?"

"She's in her grave, son. I'm sorry. I'll show you where. Tomorrow."

"You never saw her! She isn't dead."

"I wish—"

"You lied to me! You said you would save her!"

"I said I would try."

"No!" The boy pounded his fists against Robin's chest and then ran off.

Robin leaned against the great oak, then slid down to the ground, feeling as if the nausea in his belly had moved into his heart. He waved his friends away and sat watching the shadows stretch long and longer across the ravine. The sun disappeared behind the cliff. The sky turned a deep blue.

Prim set a bowl of roasted meat and turnips beside him, but he did not speak or look at her, nor did he eat. John wandered over as if he would say something, then simply clapped a hand to Robin's shoulder and walked away. The moon soared, a quarter to waning, on wings of thin white clouds. Some time later, he realized that Will was standing before him, pushing Juniper towards him.

"Go on," Will prompted the boy.

"I ... I'm sorry, Robin." Juniper's face was stained with tears.

"Gods, no! It is I who am sorry," Robin said. He searched for words that might comfort the boy. "She's gone to her rest, to await rebirth. You'll be together again someday."

"Do you really think so?" Juniper pleaded.

Robin looked up at the sky, as if he might see spirits there, but instead he saw only the cloud-feathered moon beyond the black silhouettes of trees. A sigh escaped him. "She said, 'Tell my son I love him, I will always love him, and I will watch over him forever.' Those were her last words."

Juniper threw himself on Robin's chest. Robin put his arms around the boy. "My mother is there too, beyond the veil between the worlds. Perhaps my mother and your mother will meet, and watch over us both, together."

The moon was setting before Juniper finally cried himself out and began drifting into exhausted sleep. Robin carried him back to his own cave

and tucked him into his own bed. The boy murmured a little and Robin sat beside the bed stroking his forehead until he fell asleep again.

Then he rose and went into the wood.

Juniper woke in the morning with his eyes gritty and puffy from crying. He had dreamed of his mother on the ramparts of a castle, of himself fighting fires with an arrow that turned into a Christian Bible which slid out of his blood-wet hands and turned into a boat. It sailed out of sight on a sea of trees, and he was watching after, wondering if his mother was on it, and how he might swim to it and be with her, and he waved his arms and began to move languidly through air thick as water, but the tree branches caught at his feet, pulling him down, drowning him, and he woke gasping in strange surroundings. He shuddered. Where would he go now?

He fought tears again, and a panic that any of the men should see him cry. He would run into the wood and let the wild beasts have him. He wiped the sleeve of his tunic across his face, a new wool tunic the old lady had given him, soft and warm. Must he give it back? He stumbled out of the cave into the bleak daylight and picked his way down the cliff.

Prim beckoned him over to the fire and offered him a bowl of mint tea. He shook his head, thinking he could never eat or drink again. But under her stern gaze, he took it and managed to drink the bowlful, finding halfway through, to his amazement and guilt, that it tasted good and he was hungry.

Aelflin and another woman, a dark-skinned lady with bright clothing, gold rings in her ears and one astonishingly in her nose, padded into view with bundles of sticks for kindling, which they lay beside the woodpile. With a sweet, sad look on her face, Aelflin came over and sat beside Juniper, giving him a hug and brushing his hair off his forehead. She said she would trim it for him later. Soon Allan and Harald arrived to break their fast, and then Much, who sat on the other side of Juniper and thought of the night he had lost his mother and father too.

Juniper was halfway through a slab of barley bread smeared with butter when Robin appeared and stood looking down at him with weary eyes, his hands behind his back. "Listen, Juniper. Everyone. This boy Juniper is—if he wills it—from this moment onward and for the rest of his life, my son. Do you will it, lad?"

Eyes wide, Juniper gulped down his mouthful of bread and nodded.

"Good. I adopt you." Robin knelt down in front of the boy. He pulled from behind his back a small but smooth and supple rod of bent wood, and he gave it to Juniper. Then he kissed the boy on both cheeks, and asked Prim for something to break his fast.

So Juniper, in his time of great loss, received a father, and also the bow he had long dreamed of for his arrow.

32-ROBIN BECOMES A DEVIL IN THE EYES OF THOSE WHO STAND TO PROFIT BY IT

He fought in a mad fit, like a demon! His eyes flashed fire and smoke!" Anhold, the captain of the guard, lay brandied up and bleeding into the straw in the guardroom as his squire washed and dressed the harsh wound in his thigh. "And he was called 'Robin.' I heard the name clear as day!"

Reginald slammed his fist into his own palm. "Robin Hood! Damn him! Why would he take such a risk? He braves my own stronghold to save the life of a Jewess and a Witch? The man is possessed!"

"If man he truly be!" gasped Anhold.

"He is a man and can perish by the sword like a man," said Coucy. "Let it be my sword! I'll leave at once and hunt him down!" He had received word that morning that Isabeau was pregnant. The midwives said she carried the babe like it was a boy. He would send her the brigand's ears as a gift.

Somehow Coucy's rashness always summoned the opposite in the Sheriff. "Down, down, down, Coucy. I will not have—"

"Don't speak to me as if I were one of your curs!" Augustin put his hand on his dagger.

"Coucy, you are much too important to me to have you risk your life in Sherwood. We'll find a better way to bring this wolf's-head to justice. These things must be seen to properly. Already the townsfolk murmur of this Robin Hood's daring. But he is worse than a thief, now that he has rescued a Witch. He is a traitor to the State and a heretic!" Yes, the man was a Pagan, as York had warned him.

"Forgive me, milord," begged Anhold. "I tried to stop him. He deceived us with enchantments and sorcery! He took the shape of a wolf before our eyes!"

Reginald, dismissing the idea of enchantments, nonetheless waved a hand in forbearance. "There must be a way to turn this to our advantage."

Anhold slurred, "He summoned a great demon to aid him! It appeared out of thin air! It was as tall as a tree, red-skinned as the Devil and smelling of sulphur!"

At this, the squire dropped the wash-basin, his face white. Bloody water splattered his tunic and puddled on the floor at his feet. A glare from Reginald sent him scurrying for a rag to mop up the mess.

Reginald mused, "Robin Hood has rescued a confessed Witch. This proves he is also a Witch. We shall turn public opinion against him. The reward—I'll make it two hundred marks! Any who has knowledge of Robin in the Hood becomes an accomplice in sorcery, under penalty of death if they do not come forth and speak. And certain persons shall naturally be found to have such knowledge, and they shall be hung for hiding it. After a few such examples, the people themselves will deliver up this viper who gifts them with venison, who figures so highly in their songs and stories, and they shall count themselves lucky to be rid of him."

The forest laws being what they were, Reginald soon found someone to hang. Three young brothers were caught poaching, but instead of each having a hand cut off or an eye put out as they feared, they were accused of being allies of Robin Hood, of hiding his whereabouts, of being Devil worshippers, and their widowed mother with them. They denied it vehemently, but no time was wasted for torturing them to get a confession. They were led swiftly to the gallows instead, and how they wished the lies were true, for they thought if they were of Robin's outlaw band, then they never would have been caught, or at least there would have been some chance of rescue.

As it was, they could not buy or talk their way to freedom, having no money and no one interested in hearing the truth, and they soon stood upon a wooden scaffold in the town square, their hands tied behind their backs, while the Sheriff of Nottingham looked on and his soldiers stood guard.

The hangman looped nooses around their necks. Their bowels grew watery and they wanted to scream, but would not or could not, their fear was so great. Even the widow was done with weeping and stood panicked and still as a hare brought to bay by a hound.

The peasants and townsfolk jeered and threw rotten eggs and rocks at them, which stank and stung. Peddlers hawked pasties and sausages to feed the crowd. Three mendicant friars in threadbare robes worked through the edges of the gathering, begging for alms for a pilgrimage to Compostela. They asked what crime had been committed and were cheerfully told that these four were Satanists.

"Ah, a fine day for a hanging! God's work!" said one of the pilgrims, and

called to the Sheriff, "Have they been shriven, milord?"

"No need for that," said Sir Reginald astride his horse. "They are thieves and Devil worshippers."

"Why, double the need!" cried the friar. "We must be sure to send them straight to Hell, and if you give us leave, we shall see to it ourselves."

With the people looking on, Reginald chose to act religious, so he nodded and let the pilgrims go up on the scaffold, to the cheers of the crowd and shouts of, "To Hell! To the Devil with them!"

Amid the noise, the three friars whispered in the lads' ears to wait for their command, then run for the town gates and the woods. Under cover of babbling Latin and making signs of the Cross, the friars cut the prisoners' bonds. Then, pulling long bows from beneath their robes, they spun to face the crowd and let loose with swift arrows which scraped Sir Reginald's helmet. They fitted more bolts to their bows and aimed them at Reginald's heart. Screams and gasps went up from the mob. People tried to jostle out of the line of fire, but the square was packed too tightly. The people were trapped.

Reginald motioned to his soldiers to stand still, for he knew his life was forfeit.

"Now, lads! Run for it!" cried Robin.

John hoisted the widow onto his back, her sons leaped off the platform after him and ran, and the onlookers, fearing for their lives, parted to let them pass. Covering each other's movements, Tuck and Robin leaped off the platform and tore through the crowd. Robin shouted, "Sir Sheriff of Nottingham, you evil bastard! Know that the Lord of the Greenwood spares your life only to vex you another day!"

"Robin Wood?" bellowed the Sheriff.

"Show us your face, you cowardly swine!" yelled Coucy, drawing his sword.

Robin laughed and darted out of the town square and down the main street leading to the gate, with Tuck pounding along the cobblestones behind him. The soldiers looked toward Reginald, who nodded for them to give chase, but the outlaws were too quick, and by the time the soldiers passed through the outlying village and reached the wood, a storm of arrows fell on them, for outlaw archers hid in the trees waiting for them. Several soldiers slumped to the ground, dead or wounded, and their comrades hung back, for they could not fight what they could not see.

Mocking laughter drifted down to them like autumn leaves as the thieves scrambled through the interlacing trees like monkeys and disappeared into secret warrens only they knew.

With four new and very grateful recruits, the outlaws were in a high humor as they made their way home. They snickered whenever they thought of Sir Reginald's face when he realized Robin had breached his stronghold again.

But if Robin had known Sir Reginald was happy too, his own mood would have soured considerably. At first, of course, Reginald was furious. The loss of several of his men and the embarrassment of it cut him to the quick. He had never imagined Robin would dare enter the town walls with so many soldiers on guard, armed and ready.

But then it occurred to him that Robin's interference with the hangings would only appear to others to prove the false accusations of Witchcraft against the boys and their mother, whose deaths meant little to Reginald either way.

Soon he would find another likely victim, and when he did, his guards would be better prepared to fight at the gallows. In fact, he thought gleefully, this was turning out to be a fine lure, and he might catch Robin with it. He was even able to lay the day's events before Prince John in that light and so stave off another one of his lord's ill tempers.

⌘

33-ROBIN MEETS HIS PAST AND HIS FUTURE ALL AT ONCE
STRAWBERRY MOON FULL, 1193

One hushed blue dawn, the peace of the rolling meadows outside the walls of the abbey at Nuneaton was despoiled by men shouting. The old Prioress, nodding over her Bible by candlelight, slowly lifted her head. Realizing she was not hearing the bell summoning her to Lauds, she creaked to her feet and left her cubbyhole by the gate, her keys and rosary clinking at her waist. At the thick oak double doors, she opened the shutter of the tiny window that looked out upon the world.

Flaming orange torchlight revealed some twenty mounted soldiers, two Benedictine priests and a dark-haired knight with the face of an angel who shouted, "Open the gates, damn you!"

"Good morrow and God's blessings upon you," she said in a calm voice wavery with age. "What is your business here?"

"We have come for Maerin fitz Warin. Open to us at once or we will burn our way in."

"Wait here. I shall send for the Abbess."

Coucy motioned to his soldiers. Six of them lit arrows from the torches. The Prioress sighed. To lose poor Maerin to such heartless scoundrels seemed a sin. Nevertheless, she opened the gate at once. The Abbess had warned her something like this might happen. Better Maerin lost than the whole abbey.

The men galloped into the courtyard with a clattering of hooves and swords and chain mail. A group of nuns glided past toward the chapel, their veils fluttering in the early morning breeze. The soldiers wheeled on their horses and leered, but a sturdy line of brother monks appeared bearing pitchforks, rakes and hoes as if they were on their way to weeding. Their faces were solemn. They stopped in the yard and waited.

Coucy's token Benedictines now performed their office. "No rape, no plunder," they reminded the mercenaries, who shrugged, having been paid well enough to obey.

The abbess, having heard the commotion, entered the courtyard with two nuns at her side. The monks genuflected to her. Coucy sneered at the

sight. The abbess said to him, "You have a letter for me, I suppose?"

Coucy nodded to one of his priests, who pulled a scroll from his robe and handed it to the abbess. She scanned the order from the Vatican that in essence refused abbey sanctuary to renegade brides. She handed it back to Coucy. "You and your men may camp outside the abbey walls until Maerin has gathered her belongings. She will be ready to leave on the morrow."

"Now!" Coucy shouted and spurred his horse forward. The monks raised their garden tools, but the abbess forbade them to fight. She would not sacrifice them to swords for the sake of one recalcitrant girl, much as she had grown to care for her.

Coucy and his men charged through the grounds on horseback, even rode into the chapel and the cloisters, shouting Maerin's name. Nuns and novices in the corridors fled at the sight of the armed men.

Along a wide walkway paved with grey flagstones, faced with a lintel too low for his horse, Coucy slid out of the saddle and strode through the door into a chamber reeking of soap. His soldiers dismounted and jostled in behind him.

Young novices stirred vats of black habits and boiling water with thick staves. Others wrung the water from freshly washed wimples. At the sight of the men, several girls screamed and covered their faces. Others giggled and fluttered their lashes.

Among them, still as a hunted rabbit, was Maerin, wearing the plain drab garb of a postulant. Beside her sat Elgitha, sorting a basket of laundry. The abbess had warned her weeks before that her uncle, with the help of the Bishop of York, had petitioned the Pope, that she might not be allowed to remain at Nuneaton, to shear her hair and swear her vows.

Now, seeing she was to be taken by force, she let go the oak staff she was using. It swayed to rest against the side of the cauldron. She smoothed her hands dry on her apron and walked forward. Coucy grabbed her wrist, wrenched her arm behind her, spun her around, and shoved her from the room. Maerin bit back her pain and fury, refusing to allow Coucy the pleasure of hearing her cry out. Elgitha ran after, begging Coucy not to harm her mistress, even threatening to tell the Sheriff of his cruelty. Coucy ignored her.

But in the courtyard, when Maerin saw the abbess had already ordered her black mare to be saddled, tears sprang into her eyes. Once more the Church had failed her, and it seemed the abbess could not wait to be rid of her!

Coucy hoisted her up onto her mare's back. The abbess came forward

to press the emerald brooch into Maerin's hand, for she did not want to keep that either if she could not fulfill her part of their bargain, but Maerin would not take it. Instead, she slapped the black mare on the rump so hard the creature leaped into a jolting gallop through the open gate and across the greening fields of new corn.

Coucy's stallion had a greater stride, however, and in moments he was galloping neck and neck with Maerin. He grabbed her mare's bridle, forcing her to slow to a walk beside him.

"Do not tire your mount, milady," he said acidly. "We shall not stop to rest until we reach Nottingham castle and I have bedded you as my bride."

She said nothing, determined never to speak a word to him who would be her husband. They could cut out her tongue before she would speak the marriage vows. God forgive her, she was as willful as ever. But she could not bear this burden graciously.

The soldiers and priests caught up with them. They rode in silence throughout the day with only the jangling of harness, the chirping of birds and the buzzing of insects for speech.

She should have left Nuneaton before it came to this. Why had she not run away as soon as she heard Reginald was petitioning the Pope? Why had she trusted again in the Church? But where would she have gone? How would she have lived? Her fate, as always, was strangled by the hands of men whose interests lay not in her happiness, but in their own.

But what happiness had she sought? Only to serve God. Why had she been refused again? It was her selfishness, her obstinacy, her conceit in thinking her life was worth offering to the Mother of God, when She clearly had no need of it.

As they entered Sherwood Forest, she saw a dove flitter to a landing on the branch of a birch. Another landed beside her. The female hopped to her left. The male hopped in tandem toward her. Again and again she danced a step away, and he followed, until, as the riders passed under the birch, she let him mount her from behind. With a flurry of wings it was over and they sat side by side once more, quiet and content.

Doves mate for life, Maerin thought. As men and women were meant to do. But she would never feel at peace with Coucy beside her. That contented quiet of mate with mate would never be hers.

The day waned. They took a meal as they rode and spent a sleepless night in the saddle, sparing neither themselves nor their horses, for Coucy was determined not to give Maerin another chance to slip from his grasp. The moon, almost full, shone above them, yellowish-white, flat and lumi-

nous as a piece of fine vellum held up to candlelight, and Maerin fancied she could see upon that circle of light the fateful scribbling of her marriage contract.

The morning brought only a brief rest by a stream as they let the horses drink. Then they were on their way again. By now, Maerin's eyes were burning from exhaustion and uncried tears, her whole body ached, for it had been many weeks since she had ridden, but it seemed to her that her heart was numb.

The noonday sun bore down upon the world, budding the beech and rowan leaves, blossoming the apple and wild cherry, lighting the last flowers of the chestnut trees like white ncandelabras, warming the luscious green grasses and the gentling earth, heightening the honey-scent of pink and purple hyacinth, of pink and red and white hawthorn, ripening the berries, glancing tiny rainbows off iridescent dragonflies' wings and bees swarming upon the clover, beckoning dappled into the depths of the wood and into the eyes of Harald Sparrow, high in the branches of an oak. He signalled with a bird-call.

"Twenty horses or more," interpreted Will, concealed behind a linden tree, "bearing armed men."

"I could use a new suit of mail." Robin grinned. He hooted like an owl. An answering trill of a thrush, then silence. As the company came closer, Robin saw the woman riding in their midst. "I see they bear another prize," he murmured.

She carried herself straight as an arrow. Her face was white above the drab clothing she wore. A postulant's habit, by the look of it. Then why was she riding with armed men? She was clearly of the nobility, to warrant such an escort and such a fine horse. Perhaps she had thought better of the nunnery and was riding off to be wed. Well, he would not stand in the way of that! Robin smiled. Only half the men's horses, then, perhaps a few suits of mail, a new sword or three, and the lovely lady could go on her way with his good wishes. And perhaps she'd let him give her a kiss, as a fertility charm from the woodland Gods to bless her marriage.

He motioned to Will, Tuck and John. The four of them, wearing dirty monks' robes, their faces concealed beneath their hoods, bundled into a bend in the road out of sight of their prey. They began plodding slowly northeast ahead of the riders, looking as pious and penitential as they could.

The soldiers rounded the bend. Seeing the ragged clergymen trudging along the road ahead, Coucy called, "Out of our way!"

Robin turned. "Heaven be praised! The Lord has brought you to us! Let

us travel with you for protection against thieves and wild beasts."

"Domine, domine," said Friar Tuck, making the sign of the cross at Coucy. "Bless you, my son, for your benevolence."

Coucy urged his stallion forward, saying, "You would slow us. We ride and you walk," and he tried to marshal his company past the monks.

"Then let us ride also," wheedled Robin, catching at the stallion's bridle and eyeing Coucy's chain mail to see if it would fit him.

Coucy raised his hand as if to strike, but Maerin rode forward and said, "Of course you may travel with us. I am always glad of the company of men of the cloth." She inclined her head graciously to the four friars.

"Thank you, milady." Robin smiled up at her, and he forgot chain mail at the sight of her clear skin below the black wimple, her curves beneath the black bliaut and the dark blue apron that draped her like a mantle of shadows, yet brought out the startling brighter greenish-blue of her eyes. Yet those pretty eyes seemed haunted. He thought someone ought to kiss away the dark circles beneath them, someone ought to kiss those lips to make them redden and smile, someone ought to nibble her ears and neck and shoulders and breasts to make her blush and laugh and cry out with pleasure, and that someone ought to be him.

To his amusement, she did blush under his bold gaze. She thought it hardly fitting of a monk to stare at her with such a look in his eyes, and yet something in his smile made her limbs tingle and her blood rise warmer. Her deepening blush made his grin the wider.

"Silence, wench!" Coucy was saying. "You are poor and thieves will take no notice of you. Ride on!" He signalled to his men and backhanded Robin on the side of the head, but Robin held fast to the bridle, while Tuck burbled, "But murderers and rogues! They would cut off our heads as soon as our pursestrings!" He grabbed a soldier's stirrup.

"Give us horses, we pray you!" John stood barring the way of another soldier.

"Thieves!" breathed Maerin, her knuckles whitening on the reins of her horse.

Coucy did not hear her. He was busy calling Robin an impudent lout and trying to kick him, but Robin was too quick. He dodged, caught the booted leg and pulled it in the same direction Coucy was kicking, almost unseating Coucy. Swaying off-balance, Coucy drew his sword and his soldiers drew theirs, but just then, out of the corner of his eye, Coucy thought he saw a huge horned owl fly past, briefly blocking out the sun, a bizarre sight at midday, and when it was gone, he saw a dozen men to his left and a

dozen to his right, as if they had melted out of the tree trunks like dryads, and behind, in the road, stood another cluster of men, cutting off retreat, and every thief held a longbow or a crossbow with the bolts pointed at the soldiers, and at Maerin and Elgitha, vulnerable and unarmed.

One soldier was fool enough to throw a dagger at John. In a flash, the soldier fell gurgling off his horse with Tom's arrow through his gullet, to the cries of the women and the shouts of the men, while the dagger flew wide and untrue.

"Ah, I see you have one horse free already," said Robin.

Coucy ordered his men not to attack. Elgitha clutched at Maerin.

Robin said, "Have no fear, milady, we will not harm you or your maid-servant."

Maerin looked away from him, deathly afraid, horrified at the feelings his frank stare had briefly aroused in her. She prayed inwardly, 'Mother Mary, Lady of Mercy, deliver us!' She drew up courage from she knew not where, looked haughtily at the false friar and said, "In the name of my uncle, the Sheriff of Nottingham, and in the name of Richard the Lion Heart, King of England and my cousin, I demand that you let us go."

This pronouncement was met with hearty laughter from the outlaws.

"My child," said Tuck, "those names hold no sway here. There is only one liege in these woods and he stands here before you. You have the honor to be robbed by none other than Robin Goodfellow, Son of the Faerie King, prince among thieves and Lord of the Greenwood!"

"Lucky girl!" commented Will as the other thieves yipped and howled like wolves.

"Robin of the Wood!" Elgitha moaned and crossed herself.

"Lord of the Greenwood indeed," replied Maerin coldly. "You're noth-ing but a common thief."

"Shut up, bitch!" spat Coucy, sweating with fear and fury. Her sharp tongue would make matters worse.

"A thief, yes," Robin said. "Common, no. I was the Earl of Loxley once, milady, but I have come up in the world."

"Loxley!" hissed Coucy. He knew that name.

Robin went on, "I welcome you to my domain, milady, made richer by your beauty, which outshines all the gold and silver in England, and which warms me better than a bonfire on May Eve." To hoots and whistles from his men, Robin swept back his hood and bowed elegantly to Maerin, as if he were in a Court of Love and not on a dirt track in the woods.

But Maerin said even more coldly, "The Earl of Loxley was an old man

who is now dead, and his—"

Robin straightened and his eyes blazed. "Yes, he is dead! And the men who murdered him shall meet their precious Devil in Hell, for I myself shall send them there!"

Maerin drew back at his vehemence, but she said, her voice trembling, "You admit he is dead. How can you claim to be him?"

"I am his son."

At this, Maerin heard herself burst into laughter. "You, Robert of Loxley?! You are mad enough to claim his name? I happen to know he is also dead. Though he was something of a knave while he lived, all right!" She remembered the stolen biscuits and currants in the larder in her father's castle, and she laughed the harder, as freely and fully as she had not laughed in many months, and while she laughed, she realized she must be hysterical with terror and exhaustion. To her amazement, several of the outlaws began chuckling along with her.

Something in her laugh called a memory to Robin, of flashing sun on a river, of flickering candlelight in a pantry, of muffled giggles and a little girl's shining blue-green eyes with hints of hazel, the color of exotic turquoise he had seen in Outremer, and then the smell of fresh-baked biscuits, the taste of butter melting on his tongue and smearing warm on his chin, glistening on her lips, and the kiss he stole from those lips when he was barely old enough to know where such kisses might lead. Here were those same bright eyes surely before him, here the impish laugh and the sweet melting lips that a moment ago he had ached to kiss until they burned. "A knave, was I? Begging your pardon, Mistress Maerin, but you were something of a knave yourself. Remember the butter incident?"

She stopped laughing.

"Yes, I see you do remember!" Robin went on. "And other memories now beset me! Remember the day you followed the gang of us into the river? You stripped off your clothes as boldly as any boy. Perhaps you remember a birthmark on my left thigh. You were quite fascinated by it. Shall I show it to you again? It's still there." He was grinning, she was blushing wildly and Coucy's priests were muttering, "The Devil's mark!"

Her mind reeled. Could it really be him? The boy who had borrowed her pony, who had showed off at swordplay and helped her carve her initials on her little girl's bow? The boy she had cried over but a few months past when she heard he had died a thief and a Satanist? She knew the twinkle in those blue-grey eyes, like a shaft of sunlight piercing storm clouds, and his smile was as light as a youth's in his grown man's face.

No one else could know of that day by the river. This had to be Loxley. Yet clearly he was become a thief. Why, her uncle had offered a reward for him greater than any brigand in the shire!

Elgitha, too, was looking at him with stunned curiosity, as if she recognized something of the long-ago boy in the man.

"So the Sheriff is your uncle, is he?" said Robin. "And the Lion Heart your cousin? I never knew that."

Will muttered, "No great claim. He's cousins with half of Europe and he's fucked the other half."

Maerin cringed at the obscene criticism of the King.

Robin was still grinning up at her. "I doubt the King of England can help you today, Maerin. I hear he is imprisoned in Austria, and simply because he did not think to hide the jewels on his fingers and carry himself like a poor pilgrim instead of a king. So he gave away his disguise, the fool. Is it true?"

"You dare call the King a fool?" Maerin demanded.

"What, will you tattle on me, Maerin?" smiled Robin, taking the black mare's bridle and fondling the beast's soft muzzle. "I was with Richard on Crusade. He's a better soldier than a king, and he's the first to admit it. But I've no quarrel with the Lion Heart. It's with the Sheriff of Nottingham I have a dispute, and longstanding. I must uphold my part of our feud. And I really do need a new suit of mail." Robin stepped back, drew a broadsword from beneath his robe and tilted the tip at Coucy. "Down from your horse!"

With several dozen arrows trained on them, Coucy had no choice but to dismount and bid his men to do the same.

"But—but you know me," protested Maerin, "and you say you were a Crusader! How can you rob us?"

"I did far worse under Richard's command. We had not even made it to the Holy Land before we were sacking towns as Christian as we were. It was not what I had gone crusading for, raping Christian women and stealing Christian bread. Of course, many a Jew, a Greek and a Moslem died along the way as well, so all was not lost," he said sarcastically. "Did you not hear of the sacking of Lisbon and Messina?"

Maerin stared at him, shocked speechless.

"No, I suppose you wouldn't have. Now this," he gestured about him, "I don't look upon this as stealing. I see it as taking tribute. Or perhaps as being a burr under Sir Reginald's saddle. But my quarrel is with him, not you. You must keep your fine mare as a tribute to your beauty, and your maidservant may keep her mount as well."

Maerin let go the reins and climbed down from her horse, and she bid the reluctant Elgitha to do likewise. She crossed her arms and stood motionless before Robin.

"Is that how the wind blows?" said Robin. "We who once were friends. You side with your uncle, of course."

"I side with the Blessed Virgin," Maerin replied.

"I think perhaps *you* are the virgin," said Robin.

Maerin felt as if he were chiding her. She quoted, "'Thou shalt not steal.'"

"'If you harm none, do as you will. That is the whole of the law,'" Robin quoted the counsel of the Wicca. "Your uncle will buy new armor, new horses, new swords for his men, and no one will be the worse, whereas I have people in my charge who are needy."

By now the soldiers had been forced to strip off both armor and clothing. Maerin flinched and turned her gaze away from their nakedness.

Coucy shouted, "If any harm comes to her, it will be your head!"

The outlaws snickered, for the young Norman, naked and unarmed, was hardly a threat.

"Aye, Robin has often lost his head over a maidenhead," pronounced Will, to more laughter.

"Who is this brave knight who defends your honor so valiantly, who yet calls you 'bitch'?" asked Robin.

Maerin forced herself to say, "Augustin de Coucy. He is my betrothed."

"Your betrothed!" Robin tilted his head back as if seeing her in a new light, and he began to walk in a slow circle around her. "So you are to wed, you who once played at swords in the courtyard of her father, and vowed to cut off her hair, dress as a boy and run off to be a squire. I'm glad you've left your hair long instead. It becomes you." He reached out as if to touch the long black braid hanging down her back, but let his hand drop. "And are you in love with Augustin de Coucy, lovely Maerin?"

She said nothing. His nearness made her feel faint with fear, and yet, there was something in his manner, in the sparkle of his eyes, in the way he held himself, that made her body yearn for something she could not fathom, having never felt it before.

He stood in front of her now, close, willing her silently to look in his eyes and tell him she loved her fiancé, but she held her eyes downcast, her body stiff, her face expressionless.

"I know you, Maerin," Robin said softly. "I know your heart. I saw you stand just this way at your father's grave."

She looked sharply up at him and he thought he saw a flash of desperation in her eyes.

In a flash, he was certain she did not love Coucy.

"I will do the Lady's will," Maerin said.

Robin felt a thrill run through his veins, deeper even than desire, a thrill of recognition, the subtle voice of the Goddess. He called to Much. "Blindfold them and bind their hands behind their backs."

Elgitha shrieked, "Oh, Heaven help us!"

"King Richard will hear of this!" Maerin said, her voice rough with wanting to scream and stifling it.

"Ha! If Richard makes it back to England alive, I will tell him myself," retorted Robin.

"He will never forgive you this!" she said as the blindfold cut off her vision.

Robin laughed. "He has stolen many a nobleman's daughter or wife himself, and they were the worse for wear when he was done with them. But don't worry, Maerin, your virtue is safe with me. I only take maids who are willing to my bed, and I never lack for company."

How like Robert of Loxley, to boast of his conquests! "My uncle will have you hanged!" she said.

"Ah, it is good for a woman to have male kin to protect her so well." He was laughing again. "With kin such as yours, Maerin, I think perhaps you would do better to rely on me."

Maerin rued the truth in his words. She felt his strong arms wrap around her as he boosted her onto her mare. He smelled of sweat and earth and a hint of something sweeter, perhaps cloves or cinnamon. The horse began to move beneath her. A cluster of leaves whisked against her face. She was being led into the woods. She heard Coucy scream, "You'll die for this, Robin Hood!" as his fiancée and the promise of wealth were taken from him once again.

Branches rustled as they brushed by. The coarse fabric of her bliaut snagged on a thorn and she heard the tearing sound as it ripped free. She shivered. Her old playmate, now a rogue and a thief. Not just a thief, but the infamous Devil worshipper whose reward no one could claim. How naïve she had been to mourn his supposed death.

As a boy, he had been simply a high-spirited rascal. Like herself, she was chagrinned to admit. What misfortunes of life had twisted his soul into that of a real criminal? The way he spoke of the Crusade, so cruelly and yet so blithely, as if it were some mad joke instead of a holy mission from God. But

hadn't Robert's father been a Satanist, and burned his own lands and people?

Blood will out, thought Maerin, hearing her uncle's voice. Had the father taught the son the ways of Satan? Would she herself become a virgin sacrifice in some unholy rite? Else why not let her go on to Nottingham with Coucy and his men? What could Robert care for her virtue? He was a madman, a heretic! Or had he only realized belatedly what ransom he might demand for her?

To think that in childhood she had practiced archery with him, wrestled with him on the floor, touched the mark on his thigh that day at the river, when the sunlight poured around them like a fountain of raw honey. Her fingers burned with the searing memory of that touch. Was she also damned then, for touching the Devil's mark? She prayed silently but fervently for salvation.

Yet it occurred to her, with a niggling irony, that this brigand was saving her from Coucy. Was this the Virgin's answer to her many prayers, that she be freed from Coucy only to be slain here in Sherwood Forest, her blood drunk by soulless men, her body tossed into an unmarked grave or left for wolves' feasting? Or was it Satan, rewarding her stubborn refusal to marry with Hellfire? She had thought death would be better than Coucy's embraces, but now the thought of the bloody torture that might await her made her skin crawl and her bones ache. She was clammy, cold and yet sweating. Elgitha was openly weeping.

"Elgitha, I promise you, we will be safe," Maerin murmured, not knowing whether such a promise could be kept. What could she do to save herself and her servant? "Please, Sir Robert," she began, wondering if he were still nearby, hoping to appeal to his vanity or some shred of honor by addressing him as a nobleman.

"I am Robin now."

She gritted her teeth. "Robin, then. Could you not remove our blindfolds at least?"

"And have you running back to Nottingham to tell where Robin of the Wood rests to fill his belly, so your dear uncle can hurry here to slit it open for me?"

"If you still had an ounce of nobility left in your veins, you would trust to my word as a noblewoman not to reveal your whereabouts."

"I'd chance it for my own life, milady, if only to glory in the beauty of your eyes, but I will not risk the lives of those who bide with me."

His teasing poetic nonsense annoyed her, but his mindfulness for his people, though they were but outlaws, did him credit. If only she could find

a way to appeal to this last vestige of his noble upbringing.

As they rode deeper into the woods, the quiet grew more profound. The whispering of new leaves in snippets of breeze that filtered through the forest canopy and the occasional cracking of twigs only made the intervening silence more pronounced. Once she thought she heard the warbling of an owl, and thought it unusual, unless the play of light and shadow flickering across her blindfold betrayed her senses, and the sun had already set.

They rode forever, it seemed, and she wondered if Robin led them in circles, to confuse them, to make it seem further than it was. Then her mare began to trudge steeply downhill, and mingled with the pungent odors of dirt and horse droppings, Maerin smelled roasting meat and woodsmoke. She heard women's lilting voices in the distance calling to one another. Prostitutes, no doubt, she thought; camp-followers who trailed soldiers into battle and thieves into thievery. Then she heard the hollow, steady pinging of metal on metal, a rushing of air as from a bellows, the hiss of steaming water; she could almost see the smithy in her mind's eye. Then, unbelievably, came the laughter of children, and nearby, the crackling of a fire. She heard someone call cheerfully, "Look alive, you peasants! We have guests!"

The horses halted. She felt Robin's arms around her again as she was lifted off her mare. He untied her wrists and she pulled off her blindfold to see him standing before her. Her skin prickled and her heart leaped against her will as he smiled and said, "Welcome to Brighid's Well."

A black mastiff bounded over, licked Robin's hands and jumped on his chest. "Balor! Good dog!" he said, ruffling its fur. A boy came running toward them and Robin ruffled his hair too, and bade the boy lead Maerin's horse to the stream.

By a great black cauldron stood a grey-haired woman with her hands on her hips and a look in her eyes that seemed a cross between annoyance and appraisal as she gazed at Maerin. Beside her, holding a butcher knife, stood a somewhat frail but pretty young blonde woman who looked more the farmwife than the whore. Robin went to her and bussed her lightly on the lips, whispering something in her ear which made her smile and look at Maerin.

Maerin turned away in revulsion. So he had wed a commoner, or was bedding her at least.

All around her, grimy outlaws and gaunt-faced women were greeting each other. A scattering of skinny children darted underfoot to help or hinder in unloading the plunder. One of the false friars who had stood in the road with Robin lifted up a loaf of stolen bread and a jug of wine and cried, "We

have had good luck today!"

The outlaws cheered. The children eyed the bread.

"Let us give thanks!"

They gathered around the man as if to pray. He poured a bit of wine on the ground, red as blood, and toasted, "For Our Lady and the Lord of the Hunt!"

"The Goddess and the Horned One!" someone called.

Maerin's throat caught. She knew not what Lady they prayed to, but 'the Horned One' could only mean the Devil! She felt as if she were falling into a dark tunnel, an endless well where there was no water, no earth, no ground on which to stand, nothing to believe in, only falling forever, and not even the sky above to show she had come from somewhere safe and pure. The Church had denied her, and she had come to this. Was this the Virgin Mary's will?

Friar Tuck took a long draught from the jug and passed it to Robin.

"To Our Lady!" said Robin. He drank and the people murmured, "May you never thirst, Robin."

The jug went around from hand to hand, and then the bread, with the people tearing off chunks of it, and the children cramming their crusts practically whole into their mouths and spitting crumbs as they joined their elders in wishing, "May you never thirst, never hunger," until the jug and the bread came around to Maerin.

She said, "I will not drink to Pagan Devils with stolen wine." Fear flooded through her. Would they attack her? Rip out her heart? Call down demons upon her? Well, better sooner than later, she thought with a defiant lift to her chin.

The jug was offered to her servant.

"Oh, no, me? No, I never could," stammered Elgitha, eyeing Maerin and then the jug and licking her lips as it was taken away.

The circle broke apart. People went about their tasks, casting glances at their captives, who stood awkwardly near the fire to warm themselves against the growing chill of late afternoon.

Soon Prim was ladling out a venison stew from her cauldron. The stolen food was doled out like treasure: more bread and wine, rounds of crumbly golden cheese, raisins, dates and dried figs. For the sake of the children's hunger, Maerin could almost forgive them their thievery.

But when the young woman Robin had kissed came toward her and Elgitha with trenchers of stew, Maerin refused hers, though she was hungry. At best, it would be accepting stolen food. At worst, the food might be drugged

or poisoned. Elgitha miserably followed her mistress's lead.

"It won't hurt you," Aelflin said. "'Tis not the land of Faerie! You can eat and still go free!" She set the trenchers down beside the two prisoners.

By a certain bloom in the girl's cheeks, Maerin wondered if she were pregnant, though she wasn't showing yet.

Robin's child. She felt a sudden twinge of jealousy that stunned her. How could she feel jealousy or desire for this man who had kidnapped her, who preyed upon innocent travellers, who worshipped evil? Repelled, she crushed her impure thoughts with prayer, murmuring, "Hail Mary, full of grace, the Lord is with Thee," but she dared not take out her ivory rosary for fear the thieves would steal the beloved keepsake.

Aelflin went to sit beside Allan, who kissed her and rubbed her knee while they ate.

Maerin felt another wave of disgust. Was the girl not Robin's wife? Or was she whore to any man who wanted her? Was this the fate that awaited Maerin? Had not Robin looked on her with lust?

She closed her eyes. She wished she could stop thinking. Her mouth was dry. Perhaps she should ask for water. No, she would take nothing from their hands.

When Maerin opened her eyes, Robin had disappeared.

The sun set, the air cooled, the sky slid from blue to black, stars shimmered overhead. The people swung cloaks or blankets around their shoulders, and their talk and laughter seemed muffled by the enveloping night. Allan pulled out his harp and began to sing, first a lament in the *langue d'oc*, then a silly ditty in English, and then a ballad he had composed.

> Come and listen, gentle ones
> That be of freeborn blood,
> I shall ye tell of a good yeoman,
> His name is Robin Wood.
> Robin is a proud outlaw
> As ever walked on ground;
> So courteous an outlaw as he is one
> Shall never none be found.
>
> Robin loves Our Dear Lady;
> For doubt of deadly sin,
> He will never do company harm
> That any woman is in.

Now Robin stood in Sherwood
And leaned him to a tree
And by him stood little John;
A good yeoman was he.

Will slapped John on the back. "I like this tune," John nodded as Allan sang on.

'Brother,' then said little John,
'If we our board shall spread,
Tell us whither that we shall go
And what life shall be led,
Where we shall take, where we shall leave,
Where we shall bide behind;
Where we shall rob, where we shall reave,
Where we shall beat and bind.'

'Thereof no force,' said Robin;
'We shall do well enough,
But look ye do no husband harm
That tilleth with his plough,
No more ye shall no good yeoman
That walketh by greenwood grove,
Nay, no knight, nay, no squire
That is a good fellow.

'But these bishops and these archbishops:
We shall them beat and bind,
And the High Sheriff of Nottingham—
Him hold ye in your mind!'

"And thanks be to the Sheriff for the red, red wine!" sang Tuck, tilting a jug to his lips.

"Aye, the Sheriff's health!" Tom raised his cup, but instead of drinking, he leaned his head back and let out a yipping howl, for he saw the moon was rising full, gleaming down into the ravine.

Elgitha and Maerin huddled closer together near the fire. Maerin kept to herself her growing terror that they were soon to be sacrificed in some awful rite, for Elgitha seemed frightened enough already.

Just then, Robin materialized out of the darkness. The urchin who had tended her mare was at his elbow and the black dog Balor was at his heels. Robin frowned, seeing the cold food on their trenchers. "What, not hungry, Maerin?"

Maerin fought back her panic. "No. But how good of you to share the King's deer with us."

He cocked an eyebrow. "My pleasure. But come." He held out his hand. She hesitated. "I will not compromise your honor," he teased. "It is only that the night is cool. I'll take you and your servant to shelter."

She did not take his hand, but stood and nodded at Elgitha to rise.

Keenly conscious that she would not touch him, he let his hand fall to his side. He took a burning brand from the fire and by its light he led them up a twisting path in the steep hillside. The mastiff ran ahead, the urchin followed behind. They ducked inside a small cave furnished with a pallet on the ground, a wooden shelf, a wooden bench, a circle of stones where burned a fire for warmth, pieces of wood in various stages of becoming arrows or bows, and a small arsenal of knives and swords and metal-studded shields.

He saw her taking stock of the weapons and remembered her childhood skill with them. He shouldn't have brought her to his own cave. But every other cave bristled with weapons as well. There was no help for it. He grabbed a coil of rope from a rocky ledge and said, "Forgive me, milady. I wouldn't want you to try to find your way out of these woods without my help. You might get lost or gored by a boar." He took her wrists.

She wrenched them from his grasp and aimed a sharp elbow at his belly, but he was too quick for her and dodged out of range even as he swung behind her and got a choke hold around her neck. She heard the dog growling.

"No, Balor, down!" Robin commanded.

"Elgitha, run!" she gasped, but Elgitha was much too frightened to try to escape alone through the woods at night, and besides, she would never desert her charge. Maerin knew it was hopeless even as she said it. Still she tried to stomp on Robin's feet behind her, but he was already swiftly tying her hands behind her back.

She imagined he was grinning as he said, "Ah, Maerin, I'm happy to see you have not lost your fighting spirit! I must remember to be careful to stay out of range of your teeth! Unless, of course … well, if you were to …" An image arose of her kissing him, pressing her body against him, biting his lip. Heat and desire surged through him.

He stepped backward, cleared his throat, and though his tongue seemed

ten times thicker than his mouth, he managed to keep his voice light. "As I was saying, if you were to get lost or be attacked by wild beasts, I would curse myself for not having cared for you properly. Besides, you used to be quite handy with a dagger, and I'd hate to find one of my own stuck in my back." He guided her to the bench and began binding her ankles. "Don't look so angry, Maerin. I promise I'll take you anywhere you wish to go before your beloved Coucy can finish lacing up his wilted pride."

"You expect me to trust the words of a Godless thief who ties me up like a—like a—"

"Like a lamb ready for the spit?"

Maerin tensed.

"You will tell me if it's too snug?"

Maerin lifted her chin and said, "I'll suffer anything on Earth knowing my reward will be in Heaven."

The light in his eyes went out. He said as he tied the knot, "Don't play the Christian martyr with me, Maerin. I've seen enough of martyrs in the so-called Holy Wars. I'd as soon never see another, especially one so lovely as you." He stood and made short work of binding Elgitha. "Guard them well, Juniper," he told the urchin, who piped a breathy, "Yes, Father!" as Robin strode out into the darkness with Balor at his heels.

⌘

Damn me for losing my temper, Robin thought. Maerin was frightened and so said ridiculous things. And he was an ass who could hardly reassure her under the circumstances. What had possessed him to bring her to Brighid's Well? It was lunacy. Well, that made a kind of sense. He served the Moon Goddess and now he was lunatic: moon-mad for one of her maidens.

It was not only her beauty. It was that he had never seen a woman with such unconscious grace, with such pride and yet modesty. It inflamed him. And made him act the buffoon. Every step he took was a misstep, every word he said only frightened her more.

Perhaps he had misread her. Perhaps she loved her betrothed after all and Robin had done her no favors. He should have let her go on to Nottingham with the others. He should have stolen some chain mail and weapons but left the soldiers their clothes, and sent her on to Nottingham with her escort. And by Goddess, he should have left the mind-reading alone; he had always been better at knowing the hearts of wild creatures than those of so-called civilized men and women.

He prayed tonight would prove his skills at the former ran strong in him. "Gracious Goddess, grant me your vision tonight," he whispered to the

Moon as he made his way through Her light toward the grove of trees where the others waited.

34-JUNIPER'S CURIOSITY GETS THE BETTER OF HIM AND PROVES THE UNDOING OF MAERIN

aerin could see by the way his eyes followed Robin that the urchin Juniper idolized his Prince of Thieves. Had she heard right, that he had called Robin 'Father?' The blonde woman, Aelflin, was too young to have borne this boy. Who knew how many women Robin had? She frowned.

Juniper stood scuffing the dirt with his bare feet, then squatted by the fire and set aside the bow he wore slung over his back. Maerin felt sorry for him. He had an innocent air. How long before he was corrupted by the outlaws, ensorcelled by Witches? Something in her heart reached out to him, even as it occurred to her that befriending their guard would also be to their advantage. She said, "Well, then, Juniper, is it? My name is Maerin. If we are to spend the evening together, we must be on good speaking terms."

He blinked at her. "You are wondrous pretty," he finally said, almost whispering. "Like the Queen of Faerie!"

"Not at all, I'm a Christian woman like any other."

Juniper looked dubious.

"How old are you, lad?"

He straightened his shoulders. "Nine and a half. I'm almost grown. Soon I'll go into the woods of a full moon like the other men. Robin promised."

Maerin's throat tightened. "Tonight is a full moon. Do the men go to the wood tonight, Juniper?"

"Oh, yes, and the women too."

Elgitha gasped, "Oh, milady! Do you think they are truly …?" She could not even mouth the word 'Witches,' as if saying it would make it more real.

"What do they do in the wood when the moon is full, Juniper?"

"Milady, you cannot want to hear of such things!"

"Hush, Elgitha."

"I think they dance and sing, mostly," Juniper said shyly.

Maerin bit her lower lip. Poor ignorant lad. If she could escape, she ought to take him with her. If only she could lure him, sway him in some way. "Tell me, Juniper, do you like living here in the woods?"

"Oh, yes, milady!"

"Wouldn't you rather live in a nice clean cottage, and sleep in a feather-bed?"

He frowned. The featherbed sounded good, but he didn't want to live in the towns, where Jews were hated, shunned or murdered. And what would he do there? He didn't know anyone who would take him in. Besides, Robin was his father now. Pride welled up in him. "I'd rather be here in the woods with Robin."

Maerin lapsed into silence. She would have to try another tactic. But how much time did she have? Then again, if Robin and his coven meant to kill her and Elgitha, why leave them bound in this cave? Why not carry them to the wood tonight? Perhaps they meant the women no harm after all.

Or perhaps they were preparing themselves tonight for a rite of sacrifice on the morrow. She struggled to speak nonchalantly. "So, Juniper, where do they go, when they dance and sing under the moon?"

"In a grove in the forest."

"Dear God in Heaven, have mercy on us," sputtered Elgitha.

"Is it far? Do you know where it is?" Maerin pressed.

"I'm not supposed to tell. It's a secret."

No matter. The forest was vast enough. If they could somehow escape, surely the shadows could hide two fleeing women. If only their feet were unbound, she would run with her hands tied behind her back. She could kick poor Juniper in the head and run. What madness! She would never hurt this innocent boy. Besides, he was armed, and for all the smallness of his bow and dagger, they were real weapons, like the ones she herself had played with as a child.

But if the thieves were gone throughout the night, and if she could somehow win Juniper's trust She said, "When I was a little girl, I was forbidden to do lots of things. But that never stopped me! Don't you wish you could just sneak into the wood and hide behind a tree and watch them?"

He hesitated. "Robin set me to watch over you, so's you'll come to no harm."

"Of course. Though my wrists and ankles ache at being bound. But of course, you mustn't untie me. Robin wouldn't like that. I suppose he did not

mean to tie them so tightly."

Juniper eyed her ankles uncertainly.

"Well, we can just imagine. The dancing must be grand, and the singing, and the—well, whatever else they do there."

"Milady!"

Maerin hissed, "Elgitha, leave me and the boy in peace or when we get back to Nottingham, you'll be a scullery maid." She turned her attention back to Juniper. "What a grand spectacle it must be, deep in the night, in the forest, with the fires burning, under the moon. Surely there must be bonfires?"

Juniper shifted uncomfortably. He wasn't really sure whether there were bonfires, or what the men and women truly did in the sacred grove. He had only been advised that it was of a religious nature. The other children said they were sometimes allowed to go along and play while their elders danced and sang and talked, and Robin had promised him that soon he could go too, now that he lived among them.

But not tonight. Tonight there was something special he wasn't old enough to do. He had asked Robin about it, but Robin had said little. This did not surprise him overmuch. Adults were always keeping secrets.

Everything about religion was mysterious to him anyway. The most he had seen of it was his mother chanting and lighting the Shabbas candles, when they could afford candles. It had been soothing. She had always seemed calmer and happier when she sang, although of course she never sang for anyone else but him and his father.

When his father was alive, he had taken Juniper several times to a little room where men sat bobbing back and forth and muttering prayers in Hebrew. They wore white fringed shawls over their heads or about their shoulders like women. But there were no women in the room. It seemed women were not allowed to go and chant and bob about, which seemed an easy enough occupation; certainly his mother could have done it. But then, she was so busy, she probably didn't have time. He thought of the Christian priests, who wore gowns like women instead of hosen and tunics like other men. Why did men always dress like women to do religious things? That was another of those mysterious things that adults never gave him answers for.

His father had been killed in one of the pogroms after Richard the Lion Heart's coronation, and Juniper and his mother had fled for their lives. There were few other Jews in the village where they had finally taken refuge. There had been no one to teach him the secrets of how the men worshipped.

Thinking of his parents, both dead, made his eyes sting. He distracted

himself by picking up a stick of kindling and poking at the fire.

Robin was his father now. Robin would teach him. Already Juniper was learning how to fletch arrows and shoot with his bow, to track animals, to taste the air for signs of coming rain or snow, to sit by a brook and listen for the voices of water spirits, to watch the fire for shapes and signs and omens, and to offer a crust and a few drops of watered wine or tea to the Lord and the Lady who, Robin said, watched over him.

But now this lady who seemed like a Faerie Queen and whose soft voice reminded him of his dead mother was tempting him to disobey Robin. He wished she wouldn't do that.

"I wonder if perhaps this mightn't be a test," she was saying. "Sometimes our elders want us to show how determined we are, before they believe we're really grown up. Perhaps Robin is really waiting for you to follow him into the woods, to prove you've become a man. But then again, perhaps not. Perhaps you'd better wait until he thinks you're old enough. But it would be fun to hide behind a tree and watch. I know! Take us with you!"

Elgitha let out a yelp in protest.

Maerin ignored her. "Then Robin wouldn't have anything to complain about. You would be guarding us at the same time!" She couldn't imagine where this mad idea had come from. The last thing she wanted was to go to Robin's grove. But she couldn't think of any other way to get her feet untied.

"I don't think Robin would like that."

"Well, I won't tell him if you won't! We'll be hidden and he'll never know the difference." He looked to be almost swayed. "Seems to me you're old enough. I thought you were eleven!" she lied, and promised God silently that if she lived, she would do penance for the sin of falsehood.

⌘

The moon dappled the forest floor with silver coins of light. Elgitha, who hated scullery work almost as much as being lost in the woods, stifled her protests and followed along behind Maerin and the boy.

In all her years of service, she had never had so many frights as she'd had since Maerin had returned from Fontevraud. Not that the girl wasn't a handful when she was a small. But now that she was a woman grown, her mischief was less frequent but far more calamitous. That long ride in the night to Nuneaton! Defying her uncle! That nasty Coucy dragging them from the abbey! And now, captured by thieves, and Maerin convincing the boy to take them to some devilish rite! Was the girl insane? She prayed God would preserve them from beasts and thieves and Witches. She crossed herself; her hands were tied in front of her now. The rope that ran from her wrists to

Maerin's waist pulled taut and she stumbled over a lichen-covered rock.

How stubborn and wild Maerin was! Yet she could be so generous. And she was pious. She prayed more than she ought; it made a girl's complexion wan. She should wait until after she was married for all that praying. God in His Heaven knew the girl would have plenty of reason to pray then, married to that Coucy.

"Hurry, Elgitha! And trust me!" Maerin whispered as they came to a tiny gurgling beck and jumped over it, hand in hand.

Maerin glanced up at the moon. Surely they could find their way out of the forest by its brilliant light. She could tell which way was east by its place in the sky and by occasional glimpses of the North Star through the trees.

The way to the grove seemed long, whether because it was truly far, or because it was night, or because she was mortally afraid, she knew not. But at least her feet were free.

She waited until they were far enough from the outlaws' hideout. She was about to say she had to relieve herself. She counted on Juniper's youth to make him feel embarrassed so he would untie her completely. But just then Juniper tugged at the rope which bound her wrists.

"We're close now," he whispered.

She had waited too long! She thought she heard the hum of voices, then saw an eerie flicker of firelight through the trunks of the trees. As they drew closer, she heard men chanting low and strong, words unfamiliar, indescribable, chilling. *"Io! Evohe! Io! Evohe! Io!"*

The three peered around the trunk of a massive oak. Maerin sucked in her breath and crossed herself. Juniper felt the swaying of the rope and glanced at her, but seeing her movements, he let his gaze be drawn back, fascinated, to the clearing in the middle of the grove.

Dancing in a circle, their feet trampling wild grasses and dirt, the men were naked but for animal skins, of deer and bear, wolf and fox, rabbit and squirrel, draped over their shoulders or around their waists. Their faces were daubed with mud or paint, their limbs glistened with sweat. Now and then one or another of them crouched down like a beast and pawed the ground, while others leaped in the air and jabbed at the sky with knives as if piercing the stars, still shouting, *"Io! Hey! Evohe! Io!"*

The black mastiff, with his red tongue hanging out of his gaping jaws, ran in and out of the circle between the men, whirling now and then to chase his own tail.

Maerin recognized several of the outlaws, though she did not know them by name: the portly friar who had spilled wine on the ground, the

harper, the giant red-haired, red-bearded man who had waylaid her party with Robin.

In the center of the ring blazed a fire. Beside it was a flat rock on which dully gleamed a battered silver chalice and a knife. Before this crude altar stood Robin, naked but for a deerskin and a crown of deer antlers on his head, his lean muscled body golden in the firelight.

Her knees almost gave way beneath her.

He raised his arms and he was chanting under his breath. She could not make out the words, and she thanked God and all the saints for that small mercy.

The others spun around him, furry animal skins and their own hairy flesh rippling in the moonlight and firelight, and she caught glimpses of the hairy patches between their thighs, and their privates jiggling up and down. *"Io! Hey! Evohe! Io!"*

Maerin flattened herself against the oak, her head spinning. She closed her eyes upon the primitive Pagan sight and whispered, "Holy Mary Mother of God! Pray for us sinners now and at the hour of our death!" She heard a slumping sound and opened her eyes. Elgitha had fainted. Maerin bent down to revive her, but it was no use.

She glanced up. The men were chanting so loudly, they had not heard her fall, and Juniper was watching the ritual, enthralled and oblivious to anything else. Still she hesitated. She couldn't escape without her loyal servant, leaving her to what awful fate she could not bear to imagine. But Elgitha was unconscious. Maerin could not carry her. She would have to leave her. If she could escape herself, she could send help. But by then it might be too late! But if she did not go at once, it would be too late for both of them.

Juniper was staring open-mouthed into the clearing. Maerin slipped her hands under her gown to the leather belt that had served as a garter on one leg ever since Coucy had tried to force himself upon her moons past. In that belt was a sheath for a small but razor-sharp knife. She pulled the knife out and began to cut the rope that bound her. It was quicker work than she had expected, and she thanked the Holy Virgin. She knotted her end of the rope to a low-hanging branch.

Then faintly beyond the clearing came a rhythmic drumming and women's voices lilting in song, growing louder. "Brighid, Brighid, High One, Mother of God, O Lady, come," the women sang hypnotically over and over. Then silvered and shadowed they appeared, and leading them in the dance was a dark-haired woman with gold rings in her ears, hips and bosom swaying erotically, fingers beckoning, arms sinuous as snakes. No wonder

the Church frowned on dancing as lascivious and evil! Among the dancers was the crone who had stood by the cauldron. She played an ancient, grimy drum, and the blonde girl was twining her arms around the harper, and another girl with red hair like a silken veil loose around her shoulders was dancing toward the tall red-bearded man, and the two songs and the two dances of the men and women blended together in wild harmony.

"*Io! Evohe!* Brighid, Brighid. *Io! Evohe!* O Lady, come."

Robin tossed two handfuls of herbs on the fire. Smoke billowed upward. The acrid fumes caught on the wind, filled the grove, wafted toward Maerin and Juniper.

The song of the women changed. "O Horned One, come and dance with me! Fill my body with sweet joy! Fill my body with sweet joy!"

They were calling upon the Devil! They were begging him to make love to them! Maerin's breath stopped in her throat but she could not tear her eyes from the scene.

The youngest of the men began playing a tin whistle, the steady drum became a staccato of changing rhythms, and over the music and shouting and clapping of hands, past the twirling bodies, a shadow briefly blocked out the moon in Maerin's eyes. An owl plummeted past her, noiseless, almost brushing her hair with its wings, and swooped at Robin, talons outstretched as if to clutch him to her breast. Yet he stood with his eyelids half-closed in a trance, his naked body swaying as he sang, and the owl landed on his shoulder and nestled its beak in Robin's hair, caressing him. Robin stroked the creature with both hands.

Then he grasped the owl and pulled it from his shoulder. It screeched and ruffled its feathers as its head twisted left and right. The words of the chant tangled and untangled, lost and refound, "*Io! Evohe!* Brighid, Brighid. Horned One! Come, sweet joy!"

Now the crone was tossing more herbs on the fire, and the pungent smoke was thick as a fog. Maerin felt lightheaded. Within the fog, Robin wrestled with the wild bird, which struggled, its eyes fixed on Robin's, until its body lengthened, its feathers unfurled into long tawny hairs speckled with brown and gold, its beak flattened into a rosy mouth, its glittering round eyes stretched into ovals golden-brown, and then Robin held in his arms a woman with skin as pale as the moon, her rounded breasts and belly covered with freckles, the mound between her slender legs tawny with soft curls, and feet shaped like the talons of an enormous owl.

Maerin was sure she would faint. She wished desperately she could faint and be lost in oblivion and that she had never seen this sight. She wanted to

run, knew she should run, knew this was her chance to escape, but she could not move, as if she were bound by magic.

Robin let the owl woman go. She stood before him, motionless. He leaned forward and kissed her on the mouth while the coveners howled and pounded the ground and the chanting went on and on.

Maerin felt her own body grow hot, as if Robin's lips touched hers. She was instantly ashamed; her body betrayed her. She detested and feared him. But she couldn't take her eyes off him, off his hard muscles, his long dark hair, the antlers on his head, and his eyes, half-closed as he knelt before the owl woman.

The creature raised her arms toward the sky as if she would take flight, but he held her taloned feet and said, "Gracious Goddess, Lady of the Beasts, Queen of Heaven, Mother of Gods, Moon Maiden, Brigantia, Breast of the Land, Lilith, Winged One, most beautiful and abundant, we are your children. We await the first harvest. We hunger. If there be those that are willing to sacrifice so that we may live, Gracious Lady, show us where they may be found."

With a high moan, the owl woman pressed her own hands to her breasts and cried, "Where shall they be found? Where shall anything ever be found? Within me. All creation is born from me. All creation is nourished through me. Enter the heart of me and I will show you!" And Robin embraced her like a lover.

Maerin ran. She ran as if the Devil were chasing her, as if her heart and soul had sunk to the fires of Hell and she had to run to save her body from following them. She thought her brain would burst for panic, she heard the boy Juniper crying out behind her, the chanting and singing abruptly ending, voices questioning, then shouting, and above it all came a shrill keening, like a woman in mourning, or the *bean-sidhe*, harbingers of death, or an owl bereft of her nestlings or her prey.

Maerin ran as hard and fast as she could, tearing through underbrush, cracking twigs and sliding in the mulch of last autumn's dead leaves. She was making too much noise! She clung to the shadow of a tree and tried to catch her breath, to silence her harsh gasping, her pounding heart.

I must go quietly, I must go slowly, carefully, I must escape, she told herself. She heard Robin's voice, low, not far away. She had never realized before how resonant his voice was, how it warmed her against her will. How sweet the Devil's temptations! Oh, Mother of God, was she lost already? Tears filled her eyes at the changes in her old friend, at the bestiality she had just witnessed, and the paralyzing fear and desire and shame it had aroused

in her. Her lips moved soundlessly as she prayed, again and again, Holy Mary, Mother of God, pray for us sinners, Hail Mary, full of grace, Merciful Mother of God, be with me, help me.

Willing herself to be quick and light as a feather, she slipped through the moonglow into the shadow of the next tree. She waited.

Silence.

Tree by tree, shadow by shadow, she moved away from the sound of men.

35-The flight of the white stag

She fled southeast, marking her way by the moon. Every sound in the night cried pursuit. Was the rustling of leaves in the breeze the sound of a man's arms pushing branches aside? Were the soft padding paws of wild animals, hungry and hunting, really the footsteps of men, as dangerous or more so than the beasts?

Yet she grew even more fearful when she heard nothing, for the stillness bespoke the terror of animals awaiting the silent glide of the demon succubus, shape-shifted once more into the form of an owl, her sharp talons outstretched. Or had Robin himself turned into an owl? Did he hunt her on the wing?

She heard a howling in the distance. The cries of the outlaws or of real wolves? Surely no wolf would be hungry enough in spring to attack a grown woman, she assured herself. Or was it the great black mastiff that was clearly Robin's familiar, with his red tongue lolling between his black jaws? She could hear his panting breath. He was upon her! Something gripped her clothing. She yelped and whirled to pummel the beast's head with her trembling fists, and saw her skirt had snagged on a bush. She yanked it away, her heart pounding, and hurried on.

Ahead, the trees were sparse. The moon illuminated the pale white trunks of a stand of birch on a hill, arching over a deeper blackness. A cave? She hastened toward it. Yes, a hole gaped in the earth. She touched its cool stone mouth, praying no savage beast or worse made this home. She steeled herself and inched into the dark recess.

The cave was barely high enough for her to stand without crouching. Gingerly, she ran her hands along the jagged surface of the wall. It was damp, cold, gritty. The smell in the air was musty, as if it had been long unoccupied.

Perhaps the earth had opened up to swallow her. Perhaps she stood in a doorway to Faerie, and if she went further, she could never return to the world of men.

She frowned at her fancies. Her imagination was running wild.

Well, what if this were a door to the Otherworld? What did the world of men hold for her? She'd had little enough joy of it since leaving Fontevraud.

Breathless, she waited in the enveloping darkness. She heard no sound of pursuit, saw no shadows approach. At last she ventured to peer out at the circle of moonlit forest framed by the cave's mouth.

Some twenty yards away was the silhouette of the black dog.

She fled back into the cave and slammed into a rocky overhang invisible in the darkness. She bit off the scream that threatened to escape her throat even as she slumped to the cave floor, a searing pain at her right temple telling her a sharp stone had cut her. The blackness swam. Blood trickled down her face, or was it only sweat? She raised tentative fingers to touch her wound. It was wet.

Sharp flinty rocks beneath her bit into her skin through the thick cloth of her bliaut. Shaking, she got to her feet as quietly as she could and slid her hands along the cave wall, walking into a blindness blacker than the midnight shadow under a furled raven's wing.

The cave stretched downward. Bits of broken stone crunched and slid beneath her feet. The earthy smell grew stronger, and the cave wall grew wet. Perhaps there was a spring hidden in the stone.

She kept one hand pressed against the wall to her right; if it branched off she would follow it. She clung to the knowledge that in this way, she could retrace her steps. But how long would the demon dog wait for her? What if Robin had already found him, and even now followed her into the cave?

She pushed on, praying to the Virgin to lead her to safety, praying this tunnel would open out into another part of the wood, far away.

She shivered, wishing she had her woolen cloak. But she had left it perforce in her cell at Nuneaton. Had it only been yesterday morning that Coucy had come for her? It seemed days had passed.

Her hair had come unbound and straggled about her shoulders and waist. She might never get a comb through it again, she told herself, trying to think of mundane things. And the state of her clothes! They were surely beyond mending. How Elgitha would flutter about her, calling the servants to bring hot water for a salt bath. Her chest tightened, thinking of Elgitha, still a prisoner. The woman was often annoying, fussing over her like a mother

hen, but she was good-hearted and selfless. Better than I am, Maerin thought. She would never have deserted me, left me to my fate with brigands and Satanists. I am a wretched soul.

After a time, hunger began to speak even louder than her conscience. She had not eaten since before Robin kidnapped her. She began to think of roast swan and trout with almonds and rose petals, fragrant hot wheaten bread and fresh melting butter. Then the pantry of her father's keep long ago came to mind, the stolen butter, a stolen kiss. Robert of Loxley.

She swallowed hard, trying to dismiss the image of him in happier times. Then she thought of the stew she had refused to eat this night, and the round eyes of the children hungrily watching Robin as he passed around stolen loaves.

The cave grew narrower. She was forced to turn sideways to slide through. She prayed she would not come upon a dead end and be trapped by her pursuers. She was growing tired, more tired than she had ever been in her life. Her feet began to drag, her shoulders sagged. The walls pressed upon her like a tomb. She could think of nothing clearly, not Robin and his coven, not pursuit or freedom, not even how fine clean linens on a featherbed would feel. If she ever got out of this tunnel alive, she thought she would simply fall to the earth and kiss it once before expiring.

"My dear Maerin," she could hear the abbess of Fontevraud in her head, "you are nowhere near expiring. You do have a tendency to exaggerate. You must pray to God to remove this fault."

"I *am* tired! I'm dreadfully tired, it's horrible, and that dog, waiting for me, and Coucy, like a jackal. I've nowhere to turn, I can't run, there's nowhere to hide, my head hurts and there are demons chasing me!"

"Maerin, you have always had a vivid imagination. You must not let it run away with you."

"It has not run away with me. I have run away with it! No, I mean … I don't know. Robin … he frightens me. Oh, why does the Lady turn Her face from me?" Tears of anguish filled her eyes. She could see nothing in the darkness anyway, so she let the salty drops pour unchecked down her cheeks.

But after a moment she did see something, as if through rippling water, a dim golden glow, almond-shaped like a candle flame. Was it real? Was it daylight ahead? It wavered through a film of tears, through a waterfall, perhaps. Had she found the hidden spring? She moved closer, then stopped in awe, for nestled within the glow was a little fawn with white spots, its tender head resting upon the forelegs of its mother, a doe with great, soft, black eyes, and she in turn lay resting between the protective forelegs of a stag.

Then the doe and the fawn melted away. Only the stag remained, and behind him and around him glowed the golden light of the sun or some otherworldly fire. His coat was the color of fresh cream, and across his broad throat grew a feathery ruff of thicker, whiter fur. His golden-brown antlers wove up toward the heavens like a crown, regal and graceful. His legs were delicate yet strong. His velvety nose was black, and so were his eyes.

It is in the eyes, Maerin thought.

What is?

I do not know how to name it, but it is there.

Strength and warmth flowed into her from those eyes, and a love she had never felt or witnessed before, not in any human mother or father, not in any suitor wooing a loved one, in any priestly servant of the Church or in lifelike images of Jesus and Mother Mary, or even in herself, in her own prayers, in her own love for her father or the abbess at Fontevraud.

The stag tossed his head. He seemed to be beckoning her to come closer. She ached to touch him, to stroke the ruffled fur at his throat, to bury her face in his neck. What if he darted away and left her? She thought she could not bear it. Yet she could hardly bear the beauty of him so close to her.

She walked hesitantly toward him. He did not move away. More tears, of gratitude, poured down her face.

The white stag rubbed his soft nose against her cheek like a kiss. He licked away her tears.

It is the salt he likes, she told herself, as if to tell herself he could not love her that much. His eyes seemed to say she was wrong.

She sank to her knees before him. Her heart was breaking open and love was pouring out of her and into her, swimming around her, vibrating the air. She saw the form of the stag was a mask over the face of something greater, something deeper and beyond form, marvelous to the point of ecstasy.

The stag turned and began to walk away. She rose and followed him. The cave widened. There was an opening in the rock. Beyond, the forest shone, green and gold, alight with day. She threw her arms around the stag's neck and they walked out of the cave together.

The sun poured golden rain down upon them. The stag tossed his head. She swung herself upon his back and he burst into a run. They sailed through the forest, leaping folds in the earth made of brooks and ravines, charging hillocks, dancing over and under the branches of trees without touching a leaf. Spiralling birds wing-dappled the green with red and yellow, blue and grey. The clean blue sky arched above them like a prayer. The white stag's fur

was soft, and his smell was wild and good. Maerin gripped his fur in her fingers. His strong muscles rippled between her thighs. They sped on and on without stopping as if their power would last forever, the day would last forever, joy would last forever and the forest would stretch timeless into the sea.

They came to the water, sparkling in the sunlight, a spring bubbling up from the ground into a warm pool. The white stag wheeled to a halt. Maerin dismounted. The stag lowered his head to drink. Maerin threw herself on the ground and drank as well, and the water, though warm, refreshed her like no other she had tasted, and it was clearer than any she had seen, and within it, at the bottom of the pool, swam speckled salmon, watching her, reminding her of her hunger, and yet it seemed the mere sight of them satiated her.

Then she heard a voice, the bell-like voice of the Lady that had come to her years ago among the standing stones by Fontevraud. She looked up quickly, but saw no one.

The voice said, "At last you have come to me again. The white stag brings you, for you have feared to come alone. Do not forget who brings you."

Maerin could not speak for awe, but within, she longed to know whose voice she heard.

"I hear your heart, Child of the Earth. I am Ma, Mary, Mariamne, I am Yemaya. I am Brighid, Brede, Brigantia. I am Isis. My names are many and my face may change countless times in a thousand thousand years, but Goddess will not die. I am Everlasting, the Compassionate One. I am the Great Mother, worshipped before the Gods of men to Whom I myself gave birth. I am reborn each day. I will outlast all my children. I am the Sea and the Mother of the Sea, the Mother of God and all creation, and you are my namesake, Maerin of the Wood."

The spring water turned to salt on Maerin's tongue. She was crouching on wet sand that slid between her fingers. She heard the crashing of crested waves breaking. Grey-blue water licked the shore, swirled around her wrists, knees and ankles, against her breasts, bracingly cold. The ocean stretched to the horizon, and floating above it was a Lady shimmering in light, wearing robes of white and blue, a crescent crown upon her forehead, a string of pearls draped around her neck and over her full breasts, seaweed strewn around her bare feet, and her voice like crashing surf and foam was calling, "Your womb is the sea. Open to me. Your womb is the Moon. Open, open."

Then the Lady was gone and the salt water was bitter in Maerin's mouth. Salt tears dribbled down her face from joy that the Lady had come to her

again. The pain of Her leaving was sweetened by the thought that She might return, that the stag could bring Maerin to this place. But where was she?

The ocean receded in a wash of spray, and before her was only a small spring in a fertile wood, and the white stag with his antler crown. His voice was in his eyes. She knew he was the Horned One, no Devil, but a primeval God, old as the Earth itself.

His wide soft tongue licked the tears of joy from her cheeks and his eyes said, "I am Lord of the Animals, Hunter and Hunted, proud lover, dancer in time, protector of women. Do not fear me, Beloved."

She hugged his neck. "I love you," she said or thought or dreamed, and his wild smell, intoxicating, filled her. She closed her eyes in delicious peace, and felt the morning sun flicker through green leaves and across her face. The world spun and then steadied itself.

She opened her eyes. She was lying in a patch of grassy thicket. Starlings above her darted from tree to tree.

"Maerin!" Robin's face hovered over her, and his eyes were somehow the eyes of the white stag, though they were not black but blue-grey, and filled with concern. His arms were cradling her and she felt no fear.

"Robin," she murmured his name and it tasted sweet.

He stroked her hair. She shuddered with pleasure.

He stopped and pulled away from her, thinking she trembled with fear.

Drowsy, she said, "Did you see him? The white stag. He was beautiful!"

His muscles tensed. "Where?"

"Here, by the spring."

Robin's eyes widened. There was no spring in this part of the wood. "Where? The spring—what did it look like?"

"He took me on his back. It was darker than night, but then the sun was shining. There was a cave."

"The cave—was it in a cliff, or a hillside, or—?"

"It was like a half-moon, but then it was narrow. It was in a hill. Under a birch grove, in the moonlight."

"Big enough for a man to walk through." He knew the place.

"I walked through it."

Robin stood. "Will! John! The deer herd will be by the spring at the Crescent Cave. Go!" He turned to Maerin again and said, "I must go with them. Tuck will lead you back to Brighid's Well. Are you. . . ?" he hesitated, then said, "You will be safe. Trust me, Maerin, if you can. I swear by everything you hold holy that I will never harm you."

She nodded weakly and he was gone.

She wished he could have stayed, but she had not thought to say so. She felt faint, but it was pleasant. She did not want to move, but Tuck put a flask of precious brandy to her lips and insisted she drink. He was helping her to her feet when Robin emerged again from the trees, ran to her, knelt before her and brushed the torn hem of her skirt with his lips. His kiss spun hot through the threads of the cloth into her flesh, warming her through, heart and skin and blood and bone.

How foolish, she thought. How impossible. Yet she felt it.

He looked up at her with an unfathomable expression, and she thought she heard him murmur, "Milady," in a very different tone than she had ever heard him or anyone else say it before. Then he ran into the forest for the hunt.

36-ϧAERIN RETURNS AND SAYS TϧINGS SϧE ϧAD NOT EXPECTED TO SAY

Deer had indeed been feeding by the Crescent Cave just as Maerin had foreseen, and whether she had seen it in a dream or a vision, or whether the wild journey upon the white stag's back had truly taken place, in this world or another, Maerin could not say, but several of the hunters made it a point to thank her, as if she had done something miraculous for their sake.

Robin was not with them. When she asked after him, Will said he had gone off into the woods with Juniper and would not return until the morrow.

"He will not harm the boy? Punish him?" Maerin asked, both alarmed and sheepish for leading the boy astray, and for disrupting what she now knew was their hunters' rite, old as the hollow hills.

"Hmph. More likely he'll blame you before he blames the little beggar," Will replied.

With that peculiar form of reassurance, Maerin's face fell. She turned away. She ate a portion of the kill that night, and went to bed in Robin's cave with Elgitha, who had been hysterical when she found her mistress was missing and equally hysterical on finding her alive, bruised and ragged from her flight through the woods. But with a venison steak in her belly and a sizeable

portion of watered wine, Elgitha fell to snoring long before Maerin did.

Despite her exhaustion, Maerin lay wakeful, listening for Robin's foot-steps. Questions jabbed at her brain like a barrelful of nails in a rickety wagon jostling to market. As she thought on everything he had said to her since their meeting on the Great North Road the day before, she realized she had misjudged him. He had promised not to harm her but she disbelieved him. All he did was try to protect her, in his own mysterious way. Now it seemed she could see, beneath his playful banter and his quick temper, the sincerity of his soul.

Yet what she had seen in the grove that was sacred to him was still difficult to accept, still strange and even obscene to her. Without question, Holy Mother Church would name it evil. But her feelings in the presence of the white stag were pure and holy, like a prayer—no, more powerful than her prayers. How could this be?

Perhaps she must pray harder then to Jesus, with more devotion.

An owl that could change into a woman—this was surely Witchcraft, or hallucination, unreal. Just the memory of Robin kissing that creature with undeniable, unspeakable lust made Maerin's body quake with fear and dis-gust. Yet Robin had kissed the hem of her own bliaut like a knight in a ballad. Was that evil? Had she become evil by association? Why did she feel blessed instead?

She finally dropped off to dreaming he came to her, knelt beside her, took her in his arms again and called her 'my lamb,' and just as he leaned close to kiss her lips as tenderly as one would lick the dew from a rose petal, a voice woke her.

The cave was in darkness; the fire had sputtered out. A tremor gripped her as she remembered her first panic-filled hours in the Crescent Cave. Then she heard Elgitha's steady breathing and a man's voice, "Maid Maerin?"

"Robin?" she whispered, coming completely awake.

"No, it's Will," came the answer. "Robin charged me to take you to Nottingham. We must reach there before first light. Come."

So. Robin wanted only to be rid of her. Well, she had caused him enough trouble, almost ruining the hunt. And why on earth would she want to stay? To live in a cave with outlaws? Unthinkable. There was nothing for her here. She could ask to be taken to Nuneaton, but the abbess was not free to open the gate to her. There was no refuge for her anywhere. Robin had not saved her from Coucy after all. Fate had merely twisted on Herself, coiling like a serpent; She had not changed Maerin's path. She would be forced to submit to the wedding. She must bear it. Had not the Lord Jesus suffered more?

With a shudder, she wondered if her visions of the night before had made her unfit to be a Christian. Somehow she had become entangled with a Pagan rite, more ancient than the mass. Did that make her a Witch?

Yet the Lady had come to her and called herself 'Mary,' among many other names, and Mary was holy. But then, could not the Devil take any form he chose, to tempt men and women to their downfall? The Church said the Devil often took the form of a woman. Or that all women were devils. It was too confusing. She could no longer think. She had not slept well in days. Perhaps she had been hallucinating everything. Perhaps even now she dreamed, and would wake to find herself in her cell at Nuneaton. Would that it were so!

But as she scrambled wearily out of the furs that covered the straw pallet and felt the cold cave floor beneath her bare feet, she knew this was no dream.

By dawn she and Elgitha were craving entrance to Nottingham castle. The gatekeeper let them in, not seeing the fleeting shadow that was Will disappearing down the road into the village.

⌘

Meanwhile, Coucy had scoured the forest looking for Maerin with twoscore men armed to the teeth and wary as cats, but he found no trace of Robin Hood. He found not even a shred of Maerin's clothing to show she had passed by. His failure only made him angrier and more determined to have revenge for his shame.

He had returned to Nottingham before dawn, roused an irritable Sheriff in his bedchamber and demanded more soldiers and provisions.

"Excellent, Coucy!" Reginald snarled. "You must find the brigand first, if you wish to kill him!" Reginald had slept poorly. He still reeled from the knowledge Coucy had revealed the day before, that the Hooded Outlaw Robin of the Wood and Robert of Loxley were one and the same man.

The outcast nobleman was a greater threat than Reginald had perceived. A nobleman could command authority, and he was a thief with a mission. That explained much of his behavior so far, from whom he stole, whom he chose to protect and why he went out of his way to foil the Sheriff of Nottingham. The Bishop of York was right after all. Loxley was a demon sucking the lifeblood out of Church and State.

By all the saints, what if Prince John should find out Reginald had lied about finding Loxley's body? He would swear he had been mistaken. That would be bad enough. He could lose his post for such a mistake.

Now the Hooded Man held Maerin and would no doubt demand the

lands of Loxley and Heaven only knew what else for ransom. The Church would never go along with it. What was one maid more or less when their wealth was at stake? But now Reginald's own wealth was at stake. Unless the wolf's-head could be stopped. But how? Reginald was at a loss to formulate a plan, especially with Coucy distracting him, pacing the room and foaming at the mouth with wrath and absurd notions.

Just then, the steward Aelfric and Anhold, the captain of the guard, limping still from the wound Robin had given him, entered and announced Maerin and Elgitha.

Haughty as a queen, bedraggled and soiled as a slave, Maerin brushed by them and stood gazing at her uncle and her fiancé. She wished she had pleaded with Will to let her stay in the greenwood, whether anyone wanted her there or not.

"Praise God, you are alive and safe!" exclaimed Reginald.

"Yes, I'm safe, in a manner of speaking. I go from one den of thieves to another."

Her uncle stiffened.

Coucy vowed, "We shall hang them all!"

"You must catch them first," observed Maerin, unconsciously echoing her uncle.

Coucy's lips curled.

"How in God's name did you escape?" asked Reginald.

"They released us."

"But ... why?"

Maerin laughed. "I don't pretend to know the mind of Robin of the Wood or any outlaw."

"Where is their hideaway?"

"I couldn't tell you. We were blindfolded," said Maerin. She pointed at a goblet of last night's unfinished wine on the table beside Reginald's bed. "I'm thirsty."

Reginald handed the goblet to her. She drained it in one long gulp and wiped her mouth with the back of her hand in an uncouth manner very unlike her.

Coucy fired questions at her. "Did you travel east or west? Did you feel the sun on your face or your back? How long from the main road to their encampment?"

"We travelled half of forever. Indeed, for all I know, we travelled in circles and they are camped under our noses. Well, now that we've paid each other our dubious respects, I'm tired, I'm filthy and I'm going to take a bath."

"But can you tell us nothing? These villains must be stopped!" said Reginald.

"'Vengeance is mine, saith the Lord,'" quoted Maerin lightly. "I suggest you leave their punishment to a Power greater than yourself. God alone knows where they are. You will never find them."

"Do you not wish to see these brigands brought to justice?" Reginald spluttered, puzzled by Maerin's peculiar behavior. Shouldn't she be fainting and hysterical? Why was she so in command of herself?

Maerin smiled and dimpled. "Were I to deliver Robin of the Wood to you, dear Uncle, could I name my own reward? I'd gladly set aside my whole dowry for the staying of my sentence to marry this Norman robber of whom you are so fond. Alas, I have nothing, neither the knowledge you seek nor any legal rights with which to barter for my liberty."

Reginald said, "You are half-mad with exhaustion. We will talk later."

But Coucy, cheated of his glorious dream of rescuing Maerin from the outlaws' clutches, declared, "I will avenge you, Maerin, and then you will speak of me with gratitude."

"A fine bit of avenging you have done so far, Monsieur," said Maerin, turning the force of her scorn onto Coucy. "You were not so forthright in the forest."

"My concern for your safety alone kept me from drawing my sword and fighting to the death!"

"Your death I would have observed with delight, Monsieur, as you well know. As it was, I count myself lucky to have been spared the sight of your nakedness as you crawled in defeat back to Nottingham."

Coucy's face burned with the memory of his humiliation. "Bitch! Our wedding night will teach you to sing a different tune, one I have taught many virgins to sing!"

"Enough of this," snapped Reginald. "You are fighting like children."

But Maerin cried, "How well I know the extent of your concern for me, Monsieur de Coucy! Your passion for my maidenhead is almost as sharp as your desire for my dowry. But the former is no longer mine to give you!" She did not know how those words had sprung to her mind and her lips, but she savored watching understanding dawn in their faces.

Reginald managed to whisper, "Robin of the Wood?"

"Yes!" Maerin laughed wildly. "Yes, he took me in the forest! Against a tree!" The looks on their faces filled her with a sense of glee and mischief she had not felt in many years.

"Oh, milady!" Elgitha believed her too. She knew nothing of what had

transpired with her mistress while they were separated.

"The fiend!" cried Reginald.

"I'll rip his flesh from his body with my bare hands!" raged Coucy.

"He has a member the size of a horse!" exclaimed Maerin. "And hard as an oak!" She laughed and twirled around the room. With her hair in a tangle, her torn and dirty clothes, a bruise on her forehead and dark circles under her eyes from lack of sleep, she looked more a Witch than a Christian noblewoman.

"Oh, milady! Milady! How could I have fainted and left you to his vile lusts? I shall never forgive myself."

"Oh, Elgitha!" Maerin giggled.

"You are wracked with fatigue and terror! You imagined it! You are lying!" accused Reginald.

"Whore!" shouted Coucy.

"Devil!" Maerin spat back at him.

"She was raped, you fool!" Reginald declared to Coucy.

"No! I gave myself freely! And happily, and with great pleasure! A pleasure your odious kisses could never afford me, Monsieur!" Maerin could scarcely believe the words she was saying, the dance she was dancing, the taunting, whorish tone of her own voice, and then she remembered the owl changing into a naked woman before her eyes, and Robin embracing the creature, his own naked body clearly filled with passion, and Maerin stopped dancing and stood wavering and silent.

Her uncle gave a frozen smile. "We'll see about this! Coucy, come!"

Coucy was too stunned to take offense this time at Reginald speaking to him as if he were a dog. He followed the Sheriff out of the chamber, but he said to Maerin in parting, "If this be true, if your virtue has been sullied—"

"By a man of my own choosing!" taunted Maerin.

"I will hunt down that thieving wolf's-head and skin him alive, and I'll hang his bloody body on the castle wall. And you! You I will fuck on the ground beneath it!"

He slammed the door behind him. Maerin sank to the floor and began to laugh and sob at the same time. Elgitha hastened to comfort her, anguish distorting her face. "Come, milady, a bath, as you said, and your bed." Elgitha crossed herself. "Oh, milady, forgive me for fainting! Though I'll never forgive myself, and your poor mother, may she rest in peace—"

"Elgitha, dear friend," Maerin cried through her tears, "you mustn't blame yourself for anything. It is all by the Lady's choosing. Yet I do believe I am moon-mad!"

⌘

In the Great Hall, Reginald poured them each a goblet of watered wine despite the early hour. "Augustin, stop pacing. My ward is lying."

"She is a harlot."

"She is a nun. She is hysterical. Let her rest and take one of those salt baths she is forever demanding. She will come to her senses."

"Her senses? Bah! She has none. True to her sex. By God, her virtue has been promised me! That can never be restored!"

"More important, her dowry remains intact. But I tell you, she lies."

"She lies like a harlot, in bed with a thief!"

"Drink, drink and calm yourself. There are ways of proving that she lies." Reginald sipped his wine, his eyes thoughtful. "Let's say I send for a leech from a distant shire. Someone who knows his trade but won't talk. Let me see. We could say you are a kinsman, and Maerin is your sister. You were passing through Sherwood on her way to be wed. The fiancé has demanded the examination. The leech will oblige, and you will have your answer. I swear if she is not pure, I will flog her myself."

"You'll not lay a hand on her!"

"Oho! Good! You are still her champion then! *À votre santé!*" Reginald raised his cup to Coucy.

"If anyone flogs her, it will be me," muttered Coucy.

"I tell you, she's lying. She would say anything to stop the wedding. She hates you."

Coucy threw his empty goblet to the floor with a clang, picked up the wine jug and drank from it heavily, then slammed it down onto the table. A tiny fountain of red spurted through the top. "No doctor will be fool enough to believe such a tale."

"I will pay him to believe it. Her face will be covered, her whole body in fact. A glimpse under the gown. . . he will never know who she is. Yes, you are my poor beleaguered kinsman, and you were beset by bandits. Your sister was kidnapped and held for ransom. Now that she has been returned, you must make sure the goods are undamaged. Ha! It's a good story. I could have been a *trouvère.*" The Sheriff polished off his wine.

⌘

37-OF DEMONS AND DOCTORS
STRAWBERRY MOON WANING, 1193

uy of Gysborne, once a knight of Lancashire, was not so different from other men, and since he was never the type to be plagued by nightmares, regrets or sudden inconvenient fits of conscience, he was, in a sense, the perfect product of his era.

But while some men killed in fear or in fury, in heat of battle, at command of the King or to save their own lives, and while some men raped only when their comrades did, as if to prove some mockery of manhood or as part of the spoils of war, and while some men plundered out of greed or subservience, when commanded to do so by their leaders, and still others killed and raped and plundered out of religious zeal, Sir Guy of Gysborne chose to slay at odd moments when the army had been bidden to let live, and he chose to rape when his comrades-in-arms were temporarily employed otherwise and not in the business of raping, and he enjoyed mutilating his victims so much that he had no need of the sanction of Church or King before he would indulge in it.

In short, Sir Guy did not march well in step with others. So despite being a pinnacle of achievement in bloodthirstiness, he was not rewarded, but punished by his peers. The escalating frequency of his rash and dreadful deeds caused his overlord to strip him of his title and estates, and thereafter the nobility shunned him. Then followed a period of two years in which he terrorized peasants and nobles alike in every shire from Cornwall to Cumbria. The remains of his victims littered ditches and dark woods in unsightly masses of tortured flesh, and his name was soon synonymous with the most evil of horrors.

Then he was caught.

A feather in the cap of Sir Reginald of Nottingham, for several moons he sat in a cell in Nottingham's dungeons and brooded and stewed in his own poisonous juices, raging at his Fate and wondering when that Fate would hang the noose around his neck. Childhood tales of the Morrigan, the Triple Goddess, Devourer of Men and Queen of Phantoms, flew through his brain

like flocks of black ravens promising death, but he laughed outright and cursed them all, and his guards said he was raving mad or possessed by demons, for he spoke aloud to invisible birds.

But this day the door of his cell creaked open somewhat earlier than usual, and instead of receiving the musty crust of stale brown bread and brackish water that made his daily meal, he was unchained from the wall, rechained at ankles, wrists and neck, and led hobbling forth, his eyes blinking unaccustomed to light, under guard of eight men with crossbows ready to shoot him through the heart if he made any attempt to escape.

"Now comes the noose," he thought bitterly, and wondered if it were better to flee and die quickly, with a bolt from a crossbow, rather than dangle above the castle walls and gasp his last while the villagers reviled and taunted him. But Guy of Gysborne had too much self-love to take his own life. He far preferred taking the lives of others.

While he wrestled inwardly with his narrow choices, he was led, not to the gallows, but to the Great Hall, where Lady Luck smiled upon him, gave him power to outrun ravens and a mission to achieve, and it was just the sort of thing for which he was best suited: the murdering and dismembering of a person, in this case, a fellow outlaw, Robin Hood.

Guy was well-fed and well-disguised, and set free into Sherwood, passing at the castle gate a leech arriving from Canterbury. Neither man was much noticed in Nottingham, for most of the townsfolk were in the main square, throwing rotten eggs at the jerking body of a petty thief, much scarred about the face during his stay in the dungeons, renamed Guy of Gysborne and hung by the neck until dead.

A prettier prison was Maerin's bedchamber, carpeted with bearskins instead of dung and straw, its stone walls softened by tapestries and the mellow glow and scent of beeswax tapers. Yet five maidservants were required to subdue Maerin, snarling like a ferret while they bound her wrists together and lashed her to the bed with her legs spread.

Elgitha, on pain of she-knew-not-what from the Sheriff, was forced to assist. She pleaded, "Milady, hold still, I beg you. It will be over in an instant. They should've sent a midwife, it were far more fitting. How can a man—ouch!" Her train of thought was interrupted by a violent kick from Maerin. "Oh, won't you confess that you lied, dear heart, and save yourself this shame?"

"I'll confess nothing to anyone ever, and if I'm forced to marry Augustin de Coucy, that foul, vicious, cowardly—he may get his hands on my money but I'll kill him before I let him touch me!" Maerin's screams were finally obliged to be muffled by a wad of sheeting stuffed in her mouth. A covering

of the same material was thrown over her like a shroud so her face and long dark hair would be hidden completely.

The doctor was brought in. The door was closed to keep out prying eyes. The doctor mopped his brow and gestured at the struggling figure on the bed. Elgitha pulled back the sheet from Maerin's legs and raised her ladyship's gown.

When he was done, he was shown into the Great Hall.

Reginald had already treated himself to several cups of wine and seemed senseless to the urgency of the moment, something which infuriated the man beside him, for whom an equal amount of wine served as an agitant rather than a sedative. This second man, to the doctor's eyes, was a figure mysteriously cloaked, his body covered in a long Saxon-style robe, his face hooded and in shadow.

The doctor bowed to both men.

"So, good leech, how is my poor kinsman's sister?" asked Reginald.

"Having made careful study," the doctor began, then seeing this was the wrong tack to take, he coughed and added, "careful to lay no hand upon her, as surely the handmaids will attest, it is my considered opinion—nay, it is more than an opinion, it is fact—"

"Get on with it," growled the cloaked figure.

"No man hath touched her," pronounced the leech.

"She is virgin, then," said Reginald.

"Unquestionably."

"You see, cousin? The thieves have let her go unharmed, having raped only your purse for her ransom!" Reginald chuckled.

"Shut up!" hissed the cloaked man. He advanced on the doctor. "Swear it on your life!"

"I swear it! By the Holy Mother, I swear it!"

"If I find that you lie, I'll have your head! I'll cast her off!" he shouted, swirling back to Reginald and cursing in his native tongue.

"Peace, peace, good cousin!"

Coucy turned back to the doctor. "And you touched her! Know that if it had not been necessary, I would have slit your throat for less."

"I never touched her, your lordship!" insisted the doctor.

"Ah, an expert! You see? He did not even need to touch her," drawled the drunken Sheriff with a happy laugh.

"Impossible!" said Coucy.

"I. . . used instruments, your lordship."

"Instruments." Coucy's black eyes flashed with malice and drink. He

nodded once and strode out of the room.

The doctor was sweating profusely, and it had little to do with the weather, for it was a cool night. God save him from such a clientèle! Rich merchants with gout and arthritis were his bread and butter. This place was not humble enough for his taste. Besides, he preferred to leave women's ill humours to midwives. But one could not disobey a summons from Prince John's Sheriff.

To his relief, Sir Reginald said, "You may go. Here is your payment." Reginald put his finger to his lips as he handed over a purse. The doctor mimicked him, promising secrecy, and bowed himself out of the room. He found his horse and rode at a gallop out of the courtyard and across the drawbridge, through the walled town and out of the town gates, down the lane to the sign of the Triple Horseshoe.

Several pints of dark ale soon soothed his nerves, but they also took the edge off his common sense, so that he was describing his errand to any who would listen. He finished by saying, "I never saw her face. Or his. He was said to be a kinsman of the Sheriff."

"Did the man speak with a Norman accent, by chance?" asked Bertha, the landlord's daughter.

"Oh, aye, he was Norman, of that I'm sure."

"Perhaps he is a kinsman-to-be, then," said Bertha with a knowing smile.

"I hear," said the butcher, "it was Robin Hood who took the Maid Maerin to his bower."

"He and his men don't go about raping women like common soldiers," said the landlord's wife, coming in with a plate of stew for the doctor.

"How would you know?" demanded the landlord, swatting her bottom playfully as she passed him.

The doctor put in, "I listened at the chamber door and heard a woman swear to her ladies that she gave herself to this Robin Hood with a will. But woman I saw was virgin as the day is long."

"I say, make her wed the Norman in a hurry, and give her dowry to the Sheriff. Life will be easier for us," the butcher declared.

"Nay, it's the ransom for King Richard, that's what's bleeding us dry," said a travelling merchant. "One girl's dowry won't cure that."

"True enough. Well, better the money go to Richard than his brother," muttered the baker.

"Hsssht!" Bertha said, for Prince John's spies were everywhere, and John himself was living in the castle above.

In the corner, a slouching hat pulled over his forehead, sat a man in the

clothing of a carpenter, nodding over his ale. "To the King!" he said softly, lifting his tankard.

"Long live the King!" chorused the others, and drank Richard's health.

Not to draw attention to himself, the carpenter only left the tavern after talk had wound on to other things.

⌘

Maerin paced up and down in her chamber. She wished she had a sword. Easier to hide a dagger than a sword, she thought, but she had lost her dagger in the woods. Her sewing scissors then! She would take them to her marriage bed and pierce Coucy through the heart before he could pierce her body with the dull dagger between his thighs. Then she would kill herself as well.

She fell to her knees before her altar, almost welcoming the pain of the hard stone floor as just punishment. How could she think of murder, of taking her own life, the worst sins imaginable, when she had sworn to serve the Lady? She prayed for mercy, seeing in her mind the lovely Lady who had hovered above the sea in her vision, seeing then the Horned One, the white stag upon whose back she had ridden away a night. She cried out to Mary and the white stag in the same breath, and shivered.

The Church called the Devil 'the Horned One.' Yet the power she had felt behind the face of the stag was love. Was she deluded, enchanted, mad? As the midnight hours and then the days wore away, she swayed between fear and love, her old faith and the new vision, like a spider on a web shaken in a storm. And in the path of that storm were as many thoughts of Robin, and of his kiss, that she wished now had been on her lips, as there were lace threads in her trousseau. Thoughts of the blonde woman he had kissed on the lips, who was his wife or mistress, made her vow to forget him, but she could not.

The wedding preparations went on in spite of her, while Coucy rode often to the edge of town and spent himself upon Dulcie.

He knew full well how tongues in Nottingham wagged and wiggled like ducks' tails about Maerin's rumored adventures with Robin of the Wood, and made much of Coucy and his men trudging naked through the streets, and Coucy's inability to woo or protect his own betrothed. He was a laughingstock, much as he had been in Normandy, and his frustration and anger burgeoned like weeds.

It was in Dulcie's bed that Coucy came to think, if Robin Hood were indeed a Witch, what better way to fight him than with the black arts? He himself had little patience for superstition and religion, but how else than by magic had Robin Hood evaded capture so long?

He told Dulcie he wanted her to cast a spell on Robin Hood.

"I know nothing of spells, milord."

"Of course you do."

"I swear I do not!"

He raised a hand as if to strike her.

"No, please, milord, you must believe me! I was taught only how to read the Tarot a little, never Witchcraft!"

"You lying little whore! You'll think of a spell against the Hooded Man or I'll beat you within an inch of your life! I'll be back tomorrow. See that you are ready for me."

She cowered in the bedclothes. "Oh, for pity's sake, help me, Lady!" she prayed when he left her, and wracked her brain for some chance comment she might have overheard from her old aunt or a midwife on how to banish pixies, some herb she might use, or some incantation. She prayed until she fell asleep, and it seemed the Lady heard her, for Dulcie dreamed of a grizzled old man in a hut in a wood, and when she woke, she remembered a hermit who lived near Leicester, who had trafficked in charms and talismans in the name of the Church.

When Coucy came again, she told him of the place. He threw her cloak at her and soon they were riding through the night toward Leicester. Before midnight they stood at the door of a smoke-stained cottage beside a sorry-looking chapel, face to face with a bent old hermit who, somewhat deaf and oblivious to interruptions, assured Coucy in a rush, "Yes, milord, I've holy charms, blessed by the Church, to open hearts and open locks, charms to drive away haunting spirits, charms against the toothache, the headache and the ague, a charm that wine wax not eager into vinegar, charms to carry water in a sieve, charms to find out a thief, charms to put out a thief's eye, a charm to find out a Witch—"

"I know the Witch. I want to destroy him."

"Ah." The hermit held out his hand.

Coucy put a couple of copper pennies in it. The old man shook his head. "Do you wish to kill the Witch or but give him the flux? Tell me, how has he harmed you?"

"He raped my wife."

"Ah, an incubus. Then he must be killed. Twenty marks, and his bones will turn to dust inside his flesh."

They settled on three silver marks and a charm to put out an eye, and Coucy promised if it worked, he'd be back for more, and if it didn't work, the hermit would not live long enough to regret it, and he cast a jaundiced eye on Dulcie, as if she would regret it enough for both of them.

The next night at midnight, Coucy stood in a crossroads and chanted five Our Fathers and a curse upon Robin Hood, and he drew upon the ground at his feet two ovals like eyes, thrusting his sword through them both. Then he rode home to wait for the next full moon, by which time the spell was supposed to take effect.

38-IN PRAISE OF ROBIN GOODFELLOW

Much wiped the grease of the evening meal from his fingers and his knife, picked up a yew branch and tried to imitate John's deft movements as he expertly scraped wood shavings from what would become a bow. Tuck lay half-asleep against the great oak with his hands clasped over his well-fed belly. Allan's face was half in shadow, half aglow with firelight as he plucked haphazardly at his harp in search of a new song. Prim was showing Aelflin a cap she was sewing for the baby, and Robin was telling Juniper the story of how the Stag came to shed his antlers every year, a story Allan suspected he was making up as he went along, for it shot aside from its main thread and then zipped back again like a ball of yarn tossed in play by a litter of cats.

Will, wearing the garb of a carpenter, with a false brown beard and a wide-brimmed hat to cover his red hair, slid into the circle of light. He hunkered down beside Robin and nodded hello to everyone. A chorus of greetings and grunts welcomed him home.

"And how is your Anne?" asked Robin.

"She gave me this." Will pulled from his pocket a band of red silk with a red and pink rosette upon it.

"A scarlet garter! That will look pretty upon your thigh," joked Robin.

"It's prettier on hers," said Will with a grin. "She bids me wear it as a token to protect me."

"How much sweeter than a lady's sleeve!" rumbled Tuck.

Allan said, "I dub thee Knight for the sake of your lady fair! Your name shall be Scarlet instead of Scarlok."

Prim only arched an eyebrow. She guessed the garter's real meaning, for it was a secret symbol of gentry who pursued the occult, and she thought that Anne must be instructing Will in other arts besides those of love.

"You were gone long enough," said John.

"I travelled with Anne and her family to Nottingham to see their kin. And while I was there, I heard the maid Maerin sickens and pines away for love. But not for her betrothed. For another. They even sent for a leech, for she declared her lover boffed her in the greenwood like the Goat-God Pan."

Allan laughed, strummed a chord and sang softly, "The goatherd and the lady went hmmhmm in the land. Too-ra-loo-ra-loo-ra-lay, and she took his staff in hand. . . . Hmm."

Robin frowned. "Is she truly ill?"

"Over you, Robin. She swore you took her maidenhead."

Robin's jaw dropped. Sudden fury flung words out of him before he could bite them back. "That—that bitch! I should have known! Playing the martyr! Me, sully her oh-so-noble virginity? Never! She's the kind a man would have to marry neatly in a Christian church or take by force, and by God and Goddess, I'd never do either!" He got up as if he would stomp away from the fire, but instead he just stood there clenching his fists with rage.

Allan plucked an arpeggio and sang, "I'll never, never marry, no, I haven't any hmmmhmhmmm." His voice trailed away.

"To think she accused me of rape!" Robin cursed.

"That'll add another fifty marks to the price on your head, and the hangman's noose for certain," observed John.

Tuck said, "Whereas, in the Holy Land, they simply cut off your—"

"No, no, no," said Will, savoring the moment, "it's said in the town that she said that she gave it to you. Freely."

A slow smile spread across Robin's face. The men whooped and hollered. Aelflin and Prim exchanged dubious looks.

Will added, "But that she proved a liar."

Everyone laughed and the butt of Will's complicated joke shook his head and sat down again.

Allan sang, "The lady proved a liar, and the lad he proved a hmmhmm." He warbled in fits and starts, piecing words and a tune together while a flurry of jokes went around at Robin's expense, until at last the minstrel strummed a more confident chord and began to sing.

> "Oh, good Sir Thief," the lady said,
> "I languish in my sickbed.
> It seems that I imagined you
> Did steal away my maidenhead.
> And oh, it was delightful,
> With a nonny nonny hey,

> And I wish that you would marry me
> And roll me in the hay.
> Tra la lie dee-eye dee-dye dee-doe,
> You're such a merry good fellow!"

> "No, I'll never, never marry,"
> Said the brave and handsome wight,
> "I'll ever seek a maidenhead,
> My bow must be strung tight
> By a young and blushing virgin,
> A lass who's had no lovin',
> Yet I will never tarry there,
> I'm every maiden's champion.
> Tra la lie dee-eye dee-dye dee-doe
> My name is Robin Goodfellow."

Encouraged by the snickering and guffaws of the others, Allan rose and danced mawkishly around the fire, imitating first the lady, then Robin.

> "Oh please, Sir Thief, I can't forget
> That vision of your manhood,
> A mighty staff so firm and proud
> Emerging from its tender hood,
> Yet I'm a pious Christian
> And a noblewoman owning land:
> I'll only give you sheath for sword
> If you give me a wedding band."
> Tra la lie dee-eye dee-dye dee-doe,
> But thus replied the good fellow:

> "'Tis true my life's a burdened one
> With every breast my pillow,
> A beleaguered knight a-wanderin'
> Upholding my wee arrow,
> Yet I may never rest until
> Cock Robin crows his final crooooow,
> For I have vowed to serve anon
> The name of Robin Goodfellow!
> Tra la lie dee-eye dee-dye dee-doe,

The name of Robin Goodfellow.

"Maiden after maiden
Lays her wreath upon my lance.
I joust at every mattress
In the field of sweet romance.
And I'll never, never marry
For I shall not break my sacred vow!
I daily give my life and limb
In the name of Robin Goodfellow!
Tra la lie dee-eye dee-dye dee-doe,
My name is Robin Goodfellow."

The lady fell upon her knees.
"I beg you, Sir, for mercy.
I cannot sleep nor eat nor drink
For thinking of indecency,
Yet all the Lord's commandments do
Demand I take no lovers.
If only you will marry me
And forsake all others."
Tra la lie dee-eye dee-dye dee-doe,
"But no," replied the good fellow,

"I'm sworn to succour and fulfill
Every woman's wishes.
I multiply life's pleasures like
Dear Jesus' loaves and fishes.
'Tis meet to make us merry,
'Tis not meet to marry only one,
So merry meet and merry part
And merry make 'til day is come!
Tra la lie dee-eye dee-dye dee-doe,
For I am Robin Goodfellow."

By the end of the song, Allan had a full chorus on the 'tra-la-las,' and every-
one was clapping or slapping their knees in time to the music. They went off
to bed smiling, especially Allan with Aelflin.

But the silly song annoyed Robin, though he pretended to enjoy it. It

was perhaps too true. Yet did he not honor the Goddess in every woman he lay with? To restrict himself to one wife would honor the Lady less, he told himself with a little laugh.

But laughter stopped at thought of Maerin. Had she truly spoken of him as her lover? Of course not, he told himself; it was a yarn spun for a joke. Will was taunting him. She had shuddered with revulsion at his touch the morning after her vision. She loathed him for the landless, outcast, Pagan thief that he was. He had spared her his company, letting Will take her back to Nottingham. Let her marry her Norman knight. She would be content enough. She had been brought to Robin once by the grace of the Lady, for the sake of the hunt, and that was the end of it, he told himself.

Yet he did not want to believe it.

39-THE CAULDRON OF CERRIDWEN
HONEY MOON CRESCENT, 1193

Out of the corner of her eye, Sister Gabriel thought she saw a raven flying past, but when she turned her head sharply to follow its flight, it was gone. Perhaps it was only the corner of her own black veil, fluttering in the slight, hot breeze. Let it be that, Merciful Lady, she thought; let not the symbol of death cross my path this day. Then she stumbled. Beside her, Sister Luke, a raisin-faced nun in her late forties, took her by the arm and said, "Steady, child," then felt her brow. "Lord in Heaven, you've got a fever now. We must stop and rest."

"But we're not even out of Sherwood yet!" cried Sister Jacob, coming up behind them.

"And we must get out of it," Sister Mary-Luke urged.

"Surely we can at least make Castleford," Sister Benjamin said.

"It's not much further," Sister Gabriel murmured.

"You cannot go that far. You are too ill," said Sister Luke, sounding more angry than concerned.

"But we must. I can do it, Sister." Sister Gabriel straightened her shoulders.

The others nodded, looking about for bandits and wild beasts.

Sister Mary-Joseph fretted, "This is what comes of such poorly-laid plans!"

"What else could we do?" asked Sister Jacob.

"Our Lady is with us. We will not come to harm," said Sister Gabriel.

"Do not speak so, as if you were a sibyl or some obscene mouthpiece of an oracle! You are too full of pride, Sister Gabriel."

"I'm sorry, Sister Luke."

Sister Mary-Joseph begged, "Please, let us hurry!"

They pressed onward, little knowing that behind them and on either side of them crept a scattering of silent men. As the nuns wound around a bend in the road, they saw three ragged men before them, armed with daggers and crossbows, and demanding money.

"You'll get no gold here!" said Sister Luke. "We are but church mice—nay, poorer than they, for we have eaten our last crumbs of bread, and have nothing even to break our fast in the morning. So be off with you! You may ply your evil trade to more effect elsewhere on this road, and may God forgive you!"

One of the men leered, "We'll settle for other payment then." He ripped off Sister Benjamin's veil and wimple, and cut at her robe with his dagger. She screamed. The air hissed and the would-be rapist sprouted an arrow in his ear. Sister Benjamin screamed again and Sister Gabriel fainted, as much from her fever as from shock at the sight of all that blood. The two other thieves took arrows in their hearts. Before the villains slumped dead to the ground, the nuns were surrounded by leaf-garlanded, mud-daubed men. Now Sister Benjamin also fainted. Will caught her as she fell and gently laid her down, covering her torn, blood-soaked habit with her veil.

Robin knelt over the fallen Sister Gabriel. He pulled out a leather flask and poured water over her face, then took a wineskin and poured a bit of red wine between her thin, fever-chapped lips. It dribbled down her cheeks. Her skin was marked from a childhood pox. She had a hooked nose, a receding chin, eyebrows so pale they were almost invisible; a most unfortunate face for a woman.

He whispered, "Constance!"

Sister Luke said, "What manner of men are you? I know not whether to thank you or fear you."

John answered, "Thank Robin first. He has a soft spot for women."

Sister Benjamin, coming to and hearing the name 'Robin,' fainted again. Sister Luke was not reassured by John's words either. But Robin was gathering Sister Gabriel into his arms, saying, "We must get her to Prim at once." He made for the woods alongside the road.

"Unhand her!" commanded Sister Luke, chasing after Robin and slap-

ping him about the head and shoulders. "Thief! Devil! Would you rape a sick woman?"

Robin shrugged off her blows and said, "Is this not Constance, once of Cheshire? She is my distant cousin."

"She is no one's cousin now, nor daughter, nor wife. She is the bride of Our Lord Jesus Christ."

Robin growled, "Call her what you will, while you chatter like a magpie, she fades. I know one who can heal her."

Will lifted Sister Benjamin, and seeing the nun's pretty blue eyes flutter open, he muttered something reassuring in Gaelic. She understood nothing but the tone of his voice, and relaxed in his arms.

Meanwhile, Tom was saying, as he herded the nuns off the road, "Quite the cockhorse, isn't he, your Lord? Look at all his pretty brides!" And he winked at Sister Mary-Joseph, to her horror, before he blindfolded her.

<center>⌘</center>

Prim kept Sister Gabriel in her own cave, treated her with compresses and infusions, and bathed her brow endlessly with cool water, aided by Aelflin and the other nuns, who were bidden by Sister Luke to avoid the men as much as possible. But they worried so much whether they would leave there alive that Sister Luke finally said, "Would they nurse Sister Gabriel back to health just to kill her? Use your heads, Sisters."

But Sister Mary-Joseph whispered to Sister Jacob, "They are Witches! They are fattening us up to eat us!" They barely ate and woke shaking from nightmares two nights in a row.

The third day, Sister Gabriel's fever broke. She was able to sit up and agree that she could manage a morsel of food. Prim left to fetch some soup from the cauldron by the oak.

But instead of Prim returning, Sister Gabriel was startled when a lean, dark-haired man entered with a steaming bowl, knelt beside her and fed her spoonfuls of savory broth, waiting patiently whenever she coughed or sneezed, as if he didn't mind the signs of her illness. He smiled at her and his eyes sparkled, and her heart began pounding, for she thought he was the handsomest man she had ever seen, barring one. Then she thought, this is the same man. Had her fever returned? Did she hallucinate, or dream, or see the truth?

She murmured, unsure of herself, "Robert of Loxley."

"At last you know me! I am called Robin now. Robin Wood, Robin Hood, Robin Good." At the sudden anxiety in her eyes, he said, "But you must call me 'Cousin' and have no fear of me or anyone here. You are safe,

among friends. Cousin Constance! I have not seen you since—I cannot re-member!"

"I remember."

"You were barely more than a child."

"I remember." She did not say she remembered with a girl-child's heart entranced with a much older boy who hardly noticed her except to tease and taunt her.

"How is it you've become a nun?" he asked.

She plucked at the furs that covered her and an old bitterness slipped off her tongue. "How else? I could have lived alone, growing older and uglier every day, with no dowry to speak of. My father's fortunes were dwindling. Then he died on the way to join King Richard on Crusade and ... well, there was nothing left for me."

"I am sorry to hear it." His eyes were filled with concern. She was un-used to seeing such a look on a man's face. Certainly her father and brothers had had no time to spare for a little girl, especially one as ugly as she. Even her mother had shown her disappointment in the ugly daughter that sprang from her womb. For a moment, neither of them seemed to know what to say. Then Robin offered her another spoonful of soup, but she shook her head. He set the bowl down on the hard-packed earthen floor. "I remember you foretold I'd sail across the sea one day. This was long before King Rich-ard declared the Crusade. Before he was King, in fact."

"Did it come to pass?"

"It did." He did not want to speak more of the Crusades. He always grew angry and he did not want to frighten her. Besides, she had her own sorrows over it. "Is this the only future you saw for yourself? To be a nun?"

"No. I could have stayed in the village that belonged to my father's estate. The new lord would have allowed it. Until one day his child caught the whooping cough, or someone's laying hen stopped laying, and I'd be called Witch and hung by the neck. Kirklees Abbey seemed a better choice. But you used to call my foretelling mere tricks and lies. You laughed at me."

"I was even more of a fool then than I am now, if you can believe it!" He smiled broadly.

She gazed wordlessly at him, her bitter look softening. So this, her hand-some cousin, was the brigand Robin of the Wood. She had heard that name, and outrageous stories of him, never realizing, never Seeing. "And how is it you are become an outlaw, Cousin?" she asked, her voice sounding harsher than she intended.

He did not seem offended. He shrugged. "A tale for another day, when

you are feeling stronger." He patted her hand.

She wanted to grasp that hand, to reach out and stroke his lean jaw, to trace the lines of learning in his palms, to run her fingers along the blue veins that webbed his forearm. She forced herself to look away from him. Her skin prickled; the fever was returning.

To her surprise, he leaned forward and kissed her lightly on the forehead. "Now tell me why five nuns travel alone on foot so far from their abbey. It is much too dangerous."

She was trembling so, she barely heard him. When had a man ever touched her with any tenderness? His gentle kiss, his smile, the male smell of him, and his low, man's voice made her whole body ache. It was a far cry from kissing the ring of the Bishop, she thought wildly, and tried to summon her wits to answer his question. A fluttering at the edge of her vision, like the wings of a caged bird struggling free—she turned to look, but it was only a black shadow cast by the firelight.

"Cousin?"

His voice seemed to come from far away. Was it the fever returning, or a trance? She fought it. She did not want to see what would become of her cousin, or of herself; not now; not ever.

"We needed money," she managed to say, "and went begging in London. Our benefice was taken away and the papal legate would not answer our letters, so we went to see him." She coughed, then sneezed and wiped her nose on a rag, and thought what an ugly sight she must make. She straightened her shoulders and did not hide her face. "Our Lady was merciful, for Sister Luke's tongue is quite handy, as you may have noticed."

He laughed.

"Any road, we were granted a reprieve."

"Who could take your benefice? Was it not given in perpetuity?"

"Oh, the intrigues in the Church!" She shook her head. "The Bishop of York coveted our lands and tried to turn us out. He tried to discredit the abbey, accusing us of immorality."

"Like Heloise and the Abbot Suger."

She frowned at the comparison, for the famed Heloise was reputed to have been as lovely as she herself was not.

Robin leaned over and kissed her forehead again, like in a Faerie tale the son of Oberon with just such a kiss turned a lowly hedgehog into a phoenix, arising from the flames of passion, reborn, waking the beauty within her until she was dizzy with it, and wanting to fly away with him to some impossible place.

He was saying, "I'm sorry, I've tired you. I'll leave you to your rest."

She clutched involuntarily at his hand, but mercifully she was unable to speak, her throat was so sore. She had another fit of coughing instead.

"I will return later. If there is anything you need or desire, you have only to ask." He let her hand rest in his until she closed her eyes and he thought she fell asleep. Then he laid her hand down, tucked the fur carefully around her and left, not knowing how his touch brought tears to her eyes.

⌘

"Now you have another choice," said Robin a week later as they strolled together through the ravine. He was showing her tiny garden plots, new huts covered with thatch. One was for Aelflin and Allan and their baby, when it came, another for their blacksmith. "Ours is a crude life, but here the word 'Witch' means Wise One, Healer and Seer. You'll never be called so without honor. And your skill is needed."

She stopped at the edge of the silvery stream that meandered through the ravine. How precious to her that he had asked her to stay! And how impossible. Her way was like the stream, she mused, wandering half-hidden by weeping willow fronds and nettles, with brief moments of peace, as when the water lay still in a pond sparkling in the light, then flowing away again, joy out of reach.

The trickling song of the water grew to a rushing in her ears. There is a waterfall nearby, she thought, and then the flecks of light upon the water leaped into the sky and spread, catching the forest on fire, and a wall of orange flame descended on her. Fear filled her heart, fiery sparks rushed in sheets past her feet, smoke filled her lungs and the sky was blackened with a pall of acrid fumes until day became night. A voice came through her, someone else's voice, she knew not whose or even whether she spoke aloud, and it said, "Flames like a storm. You may slow them but not stop them. The burning … the burning times come."

The vision wavered and was gone. She was in the quiet, narrow valley again, with the noonday sun streaming down, the steady sound of the smith's hammer, the birds twittering, and all the world as joyful and new as a baby's smile.

Robin was staring at her.

"Did I … did I speak?" she asked, trembling. She hated when the Sight came on her so strongly, unbidden. She never sought it anymore, but it came in spite of her.

He shook his head, as if repeating her words would give them power. "There is no future that cannot be changed by the grace of the Lady and the

Lord, and the strength of our will blessed by Them. Stay here. Your Sight is a gift. We need you."

"No." Her abruptness surprised them both. She went on, faltering, "I have accepted the Christian faith. There is good in it, Robin."

He snorted. "Aye, there's good in it, as in any faith. They steal from the old and claim it as their own."

"Perhaps. Does it matter? So they call the Sacred Chalice the Holy Grail, and the bread of the Grain God Lugh the body of Jesus Christ, and the wine of the Goddess His blood. The same mysteries, by different names. Does it matter? The source of all power is one."

"And what of their other teachings, that the flesh is sinful, that the Earth, to which we owe our lives, is evil? That women are to be reviled and suffer in childbirth? That to eat of the Tree of Knowledge is also a sin? Would you have our children's children swallow their whole potion, honeyed poison and all? You are blind if you think evil will not come of their beliefs."

"Do you so hate the Christ?" she asked, fearing for his soul, fearing that perhaps the Church was right, that Heaven was a place of clouds and angels, and Hell was eternal flame and torture, and Robin might end in the latter for his beliefs.

"It is not the Anointed One I hate," he said. "It is the Church, that says Jesus was the only one to be so anointed. The Church, which seeks to profit by twisting the truth, destroying our wills, stealing our freedom, crushing the soul of life! Look at the power and greed of the Pope! Look at the evil done in Outremer under the banner of Christ! Look at your Bishop of York!"

"He is but one man."

"I have chosen my path and will follow it to the end, wherever it may lead. Would you help their cause, rather than mine? When in truth they are against you, and me?"

"You are wrong. They've given me a haven."

"A hiding place! A prison!"

Tears started in her eyes, for his words rang with truth. She had run away from the world. Luckily the abbess had not questioned her too closely on this score when she took her vows. She said, "Druids often spent their lives in study and contemplation. It is not so different."

"Does the Church encourage and respect your prophecies?"

"Of course not! And I'm glad! It leads to madness! It serves no one!" Her tears dried in her eyes, uncried. "The course of life cannot be changed by merely knowing it."

"You think not? I don't agree. Everything changes in the Cauldron of

Cerridwen. And it is up to us to tend the fire and stir the broth."

"We have no right to tamper with God's will!" She straightened her shoulders. "I have chosen my path also, Robin. And I fear you march against the tides."

Robin struggled not to lose his temper. He saw the tears starting in her eyes. He regretted every teasing word he had spoken to her in their youth and he hated to cause her anguish now. He had said what he could, perhaps too much. She could not, would not hear him. Now he must keep silent. So often he spoke without thinking and hurt those he cared for the most: his father, Maerin—yes, Maerin, who was frightened of him, who could not bear his presence.

"So be it," he said, and walked away.

To her, his words were like a knife cutting the cords of their friendship.

She was so tired. She could not face walking back along the stream toward Prim's cave, passing by other people, who would stare at her, and joke about her ugliness behind her back. She lowered herself weakly to the ground beneath the willow tree and listened to the leaves whispering in the warm breeze. They seemed to be telling her to sleep, to take her ease.

But I must leave tomorrow, she told herself. She would tell Sister Luke that she felt well enough. A lie, but she would confess it to the priest, and he would tell her as always to say ten rosaries and an Act of Contrition, and so she would be absolved, and when she died, she would go to Christian Heaven, if it existed. It did not matter. It was in this life she needed Heaven. She longed for the quiet of the convent and the absence of the cruel eyes of men.

She had spoken truth to Robin, had she not? Was it lying, to withhold part of the truth? Should she confess the omission to the priest? But she could not bear to speak of her shameful lust to any man, even a confessor. She could never tell Robin that she could not bear to be near him, that her flesh and her heart, even her soul burned with desiring him, and suffered in misery knowing he would never feel the same.

She had seen that much of her future—another sin for confession, all this prophesying—and knew her body would never know the joy of a man.

She would study healing. Already she assisted in the herbarium at the abbey. The smell of the earth in the garden and the fragrant herbs, freshly picked and drying, soothed her. She closed her eyes, and did not look to see the many strands in the web of her life, for she followed the one that led to the convent at Kirklees. Yet one or two, thin and new and wavering, wound away to mist, and who knew what love or pain or fortune might lie at the end of those? She was afraid. She did not want to See.

In the early morning, the black-robed nuns flocked to Prim's cauldron and accepted tin cups of thin porridge. Harald, Tom and Will, disguised as soldiers, waited to lead the nuns out of Sherwood and guard them to home. Prim stoked the fire and wondered where Robin dawdled and why he did not come to wish his cousin farewell.

Sister Luke patted her mouth dry with her sleeve and said, "It is time."

Sister Benjamin announced, "I am not going with you." Then she looked toward Will, with unmistakable yearning. He blushed crimson.

Aghast, Sister Luke muttered in her ear, "You are bereft of your senses, child! Would you renounce your vows to live in sin with thieves and Pagans?"

"I shall stay," the girl said.

Now Will went pale. He was promised to Anne! What was this girl thinking, darting sultry glances at him? She was a nun, for pity's sake!

Robin appeared then. With a sly glance at his friend, for he had overheard everything, he said, "You are welcome to stay, Sister Benjamin. Is she not welcome, Will Scarlet?"

Will swallowed hard.

"You are all welcome," declared Robin, spreading his arms wide as if to embrace them and the whole valley. "We will teach you how to worship under the sun and the stars and the moon in plain sight of the Lord and Lady of Creation, instead of hidden in a church as if you were afraid your own God might see you."

"Blasphemous, evil creature! God knows, we are God-fearing, and proud to be so," said Sister Luke.

"Pride goeth before a fall, Sister," said Robin with a grin.

She crossed herself and said, "Even the Devil may quote Scripture."

Robin laughed and dipped a ladle into the cauldron.

Sister Gabriel bent close to Sister Benjamin's ear and whispered, "Will Scarlet is betrothed."

The girl flushed and whispered back, "How do you know?" Yet she knew it must be true, for Sister Gabriel often seemed to know things which others never guessed. "I will lie with him just the same, if he'll have me. Is it not more than my cold cell and my narrow bed and my crucifix may offer?"

Sister Gabriel was about to protest, to speak of the profounder joys of the spirit, of the obligations of keeping one's vows, but one more look at the girl's face, the clear skin, the long eyelashes, and the rosy lips, taught her otherwise. Though jealousy twisted in her, she knew this was a girl with no dowry, like herself, with three older sisters and no prospects despite her beauty,

who had come to Kirklees against her will. Sister Gabriel cleared her throat, which was still sore from her illness. "Then stay," she said, "and seek what you desire." She did not add what she knew the girl would find, for was it not both joy and heartbreak, any road? She turned and took the blindfold dangling from Tom's hand and began to tie it over her own eyes.

Sister Luke sputtered, "It is not for you to say, Sister Gabriel. She must get dispensation from the Pope. She must come back with us, and make her request of the abbess, and sign the papers."

"Then you will be the one to drag her along with us, for I will not," said Sister Gabriel.

"Insolent, prideful vixen!" Sister Luke made as if to strike Sister Gabriel, but Robin stepped forward and took the blow on his forearm instead. Behind her, Will made a face at Robin for his meddling, unseen by the pretty Benjamin, who was already taking off her wimple, shaking out her short-cropped golden hair, and announcing her name was really Honorine.

With a last curse upon her willful charges, Sister Luke submitted to her blindfold.

On his return from Kirklees, Will avoided Honorine and spent a great deal of time at Snaith. Thus spurned, Honorine shifted her attentions with disconcerting alacrity to none other than John Nailor, who was flustered and awkward around her, having had little experience with such pretty women in the past. He was subjected to a heavy dose of teasing from his friends, and he went hunting every day just to avoid not knowing what to say to her.

It was not long, however, before she taught him that he did not need to say much.

<p style="text-align:center">⌘</p>

Sister Gabriel lay with her arms splayed at her sides in the sign of the cross, her face pressed against the cold floor of the chapel, tasting the soap-scoured stone with her tongue as she named her sins before her Sisters and the Reverend Mother. It was her first time in several weeks to do so, for her fever had come back in full force during the return journey, and she had lain ill in the infirmary for some time before she recovered enough to dress herself, stumble along the silent cloister and return to her duties.

She coughed and continued reciting her list of sins, for after all this time it was very long. "I accuse myself of not encouraging Sister Benjamin to come away with us. I accuse myself of leaving her in the hands of outlaws." She could hear the horror of her Sisters in the silence. "I accuse myself of being rude and lying to Sister Luke, saying I felt well enough to travel when I did not, and I accuse myself of inconveniencing my Sisters by falling ill

twice. I accuse myself of speaking with the tongue of a serpent and the voice of an oracle, and of being prideful and obstinate in my refusal to cease. I accuse myself of arguing with Sister Benedict about the meaning of the Scriptures, when my betters have greater knowledge than myself. I accuse myself of twice speaking during the Grand Silence. I accuse myself of jealousy of another Sister's beauty. I accuse myself of self-pity." By now she was crying and trying to hide it, but relentlessly she pursued her own faults. "I accuse myself of eating a larger portion of cheese than I really needed on the Sabbath, and I ... I accuse myself of having lustful thoughts of a man and terrible wanton dreams of him, may God forgive me!"

Sister Gabriel's penance was commensurate with her sins. For a month, she was not allowed to sit at table with her Sisters at meals, but had to eat her portion crouched like a dog on the floor by the door, and the other nuns stepped over her as they entered and left the refectory. This was designed to teach her humility. She was forbidden to speak except in prayer, in order to destroy the demon that controlled her tongue with foretellings. She was given a long, many-stringed knotted scourge to be used twenty times on each side of her naked back on retiring and rising each day while reciting the Lord's Prayer, to drive out the lusts of her body.

Yet despite these efforts to perfect herself through the grace of God, for a long time she was still subject to lewd and passionate dreams of Robin, and she forced herself to confess them so many times, albeit without mentioning his name, that eventually the abbess sent for a priest to exorcise the incubus that defiled her in the night. This was done in great secrecy in order to avoid inciting further harassment against the abbey from the covetous Bishop of York.

The officiating priest, left alone with Sister Gabriel, his head filled with rumors of the indecencies of Kirklees Abbey and his loins filled with irrepressible urges, took advantage of her in such a way that her hymen was left intact. She was given to understand that this was part of the exorcism.

After that, Sister Gabriel was calmer, for she thought the pain she had endured purified her. She began to dream she made love to Jesus instead.

"Truly I am the bride of Christ, and I desire no other," she would think upon waking, with tears of happiness in her eyes. But for some reason, these dreams slipped her mind during the day, and she never confessed them to anyone.

⌘

40-THE DEVIL IS LOOSE
HONEY MOON WAXING, 1193

Coeur de Lion stood trembling with repressed energy and a recurrent ague, keeping watch through a narrow barred window in an otherwise pleasing chamber in a high tower overlooking the German hills. Wheeling hawks speckled the white clouds that freely roamed the summer sky, boughs of lush greenery tossed in the unfettered wind, dogs were unleashed to run down pheasants, even the peasants sweated in relative freedom in the fields, and as the Lion Heart watched this veritable orgy of freedom, there arose in him a surge of anger so great that he almost smashed his fist through the windowpane. Instead he spun on his heels and grabbed his lute, quelling the urge to throw it across the room and smash it into satisfying pieces. He knew he would miss the instrument when it was broken, having destroyed more than one in similar fits, so instead he strummed it with somewhat more force than necessary and let loose with a lament he had penned not a moon since.

> Feeble the words, and faltering the tongue
> Wherewith a prisoner moans his doleful plight;
> Yet for his comfort he may make a song.
> Friends have I many, but their gifts are slight;
> Shame to them if unransomed I, poor wight,
> Two winters languish here!

> English and Normans, men of Aquitaine,
> Well know they all who homage owe to me
> That not my lowliest comrade in campaign
> Should pine thus, had I gold to set him free;
> To none of them would I reproachful be—
> Yet—I am prisoner here!
> This have I learned, here thus unransomed left,
> That he whom death or prison hides from sight,

Of kinsmen and of friends is clean bereft;
Woe's me! but greater woe on these will light,
Yea, sad and full of shame will be their plight
If long I languish here.

He growled and set the lute aside, stood, paced the room, then sank down on
the bed and buried his head in his hands, a gesture of desolation he never
showed anyone, not even his closest comrades, certainly not his captors.

Word had come to him this morning that the King of France was on his
way to see the Emperor Henry VI, here in this palace. There could be only
one reason King Philippe was coming: to bargain for custody of Richard and
then use him as a royal hostage against England, the Aquitaine and Normandy.

Often in the late hours of imprisoned nights he had feared to meet his
death in the hands of his Austrian captors, then the German ones. Yet how
much more ignominious to die in a French prison! To even set foot in one,
be it palace or dungeon! To allow his old rival and one-time friend Philippe
such a victory was unthinkable. And by God's legs, well he knew his own
brother John conspired with the Parisian king.

He must find a way to outwit them. But wrangling and subterfuge and
spying, for all that he excelled at it, drove him half-mad. Better the battle-
field, with his sword and mace in his fists and the dust of the desert sands
blowing so harshly it chafed the very skin from his sinews and made of the
world a mirage that was, even so, more substantial than mere words. Nego-
tiations, diplomacy? Nattering and chattering. These conniving kings and
emperors would never dare to face him on the field! His own father never
fought a battle in his life, so far as Richard knew, but had his marshals and
soldiers do it for him. This was why Richard inspired such fear in his enemies
and such loyalty in his troops. Unlike most rulers, he charged into battle
beside his men and himself could do damage worthy of a whole tribe of
screaming blue-painted Picts.

Would that he had such a tribe to win him free now!

Richard swore under his breath and began pacing the room again. He
walked the equivalent of several leagues before night fell, his evening meal
was brought and he feigned merriment in toasting his jailers with the
Emperor's Spanish wine.

Despite the wine, he lay awake most of the night, struggling to devise a
plan, praying for aid, confident that somehow God must hear him. He was
an anointed king. He ruled by Divine Right. God could not fail him.

By dawn's light, he knew what to do. He sent three messages, for he was

allowed to communicate with his family and certain of his subjects in order
to expedite his ransom. One letter went to his mother warning her of the
impending danger of Philippe's visit, one went to Longchamp similarly
phrased, and one was addressed to his royal warden, Emperor Henry VI,
seeking an audience, to be delivered as soon as the Emperor woke.

Then he wrote five more letters, addressed to five of the Emperor's
most unruly barons, each one signed by his own hand, and awaiting either
the Emperor's signature and waxen seal, or the fire in the hearth if Henry
liked not the contents. But Richard felt confident he would receive Henry's
favor. His plan was sinfully clever and he thanked God for it.

He dressed in the best clothes remaining to him and breakfasted lightly.
As before a battle, his mind seemed more alive than if he had slept peacefully
the night through. But now he could only wait upon Henry, as he had done
for months, and this waiting strained his muscles and made them ache and
tremble.

An hour passed, then two. At last the sliding of the bolt at the door
roused him from his reverie. He stood at his full height and pride to confront
his guards. He smiled grimly when they said they came to escort him into
the Emperor's presence. His plan was set in motion.

A fortnight later, Prince John Lackland, who styled himself King John,
in his mind if no one else's, received a brief and enigmatic message from
King Philippe, "Look to yourself; the Devil is loose."

At first John took it that his brother had escaped or been set free, and he
called for a stronger guard around his person, waking and sleeping, and fret-
ted about the castle waiting for more news. But when it arrived, though it
was bad news, John breathed a sigh of relief, for at least his brother was still
in prison.

The wily Lion Heart, in fox-fashion, had worked a truce between the
Emperor Henry VI and five of that sovereign's most powerful and recalci-
trant barons. In return for this favor, which granted Henry a respite from
strife in his own lands, Henry had consented to send the King of France
away without seeing him. Philippe had travelled all that way only to be re-
fused an audience!

This insult was almost more than could be borne, or so John would
have thought, but Philippe wasted no time with hurt vanity. He was fast
seeking other inroads upon the Emperor's weaknesses.

"We will buy time even if we cannot buy Richard," proposed Philippe,
with his eye on the Vexin and the Aquitaine, and John agreed at once, his eye
on the English crown.

Philippe's new gambit consisted of pooling their resources to bribe the Emperor: one hundred and fifty thousand marks as ransom for releasing Richard into Philippe's and John's hands, giving Henry a staggering profit on what he had paid to Duke Leopold. If Henry refused, they would offer one hundred thousand marks if the Emperor would simply hold Richard until autumn, when the best season for battle would be over. This would give both John and Philippe a chance to consolidate their power. If this offer also were refused, perhaps the Emperor would accept a thousand pounds a month for as long as he would keep Richard captive.

These three clever ploys, however, met two obstacles which, though outnumbered, proved insurmountable. First, any monies John tried to gather from shires north or west of Nottingham had to pass through Sherwood Forest, and in so passing, more often than not, they were stolen by outlaws, and more often than not, those outlaws ran with the Hooded Man. Second, though the Emperor was sorely tempted by these generous bribes, his own courtiers counselled him to stand by his agreement with Richard.

The only tangible results of this plotting of princes was that masses of wealth fell like a bejewelled golden harvest into the receptive hands of Robin and his band. Every merchant, villager or serf who traded with them, sheltered them or but turned a blind eye to their doings was also blessed by increasing bounty.

Prince John's and Reginald's hatred and fury toward Robin in the Hood therefore increased tenfold, and so did the reward for the outlaw, dead or alive. The Prince and the Sheriff were locked in battle with Robin Hood like stags whose antlers have locked in fighting over the same doe. They did not stop to think how, from time to time, the rotting corpses of two stags would be found in the woods, antlers entwined, unable to break free, dead from starvation.

But Sir Reginald and his liege had a ray of hope: Guy of Gysborne still stalked the forest hunting the infamous thief.

⌘

41-the beast
lughnassadh, 1193

ugh, God of the Grain, God of Light, brought the first harvest. The early morning sun beat down hard through the star sign of the Lion upon the ripe fields. The men swung their scythes and the women followed, binding the sheaves and heaving them upon carts to be borne to the threshing floor, with a will to be done by nightfall.

Then they would celebrate the land, to which they were bound by the toil of their backs, the rime of dirt beneath their fingernails, the sweat slicking their skin. There would be feasting and games, contests and weddings, and if a number of the brides were ripe with fruit also, it was said the Beltane fires had blessed them.

The Christian clergy could not stop the Pagan revels, so they offered a church service called Lammas, the Loaf-Mass. But country folk knew it was to give thanks to the Sun for the harvest which would stave off hunger through the winter and provide spring seed, and so carry them around the Wheel of the Year once more.

The woods were but a hair cooler than the fields, and very still. There was no wind, no rustling of leaves among the intertwining trees. The fox was too hot to hunt, the lark too languorous to sing or flit from branch to branch. Only the bees carried their incessant hum to the honeysuckle.

At Brighid's Well, a shimmering murmur of anticipation underlay the forest silence. Prim was directing the roasting of fresh-caught game over several fires, gifts for the farmers, with whom they would break the first loaves of the harvest's fresh bread. Groups of men were stretching or sparring together, loosening their muscles in preparation for the games. Occasional bursts of laughter and muffled groans, and the hiss and thwack of arrows finding their marks curled in and out of each other like the tendrils of a vine.

Allan sat beneath the great oak with his harp and stretched his voice, for he would sing that night. He toyed with an old ballad that spoke of the birth, growth and sacrifice of the Corn God, and if he forgot a word here and there, he thought of one better to substitute.

There were three men came out of the West,
Their fortunes for to try,
And these three men made a solemn vow:
John Barleycorn must die.
They ploughed and sowed and they harrowed him in
With clods of Barley's head,
And these three men made a solemn vow
John Barleycorn was dead.

Dead he did lie for a long, long time
'Til the rains from the sky did fall,
And Little Sir John sprung up his head
And so amazed them all.
They let him stand to Midsummer's Day
When he looked both pale and wan,
And Little Sir John grew a golden beard
And so became a man.

Then came three women with their sharpened scythes
To cut him off at the knee.
They rolled him and tied him by the waist,
Serving him most barbarously.
Then came three men with their pitchforks keen
Who pricked him to the heart,
But the carter he did serve him worse than that
For he bound him to the cart.

They wheeled him around and around the fields,
And fetched him unto a barn
And there they did lay out upon the ground
Poor John Barleycorn.
There came three women with their crabtree staves
To flay him flesh from bone,
And the miller he did serve him worse than that
For he ground him between two stones.

John Barleycorn is the choicest thane
That ever was buried on land,
He can do more than any grain

By the turning of your hand.
He'll make a boy into a man,
A man into an ass,
To silver he will change your shiny gold,
Your silver into brass.

And Little Sir John with his nut brown bowl
And his brandy in a glass,
Little Sir John with his nut brown bowl
Proves the strongest man at last.
The huntsman he can't hunt the fox
Nor so loudly to blow his horn,
And the tinker he can't mend neither kettle nor pot
Once taken by the Barleycorn.

Having finished that warning of the powers of the fermented grain, Allan struck up another tune that sang of love. Aelflin paused in basting a duck with honey and crushed mustard seeds, brushed a wisp of hair off her brow and cast a doting smile at Allan that warmed him to the core.

So the first hour of morning passed pleasantly for everyone except Robin, who was striding about with a moody look on his face, fidgeting at this and that and accomplishing nothing.

John cast a questioning glance at Will, who shrugged. The next time Robin paced by, Will stuck out a leg and tripped him. Robin stumbled, whirled on his friend, thought better of it and turned away again, but Will grabbed him by the arm. "You're in a merry mood for a feast. Did you drink sour milk, or did you but lose the knack of making it, Hobgoblin?"

Robin forced out a grin and said, "Sour dreams, Will. It's nothing," before walking away. He followed the stream down the narrow valley until he came to the willow tree where he had argued with his cousin Constance.

Would that she were here now, he thought, to aid him with her Sight. The clash of wills between them weighed on his mind. If only he could have spoken more wisely, more compassionately, or more forcefully—whatever it would have taken to sway her. But she walked her path and he walked his, and they could not walk beside each other.

Then there was Maerin. He could not forget her face, her voice. He could not bury her memory in love-making; no other lass would do for him now. But she was safe in Nottingham castle with her betrothed and thought nothing of Robin, he was sure. The thought grated at him.

He knelt down and picked up a flat black stone, gazing at it as if he could see the world there. The dream he'd had the night before seemed as vivid and hard and real as the rock.

He was walking on the face of a high black cliff, on a narrow ledge, with rock sheer above him higher than the clouds, and the sea black below, for it was night. The rain fell in sheets like flapping sails in a mad wind, whipping at his face and cloak until he thought he'd surely be blown over the edge to his death. Yet he knew he must keep on. Home was somewhere up ahead, though he knew not this path or this country.

Then a light appeared in the darkness. Shelter? A great black horse, a stallion, was barring his way. Eyes blazing red, watching him. He made a move to catch the beast, thinking to lead or ride him to safety, but the stallion reared up like a warhorse and his hooves came down towards Robin's face.

The agony woke him. He had to feel at his own head with his fingers before he believed himself alive.

He stood and whipped the stone into the stream, watched it bounce three times before it sank. He could tell Prim the dream, to see what she would make of it, yet he hated even speaking of it. He would not give it power with words. A dream of death did not always mean death, he reminded himself. Only change. Or perhaps it signified the death of the Grain God, celebrated this day. Yet wasn't he himself married to the land now? Did the dream foretell he was to die today, that the land could be nourished by his blood and flesh as the land had nourished him? Had he not promised as much to the Lady, to go willingly into death?

Some day he would have to keep that promise. His limbs flushed with heat that competed with the blazing day.

He knelt at the stream and splashed his face with tepid water. It was far from refreshing. He sat back and listened to the water gurgle lazily under the blazing sun, watched diamonds of reflected light dappling the surface. Dragonflies darted across the stream like elfin arrows targeting shade, where tiny frogs the size of a penny and glistening bluish-green sat croaking at each other in the mud. A yellow butterfly whickered by like a mockery of his mood. But for the killing heat, it was a beautiful day, a day for rejoicing and celebration, and here he was, glowering like a maddened bull at everyone around him and glumming over his fate.

He shook his head. Not every dream was full of portent. Maybe this one meant he would win a black horse at the fair! He laughed at himself.

By the time he returned to the great oak he had cast off much of his

gloom. The roast meats were ready, wrapped in leaves and hides or carried trussed on poles between two men. Soon those who chose to risk being seen in public were tramping in small groups toward Lincoln, wearing their peasant best, with the younger lads and lasses chirping and giggling with each other like excited squirrels.

Robin, Will and John travelled together disguised as a forester, a tinker and a butcher respectively. Will wore a false beard and Anne's scarlet garter as a headband on a battered cap, John relied upon a smudged face and wide-brimmed hat to hide his features. Each planned to compete at the games in his own specialty, John with the quarterstaff, Will at swordplay and Robin at archery.

The bright sun pierced the forest greening, the spongy ground sprang back after every step, the perfume of wildflowers tantalized them as they hiked eastward along a winding path, each lost in fantasies of what Lughnassadh might bring.

They stopped in midafternoon to eat and drink from a brook, dowsing their hair and sweaty faces to cool themselves. Will led the way on, but after twenty paces or so, he halted in his tracks and lifted a hand in warning. The others silently joined him and followed his gaze.

In the distance, slumped against a tree, faintly visible beyond the shafts of sunlight dazzling their eyes, was some indefinable thing, a lump with limbs, dappled disconcertingly with light and shadow, criss-crossed with leaf and branch. It rested on limp haunches, sitting like a man, but with forelegs dangling by its chest. It had two heads, one above the other. The lower one drooped forward and seemed to be fringed with a grizzled beard, and the upper one leaned back with a long muzzle and pointy ears jutting toward the sky, as if the two heads were standing sentinel for each other against the realms of Heaven and Hell. Yet the creature appeared to be sleeping.

"A centaur," breathed John.

Will shook his head. "Some other mythical beast, for it sports two heads."

Robin's body surged with adrenalin and awe as two worlds collided, the one of myth and magic, the other of reason and daily life. So it was when he saw the white stag, or when he called to Goddess to aid him.

Though he himself followed the Stag-God Herne and the Goddess of Moon and Sea, he knew others worshipped the Divine in the form of a Horse-God and the Horse-Goddess, Epona. He had once been to Pin-Hole Cave in Derby, where a man's figure with a horse's head was carved into the stone by some long-dead hand. And he had seen the great chalk cutting of this God in the south, for Cal had taken him there one full moon night and

they had called upon the Shining Ones.

But why would this God appear to them now?

Then last night's dream bolted back into his mind. His heart seemed to swell like a wineskin filling with wine and then shrink to the size of a walnut with every beat. Death had stalked his dream in the shape of a horse. And here that Death slept before him. Could he could pass by without waking It?

By God and Goddess, he was no coward. He put his hand on the hilt of his sword. If this were to be his end, he would not run from it, though his body prickled with fear.

Then he saw a slight movement among the trees. Two men crept into view carrying crossbows, and their prey was clearly the magical beast that slumbered unknowing. Robin could see their chain mail glinting in the sun. Their livery revealed them as soldiers of Nottingham.

Robin said softly, "Any man or beast hunted by the Sheriff is friend to me."

"I'll take the dark-haired one," nodded John.

"I'm for the other, then." Will melted into the trees with John behind him.

Robin crept toward the mythical beast. The air was heavy and still. Then a whizzing sound that faded into nothing spoke of a crossbow bolt missing its mark. A shout, "After them!" a crashing of branches breaking, and in a moment the woods were quiet again.

The two-headed horse was wakened by the commotion and the first sight to greet his eyes was a forester standing before him, leaning on his longbow and examining the mythical become mundane. For now Robin saw the beast was but a man, covered from head to toe in a horse-hide, complete with head and mane and tail, with the hair still matting the outside. Beneath this hide, the man's garments were ragged as a beggar's and hung loosely on him as if he were half-starved. About his thin waist he wore a leather belt with a sturdy scabbard and broadsword, a dagger and a sack of arrows. Beside him lay his longbow. The weapons were in excellent condition, but the man's face was gaunt, creased and grimy with layers of dirt, burned reddish-brown by the sun. His expressionless eyes, sunken in their sockets, focused on Robin, who said, "I take it you have some unfinished business with the High Sheriff of Nottingham. Even now my friends are chasing two of his soldiers from your trail."

The man lifted a black eyebrow.

"Perhaps I may help you to finish that business, for I have no love for Sir Reginald," Robin offered.

The man grunted, coughed and spat a wad of phlegm into the dirt.

Perhaps he was ill. Robin leaned his bow in the crook of his arm and offered him a wineskin, then took barley bread and a roasted fowl from his pack, the latter of which he had been taking to the festival, but the need seemed greater here. The horse-man grabbed the food and devoured it without a word.

Robin asked, "What was your crime?"

The man snorted and wiped the grease from his mouth with the back of his hand. "To fart is a crime in Nottingham."

Robin grinned. He wasn't sure he liked the look of this man, but their common foe made them kindred. Besides, any man who had been fleeing from soldiers and starving would look grim. Perhaps this horse-man would make a good addition to his band. They could always use someone who could fight.

Robin would test the man's mettle before taking him to Brighid's Well, though. He said, "I'm on my way to Lincoln to compete at the harvest fair. You look to have a sturdy bow. Shall we try our luck against each other? If you can best me, then perhaps you should go to the fair instead of me."

In answer, the man rose to his feet and strung his bow.

A man of few words. That suited Robin well enough.

They set up a target at a good distance and plied their arrows one after the other, with little talk, but a begrudging nod from the horse-man when Robin bested him. The man said, "I am better with a broadsword than a bow, and better yet with a dagger at close range."

"Then let us try swords," said Robin.

"Let us try daggers," growled the man, drawing his, "but first, tell me your name, because I would know the man I kill."

At first Robin thought this was a jest, but the man's soul-empty stare, the lips compressed in a grimace, the dagger in his hand feinting forward said otherwise. He had been far too trusting. No doubt the beggar saw Robin's weapons and bulging pack with an eye to making them his own.

I'll not be outthieved, Robin thought. He flung down his bow and reached for his sword's hilt, but the horse-man leaped into the air, kicked, and sent the sword flying. Robin drew his own dagger as the horse-man lunged at him. Only Robin's quick feet spared him a knife-thrust in the heart.

The two circled each other.

"Whose are you, Forester? Prince John's? King Richard's?" hissed the man. He stabbed empty air with his knife as Robin spun away. Robin slashed

forward with his own dagger, cutting the back of the man's hand.

"I am my own man," Robin said. "As for you, tell me your name or die nameless, I care not. I know your true name, and it is Murderer."

The man's lips stretched in a parody of a smile. "That you have right. I am Guy of Gysborne, Sir Reginald's bane. Tremble your last on hearing my name, for I've killed bigger and stronger men than you, and taken better plunder."

A chill snaked along Robin's spine. He had heard of Gysborne. He said, "They hanged Gysborne not two moons past in Nottingham square."

"Another was hanged in my place, I warrant, to fool the peasants. I am set like a wolfhound upon the trail of a brigand, to cut off his head and take it to the Sheriff for reward, but if I disobeyed my charge, it would have been my head, and the Sheriff's two soldiers would have taken it from me. But I have searched these evil woods many long weeks for Robin in the Hood without a sign of him, and those damned soldiers following me at every step. So I thank you and your friends, Fool, before I kill you, for now I'm free of them."

He leaped forward and again Robin darted out of range.

"You seek Robin Hood? I hear he is a wood sprite and only those he favors ever see him."

"If you know aught of him, tell me and I will kill you quickly."

Robin crouched and shifted. Guy of Gysborne circled him, growling, "Shall I carve it out of you then? I will take the flesh of your forearm first, the left, then the flesh of the other, the right, then the thigh, the left, then the other thigh, the right. So firm you are, such a pretty jawline and pretty eyes. The ladies must like you. They never cast their eyes on such as me, but when I have done with you, no, they won't like you then. Cutting bit by bit and bone by bone—you'll beg to tell me what you know, but I'll take first the one ear, the left, and then the other, the right, I cut out the lips but leave the tongue, you can talk then, tell me what you know, and you'll scream, and it's toe by toe and ball and rod, and if you know nothing, it's all the same to me if you suffer for nothing." He pounced and jabbed with his knife, drawing blood from Robin's left arm.

Robin ignored the wound, swallowing his nausea at the man's bizarre speech.

Gysborne went on, "This is more to my liking than chasing after will o' the wisps. Five thousand marks that bastard Sheriff promised me."

"Five thousand. For one outlaw's head? How generous a liar he is. He'd have hanged you first." Robin lunged, Gysborne swayed aside and Robin's

dagger missed, but he danced away before Gysborne could slice him.

"I could use your head and say it's Robin's."

"The Sheriff would not believe you, for he knows my face, as Robert of Loxley."

"Loxley!" Gysborne crowed with exultation. "Then I have found my man! For the Sheriff told me Loxley and Robin are one and the same!"

Robin cursed under his breath. How could Sir Reginald have known? Only Maerin could have told him! Nausea swept over him again. Betrayer! Bitch! Well, and could he blame her? He had kidnapped her and she hated him. The bile rising in him, he charged the horse-man with renewed fury.

Gysborne's pride in his skill with a knife was no empty boasting. Before long, both men were cut and bleeding in a dozen places, yet no mortal wound had been dealt. Sweating and cursing, gasping for breath, they grappled with each other like wrestlers, dodged and feinted like acrobats, slashed with their knives, pounded with their fists, kicked and tripped each other, and all the while Gysborne was reciting the ways he would mutilate and humiliate Robin's flesh, laughing low-pitched when he described the death blow, and when he finished his recitation he would start again at the beginning, like a ritual, saying, "First the flesh of the forearm, the left, then the flesh of the thigh—no, no, the flesh of the left forearm, then the flesh of the right. Then the thigh, the left, and then—" Gysborne leaped and clamped his teeth onto Robin's left ear, tearing at it like a carrion crow ripping meat from a carcass, but Robin pounded Gysborne's lower back with his fists until the man screamed and loosened his hold, stumbled back, gasping, then started his chant again.

Sick with revulsion, Robin tried to focus on the battle and the strength within him, instead of Gysborne's words. They fought until Robin's head reeled and he tasted his own blood in his mouth. He knew he was nearing the end of his strength. He fought despair. Only a miracle could help him now, and right enough to ask for one, for he had done everything he could, as Prim had taught him, not to resort to magic unless all else failed. But he could not stop and prepare himself with prayer and trance, smoke and firelight, fashion a talisman or a poppet to bind his enemy, cast a circle with his consecrated knife or sorceror's staff.

Yet was he not describing circles and other shapes with his dagger? He imagined every flick of his blade leaving a trail of blue flame. He drew a pentagram before him, and to his joy, Gysborne drew back howling, and would not or could not walk through it.

Amazed his enemy could even see it—but it was true the mage often walked the line between the ordinary man and madness—Robin drew another. Gysborne dodged around it and attacked again. Robin parried and feinted until the air was filled with incomplete blue swirls that slowly faded, and he knew he could not concentrate well enough on the task to protect himself with this magic.

He prayed aloud as he fought, a counterpoint to Gysborne's raving. "Goddess ... Gracious Goddess ... Horned One ... Powers of Air, Powers of Fire ...Water, Earth ... Creators, Preservers, Destroyers of the World! Mighty Ones, Shining Ones! Look upon me, your servant, Robin. I offer you my life, I vow ... but I will not go willingly to the sacrifice if this be the priest you provide me! Let it be on sacred ground, my Lady! But all your ground is sacred." His mind was wandering with fatigue. With a last burst of determination, he cried, in between strokes of his knife, "If it is my time, Great Goddess ...Thy will be done, and if it is not ... Thy will be done also ... but by my soul, give me the strength for either one."

By now, the sun was sinking. The sky turned black and darkness shrouded them both.

42-ROBIN'S HEAD

ohn and Will shot the crossbows out of the hands of the Sheriff's men and chased them through the forest. The wisdom of the greenwood was in their feet, which knew every curve in the earth before they touched ground. The soldiers, who were used to fighting in open fields or laying siege to castles, stumbled and thrashed through the underbrush, which clutched at their clothing and slapped into their faces as if trying to slow them down. John's next arrow pierced the loose linen of one man's overtunic, pinning him against an oak. The other surrendered, pleading for his life.

John and Will claimed their weapons and valuables, bound the men hand and foot, gagged them, dragged them unceremoniously through brush and briar to the first cart track they could find, and left them to be discovered sooner or later by some passerby. John said, "Tell your Sheriff of Nottingham the Lord of the Greenwood sends Harvest greetings!"

Then off they strode to the fair, feeling so pleased with themselves that Will began singing snippets of Allan's ballads at the top of his lungs. John

joined in with his own tuneless bellowing, until Will threatened to strangle him.

By the time they reached the stubbly fields outside Lincoln's ancient Roman walls and sighted the spires of the cathedral atop the hill, the worst heat of the day was giving way. In the distance they heard a young boy shout, "The hare! The cutting of the hare!" and knew the harvest here was done, for hares often took refuge from farmers in the last clump of corn. The lad seized the final stalks of grain and raced rabbit-like about the fields with it, chased by the other children. The women in their dusty skirts, the sleeves of their sweat-stained blouses rolled up, straightened their backs and the men dug the points of their scythes in the ground, leaning upon them and mopping their brows or swigging warm ale from leather flasks.

Then they caught sight of John and Will, who halted. They began to edge back toward the wood, but it was too late. The women let out a collective shriek and charged the outlaws, crying, "Two strangers! God has blessed us!"

John and Will then stood their ground and accepted their fate, for to do otherwise would have been bad luck for everyone. The women soon fell upon them with smacks and shoves, and then the children were roiling about them, pinching and tickling them, dragging the outlaws down to the ground and rolling them in the furrows with shoves and kicks. They tied fistfuls of grain stalks to their limbs and heads until they looked to be half made of the corn. This apparent violence was accompanied by shrieks of laughter and crude jests.

"A pretty! A fee! A token!" demanded the children once the outlaws were dressed in the guise of the Grain God. The men brandished their pitchforks in mock threat until Will brought forth a handful of pennies and tossed them in the air. The children scrambled for their prizes with shrieks of delight.

"May it rain gold upon you all!" John declared.

"May it rain," said one old dame simply, wiping her sweaty brow.

They lifted Will and John into a cart full of sheaves and drove them toward the barn, then wrestled them inside and to the floor, and made a show of beating the outlaws until the corn had been unloaded and was ready for the threshing.

For good luck, John and Will took a turn at helping to pound the grain free from the stalks. As they worked, a grizzled farmer asked, "From whence do ye hail, strangers?"

John said, "Papplewick," even as Will said, "Selby."

The old man raised a wispy white eyebrow, for the two towns were in opposite directions.

"We met in the wood and travelled together for safety," offered Will hurriedly, bragging, "for a butcher and a tinker together are as good as an army!"

"He was lost," said John, with a grin that made the peasants smile, except for the old farmer, who had a suspicious look in his eye.

"Nay, it was you was lost," protested Will.

"Ye're right free with yer pennies fer a poor tinker," muttered the old man.

Will said, "Well, I cannot be close with them. 'Tis the harvest! In truth, I seek a wife in Lincoln, and saved my pennies to buy her pretty baubles."

"Many fine lassies right here," said the old man. A couple of young, unmarried girls looked up, stifling giggles.

John bent his back harder to his work and left this touchy moment to Will, who managed to murmur, "Aye, it's a right good harvest of pretty girls ye have. But I've a certain lady in mind, promised to me, for this is her garter." He pointed to the scarlet band on his grain-spattered hat.

The old man hefted the stick he had been using to thresh the corn and said, "Then does she like ye best wi' the beard or wi'out it? Or is it that she cannot decide?"

With a sinking feeling, Will felt his false beard. It was drooping off his chin from the heat, the roughhousing and the hard work.

"Ye're no tinker!" pronounced the old man. "Ye're a liar and I've a mind ye're a thief, and it's stolen pennies ye've gi'en us! We'll ha' none o' that here!"

The peasants lifted their farm tools like weapons now and watched, grim and silent, to see what Will would say.

"Faith, you're too clever for me!" Will said nervously. "I am a player, on my way to the fair, searching to join a troupe. But I see I cannot even mime a tinker. I'm a failure." He attempted to mope.

The farmers looked unconvinced.

John straightened. "You have fooled me! I thought you a tinker right enough! And I do not like to be tricked!"

"But it was such an easy task," said Will, following his friend's lead, "for your head is as thick as your belly!"

"Unruly lout!" said John, pointing to his own stomach. "This be pure muscle! And I've a mind to batter your brains out for your jesting!"

"My brains may be battered and fried," taunted Will, "yet I shall be the wiser of us two!"

"Hind end of a sow's runt!" John brandished his quarterstaff and charged Will, who ran out of the barn. John chased him, followed by the shouting peasants, for whom this was rare entertainment.

Will sped across the fields with John behind him, and after some effort, they outpaced the tired farmers, who trickled back to the threshing floor and went back to work with much to gossip about.

"Quick thinking, little John," Will gasped as they stopped for breath under the canopy of a single oak near the lane.

John nodded. "Ye'll owe me a bowl of brew for that."

"Done." Will hastily repaired his beard and the two made their way into Lincoln.

Inside the town walls, the warm, humid evening was filled with disparate strains of lutes and harps, pipes, drums and tambourines, as a dozen tunes mingled and fled from street to square to tavern in a mad conductorless symphony. Through the shuffling feet of dancers, the lilting drift of storytellers' tales, laughter and playful shouting, and the savory smells of roasting meats and baking bread, John and Will found several of their comrades by seeking and following Allan-a-dale's resonant voice.

He was singing such a mysterious ballad that the floods of people flowing by him paused in mid-twirl or mid-laugh, or with food halfway to their mouths, and closed their eyes to see the other worlds and strange delights of which he sang.

"Where is Robin?" Aelflin whispered to Will.

"Is he not here yet? Off on one of his quests, then, I think." The image of the mythic beast they had seen in the wood went through his mind, but he forgot both beast and Robin at the sight of Anne with her mother and father, standing and listening to the music on the balcony of a wealthy merchant's house across the street. He sidled nearer to her and flicked a coin toward Allan, which got her attention. In public, she could not deign to greet a mere tinker, but the sparkle in her eyes spoke clearly to him, and he knew he would meet her later that night.

Lincoln was alive all night with harpers, dancers, pipers, jugglers, acrobats, trained bears, pickpockets and beggars, and a troupe of actors playing scenes from the Bible from the back of a cart, their voices booming over the din.

As the morning sun burned away the shadows, ropes were strung on posts around a square patch of earth and the wrestling matches began. Amid boisterous wagering and shouting, bare-chested men grappled with each other. A man from York who had thick corded muscles and a steely glint in his eye

won five bouts in a row. He vowed he would take all comers and give them a coin from his own pocket if any could win against him.

There were no takers.

The wrestler sneered, "Any Yorkshire man, be he weak and scrawny as a girl, can best the best of Lincolnshire any time." The crowd booed and hissed.

"You'll not best a Scotsman," called Will. He stripped off his tunic, to the cheers of the men and the admiring squeals of the women.

"Don't do it, laddie!" shouted one old crone with her front teeth missing. "Don't let him ruin your handsome face!"

The wrestler from York strode around the ropes clasping his fists together in dark glee.

"You can do it, Will!" said Harald, who was ever eager for his heroes to get themselves into trouble. Juniper watched wide-eyed with delight, while Allan hugged his harp to his chest and was glad he could prove himself with music and not muscle.

Will stepped into the ring. The betting was fierce, for all Nottingham and Lincoln stood behind any man who would challenge the toplofty upstart from York.

The two wrestlers circled each other for a moment, then grabbed hold and struggled to fling each other to the ground. They grunted and strained, their hands slipping on each other's sweaty skin. Then the Yorkshireman tripped Will and both men fell to the ground to roll over and over in a cloud of dust. It was difficult to see which arm belonged to whom and why a fist or a leg appeared where it did and then disappeared again. When the dust settled, Will was pinned beneath the Yorkshireman, who held him there until he was declared the winner. The boos were deafening. John shook his head and Harald moped, but Will only shook the victor's hand and bought him a beer, and then the Yorkshireman bought Will one, and then a third led to a fourth, and they were soon staggering about with their arms around each other's shoulders like the best of friends.

At noon came the crowning. The prize-winning goat with the thickest coat and the clearest eyes was chosen to be King for the day, not King of England or any body politic, but King of the Harvest. The Royal Goat was draped in a faded green linen cape, his horns were crowned with a wreath of vines, and he was carried in a processional around the town on a hay-filled cart, chased by cheering children and the frowns of the local clergy at such Pagan antics.

Then the Goat King was tied high upon a platform where everyone could see him, and he was fed tidbits of the tastiest food by a little girl and a

little boy, and his furry body was cuddled and teased, and his cape and crown were fussed over and patted into place whenever the wind blew, and his beard was tugged, and his tail. As if born to this glory, the Goat King chewed serenely and surveyed his realm, where preparations were underway for the quarterstaff contests.

John stripped to the waist and hoisted his staff, confident that he would win. He bested his first three opponents with ease, and with such generous and creative cursing that he fast became the darling of the crowd. Then above the cheers a shout was heard, "That's him!"

With no further warning, a half dozen foresters and a regiment of Lincoln's soldiers descended upon John. He managed to bash four men to the ground before being overwhelmed by staffs, fists and swords. He was dragged struggling toward two more soldiers, Nottingham's men, the ones the Sheriff had sent to spy on Guy of Gysborne. They had been found on the cart track and freed, and followed the direction John and Will had taken out of the wood.

With the easy joy gone out of the day, the watching townspeople and peasants muttered and hissed, but no one was brave or foolish enough to stand against so many armed men.

"Aye, that's one of them, all right," said one of the soldiers. "Where is your friend, you thieving filth?"

John said nothing.

With no warning, the two soldiers slammed their fists into John's face and stomach until he bled from the mouth and was doubled over in pain, but he kept his silence.

"There's a man in Nottingham's dungeons will know how to pry loose your tongue," the first soldier finally said, rubbing the sore knuckles of his right hand. He nodded at the captain of Lincoln's troops.

John was bound to a cart in chains and borne off with an armed escort toward Nottingham.

Harald, witness to this disaster, melted into the crowd unseen and quickly found Tom. Soon a group of outlaws were hurrying to Nottingham to discover John's fate, or perhaps to free him on the way if they saw their chance.

Will went in search of Robin. For the first time, through the haze of ale and other good spirits, Will wondered why he hadn't yet seen Robin at the fair. Sure, the crowds were thick, but still, it was odd. Had his friend met with some misfortune? Had he been enchanted by the mysterious two-headed horse, as he had been by the white stag? Was he carried off to the land of Faerie? Was for once the shadow-realm too much for him?

Berating himself for leaving Robin alone with the beast, Will worried his way through the wood.

<div align="center">⌘</div>

Everyone in the Great Hall was mute, waiting: Anhold and his soldiers, the steward Aelfric, a merchant who had come to beg a favor, the scribe Denys.

Sir Reginald scrutinized the man standing under heavy guard before him. "John Nailor, isn't it? Of Hathersage, I think. You started your rampage of lawlessness two years ago, killing the King's deer. How far you've come since then. You are known to be Robin in the Hood's right hand, and you shall be punished for each of your crimes accordingly. As Robin Hood has already been punished." John and his henchman may have driven off Reginald's spies, but Robin had gone to meet Gysborne, the assassin. Robin Hood was dead. Reginald felt the thrill of triumph. "Hear your sentence, then, Wolf's-head. First, your eyes to be put out with a red-hot iron, to pay for the poaching of the deer. Then your hands to be cut off for your thieving, your tongue cut out for heresy. For insurrection and treachery against Church and King, the traditional punishment for treason: you will be hung by the neck, disemboweled while you live, your skin flayed from your flesh, your body drawn and quartered and your head stuck on a pike outside the castle walls as a warning to all who ran with you and your devil-worshipping master in Sherwood. This to be carried out at dawn tomorrow. I only regret I cannot hang your Robin Hood beside you, but I trust his head has already been cut off. It will be stuck on a pike beside yours, you may rely upon it."

The guards put their hands on John to haul him away.

Struggling ferociously, John shouted, "You'll never catch Robin! He is the son of Herne! The arrow of Brighid!" The soldiers hesitated at the mention of the Pagan God and Goddess. "He can disappear at will! No chain can bind him! And he comes back like the ghost of Cu Chulainn, bristling with daggers and swords, and the teeth of invisible beasts are clacking at his feet. Hell-fire shoots out of his ears and his mouth, and his enemies burst into flames!" This confabulation of horrors was strung together from legends John but half-remembered. Desperation fueled his speech. He was rewarded: his guards were turning pale as moths.

But Sir Reginald pointed at him and snapped, "Get this vermin out of my sight!"

<div align="center">⌘</div>

The horse-hide was spattered with drying blood. His skin was rife with wounds, some still seeping red. His face was grimy and his eyes were grim under the hollow horse's head and mane. A sheathed sword banged at his

side. Another, blood-stained, he held naked in his hand, as if to slay any who so much as stepped into his path. Under his left arm he carried a moist, stained, cloth-wrapped bundle that every so often leaked a thick droplet of blood.

He reached the village outside the castle walls. He glanced neither left nor right as he made his way up the hill. Mongrel dogs barked at his heels and snapped at the rank bundle under his arm. Men and women dancing and feasting in the harvested fields saw him and stopped. Children fell silent. Musicians ceased their strumming and piping. The villagers crossed themselves at his ghoulish passing, fearing for their lives and their souls, for they thought he was not a man, but a demon.

He passed through the town gates unchallenged. The Harvest celebrations clogged the streets, but where he walked, people parted and fell silent, as if a shadow had passed over the sun.

He reached the castle. Aghast, the keeper of the gate sent for the captain of the guard. Anhold at once recognized the strangely-clad creature as the paid mercenary of the Sheriff.

"Let him enter." Anhold himself escorted the man to the Great Hall where Sir Reginald was even now ordering John Nailor out of his sight.

The murmuring of courtiers announced the beast as well as any herald. Reginald clapped his hands. "Ah! My knight of the Order of the Horse!" he jested. "At last! This is a great day for me and all of Nottinghamshire. John Nailor, before you die, see the head of your Robin Hood, your *puca*, your ghost of Cu Chulainn!"

The horse-man did not bow, but unwrapped his ragged bundle and grabbed a fistful of the matted hair within, tossing the bloody head onto the floor. It rolled to a stop at Sir Reginald's feet. "Use it for an Oracle," snarled the horse-man.

John almost sank to his knees but for the fact that soldiers held him up. With the death of Robin, his luck had run out, and he had lost as true a friend as any he'd ever had.

Reginald stood and kicked the head with a sodden thud.

"Loxley!" breathed the Sheriff, and then his satisfied smile froze as the head rolled several inches from him, for he recognized then the soulless eyes of Guy of Gysborne, empty in death as they had been in life, and the filthy, bearded face of Robin of the Hood, Robert of Loxley, very much alive under the horse's head before him.

"Little John!" Robin called out, drawing his extra sword and tossing it through the air.

"Robin!" With renewed strength, John slung his arms forward and smashed together the heads of the surprised guards who held him. They fell to the floor as he caught the sword-hilt and swung it behind him to cut down the guards at his back.

Soldiers descended on Robin, who edged his way toward John as he fought. They stood back to back, holding off their opponents while making for the door.

"Loxley!" the Sheriff screamed in rage.

Shouts and the clashing of swords resounded through the castle. Coming down the winding stairs, Prince John feared the noise meant an attempt on his life. He turned and fled back toward a secret passage he alone knew of.

Near that secret passage, Maerin languished with Elgitha in the private prison of her chamber. Since her return from the forest, she had not been allowed out of the castle, nor could she even walk through it without an armed escort, which was clearly not meant to protect her, but to keep her from running away. She had tried bribing her various wardens, tried sweet-talk and silver and stealth, but she had not been able to sway their loyalty to Reginald or to elude their grasp.

Now, hearing the anguished roaring of her uncle, the distant sounds of battle and the alarm bell ringing, she saw her chance. She threw down the embroidery over which she had been laboring listlessly, jumped up, wrenched open the heavy door, and saw that her guards had left their post and gone to join in the fighting. She was halfway down the stairs before Elgitha could even get to her feet. "Milady! You mustn't!"

Maerin reached the lowest curve in the stairs just as Robin and John were staggering backwards out of the Great Hall, their swords flashing. At their feet lay her two guards, necks and chests bloody as they groaned out their last breaths. The sight of the blood-smeared horse-hide, Robin's dirty, drained, exhausted face, the fresh wounds beneath his torn and blood-stained clothes and the harsh look in his eyes as he fought chilled her to the marrow.

She heard him shout, "Now!"

The two outlaws surged forward once more with a slashing of swords, forcing their opponents back into the Hall. Then they leaped back and managed to slam shut the double doors. Robin quickly tied the handles together with the stained rag that had held Gysborne's head, then he and John braced the doors shut with their backs and wondered how much respite this could buy them. Already the passageway echoed with the tramping of feet and the shouting of soldiers from the guardhouse and the barracks, speeding to the aid of the Sheriff.

Behind them, men were pounding at the doors. They were about to give way.

Robin wiped the sweat from his palms and grasped his sword again firmly.

"You're a madman for coming here," John said. "How did you know I was prisoner?"

"I didn't," Robin answered.

"My luck!"

"But we're for it now."

"Better the sword than the rope," growled John. "Not to mention what was to come after."

"Milady! No!" screamed Elgitha, as Maerin flung herself down the stone stairs toward Robin and cried, "Put your sword to my throat!"

His eyes widened, his jaw slackened. Lovely, untouchable, the figure of his fantasies stood before him. Her green undergown and spotless white bliaut brought her blue-green eyes and dark braided hair into bright relief. And this was the woman who had betrayed him to the Sheriff, her uncle? No, it was not possible! And what lunacy was she proposing now? It was all impossible, and her cheeks were impossibly rosy from running downstairs, and her lovely, full lips parted and she commanded him unbelievably, "Hurry, Robin, the sword!" and threw herself into his arms.

His paralysis left him. As the door behind him reverberated with the blows of the soldiers within, he spun her around so her back was pressing against his chest. He gripped her waist with one arm and put the flat of his sword to her tender neck.

She felt the bloody blade cold and wet against her skin. His breath was hot in her ear. His arm was an iron band around her waist. He stank of blood, sweat, fear and rage.

Maerin trembled. What madness had propelled her into his arms? What promise did she have that Robin would not kill her? Would the soldiers, whose first loyalty was to her uncle, surge forward regardless of the threat to her life? Men grew desperate when cornered, rabid in battle. They forgot themselves with blood-lust. Only now she realized she could have run the other way and perhaps escaped her imprisonment. She could have left Robin to find his own fate. But would she not have gone to seek refuge in Sherwood, by Brighid's Well, with Robin? There was nowhere else left to her. There was nowhere else she wanted to go. Not even Fontevraud.

No, even had she thought of it in time, she would not have left him to face death alone. It was too late to question her instincts to save him, and she

wavered in and out of trust and fear as he dragged her to the center of the corridor.

Soldiers poured into the hallway from all directions as the doors to the Great Hall burst open. They stopped in their tracks at the sight of Robin holding Maerin hostage.

Robin shouted, "Any closer and she dies!"

"On! On, you bastards! Kill him!" Reginald shouted at the same time. "Why do you hesitate, you cowards?" He pushed his way through them. Then, seeing how the game was lost, he let out a wordless yell.

"Mark this day well, my lord Sheriff, for I swear by land and sea and sky, the next time you set a fiend like Guy of Gysborne free into Sherwood, I shall come here and have *your* head." Robin began to drag Maerin away. The soldiers looked at Reginald for orders.

"Let them go! Don't harm the girl!" Reginald commanded. "Loxley! I will not rest until I see you hanged!"

They ran.

Once free of the castle and the town walls, John took the lead. Robin lifted his sword from Maerin's throat, grabbed her hand and pulled her along. They ran through the outlying village, chased again by barking dogs and the stares of alarmed peasants. They neared the last hovel, beyond which lay open ground, then the forest and safety, when Coucy emerged, strapping on his swordbelt. Behind him, Dulcie's blonde head poked around the door. The bell ringing the alarm at the castle had interrupted their own private celebration of the harvest.

Coucy drew his sword and charged, shouting, "Robin Hood! Release her or die!"

In a glance, Robin took in the blonde woman, Coucy, and all that their disarray implied. This was the man Maerin wanted to wed? He'd lay twenty marks that this bantam cock was lying with half the women in Nottingham. A jealous fire blurred Robin's vision. He could not understand her. She found him repellent, but risked her own life to save him. Why? Damned if he would ever understand women. Well, if this was her choice of husbands, so be it. He swung his arm forward and let go of Maerin's hand, shouting at Coucy, "Take her, then!" without breaking his stride.

"No!" screamed Maerin, to Robin's surprise. She stumbled. Coucy lunged forward, grabbed her wrist and wrenched her to his side. Her despairing eyes sought Robin's. He slowed his pace. He saw Coucy shove her sprawling to the ground and stride forward to meet him just as soldiers on horseback pounded out of the walled town.

Seeing them, Maerin spat the dust out of her mouth and screamed, "Leave me! Robin, go!"

Confused by her conflicting cries, hopelessly outnumbered, Robin cursed and ran full speed for the wood behind John.

Huddled in the doorway, Dulcie stared after the famous Robin of the Wood. He certainly did not look the part of a dashing brigand who stole from the wealthy clergy and gave alms to the poor, who did no harm to women. Yet a part of her longed to run after him. He lived free of the prying eyes of townsfolk and the laws of the Crown.

Coucy made as if to strike Maerin, but the soldiers were swiftly closing on them, and he dared not hit her in plain view. They might report it to Reginald. The right to beat her was not his. Not yet.

The troops galloped past.

Coucy gave Maerin a venomous look and ran for his horse. "I'll skin that stinking thief alive and bring you his hide as a wedding gift," he shouted as he swung up into the saddle and galloped off to join the chase.

But Sherwood Forest embraced the outlaws like kin. Robin and John disappeared into its depths like shadows swallowed by oncoming night. The soldiers flailed about, searching for them in vain, and Coucy cursed his own stupidity in paying for a worthless spell to blind Robin. How the townsfolk would laugh at him if they knew! How that hermit would regret his failure!

Watching Coucy ride away, Maerin thought briefly and wildly that she might yet escape, but two knights stopped to 'rescue' her, their hands on the hilts of their swords. Slowly, resigned, Maerin got to her feet.

Then she felt another, softer presence, and turned to see Dulcie standing behind her, her blonde hair tousled and her clothes still somewhat awry. Shyly, Dulcie bobbed her head and asked, "Are you all right, milady?"

Maerin turned pale, then flushed. So this was where Coucy went to relieve his base urges! She heard herself say, very distinctly and with powerful scorn, "Whore."

Then she turned to walk back to the castle, her head held high, the two knights following her on horseback, and Dulcie watching after, her head drooping and tears in her eyes.

⌘

43-A GOOD KNIGHT VERSUS A BAD BISHOP

CORN MOON WANING, 1193

ugust burned slowly toward September, and the castle at Nottingham settled into a hot stupor. Reginald brooded over Robin's threat to have his head, Robin's audacity, Robin's infernal elusiveness. Occasionally his glowering silence would give way to eruptions of fury so fiery, servants scuttled out of the way, the hunting hounds cowered by the hearth and his cupbearer began to dread the call for more wine. Aelfric, his steward, suffered the brunt of it, closeted as he was each morning with the Sheriff, going over the accounts for the fief and other business matters.

Word had gotten out—unproven rumor, but vile nonetheless—that the Sheriff had released the murderer Gysborne to do his Sheriff's work for him. Suspicion and distrust grew among the people, as did their tendency to admire Robin and snicker at Reginald behind his back for his failure. Coucy, no stranger to being a laughingstock himself, took secret delight in Reginald's discomfort.

Maerin avoided them both. She sweltered in her chamber, barely speaking except to pray. For those few wild minutes as they had dashed along the lane leading out of Nottingham to Sherwood, she had tasted freedom. Then Coucy appeared, and Robin fairly leaped at the chance to be rid of her! How easily he threw her back to Coucy, like a fish too small for the frying pan, tossed back into the pond! With not even a word of thanks that she had risked her neck to save him! Every time she thought of it, she was enraged all over again. But, she reminded herself, it was not as if they stood in some elegant court to bid each other *adieu,* with a bow and a curtsey and a, 'by the by, milady, thanks be to you forever for saving my worthless hide!"

Was there a moment when he hesitated? Would he have turned back to rescue her, had there been more time? Or if she had pleaded with him to do so? She would never know.

Well, what was the point of saving him in the first place, if he died

fighting for her later? She did not regret telling him to leave her. Let him go, and by God's grace, by the grace of any Gods Robin worshipped, let him be safe.

She prayed for him, then for herself, but no longer did she pray to be freed from the shackles of her station and her impending marriage. Instead, she prayed for acceptance, to feel the peace of the Lady in her heart and accept the inescapable burden of her fate. To her amazement, it seemed instead that a burden lifted from her. Awareness flooded into her. She had longed to serve the Lady, but had selfishly, willfully imagined she could determine what that service should be. She had not truly offered to be a handmaiden to the Mother of God. She had wanted the Lady to serve her.

Now she prayed to surrender her obstinacy and foolishness.

Yet as she gazed on the flickering altar candles, she thought of the light in Robin's eyes and yearned for him. She closed her eyes, bowed her head, and offered up her longing as a sacrifice.

In Sherwood, meanwhile, the deer fed peacefully among the trees. The stags' antlers grew into branched and mighty oaks of bone, the fawns grew out of their spots, and the doe and the hind fattened themselves in preparation for winter. The rut was not yet upon them, and they were safer at times of harvest, when farmers were too busy in their fields to think of hunting and poaching.

Robin, too, was far from playing the hunter. He lay in his cave on his pallet, bound up in bandages wherever Guy of Gysborne's knife had made a latticework of his flesh. He shivered with fever, coughed, wheezed and blew his nose on a rag. The fight with Gysborne had drained him of his strength. At the end, thank the Lady, Her power had been a river flooding through his veins to aid him, but now he felt uprooted, ruined, washed up on a rock like a dead sapling.

Prim nursed him with bitter teas, wine mulled hot with healing spices, sweet syrups of honey, mullein and rue. She rubbed his chest with goose-grease mixed with mustard, boneset, ginger root, cayenne, and the Gods knew what else, and kept a hot stone wrapped in flannel at his feet despite the August heat. He was too delirious to know his friends, yet from time to time he thought he felt his dog Balor's tongue licking his palm, or dimly heard Juniper's voice pleading, "Don't die, Father!"

Robin tried to speak, to say of course he would not die, he felt too terrible to be dying and dead men felt no pain, but he could not summon the sounds from his throat.

The fever seemed to abate and return with the tides. For a fortnight he

lay fretting over his forced inactivity, whenever the fever left him lucid enough to fret, and he was plagued with visions unwanted, of black warhorses rearing to strike, Guy of Gysborne's sneering lips and mad eyes, John in chains, Sir Reginald raging, and worse, his last sight of Maerin.

Prim's hand on his feverish brow, he wished that hand were Maerin's, and cursed himself for a fool. Maerin would never touch him with such gentleness and concern. Maerin hated him. But why had she risked herself to save him? She could not have been the one who revealed his old identity to the Sheriff. But then who did? His brain wrapped around these questions so tightly his head ached.

She had screamed when he had flung her at Coucy, and for a moment, the look in her eyes had seemed to speak of some desperate longing, hatred for Coucy, and perhaps something else ... ? But of course the maid had cried out. She had probably twisted her ankle or the like. He had pushed her too roughly. She hated him. Deservedly.

But what did he care what the little imp thought? He vowed to set his heart aright as soon as he was able, with a visit to a certain dimple-cheeked serving maid at Snaith. But as often as he came around to that thought, he circled back out of it again, until he was riding horseback in his mind to Nottingham to pray Maerin's forgiveness, to steal his way inside the castle and see her in her green gown, to feel her slender hand cool and gentle on his brow, on his lips, on his heart.

This was not love, he protested inwardly. He should not imagine it, not for a moment. Yet it was not mere lust, for that feeling he knew well. Perhaps it was that their souls had touched and joined in the land of shades and Faerie. She was his Queen. Their lives were reeds braided together into a vessel that held invisible mysteries. There was no other lady for him anymore, not really. But he vowed feverishly to bed a few anyway and try to forget her, as soon as he was well, for Maerin could never be his in the physical realm, not in this life. Perhaps they had known each other in other lives, in other times and places. Perhaps they would again, if Goddess willed it. But he must forget wanting to hold her now, cover her with kisses, make love to her.

The thought made him ache, or perhaps it was only the fever.

As soon as he vowed to forget her, he remembered the fullness of her lips, her husky voice, her warm body pressed against him as he held a sword to her throat—ah Goddess, how she must hate him! How weak he had been, allowing her to endanger herself for his sake. The brave knight of the realm! Lord of the Greenwood! Fearless protector of women!

He had failed not only her, but himself.

He coughed and spat and swore. He complained to Prim that her con-coctions were making him worse. She felt his forehead, and damned if he wasn't off on horseback to Nottingham again, thinking of Maerin's touch. He swatted Prim's hand away and said, "Leave me be, Witch!"

Prim promptly gave him a tongue-lashing for his irritability, and then she sat up the whole night with him, pounding her drum in a slow, steady heartbeat, while incense made of mullein and other herbs spiralled up from the fire and made his cave a cloud. He hacked and coughed until he felt he would cough up his lungs. Then he felt them clearing. Finally he floated onto the cloud of smoke and fell dreamlessly asleep, and in the morning, the fever had broken for good.

Soon he was well enough to stand, sponge the dried sweat off himself, dress, and make his way down the cliff path to the valley, where his friends greeted him with relief. He ate a bowl of thin porridge, then wandered down-stream to rest in the shade of the willow. With Juniper and Balor curled at his side, he sat most of the morning lost in thought, scowling from time to time at the stream as if it flowed too slowly or too quickly, or held the blame for not bringing him what he desired, or for not washing those desires away.

Lulled into the feeblest of activities by the relentless heat, several of the outlaw band were gathered beneath the great oak. John passed the time by scraping the bark off a sturdy branch. "This may prove a better quarterstaff than that taken from me in Lincoln," he mused aloud.

"Good," said Prim as she passed by. "Use it on Robin's head."

"My mother tires of nursing," grinned John.

"Robin's spirit is melancholy. That is why he is slow in recovering," announced Tuck with an air of wisdom.

"Perhaps a guest would cheer him," suggested Will, thinking of the serving maid at Snaith.

"The sight of an abbot begging for mercy, that's the thing!" Tuck said.

"A bishop, with a purse full of gold." John chuckled. "That would cheer me as well."

"An archbishop!" said Tom.

"The Pope!" said Harald.

"Aye, would that he were here, for Christian charity!" Tuck said.

They laughed, then paused and looked at each other. In silent accord, they shook off their lethargy, gathered their weapons and slipped away into the wood in search of a likely victim, for Robin's sake.

They waited in hiding, praying for breezes, until the sorriest-looking

knight they had ever seen came drooping along the road, riding an old nag that would have made better dog meat than soldier's mount. The man's mail was rusty, and his head, bare of helmet, was also bare of hair but for a few straggling reddish-grey wisps, uncombed. His grey beard and mustaches were untrimmed. One foot rode within the stirrup and the other waved loosely without, and his limp hands did not grasp the reins, but hung at his sides like lifeless pheasants in a hunter's brace. His brow was furrowed, his pale grey eyes red-rimmed and moist with tears, and his frown was desolation.

"This one looks to need our silver more than we need his," Tom said.

"Let him pass," growled John with more selfishness than charity, for he had in mind better pickings.

But as the knight drew nearer, Friar Tuck's eyes widened, and he stepped out into the road. "Ho, there, my good man! Are you not Richard at the Lea, who often gave alms at Fountains Abbey?" He reached for the nag's bridle and the poor exhausted creature willingly stopped in her tracks.

The knight gazed at Tuck, still frowning. "Aye, Richard is my name, but it is long since I've given alms at Fountains."

"Well, it is long since I've received alms at Fountains, for I've found a wayward flock to tend with the word of Christ. But what brings you to this pass? Where is your escort? You once had the best horses in the shire." Tuck wrinkled his nose at the nag, who seemed used to insults and did not even twitch an ear. "Do you not know me, Sir Richard? I am Friar Tuck, though I am but a shadow of my former self, for I eat far less than I was used to when I lived by the abbey."

"Tuck? Ah, yes, I recall you now," said the knight, thinking Tuck looked hearty enough.

"And how goes it with your wife and son? I remember them fondly."

Sir Richard's frown lengthened. "It is my son has made me a shadow. He killed a Knight of the Templars. There was a brawl. Both were drunk. My son is young and brash—well, it is a long tale. His freedom cost me heavily, and to get the money, I sold most that I owned and was forced to borrow six hundred marks from the Bishop of York. But our harvest was poor this year, and the loan is due. I have just been to beg the Sheriff of Nottingham for aid. I once fought with him under King Henry. But Nottingham refused me."

"Anyone with their head above ground could have seen that coming and saved you the trip. He and York are thick as thieves."

Sir Richard sighed. "In three days' time, York will own my lands and my livelihood, and I ... I will throw myself in the river to drown."

"Nay, nay, drowning is a terrible thing, terrible for the lungs, my good

man, not to mention a venial sin. Or is it cardinal? Or original? No, no, original comes from being born, I think. I've forgotten. I have been too long among unbelievers. By God's mercy I am here to guide them to Divine Grace. But never mind, Sir Richard, for all that they are Heathen, they are true." Tuck waved at the trees and to Richard's surprise, several rugged-looking men loomed into view.

Tuck said to John, "This knight will cheer Robin, if only to see someone worse off than himself."

Sir Richard heard the words 'Heathen' and 'Robin' and realized he was met with the most infamous band of thieves in Sherwood. But he let the outlaws lead him blindfolded into the wood. He had nothing worth stealing, and he would rather die at the hands of brigands than face his beloved wife with the news that their last hope of help had been denied them. Besides, if they sacrificed him to their Pagan Gods, it would save him the trouble of drowning himself.

To his amazement, Robin greeted him with a courtesy that would have befitted a King's court.

"Our Lady be good to you, and welcome, Sir Knight," Robin said. "If you are a friend to Tuck, you are a friend to me."

Sir Richard summoned his best manners from the dark closet of despair where he had stored them. "God save thee, Robin, and all thy company."

Juniper brought water for the knight to wash his face and hands, while Tuck told Robin of Sir Richard's plight.

As the sun set, Sir Richard saw a feast laid out that would have graced any castle board in England, with new cider, ale and wine, roasted swans, pheasants and quail, salmon baked and poached, the heart and liver and haunches of venison, and other delicacies, some bought and paid for, and others no doubt stolen.

Robin crumbled a bit of bread on the ground and poured wine from his silver chalice beside it, murmuring, "For the Lord and the Lady."

Sir Richard simply crossed himself and thanked his own God before he fell to his food. He had not dined so well in many months. He was further amazed when a young man serenaded them with harp and lute as well as any trouvère of Aquitaine.

Robin watched their guest like a hawk, urged food and drink on him, and under cover of his hospitality, questioned him to discover if his tale of woe were true, or if this were some ruse of the Sheriff's. Richard had just come from Nottingham. Perhaps he sought the reward on Robin's head. Tuck often erred on the side of thinking the best of everyone. Robin himself

had trusted Guy of Gysborne. He would not make such a mistake again.

As the evening progressed, he murmured his suspicions to John and Will, who looked upon the knight with new and less welcoming eyes.

When the moon rose over the edge of the ravine, Robin clapped Sir Richard on the back and said, "Now you've eaten your fill, you must pay for your meal. It was never right, by my lights, for an outlaw to pay for a knight."

Tuck spluttered, "Hold, Robin! Sir Richard is my guest!"

Richard waved away Tuck's objections. He had expected a reckoning such as this. He supposed Robin would slay him when it was proved how poor he was. "I have but three marks to my name," he said, "yet they are yours, for they do me little good when I need six hundred."

Robin nodded at John and Will. They searched the knight. They found no hidden coin or purse, no warrant for Robin's arrest, or any safe passage on parchment from the Sheriff of Nottingham, only a small leather pouch, which they upended. Out dropped three marks, no more.

"An honest man is a breath of May," Robin carolled, as if he himself had never stolen or lied in his life.

"Robin, you are too untrusting," grumbled Tuck.

"Then I shall make my penance," replied Robin. "Sir Richard, more wine." He filled Richard's goblet for him. "If you are in the service of the High Sheriff of Nottingham, might I say he pays you but poorly?"

"You yourself have given me more than the Sheriff ever did. He did not offer me so much as a crust of bread. But if you wish to take my sorry life, do so now, I pray you, and I'll forgive you, and thank you for sparing me the sight of my wife's face when she finds we are without a home."

Robin felt a splinter of shame for his mistrust. "Take your life? I did not fatten you this night for the slaughter. You'll rest here tonight and go on your way the better for it in the morning, with a purse full of marks."

The knight's lips twitched and his eyes filled embarrassingly with tears. His life having been spared, he knew not what to do with it. Surely he could not throw himself in the river now that, through God's mercy, Robin had not cut him down. He declared, "In thanks that you have spared my life, Robin of the Wood, if I go free of this forest, I will go on pilgrimage to the Holy Land. Perhaps then, Jesus in his mercy will finally hear my prayers."

"Oh, aye, pray to Jesus!" Robin exclaimed. "He's helped you right enough 'til now, I can see that. Look at you: three marks to your name, your clothing thin as dried leaves, your mail rusting off your back, and Jesus the Christ's own so-called servants standing by like hungry gryphons to tear your estates from you! As they have stolen mine. Pray to Jesus if you will, Sir Richard,

that is anyone's choice, but look for aid from one still living on this earth. I will lend you the money." At the shock on his guest's face, Robin grinned. "There is no bishop alive who is friend to me. It would please me to do York out of your estate. Only tell me, who will stand surety for you against my loan? Six hundred marks is nothing to piss at."

The brief light of hope drained from Sir Richard's face. "When I was rich, I had friends in plenty. Now I am poor and beholden to York, they pretend not to know me. There is no surety for me but God that died on a tree."

"Which one?" Robin asked with an innocent air.

Sir Richard stiffened at this hint of heresy.

Robin teased, "Is it Woden? Odin? Or Cu Chulainn?" He chuckled and relented. "I know who you mean. I do not think a God so entwined with the will of the Roman Pope would guarantee for me. No, by the Ones who made me and shaped both sun and moon, you must find me a better surety."

Sir Richard said, "It is a fair request. But I have no other, unless it be the mercy of Our Lady."

"Done," Robin said, to the bafflement of his guest. "Well, friends, have we six hundred marks to save a knight from a bishop, for the sake of Our Lady?"

In answer, Will took a brand from the fire and and nodded to Much, who scrambled after him to a cave in the cliff which was overgrown with shrubs and brambles, and invisible from below even in daylight. Inside were iron-studded wooden chests of various sizes and designs, bolts of cloth stored off the ground on wooden tables, weapons of all kinds, intricately worked leather trappings for horses, several rare illuminated manuscripts and other treasures.

Will counted out six hundred marks from a large chest of coins, but before he swept them into two leather bags, he hesitated, then carefully counted out sixty-six more.

"You have mistold," objected Much.

Will said, as if reciting a lesson, "Three, and three times three, any counting of three is sacred to the Goddess in her guises, the holy trinity of Maiden, Mother and Crone. And when She is honored, She returns the bounty threefold. So say Prim and my Anne, any road, and now we will see if it is true. But first we must bless the coins, that they may do only good." He said a quick prayer to the Lady.

On their way back to the oak, Much figured that if generosity brought luck, the more they gave the better, so when they laid the money before Sir

Richard, Much asked, "Robin, shall we provide him with new clothes?"

"Yes, we must," Will said, "and a new suit of mail."

"A good broadsword would stand him in good stead," Tuck said.

"And a dagger," Tom said.

Aelflin, still the noblewoman, said, "We must send to his wife as well. No doubt she has gone without a new dress for some time. Have we not wool and linen and silk, of scarlet perhaps, or green?"

"Scarlet and green, royal blue, light blue, yellow and indigo," Harald said, ticking off the colors on his fingers.

Richard protested, sure they were jesting, but Robin said, "He'll have nine yards of every color, then, to take to his lady."

Prim said, "He'll need a packhorse, to carry everything home."

"But he must have a horse to ride also!" blurted Juniper.

"And therefore a new saddle," Robin said, amused.

"Yes, and a new pair of boots," offered Allan.

Will lifted a skin of wine, and now he and John, Allan, Harald and Much trooped back to the cavern to gather the goods, with John singing boisterously out-of-key, and Will and Allen charging him to shut up.

Harald pulled out bolt after bolt of cloth and John used his long-bow to measure it out. Much did the cutting. But at each measure, John jerked the material through Much's scissors before he could cut, adding an extra length, until Much snapped, "What devil's draper are you?"

Will laughed. "John may give good measure, for it costs him but light!"

Much reddened. He bent to the cutting of the stolen goods and kept his mouth shut after that, for fear of appearing the fool a third time.

Surrounded by gifts, Sir Richard's eyes grew moist, and he said, "Your goodness belies your brigandry. I swear by the Lady, I shall do all I can to repay you. What shall my day of reckoning be?"

"In thirteen moons, a year and a day. But a knight must not ride alone, without squire or page." Robin looked around the fire, and his eyes lit on a hopeful face. "I lend you my son, Juniper, to be your squire. But him you must return to me as soon as you are quit with the bishop, for I cannot do without him for long." The sight of Juniper's eager smile more than repaid Robin for the loan.

⌘

Early morning sun glinted off Sir Richard's polished helmet and dappled the mane of his proud bay with coins of sunny gold as they cantered easily along a winding woodland path. He held the reins firmly, and his head he held high. He looked a different man altogether from the one who had plodded

into Sherwood the day before.

Beside him rode Juniper, still too excited to speak at this great adventure. He bounced in his seat, gazing at his temporary master's dignified face, peering down at his own squire's tunic and prancing pony, at the brilliant blue sky overhead, at the branches tossing in the morning breeze. Fantasies flitted through his brain like the jewel-colored birds flitting through the trees. To be a squire, perhaps someday a knight! That he, a Jew and a pauper, could even imagine it! He twisted around again to admire the packhorse, was struck by a low-hanging bough and almost toppled off his horse.

Sir Richard helped right him, pointed to the trail ahead and advised Juniper to keep his eyes on it.

As soon as they reached the main road, they dug in their heels and galloped hard for the north.

At noon, the Bishop of York was at table with two guests, a monk who was also a scribe, and the Sheriff of York. The momentous occasion, the legal increasing of the Bishop's personal wealth, called for a grand repast, and they were waited upon by a brace of pages and serving maids, the high cellarer, a cupbearer and a steward.

The weather was viciously hot and the chamber, despite its thick stone walls, was a furnace. The three men sweated profoundly as they ate their unseasonably heavy meal, and they tried to cool themselves by loosening their robes or tunics, by splashing water on their faces and necks and sluicing their arms as well as their hands between every course. Yet because there was no breeze, the liquid acted more as a basting sauce than a cooling agent. So they were dripping wet and well-roasted by the time the angle of the sun's rays pouring through a window announced the hour Sir Richard at the Lea was due.

The bishop set down his goblet of watered wine and began scrubbing the grease off his fingers in the water bowl beside his silver plate. "It's time. Well I know the man has no money to repay his debt, but I thought he had pride enough to show his face." He gestured to the scribe, who began washing his hands also, that he might fish out the final papers. But he had barely dried his hands on his robe when a herald announced Sir Richard, who had donned his old rags and his mournful face at the suggestion of the trickster, Robin. He knelt before the bishop. "Your Grace."

The bishop wasted no time on false pleasantries. "Have you the money?"

"I have come to beg Your Grace for more time," said Sir Richard. "I pray you give me until All Hallows' Eve. Grant me but two more months, that I may send to my cousin in Normandy to beg him for the money. Then

you shall have every penny I owe plus whatever interest you wish to charge."

"Preposterous! You should have thought of this cousin before now. Your lands are forfeit. Bear witness, Sir Sheriff."

The Sheriff nodded, swallowing a large mouthful of mutton.

"But my cousin was ill and is only now recovered! Sir Sheriff," pleaded Richard, "defend me! I have come in good faith at the appointed hour, and ask only for more time, for pity's sake!"

The Sheriff shook his head. "The law must be upheld."

"My lord Bishop," begged Richard, "let me be a servant to you, in the name of Christ, 'til I may earn the money and save my land!"

"Get money where you may, you'll get none of me." The bishop mopped his brow and nodded at the scribe, who fiddled about in his knapsack to draw forth the mortgage parchment.

"By dear worthy God, you shall not buy my land so cheaply!" Richard stood and drew his dagger, and slung it at the parchment, pinning it to the table.

The Sheriff threw down his leg of mutton, leaped to his feet and drew his sword.

"You dare threaten me? False knight!" thundered the bishop. "Your son murdered a man of the cloth! It is for this you suffer, and rightly so! Get out of my hall!"

But Richard said, "Here is your money, you evil schemer, and may it weigh you down so heavily that it pushes you into your grave!"

At the uttering of this curse, Juniper, who was waiting just outside for his cue, appeared in the doorway with a large sack, which he emptied on the table, dousing the remains of pheasants and pies and water bowls with shining coins, and wishing Robin were there to see him make such a splendid gesture.

Sir Richard flung off his rags to reveal the new clothes and mail Robin had given him. "I have been a good Christian since the day I was baptized, and have never seen such an abuse of the House of God! You could not grant me a few paltry weeks to save my livelihood, but would take it—devour it like a quail's drumstick! You would ruin me and my good wife without blinking! You did not even bid me stand in your presence, but kept me kneeling like a criminal or a whipped dog. Take your money and be damned!"

"Ignoble cur!" But the bishop growled to the scribe, "Count it."

Sir Richard stood erect and motionless until it was done, then held out his hand for the deed to his lands and quit the hall, with Juniper striding behind in his footsteps and feeling he had just come of age.

44-Of brotherly love ... and other fictions
Ivy moon dark, 1193

Yellowish-grey clouds coiled across the sky like banks of smoke from a burning earth. Heat lightning flashed on the distant tors, but no rain came. The late afternoon air hung heavy in the Great Hall. The occasional hot breeze did little to dispel it. The hounds lay panting on the stones by the unkindled hearth. Several knights and their squires loitered in the shadowy corners of the hall, waited on by lethargic servants. Reginald and Augustin sweated over a game of chess, while Maerin, driven out of the false security of her upstairs chamber by the suffocating heat, sat near the throne on the edge of the daïs, feeling as much a prisoner as King Richard himself. Even now, Prince John conferred in his chambers with another visitor from Paris.

After she had surrendered privately to the Holy Mother, Maerin had gone to Reginald with lowered gaze, thinking she did the Lady's will, and apologized for her stubbornness and pride. She promised to be humble and malleable, to be guided by those whom the Lord had placed above her.

Her uncle narrowed his eyes. This was unlike Maerin. But then, she no longer had a champion in Robin Hood. To submit to the inevitable showed practicality. He bade her sit by him, called for watered wine, patted her hand and said, "Only a foolish woman learns nothing from her mistakes."

Maerin bit back a retort.

But Robin's eyes, his face, his touch, his voice assaulted her dreams. In some, their limbs were hotly entwined, their lips met, and their hair tangled together in a fever of love-making that made her body ache with violent desire that lingered long after she woke. In others, he caressed her as gently as a swan floats upon a lake. In yet others, he caressed his blonde wife, or seemed to look through Maerin as if she did not exist. She railed at him in one dream, turned away from him herself in the next, feeling empty desolation. Waking was more emptiness, finding herself alone.

Now she wiped her sweaty palms on her bliaut as if to wipe away dreams, pulled her lute onto her lap and played one of the newly popular ballads the King had written bewailing his imprisonment.

"Another tune, if you please, Maerin," Reginald interrupted. "Something merrier. This infernal weather plagues me."

Maerin swallowed her annoyance. Even her voice was not free. She frowned. Had she lost her peace and trust in the Lady already? Yet it was so difficult to bend her will to that of her uncle, or Coucy, no matter how much it seemed to be the Lady's will also.

Her fingers sought the chords to an air she had heard the servants singing when they thought no one else was near.

"Maerin, your training fails you," said Reginald peevishly when her strumming faltered.

"I've heard that tune, but never the words," Coucy commented. "Sing them for us."

"Your command is my desire," Maerin replied with a sneaking sense of mischief. She began to sing in a clear, innocent voice.

> Robin Hood and little John
> Were travelling to the fair,
> With bow and arrow and quarterstaff
> To ply at Lincoln square,
>
> But all along in the dappled wood
> A strange sight they did see:
> There were the wares of a wight yeoman
> His body leaned to a tree.
>
> A sword and a dagger he wore by his side
> That had been many yeomans' bane,
> And he was clad in his capull-hide
> Top and tail and mane.

Reginald had turned a dark gaze upon her, but Coucy called out, laughing, "Play on!"

> "Satan's curse on thy heart!" says Guy,
> "But fellow, thy shooting is good;
> And if thy heart be as true as thy hands

Thou wert better than Robin Hood.

"Tell me thy name, braw fellow," quoth Guy,
Under the leafy vine.
"Nay, by my faith," quoth Robin,
"'Til thou have told me thine."

"Must you mock me?" demanded Reginald.

"You must ask my future husband if I must," Maerin said, bowing her head.

Augustin snickered.

Maerin bit her lip. She dared not make Reginald her enemy. He was the only man who could keep Coucy in check. "Take heart, Uncle. The common folk say it was no mere man who bested you, but a *puca,* and who could outwit such as he?"

"What the common folk say is no concern of mine."

"Perhaps it should be," Maerin said, then bit her lip again. Her haughty habit of baiting Sir Reginald was hard to break.

But the Sheriff only snorted and turned his attention to his Queen's knight. Coucy, however, said, "Sing on, Maerin."

A quiver of anxiety ran through her. She strummed the chords to a new tune, but Reginald swept his hand across the chessboard, knocking the men to the floor with a clatter. The hounds lifted their heads. Reginald lunged toward Maerin, his hand raised as if to strike her. She stopped playing and her face went white, but she made no move to run or defend herself, whether from submission or defiance, she herself could not have said.

Enraged at her lack of fear as much as the taunting tune, he slapped her hard across the face. Tears stung her eyes, her cheek burned, but she did not cry out. He hesitated, towering over her, his fists clenched.

Coucy sniggered, "That's right, beat the bitch," which was enough to turn Reginald's stomach sour.

A crack of thunder startled them all. The hounds whined. A gust of wind, stronger and cooler than before, shuddered through the narrow windows. Then they heard it: sheets of rain sweeping across the battlements. The wind tossed drops of hot rain through the windows, spattering the rushes at their feet.

"The heat has broken," Maerin said.

Reginald lowered his fists. He nodded curtly to a page, who scurried to pick up the chessmen. The air was still thick with tension when a herald

appeared in the doorway and announced a courier in a drenched Norman cloak.

"A letter for Monsieur Augustin de Coucy." The messenger bowed and offered a scroll.

Maerin watched a curious blend of emotions play across Augustin's face as he read. His eyes widened, then narrowed; he frowned, his breath quickened and then a glint crept into his eyes. He rolled up the parchment and announced, "My brother is dead."

Reginald raised an eyebrow.

Maerin said, "You have my sympathy, Monsieur."

"How sad that someone must die before you honor me so," Coucy replied.

Maerin's lips tightened.

Coucy turned to the courier and said, "Wait for my reply."

"Grand merci, Monsieur." The courier bowed and followed the page into the kitchen to be fed and warmed by the fire.

"Jousting? Hunting? Fighting?" asked Reginald.

"A bad leg of lamb, it seems."

"Inheritance?"

Coucy gave a thin smile. "The only portion I could expect from my brother's estate would be some of that which killed him."

"You will attend the funeral?" Maerin asked.

"Hardly. Excuse me, I must write a reply." He rose and gave a perfunctory bow before quitting the hall.

Maerin knew she should feel sorrow at someone's death, but instead she felt hope. Had not Coucy once loved his brother's newly widowed wife? Perhaps he still loved her! Perhaps he would beg leave to go to her, and void the marriage contract with Maerin! She must speak to him at once. "Have I your leave to go to my chamber, Uncle?"

"Yes, and take that damnable lute! And Maerin, if you play that song again in my presence, I will clap you in the stocks and make an example of you. I've a mind to forbid the singing of it within the town walls."

"As you wish, Uncle. As always." She curtseyed. "Only tell me whom I must first obey, my guardian or my future husband."

"Get out," he snapped.

⌘

Isabeau.

Coucy sat brooding at the desk in his bedchamber while the rain studded the closed window.

There had been no hint of her old coquettishness in her letter, of course, nor any hint of sorrow. Only the unembroidered facts of his brother's death. Well, she had never loved his brother any more than she had loved him. Edouard, as the eldest, had inherited the wealth of their family; that was what had sealed their marriage bond.

It would not surprise him if she had had something to do with that rotten leg of lamb. 'Inheritance powder,' they called it. A little arsenic each day, and she could add her dead husband's estate to the riches she had received from her father. The greedy, cold-hearted cunt.

Still, Coucy would surrender all of Maerin's dowry for one of Isabeau's kisses. His body burned with the remembered ache her teasing embraces had aroused in him so long ago.

Damn her.

What did he have to offer her? What wealth, what power? He would not give her the pleasure of rejecting him again.

He drew a sheet of parchment toward him and wrote, "Dear Sister, I am in receipt of your letter. I loved Edouard as well as you did, and I grieve in equal part at his death." He was sure the irony of that statement would not be lost on the clever Isabeau. He continued, "How sad that matters concerning my own nuptials force me to remain in England. Perhaps some day I will come with my bride to pay my respects to Edouard's grave, and to you, Madame. In deepest sympathy, Augustin de Coucy."

Only then did he consider what inheritance powder could do for him, once he himself was wed.

⌘

Maerin also was writing a letter, in a frenzy of haste, that it might be delivered by the same messenger who would take Coucy's reply to Normandy. *"Chère Madame de Coucy,* forgive my presumption in writing to you, who do not know me. Yet believe that I have your own interests and happiness at heart, even as I do my own.

"Please accept my condolences in your time of sorrow. I pray that you will forgive my impertinence and rashness in writing to you of such things so soon after the death of your husband, but there is no time to waste.

"I am the intended bride of a man who once loved you, who indeed loves you still. I write of the brother of your departed spouse, Augustin de Coucy. His heart can never be mine, for it is yours and always will be. I say this without rancor or jealousy. I cannot love a man who cannot love me." Here Maerin paused a moment, wondering if that were completely true, for did she not love Robin? And she knew nothing of his real feelings for her, or

if the blonde woman he bedded were his legal wife or otherwise. Well, there was no time to put too fine a point on it; this letter must be finished quickly, and may the Lady forgive her for any phrase that rang of falsehood. She wrote, "I do not fault Augustin for his lack of affection towards me, for such is often the case with arranged marriages, and the high esteem in which he holds you tells me much of your good character. I trust that, were we to meet someday, we would be kindred spirits.

"*Chère Madame,* the purpose of my letter is this: if you were to open your heart to this man whose every waking moment is a torment without you, if you were to let him know you would welcome him, after a proper period of mourning, of course, into your home and your affections, I have no doubt that you would grant him joy and even save his soul, as well as mine. Although I have made my peace and submitted my will to that of my guardian and my *fiancé* Augustin, in truth, I have long felt a vocation for the Church. My greatest desire is to enter the convent for a life of service and contemplation. In short, I am no fit mate for this passionate man who adores only you.

"Please, write to me—nay, write to him, if you love him!—and let us know the workings of your heart. I pray that the result will be three souls, three hearts, living in harmony and happiness.

"In deepest sympathy and good will, your servant, Maerin fitz Warin."

She sat back. What woman could resist this plea, this declaration of love? Her second letter was less fervent.

"*Madame l'Abbesse de Fontevraud,* forgive me for not writing to you sooner. In my willfulness, I forgot that your friendship and kindness to me, arising as they do from the source of all love, the Christ, must outlast any change in my fortunes. Though I have bowed my head to accept the future my guardian has fashioned for me, word has come today that causes me to believe I shall soon be released from my marriage contract. If it be Our Lady's will, I should like at such a time to forsake the world, retire to Fontevraud and take my vows." Unexpected tears jabbed at her eyes, and a gut-wrenching sob escaped her that Reginald's blows could never conjure. If she were to go to Normandy, Robin would be lost to her; she would never see him again. But she could gain her freedom no other way. With Coucy gone, her uncle would only find another fortune hunter for her to wed.

She quickly wiped her tears away before they could fall on the parchment and smudge the ink. May God grant her refuge, if not a love that she had never dreamed possible any road. She would never marry. Better that it were so. No other man could win her heart.

Oh, no, never, she thought then, for Robin had too much to recommend him! A thief, a Witch, a womanizing trickster—why, no one else could hold a candle to him!

She shook her head at her own folly, and wrote, "You see that despite my sojourn in the world of men, which I have found to be a chastisement against my selfishness, I still feel strongly my vocation. I ask only that you consider my postulancy once again, if I am freed from impending wedlock." She paused. That she might be freed from her prison, as Richard the Lion Heart might be freed!

Thinking of her King, languishing in captivity, of John, continually conspiring against him, she dipped her quill in the ink again. "But I write you not only on my own behalf, but for the sake of Queen Aliènor of Aquitaine, who frequents your abbey. I am sure she would rejoice to have word of her son John, who, as you know, bides with us in Nottingham. He is not cut off from the world, however, for she will like to know he has many visitors from London, and even Paris. Methinks they have to do with the King's imprisonment, which I know the Queen and her son labor to end." Maerin did not say which son. "Perhaps the Prince is too busy with matters of state to write his mother, and so I hope to enlighten her mind.

"But enough of ghastly politics. I am only a young maid, convent-bred, and know little of such things. I busy my mind with less taxing stuff. You know I have always followed the latest fashions with great interest." Certainly that bit of nonsense would alert the abbess if nothing else did! "One of Prince John's closest confidants has a decidedly Parisian flair to his clothes and manners. Though we English, and even the Germans and Austrians, often mimic the French in such things, I myself do not think we are less sophisticated than they.

"Today the rains came and we are grateful. Perhaps tonight's supper will find our Prince in a more genial mood than usual, for he worries so over his brother's fate. If a smile be not summoned to his royal face, I shall do my best to cheer him if I may. In the name of Christ and Our Divine Lady, Maerin fitz Warin."

She sealed the letter with wax and her signet ring, summoned Elgitha and bade her take the letter in secret to the courier in the kitchen.

Why should she not meddle in affairs of state? Other women did, many to good account, most notably Queen Aliènor herself. What better spy upon upstart royalty than one who lived in the same castle? For the sake of rooting out information, she vowed to make herself more sociable with Prince John, whose presence she had so far responded to with the utmost propriety, a

distant civility bordering on coldness, determined to keep him at bay, for she knew the Prince's reputation for chasing women. Already more than one of the serving maids were showing the results of his attentions. But surely he would not dare to take liberties with a noblewoman.

The next morning, she spoke with Coucy, giving him leave to renounce her and pay court to Isabeau. He laughed unaccountably in her face. She flushed with outrage and embarrassment, and left him.

She reminded herself that her letters were on their way and the future was not hers to predict. She happened to pass Prince John on the stairs, and curtseyed more deeply than usual. He noticed her sudden blush, and inquired after her health. She said she had slept little the night before and even now, felt a slight headache. The Prince suggested she have her maid place wet tea leaves in muslin, saying this was most soothing to the eyes. She forced herself to reply with more warmth than she felt, thanking him for troubling himself on her unworthy account, to which he replied with an unmistakeable leer that she was far more worthy than she gave herself credit for.

Maerin curtseyed low again. Perhaps she could win, if not his friendship, at least his indulgence. He might then take up her cause with Sir Reginald. If not, at least she might ferret out his plans regarding Richard.

Her head now ached in reality from considering all these desperate ploys and machinations. How spies must lie and connive! Did they confess their doings to a priest? And was she totally mad, thinking of joining their ranks? This was what came of being lost in the greenwood under a full moon! The path she had undertaken was folly. She should abandon it at once.

But when Prince John chucked her on the chin before going on his way, she managed not to recoil.

45-THE THREEFOLD LAW
IVY MOON WAXING, 1193

aint autumn crispness tinged the early morning air in the greenwood, but it wore away as the sun rose, until the day felt as warm and somnolent as high summer. The cry of a lark filtered through the forest from a leafy tree, but it was Harald and no lark.

"Here's a piece of luck!" whispered John Nailor in his hiding place, for he could see the chestnut and bay and dappled grey of some two dozen

horses, the black of monks' robes, the glint of soldiers' helmets and mail, and best of all, a flutter of purple cloth. "Bishop."

"Money," Tom said happily, and strung his bow.

Two soldiers rode in the lead, carrying pikes. Behind them came nine more soldiers riding three abreast, their hands on the hilts of their swords, ready for trouble. Then came two Benedictine monks, the purple-robed bishop on a sturdy stallion, and more clerics and soldiers bringing up the rear. The clopping of hooves, the jangling of harness, the rustling of leaves in the wind, and then the unlikely hoot of an owl in midday, and Tuck and Juniper, concealed on either side of the road, cut the vines that held counterweights. The net of sturdy vines hidden under the roadbed sprang upward. With a loud whinnying and yelling, tumbling and tangling of limbs and weapons, the two lead soldiers and their horses bounced in mid-air above the Great North Road.

Warning arrows shot out from the trees. Horses snorted and reared. Soldiers shouted and drew their swords. Others aimed their crossbows into the trees, seeking invisible targets. Attacked, the thieves fought back. Several soldiers fell dead as arrows found their marks. Where the wood on either side of the road had seemed empty of human life a moment before, now two score men appeared, seeming half-beasts, with animal skins draped around their bodies, painted faces, leaves and vines twisted in their hair, and deadly longbows aimed at the travellers.

"Why, 'tis a prancing peacock of the Church!" blithered Tuck as he and John swaggered into the road. "A finely fattened peacock, too!" Then his eyes widened. "God's blessings upon us! Is it my old friend, the Bishop of York, or do my eyes fail me? By St. Swithin, it is none other! No doubt you are on your way to succour the needy, Your Grace. As luck would have it, I have a friend in need. In sore need of entertainment. Nothing would please Robin better than that you of all people should provide it."

"Friar Tuck!" spat the bishop. "Well I remember you and your Heathen ways! I cast you out from St. Mary's for it. So you have fallen to brigandry. I am not surprised."

"Ah, but Your Bishopship, what harm is a May dance or a bit of swiving in a field between friends? Does the sight of naked flesh inflame you to iniquity? Or is your spite aroused because none would have you? That would make your vows to renounce women a pretty sham, wouldn't it? Dear, dear, that would never do!" Tuck chortled. "Yet I see that like me there is one joy of the flesh you do not abhor." He patted his own big belly. "Come and dine with us, Your Grace. I promise you a feast you'll never forget."

⌘

Under the great oak at Brighid's Well, the bishop was dragged from his horse and his blindfold removed. He found himself face to face with a lean man, bare-chested in the heat, with blue-grey eyes under dark eyebrows and long, tousled hair.

"His Eminence the Bishop of York," said Tuck with a grand sweep of his arm. "Your Grace, may I present the Lord of the Greenwood, Robin, known also as Robin in the Hood, Robin of the Wood, Robin Goodfellow and also Puck, a noble, a beggar, an archer, a hunter, a trickster, a lover, a king and a thief."

A vein in the bishop's forehead stood out and throbbed.

Robin said, "York? The same who held mortgage on the lands of Sir Richard at the Lea? But your face and your form are familiar. Are you not also the same bishop who refused to marry these two?" He gestured to Allan and Aelflin, who stood nearby with their arms around each other's waists. "I seem to recall leaving you bound and gagged at the altar. How glad I am that you were freed safely." Robin fingered the gold medallion hanging around the bishop's neck. "The last of these I took from you made wedding rings for Aelflin and her man. I wonder whose rings this shall become." He yanked at the medallion and broke the chain. Then he grinned. "Merry meet again, Your Grace!"

The bishop made the sign of the cross in mid-air between him and Robin. "Do not mutter Heathen incantations at me, you thieving whoreson! I abjure thee in the name of the Father, the Son and the Holy Ghost!"

"What an ungracious greeting, Your Grace. And yet I welcome you to Sherwood, in the name of the holy trinity, Maiden, Mother and Crone."

"Conjure not the whore of Babylon!"

Robin laughed. "She shall conjure Herself if She so chooses. But shall I conjure you up a feast instead? We work magic on the King's deer and you may share the bounty with us."

"Fiend! Bedevilled like your father, I see! Well it is that the Church took Loxley from you and gave it to those who would use it in the service of the one true God."

Robin's smile faded. "Loxley? What does the Bishop of York know of Loxley?"

"I know all," said the bishop haughtily.

"All." Robin felt he could not breathe. His eyes bored into the bishop's. Certain knowledge flooded his heart. His voice was hoarse. "You burned it."

"I myself did nothing."

"You knew of it! You put your blessing on it!"

"I knew God's will."

Robin drew his dagger. "Then suffer my will!" He leaped at the bishop, knocking him to the ground despite his bulk. The bishop flailed and cried out. Robin dug his knees into the bishop's rolling gut, shoved the fat face sideways into the dirt and raised his dagger to plunge it into the man's neck. The bishop's men shouted and struggled in vain to break free of their bonds, while Will and John and the others watched Robin in fascinated horror and surprise.

But the dagger did not drive downward.

It shivered in Robin's right hand. His left hand at the bishop's throat pressed harder, then released. With an icy calm, he stood. "Bind him to the oak." He staggered away without waiting to see if he was obeyed.

He plunged through the ravine half-blind with rage. What had stayed his hand? He cursed himself, cursed the bishop, cursed the Crusade for ruining his taste for killing. How he would have loved to see the blood spurting out of the bishop's throat. Why had he not slain the man at once, while fury possessed him?

York had destroyed his father. York had destroyed his home, made him an outlaw. York had set Robin's feet upon the path he now trod.

But was it not a better path than the one he had walked before?

Robin ground his teeth together. Should he thank the bishop then, for burning his home, raping the land, killing his father?

He screamed aloud, dropped his dagger, and flung himself to his knees beside the pool where Brighid's brook tumbled down the rocky cliff. His scream reverberated against the stones and echoed back to the camp, where everyone halted in their movements as if they heard a werewolf or the *bean-sidhe*. The bishop, lashed to the oak, felt as if the blood in his veins stopped flowing at the sound.

Again came the otherworldly howl of anguish, then silence.

Will, John and Tuck conferred with a glance: should one or all of them go after Robin? Tuck shook his head. Now was not the time to reason with Robin or even try to comfort him.

Robin crouched at the pool, gazing across the water, registering nothing of what his eyes saw, until his vision blurred and a mist seemed to rise up from the sacred pool. Images came to him in the mist, of the bishop trussed to the great oak as if Woden hung there, a sacrifice, or Odin on the World Tree, or Jesus the Christ on a wooden cross, the cross itself a bastard, a rape of the living spirit of a tree, like a hangman's gallows. As he watched, the bishop

lolled limp and his blood poured down into the roots of the oak, feeding it.

Was York a gift of the Goddess, the chance at last for vengeance upon the man who had caused his father's murder? Was it a blood sacrifice the Lady desired? Or was it only Robin's own desiring? Whom would he serve, the Lady or his need for revenge? True sacrifice came of the self, not of another. So spake the Old Ones. He fought this wisdom, his blood boiling, but he knew he himself was the one who must go willingly to it, when the time came, or it would be no true sacrifice, only suicide.

Those who knew the Mysteries counselled, "If you harm none, do as you will." Then was it evil to kill the bishop? How many people would be spared if the Bishop of York lay dead? A bishop who made so many innocent, unwilling sacrifices to his own bloodthirsty God? Killing the bishop would surely be for the greater good. For many others, not just himself.

The image in the mist wavered. Instead of the bishop he saw his own body hanging on the tree. His felt his own limbs jerk and quiver in death, his own breath choking in his lungs. In the darkness the single eye of the Moon Goddess shone behind the branches. The thought came to him that he and the bishop were of one body.

"But ye Gods and Goddesses, I hate the man!"

"Hate him if you will," came the whisper of the water, the silken silver voice of the moon, "but nevertheless, know you are one, and you are both Mine, and the harm you do to him, you do to yourself and to Me."

A cry of fury and frustration escaped him. He raised his arms as if beseeching the moon for a better answer. "I am no Christian saint! I am a man! Only a man!" He stood, turned, felt no escape, then threw himself into the pool, through the mist, swimming downward and deep, straining his arms and legs and lungs. The light penetrated the water, inescapable, until he felt he swam to the moon and stars, but at last the light left him and he saw only darkness.

He burst to the surface again, gasping for breath. He let his body go limp, floating on the water's placid surface. Now the earth's moon, the mirror of the moon of his visions, rose near to full, promising increase and the bounty of the second harvest, shedding light on all things without discrimination, without hatred, without judgment, cool, open and all-embracing.

Damned if it were not an inauspicious time for a blood sacrifice any road. If only the moon were waning or the time of Samhain were upon them, perhaps Robin would not be so careful of the bishop's life. Perhaps the words to come to him in his scrying would have been different. But even as he thought that, he knew it was not so. He groaned and muttered, "Lady,

give me the strength to do Thy will."

He slid out of the water, picked up his knife and slogged back to the others. He stood dripping in his wet clothing before the great oak. The bishop almost lost control of his bowels at the bare glint of Robin's blade.

Robin said, "You may thank the Lady that you do not die tonight. But this I lay upon you. Disobey Her will at your peril. You will acquire no more wealth, but give away all you have to the needy, regardless of their faith. You will renounce your title of bishop and become a friar, like Tuck here, and learn the humility of which your Church fathers prate. You will take a vow of poverty, and keep it. If you accomplish this by the Hunter's Moon, you shall yet live. If not, you shall die before Sunreturn, and if Goddess will it, I pray my hand be the instrument of your death!"

The bishop's guts twisted. Nausea spread through his limbs as this fate was pronounced. But he would not forswear his faith by paying heed to a Heathen's curses! He must not say as much, though, or it could mean his life.

As if reading his mind, Robin said softly, "Mark me, Bishop. My word in this wood is law." He cut the bishop's bonds. At his signal, the other prisoners were unbound so they could eat under the wary gaze of armed outlaws.

Prim threw a cloak over Robin's wet clothing. He nodded his thanks to her. He led the others in crumbling a bit of bread on the ground and pouring out a few drops of wine. Their prayers made a tangled murmuring. "For the Lord and the Lady."

"May we partake of Thy truth with this night's feast."

"Thy wisdom, Lady."

"Thy strength."

Robin said to the bishop, "You see how every meal is Holy Communion for us."

The bishop scowled. "Only ordained priests can consecrate the blood and body of Our Lord."

"Nonsense. But do you not pray before every meal?" Robin said, spearing a broiled quail with his dagger. "Is it so different?" Then he flushed, remembering his cousin Constance saying similar words to him.

The bishop did not reply. He refused to eat, and under the stern and disapproving eye of their master, the monks sat back and stared hungrily at their tankards of ale, bowls of stew and slabs of bread. The soldiers, meanwhile, were stuffing themselves.

"Have you lost your appetite, Your Grace?" Robin asked. "Now I believe anything is possible!" The outlaws laughed, somewhat relieved to see

that Robin was recovering his mischievous streak. "But this is an evil thing. We cannot send you back to York wasted away from starvation. It might give us a bad reputation."

"I'll not partake of this Devil's Mass." The bishop sat with his arms folded across his chest.

With his dagger, Robin speared a chunk of dripping venison from the stew and pressed it messily to the bishop's tightly pursed lips. Presented with the business end of a knife as well as the lure of the savory meat, the bishop finally opened his mouth. The outlaws applauded. With a flourish, Robin poured the bishop a tumbler full of wine. Allan tuned his harp and launched into a ribald song that made the bishop's ears burn, especially when several of the soldiers forgot themselves and joined in on the chorus.

Robin toasted Allan for his music. Then he turned to the bishop. "I think we humble folk of the greenwood must aid you in fulfilling your vow of poverty."

The bishop snapped, "You have already stolen our weapons and our horses. We have nothing else of value."

Robin smiled and gestured to John, Will and Harald, who began to search their prisoners for money bags and purses. Among the soldiers, they found a few coins, but there was not a penny to be had among the monks, and the saddlebags on the bishop's horse were surprisingly empty of coins or jewels. The bishop reached into his robes and threw down a small pouch. "I brought only enough coin to pay for lodging for one night."

Harald opened it and counted. "Five marks."

Robin said, "Why do I find this remarkable? You travel like a lord, with a retinue. Your robes are of the finest weave and dyes, your horses, also the finest. One night's food and lodging for so many men would surely come dearer than a few marks. Or do you simply steal what you need, like an army on the march?"

"Or like a thief?" replied the bishop coldly. "Our credit is good."

Robin laughed, nodded to John, and between them they stripped off the bishop's robes until he sat naked before them. His sagging, mottled breasts, mountainous white thighs, and vast rolling belly half obscured the money belt he wore around his middle.

"What a surprise!" John said.

"Shocking," Allan said. "Do you think there's money in it?"

"Surely not," Will said.

"A man of God would not lie!" Friar Tuck said, crossing himself. "It must be empty."

"Lord and Lady forgive me for my suspicious nature," Robin said. "Open the belt and prove me wrong, little John, I beg you in the name of all that is holy."

The padded belt was wound around the bishop's girth four times, and when John had unwound and opened it, a staggering number of gold coins jangled out onto the purple robe at the bishop's feet.

Harald and Aelflin settled down to the laborious task of counting the money.

"Demons and traitors!" sputtered the bishop. "This money is meant for Prince John, for the ransom of King Richard. If you stand in the way of your sovereign's deliverance, there will be no mercy for you when you are caught."

Robin laughed. "I would sooner believe that fishes ride horseback than that Prince John will deliver Richard." Then he added, sobering, "I should have known you'd be on your way to Nottingham and the man who set his seal upon my father's death."

"Almost two thousand marks, Robin!" Harald said.

"It seems Our Lady has stood surety very well for me," Robin said. "I lent Sir Richard at the Lea six hundred marks to pay you, Bishop, and now my loan is repaid threefold and then some."

"So it does work," Will muttered, looking awed at Prim.

"You!" exploded the bishop, for he had wondered where Sir Richard had found the money.

"Let us give thanks for the goodness of the Goddess, and for making this bishop the humble agent of Her generosity," Tuck said. The outlaws bowed their heads in mock solemnity while the friar intoned their gratitude in a prayer punctuated with Latin phrases and common homilies.

As for the bishop, he was too incensed with rage to speak.

He spent his night in the greenwood fidgeting and uncomfortable in his peasant's bed of pine boughs, and in the morning, he was blindfolded along with his men and hustled bootless through the woods. They were released near the Great North Road to find their way to Nottingham on foot. The last words the bishop heard lilting out of the trees were, "Merry meet, and merry part, and merry meet again, Your Grace!" and a ripple of laughter.

The bishop cursed roundly until the silence in the forest told him no outlaws lingered to hear him. He ordered his retainers to build a litter on which to carry him, and he fretted and cursed them when they took too long making it, and then whenever they stumbled under their unaccustomed burden.

Robin had cost him as much pride as money, and his hatred was, like

Sir Richard's loan, increased threefold. He vowed he would not rest until Robin paid the price.

46-DEATH DISHONORED
IVY MOON WANING, 1193

The rising September sun caught the corners of the buildings, casting daggers and diamonds of light against stone and timbers. From a second story window, a woman dumped a bucket of watery waste into the street. A cat yowled and streaked away from the offending spatter.

Her basket on her arm, Dulcie made her way along the narrow streets leading to the marketplace, though it was not market day. She wore a shawl over her head to cover her flowing blonde curls and she kept her eyes downcast, but the weaver's apprentices saw her. One lad called, "My bed's still warm, cunnikin!" He gestured obscenely to show what he would do with her there. The other man spat at her feet and leered. She pretended not to notice, though her cheeks burned and her heart started pounding like a hare's when she heard one of the boys hiss after her, "Witch!"

She took a deep breath and hurried on, past the chandlery and the bakery.

"That one ought to jump the broom by the next full moon," announced the mistress of the loaves as Dulcie went by. "But who would wed her? Look at her! I can tell by the way she walks and the color of her skin. Two months pregnant, I'd say, and with a bastard. But isn't she full of airs, with that pretty shawl, and I should think I know where she gets every bit of it."

Her husband only grunted, having heard this speech many times before. He thought any man who could, would have Dulcie to wed, she was that lovely, but of course he did not say so.

Gerta, the blacksmith's wife, stood waiting with a penny. The baker pulled a heavy board out of the oven with eight fresh-baked loaves upon it, round and brown and sweet-smelling. His wife handed Gerta her daily bread, took the penny and said, "That girl come in here with her eggs one day and wanted to trade for a loaf. I said I hadn't any need for *her* eggs. She understood me right enough, for she never come in again."

Gerta tucked the hot loaf under her arm and bid the bakers good day.

"Doesn't say much, that one," said the wife when Gerta was gone.

Her husband grunted, wishing Gerta's taciturnity were more widespread.

"Well, no wonder," his wife continued, "married to that husband of hers. I've known that man all my life and never heard no more'n three words out of him at a time since the day he first drew breath. You should have been brothers!"

At this her husband chuckled.

Gerta wound her way toward the part of town where the smithy stood, near the well. Her husband was already at his forge. She heard the pounding of the hammer. The girl Dulcie waited by the door of their cottage. Gerta nodded at her, went inside and soon came out again with half a loaf of fresh warm bread. "I need four eggs today," she said, taking the brown beauties. Dulcie bobbed her head and the two women exchanged smiles. If Dulcie thought she had one friend, it was this quiet woman who did not scorn her, though they rarely spoke more than a greeting.

Dulcie put the bread in her basket and walked back toward the butcher's hoping he might have need of a few eggs, and give her a bit of sausage to go with her bread.

It saddened her that some of the townspeople shunned her, but others, closer to the earth, knew the way the world had, as often as not, with peasant girls, especially pretty ones, and it was no business of theirs if a nobleman satisfied himself with a willing lass.

In any case, Dulcie was used to being an outsider, and how much more so she had become in the big town of Nottingham than she had been in Loughborough, where everyone knew everyone else's business. Here she was less noticed. She preferred it so. And did she not have plenty to eat for the first time in her life? And she had not one skirt but two, and a good woolen cloak as well as her shawl. She had grown accustomed to the taste of wine instead of ale, though she never drank spirits when Augustin was not there. But above all, she had her lover's touch, fiery if not loving, insistent if not tender. She knew he cared for her, desired her, needed her. He simply did not speak words of love easily. She had heard that many men did not know how.

Yet her thoughts were troubled today. It had been so long since Augustin had come to see her. She feared he was bored with her, or angry, though she had tried to obey his every whim. More than once he had struck her, and she had cringed in the corner, which in turn had angered him further. She did not understand him. Nursing a black eye or a sore jaw, she knew she ought to run away, but each time she delayed until he came back to her again, with his gifts and his smooth tongue and his hard body.

Of course! It was because of what had happened last time! That was

why he had not come back. He had taken her to bed and lost his manhood. This had happened before, but he had always been so drunk he had fallen asleep and forgotten it happened. This time, however, he was angry with her. He said it was her fault. And perhaps it was. If only she knew better how to please him.

But then he called her Witch. He said she had ensorcelled him with her beauty and her evil eye. He threatened to destroy her if she did not undo her spell. Weeping, she protested her innocence, but she knew by now he would listen, not to her words, but to her touch. It had taken an hour or more of constant stroking with her fingers and tongue before he considered the spell undone.

She told herself he would be gentle with her the next time he appeared. He was often so: harsh one day and tender the next.

She finished her shopping and trudged home. She felt tired and it was not even mid-morning. But as she neared her hut, her spirits lifted. René was at her door! Coucy had sent his squire at last with a message! Tremendously relieved, she bid René good day with a sunny smile.

He smiled back, but said nothing, and after an awkward moment where he seemed to have trouble knowing where to put his hands, he pulled out a purse and handed her a few marks.

She stared at the coins in her hand as if she could read them like the lines in her palm or the dregs of a cup of catnip tea. "Is there no message from him?"

"No." René looked into the distance.

"He has been called away, to Normandy?" she asked timidly.

"No."

"But—is it his wedding? That is weeks away!"

"No, Mademoiselle. He is … it is only … he sometimes … " René shrugged helplessly.

"He has found someone else to amuse him!"

René said nothing. How could he tell her that Coucy always had someone else to amuse him? How could he tell her the way Coucy spoke of her? That she was a dirty beggar, a Witch, an ignorant, passionless, whining *putain*. He said he had used her up. He would ride further afield to seek his pleasures, or if he stayed at home, how much simpler to call for a skin of wine and take the serving girl who brought it.

Tears welled up nonetheless in Dulcie's eyes, for she saw in René's honest face the truth of her worst fears. Her protector had grown tired of her! He had paid her off with a few coins and would never come to her again!

René longed to take her in his arms and comfort her, but he dared not. She would misunderstand. She would think he abused her, that he too thought of her as a whore. He stood helpless as she ran inside the hut and slammed the door. He heard her sobbing. He paced outside the door, then knocked and murmured some kind words, but she did not reply. He wandered miserably toward the wood and gathered a posy of autumn flowers, which he left on her doorstep, and then he rode home, where his master berated him for being gone without permission and boxed him on the ear until his head rang. But in answer to Coucy's questioning, René said he was dicing with some off-duty soldiers. He would not tell the truth of where he had gone, for Coucy would surely beat him the harder, and who knew what he might do to Dulcie?

Dulcie did not step outside her hut for two days running, and when at last she roused herself to feed her squawking hens, she found the wilted flowers on her doorstep. Her heart leaped, thinking they were from Coucy. Then she realized that he would never do such a thing. If he wanted her, he would come into the hut and take her.

She could not imagine who would leave her wildflowers. She feared the whole town knew she had been abandoned, and now every man would think she was free for the taking, and the women would shun her even more.

She fed the chickens, wondering if Gerta would still trade her part of a loaf now and then.

She cast the Tarot twice daily upon the wooden table, seeking to read her own fortune despite the confusion of her thoughts, and it seemed to her that the cards foretold Augustin would come back to her. The Knight of Swords—that would surely be him—was in her future.

Then she realized one morning as she lay abed dizzy and depressed, that she had missed her monthly flow. In fact, she was close to missing a third! Panic filled her. How the townspeople would mock her and hate her now. If she would sleep unwed with a man, she should have taken steps to ensure she did not get with child. How could she have ignored such a simple thing? She had not even thought of it, somehow trusting Coucy in spite of his rages always to return to her, protect her. There were herbs to prevent childbearing, herbs to force it early out of the womb. But she only knew the former well enough to find them. Where could she find the other kind?

There was no midwife here in Nottingham, only doctors, who must be paid with coin, and were unlikely to know of women's herbs any road. She had heard of a nun who was a healer, who lived in Kirklees Abbey, but that was so far away. Besides, the Church said God decreed women should bear

children in suffering. This nun would not help her get rid of a baby.

She wept. She did not really want to rid herself of the child. How could she not love it, the seed of her lover?

She must see Coucy, the Knight of Swords. Augustin would take pity on her. She tried not to think how he of all men would hardly have feelings for a bastard child.

She told herself this meant he was linked to her forever. She would throw herself at his feet and swear to double her efforts to please him. She would beg for his protection. How else would she feed the child as it grew? She did not want to become a prostitute. If only he would find a place for her in the castle, though that thought terrified her as well, for she still feared the Sheriff and hid from him every time he rode by.

But that evening Dulcie summoned her courage, dressed in her cleanest skirt and her woolen cloak, and made her way up the winding roads to the castle.

She asked for Coucy at the gate. The guards jeered at her and made lewd comments. She pretended she did not care and asked for René. Finally, after much joking, René was sent for, and when he saw her, he lied that Coucy would be furious with them, and they sobered at once.

René was stunned to see Dulcie here at the castle, and looking so pale. And the last thing he wanted was for her to see his master. At best it would only annoy Coucy, and indeed, why would René take the woman he loved to his rival? Instead, he led her to a small antechamber near the kitchen that served as a pantry, where bins of grain and apples stood ready for winter. He explained truthfully that Coucy was in conference with Sir Reginald and was not to be disturbed.

"Then I shall wait. I must see him."

"I will tell him you came and deliver a message for you."

"No, I must tell him myself."

"Is it so private?" asked René.

Dulcie looked at the floor.

René swallowed hard and said, "Is it that you miss him?" His heart thudded in his chest. "Is it that you love him?"

Dulcie nodded, and René felt that tiny motion of her delicate head was as sharp and final as the blow from an axe. He wanted to say that his master was selfish and savage, that Coucy loved no one, that he had used her and cast her aside, but again René's own love for her would not let him wound her with such words. Why could she not look on him with tenderness? He knew he was not so handsome as his master, or nobly-born, but could she

not see the love in his eyes, in his heart?

He said, "I will tell him. It is best you return home."

"No, there is more. I must see him. I'll wait."

She glanced about for a place to sit. He hurried to pull a bench over, dusting it off with his sleeve. She sat, looking tired and lost. "You will take me to him later?"

"Yes."

They sat quietly for awhile, their thoughts in separate turmoil.

"Dulcie," René began, and stopped.

"Yes?"

"You are with child."

She looked more desolate than ever. He knew he had hit upon the truth. Somehow this gave him hope. She would need help. She would see that he could help her. He said, "You know he is to marry the Sheriff's ward."

"Of course. But I am still his."

"Do you not … could you not … find another man? Monsieur de Coucy is not … do you not desire a husband of your own? There are many who would love you. You are so beautiful, so sweet," he added, his voice filled with a longing she did not hear. His English began to fail him as he struggled with his passion. "In the country, in Normandy, where I am come from a small village, you see, a man and a woman, often they do not wed until she is with child. So they know the babies, they will make together. Many men would love you with this child. They do not care who fathers it."

She shook her head.

"I would love you."

Her eyes widened.

"I do love you. I have always loved you. Do not go to him, Dulcie. He will not have you." He reached for her hand.

She pulled her hand away. "Why do you speak to me so? You betray him!"

"No, he betrays you!" Now René could not stop the rush of words. "I love you! As he has never loved you, or anyone! We could be wed—or not, if you choose. Whatever you desire! I leave his service and I—I hate him! He is ruthless and an unworthy master. I am a farmer, then, or a blacksmith or a cobbler." He knew nothing of these things, but he was sure he could learn, and he would do anything for her, even give up his dreams of becoming a knight himself someday. "Come away with me! Tonight!"

With a little cry, she leaped up and ran out of the room.

He ran after, caught up with her, took her by the shoulders and swung

her around to face him. She cried out again and tried to pull away, and he managed to stutter, "You do not know the way. I take you, then, if you must go." He released her and stood looking at her, crushed. She would not meet his gaze.

He led her through the castle to the old keep. They climbed the staircase that wound around the central tower until they stood in a corridor outside a heavy oak door. There René left her, for he could not bear to see her, knowing that she did not love him, nor could he bear to hear what craven things Coucy would undoubtedly say to her, and the grief it would give her, and himself powerless to comfort her, for she would not let him.

Dulcie waited in the corridor for what seemed a very long time, twisting the ends of her cloak into knots, taking it off when she felt warm, feeling chilled a moment later and putting it back on. She kept thinking of the terrible things René had said, that Augustin did not love her. She knew this was true, and yet she hated to hear it. What did it matter? He was bound to her. He was in the cards. She could not run away. René had always been so kind. Why was he being so cruel tonight? Her head swam. She was hungry. She had not eaten. She had been nauseous off and on all day.

She heard footsteps on the stairs. A young page appeared, precariously balancing a silver tray with two large pitchers upon it. He hardly gave Dulcie a glance as he knocked upon the door. He went in. She heard the murmuring of men. The page came out empty-handed, swung the door closed behind him and trotted away down the corridor. But the lad was slight and in a hurry, the door was heavy, and it did not shut completely.

Dulcie crept closer and peered through the crack in the doorway hoping to see Coucy. Within was a stone chamber, with a flagstone floor and a cold hearth on the far wall. Two candelabra were lit, one upon the table, three-pronged. Beside it was the silver tray. Another candelabra was attached to the wall at the height of a man's head, with a single fat white candle, the hours marked upon it in horizontal lines of black wax.

The flame seemed to flicker as if from Dulcie's breath, and she almost recoiled in fear, but then she saw the open window, deeply recessed in the massive stonework to the right of the hearth.

A man sat in a wooden chair covered with embroidered cushions. He was heavy, with rolls of fat under his chin and beady black eyes. He was wearing an ill-fitting black monk's robe, and he twitched from time to time as if it constricted him. Opposite him sat Sir Reginald. Coucy sat beneath the window with his face half in shadow, half in candlelight. Dulcie's heart trembled at the sight of her lover. He was staring into his silver chalice as if its

contents were bitter. Abruptly he stood and poured himself more wine, not bothering to mix it with water from the second pitcher, and he drank it off before refilling his cup and returning to his seat.

"It must be something he can't resist," the fat monk was saying. "Something to entice him out of his hiding place."

"An archery contest," drawled Sir Reginald.

The monk's eyes narrowed.

"We'll offer an irresistible prize. A silver arrow! If accounts be true, and he is as arrogant as he is skilled as an archer, he will not stay away."

"Must it be a silver arrow? It could be copper."

"My dear Bishop of York, your thriftiness is a constant credit to the Church and a lesson in humility to me. But I am a nobleman, and must make a good showing. Besides, do not the Heathen say that silver is the metal of the moon? Silver will lure him."

"What you say smacks of Witchcraft." But the bishop did not object further, for it served him.

"Let it be silver, tipped with gold. I will cause it to be made from my own treasury," the Sheriff said. "We will trap the brigand and marry you off," Reginald gestured at Coucy, "in a fortnight of feasts and tournaments. We shall have a Round Table, to re-enact King Arthur's battles, and altogether impress Prince John with how well we can entertain him. He grows petulant waiting for word of his brother."

"The wedding should be first and the trap for Robin Hood set after," Augustin objected. His gambling debts were mounting. He needed Maerin's dowry, and quickly.

"Nonsense," replied Sir Reginald. "Festivities before a wedding are expected, and the archery contest will simply be a part of the celebration. No one will suspect."

At first Dulcie thought little of their talk beyond the pain of hearing Augustin speak of hastening his marriage. But then the rest of their words began to sink in. They were going to kill Robin of the Wood, the brigand who put the Sheriff to shame, who made knights and mercenaries quake with fear, who tricked bishops and bounty hunters, and lay with women in the fields to bless the corn. And to think she had seen him herself, not two moons ago! He had raced past her hut, dragging the maid Maerin, throwing her to Coucy as if she were no better than any peasant, boldly outrunning the Sheriff's men, and a wild look in his eyes like some untamed thing—a stag, a wolf, or a stallion not yet broken to the saddle and the spur. Perhaps it was the blessing of his presence, a Druid priest of the Elder Gods, that had

caused Coucy's seed to take root in her womb.

She would go to him! Robin would not ban her for her skill with the Tarot. Robin would not shun her for bearing a child unwed. If Coucy would not care for her, she would take refuge in Sherwood. Excitement shivered through her, followed swiftly by the realization that if she took to the woods, not only would she be outlawed and in danger of being hung as a Witch, she might never see Coucy again, unless it be at her own gallows.

She stifled a sob, unsure whether to wait for Coucy, to tell him she carried his son and perhaps to see his face soften at last, or to leave at once for the forest. She drew back from the door, stumbled on an uneven stone and dropped her cloak. The heavy cloth slid into a heap on the floor. As she bent down to pull it to her breast, she heard noises in the chamber and looked up to see the three conspirators crowding the door. They had heard her muffled sob, and the whisper of the falling cloak.

Dulcie stood and inched backward.

"A spy!" The Sheriff launched himself at her. She shrieked with terror. He grabbed her long blonde hair, twisted it around his arm and forced her to her knees. "What are you doing here? What have you heard?"

"Nothing, nothing, milord!" Dulcie cried. "Please, I only came to speak to Monsieur de Coucy!"

"Liar! Harlot!" fumed the Sheriff. "Can you not keep your women in their place, Coucy?"

"She is nothing to me," Coucy replied.

At these brutal words from her lover, Dulcie wailed.

"She's a Witch and a spy for Robin Hood!" The Sheriff drew his dagger to slit her throat.

<div align="center">⌘</div>

René wrestled with his misery in the tiny room he called his own, which adjoined Coucy's. He thought he was but half a man, for when Coucy spoke harshly to Dulcie, should not René be nearby to dry her tears? He had abandoned her and failed this test of love.

Then he thought, vicious words were only the beginning with Coucy. Suppose his master had been drinking? And of course, he would have been drinking, for it was night, and night and drinking and plotting and planning with the Sheriff and the bishop, growing more embittered and frustrated as the evening wore on, all went together in Coucy's heart like so many blackberries in a pie. Suppose Coucy lost his temper completely? Suppose he did more than curse the sight of her? Suppose he struck her? Or worse?

René sprang to his feet, seized one of his master's swords and ran out of

the chamber and down the stairs. His eyes barely registered Elgitha coming out of Maerin's chamber as he rushed by.

Elgitha darted back into Maerin's room.

"Elgitha? Are you not going to the kitchen after all?"

"It's that squire of Coucy's! He's charging down the stairs like a madman."

Maerin threw off the bedclothes.

"Now, milady, you mustn't concern yourself … I think it far better … oh, milady, I wish I'd never told you!"

Maerin pulled a robe over her lace-trimmed nightshift and ran out to see for herself what the trouble was. Reginald had not bothered to replace the two guards outside her bedchamber. He knew she had no refuge now, not even in Sherwood, and trusted the gatekeeper to keep her locked in the castle grounds.

She fairly flew after René down the wide staircase, hardly able to keep up with him, and he oblivious that he was pursued. If René were armed, he was probably speeding to his master's side, she reasoned. Therefore Coucy was in trouble, and Maerin did not want to miss a minute of it. She hoped, with a scandalous lack of compassion, that René did not get there in time.

He ran toward the old keep. Inside, he bounded up the winding stairway two steps at a time. A woman's screams doubled his pace, and Maerin's behind him.

He burst into the corridor just as Sir Reginald, gripping the wailing Dulcie by the hair, drew his dagger. He pointed it at Coucy and shouted, "And you, you drunken, fornicating devil, you have told her everything! A Tarot reader and a Witch! Who did you think she ran to with every word out of your mouth? What do you babble to her in bed while you're fucking her? No wonder our plans to capture Robin Hood have been foiled time and time again!" He dragged his dagger across Dulcie's throat. Her blood spurted onto the stone floor, her screams abruptly ended and her eyes froze wide, trapped forever in horror.

The Sheriff let go her hair and her tender body jerked and spasmed into a slump at his feet.

The bishop pronounced with an air of satisfaction, "A fitting death for a whore and a traitor. Her soul will go straight to Hell."

With an incoherent sob, René lunged at the Sheriff, brandishing his sword. Coucy spun around and with a jolt, recognized his squire.

The Sheriff was armed only with his knife. Coucy drew his own sword and stood against René. Their two weapons clashed in midair with a screech-

ing and a hiss as the blades slid off each other.

The bishop moved back from the fray, watching with a look of stern distaste, while Reginald ran into the chamber for his own sword.

"You would avenge the death of a spy? Traitor!" Coucy swung again.

"Never!" shouted René, tears of grief half-blinding him. Their swords met with a clang.

"Perhaps you are the spy!" Coucy accused, thinking to turn suspicion on his servant instead of himself.

"Never!" René gasped. Coucy was a far better swordsman than he, and the mismatch was already telling on René's strength.

"You fucked her as well! You took your turns on the bitch, while I waited outside!" Coucy shouted. "She spread her legs for you and you told her everything, you treacherous bastard!"

Outraged at these lies, with a last burst of effort, René swung his broadsword at his master's neck. Coucy delivered a thunderous blow to parry and René's weapon broke in two. The blade clattered across the floor.

René stood for a moment swaying, holding the hilt in his hand. Then he dropped it and fell to his knees, sobbing, "Dulcie, *ma douce,*" which only served to confirm suspicions against him, that they were lovers. But when he lifted his eyes and said beseechingly, "She was with child," as if that fact would bring her back to life, or bring pity to his master's heart, Coucy's lips drew back in a snarl. The bishop and the Sheriff assumed the child was René's.

With a single stroke, Coucy lopped off his servant's head. Blood splattered across René's tunic and Coucy's, across the stone floor, the stone walls. In the silence that followed, the bishop, Reginald and Coucy shifted about on the edges of an ever-widening pool of red, René's blood mingling with Dulcie's.

Coucy leaned over to wipe his sword dry on Dulcie's cloak.

Reginald frowned, thinking he'd have to send for someone to clean up the mess. Perhaps, with such intrigue in his own house, he should increase his personal guard.

Maerin, crouched against the wall of the winding staircase and peering around the doorway at knee-height, watched the gruesome scene unfold. Now she backed away, stifling her need for air lest she be overheard. One sound and they would be upon her, and she knew her throat could be cut as easily as Dulcie's, and for all that she was a noblewoman, would that protect her from men such as these?

As she crept down the stairs, she heard her uncle saying, "Our plans are safe. The archery contest and the wedding will go forward as we agreed."

Coucy said, "Give me Robin Hood as a wedding gift and I will spill more of his blood than these two together."

At the bottom of the stairs Maerin broke into a run. The words and deeds she had seen and heard garbled together in her mind, unfathomable. Dulcie's screams, cut short. René's head thudding to the floor. Were they spies? Traitors? Did the blood of two innocents stain the stones? An archery contest. Robin's name. Robin's blood.

And her wedding to Coucy was linked to it all.

47-Tbe weepING Laoy

Maerin could not sleep. She churned her bedclothes into a tangle with restless tossing, and finally gave up. She rose, careful not to wake Elgitha, who snored on the trundle bed at her feet. She made her way downstairs toward the kitchen thinking of hot milk and honey, but then thought better of it. She would end by clattering about, rousing the scullery maids who slept on the hearth, and then they'd run into the Great Hall and wake the head cook, who would fuss over her, and that she could not bear, for she could not speak to anyone of what distressed her. So she wandered about the castle like a nervous colt drawn by hidden reins, listening for the whispers of conspirators, hearing only the distant clang of a pike upon the ramparts as the guard changed in the late watches.

A flash of a forked silhouette appeared upon a wall. She drew back, trembling. The shadow-antlers of a stag loomed immense above her. A stag inside the castle? Or had she slipped, sleep-walking, into the land of Faerie? Had the white stag come to her again? The floor seemed to quake as if his sharp hooves beat at the flagstones. Did he bring wisdom, or a warning? Then she realized it was only the head of a deer, a trophy mounted above a door, the shadow cast by the candle she carried, and the quaking was her own jittery heart and shaking legs. She walked on, feeling acutely silly.

Eventually she found herself in the hall where Coucy had first forced himself on her so brutally months ago. The place seemed to hold his dark spirit; she feared at any moment he would leap upon her from the shadows and rape her, or cut off her head as easily as he had that of his faithful servant. To think she was promised to such a man! And Sir Reginald, gripped by greed—how could her father have entrusted her to his selfish brother?

But all men were not heartless. Her father had been kind to her, when many fathers paid little attention to their girlchildren.

And another man's kiss was gentle once upon the hem of her gown, and his voice had gently murmured, 'Milady.' His arms had once held her tightly, as he held his sword to her throat—oh, how romantic! To desire Robin was delusion, folly. Would he have killed her if he thought it necessary? Was he any different than Coucy? And he threw her to Coucy anyway, the swine!

Again she reminded herself that she had told him to leave her. Otherwise he might have stayed and fought for her. She would never know, but she could not, must not blame him. Besides, they had enemies in common. Treachery was afoot, and it would take place during an archery contest, under Prince John's nose, perhaps with his approval. And then would come her wedding.

She had to get a message to Robin at once. He was a thief, a heretic, and she was mad to love him, but there, she admitted it: she loved him.

She stopped in her tracks, tears springing to her eyes. He lived the spirit of the greenwood, where both times the Lady had come to her. Not in the dozens of churches and chapels she had frequented, not before her own altar in her bedchamber, but in the wild wood. And Robin belonged there, alive, himself wild, brave and reckless; above all, he was free, beyond Reginald's power, beyond Coucy's, and by the Lady, so she would help him remain.

With new determination, she turned to make her way back to her bed, when she glimpsed a silvery light staining the narrow windows. The garden would be lit by the moon. The roses were no longer blooming, but there would still be fragrant, late-growing herbs. Perhaps she could find some mugwort or lavender to place under her pillow to help her sleep, for she must rest and clear her mind, to plan how to get word to Robin.

The hinges of the low arched door that led into the garden creaked like the scream of the *bean-sidhe,* startling her. Had not the Queen of Phantoms found enough dead souls to carry away this night? But after a skipped heartbeat, she realized the door was not so loud. It was just that the night was so still and she was overwrought. She frowned. The *bean-sidhe* was a fey tale. Why did she think of it now? She must pray to the Virgin for protection.

The moon was barely more than a waning crescent. How had its light been strong enough to penetrate the window? Shading her candle from the breeze with one hand, she stepped lightly along the well-swept paths to one of the herb beds.

She knelt, searching for mugwort, when she saw a flicker of light through a hedge. At once she blew out her candle and crouched low. Had she stumbled

on yet another secret meeting between Coucy, her uncle and the Bishop of York? Prince John with one of his Parisian schemers? Perhaps Coucy had brought one of his slatterns here. She bit her lip, wondering if her luck would hold and she could escape again unseen.

But what if they were talking of King Richard? Or her? Or Robin?

She crawled forward as quietly as she could, inch by inch, sure the moon would set before ever she reached the hedge, when the light flickered to her right and appeared at the corner of the bushes.

Maerin froze.

The light grew brighter, larger. It was coming toward her, and it was no candle or torch, but a wavering, willowy shaft of ethereal white, as if the moon were full and poured its glowing down into a pillar of cold moving fire. The light rippled into an elongated star, taking the form of a maiden, naked, her bare white legs stiffly treading air above the earth, her long flowing hair silver over her breasts, her arms raised, beseeching, her eyes vacant. Long black lines marked her white forearms, black droplets slipped off her wrists and onto the ground at her feet. She wavered to the left, then turned back and forth and around in a circle, as if lost, or seeking someone. Her mouth opened wide in a hideously high, sheering scream as she walked unseeing past Maerin, through the solid wall of the parapet and into the black sky where she faded into starry nothingness.

Maerin hunched in the dirt, her stomach cramping with fear and nausea, her whole body shaking, as the maiden's screaming filled her ears, "Justice! Justice and Mercy, I beg you! Sweet Mother of God, why could you not save my lover?"

⌘

Robin slept in fits and woke in starts, troubled with a vague unease, though he could not think why. He had been too long idle, he decided, cosseted during his illness, stuck in the ravine, away from the deep woods and sacred groves, away from the hunt.

Before the sky lightened to grey, he rose, took his sword and staff, bade Balor guard Juniper in his sleep, and made his way alone and silent as a wraith out of the ravine, breathing more freely with every step.

He wandered without aim, unsure where his heart drew him. Why did he feel so adrift? If there were answers in the whispering trees and the chittering birds, in the rustling yellow cattails and reeds that grew alongside the gurgling streams, he could not still his mind enough to hear them.

The morning sun was halfway to its zenith when he came upon a place on a hill that spoke of a Druids' grove. It was long unused and untended. An

old gnarled oak commanded the center, overgrown with brambles and autumn asters, and twelve great oaks stood evenly spaced around it in a circle, among ash and rowan and birch suffocating under vines and brush. One of the oaks had been struck by lightning in some forgotten storm. Now it stood half-burned and broken, yet from the trunk still grew a heavy branched limb studded with foliage, and amid the fading summer green and newly gold-edged autumn leaves perched a shiny black raven. She rasped her razor-cry and soared away.

The cry of death, he thought at first, and yet she had waited for him on the blooming branch. A clear message: out of death, life; out of life, more death, the one leading to the other in an endless spiral dance.

A movement across the grove caught his eye. A fox or a ferret? What other omen would he see in this sacred place? He hid behind an oak and was about to summon the shy animal closer with a low crooning, when instead of a ferret, a lad stepped into the open. He wore an ill-fitting but expensive suit of livery that Robin recognized as Nottingham's. He wore a large cap pulled down low over his forehead, and carried a small sword at his waist, a small but well-made longbow and a quiver of arrows upon his back. The page-boy stopped at the central oak and looked about him as if lost, yet he called to no one and he did not retrace his steps.

So the lad was alone, and easy prey. Robin thought the sword would do nicely in the hands of young Juniper. The bow, too. He would make short work of robbing this lost page, and send him on the right path back to town, with a warning not to set foot in Sherwood again, for other outlaws were not so good-natured as he. Robin felt his unease fade in anticipation of this pleasant diversion, the chance to rob Nottingham of a sword. He drew his scimitar and called out, "Stand and deliver, you milk-livered runt!"

The page swung about, eyes wide, but wasted no time in pulling his own sword from its sheath, and stood waiting in the shadow of the oak with a look of bravado on his face.

"Drop your sword, and your bow and arrows as well, and I will let you go free," called Robin. "Though it seems to me I should steal your clothes also, for then the Sheriff of Nottingham would caution his tailor to make you a better fit."

The page hefted his sword and said nothing.

Robin laughed. "Brave soul! Have you the heart to challenge Robin of the Wood?"

At mention of his name, Robin was used to seeing seasoned warriors blanch, but a fire seemed to light in this young page's eyes. A brave soul

indeed! This both pleased and amused Robin, and he ran forward to do battle as if it were a game. His heavy scimitar met the little broadsword in the air with such force that it knocked the page's weapon out of his hand and across the clearing. The boy gasped and fell to his knees.

Fully expecting to clap the lad on the shoulder and help him to his unsteady feet, Robin demanded, "Do you yield?"

To Robin's amazement, the boy curled up and rolled over and over like a ball tossed by a puppy at play toward his sword, which he deftly retrieved. Leaping to his feet, he threw himself at Robin, and delivered a rain of blows with a light but skilled hand. Robin stumbled backward at the unexpected attack. A flurry of low-spoken words streamed from the page-boy's lips, punctuating his sword thrusts. "You ugly … ignorant … lout of a rogue! How dare you … order me to stand and deliver … as if I were a wilting maiden with a heart made of treacle and feet of clay? Is it thus you bait every youth who crosses your path? Is this how the Lord of the Greenwood reigns? You ought to be ashamed of yourself, you greedy … unthinking … miserable … unholy skunk!"

Robin stuttered his objections, got tangled in some brambles, wrenched himself free still parrying the page's blows, tripped backwards over a root, and landed full-length among the wildflowers with an awkward thud. His sword hand was quickly pinned to the ground by the flat of his opponent's blade, his stomach firmly riveted by his opponent's nimble knee, and a sharp little dagger found its way to nick at his windpipe. Then long dark tresses tumbled down from the page's cap, which had gone awry, and the tresses danced like trained cobras when the page shook his head and growled, "Stand and deliver indeed!"

"Maerin?!" He could not believe his eyes.

"Yes, it's me, you ignorant piss-pot."

"You're the piss-pot! You dress like a boy and wander unguarded through the wood expecting to be treated like a queen in a carriage?"

"Well, if you are the worst danger I shall encounter, then I have no need to fear, have I?"

He laughed. "No. You have fought well and won me. What shall you do with your prize?" His eyes sparkled.

Maerin blushed. "Some prize," she muttered in a derogatory tone. She stood and sheathed her sword.

He got to his feet and dusted the dirt off his tunic. "I'm glad you have not forgotten everything your father taught us in the arts of war. I am humbled. So where are you off to? No, don't tell me. You've run away to join a troupe

of players. But beware: if they find out their new actor is a woman, you'll be branded or flogged."

"I came to warn you, Robin. My uncle plots against you."

Robin threw back his head and laughed. "This is news! For this you risked your life in Sherwood?! Tell the truth, you came to see me because you find me irresistible."

She blushed again. "How highly you think of yourself! I heard my uncle plotting with the Bishop of York. And Coucy. They spoke of an archery contest. I think they mean to trap you. Perhaps they think you cannot resist the chance to show off your skill with the bow."

He grinned. "I am the best."

"And a braggart as well!"

"It isn't bragging if you can deliver!" he protested. "The tales you have heard of my prowess are true. And I'm good with bow and arrow as well." How easy it was to bring roses to her cheeks!

She shook off her embarrassment and urged him, "Promise me you will stay away! I saw a vision." She twisted her hands together. She hated to speak of her visions. It seemed to cheapen them, weaken their power. Only once had she dared to tell Coucy, and he had ignored her. But she had to warn Robin. She told him of the bleeding lady she had seen on the battlements. "There is death, death and treachery!"

Robin's smile faded. Instead of fear, however, his heart swelled with the knowledge that she had risked herself again for his sake. If the Sheriff found her out, she could be tortured or hung as a spy, despite her noble blood. She had seen the white stag, and now she spoke prophecy, and she had come to him, to tell him so. She was his Lady.

"Promise me you will stay away," she said again.

"Don't you wish me to call upon you in Nottingham?" Robin teased.

"Don't joke about it!"

He took a step toward her and his voice grew tender. He said, "Maerin, do you care for me?"

Maerin bristled. How dare he ask her to reveal her heart without first declaring himself? The rogue! Indignant, she retorted, "I do not care to see you flayed alive and hung in the public square."

"Yes, that would be a nasty sight."

"Indeed, I only wish to spare myself."

He rubbed the morning stubble on his chin. "Am I really an ugly lout?"

"I see you do not take me seriously. I should have known not to come to you!" She turned to go.

He grabbed her wrist. "Oh, but I take you very seriously, Maerin, for all that I cannot take you." He gazed at her, his eyes penetrating. Even boy's clothing could not hide her loveliness. She looked like a Goddess. He reached out to touch her cheek.

She thought she could not breathe, at his look. She turned away, frightened by the power of her own desire, by his nearness and the strength of his spirit, let alone the taut muscles underneath his tunic.

He dropped his hand to his side. "When is your wedding?"

"Never, were it up to me!" Now she looked fierce.

"Then you do not love him!"

"I detest him."

"By Our Lady, I thought—never mind what I thought. I'm an ignorant piss-pot, as you said, but tell me, is there perhaps another that you could love, or do you spend all your passion on the passion of Christ?" She stiffened but did not stop him when he reached out once more and ventured to slide a finger along the fine curve of her cheek. "That day in the wood. After you rode the white stag. I saw the crescent crown upon your head and knew you were the *wudu-maer,* the Maiden of the Grove, and the Queen of my heart. Yet I thought you loved another. I would not take you against your will even if the Gods ordained it, for they would not be Gods worth serving!"

She took his hand and pressed it to her lips. She was kissing his fingers, his warm palm, smelling the earth and the sweat of his skin and the faint tang of metal and leather from the hilt of his sword. He put his other arm around her waist and pulled her to him, bent his head and kissed her on the lips. She felt his blood and his flesh were pouring into her like iron ore melting in a blazing forge, and the world melted around them, golden leaves lifting in the breeze and dropping into the sweet pool of waving grasses that swirled in the river of life at their feet. Then she was blind and deaf to everything but Robin's hard chest and his strong arms and his hips pressed into hers, and the throbbing that swam up between her thighs, through her heart and into her throat and honeyed upon her tongue as he softly slid his own between her lips.

Desire flooded him. He pushed her against a tree trunk, overpowering her, his fingers searching her hair, her neck, her breasts. She did not resist him. Her knees grew weak. She thought she would fall, or float away, or die of ecstasy, for she had never felt so alive. She wrapped her arms around him.

"My lady, my love, my dove, come with me. Stay with me," he murmured, his breath hot in her ear.

At his words, fear invaded her desire, followed swiftly by anger and

then despair. She pushed him away. "This is folly! I am not one of your strumpets, whom you can plough like a field on May Eve and leave for better men to tend for the harvest! I am a noblewoman, not a peasant. Your wife may not mind sharing you with every woman from here to Wales and back, but I will never willingly share you!"

Utterly bewildered by this outburst, Robin said, "Wife?"

"I saw you kiss her! She was pregnant with your child! Or perhaps someone else's. Holding her in common with your minstrel and Lord and Lady know who else—it's revolting. It's unholy!"

"What on earth—you mean Aelflin?" Robin began to chuckle. "Me, wed to Aelflin? Well, she is a pretty little morsel, but she is Allan's, never mine. I have no wife."

Her anger drained out of her.

He embraced her again, laughing, but she shoved him back and took several steps away. "I must go. If I am discovered missing, you will be in even greater danger. Even now my maidservant risks her life, lying and saying I'm ill in bed. If our trick is found out and they discover I am gone, they will torture her, kill her, and surely they will blame you. They already blame you for every overturned milk pail and missing hen in the shire, let alone the damage you really do."

"Damage? I do miracles! Have you not heard the songs? I am a merry Puck of the greenwood. Give me my due and I'll do you good. Besides, your uncle and his men can never catch me. Do you not know I am invisible to Christians?"

"I am a Christian!"

"Really?" He feigned astonishment.

"Oh, Robin, you're such a muckabout. You always were. And if I were responsible for their catching you, I would die of sorrow!"

"Then I hope no one followed you into the forest," he said, looking around him with mock alarm.

"And me!" she said, ignoring him. "They have already caught me! Stay free, for my sake, Robin, please!" Tears filled her eyes and she buried her face in her hands.

He frowned and stood clenching his fists, not knowing what to say to stop her crying. He put his arms around her, and carefully pressed her cheek to his chest, saying, "Hush, sweeting. Hush, my lamb."

"Don't!" she said, pushing him away again, for his touch and his endearments only weakened her resolve.

He flushed and said, "You're right. You cannot stay. It's no life for you

here. We live in caves, not castles. There are no banquets for wearing silken
gowns or featherbeds on which to sleep. And in winter, there is hunger, such
as you have never known."

"I care nothing for silks and featherbeds!" she declared, wiping away
her tears.

"But you do. It is what you are used to. You would miss it soon enough."

"One can grow used to anything. I have," she replied coldly, insulted by
his tone.

He shook his head, thinking of the Crusade. Would she have gotten
used to that? He never had. He sighed, repenting his hasty words, as he so
often did. "I would not ask it of you, Milady."

"No. It is better that you don't. I must go," she said, and began to wind
up her hair and fasten it under her cap. "Besides, I have set myself to spy on
Prince John. I have a friend at Fontevraud who knows the Queen."

Now Robin was appalled. "Maerin, take care! If you are caught—"

"I am already caught!"

"It need not be so."

"It is too late. The abbess was right. This is my fate."

"I do not believe in a fate that cannot be changed. Only in vows that
should not be broken. But you must pray to a different God than you are
used to, one who grants you your own power, if you wish to have aid in
reweaving your life."

"I pray to the Lady. She is the only one who comforts me."

Robin wished he could be the one to comfort her. But he said, "You are
right. Is She not the most powerful, the Queen of Heaven, the Light of the
World, Mother of the Gods? She will aid you if any will. Know that I serve
Her, before any other. If you need me, ever, for anything, I will come. Send
a message to me, through the blacksmith at Nottingham. He and his wife
Gerta can be trusted. Now come. If you must return, I will walk with you."

"Not too close."

"I will never touch you again if you do not wish it," he said in a hurt
voice.

"No," she said, laying a hand on his arm, "not too close to the town."
She smiled sadly up at him. He wanted to kiss that sadness gone, as if he were
the sun and she the moon, and his love could move the darkness from her
face.

Their journey was slow, for every few hundred yards some creature
seemed to call to them to pause a moment and watch in hushed wonder. A
family of squirrels chattered over their acorns. A red fox darted into his den.

A doe with her growing fawn fed among the leaves, their delicate legs moving soundlessly through the brush. Maerin's arm stole around Robin's waist. Her head drooped against his shoulder and he stood motionless, not saying a word for fear she would pull away from him again. But at last the deer edged out of sight and it was time to move on.

By evening, they neared the edge of the forest. Robin took Maerin's hands in his and kissed her palms. "Farewell for now, but not for long."

"Oh, Robin, how can I make you understand? We must ruin their plans every way we can. Do not make of my wedding celebrations a funeral procession for you. Promise to stay away."

"This only will I promise, Milady: I will do everything in my power to free you from your prison, even if you never come to live with me in Sherwood." He brushed her lips with his. "Merry meet, my love. We will meet again." He turned, and before Maerin could caution him further, he dissolved into the trees as if he had never stood beside her.

48-HEART'S MEASURE
HARVEST MOON WAXING, 1193

lgitha sat rigidly before the hearth in Maerin's bedchamber, with a pitcher of yarrow tea grown cold beside her, and a basket of unused fabric and herbs for poultices for her supposedly sick charge.

Stunned to see Elgitha so quiet instead of fussing, Maerin knelt beside her, took her hands and begged her pardon for endangering her, swearing she would never do so again.

Elgitha drew breath as if it were her first in a great while. "Child, I know not what's to become of you."

Maerin bent her head. "It is in Our Lady's hands."

"Did you ... did he. . . ?"

"I saw him, he has been forewarned, but he did not give me the promise I sought."

"I care nothing for the promises of a thief any road! Did you keep your maidenhead?"

Maerin had never heard her nurse speak so directly and harshly to anyone, especially herself. Taken aback, she snapped, "To what purpose should I keep it? To salve Coucy's pride? He was ever more of a liar and a scoundrel

than Robin! No, no, do not look so horrified. I have my precious virtue, worth thirty pieces of silver!"

Elgitha stood. "Let Robin Wood be caught or not! It is your safety I am charged with! I promised your poor dear mother to watch over you, the very day she died. Then she went riding, proud as you please, and oh, she was beautiful, as beautiful as you have become. They told me her horse startled. Threw her into the river where she drowned!" Tears rolled down Elgitha's cheeks. "The rains were so heavy that spring. The floods. . . . I took that promise I made to heart, and I have tried to protect you, stubborn and willful and careless as you are. If you had not threatened to go to the wood today without my help, I would never have agreed to this deceit. Everyone in the castle inquires as to your health. Even Prince John! And you little realize how fond the servants are of you, for you treat them like people instead of dogs. All except me! For you scarce listen to my counsel, and you are forever running off to do such mad things, I know not!" By now her voice was high with familiar hysteria.

Touched, Maerin said, "It is over, it is done. I am returned safe enough. Soon I will be wed. I am no longer a child. I release you from your promise."

"It is not for you to release me!"

"Then who can?"

The two women stood face to face in frustrated silence, yet it was as if they were seeing each other with new eyes: Elgitha, not merely a nurse and servant, but a woman; Maerin, a woman no longer a child.

Maerin said, with sudden understanding, "Have you never loved anyone as much as my mother?"

"Oh, child, love does not come in a barrel so's you could measure it out like the corn, a handful here and a heartful there. The year you were born, I'd lost my little daughter and my man, both took sick in the same winter. I put you to my breast and gave you the milk meant for my babe, and never begrudged it to you. You were such a sweet little lonely thing. And here you've grown so pretty, but you are worse than a goose who wants to nest in the dovecote!" She smiled and held out her arms, and Maerin sank into her bony but welcoming embrace. For a moment she felt a reprieve from her troubles. Elgitha murmured, "Thank the Lady you have come back safely!"

"I would have stayed with him if not for you," Maerin said, her voice muffled, and she felt Elgitha shudder and hold her tighter. "I love him."

"I think you always did, more's the pity. I remember him as a child. The rascal, he doesn't deserve you," Elgitha said, but her gentled voice belied her words.

Reluctantly they released their embrace. Maerin bent down to the basket of rags. "We must make these look used. And you will put it about, please, that I am feeling better."

⌘

Preparations for the tournament and wedding threw the castle into a frenzy. Guests arrived from the surrounding shires, and every nook and cranny of the castle was aired out, scrubbed and made into a bedchamber for someone. There were mock jousts and games in the courtyard, and royal hunts led by Prince John, which served the double purpose of entertainment during the day and feeding the many hungry mouths in the Great Hall at night. Lords and knights, soldiers and even some well-to-do merchants went hunting in Sherwood, with the peasants stalking through the underbrush to flush out the game birds in the misty, humid mornings, the greyhounds and mastiffs baying for the boar and the deer darting panicked through the glens.

It was often the custom for noblewomen to join the hunt, but this time they were denied, for their menfolk said they must be kept safe from Robin Hood. There was little they could or would do to disobey, but in private, they gossiped over their embroidery or backgammon that it was not the fear of danger, but rather the fear that the Hooded Man might seduce them all that influenced their fathers, their husbands and brothers. Robin's reputation as a lover was such that other men suffered by comparison, and several women declared with varying degrees of seriousness that they would give themselves to the brigand gladly, if only they should chance to meet him. Other women reprimanded them and were teased in turn.

Maerin listened to their banter with her heart in her throat, bearing the brunt of her share of the teasing. She was unused to being surrounded by such a crowd of gabbling women, and found herself speechless when one giddy girl cooed at how handsome Coucy was and how lucky Maerin was to have him.

Every night there were musicians and players and dancing to distract the ladies from their confinement and give them more to chatter about, and with so many strangers of all ages come together to celebrate a wedding, the castle was rife with new-sprung romantic encounters. Though he was the groom, Coucy found himself the target of several ladies' lust, and his good humor increased in direct proportion to their attentions.

Maerin's own aloofness kept opportunists at bay, but amid the merry chaos, she sought a moment here and there to speak to Prince John, hoping to win his trust and ultimately, his confidences regarding his brother Richard. She thought she was gaining ground when one early morning he ap-

peared alone on the stairs outside her chamber and stood talking with her for
several minutes, while Elgitha went down to the kitchen to fetch breakfast.

But when they heard boots and spurs on the stairs above, John's aides
coming to escort him to the hunt, the Prince swept Maerin aside, lifted a
thick tapestry from the wall, and pressed her into a dark recess she had not
even known existed. The footsteps receded as his aides descended the stairs.

He said in a low voice, "I do not feel like hunting deer today. I have a
better quarry in hand," and he kissed her sloppily on the mouth, forcing his
tongue between her lips and squeezing her buttocks with his fingers as he
ground his hips into hers. "I think it's time I exercise *le droit de seigneur,* don't
you? I have the right, as your overlord, to take your maidenhead. I will but
make the way easier for your husband!"

Maerin struggled, protesting, which excited him further. He shoved her
against the back wall, which gave incredibly. She staggered backwards with a
yelp. To avoid losing his balance, he let go his hold upon her and she fell
screaming into darkness.

She heard him curse as she landed hard on stone and hit her head on
something sharp. The world faded with an echo of an oath.

She came to groaning in total blackness and silence. For some moments
she could not move. She felt bruised all over. She reached out a tentative
hand and met empty space on the left, a stone wall to her right. She pulled
herself up to a sitting position, her gown tangled under her legs, her head
aching. Touching her temple, she felt wetness. Blood?

She drew a shaky breath and spread her hands along the clammy, dusty
flagstones. Cobwebs stuck to her fingers and she drew back fearing spiders,
then forced herself to reach out again, and found, to her extreme relief, steps
leading upward. She crawled up and soon her scrabbling fingers met the
upper door. She beat against it with her fists and screamed for help.

How long had she lain unconscious? Had anyone noticed yet that she
was missing? Her uncle and the rest of the men had probably already ridden
out. Wouldn't the women notice her absence? They were probably gathering
in the Great Hall for the morning meal, but she often took breakfast alone in
her room. Would Prince John tell anyone? Had he even tried to rescue her?
Would he admit to forcing himself on her? What harm could come to him,
even if he did admit to it? He was a Prince. No one could gainsay him.

Elgitha, of course, would wonder where she had gone, and might imag-
ine Maerin was off on some new escapade without warning. Sooner or later
she would raise the alarm, but who would know where to search? If Maerin
were trapped here, and died here, Prince John could pretend he knew noth-

ing. She would simply be gone. Well, at least that would confound her uncle's and Coucy's plans for her!

She shouted again for help, beating on the door, her temples throbbing. Eventually, fists bruised and throat sore, she left off the struggle. The stairs had to lead somewhere. There had to be another exit. Unless this led only to an oubliette. Then she was truly dead. She fought fear, refusing to succumb to it. She recited the rosary over and over as she inched down the staircase. She supposed it seemed much further than it really was, in the darkness, her fingers brushing spiderwebs, dust, and probably rat droppings.

At last she found herself boxed into a dead end once more. She forced herself not to sink to her knees in despair, but to feel the rough walls wherever the blocks of stone were joined together, pressing, scraping, searching for a door, should the Lady bless her, a keyhole perhaps, or some trick opening. She stood and pressed her whole body against the wall. Nothing happened. Her fingers brushed upward across a little nub of rock, protruding only slightly from the rest of the wall. It seemed to give. She pushed with all her strength and was rewarded with a quiet scraping sound. Dust shimmered down around her and made her cough, and then there was a faint light and a pungent odor. Grunting, she shoved again and the heavy wall moved. She sagged against it, gasping with relief, slid her feet forward, testing the floor, and found herself in a dimly lit, roughhewn rock corridor. The smell of hops and yeast, ale and mead, assailed her nostrils. Metal-hooped barrels lined the walls. She was in a tunnel leading to the castle brewery and tavern that lay in the depths of the castle cliff. She knew of it, but had never used it herself. She had once thought of trying to escape through it, but knew it would be busy day and night with workers, overseers and customers.

She leaned against the wall, dizzy, until her heart stopped pounding. Then she threw her whole body weight against the secret door until it swung shut again. She hurried up the passage, almost certain it would lead efficiently to the kitchen, worrying at every turn that some servant would see her and she would have to manufacture some falsehood about her presence there. Sure enough, before long a clamor of voices and clanging kettles and pots made her freeze in her tracks. But there was no help for it, she had to go on.

The passage led to an open storage area off the main kitchen. Beyond, she saw steam rising from cauldrons set over the vast hearth, rabbits roasting on spits, turned by spit-boys, apprentice cooks and servants going to and fro about their work.

By the look of the light coming through the open door to the courtyard

and the high windows, it was late morning. The noon meal was being prepared. Maerin had not been unconscious that long.

The kitchen was so busy, she wasn't noticed coming out of the storeroom. Once the servants and serfs saw her, they presumed she had come in from the courtyard and, alarmed at the trickle of dried blood on her cheek, presumed also that she had taken a fall outside somehow.

"It's nothing, Elgitha will tend to me." She ordered them back to their work as she hurried past. They bobbed their heads and darted questioning glances at each other.

The Great Hall was deserted and she reached her chamber door unnoticed. But before she went in to her sanctuary, she thought to swing the tapestry aside and force the hidden door ajar. Much calmer than before, she searched until she found the trick that opened it from inside. Then she closed the door again, smoothed the tapestry into place, and went to wash the blood off her face. There would be a small bruise, but her hair hid it.

Her breakfast tray sat on the table near the hearth. With shaking hands, she drank the mint tea, now cold, changed her dusty, torn clothing, and went to join the other ladies in the hall by the herb garden.

Elgitha looked up at her sharply. Maerin took up her embroidery as if nothing had happened. When the other women teased her about her absence, asking if Coucy, too, was late for the hunt, she strove to bear their ignorant insinuations with grace, and said only that she had been practicing her archery.

That evening, she joined the feasting in the Great Hall dressed in a fine blue and yellow gown, with a blue velvet ribbon braided into her hair that brought out the blue in her eyes. Prince John's face went pale at the sight of her. As she had suspected, he had told no one of the morning's devilment. How little her life was worth to this man who sought to reign over all England! She greeted him with cool decorum. They did not speak again during the meal.

She felt sure he would not trouble her again. She was grateful and yet sorry she had failed in her mission. Now she would never pry his secrets from him. She realized she would have had to sleep with him to achieve her goal, and this she could never have forced herself to do. Even then, she might have failed. He might have revealed nothing. It would all have been in vain. How ill-suited she was to be a spy! That she could even be thinking of these things dismayed her. What had she become?

But if she were made to bed Coucy, what matter if another pricked her as well? She could not give her maidenhead to the man she loved. It had been

sold instead to the highest bidder against her will. Was she much better than a whore?

Dulcie's face rose in her mind, and she remembered her own venomous behavior toward the girl. What did she know of Dulcie's fortunes, Dulcie's will? Was she so different? How could Maerin have judged the girl so harshly?

Shamed, Maerin drank a great deal of wine that night, unwatered, temporarily easing the pain of seeing her own cruelty so clearly. Yet on waking the next morning, she was faced with it again, and an aching head as well.

She did not call for wine or even meadowsweet. She took the pain as her due, and fell to her knees before her altar. The little ivory rosary made its way again and again through her fingers while she grieved her faults. Her tears flowed until she had none left. She felt at last the heart's-ease of the Lady's generous mercy. She felt shriven, purified. She felt, too, that Dulcie was forgiven, that indeed, neither Maerin nor any man or woman could judge or even know what another's sins might be. That knowledge and justice belonged to the Lord and the Lady. Now she knew that she and Dulcie were one in the sight of the Lord, and that in Dulcie's salvation lay her own. She pressed her rosary to her heart and with faltering words, she prayed that Dulcie's spirit find peace, and René's, and that she herself might keep the Lady's mercy in her heart and learn to share it with others in full measure—not a handful, but a heartful, no matter their station in life.

Then she realized this mercy must also extend to Coucy and Sir Reginald, and to Prince John, for their humanness, their blindness, their errors, as she herself had been blind or erred. But try as she might, she found it impossible not to hate them.

49-THE GREEN KNIGHT

It was said that owls' eyeballs, charred, dried and powdered, would cure failing eyesight. Some declared, however, that this preparation prevented madness, while eyesight was improved by simmering owl feathers in water over a low fire and bathing the eyes with the warm broth. If the whole body of the owl were boiled, a cup or two of that broth would ease a child through whooping cough. But better to have a stuffed owl or owl's foot upon the cradle, and the child would never get sick in the first place.

Char an owl's foot and put the ashes in a poultice for snakebite. Owls'

eggs raw would keep a man from drink. Pickled owl would chase away gout. Rheumatic joints could be soothed with a salve of jellied owl soup. Ease a headache with owl brain stew. Wear an owl's eyeball, preserved, on a thong around the neck to ward off the evil eye. Place an owl's heart upon a woman's left breast as she slept, and she would speak truth as she dreamt, while an owl's heart carried into battle would make the wearer fight with the courage of a score of giants.

This last bit of folk wisdom inspired Augustin de Coucy to send his new squire, Quentin, into the wood to capture an owl, a task that filled the young servant with foreboding, for it was also said that owls heralded misfortune, that if a woman in labor heard an owl call, the baby would be stillborn, that owls were signs of the Devil and familiars of Witches, that sometimes owls were themselves Witches in the form of a bird.

Having heard rumors, however, that Coucy himself had slaughtered his former squire without the aid of either owls or Witches, Quentin chose the less immediate of two terrors and hied himself to the wood, where, after much searching, he found an owl's nest, captured her during the day as she slept, and brought her back to the castle, where Coucy himself cut out her heart at midnight and let the blood drain into a bowl.

The owl shrieked her death-cry.

Robin woke in the wood from some dark dream with his heart pounding and his ears keen for the sounds of the night.

Quentin cowered in a corner while Coucy dried the heart before the fire, and when it was done, he put it in a small leather pouch and hid it beneath his tunic on a thong around his neck, over his heart. He swore his squire to secrecy on pain of death, for if it were known he had resorted to Witchcraft to help him gain honor on the field, there would be a great hue and cry, and he would be barred from the jousting or even imprisoned, though others would go unpunished for their own lucky rabbits' feet or ladies' tokens, or lances thrice-blessed with holy water from the fount at the local church.

The first day of the tournament dawned clear and bright. The autumn leaves sparked gold, russet and crimson against the cloudless sky, and a stiff breeze tousled them like jewels on azure silk. The edges of the grassy field outside the town were swarming with a happy lot of peasants and serfs, who swelled the ranks of Nottingham's citizens by the scores, for the first harvest was in and the second not yet ready for the reaping, and their masters had allowed them a day or two of pleasure in honor of Maerin's wedding. They milled about or sat tailor-fashion on the earth, munching flat barley bread

they had brought with them, or hot meat pies or sausages bought from the vendors who had set up wooden stalls at one end of the field.

Behind the peasants, on slightly higher ground, clustered yeomen, foresters and tradespeople in their finest clothes, seated on furs or brightly colored cloaks or little three-legged wooden stools they had brought.

Pickpockets sought to ply their trade among the merchants, and lost themselves among the mimes and acrobats, dancing bears and actors whose rewards were the boisterous laughter of the poor and pennies from the rich. Everywhere patrolled the soldiers of both Nottingham and Prince John, in gleaming mail and armed to the teeth.

One end of the field boasted a long wooden gallery of two tiers, festooned with a yellow awning, scarlet banners, violet bunting, and bunches of yellow chrysanthemums and daisies. Chairs and benches had been brought from the castle for some two dozen nobles, whose brilliant silks and velvets whispered sylph-like in the breeze and at every movement. Their jewels were rainbow flames when they caught the sun. As they sipped watered wine from silver goblets brought by liveried cupbearers, they bent their elegant heads and gossiped.

Their voices mingled with the songs of birds greeting the morning, the nervous neighing of horses and the impatient shouts of knights and squires beyond the vendors' stalls, where blossomed dozens of pavilions, like gigantic multi-colored flowers with stamens of banners fluttering high, and bold standards of azure, scarlet, black, emerald and violet thrust in the ground before them, emblazoned with dragons, lions and gryphons, trimmed with ermine or bear, silver or gold. The knights were themselves bedecked in fanciful costumes over their polished chain mail, as they pretended to be the various Knights of the Round Table.

Minstrels also strolled among the crowd, watched carefully by the Sheriff's men, for these were the most likely to be spies. But one could not arrest every passing warbler, so even the most scurrilous of them was left free for the time being to roam and suffer the jibes and hissing of their audience if they could not carry a tune well enough or did not sing a song bawdy enough.

Among them was a slight young man with light brown hair and eyes, whose blue velvet cloak, red linen tunic and blue hosen bespoke a nobleman more than a minstrel. No doubt he was the hire of some rich knight who was a troubadour himself, but would not lower himself to sing at such a gathering. This minstrel by-passed the rabble and went directly to the gallery, bowing before the places of honor where Prince John lounged, with Sir Reginald

and the Bishop of York to his right, and to his left, Maerin, Elgitha and Hugh of Nonant.

Maerin's somber mood had lifted somewhat, for the anticipation in the air stirred her youthful blood, and the archery contest was not until the end of the week. Robin was safe for now. So she eagerly awaited the jousting. She knew she should not hope for it; it was unholy; she would confess it to the priest at St. Mary's in Nottingham, and she would say a hundred Hail Marys if need be, but she could not help hoping Coucy might meet his death today.

The well-appointed minstrel interrupted her thoughts, saying in a thick accent, "Your Highness, Your Lordships, Your Grace, Milady, I am Derec of Cornwall, at your service," and without waiting for permission, he began to sing of the glorious day, and how it was yet no match for the beauty of a fair maiden, and it was clear by his tone and the glances of his limpid eyes that the fair maiden he meant was Maerin.

By now she had grown used to the unsought attentions of travelling troubadours. It was good business for them to praise their hostesses. She did not blush, but listened courteously. His face seemed familiar to her, but she could not place it. Perhaps he had travelled this way before.

Prince John commented, "This minstrel has a true and pleasant voice."

"Indeed, Your Highness," replied Reginald.

Derec of Cornwall finished the song with a flourish.

My staff is strong; you may lean upon me.
I'll place you above me on a high seat.
What is hollow is full, what is full is empty.
I in thee, Thee in me, in Divine Mystery.

The Bishop of York frowned. "Cornwall remains a bastion of Pagans and heretics. Play no more Heathen airs for us, Minstrel, or suffer the wrath of God."

"Indeed, Your Grace, I never play Heathen airs, for the air of the heath be fresh and wild, and cannot be tamed into a song. Though if you were to walk upon the heath, the air would play upon you." He glanced at Maerin. "But let me bide with you awhile, and I shall sing of Eriu and Avalon, of love lost and love won, of Arthur who lost his lady fair, and through my songs, you shall lose your cares."

Reginald said, "A clever wordsmith. What say you, Maerin? Shall we keep him to play at your wedding?"

Her answer was drowned in a blare of trumpets as the heralds announced

the first joust. Raucous cheers greeted two warhorses trotting onto the field with their proud riders, one bearing the standard of Sir Lancelot, the part Coucy had chosen to play.

Merchants and nobles threw coins at the feet of the champions, whose squires scurried to gather up the money.

The two knights paused before the gallery, dipped their lances, received a nod from Prince John, then pranced their horses to opposite ends of the field, wheeled and faced each other. At the field marshal's signal, they spurred their mounts and charged, their lances raised, then lowered to strike, then harshly striking.

Coucy unseated his opponent with a single blow. Boos rent the air above the crowd: it was too easy a contest. They settled back to their games and food until the next challenger appeared.

Coucy seemed charmed that day, for he bested all comers with relative ease. He won long-coveted horses, mail and weapons, wounding several men in the process, one of them mortally, which brought wild delight from many, but the sorry shaking of a few heads, for the knight who died had been a good man.

Coucy never seemed to tire. After he defeated five men, Reginald commented, "It seems your betrothed has chosen his part well. Sir Lancelot, too, was unstoppable."

Maerin said nothing.

A sixth knight came forward to challenge Coucy, but as his horse stepped nimbly among the coins tossed by the throng, the people began to shout and whistle, pointing at another knight galloping through the pavilions and onto the field, churlishly interrupting the proceedings.

His warhorse was so black as to shine almost blue, and the horse's trappings were all in green. The knight himself was dressed in chain mail from head to toe, and over this he wore a long tunic of green that draped to his calves, but was slit to the waist so he could sit astride. His shield also was painted green and bore no other device, but was garlanded with a live winding vine of climbing red roses, the last roses of summer, from which occasional petals fell, leaving a trail of red like drops of blood wherever he rode.

As he charged by, the shouting peasants fell into a hush, for instead of a typical hood-like drapery of chain mail and a helmet that covered only forehead and nose, this knight's helm covered his whole face and was fantastically shaped into a deer's head, with oval openings at the eyes and a silvery muzzle. On the crown were fastened the bony antlers of a seven-tined buck, also wound with roses.

This bizarre apparition reached the gallery at the same time as a brace of soldiers. The stranger dipped his lance, not to the Prince or the Sheriff, but to Maerin.

Prince John demanded, "By whose leave do you interrupt our games?"

The knight's voice was a hollow ringing from his helmet. "I challenge the winner of the last joust. If he can cut off my head, he may come to me in a year and a day and I'll take his."

Reginald said, chuckling, "So you play the part of the Green Knight, who challenged King Arthur's court at Yuletide! Very clever."

A murmur of excitement and appreciation spread among the nobility.

"Grant me leave to joust here and I shall not disappoint," the Green Knight said.

With a chill, Maerin realized that voice had once murmured in her ear, knew those blue-grey eyes, peering through the eyeholes in the helmet, had gazed upon her before.

Reginald said, "I would know your name before I grant you anything."

"That I cannot tell you, milord Sheriff, for I have taken a vow that forbids me."

The Bishop of York narrowed his eyes. "What sort of vow is it, that a man cannot speak his own name?"

"It is the fourth vow. First is to know, second, to will, third is to dare and the fourth, to keep silent," answered the Green Knight.

"Let him fight," cut in Prince John with some annoyance, to hide his relief that this man did not bring news of his brother Richard. "For myself, I care not what name he bears. If he can unseat Coucy this day, I will hire him myself. I could use another good soldier. And if he loses, his mount and his armor are forfeit, and we have lost nothing."

The mysterious knight dipped his lance to Maerin again, and with the merest pressure of his knee, commanded his warhorse to spin about and gallop toward the end of the field, where a young squire dressed in green had materialized, holding the reins of his own pony and an array of weapons for his master.

Coucy's hand went involuntarily to his owl's heart. If he could kill the Green Knight, he would be the talk of the tournament. Yet the old legend told that the Knight had picked up his head and ridden off with it, and his opponent, Gawain, had gone to forfeit his own head the next autumn. Coucy could not remember the end of the tale. His heart began to pound. Did his dabbling in the Black Arts bring even greater sorcery to oppose him?

No, the silly tale was but myth, he told himself. No one could live with

their head cut off, like a chicken. He let his hand drop from the owl's heart. He would win.

At the signal, the two knights charged, lances raised, then lowered. They used their shields to deflect each others' blows, and both lances shattered and splintered onto the field.

They galloped back to their marks to take up maces, and charged into the center of the field again, whirling their weapons into a tangle in each others' shields and wrenching the maces from each others' fists.

The crowd cheered. These contenders were well-matched.

Next they attacked with axes, and bid their warhorses to rear and slash with their hooves, and as the battle clamored on, no one noticed how Maerin was pale as a plucked lily and seemed likely to faint.

The Green Knight's axe rang against Coucy's shield again and again. All at once the axe-head flew off the handle and ripped into the grassy turf. A gasp went up from the crowd. The Green Knight was off-balance and weaponless and it was the work of only a moment and a mighty shove from Coucy's shield to topple the challenger from his mount.

Peasants and nobles alike leaped to their feet, cheering and shouting for blood. The Green Knight rolled clear of his horse's sharp hooves, but Coucy jumped off his own mount with his sword drawn, and before the Green Knight could rise to his feet or pull his own blade, Coucy thrust the point of his sword up under the Green Knight's helmet.

The crowd roared. Maerin held her hands to her face and screamed, "No!"

Yet she could not tear her eyes away from the scene, and did not notice the wondering glance sent her by Sir Reginald.

Coucy hesitated. He began to tremble. What if he cut off this man's head, and headless, the Green Knight rose again? What if this were no man, but a spirit or Pagan God? What if his own life would soon be forfeit, and he would be cast down to Hell for his own Witchcraft? He bought time by challenging, "I would know whose head I sever. Tell me your name."

"I come in the name of the Lady," the Green Knight rasped. "No other name will I speak. Why not tell me whose heart beats beneath your coat of mail?"

Again Coucy's left hand went to the hidden owl's heart and he shuddered, tense and sweating. Could the Green Knight know of his magic talisman? How? It was impossible! Was he indeed from the realm of Faerie?

"Kill him! Deal the death-blow!" the people shouted.

Coucy was trapped. He could not slay the man, nor could he walk away

without damaging his reputation. Sweat trickled down his ribs underneath his mail. The yells of the watching throng were deafening.

A fluttering caught at the corner of his eye and then dove down at him, a fierce black shadow with talons. He choked back a scream and swung his sword, sure he could hear the owl's screeching, anguished and angry, like the one he had killed at midnight. It was a ghost-bird of prey, attacking him! Then it was gone and the crowd was jeering and hissing.

The Green Knight lunged to his feet and stood before him, sword drawn. Coucy could have sworn the metal deer's-muzzle grinned. He felt as if he were sinking in a quicksand of shame. He had lost his advantage and his reputation in that moment of madness when he had fought a shadow. "Treachery!" he shouted. "This man is a sorceror! He bewitched me!"

More jeers and booing erupted from the crowd.

"A bee buzzed around him and he sought to behead it!" shouted someone.

"A fearsome beastie is a bee!" exlaimed another.

Laughter filled the air, and curses from those who were disappointed at being cheated of blood. They longed to see the Green Knight rise headless, pick up his head and ride away with it tucked under his arm, and they would have had the whole year to look forward to Coucy riding after him to have his own arrogant head cut off. What a tale that would have made to tell of a long winter's night!

"Coward!" came another shout, and the cry was taken up like a chant. Soldiers struggled to hold the rabble back from the field.

The Green Knight lifted his sword. The sun glanced off it blindingly. Coucy squinted. The Green Knight challenged him, urged him to attack with taunts and insults. The roar of the crowd filled his ears until he couldn't think. He was deaf, he was blind. He was no match for this magic, owl's heart or no. He would die if he stayed here. He had to get away.

A press of people broke through the cordon of soldiers and mobbed the field, screaming for Coucy's head.

Maerin stood, clenching her fists.

At a signal from the Sheriff, mounted knights charged forward to protect Coucy from the mob, and perhaps from the Green Knight as well. Outnumbered, the stranger turned and made for his blue-black horse, flung himself upon its back and galloped from the field, followed by his squire. He left chaos in his wake, for the soldiers used force to end the disruption. Peasant blood was spilled that day. It was seen by all as an ill omen for Maerin's wedding, though none dared say so aloud.

Despite her horror and sorrow at these needless deaths, the rapid pulsing of Maerin's heart slowed and the color rose to her cheeks again, watching the Green Knight ride away alive.

50-A PEASANT'S ROSARY

Robin rode toward home with his thoughts bothering him more than his wounds, which were minor. So much for trying to fool the Sheriff by springing his trap early! He had relied on his skills as a warrior and former knight of the Crusades for this day's deeds, no other power, and he failed. The failure rubbed his spirit raw. Yet something worked on Coucy to keep him from killing Robin. When it looked as if Robin's life were forfeit, Coucy behaved as one sunstruck or moon-mad, giving Robin the chance he needed to gain his feet and fight honorably. But the milk-livered bastard would not strike!

Coucy had shouted, "Sorcery!"

But whose? Why did neither of them triumph? Was Robin fighting Maerin's fate unblessed? Did the Lady frown on his quest? Or did She save him for some other battle?

Juniper's voice interrupted his thoughts, brought him back to the present. He replied, "No, lad, my wounds are slight. We'll make for home and rest there. You did well today. You are my right hand."

Juniper beamed and sat up straighter on his pony.

⌘

The feasting at Nottingham castle that night was far from festive.

Coucy, sullenly in his cups, bore grim stares and snide remarks from those who scorned his behavior on the field, and for all that the hearths were blazing, his blood ran cold. He had thrown the owl's heart into the fire when no one was looking, for he feared the spirit of the owl had come back to haunt him.

Prince John was disgusted that the tournament had been interrupted. The deaths of a few rabble-rousing serfs was a regrettable inconvenience, but afterwards, the jousting was lustreless. He drowned his disappointment in unwatered wine and wished he were in London on the throne where he belonged instead of buried in this backwater.

Reginald watched his ward with curiosity. She seemed calm now, pick-

ing at her roast quail. But she had seemed near fainting when Coucy held the Green Knight at swordpoint. Why? Who was the man? Surely Maerin had not cast her favors on some other lover, without his knowledge? Impossible. Where would she have met anyone? She was little more than a prisoner—for her own safety, he told himself. Besides, for all he could see, the wench was in love with the Church. Coucy was right; she was pretty but prudish, and would make a cold bedmate. Well, Coucy never lacked for partners, and as long as he had Maerin's money, he would be satisfied. As for what had happened on the field today, Reginald put it down to Coucy's tendency to drink too much, and did not worry over it. The archery contest to come was much more important than the jousting.

As the meal drew to a close, the minstrel Derec of Cornwall, seated at a table well below the salt cellars, lifted his goblet to toast Maerin. "The fairest among us."

The company joined in toasting her beauty. She knew full well that she was not truly the fairest, but she supposed she was fair enough. More to the point, she was nearest to the most powerful men, and many sought her favor for that reason alone. She nodded graciously at the flattery, so typical of court dinners, and asked the minstrel for a song, feeling she was acting the part of the noblewoman in some mummer's play, while inside, in the real world of her desires and dreams, she was running through the wood barefoot, her hair unbound, to be with Robin.

At a nod from Reginald, a page boy ran into the center of the hall with a wooden stool. Derec sat on it with a flourish of his cape, swung his lute into his lap and struck a chord. "I had thought to sing of Gawain and the Green Knight, but perhaps the tale must be rewritten after today's events."

Coucy scowled and colored at the mocking laughter that erupted.

"But that is a ballad more fitting for Yuletide any road," Derec went on, "for this is the time of harvest. Yet when the grain is cut down, it gives us the seed which will spring to new life in Springtime. It is very like the tale of the Green Knight. Though his head is cut off, he lives. The Year-God dies, and is reborn at the darkest hour, like the Christ."

"You compare Pagan heresies to our Lord Jesus?" the Bishop of York demanded through a mouthful of roast swan.

"I speak only of tales told long before we told time by Christ's birth," said Derec mildly, "and if such stories bear a resemblance to one another, it is no fault of mine."

"Christ's birth, death and resurrection are facts, not tales!" boomed the bishop, throwing his food down onto his plate.

"Your Grace, I meant no offense." Derec bowed his head to hide a secret smile, and let his fingers drift across the lutestrings. Then he lifted his voice in a sweetly pious hymn that eventually lulled even the bishop.

When he was done, however, Prince John declared it was too somber a song for a celebration, and that everyone present must play a more cheerful tune in turn, to earn their keep. So one after another, the guests began to play, some to worse effect than others, but each trying a merrier song than the last, until Maerin herself, unable to follow a markedly bawdy ballad with one bawdier still, sang a psalm with a melodious voice and a spirit of such sincerity that the hall was hushed in listening spellbound.

Derec bowed to Maerin and said, "You are a nightingale, milady. I shall write a *chanson* for you, who are soon to be wed. Who is the lucky groom? No, let me guess." His eyes roved among the diners. "This one's bones would creak too much and keep you awake nights," he said of an older knight. His audience tittered. "This one prefers the company of men," he said of one of the bishop's retainers, to shouts of laughter and the monk's stoic blush.

"This minstrel is also a jester," commented Hugh of Nonant to the Prince.

Derec scanned the hall and said, "I think there is no man here so worthy as to deserve the hand of the maid Maerin. Unless it be the Prince, of course."

"And a flatterer," murmured Prince John to Hugh.

"Nay?" said Derec. "The Prince is not the groom? Then she shall marry beneath her!"

Coucy stood abruptly, knocking over his wine. He was sick to death of the jests at his expense and the attentions paid his fiancée. Everyone knew she resisted him. But now, with all eyes expectantly trained on him, he found himself tongue-tied with rage.

Derec frowned. "What's this? You are the groom? Well, tell me your name, Sir Knight," Derec said, "and I will write a special song for your wedding feast."

"He is Augustin de Coucy, noble cousin to the Coucys of Picardy," put in Sir Reginald, hoping to diffuse the tension in the room with a compliment.

"An excellent name! A name most easily rhymed," Derec said. "Let me see—Coucy, juicy, marry me, fidelity, *courteoisie*—an accomodating name for so formidable a man. I have heard tell of your doings, Monsieur, and never did I hope to meet you."

Coucy knew well that last remark could be taken in two ways.

Derec went on, "But I will keep my counsel in my wedding hymn, and mention only those acts that sing of your bravery. It will be a short song."

The company heard this jibe in delighted shock.

Coucy's hand went to his sword hilt. "Keep your mouth shut, Minstrel, or I will have your tongue."

"Noble words from a nobleman," Derec said, "for I am armed with the deadliest weapon, a lute and a word, while you have only a broadsword." He swung his lute about like a sword, as if jousting with shadows.

The guests watched breathlessly to see what the outcome of this dangerous game would be.

Reginald clapped his hands. "We want minstrels here, not court jesters. Use your lute for a song, or be banned from the hall."

Maerin bit her lip and stifled a smile.

Derec said, "At last I have made the maid Maerin smile. She has not shown a dimple in her cheek the whole night through, and I cannot bear to watch a frowning woman wed. It goes against the grain. It reminds me of my own wife."

"I hardly blame her that she frowned when she wed you, jester," called the Prince. Several knights and ladies laughed.

Derec chuckled and replied, "No, Your Highness, she was to wed another man against her will, and it was that which took the blush from her cheek. Such a cruel fate no woman should suffer." Maerin paled. "But Providence and Grace aided me in the form of a *puca*," the minstrel went on in a singsong voice, "and the wicked knight took such fright at the sight, he forsook the lady, and left her free to marry me." He bowed.

"Shut up!" Coucy looked ready to leap across the table at Derec's throat.

"Forgive me, milord, you are quite right. It is not meet that I should speak of my own travails in such august company. Let me sing of nobler things." Derec struck a playful chord and grinned at each woman in turn as he strolled and sang.

> Walking in a meadow green,
> Fair flowers for to gather,
> Where primrose ranks did stand on banks
> To welcome comers thither,
> I heard a voice which made a noise,
> Which caused me to attend it.
> I heard a lass say to a lad,
> "Once more and none can mend it."

They lay so close together,
They made me much to wonder
I knew not which was whether,
Until I saw her under.
Then off he came and blushed for shame
So soon that he had ended,
Yet still she lies and to him cries,
"Once more and none can mend it."

The bishop stood and left the table, his retainers at his heels, but Prince John laughed and applauded. Coucy lowered himself back into his seat.

His looks were dull and very sad,
His courage she had tamed,
She bade him play the lusty lad
Or else he was quite shamed.
"Then stiffly thrust and touch me just,
Fear not but freely spend it,
And play about at in and out;
Once more and none can mend it."

And then he thought to enter her
Thinking the fit was on him,
But when he came to enter her
The point turned back upon him.
Yet she said, "Stay, go not away,
Although the point be bended!
But do it again and hit the vein!
Once more and none can mend it."

Coucy felt his face grow hot with embarrassment. Yet no one was looking at him. All eyes, thankfully, were on that damned minstrel. If he left the table now, who knew what conclusions people might draw? So he stayed while the hateful song seemed to trill on and on of his own growing impotence.

Then in her arms she did him fold
And oftentimes she kissed him,
Yet still his courage was but cold
For all the good she wished him.

Yet with her hand she made it stand
So stiff she could not bend it,
And then anon she cries, "Come on!
Once more and none can mend it."

"Adieu, adieu, sweet hart," quoth he,
"In faith I must be gone."
"Nay, then you do me wrong," quoth she,
"To leave me thus alone."
Away he went when all was spent,
Whereat she was offended:
Like a Trojan true she made a vow
She would have one should mend it."

Maerin sent Derec a small purse of coins by way of a page, as was the custom. The minstrel had an excellent voice and with the exception of this last ballad, she had liked his singing and playing very much, not to mention his taunting of Coucy. She hoped by her largesse that she had set the standard for other nobles to reward him as well.

She listened politely as another minstrel took the floor, but excused herself soon after. She and Elgitha were halfway to her chamber when she heard footsteps behind her. She turned to see Derec of Cornwall bearing a garland of roses somewhat the worse for wear. He knelt before her on the stone stairs and said, "The Green Knight bade me give you this, milady. It is but a peasant's rosary, he says, yet he has told each bud like a prayer, 'She loves me, she loves me not, she loves me.' He prays you accept it."

Trembling, she took the garland. "Is it you writes such romantic nonsense for him, Allan-a-dale?" But she looked happy. "Have no fear, I will not reveal you. I believe you are a master of disguise or magic, for I did not know you until now! How … how is your wife?"

"She is well, thank you, milady."

"You must tell Robin to stay away from the archery contest."

Allan shook his head. "I cannot bid a *puca* to come and go at my behest. He follows his own star, and the moon. But know you that I owe him my life and happiness. I will never desert him. Now I must go. The soldiers in the gatehouse await me. I have promised to let them lose their money to me at dice. And if along the way, I find out how they will be deployed at the archery contest, all to the good."

Allan bid her farewell with a grin that did little to reassure Maerin's

heart. She was left to fret herself to sleep if she could, with the living rosary draped upon the posts of her bed and the faint fragrance of love in her every breath.

51-THE SILVER ARROW
HARVEST MOON WANING, 1193

essel of Holiness, Immaculate Virgin, protect Robin and keep him from Nottingham this day. Let not the sin of his pride lead him to destruction. Oh, Mother Mary, have mercy on us both! But in Christ's name, not my will, but Thy will be done. Amen." Maerin lit yet another votive before the little statue of the Virgin in her chamber, where a dozen candles already flickered.

She drew in a sharp breath as the wick of the new votive sputtered and went out. It seemed a perilous omen. Or was that unholy superstition? How dared she petition for a Pagan lover with Christian prayers? God would not hear her! But surely Mother Mary, who forgave all sins, would listen?

Anxiously she relit the candle, watching until it caught and burned bright. Then she buried her head in her hands. Could the Virgin Mary forgive Maerin's lust? Her body burned at the thought of Robin's kisses, burned away her old confidence in her Christian vocation, burned away her desire for chastity, her longing for the quiet of the cloisters. Her loyalty to family, to her father's will and therefore her uncle's, had burned away long ago.

But the Lady who had come to her in her visions—She was the Mother of God, the All-Merciful One. Mary was only one of Her names. Maerin clung to the memory of that Lady's robes, the light around Her, the look in Her powerfully loving eyes.

The tiny engraved ivory beads told through her fingers once more. "Hail Mary, full of grace, the Lord is with Thee. Blessed art Thou amongst women, and blessed is the fruit of Thy womb. . . ." She faltered at the name of Jesus, thinking of the white stag, of Robin, of the grove of dancers in the moonlight wearing the skins of beasts. Perhaps Allan-a-dale was right, and the deaths of the Old Gods had the same purpose as the Christ, to redeem their people.

Or perhaps this was heresy and she would go to Hell for thinking it. She whispered, "Holy Mary Mother of God, pray for us sinners, now and at the hour of our deaths. Amen. Hail Mary, full of grace. . . ."

❦

That same dark before the dawn, pungent smoke made its journey like a prayer into the ethers, and filled a cave with incense. The small wood fire crackled and hissed in the gloom, casting against the far wall a hulking shadow of the naked man crouching before it.

In his left hand he held an arrow. He rubbed the arrow with his right hand, breathed on the tip and licked the feathers, chanting softly, "Praise to Brighid, the High One, Warrior, Protectress, Queen of Word and Deed, Fiery Arrow, Moon-Marked. I am your servant and priest, Robin. Let me be an arrow shot from your bow. Let your target be my target, your will and hand and eye guide the wings of my flight. Oh Lady, High One, send me your justice, lend me your sight."

He set the arrow aside and picked up a beeswax taper. With a curved knife he carved sigils upon it, then rubbed it with crushed bay leaves and a precious cut lemon. Then he tossed the leaves and the lemon into the fire. He licked his fingers and the astringent-sour taste of bay and lemon rind bit into his tongue. With his saliva he drew a spiral on the candle's shaft from wick to base, drawing power in, a fearful power on this waning of the moon. A chill knowledge gnawed at his heart. Someone would die this day. It might be him.

He lit the taper with a twig from the fire and went to a niche in the cave's stone wall, a natural altar. He let a few drops of wax pool upon the stone above the frozen waxen waterfall of other candles long since burned away. He set the taper in place, brought his palms together before his heart, then picked up a bowl of blue woad. With the dye, he painted blue suns on his chest, the soles of his feet and the palms of his hands. He went back to the fire and doused it with clumps of dirt. He sat cross-legged, holding the arrow, his eyes closed, upturned in his head, as if seeking the sun through his skull, so deep in trance he did not feel the cold night air or the passing of time. His breath slowed to stillness.

He felt rather than saw the sun rise, but at last red filled his inner vision. He opened his eyes. Rosy golden light bathed him. The embers of the fire had died to ash. He plunged his hands into the mixture of earth and burned woods, lemon and bay, and dusted his body with the fine, sharp-smelling powder.

❦

At Nottingham, the edges of the field were once again mobbed, the gallery was gemmed with nobles, and the shooting range, or butts, had been set up, a row of a dozen straw-filled targets attached to wooden frames. Their sturdy

sacking was painted in bright colors with the fanciful profiles of, respectively, a boar, a bear, a hare, a bull, a ram, a stag, a wolf, a fox, an otter, a pheasant, a peacock and a swan, so that the eye of each one formed the center of the target. The boar's was red and furious, the stag's soft yet wild, the fox was crafty, the otter playful, the hare timid, the swan serene.

The first competition was for unmarried noble maidens, most of whom used this contest to show off their charms, so that in a sense they were themselves the targets, hoping for the arrows of love, and the real competition was a subtler one than the winner of the prize, a quiver of arrows, would show.

At her uncle's behest, Maerin had agreed to compete. It would help distract her from her fears, and it spoke to the Sheriff's pride. Let him think her malleable at last. She did enough to defy him secretly already.

Each maiden chose a target, bearing the jokes and catcalls of the commoners if they chose a horned beast. Maerin found herself before the hare and thought it fitting for the state of her nerves, but someone made a joke about fertility and her upcoming marriage, and she wished she had a different target.

The heralds trumpeted, the field marshal gave a shout, the maidens' arrows flew, and after three volleys, Maerin found herself among the final three competitors. Pages and squires ran out to take away all targets but that of the swan, who mates for life. This target was moved some paces farther back to create a greater challenge.

The three maidens would now shoot separately. The first took her place with a coy smile and a toss of her blonde head, showing to good advantage the alluring silhouette she made with her white and blue costume and her pretty arms outstretched with the bow. She took aim, then stopped, pretending to be flustered, and smiled apologetically but radiantly at the nobles' gallery, to the indrawn breaths of several youths. Maerin could practically see the girl scheming: she must not seem to be too proficient an archer. The men would not like it. Whereas if she did well enough but failed, she could let them play at comforting her.

She hit the target in the long curving neck of the swan, just beneath the jaw, close enough to the eye to make it appear as if she'd tried her best. She made a little pout and bit her rosy lip, then forced a sad smile and curtseyed to her round of applause, her lashes lowered over her calculating eyes.

Maerin stepped forward to take her place, but faltered herself, for at that moment she glimpsed in the crowd a beefy man, a player with a troupe, or so he wished to appear, in long scarlet robes, a white turban and a thick black beard. She was almost sure he was one of Robin's henchmen. Beside

him danced a dark-skinned woman in an exotic costume, with pantaloons almost as wide as a skirt, belted with rows of gold coins strung on chains, a bodice with puffy sleeves, an embroidered veil covering her face as well as her hair, her hips moving in swaying circles and jiggles, her torso undulating in a way that was most unChristian. Maerin recognized her at once from the outlaws' moonlit grove. Probably she had been a slave brought back from Outremer who had escaped her master to live in the greenwood.

She must not draw attention to them. Maerin looked away, took a deep breath, aimed and let her arrow fly as she exhaled. It whined through the air and thwacked into the eye of the swan, a perfect shot.

The people cheered. She waved, thinking, "Dear Lady, let them look at me, no one else. Let Robin be far from here and safe."

The next archer was a stocky, ruddy-faced girl who seemed to care not a whit for the kind of silhouette she might make. She took careful aim with no fanfare, lifting a brow at a slight breeze as if she could see it, and her arrow hit the swan's-eye dead center, nestled next to Maerin's.

There was some grumbling in the crowd, for the locals wanted Maerin to win. The field marshal strode out to the target to see for himself which arrow was best, and proclaimed Maerin the winner, but Maerin graciously lifted the other girl's arm in victory, and the people cheered Maerin's nobility. The finely-wrought leather quiver of arrows with peacock feathers on the shafts, was divided between the two winners, Maerin receiving the arrows, the other girl preferring the quiver.

Maerin cared not an ounce for her prize, but put on a show of being pleased for the sake of those watching, then went to the gallery and took her seat. Reginald leaned over to her and patted her hand. "I shall have one of these new-fashioned quivers made for you if you like, after your wedding. Some say it is better than a sack at the waist, for speed in nocking an arrow to the bow."

She forced herself not to pull her hand away, and murmured her thanks as the targets were dragged into place for the men's contest.

A score of soldiers armed with pikes, spears and swords quietly appeared, reinforcing those already surrounding the field and the gallery. Maerin turned to Reginald and said, "Are your men preparing for war?"

"You know how it goes, my dear, as the day wears on and ale drains from barrels into bellies. My soldiers will keep the peace, never fear."

As if she feared a drunken villein! Maerin swallowed her irritation and tension. She knew for whom these soldiers lay in wait, and it was not some rowdy goatherd with beer in his beard, though indeed the gathering was

growing more boisterous. The peasants impatiently shouted for the next trials to begin, and threw apple cores and other garbage at acrobats or mummers who displeased them.

Maerin caught sight of Allan, still styled as Derec of Cornwall, plying his trade. He was rewarded with coins from the merchants and coquettish smiles from their ladies. Then Maerin saw a swift hand dart forward with a tell-tale glint of steel, and the leather straps of a townsman's purse were cut while Allan stood entertaining the fellow.

Maerin flushed. How could she think Robin's men would abandon thievery simply because he had proclaimed his love for her? How far she had forsaken her duty! She should alert the Sheriff, but she knew she would not, though it was a sin.

So add another to the list. She must go to confession soon.

Of course such an assembly would be rife with cutpurses, pickpockets and liftskirts. Let the soldiers take care and the townsfolk beware. She felt hot and fanned her neck with her hand.

"What is it, milady?" asked Elgitha.

"Nothing, only a fly." She let her hand fall back into her lap.

Nearer to the gallery, along the eastern side of the field, a brawny red-bearded man played the jester, with a chamberpot on his head for a helmet, a scarlet garter wound around it as his lady's token, a large skillet for a shield, a wooden board tied at his waist for a sword, and a tunic of chain mail. He marched up and down with an exaggerated expression of solemnity, mimicking first one soldier and then another. Having roused the happy jeers of the peasantry, he pretended to assist Sir Reginald's troops in keeping the commoners in line, pushing them back if their toes overstepped the banks onto the field of play, reaching into his false sack of arrows and pulling out handfuls of flour which he threw in their faces if they did not obey, and for his pains, receiving cheers and hoots of laughter from some, shoves and curses from others, and giving back as good as he got. Soon he was embroiled in a spitting match with a burly drunk whose front teeth were missing, which offered him a wide gate for beery spittle to rain upon the multitude, to everyone's screaming delight.

At last came a fanfare of trumpets. A rowdy hurrah went up from the throng. Then the people quieted enough to hear the field marshal announce the names of the twelve competitors. Applause greeted the names of some, known as fine archers: Adam of Ludlow, Roger Lin, and Simon Bridewater, said to be one of the best archers and fletchers alive. Prince John's best archer was Sir Ralf of Horncastle, perforce the champion of the nobility if they

wished to curry favor with the Prince, but from the common herd, he met with sardonic cries and little warmth.

The field marshal ended by declaring, "The winner to receive a purse of thirty silver marks and an arrow of pure silver, with gold upon the tip and solid gold feathers!" The crowd applauded again.

The men took their places. The heralds sounded their trumpets. The field marshal bid the men nock their arrows.

As the archers took aim, a tramp limped onto the field with a battered oaken staff and paused before the target of the wolf.

The people gasped.

The archers lowered their bows.

The beggar looked about him as if befuddled, then saw the targets and nodded, turned and began limping toward the archers. His tunic of stained brown linen flapped over torn black trousers. Over all, a worn smock was tied at the waist with an aged leather strap, and upon this makeshift belt hung a sack of arrows. Rags woven around his filthy feet passed for shoes. Worn woolen gloves with the fingers torn off covered the palms of his hands. An eye-patch covered his left eye; his good eye peered out in a squint. His skin was ashen. His stringy brown beard was streaked with grey, and his stringy hair and soiled face were half-hidden by a greasy black hunter's hood that had seen many better days. Over this tattered ensemble rippled a ragged brown cloak, patched in three places with mismatched cloth, and beneath this cloak, a slight hump at the right shoulder told the world the beggar was also a hunchback. Yet across his hump was slung a sturdy yew bow.

"Remove that refuse from the field!" commanded the Sheriff, but even as two soldiers hastened to obey, the beggar loudly declared, with a lisp and a West Country accent, his wish to compete.

Howls of derisive laughter filled the air from the watching throng.

The tramp nodded and smiled, showing black gaps in his stained teeth, and he bellowed, "Laugh if you like. I am Beck of Somerset, and if you think I cannot match the best archers in Mary's England, then let my shooting but make you merrier. I wore my shoes away in walking here, with that silver arrow like a beam in my eye. Or do you allow only nobles and rich men to try their skill in Nottingham?" He spit on the ground and cast a sneering glance at the archers. In truth, some of them were by no means well-to-do, but the poorest of them looked wealthy compared to this vagabond.

"Impertinent wretch!" blustered Prince John, but the commoners were already claiming the beggar as their own.

"Let him play!"

"Let him shoot!"

"He is but a jester, milord," said Hugh of Nonant.

The Sheriff leaned toward the Bishop of York and murmured, "Again a stranger comes into our midst, as in the jousting. Do you not count it odd?" They exchanged meaningful glances. Maerin could not hear them, but saw them conferring. Fear coiled tighter in her stomach.

"I'll get rid of him." Coucy made a move to draw his sword, but Reginald ordered him to stay still.

The Sheriff struggled to see beneath the hunchback's grime and rags, to recognize beneath, if he could, the face of Robin Hood, whom he had seen but twice in his life. But the beggar was too far away for him to be certain if he was the hated outlaw. If he won the contest, that would be as sure a mark as his own signature. The commoners were raucously taking up his cause; they could react badly if the man were captured at the wrong time. To forestall a riot, Reginald waved a hand to countenance the beggar, then beckoned to his captain of the guard. "Let your men keep a watchful eye on this baggage."

Coucy overheard and light dawned in his eyes. He slumped back in his chair feeling an utter fool. Of course Robin Hood would come in disguise! Had he thought a wanted man would sally forth dressed in Lincoln green and covered with stolen jewels? He called for more wine and was about to drown his wounded pride in it when Reginald hissed, "Keep your wits about you, man! You'll need them!"

Coucy, struggling to save face, snapped, "The wine is for Maerin. She looks faint." And indeed she did, and he handed the wine to her and thirstily watched as she sipped it.

Another target was carried out for the hunchback. Had anyone been close enough, they could have seen Beck's one good eyelid twitch. Had they known his heart, they would have felt its sudden pounding, for the target bore the brown face of a snarling Saracen with the blood-stained fangs of a vampire, a bloodied scimitar above his red-turbanned head, and a glaring, bloodshot eye.

He felt the sky lighten to desert white, the grassy field beneath him gave way to desert rock and sand that shifted beneath his every step, and it was dry, so dry he could scarcely swallow. He scanned the crowd again as if they were armed warriors charging him, and he gripped his staff with a sweaty palm. Then he saw Maerin in the gallery, felt her fear for him, remembered his purpose, and there was grass under his feet again, solid ground, a moist autumn breeze caressed his face, and the blue sky of England overhead. The

rapid beating of his heart slowed to normal.

He took his place beside Sir Ralf, who declared, "The stink of this vermin is strong enough to knock my arrows askew," but none would trade places with him.

The trumpets blared, the archers aimed and thirteen arrows fled to their marks. The men were allowed three volleys each, the best six archers were chosen, and among them, to the delight of the peasants, was the target of the Saracen. But in the gallery, pages, cupbearers and stewards noted the taut expressions on the faces of their overlords, as if this contest were a deadly battle instead of a pleasant pastime.

The targets were moved further back, again the field marshal gave the signal, and three more volleys arched across the field. Beck the hunchback's arrows flew true. The poor chanted his name ecstatically, for all that he was not of Nottingham.

When the contest narrowed down to three archers, the beggar was among them. Now they were allowed but one shot apiece, at the target of the bull, which had been moved back another score of paces. Drawing lots to see who would shoot first were Sir Ralf of Horncastle, the yeoman Simon Bridewater and Beck, the darling of the riff-raff.

"By God's legs," said Prince John, "where did that ragbag learn to shoot so well?"

"Indeed, milord, this contest is as close as any I've seen," replied Hugh of Nonant.

"Think, Hugh! Don't just sit there on your ass! Where would such a man come from? I think he wears a disguise. I want him unmasked!"

"If you will permit me, milord," cut in Sir Reginald, "I am almost certain this beggar is the outlaw Robin Hood, walking into the trap we have laid for him, just as we expected. Your royal patience will be rewarded—we will boil him alive in the marketplace if you so desire—but let him win first. Our plan depends upon it."

Maerin held herself still as stone, afraid the merest movement would betray her, and Robin. Frantically her mind sought some way to create a disturbance. Perhaps she should pretend to swoon.

"You think that swill will beat my own Sir Ralf?" protested the Prince, raising a haughty eyebrow.

Reginald held back a sigh. "I meant no offense, milord, but if this is the Hooded Man. . . ." He spread his hands in a helpless gesture.

The Prince frowned. Hanging that wolf's-head would give him pleasure, of course, but worse worries beset him these days. What if this beggar

were instead a spy from his mother or even Richard himself? He fidgeted in his seat as Simon Bridewater stepped up to the mark.

Just as Simon's bowstring twanged, a flirt of a breeze danced up and his arrow flew a half-inch wide of the bull's-eye. The assembly groaned, for such a stroke of ill luck could have put any archer's shot awry. Simon shook his head and stepped away.

Sir Ralf took his place, aimed, and with a hiss, his arrow sprouted in the center of the target. He lifted his head proudly to the applause from the gallery.

"Let your vagabond better that shot!" exulted Prince John, as if he still did not understand what was at stake.

Maerin inched forward in her chair, her own body strung like a bow.

The hunchback was at the mark now. He narrowed his good eye and lifted his bow, and the commoners booed and laughed to see he had no arrow nocked. He pretended amazement, then laughed with them, bowed to them, and spun around on his heels as if searching for the sack of arrows tied to his belt, like a dog chasing his tail.

"Now we see his true colors!" Hugh laughed. "As I said, he is but a jester."

"A jester who shoots so well?" snapped Prince John.

The beggar whipped an arrow out of his sack, threw back his head and let out a cry, like a wolf lonely for his mate, like a stag belling urgently of danger, stunning the onlookers into silence.

In a single swift motion, he nocked the arrow and let it fly, speeding faster than sight. Then came a cry, "He has split the wand!"

A roar went up from the crowd as the field marshal ran to check the target. When he nodded and shouted the winner was Beck of Somerset, Sir Ralf stalked off the field in disgust. Simon walked over and congratulated the beggar, who nodded and hobbled toward the gallery for his prize, while players and jugglers danced about shouting and jangling tambourines. The peasants pressed eagerly into the field and toward the gallery, hoping for a better view of the winner accepting the silver arrow.

The captain of the guard made a move to intercept the tramp, but Reginald said, "Wait, Anhold! Let him get close to the gallery, away from the peasants whose champion he has become. He'll take the silver arrow from Maerin, and with his hands busy and his eyes distracted, your soldiers will surround him. We will give out that he threatened the Prince."

The beggar's smell preceded him. Prince John put a handkerchief to his nose. The odor was indefinable, pungent and strange. Some of the ladies

began fanning their faces. A glint of amusement appeared in the vagabond's eye. He mounted the stairs and stood before the Prince and the Sheriff. A soldier pressed rudely on his shoulders, forcing him to kneel.

Sir Reginald gazed at the grimy face, the straggly beard beneath the soiled hood. It was a masterful disguise, but it had to be Loxley. He was as good as jerking his legs on the gallows. A wave of satisfaction went through him as he said, "Well, Beggar, it appears that you have won."

"Aye, milord."

"Where did you learn to shoot so well?"

"Here and there, milord."

"Here and there? In Somerset? Or Sherwood?" he added meaningfully.

"In the butts, milord."

Several peasants giggled.

"Do not mistake me, vermin. You have won the contest, but you have not won the right to be insolent with your betters."

"No, indeed, milord, and if ever I find my betters, I shall be respectful." He looked up with a sly smile.

Reginald's hand itched to draw his sword. Perhaps he really could goad the bastard into making the first move. Then the rabble would have naught to complain of when their hero was taken prisoner. He said, "Are you a half-wit or merely ill-bred?"

The beggar said nothing.

"You remind me of someone. A devil of a man."

"Have I won or not, milord?" Beck demanded loudly.

The peasants shouted, "The prize! The prize! Give him his winnings!"

Reginald frowned, but nodded to his steward, who stepped forward and handed over the purse of thirty marks to Beck, who weighed it approvingly in his hand.

Maerin fought to keep her features frozen and her hands from shaking as she took up the purple velvet cushion on which the silver arrow lay. It was the length of a man's hand, slender as a woman's finger, with a glistening golden point and golden feathers at the end of the shaft. As she approached the beggar, she tried to follow the line of his jaw under his beard, to search for a lean build under the hunched back and baggy clothes. She could determine nothing. But the color of his eye, and the mischievous but hardened gleam in it: that was Robin to the core. Did he really think this disguise would fool her uncle? She felt nauseated. Perhaps the smell of him made her queasy. How could she love a man who stank so? What had he been rolling about in? And with whom?

But she could not tease or berate herself out of either her fear or her desire for him. She warmed to his presence regardless, and his eye flickered an answering fire when he looked at her.

A shout went up beside the gallery. Everyone turned instinctively. The jester-soldier with the chamberpot on his head was mimicking the beggar, hunched and hobbling, then mimicking Maerin, with mincing steps and rigid back. The peasants jeered and shoved him away. The jester swaggered up to a stony-faced soldier and kissed him on the mouth. The soldier swung his fist, but the jester ducked, and with his head lowered like a bull, rammed the soldier into the throng, where he fell into a tangle of skirts and limbs.

"Here, now, you big handsome side of beef!" cried a hefty older woman. "Here is a contest you may win!" She flung herself on top of the Sheriff's man and made mighty pumping motions with her hips, to the applause and yells of her audience, while the jester stole the soldier's pike and raced in front of the gallery with it.

"Stop him!" ordered Anhold. Two soldiers deserted their posts in the gallery to give chase.

"No!" Reginald leaped to his feet too late to forbid it.

Robin opened his prize purse and flung the coins in the air behind him, shouting, "Alms for the poor!"

In a flash, shouting peasants were storming the front of the gallery scrabbling for the silver.

The jester threw the pike sideways at the shins of his pursuers. They tripped and went down. From the wooden paddle at his waist the jester drew a steel blade with a wooden handle, which had been fashioned to hide in the wooden scabbard. With a battle cry, he slit the throats of the fallen soldiers and bounded up into the gallery. Hissing steel filled the air as soldiers drew their swords to defend the nobility, who were shouting, calling for arms, trying to run, or fainting. Even the bishop lost his haughty demeanor trying to push his bulk out of the gallery.

In the field, turbanned John Nailor was plunging among the soldiers with a lethal swinging of his scimitar. Then a tinker and a potter, a miller and a carter, several monks and a carpenter, all outlaws in disguise, were suddenly armed with blades and staves, longbows and crossbows, which they had kept hidden until now.

Robin grabbed the silver arrow from the purple cushion. At the same time he wrenched a broadsword from a scabbard hidden beneath his rags. He lunged toward Coucy, who had already drawn his own sword and was rushing forward with a malevolent howl. Their blades met. Maerin heard

herself screaming and stuck her fist to her mouth to stop her cries.

Pandemonium raged. By now, the Prince and the bishop had been hustled away to safety. Reginald and Anhold traded fierce blows with John.

The jester with the chamberpot helmet was fighting a soldier not five paces from where Maerin stood. His sword was struck out of his hand. His opponent triumphantly raised his blade to deal the deathblow.

There was a shout, "Will Scarlet!" and John's dagger was stuck in the soldier's heart, a direct blow from close quarters that pierced the chain mail as if it were a sponge. Will grabbed the dying soldier's sword and hurled himself back into the fight.

Robin and Coucy circled each other, inching sideways in the narrow confines of the gallery. Then they hurled themselves at each other. Their heavy swords smashed together and held there, crossed in the air. The men grunted and pulled back, but Robin's left hand flashed upward and ripped at Coucy's face with the silver arrow. Coucy yelled and stepped backward, bleeding from his cheek, but he plunged forward again. Sparks flew as swords met, steel screeched against steel as they drew their weapons back.

Clutching the velvet pillow to her breast, Maerin sank against the gallery railing. Swords and pikes, staves and bodies, blood and screams whirled around her. Half the crowd had joined in the fray; the rest were shouting and trying to escape.

Her prayers had not been heard. She should have known how fruitless it would be to try to control Robin. Tears filled her eyes. Robin fought for her sake, though she had begged him not to. He was mad to do it. His men were outnumbered. They were doomed.

She thought then of her bow and arrows.

"Milady," Elgitha begged, "you must come away!"

"You'll not use her as a shield this time, coward!" Coucy yelled.

"Maerin, go!" was Robin's gutteral reply as his sword arced through the air to batter Coucy's.

Maerin obeyed. By staying, she might distract Robin. Worse, Coucy might use her against him. She picked her way through overturned benches, fell to her knees to avoid flailing limbs, and took up her bow and sack of arrows. She crawled with them out of the gallery, Elgitha behind her.

But the moment she stepped onto solid ground, a hand gripped her wrist. "No!" she cried.

"I will guide you to safety," Allan said urgently in a low voice. He was a small man and his tone was gentle, but his grip was firm, and she had no choice but to let him lead her and Elgitha to the relative safety of a deserted

baker's stall on the edge of the field. He bade them stay well hidden until he returned.

In the gallery, Maerin saw Coucy forcing Robin backwards toward the stairs. He landed a sideways blow across Robin's shoulder, shredding his ragged tunic even more, and glancing off the chain mail hidden beneath. Robin ducked and charged low. Coucy stumbled over a fallen chair and scrabbled backward, gaining his feet as Robin leaped toward him. Their swords met in the air once more, but Coucy drew his dagger and sliced at Robin's hand, ripping the glove he wore. Blood welled up and Robin dropped the silver arrow, yet he did not cry out.

His lips moved in a soundless incantation to the Goddess. His eyes were unblinking.

Perhaps he prayed to the Devil, thought Coucy, or perhaps he was a devil himself. The man was tireless as a demon, even bleeding from his wounds.

Coucy's own eyes blurred with sweat, fatigue and blood from where Robin had cut him. His weakness made him angrier. Always it was thus! In jousting, in bed! When it came time for the kill, he faltered. Damned if he would do so now! Growling, he forced himself to fight on.

Every battle he had lost, every gambling debt he owed, every woman who had spurned him or succumbed to his will out of duty or fear, rose up in him like a spectre, feeding a red fury against Robin Hood, who had mocked him, shamed him. He would kill this man and in so doing, have his revenge upon his scornful brother, scornful Maerin, Isabeau, Reginald, Dulcie, even René, whose innocent ghost haunted Coucy's dreams, the Devil take him!

Awash in rage, he swung his sword again and again, forcing Robin back and down, to his knees. He would see this outlaw grovel and plead for his life, for a mercy Coucy would not grant. A snarl stuck in Coucy's parched and constricted throat. He raised his sword one last time to split Robin's skull.

Maerin, watching from behind the wooden counter of the baker's stall, gripped the wooden planks so hard she tore splinters from them with her fingernails, but she barely noticed the pain. The two men had been moving so quickly, locked together so closely in battle, she had not been able to send a single arrow to Robin's aid.

Now Coucy's blade was swinging toward his head. At the last second, Robin twisted to the side and down, half rolling away. Coucy's sword splintered the wooden railing of the gallery. A sudden upthrust of Robin's sword impaled Coucy, ripping his bowels, heart and lungs, from groin to chest.

Coucy froze. His face transformed from the rage of battle to a stunned

and stiffening agony, and a haunting rictus of despair. He had failed, failed again, and he would never win.

Blood dribbled out of his mouth. Robin yanked his broadsword free and Coucy fell to the boards choking on his final breath.

Reginald ran toward Robin, sword in hand. He saw Coucy collapse, saw Loxley was the agent of his defeat. Loxley who made a laughingstock of him at every turn, who thumbed his nose at the law. He stifled a scream of fury that would give him away to his enemy as he took the stairs into the gallery.

Seeing Coucy fall and Robin stagger to his feet, Maerin barely had time to gasp for joy before Reginald was bearing down on Robin unknowing. The whole tableau spread before her like a painting or tapestry, moving but somehow unreal. Her uncle's sword-hand lifted.

"Robin! Behind you!" she screamed, but knew he could not hear her. In a swift, desperate motion, she drew an arrow and shot to kill her uncle.

Reginald groaned as an arrow grazed his cheek and lodged in the gallery wall. His groan and the report of the arrow thwacking into the wood alerted Robin. He spun around and parried Reginald's swinging blade with such force, he knocked the Sheriff sideways. Reginald lost his grip on his sword and smashed through the railing to the ground below.

With an exultant yell, Robin crouched and swept the silver arrow into his left hand, leaped from the gallery and ran into the field, belling like a stag to call his men, who rallied, bloody, weary and proud. They fled from the field, helping their wounded where they could. Their yipping and ululating filled the air like the hounds of Herne as they made their escape.

Swearing, Reginald climbed back into the gallery to reclaim his broadsword. He jerked the offending arrow that had made him lose his prey out of the wall. He would have broken it in his rage, but with a slow flush of a colder fury, he recognized the feathers adorning the shaft. Peacock feathers.

Maerin's.

⌘

51-ThE GAME IS BORNE AWAY

et me go, I command you!" Without waiting to see if Elgitha would obey, Maerin ran out of the baker's booth. She fled over slippery blood-stained patches of grass, past dead bodies, a lost shield, a startled horse that shied away. But when she tore past a badly wounded peasant, prostrate and groaning for water, she faltered.

Blood blinded his eyes from a gash in his forehead, his leg was splayed at an impossible angle and the front of his brown tunic was sopping with blood, whether his own or someone else's, Maerin could not see. Yet he suffered for her sake. All those dead or wounded this day suffered because Robin had come to aid her. It was as if she had struck them down herself. Her heart wrenched with guilt and pity. Could she call herself a good Christian if she abandoned this man? But if she stopped to help him, she would never escape. Every second she delayed was a danger to her.

Torn, she looked across the field in the direction Robin and his men had already disappeared. Then the moment for choice was gone. Something gripped her hair from behind, twisted her braid swiftly around and jerked her head backwards. She yelped, stumbled and fell awkwardly, painfully, to her knees.

A sword flashed in the sunlight above her. "Traitor!"

Maerin recognized Reginald's voice booming above and behind her, heard Elgitha's screams in the distance, and then his blade was coming down toward her neck, and she watched paralyzed with shock.

She heard a clanging sound. Reginald's sword hung miraculously in the air, crossed by another blade. Will Scarlet held the hilt. He was wounded, bleeding, yet he swung his sword as fiercely as if he were whole.

Reginald matched him blow for blow. Five times the steel rang out, then Will halted with a dismayed expression. He looked down, gaping. An iron barb protruded from his chest, crimson dribbled down the links of his chain mail. A pikethrust from behind had pierced his heart, and the soldier who had done it was already drawing his sword.

Will sank to his knees, struggling to lift his own sword. With an an-

guished look at Maerin, he mouthed the name, "Anne."

Reginald himself hacked off Will's head. Blood splattered onto the field, onto Maerin's clothing. Screams rose in her throat as another soldier speared Will's head on his pike and charged off with it, yelling, followed by his comrades.

"Traitorous bitch!" Reginald backhanded her across the face. Ignoring her screams, he began dragging her by her hair across the bloody, corpse-ridden field.

She struggled in vain to gain her feet, gasping, "Uncle! You dishonor me!"

His eyes blazed and his mouth twitched as if he would speak, but he choked with rage and no words came from his throat.

Elgitha came toward them shrieking, begging Reginald for mercy, but he kicked her out of the way as if she were a pesky dog. She followed then at a safe distance.

Reginald made to commandeer a riderless stallion. Maerin writhed out of his grasp and ran, but in two large strides he caught her again and slapped her face so hard, her lip split and began to bleed.

"You've gone mad," she whispered, but he did not seem to hear her. He ripped the string from her bow, which was now broken from her fall and flapping at her shoulder, and he used the string to bind her wrists behind her. Then he hoisted her like a sack of oats onto the horse, swung up behind her and with a violent kick to the stallion's haunches, made for the castle at a gallop.

Down the stairs to the dungeons he half-dragged, half-shoved her. She heard screams echoing. Elgitha's, or a tortured prisoner's? Her heart skipped in fear. A rat scurried across her path, its tail slithering at the hem of her skirt. At the bottom of the stairs, Reginald shoved Maerin into a dark cell. With her hands tied behind her, she could not break her fall. Her knees bore the brunt of her weight on the straw-covered stone floor. She cried, "Uncle, you've gone mad!"

The back of his hand came down blindingly on her cheek again and again. He found his voice at the heart of his fury, and it rasped into the darkness like the whetting of an axe. "I'll not be deprived of your fortune, you conniving cunt! I'll find a way or have you burned at the stake as a Witch! Was it Robin Hood bewitched you? Or did you bewitch him, to make him kill your betrothed? On my oath, he too will die before the week is out! You will be the bait to lure him this time. I'll have his head on a pike and yours will be set beside it, you treacherous Witch-mongering whore!"

The words stung her, her head was reeling, her jaw ached, tears and
darkness covered her eyes, her voice was hoarse from screaming. Desperate,
she gasped, "You are wrong! He will not come! I am no traitor, and the Lady
knows, never a Witch or a whore!"

"Your arrow, Maerin."

She fell silent.

"Pray for your soul, Hell-bitch. Pray until your last breath. It will be
soon." He turned and quit the cell. The heavy iron-studded door creaked as
it slammed shut behind him, leaving only darkness, black as the secret pas-
sage outside her bedchamber, black as the cave in Robin's wood. She heard
the rusty turning of the key in the lock.

Reginald spied Elgitha cringing against the wall. He grabbed her arm,
twisting it and dragging her up the stairs with him, ignoring her protests as
he croaked, "Go to him. Go to Robin in the Wood and tell him his lady fair
is to be burned as a Witch. No doubt she has used you as her spying messen-
ger before, you ugly old crone! Be grateful I don't hang you as well! Tell your
demon master Maerin's fortune is forfeit to the Church he abhors. Tell him
the Bishop of York will light the pyre! Tell him I will dance at her bonfire!
Tell him he must come forward—unarmed—and surrender himself to me in
my own hall. Tell him, his life for her life. Do you hear? His life for her life!
And tell him to come alone!"

He shoved Elgitha through the castle gate. "Get into Sherwood and
never show yourself here again!"

Elgitha stood transfixed, watching Reginald stomp back across the court-
yard. She gulped and turned to look out over the town and the fields and the
wood beyond. She did not know where to go. She had no idea how to find
Robin Wood. Only the knowledge that her lovely duckling's life rested in
that brigand's hands made her set one foot after another down the road.

<div align="center">⌘</div>

The half-lidded eye of the waning moon was drooping toward the horizon,
yet its blue-white shimmering still sought the silver arrow, the precious moon-
metal chased with gold, which hung by leather thongs from the great oak by
Brighid's Well, and shot flashes of reflected firelight into gleaming eyes, both
human and otherwise.

Beer, mead and wine flowed freely, the remnants of a feast lay scattered
about on blankets and on the ground, hounds and birds and insects munched
on the leavings, and talk was loose and laughing despite an undercurrent of
worry for the wounded and the missing.

There were those who had already paired off and slipped away into the

woods to honor the victory in another fashion. Soft cries of pleasure, groans and gasps marked a syncopated rhythm beneath the skirling of tin flutes, the ringing chords of Allan's new dulcimer, freshly stolen by Harald from a stall at the tournament, and the melody of a new ballad Allan was creating even as he sang it.

"Wait, this shall be the beginning," he said, shushing his makeshift chorus as he experimented.

> Peace and listen, gentle friends,
> And hearken what I shall say,
> How the proud Sheriff of Nottingham
> Did cry a full fair play,
> That all the fine archers of the north
> Should come upon a day
> And he that shooteth all the best
> The game shall bear away.

"Sing instead how Robin gutted Coucy!" called John, toasting his *puca*.

"Patience, my friend, I'm coming to that," Allan replied.

"Aye, in a year or two!"

"One must build the tale," Allan protested.

"Patience is its own reward," intoned Tuck, belching at John.

"Tell how Robin split the wand!" Juniper said. He sat as near to Robin as he could without actually sitting in his lap, relieved more than he could say that his father had come home safely. Robin ruffled his hair. Juniper grinned happily and went back to cuddling the young stray cat Harald had also brought from Nottingham in a basket, to make up for Juniper having been denied the danger of attending the archery contest.

"Better yet, tell how Prim stole the soldier's manhood." Tom laughed, remembering the amazing sight of stoic Prim pumping away on top of the soldier, disarmed but far from charmed, in front of the jeering crowd.

"Does Prim still tend the wounded?" asked Robin. He himself was already salved and bandaged wherever he had need of it, and was resting with his fingers furled in the black fur of his dog Balor, who in turn stared fascinated at the tumbling cat with a suspicious drop of drool at his jaw.

Despite his exhaustion, Robin rose. "I'll take her some food."

"Rest yourself. She feasts on other fare." Allan winked. "I saw her hasting away to make the two-backed beast with one of our monks."

Robin's eyes widened in surprise, for he had never pictured Prim with a

lover. Not that she was too old, only that she seemed not to have any interest in it.

John looked up from his wine with his mouth agape. "Who was it?"

"I could not see his face for his hood."

"Who was disguised as a monk this day?" asked Robin.

"Tuck," offered Harald.

"It is no disguise! I *am* a monk! Mostly," Tuck protested.

Tom threw an apple core at Harald. "Tuck is here beside us, brainless!"

"Much," suggested Harald, unperturbed.

"Oh, not Much, he is much too young," Allan said.

"But a youth may learn much from an experienced woman," Robin said, "as I well know from experience."

"True, and much good it will do him when he fancies—"

"Much isn't here," Juniper interrupted.

They fell silent. Did he lie dead on Nottingham's field, or lie with a lover in the wood?

Robin frowned. "He would join the fight when I bade him not to."

"Perhaps even now he returns from Nottingham with some merchant's fat purse," Tuck said.

"Or some fat merchant's purse," said Tom, trying for a jest.

Tuck nodded. "With Will to help him find the way."

"Did anyone see Will fall?" Robin asked.

John said, "I thought he was behind us when we fled the field."

"Prim's monk was a tall man, a broad man," said Allan, to take their minds off Much and Will. "Now that I think on it, I didn't recognize his habit, his manner or his gait."

John stood hastily, dropping his cup and spilling the wine.

"Sit down, little John," Robin said. "Did she not go willingly?"

"Did she?" John demanded. He seized a burning branch from the fire for a torch and sprinted into the wood.

With a glance at Tom, Robin grabbed another brand, and the two friends hurried after John, to keep him from causing trouble, or perhaps to cause more with him if necessary. Perhaps some stranger had infiltrated their camp.

Balor bounded after Robin, eager for adventure. Soon the thickets rustled with darting wildlife, disturbed from sleep. A man and woman, limbs entwined, cursed with annoyance when they heard a heavily panting dog and saw faces hovering over them in torchlight, with a voice whispering, "Mother?"

"Go on out of here!" said a surly voice in reply.

"It isn't her."

"Come on, then."

"Agh! You kicked my shin!"

"Arse! You bumped into a tree stump!"

Balor barked.

"There he is!" John thrashed a blob in the darkness. "Ow! Look sharp! The bastard has a knife!"

"Ignoramus, that's a thornbush. Come on." Tom dragged John off into the wood, muttering, "If I'd drunk as much as you have this night, I'd have drowned."

Robin let them go bumbling off, and he and Balor ran a different route, following instinct. He thought he heard Prim's voice murmuring, a man chortling. He veered to his left, tripped over something knee-high and fell to the ground with a grunt. The leg that had tripped him shot out again and kicked him none too gently in the buttocks. Balor barked and growled. Booming laughter erupted from the glade, and then a broad-shouldered, black-bearded man in a Druid's hood was looming over Robin. "Ho, Robin! Merry meet!"

"Cal? By our Lord and—down, Balor!"

The mage helped his former student to his feet.

Prim peered out of the shrubs. "A little late in the night to be deer-hunting, isn't it, Robin?" she asked dryly.

"I—we—John thought you might be in trouble."

"Ha! I can't get the kind of trouble I want from Cal!"

"A fine contest today," Cal said to Robin, a strong scent of mead on his breath, "though I preferred the archery to the swordplay. I almost joined in the latter, but I was loath to steal any of your glory."

"You were at Nottingham?"

"All England was there! I heard there'd be an archery contest, and thought I might find you. And see my old friend Priscilla Nailor. But look at you. You've become nothing but a hedge-Witch."

"I do well enough."

"I thought you'd return to study the Way of the Wyrd with me."

"Other matters pressed upon me. We both knew my path might wander when I took the name Robin. Though in truth, I always thought it would wind back to you."

"Well, there are a few more turnings yet in this labyrinth. Who knows?"

"We'll leave it to the Lord and Lady. And I'll leave you to whatever mischief you two are brewing," Robin said, adding to Prim, "but beware your son John. He is not in a reasonable mood."

"Is he ever?" Prim said tartly, emerging from the thicket. "We'll go back with you. We've said our say to each other, and it's you we must speak with now."

"This sounds too solemn for my tastes. This night is for celebration. Can we not leave your tidings for tomorrow?" Robin asked as they made their way back through the ravine toward the great oak.

"It is already left too late, I fear," Cal said. "I was casting the runes, my practice at the waning moons, as you know. Yet I could not read the signs. They were crossed and strange. It troubled me, and I thought my eyes were failing me. I looked into the fire, no diviner's fire, but a simple cookfire, and I threw another branch upon it for warmth, and the burning twigs made curving lines of flame red-hot among the coals. I saw in them a woman's face, and her body, with wings like a gryphon, a lion's haunches and tail, three breasts and snakes for her hair. She is a woman's Goddess, an Eater of Men, and She has no mercy for those who do not solve Her riddles. My own heart was pounding. I tell you, I feared for my very life. But she showed me your face."

Robin's throat constricted. Did the Dark Goddess hunt him already? Right on the heels of his victory for her handmaiden? It could not be. Had he unwittingly betrayed his vows somehow? He forced himself to listen, to keep silence.

Cal said, "Your time is coming, Robin, for good or ill. I have heard you called Lord of the Greenwood, yet you are but Prince, not Lord. You will either summon your true power or die trying, I fear. I have come to warn you. You are in danger without the *wudu-maer* to reign beside you."

Fresh anger and grief smothered any fear of the Devourer. His voice was sharp. "I thank you for your warning, but my Maid is sworn elsewhere. And that is surely as the Lady wills, or it would not be so. What good is your foretelling to me, if your Oracle had no words of wisdom or counsel for me, or even comfort, for that I must ever leave the one I love to another's bed and board?" he added bitterly. Though Coucy was dead, Maerin was still not his to claim.

He forged ahead on the trail, both to light the way and master his anger. Cal watched after him astonished, and glanced at Prim, who herself seemed taken aback at Robin's ferocity.

Prim whispered to Cal, "It is Maerin fitz Warin. If ever I thought a man bewitched by woman! It is not Robin's nature to long for one woman only. He takes this or that serving maid or shepherdess to bed, with no promises made and so none broken, and how there isn't a gaggle of the God's children

running about looking a lot like Robin is a mystery to me, for few know how to prevent it."

"Perhaps his seed is not strong. That bodes ill."

"Well, and there are herbs for that too. Perhaps I must make him a special tonic. But this Maerin is another matter. From what little I saw of her, she would not be fit for this life, and besides, she held Robin in contempt. She has a tongue like an adder! Now he has killed her betrothed, for her sake, for she hated the match, and see how he risked his life for her, and all our safety as well! But he has the loyalty of the people. They'd follow him into the Underworld if he asked them, and not bother taking a penny for their fare!"

Cal chortled. "Why, Prim, from what you tell me, I should have thought this Maerin would meet with your approval. You are quite adder-tongued yourself."

"Bah! Any road, she may marry another or she may choose the cloister. She is Christian and convent-bred, of all things!" Prim shook her head.

"I wondered why he attacked the nobility today. I had thought he would simply hobble off with his winnings, and thumb his nose in secret at them. Then when he drew steel, I thought he would kill the Sheriff, his sworn enemy. But no, he let the man live. Now it becomes clear. He would not shed kin's blood. Perhaps he dreams of a handfasting with the Maid Maerin, for all he claims she is lost to him." Now it was Cal's turn to shake his head. "Why could he not have chosen a priestess of the old path for his *wudu-maer*?"

"And where would he find one? In the hollow hills?" Prim asked sarcastically.

"Indeed, and he should have come there, before ever he set eyes on Maerin fitz Warin. Do not think the hollow hills and the Mysteries of the Old Ones are closed to everyone, merely because you, Priscilla Nailor, with your simples and potions, do not know the Way in."

"Confound you, you trumped-up, overbearing wad of snobbery! What little you know of Women's Mysteries would fit in a thimble and room left over, and yet you dare to—"

"Nay, let us not revive old rivalries tonight. We must work together now, as we did when we were young."

"And foolish!"

"Aye, that we were. But think of Robin, and the greenwood. We must help him choose another Maid to rule with him. Though Lord and Lady know, lately we have not many young Druidesses with enough wisdom and

power to fulfill the role of Grove Maiden."

"And even if we did, is it he who truly does the choosing, or Goddess?"

"Goddess or not, it is poorly done!"

"Watch what you say!"

"Ah, Prim, don't try to frighten me! Do you think the Lady will punish me for criticizing Her? Perhaps She has nothing better to do, and the dryads in the trees have ears and will carry my blasphemy to Her! Do you think Our Lord and Lady care for such prattle, as if they were like the Christian's God, eavesdropping on poor humans and counting up their sins, naughty words and all?"

Prim gritted her teeth. She could not bear to admit he was right. "Old man, you try my patience!"

"Old woman, it is for that I was created!" He laughed.

When they caught up to Robin, Cal sobered and said, "I can offer this counsel only, friend: whatever the price, you must serve the Lady. You come not by your power without Her and you must not forget it."

"I know it well."

"Yes, but there are meanings within meanings. It is for you to decipher it for yourself, and find your own way. I cannot say for you, much as I'd like to, I assure you." He smiled, but sadly.

They came to the great oak. Beside it and the flickering fire, Allan sat singing his new ballad to himself, the moon and Juniper, who was curled up in a sheepskin with his cat, fast asleep. This picture of peace seemed too perfect to be disturbed, so the three mages watched in the shadows until the song of Robin's bravery was done.

<p style="text-align:center">⌘</p>

Maerin lay on her side in the darkness, hungry, cold and itching, for lice and fleas, lately living in rotting straw, were finding new homes in her hair and clothes. With her hands tied, she could not scratch, which minor annoyance drove her mad, while the cuts and bruises in her mouth, on her face and knees ached and burned. The stench in the dungeon was so strong, she gagged even breathing through her mouth instead of her nose. She tried in vain not to separate the complicated odor into its component parts of feces and urine, old and fresh blood, burned flesh, mildew, sharp fear and human sweat.

She did not know how long she lay there, hours or days. She thought she fainted and came to several times, for the time she lost did not feel like sleep, and her dreams were too real and yet confused, of Beck the hunchback's arrow finding its mark, John in his turban, Allan singing to a cutpurse and a dark-haired dancing girl, the silver arrow in Robin's fist scraping up Coucy's

cheek, drawing blood, and more blood staining Will's chain mail, and Coucy dead—dead, and she could not help but thank God for it!—and then Reginald towering over her, beating her until she woke with screams catching in her throat, trying to raise her arms to defend herself, unable to move.

Why had she not realized her arrow's markings would betray her? She had shot without thinking, to kill, and if Reginald had not been surging forward she would surely have hit his eye and pierced his brain. Why had she not gone hunting more of late, instead of relying on target practice? Well, because Reginald had not dared let her out of the castle. And because she had not planned on trying to kill anyone! If she had known, she could have killed Coucy herself and saved Robin the trouble!

But to kill a man was a mortal sin. She had never thought to do such a thing, though she had prayed God might do it for her. She was damned both for her thoughts and for her arrow's flight, and Robin too would surely go to Hell.

But were not warriors shriven before they went into battle? Robin was a holy Crusader. His killings had been blessed by the Pope. Whereas she was never Christ's soldier.

Would that she had been a better shot, since she was damned anyway for trying! If Reginald were dead, she would be free. Or would she? Had her arrow found its mark, would not Prince John have arrested her for killing Reginald?

Not if she had escaped, by God's eyes!

She realized with a shiver of fear that despite her ability to curse in several languages, this was the first time she had taken the Lord's name in vain.

Well, if God would strike her down for it, now would be a good time, she thought with unaccustomed cynicism. She had fallen low enough, it seemed, without the need for Him to strike her. Or perhaps He worked his will through Reginald. An unlikely candidate for the Hand of God!

Think of Job, she told herself. Have I suffered less than he and yet lost my faith?

At least Robin had escaped. Surely he would not surrender himself for her sake. He would know Reginald never meant to free her. And surely Reginald would come to crow at her as soon as Robin were caught. So the longer Reginald stayed away, the better.

She squirmed, trying to find a more comfortable position. It was no use. The straw was stale, the stone floor hard and cold, the stench noxious. She struggled to sit up, her stomach heaving and empty. When the dizziness

passed, she inched forward in the darkness, trying to ignore the offal around her, until she came to a solid wall. She shifted bit by bit until she could rub her bonds against the uneven stone and try to tear the gutstring and free her hands. And when her hands were free, then what?

Would her uncle truly have the audacity to kill her? Perhaps he would send her to a nunnery. That she could bear. Had she not at one time wanted it to be so?

But now … now there was Robin. To think she might live a lifetime never knowing his touch again, never knowing where his kisses might lead, never knowing his hard body pressed against hers, his tongue soft and wet and swirling between her lips, hot flame searing her thighs—yes, she was damned; the pyre burned inside her. But how could such ecstasy as she had felt in Robin's arms be called evil by the Church?

Better to be dead than in a nunnery!

Though not all nuns and priests took vows of celibacy. Some of them still married, though the Church frowned upon it. And rumors ran rampant that others found ways to satisfy the flesh despite their vows.

Oh, she did not know what to believe any longer. She only knew she would never want any lover but Robin.

At least he was free. She cherished that knowledge. But for how long? She had prayed with her whole heart and soul that he would stay away from the archery contest. The Virgin had not answered her prayers. Why pray to Her now?

Or did the Lady have some greater plan? It must be so. Had not one prayer been answered at last? Coucy was dead, and she was glad.

Yes, she was evil, and she would see him alongside the Devil in Hell. What torment that would be! How God would punish her. She should repent. But she was too honest. And she did not regret her love for Robin, did not regret her longing for his kisses and his hands upon her breast. She would not give him up, in heart or mind or soul, even if she never saw him again in the flesh. She was lustful as any harlot. She was doomed. But then, had she not felt in her heart that poor Dulcie was pardoned in the eyes of the Lady? And what of Mary Magdalene, whom Jesus Himself protected and called his Dearly Beloved? At the house of the Pharisee, did the sinner herself feel nothing when she anointed the Master's feet with oil and dried them with her hair? Was she so chaste that she did not long to kiss His feet, to feel Christ's kiss a blessing on her lips?

"Lady forgive me!" she wept. "I do not know the truth any longer!"

As the hours wore on, she kept losing the thread of her thoughts and

prayers and dipping into tortured dreams of convents and covens, of Beltane fires and burning at the stake, of flames eating her flesh and smoke spiralling into heaven, the essence of her body streaming into the sky, invisible as the veil between the worlds. She whimpered as she slept.

53-ROBIN BECOMES A BUTCHER
HUNTER'S MOON NEW, 1193

obin lay awake on his pallet, and though his eyes traced the path of the last moonbeams slowly sliding across the rough shelves and walls of his cave, all he saw was Maerin in his mind. He hardly felt the sting of his wounds.

She was barefoot in her bedchamber, her pale skin golden in hearthlight. Her turquoise eyes, so often flashing with defiance, were now downcast and dreamy. She dreamed of him. He could smell her fragrance, of rare amber or exotic myrrh—no, it would be rose, in honor of the Lady. She was combing out her long, luxurious hair before a polished silver mirror, and he wanted to take a curl of that lovely black silk in his hand and draw it to his lips. The dark tresses curled down her back and over her shoulders, over the white linen of the nightdress covering her bosom. He could see the rise and fall of her breath, and there was lace, lots of white Nottingham lace, and perhaps a blue ribbon, which he could untie … but first she raised her eyes, she saw him reflected in the mirror, and for once she did not argue with him, tease him, nor was she startled or fearful, but she turned and smiled in welcome. She stood and with graceful fingers, untied that ribbon for him. Her nightdress fell to her feet.

He must go to Nottingham. He must know she was well and happy, now that she was free. He might even catch sight of her. She would be riding to church on her fine black mare to offer thanks to her God for working through Robin the death of her fiancé.

But that wouldn't be like Maerin, he mused early the next morning as he shaved and smoothed away the stubble on his chin with a pumice stone. She would be too pious and modest to lay such a violent act, however merciful the result, at the Christian God's doorstep. She was naïve. She had never joined a Crusade.

He picked up a hazel twig and began scraping his teeth clean.

Herne the Hunter was the God she must thank. Yes, he would remind Maerin that Herne must have his due, and when Maerin asked what she owed, Robin would say, "A kiss, and you must give it to me, for His sake." She would bristle and argue and he would take her in his arms just the same, and—he laughed aloud and reached for the flask of water mixed with oil of clove, swishing some in his mouth to freshen his breath. He was gargling tunefully when Juniper walked in, dried leaves in his tousled hair from sleeping under the great oak, eyes bleary but content, his green-eyed cat tucked into his tunic, peering out of the folds with its pink and grey nose twitching. Juniper, too, smelled the scent of cloves, saw Robin's hair combed and his chin freshly shaved. "Go you to Snaith today, then, Robin? Can I go too? I want to see Will!" The outlaws had assumed Will had gone to be with his lady love after their triumphant battle at Nottingham. "I want to show Anne my kitten!"

Robin felt the blood drain from his face and his groin. He spat the mouthwash into the basin and felt as embarrassed as when he'd been a boy caught pilfering the pantry. Memories of rolling about the pantry floor in a bed of biscuits, tussling with the urchin Maerin had once been, made him blush, and his blush made him blush even more, because it had been so long since he had blushed at anything.

Had every lass he had known since then been only a shadow of Maerin, a search for her? He had not lain with another woman since Maerin had come to him in the woods to warn him away from the archery contest, since he had held her, kissed her, felt her soft and straining against him. "Run and get me a cup of tea from Prim, lad, if you will."

"Aye, Father."

Robin watched Juniper go with relief, then flung himself down on his pallet and contemplated his crude cave dwelling.

Cursed if he wasn't in love. He had caught the dread disease Allan suffered for Aelflin. His meditations were often but daydreams of Maerin, his night dreams were full of desire for her, his desires ran rampant and hot through him like molten metal, and formed a sweeter sword than any he had ever wielded. Sweeter but more cruel.

Not for Maerin a simple release of the body's needs, a playful tumble in a stable or slap-and-tickle in the fields, and then to forget it from one smile to the next. That would satisfy neither of them.

But neither could there be a handfasting between them in a sacred grove. He was an outlaw, she was a lady—and a Christian—and he could no more return to a nobleman's life than he could bring back the dead, let alone pray

beside her in a church and seek some celibate bishop's barren blessing on their union.

Maerin would never live with Robin in Sherwood, in a cave. He would never ask it of her.

Now that Coucy was in his grave, she would marry some other knight or noble. Robin had closed the door upon one evil only to open the window to another, at least in his view. Perhaps the next candidate for her dowry would not be so distasteful to her. She was a lusty wench for all her Christian modesty. The few kisses he had stolen from her proved that. She wouldn't want to go forever without a lover. But that lover would not be Robin.

And here he had bathed and scented himself like a knight in love, the while planning to disguise himself as a filthy palmer for whom Maerin would never even spare a glance but to give alms. His love had made him silly.

He rose and dressed in the clothes he had laid out: the belt for his sword, dagger and horn hidden underneath a coarse serge robe, much worn. He strapped on the dusty sandals. He smudged his face with dirt, darkened his brows with charcoal, made a tooth disappear through the judicious use of tar, and rifled his hands through the hair he had so carefully combed, until it was a righteous Witch-knot of tangles. He took up his oak staff and a palm branch from the south of England that would pass as a token from the Holy Land.

He would go to Nottingham only to hear the gossip that Maerin fared well, and to send her a message through the blacksmith that, go where she would or wherever she was bid, married or not, if she had need of him, she had only to send for him. Perhaps this was the meaning of Cal's message, that he should serve an earthly lady as well as a heavenly one, and be selfless in it.

Every inch the palmer, he made his solemn way down the cliff path, only to see Prim approaching, holding a steaming cup, and Juniper behind her. She held out the tisane. Robin sniffed at it and looked at her askance.

"It is but a tonic for you, Robin," she said.

"You drink it."

"It is not a woman's drink."

"From what I think I smell in it, I think I need the opposite."

"Indeed? I thought you were off to Snaith to do a bit of late autumn planting, and I haven't seen much harvest of your husbandry these months, unless you've kept it a secret from me. So drink up and do not waste it. The ingredients are not easy to come by."

Robin's grin turned to a look of astonishment. Then he laughed out-

right. "I have no need of your philters, Prim. I know when to store my seed and where to sow it, and when and where the ground is not ripe for it."

Juniper listened with a wrinkled brow. It seemed there was more to this conversation than farming, but he was not at all sure what it was.

Robin went on, "It is a Mystery I learned in the Holy Land, from a priestess of an ancient Goddess whose name is long forgotten. She is known only as the High One, as our own Brighid is called. Keep your tonic, Prim, or give it elsewhere. I go not to Snaith, but to Nottingham, to find word of Will."

"Will, is it? Or Maerin fitz Warin?"

His eyes darkened.

"You said yourself she is not for you," Prim pointed out.

He turned to go.

She declared, "You are wasting precious time! You must not go there, certainly not alone. It is far too dangerous."

"It is the last thing they'd expect. Besides, I am well-disguised, and I have the Lord as my companion." He waved his palm branch and started off again.

She called after him, "We will speak of Maerin fitz Warin when you return. As you say, you know where the ground is not ripe."

His back stiffened and he halted for a moment. Then he walked on without a reply.

Her hand on Juniper's shoulder, Prim stood watching Robin go, with more concern for him in her heart than her face or words had shown. With her free hand, she drew a swift pentagram in the air, a blessing upon his departing figure, then sighed. "I cannot interfere with his Fate. Or at least, I have failed in trying!" She turned a faint smile on Juniper. "Come, lad, you have not broken your fast yet this morning, I'll warrant, and I have a smidgen of green herb for your new four-legged friend. Know you how to grow catnip? 'An ye set, the cat will get; an ye sow, the cat won't know.'"

"Is Robin going to plant catnip then?"

"Wherever did you get that idea?"

"Robin's harvest, and storing seed. . . ."

Prim laughed and led him toward the cookfire. Here was another matter Robin must face on his return: the education of young Juniper in the ways of a man with a woman.

The morning was overcast, chilly and damp with threatening rain, which suited Robin's mood. His sandalled feet grew cold. He glumly changed the patterns of his breathing and picked up his pace, imagined walking on hot

coals, using his mind to warm his toes, a trick Cal had taught him.

He was on the Great North Road when he heard the rattling of wheels and the jingling of harness behind him. He turned, thinking to beg a ride. A wagon drawn by a sturdy nag creaked into view.

"Hold, Carter, I pray you, in the name of Our Lord," called Robin with an air of piety.

The burly driver drew up his horse and reached for his staff, which rode beside him in the cart like a stout soldier, in case of trouble.

"No need for that, my good man," said Robin. "I mean you no harm. I am but a palmer on my way to Nottingham, where it seems you must also be bound."

"A palmer, are ye?" the man answered distrustfully. "A likely tale."

Robin feigned surprise. "I have been in the Holy Land for seven long years. Has the Lord's greenwood fallen into wayward hands, then?"

"Terrible wayward," answered the driver, his pale blue eyes narrowing. "Many outlaws disguise themselves in these woods and set upon innocent travellers such as meself."

Robin crossed himself. "Lord have mercy on us. I but beg your charity, good Carter, to spare my weary wandering feet."

"I be no carter, but butcher," said the man. "I'm to market in Nottingham and the Sheriff's feast for the Guilds, and time's a-wastin'. But ye look an honest man. Ye may ride with me, for two are safer than one."

At mention of the Sheriff, Robin's spirits lifted. The poor would be crowding around the gate expecting their portion, and the Great Hall would be open to the merchants and guildsmen and women.

If he could bluff his way into that feast, he would surely see Maerin in the Great Hall. The Lady had blessed him, bringing this butcher across his path. "I've a mind to buy your wagon and wares instead, and trade my garb for yours. The thought of a feast sets my hungry mouth drooling, and I think I would rather be butcher than palmer today."

"Buy the wagon?" exclaimed the man, his suspicions returning in full force. It occurred to him that this palmer had called the forest 'the Lord's greenwood' and not the King's. He wondered what manner of man he had before him, or if indeed he were a man at all, and a thrill of excitement and fear went through him. "A right well-to-do palmer must ye be, then, if you're fer buying such goods all at one cluck," he said.

Robin thought quickly. "From the selling of relics, my good man."

"Runnin' a brisk trade, are ye?"

"Sprightly enough."

"Belike folks as haven't got a brain in their nobbin'll buy a boar's bristle and think it a bit of the Savior's beard."

"Plenty of folk like that in these parts."

"I'll wager there be more splinters of the True Cross in England than to build a whole town," the butcher said without cracking a smile.

"Indeed," nodded Robin, "and enough bits of the Savior's foreskin to build a cock the size of the Cerne Abbas giant's."

Amusement flickered in the butcher's eyes at mention of the Pagan God's magnificent member. "Well, one cannot put a price on faith, I suppose."

"You are as wise as a pilgrim, and suit the profession better than I."

"An I see some silver, perhaps we'll trade our trades for all that." By now the butcher was thinking on tales of men who happened upon a Faerie festival or market, or upon some pixie in a woodland Faerie-ring, and how if a mortal did not take what was offered and give what was asked, the Faeries would come at midnight for their pay, and it would not be in coin, but in souls. He thought it best to indulge this creature before him.

Robin pulled out a small purse. "Alas, you ask for silver and I have naught but gold."

The butcher said he was sure it would come out fairly in the end, so long as the palmer was content.

Having sold his goods at an amazing profit, the butcher, now dressed as a palmer, hustled back in the direction from which he had come without once looking over his shoulder, for so anyone who had met with a *puca* was advised to do. He hoped the precious purse of coins did not turn into dead leaves on the morrow, but he was one man who would leave bread on the hearth and a saucer of milk on the doorsill for the Faerie Folk that night.

And if it were real gold in the purse, he and his wife and children would never want for anything again.

Robin, wearing the voluminous smock and cloak of the butcher, climbed onto the wagon, twitched the reins and urged the nag on to Nottingham.

He drove through the open gate of the walled town, through the narrow twisting streets to the central square and set up his heavy butcher's block with a good view of the church on one hand and the high walls of the castle on the other.

The crowds were thick and no one took particular notice of him, for the market was already in full swing. There seemed to be more soldiers than usual about, well-armed, and a strange moodiness in the air. Robin watched people's faces closely for clues as to what was amiss, but on the surface, the

market appeared to be normal enough. Shouting children and barking dogs
barreled through the crowd. Pigs and chickens squealed and squawked amid
the chanting of the men and women as they cried their milk, butter and
eggs, their woolens and linens, bracelets and brooches, kettles and pots, apples
and turnips. Acrobats and mummers held passersby with their antics, and
begged for money, reciting,

> Ladies and gentle men, thus doth our story end,
> And now our money-box courteous we recommend.
> A pair of bright marks will do us no harm
> Copper or silver or gold an ye can.

Robin joined the clamor with a drawl, "Mutton fer a penny, chops fer a
ha'penny, bones fer a song! An ye have none, sassage fer kisses from pretty
lasses!"

A girl passed by with her basket, and noticing the young butcher, a
stranger to this town, and handsome enough beneath his scrubby smock and
cloak, she fluttered her eyelashes and said, "Is your sausage fresh-made?"

Robin shouted, "Aye, milady, it's fresh as I am." He winked. People
laughed and paused to listen. "Gi'en us a kiss, then, lassie, and ye'll get yer
sassage fer no more coin than a' that!"

Blushing but bold, the maid pursed her lips and kissed him squarely on
the mouth, then held out her hand. Three plump sausages he plopped into
her palm, saying, "Take care an' ye put 'em to good use, love!"

"Mayhap you've a mind to help 'er!" called someone.

She tossed her head. "Ye mun wait 'til the May to dance with the baker's
daughter!" Having thus taken care Robin would know exactly whose daughter she was and where to find her, she walked away from the delighted chortles
of the onlookers.

Robin shrugged and grinned. Not long ago he would have made sure to
find Nottingham's Baker Street, but this girl, pert as she was, paled beside
Maerin. "Mutton fer a penny, chops fer a ha'penny, bones fer a song! An ye
have none, sassage fer kisses from pretty lasses!"

With such silliness, Robin drew a crowd, and though he flirted with the
prettier girls, he would not deny any poor woman, however old or unpleasing to the eye, a bit of meat or stewbone to tide her over. He gave each crone
a peck on the cheek instead of demanding payment, and their eyes brightened from his kisses, with echoes of the young maidens they had once been.

"Only a fool would give away good meat," another butcher jeered. "Be

sure it is not dry sticks you are buying for bones, or dog turds instead of sausages!"

But an old woman said, "If they're Faerie gifts, perhaps they'll turn to gold in my kettle!"

Since Robin gave away as much as he sold, his stock was gone in no time, and since the town was crowded with visitors, every butcher soon sold well and left off begrudging people Robin's wares. He gave the nag a bucket of oats from the wagon and wandered over to the other butchers' stalls. He said his name was Jack, cooed over what good prices they got and what excellent meats they had, and declared himself amazed at how they managed it, as if it were some marvelous miracle of the saints.

The locals warmed to him in spite of themselves, thinking him something of a simpleton, but friendly enough and entertaining, so as noon approached, they invited him to walk with them to the castle for the feast. Along the way, they gossiped, and Robin, already established as a ladies' man as well as a buffoon, said, "Hast heard the daughter of the Sheriff be a pleasin' wench to look upon. Will her be at feast, thinkest thee?"

"Not daughter. Ward," said a taciturn mason.

A butcher said, "She be pleasing, but she'll not be feasting, I doubt. They've locked her in a cell, some say. My neighbor's wife heard it from the cobbler's son, who heard it from one of the spit-boys at the Triple Horseshoe, who got it direct from a squire of the castle." He nodded importantly.

Robin forced himself to keep walking. Maerin, in the dungeon? It could not be true. Surely a rumor retold so often would be embellished beyond belief. No doubt she pretended to be in mourning for Coucy and had locked herself in her chamber to pray. He swallowed hard and managed to ask with a steady voice, "Had she such a gabble o' suitors then, to be locked away fer her safety?"

"No suitors but a dead one," the butcher said. "They say she's a Witch and it's her evil eye what killed him."

"They lie!" said the landlord of the Triple Horseshoe. "She's a good maid, prayin' in church like every day was Sunday, and givin' alms like every peasant was the Christ Himself. It's Robin o' Wood what killed Coucy. Took the form of a black dog, with a sword in his teeth, they say!" He crossed himself. "And why he did it, well, that's women's tattle."

A carpenter said, "It's the Archer King has chosen his Maid. But now the Sheriff makes her ransom out to be Robin Wood's life. They'll hang him as a Witch an he comes forth."

The butcher spat into the sewage ditch beside the cobbled lane. "An he

comes forward or no, she'll burn. She's been accused."

"Not official," the mason said.

But the butcher shook his head and crossed himself. "She'll not walk out of that dungeon alive, unless it's to the stake or the gibbet, for many's the time I've seen it happen."

Listening to their prattle, Robin's body grew taut with worry and rising fury. This would explain the soldiers in the market today. But the Sheriff would not dare imprison Maerin! Why would he? She was his ward, and faultless as the sunshine to boot. Praise Goddess Robin had come to Nottingham to see Maerin safe!

Sir Reginald sat alone at the high table in the Great Hall, for neither Prince John nor the Bishop of York would bother with the lower classes, Coucy was dead and Maerin was in prison. The Sheriff glowered at the proceedings as if his mind were elsewhere, and Robin, so carefully disguised, might have danced on the table-top and gone unnoticed. Maerin's absence confirmed his worst fears, and the Sheriff, in greeting the Guilds, had not even made excuses for her, to say she had taken ill, perhaps, or was away, or in mourning.

The succulent dishes Robin ate were tasteless in his mouth. His mind raced. If Maerin were under lock and key, surely she would be in her bedchamber? Not for a young noblewoman the dungeon. But where was her chamber? Somewhere up the winding stairs. Could he slip away and free her, alone and unaided, not knowing precisely where she was? His knife to a guard's throat, and then what?

Disguise her.

How?

Carry her out on a Cross. His heart sickened, thinking of Juniper's mother. But Maerin was not accused a Witch. Was she?

If so, he would need Reginald's pardon for her. Else storm the castle, with siege towers, catapults, an army. Which he did not have. He must keep the Sheriff alive.

If only he could lure Reginald out of the castle, into Sherwood, onto his own land, in his own stronghold of the greenwood. His friends were tracking deer and other game there even now, and a blast of his horn might bring aid. The Sheriff at his mercy was a welcome image.

He was so lost in frustrating thought, he was taken off-guard when the Sheriff bellowed, "Tell us, then, Jack of Derby, how a butcher can give away sausages for kisses and still have meat for his own table!" The other butchers had been gossiping.

Robin cleared his throat, stood, ducked his head, twisted his cap in his hands, and embroidered a wandering tale having little to do with sausages. "Milord High Sheriff, I be but a poor villein never acted as vendor before. I fear I shall be the ruin of my betters. Yet they be ruined already, so what matter? You see, milord, my master hath died, an' his son be but nine summers an' canna hold the great estate now fallen to him. His fool of a guardian, beggin' yer pardon, sire, seeks to sell goods and herds and send the lad to cousins in Normandy, but betimes he sends his serfs and servants to do such tasks as they know not how. He made me butcher when I be but herdsman. He hath four hunnerd head o' horned and hoofed beasts, an' he vows he'll part wi' these an' the land for but four hunnerd marks! Lord bless us, 'tis ruin come upon us. An' what will become of me? But I scarce should trouble ye with such tales. I thank ye for yer charity and kindness, good milord Sheriff." He bobbed his head a few times, looking ever more the dunce.

Reginald's breathing grew shallow. Four hundred marks was a very low price. He desperately needed to increase his own estate. Rising taxes and the thousand trifles Prince John required to make life comfortable at Nottingham were sucking his coffers to the marrow. And now, with Coucy dead, his share of Maerin's dowry was lost to him. Unless he found her another husband. With the goods from this Derbyshire estate, he could meet John's demands and then some.

He was saved. Though perhaps not in a religious sense, he thought capriciously, and almost smiled. When the feast drew to a close, he retired to his study and sent for Jack of Derby. "I wish to see the estate of your young master."

"Ride wi' me now, milord, an ye will, an' I shall show thee! Thou'rt a savior to my master, and to me, milord Sheriff!"

"It is late in the day to set off for Derby," said Reginald. "We will go tomorrow."

Robin hastened to say the estate lay close to the border, and he knew a shortcut that would get them there by nightfall. "Yet perhaps he hath sold it already and there be no point to hurry."

Reginald hesitated only a moment, then called for Aelfric and ordered two hundred marks to be divided into eight purses holding twenty-five marks apiece. "This shall be down payment," Reginald said. He ordered horses to be saddled and a company of eight knights to ride with them. The moneybags were divided among them as a precaution against thieves, while two more soldiers followed behind with the butcher's wagon. Before an hour was out, Robin was guiding them into Sherwood.

Reginald grew tense as the trees crowded in above him, but he dismissed his anxieties one by one. Did he truly fear Robin Hood and his men? Robin could have killed him at the archery contest, but forebore to do so. Why? It mattered little the reason; the result was the same.

Besides, it was common knowledge that Robin's outlaws loved best the prey that bore a pelt of black, brown or white, of the Benedictine, Cistercian or Carmelite, not the mailed and helmeted, armed knight. Still, there were other less particular thieves in these woods. But his soldiers would be more than enough match for such men. He signalled his entourage to keep a sharp eye out for danger, a signal that was hardly necessary, for they were already as wary as rabbits in a farmwife's vegetable garden.

They came to a deer track crossing the road. Robin turned onto the track, saying it was the shortcut. The Sheriff sent the wagon on along the main road, with Robin's clear directions to the fictitious estate.

The men rode single file into the dense undergrowth and deepening darkness, winding into a part of the forest so primeval that Reginald wondered how any man knew of it. Autumn splendor still clung to many of the ancient oaks, though dry leaves fluttered down like dying butterflies and slithered beneath the horses' hooves. Branches and vines arched like a coil of serpents above their heads, and thickets of holly and other evergreens appeared almost black in the lowering light. The sky was leaden, growing ever darker with the coming of night, and the crimson and gold foliage began to fade into grey as the path twisted and turned and forked, leading past walls of briar bushes taller than a man on horseback, and black-barked blackthorn trees, jabbed together so impenetrably they blotted out what was left of the day, their sloes unripened among dagger-like thorns that could pierce a man's hand right through.

As they rode, Robin formulated his plan, and hummed an oddly alluring tune that seemed to lead in as many directions as the tenuous path.

Reginald regretted having only this half-wit to lead them. When at last they reached a small clearing, from which several almost invisible tracks led in different directions like the spokes of a misshapen wheel, he was alarmed when his guide paused and scratched his head as if thoroughly baffled.

"You have not lost the way?" Even at normal pitch, Reginald's voice boomed in the silence, startling them all.

"Nay, but where be th' horned beasts? This be where Master keeps 'em."

Reginald's face darkened. What lord kept cattle in the middle of a fortress of trees? This serf and the entire family he served seemed mad to him now, not merely dimwitted. Had he been brought here by a lunatic? Led

astray by some will-o'-the-wisp? The second thought unnerved him more than the first, for he trusted himself and his knights in a fight, but sorcery was beyond him. Every time he made a foray into the land of shadows, he regretted it. Yet even an ominous Tarot reading could be dismissed from the comfort of his castle hall, with a flagon of mulled wine beside him to chase off the rare chill of panic. Here in the woods, however, he was not in his element.

Had he been bewitched? By Jack? By Maerin? Had she been enchanted herself? Did the Devil seek to bind Reginald in retribution for imprisoning His handmaiden? Was this serf the Devil's apprentice? He almost expected Jack to turn into the Evil One right before his eyes, or to disappear in a cloud of sulphurous smoke, leaving Reginald and his knights to wander forever lost in Hell, or in Faerie, where there was neither night nor day.

Robin grinned at the Sheriff's obvious discomfort, then arched his head back to let loose three long and mournful cries. Then "hssht," he said, "the beasts, they come," his eyes gleaming, and after a moment came a rustling and clacking. Wind in the branches? Wild beasts or worse in the underbrush?

A steely hiss filled the air as Reginald and his men instinctively drew their swords. They cast their eyes about in the gloom, but saw no enemy. Then tree branches became the rack of a stag, dappled shadows became dark pools of eyes, fallen leaves stirred as if by the breath of snakes, and score upon score of deer daintily picked their way into the clearing, the red deer and the fallow, stag and buck, hind and doe and fawn, surrounding the soldiers, unnerving the horses. Among them were men, stalking the deer as noiselessly as owls night-gliding, and these men wore deerskins, antlers tied upon their heads, and their faces and limbs were smudged with dirt and ash, with stripes and spirals of brown and blue dye, and they were armed with longbows and arrows pointed at the soldiers' hearts, and at Sir Reginald's.

The soldiers held their breaths and crossed themselves as a doe went to Robin's side and licked his hand.

"Here are the fine horned beasts of my master, as I promised," said Robin, dispensing with his Derbyshire drawl, "for my master is Herne the Hunter, and these men are his gamekeepers. I confess I have lied to you, Sir Reginald. Four hundred marks is too little with which to buy his beasts or his woodland. In fact, I think he might be offended at such an offer. If you give your money to me, however, I may agree to lead you out of the wood again alive." His teeth flashed in a grin.

Reginald recognized his guide at last. "Loxley!"

"Reginald, old friend, I never thought you to be such an ass. Following poor addle-pated Jack into Sherwood." He clucked his tongue and shook his head. "Your greed will be your downfall."

At Robin's knee, a voice muttered, "Stop the jesting and let us get on with the robbing."

"Patience, little John. Sir Reginald has another treasure which interests me more than gold. I will be generous with you, Sheriff. Give me your money and the life of Maerin your ward, and you shall live to see the sun rise."

"Maerin! That she-devil!"

Robin smirked. "The pious churchmouse, become a she-devil? When did this occur? I'd like to have seen it!"

"And you are a fiend, like your father! Would that I had slit your throat the first day you showed yourself in my court. Your impudence deserved it and your heritage demanded it. I was too lenient."

"Have you imprisoned her?"

"What is Maerin to you, Robin of the Hood? Why did she save your life?"

"Did she?" Had Maerin confessed throwing herself into his arms the day he brought Gysborne's head to the Great Hall? Is that why Reginald had locked her up?

"My sword would have bitten your neck at the archery contest, but an arrow grazed my cheek and slowed me, Beck of Somerset, Jack of Derby, liar, deceiver, traitor, thief! Demon's get!" The Sheriff cursed until he ran out of epithets. "The arrow was hers."

"Then she saved my life twice!" Robin's face lit up. But just as quickly he sobered. "So you imprisoned her."

"Treason," Reginald acknowledged.

"A pox upon it!" grumbled John. "Next you'll be having us storm the castle for the girl."

"A shame she missed your heart, milord Sheriff," Robin said. "But you will not put her to death. Try it and your life is forfeit. I and my men will save her before the eyes of the whole town, and carry you into Sherwood for worse torture than you'd mete to a Witch. You'll be the laughingstock of England, and painfully dead besides. And do not think to do away with her in secret. The day I hear of her death, I will haunt you into your grave."

This threat chilled Reginald to the bone. Who knew what magic this moon-worshipper could perform? He choked out the words, "Why do you not kill me now? What is it you want? Your lands of Loxley? I can do nothing! They belong to the Church."

"I want only this, milord Sheriff: the moment you return to Nottingham, Maerin shall go free from prison and be restored to her rightful place. Your oath upon it."

The snuffling of animals and the shifting of their hooves in the dirt were the only sounds in the clearing. Robin drew his dagger out of his boot and turned it over and over in his hand, watching Sir Reginald, who seemed to be considering much when he had so little choice before him.

But at last the Sheriff said, "So be it," and began casting his money bags down among the deer.

54-CONFESSION
HUNTER'S MOON FULL, 1193

They brought her bread, white and fine and fresh from the oven, and the water was clean, far better treatment than most prisoners received. The guards untied her wrists so she could eat. She had grown used to darkness and the flickering torchlight blinded her until they took it away again. She drank the water, but when they opened the door to take away the tin tray, they saw the bread lay untouched except by rats, which scurried away at the creaking of the door and the coming of light.

The guards gave her a glance she could not read.

Let Reginald be shamed! She would not eat.

There was no chamberpot. She was forced to use a corner of her cell, strewing the filthy straw from the floor over the worst of it. In her exhaustion, she slept again. She woke to sticky wetness dripping down her thighs and a steady pulling sensation in her womb. Her moon-flow. She tore strips of cloth from her overtunic to use as rags, and tried to wash herself with the pitiful beaker of water when next they brought it.

She begged to see her maidservant Elgitha, begged for word to be sent to her, or to Prince John, who she wildly thought might have mercy on her, out of a sense of guilt if not honor. But the guards avoided her gaze and said nothing, as if Witchcraft were catching, like the plague, or as if she might give them the Evil Eye and cause their manhood to shrivel up.

She knew not whether it was day or night, or even if she had been accused officially of Witchcraft or simply forgotten by the world. She had never felt so alone, even when she had grown old enough to realize she had

been deprived of her mother, even when her father had died and she had been sent away to Fontevraud to live among strangers. Tears rolled down her cheeks at thought of the convent. This was what her beloved abbess had decreed to be Maerin's fate! How unholy! "Your place is in the world," the abbess had said. What place was there for a woman of honor anywhere in the world of men?

Her lips were dry and cracked. Her mind wandered with fear and grief, bitter anger, hunger and thirst, distracted by the scratching of rats and cockroaches in the straw, the interminable itching of her unwashed body and the wetness between her thighs.

The door opened once more to admit the Bishop of York. He was followed by a tonsured monk and a guard, who put a spluttering torch into an iron sconce on the wall. The flames cast light and ghoulish shadow upon her. She scrambled to her feet, touched her matted hair, conscious of her unseemly appearance, her torn, filthy, bloody clothing.

Was this the beginning of interrogation and torture?

The bishop turned up his nose at the smell. He looked like a young pig rooting for his mother's teat. He stretched out his hand, expecting Maerin to kiss his ring. Once an obedient daughter of the Church, Maerin automatically moved to do so, but then she remembered how this man had conspired against Robin, and against her, and she withdrew into herself.

The bishop's pebble eyes narrowed. "I see your soul rots already within your putrid flesh, wayward woman."

Maerin said nothing.

"Speak. Defend yourself, if you can."

"Against what shall I defend, milord Bishop?"

"You are accused of Witchcraft and Devil-worship."

"Both? How thorough."

The bishop's lips twisted. "Have a care, woman, with your brazen taunting. Your soul is in peril. The only way to salvation is through confession. Tell me of your coven in Sherwood Forest. Where is your meeting place? Is Robin Hood your Man in Black? Does he take the form of the Devil in your evil rites? Do you have carnal knowledge of Satan in the form of a black dog? Speak, woman! Where in your chamber do you hide the broom you use to fly to them?"

Maerin could not restrain a disbelieving laugh.

"You dare to laugh in the face of God?"

"Are you God, then, milord Bishop? I had imagined our Heavenly Father as somehow ... not quite so fond of roast duckling!"

"Whore of Babylon! Demon temptress! 'A harlot is a deep pit, an adventuress is a narrow well. She lies in wait like a robber and increases the faithless among men.'" He was quoting Scripture at her; she knew it chapter and verse. "'I myself will lift up your skirts over your face, and your shame will be seen. . . . Woe to you, O Jerusalem! How long will it be before you are made clean?'"

"Free me from this cell, allow me a bath and I will be clean."

In a voice thick with contempt, the bishop demanded, "Why did you save the life of the Witch Robin Hood? Did you not once swear you lay with him?" Then he shook his head, sighed and adopted a softer tone, as if he would reason with her. "The Bible tells us women are corrupt vessels of fleshly sin. You have been led astray by your lusts and by the weakness of your sex. You are more to be pitied than reviled. Give up your wickedness, my child. Confess, renounce evil, and the arms of the Church will embrace you."

Bitter tears sprang to Maerin's eyes. "I tried to give my life to the Church and was refused. If I heard aright, it was you who wrote to the Papal Legate in support of my uncle, you who made certain I was turned away from my vocation."

"Vocation? A Witch with a vocation for Holy Church?" The bishop's lips spread wide and his belly and chins shook with soundless, mirthless laughter.

"You have already sat in judgment of me, though that is God's place and no man's. You insist I am a Witch. I see there is nothing I can say to defend myself. Burn me or not, as you please. You will have my dowry either way. How convenient for you that your God sanctions your avarice."

"There! You have confessed!" The bishop raked his gaze toward the guard and the monk, who both looked as dumbfounded as Maerin. "You heard her say she is a Witch. You are witnesses. You will testify in court."

His aide nodded at once, but the guard trembled as he agreed, knowing if he refused to go along with the bishop's lie, he himself would likely be accused of Witchery himself. Inwardly he bemoaned his fate at being assigned to guard the former mistress of the castle that day.

The bishop turned to Maerin again, with a sorrowful frown. "Yes, your dowry will be ours, Maerin, though it saddens me to think it should be gained in this way." He commanded the guard, "See that she does not sleep from this moment onward. You will knock on the door every fifteen minutes, and if that fails, a slap in the face will wake her. And no food, only water."

"She has not eaten since she came here, Your Grace."

The bishop looked annoyed. What good was it to deprive her of food if she already deprived herself?

They left her the torch. For the first time she could study in detail the grim reality of her prison. She gazed at the torch flames. She could almost feel them already, the harsh hot lapping at her tender skin, burr-tongued hell-cats at a saucer of cream.

This had clearly been the formal accusation. Her words had been twisted and used against her. Now she was a confessed Witch, though she had confessed nothing. If she did not reveal more, of Robin, of whatever they wanted to hear, through starvation and lack of sleep, torture would be next, and then the horror of burning alive. Unless Reginald stuck to the letter of English law and was kind enough to hang her instead.

She shuddered and her throat seemed to close up until she could not breathe. She had heard some Witches smuggled pain-deadening potions to their imprisoned brethren. But Maerin knew no Witches. Only Robin and his people. Would he come to her at the last and save her from the stake? Would he free her, or somehow provide a merciful death?

She took some comfort in knowing she could not betray him, no matter how cruel the torture. He had blindfolded her when he took her to his hideout. The day had come when that simple act would save him.

Yet she had seen the camp itself. If tortured, would she describe the ravine, the sacred spring, the great oak? Would they somehow find the place? Robin, and all those men and women and children—would they die beside her on the gallows or the stake? God in Heaven, surely her uncle would not stoop to torture her! That was for peasants, old widows and Jews!

She hugged herself, gasping for breath as if the noose already hugged her neck, imagining the agonies of those she had been taught to think were beneath her. How many of them had sat in this same cell and cowered under the eyes of this same bishop? How many of them had been innocent of their supposed crimes, and how many times had truth been ignored to feed the bishop's pride and greed? What kind of God would give such a fiend His blessing and His power?

She could not believe the true Christ would sanction it.

But perhaps Christ had deserted her the night she rode the white stag, though she had not chosen this path. She had stumbled upon it. Why had the Elder Gods chosen her? She had not sought Them.

Hands shaking, she picked at the straw, gathered a few wisps together and plaited them mindlessly into a braid, then tore them apart and stared into the wavering shadows. But her fingers soon found their way back into

the straw, forcing it through her hands, twisting it into shapes, braiding, twining and tying, until she found she had fashioned a little hooded man, a poppet, the sight of which frightened her, for this was surely Witchcraft. But she whispered, "Robin," held it to her breast and wept.

55-THE MARRIAGE BED UNMADE

n his return to Nottingham, Reginald sent first for mulled wine and then for the Bishop of York.

"But she is condemned!" the outraged bishop objected, on hearing Reginald's plan. "I have begun the interrogations."

"By whose leave did you go to her? I did not command it!"

"Heresy is the province of the Church," the bishop said stiffly. "It is out of your hands. She has already confessed."

"God's eyes! You tortured her!"

"Not yet. She freely admitted her Witchery, and with the proper persuasion, she will reveal everything about the demon Robin Hood."

A spasm of fear ran down Reginald's spine. Had Maerin truly confessed? Had she blasphemed so far as to become a Witch? She had seemed so pious! He must find a holy amulet to protect him. He must send for an exorcist at once. He must—no, this was panic! He must not begin to believe his own lies. Maerin was no more a Witch than he was, and Robin Hood nothing but a cunning bandit.

He would proceed with his plan. Not that he cared a fig for a promise made to that wolf's-head, but having lost two hundred marks to the thief, he had to keep Maerin alive, or he would get nothing of her dowry. "Whom have you told of her confession?"

"There were witnesses."

"Witnesses can be silenced."

"I will not be silenced! I was writing my report to the Church when you summoned me."

"Burn the letter."

"You presume to command me?"

"You will do as I say."

"You ask me to lie to my superiors, before God? This is unspeakable! And as to the rest, the ties of kinship—"

"Lower your voice!" Reginald took a deep breath and added in a milder tone, "I have noticed, milord Bishop, that your morality continually bends to suit your purposes. Whence this sudden concern with falsehood? You regret the loss of Maerin's dowry, nothing more. But I have just lost two hundred marks. I must have her inheritance. Hear me, Bishop. If you do not support me in this, there are many truths I might reveal about you, that have gone unspoken for years."

The bishop's mouth dropped open. "I have conducted my life in service of the Church."

"Perhaps. And yet, you have not been so devoted to the law of the land."

"God's is the greater law!"

"I recall false accusations against certain landowners," Reginald went on. "In fact, was it not your own calumnies against his father that helped create our scourge and bane, Robin Hood?"

"You signed those documents!"

"Then we'll go to the gallows together!"

"You are moon-mad, and it is Robin Hood who has bewitched you!"

"Maerin was bewitched. So you will phrase your report. Now she recovers herself. The demon is exorcised. Her soul has been saved! Through God's grace and the guidance of the most holy Bishop of York. I myself will pen a letter praising you for saving my beloved ward. Perhaps at last you will receive the archbishopric you have coveted for so long."

The bishop contemplated his ally become adversary. He cleared his throat. "Your charity to your orphaned niece will be rewarded in Heaven."

Reginald almost smiled. "At dawn tomorrow, then." He called for the captain of the guard and ordered Maerin released from the dungeon.

When Anhold came for her, she was light-headed from lack of sleep and food, purged from hours of sobbing and prayer. She felt she held no more tears to cry, that she would never cry again. An ocean of anguish and fear had drained from her heart to reveal a secret island of peace in her soul. She almost regretted leaving the cell, as if movement would cause the sea of life to submerge that island once again.

For all she knew, she was being led to the stake or the gallows. She thought, "Thy will be done, my Lady," and focused on each step she took, the lifting and the setting down of the foot, heel to instep to toe, as often she had in walking meditation in the cloister at Nuneaton, sensing the bones and muscles inside the skin, the steady forward rhythm, then the increasing light, the changes in odors, the sounds of the courtyard, horses neighing and

hens squawking, servants calling to each other as they went about their chores. She had never realized how lovely those familiar sounds were. She was entranced by them.

She was brought before Reginald in the Great Hall.

Seated on his throne, he eyed her with revulsion. Dark circles under her eyes marred her pale skin, skanks of hair tangled and knotted and teeming with lice hung before her face, and she stank of dried blood, sweat and filth. Her uncle bade the guards escort her to her chamber. "Get one of the serving girls to clean her up." He spoke not a word to his niece.

So absorbed was he in his plotting, he never noticed the cupbearer lingering behind a pillar in the shadows, who now slipped away and carried his gossip to the kitchens along with his empty tray. When his duties were done for the night, he went to the Triple Horseshoe for a pint, a game of dice and a word with the town blacksmith.

So by Ogham signs and whispers, by messenger, rumor and dream, augury and premonition, the startling news was passed through the shire and into the heart of Sherwood.

By dawn, a crowd surged in front of the gate to the castle's outer bailey. "Hu! Hu! Hu! Hu!"

The shouting and pounding of drums reached Reginald's ears even before the urgent message from the guards at the gates could reach him. Dressing in haste, he strapped his sword belt around his hips while running down the spiral staircase.

Small uprisings in isolated villages were frequent and easily put down, but an army of caterwauling serfs at the gates was a different matter. If he trampled them all, who would work the fields? He could loose his soldiers on them to scare them off, but if they fought back, the soldiers might forget restraint and kill. Damn them all! He could not afford to lose them.

Catching sight of him through the iron bars of the gate, a grey-haired hag keened, "Set free the maid, Maerin!"

The mob took up the cry, "The maid! Maerin! The maid! Maerin!"

With Anhold standing beside him grim-faced, Reginald lifted his arms to call for quiet, shouting, "Hear me! She is free."

The clamor lessened slightly.

The blacksmith's wife Gerta called out, "Give her to us, then."

"I am to be her husband," the Sheriff replied.

This drew boos and hisses. "She is Robin's!" called someone far back and hidden by the crowd.

The people began shouting, "Robin! Robin! Robin of the Wood!"

Reginald ordered Anhold to have archers take up positions on the walls, thinking to send a warning volley over the people's heads.

Then a farmer warned, "If you take her to wife, milord Sheriff, begging your pardon, we'll plant nothing come spring, for it won't rise up."

A chorus of voices agreed. "'Tis baneful."

"It'll blight the crops."

Sir Reginald shouted, "I am liege lord in Nottinghamshire, by grace of the Plantagenets. I do not take orders from serfs and gutter-bloods."

"John Barleycorn'll not grow his beard without his lady to pull it!" called another voice.

The mob erupted into cheers and shouts, "Hu! Hu! Hu! Hu! Maerin the Maid! Robin the Good! Long live the Maiden of the Grove!"

These cries, muffled and unintelligible, reached Maerin in her chamber. The night before she had bathed, eaten, carefully combed and cut the tangles out of her matted hair, while a maidservant picked and washed the fleas and lice out. She asked for Elgitha and was told she was banished into Sherwood. Her sense of peace wavering, she hoped and prayed that Robin and his men might find Elgitha quickly. She could not bear to think what terrible things might befall her faithful servant. But she was too tired and baffled to waste energy wondering what Reginald had in store for herself. She sank into the clean bedding and felt vaguely guilty for enjoying so much pleasure in her uncle's house after she had believed herself ready to die. She slept.

Now, hearing the distant tumult, she ran to the door, tried it and found it locked. She dressed hastily, rebraiding her hair as the shouting grew louder. Was this some treachery to do with Prince John? Was it Richard, returned? Would it have any bearing on her state? She felt excitement, no fear. Even if it were a crowd gathering to watch her hang. She did not kneel before her altar, she lit no candles, murmured no prayers, but stood by the window feeling the light on her face, wondering if it would be for the last time.

She reached into a pocket of her overtunic and touched the straw poppet she had carried with her out of prison, hidden in the torn folds of her ruined clothes, knowing it was madness, for if it were found on her, it would be taken as proof that she was a Witch. But she could not bear to leave it behind. It was too much like Robin, like him and yet not at all like him. She could not tear it to shreds, for it would be like tearing him. Now, holding it, she both hoped he had come for her and that he had stayed as far away as the wood could keep him, safe and full of life.

A brisk rapping came at the door. It was unlocked, thrown open and

four soldiers marched in. Their sergeant said, "You are to come with us, milady."

"What is that shouting?"

The soldiers did not reply. She had little choice but to follow them. The din grew louder as they went down the winding stairs. From the courtyard came the tramping of booted feet, then men calling, "To arms! To arms!"

Her guards looked at each other with alarm.

"You, take her to the Great Hall," commanded the sergeant, drawing his sword. "Guard her well, or you'll know the noose! You and you, come with me." The three ran to join the battle, leaving the fourth soldier to take her to the hall.

Reginald opened the outer gates and set his knights on the mob, but the commoners had pitchforks, hoes and staves, and the smiths their best swords, and among them other swordsmen and archers blossomed as if by magic. Some fought their way through the gates into the inner bailey, followed by a roaring horde of serfs. Those who died were trampled underfoot as if they were planks of wood.

In the Great Hall, with the heavy oak doors shut, the sounds of fighting were muffled. Agitated, her sense of peace spiralling away between twin eddies of hope and fear, Maerin paced up and down in the pools of light cast by the candelabra and torches in sconces. Above, the arches of the gallery gaped black like the mouths of caves. Maerin's guard drew his sword and his eyes followed her every move. She wondered if she could trick him, or overpower him in some way? If only she had the wiliness of some women, she could pretend to charm him, beguile him, flatter and soften him. "Pray tell, good sir, what is your name?"

Before he could reply, the door was flung open. Shouts and screams and the clashing of swords grew briefly louder as Reginald strode in, with two knights escorting him. The Bishop of York followed. Maerin froze where she stood at the sight of him.

A canon bearing an altar cloth and other items entered next. Maerin recognized him from St. Mary's in the town, where she had gone many times to pray. Then came Aelfric, the steward, who shut the door behind them.

The bishop said coldly to Maerin, "A happy day, my child. You are saved."

She took a deep breath. She was not to die today. Yet Reginald gave her a look of pure venom.

"How beautiful you look, milady," the canon said. "What shall we use for an altar, milord?"

Reginald strode to the chess table and swept a mailed hand across it. The playing pieces clattered against the wall and fell, some broken, onto the rush-strewn floor.

"A gaming table! It is hardly seemly, milord," protested the canon, glancing anxiously at the bishop.

"Do it and shut up," said the Sheriff. The bishop nodded at the canon to proceed.

"Are we then to celebrate the mass?" asked Maerin, her voice trembling involuntarily.

The bishop's upper lip curled. "I doubt there is time for mass before the wedding."

Maerin's trembling turned to stone. "A wedding? Here? Now?"

"There, there, all brides feel skittish before their nuptials," clucked the canon.

"Brides!" She turned on her uncle. "Who then have you found to share my dowry with you? What slimy, evil-minded rot have you betrothed me to this time?"

The canon glanced nervously at Reginald, whose surly frown transformed into a thin, cruel smile.

Maerin stared at him in dismay. "You cannot mean—! You cannot mean to marry me! I—it's a travesty! A sin! You are my uncle!"

"Better to marry than to burn, isn't it, Maerin?" he replied.

Sickened, she whirled around to plead with the canon, saying the Church would abhor such a marriage, would annul it, but the canon spluttered, "There, there," and would not meet her eyes. Her words trailed away. He would not go against his superiors, no matter what his conscience might say. She turned away so they would not see the hated tears welling up in her eyes, tears she thought she had done with forever. She thought of running for the door, but they would not be merciful enough to kill her. They would only drag her back to the altar.

She would not lower herself to beg before the Bishop of York. To whom could she appeal, after the wedding? The Pope? Surely he would have the grace to annul a marriage that was so clearly sullied by such close family ties. But would she have the money to pay for such a favor? Her uncle would have her dowry. She would have nothing left of her own with which to bargain for her freedom.

Again, trapped. Each time the cage door opened she flew into another cage. Yes, in her meditations, she had been right: the only true freedom was Death. Yet if she chose it, that would be suicide, and a sin.

The canon set the chalice and a black leather-bound Bible upon the altar cloth, along with an ornate gold crucifix.

There had to be a way to delay this. The fighting outside seemed to be drawing closer. Perhaps her salvation lay there somehow. Maerin swallowed her seething distaste, went to the bishop and knelt before him. "Please, Your Grace, I beg you, in the name of Our Lady, if you will not forbid this marriage, will you not at least hear my confession before I am forced to wed my uncle? Do not let me go into this sinful union with other sins on my conscience."

"I have heard your confession," he replied starkly, "yesterday, in prison." He turned his back on her.

Reginald nodded at his knights. They surrounded Maerin.

<div align="center">⌘</div>

Three men ran from the cover of a stand of trees, across an open field. Over their mail, they wore scarlet mantles with crosses of blinding white sewn upon them. Knights Templar. The sight of them made the archers atop the castle walls quail. Most of their number had gone to defend the gate. Nonetheless, the few that were left bravely strove to shoot down the new attackers. One Templar held up a broad, heavy shield to cover the second, who halted to press his longbow. In a flash of grey goose feathers, one of the Sheriff's archers fell back screaming with the arrow in his neck.

The three reached the shelter of the wall. The third Templar held a long, heavy coil of coarse rope as thick as a man's fist. Fastened to one end was a massive three-pronged iron claw.

He breathed deep and hard, then stepped out from under his comrade's shield and swung the iron claw around and around his head, faster and faster, until up it flew, scaling the heights like a serpent. It clanked against a crenellation and fell back to earth. Three times the knight threw the claw, while his accomplices fought off the arrows from above. The third time, the rope topped the wall, the claw tightened against the stone, the Templar tested the rope and began to climb.

By now one lone archer was left alive above. He ran to the rope and began hacking at it with his sword, but the Templar swung over the wall and his scimitar sliced into the archer's gut before he could blow his horn and call for help.

<div align="center">⌘</div>

In the Great Hall, before the makeshift altar, Maerin was forced to her knees by a knight's heavy hand. His sword lingered near her neck. Reginald knelt beside her. Though Maerin refused to speak the vows, Reginald agreed to

them for her and the ceremony proceeded as if she weren't there. They were pronounced man and wife. So quickly was she wed that she scarcely believed it had happened. She rose woodenly as the bishop gave them his final acrimonious blessing. To her relief, Reginald made no move to kiss or embrace her, but grimly ordered his men to take her back to her chamber.

"So it is done," she said in a quavering voice. "My dowry is yours. I pray you give me leave to retire to Nuneaton."

"Pray all you like, bitch. You would be wise to cease asking favors of me, or you may find yourself in the dungeons again. And next time I will not be so gentle with you. Go and ready your marriage bed while I have done with the rabble outside."

Maerin's knees weakened. Of course he would bed her. He could lose the dowry if she could prove the marriage unconsummated. But she could never give herself to him, any more than to Coucy! It would be rape, legalized by the State, blessed by the Church. Numbly, she allowed the Sheriff's men to crowd her toward the door.

She heard a hissing sound, then three groans, and the soldiers slumped to the floor, arrows lodged in their hearts.

Reginald drew his sword, leaped forward, grabbed Maerin and yanked her behind a column just as a knight in a scarlet mantle, brandishing a scimitar and screaming, swooped down from the gallery on a rope.

The bishop and the canon fled behind the throne and cowered there, while the steward took cover under the cloth-draped chess table.

Still screaming, the Templar charged at Reginald. The Sheriff brought the blade of his sword to Maerin's throat. The Templar stopped in his tracks.

"Do we take him?" came a shout.

Maerin's eyes flickered upward. Two other Knights Templar stood in the shadowed gallery with arrows aimed at the Sheriff. But Maerin was his shield. The first Knight forbade them to shoot with a shake of his head.

"Tell him," Reginald growled in Maerin's ear.

"I—it is too late, Robin," Maerin said faintly.

"Is this how you honor your word to me, Sheriff?" accused Robin. "She was to go free."

"Indeed, she is free of the dungeon, and restored to her rightful place as lady of this castle, for now she is wed."

Robin was speechless for a long moment. Then he said with irony, "Not to one of these knights here, I hope." He gestured at the dead soldiers. "If so, forgive me for killing your husband as I killed your fiancé." Robin watched Maerin's face grow paler.

"She is mine now, Loxley. As you are."

Understanding flooded Robin's mind, and his limbs slackened as if the life were flowing out of him. "Is it so?"

Maerin nodded as much as she dared with a sword cooling her neck.

"Answer me this, then, milady. Did you wed him with a will, or against it?"

"With or against, she is mine," Reginald declared. "Drop your sword. The game is up. Surrender or she dies."

"How loving a husband you are."

"Once it was your blade held her so, Loxley. I should have known you would not be man enough to kill her. I am not so weak. I have wasted no sentiment upon her since the baggage was born. You escaped me the day you brought me Gysborne's head, but tell me, if you loved her, why did you let her go then?"

Robin said nothing, gazing into Maerin's eyes, thinking what an utter fool he had been.

Reginald gloated, "Now it's my sword will taste her blood, whether metal blade or flesh, across her throat or between her legs. You choose, Robin of the Druid's Hood!"

"How lightly you break your pledge to me. But I am not the one whose trust you have broken. You made a vow to the Horned One through me. Though you kill me and Maerin, Herne will not go lightly with you, in the end."

A stab of fear rushed through Reginald's body at mention of the Stag-God, but he said, "You should word your oaths more carefully. I have experience with the law. I kept to the letter of what I promised you."

Robin's mind reeled. He could not think exactly what he'd said to Reginald in the wood. Was he no better Witch than that, to be so careless with words of power and binding? "By my faith, a woman wed against her will is not wed at all. You may find Our Lady has other plans for your steel. She sometimes has an unpleasant way with men who behave to Her handmaidens so discourteously."

"Robin," Maerin whispered, and then her whisper turned to a pleading cry. "Stop this! Go! Leave me to my fate. Every time we seek to reweave it, we but twist the ends of it tighter. It was woven years ago. The abbess knew. Your Gods must know it too. Your death will not save me. Go free!"

Robin smiled and tossed his scimitar to the floor. He bowed his head. "Your servant, milady."

A gutteral moan escaped Maerin's throat.

"Let her go," Robin said.

"Bows and arrows down," commanded Reginald, unmoving.

Robin motioned to his men. Tuck and John dropped their bows and arrows over the gallery wall. Wood and bowstring hissed faintly in falling, and several arrows tumbled out of the sacks and littered the rush-covered floor.

"Daggers and swords," snapped the Sheriff. Tuck and John complied. Robin pulled his own dagger from its sheath and another from his boot and flung them down.

"On your knees, Wolf's-head."

Robin dropped easily to his knees.

"I would hear you beg for mercy."

Maerin was sure Robin would never lower himself so, and was stunned when Robin mouthed the word, "Mercy."

She groaned. All was lost.

"How many months I have waited! Too many times you have made a mockery of me! Mercy is it you crave, Wolf's-head?" Reginald's sword slashed forward and the tip grazed Robin's cheek. A line of blood pearled there.

"Mercy," said Robin, toneless, motionless.

"Mercy for a thieving traitor and a Witch? I'll give you mercy! I will flay your skin from your body while you live, you and your two henchmen, in full view of the townsfolk and in front of pretty Maerin as well. Your bodies will be crow-feed in the town square. That will stop the peasants raving at my gates." He lowered the sword to Robin's throat.

"Mercy," breathed Robin. His eyes were unblinking, unfocused.

Reginald released Maerin. She ran to Robin, knelt and threw her arms around him. He shoved her away, not conscious of his strength, only knowing she must stay far from him. She stumbled backwards, shocked at his sudden cruelty.

Reginald laughed. "He has no use for you now that you are my wife!"

Maerin couldn't bear to see Robin humiliated and weakened. And how it stung that he had pushed her away once again. But Mother of God, she was married! What could she expect from him? She clung to a nearby pillar as if to draw strength out of the stone, her eyes never leaving Robin's bleeding face.

Reginald called for his steward. "Bind him hand and foot."

"Aye, milord. With what, milord?"

"Damn you, find something, quick!" The tip of Reginald's sword still hovered at Robin's throat.

The canon ventured forth from his hiding place and offered the cord that tied his robe around his waist. But as Aelfric shuffled over to get it, there came from the shadows a low whimper, a keening that crescendoed into piteous howling, like a wolf crying in dark winter's night for his mate.

The call sent chills into Reginald's blood. "None of your Witchery!" he shouted, but Robin was silent, unmoving. High in the gallery, Tuck and John looked about as if seeking the source of the agonized cries.

The bishop came forward brandishing the crucifix from the altar as if Robin were a vampire and could thus be stayed, but still the wolf-cry echoed in the hall like the ringing of an awful bell. A wind rose up and made the torches flare and sputter. Their smoke stole through the air like the fingers of a Faerie-mist. Footsteps, light and scampering like mice—Reginald looked up wildly. Tuck and John had disappeared. He cursed. Then a clacking sound like teeth chattering with cold, and in the instant, Robin was gone, and the wolf-cry with it, and there was a stagnant silence.

A shadow darted across the corner of Reginald's eye. He whirled and saw an enormous black dog slinking between two columns in swirling shadows and smoke. "The Devil!" he cried, furious and frightened, and charged the shadow only to find nothing there.

The canon was paralyzed with terror. The steward fell to his knees. "Christ have mercy, it's a snake!" He dropped the cord meant to bind Robin and it seemed to wriggle into the straw like a live thing.

Seeing this evidence of the sorcery he had reviled and feared his whole life, the bishop's sweat-slimed hands wavered. He choked, dropped the crucifix, clutched at his chest and sank heavily to his knees beside it, his mouth opening and closing like a fish underwater.

The canon stammered Scripture in Latin and inched toward the altar, fumbling for the Bible in hopes it would protect him. The oak doors slammed. Reginald wheeled to face them. There was no one there.

Where was Maerin?

A wolf-cry erupted to Reginald's left. He spun around again. Robin leaped at him with a halo of fire above his head. Reginald cowered, then saw the end of a torch in Robin's fist. This was no Faerie Fire, but an earthly one. Reginald swung his sword and lopped the flaming head off the torch, but Robin's legs smashed into Reginald's chest. The Sheriff staggered backward, the breath knocked out of him.

Robin darted across the chamber for his scimitar, calling the secret names of the Horned One in a tumble of primeval poetry. He felt every hair on his body begin to stand on end, his bones and muscles and brain seemed to

revolve inside his skin, his legs shrank, his arms grew massive, his head was as big as the hall, and when he screamed again, every flame and stone in the castle screamed with him.

The doors burst open and a knight ran in yelling, "Milord, we are driving back the mob." Disconcerted, he hesitated, his eyes adjusting to the poor light, and then he made out Robin and Reginald stalking one another. The knight charged forward to defend his master.

Hidden behind a pillar, watching, Maerin scrabbled in the rushes for a dagger or a sword. Her fingers found a blade so sharp it stung, drawing her blood. She slid her hand to the hilt and saw it was a dagger: Robin's own, surely, with runes inscribed upon it. Blessed by magic. She kissed it and threw it at the knight's back. It lodged in his right arm. He groaned and pivoted, seeking through the wisping smoke for his hidden opponent.

Maerin huddled in the shadows, staining her skirt red with the knife-drawn blood of one hand, clutching her hooded poppet in the other. As the soldier came closer, John swooped down from the gallery on the rope. His feet rammed into the knight's back. The man fell to the floor with a grunt. John ripped the dagger out of the knight's arm and neatly sliced his throat with it.

Tuck retrieved the rope and swung down on it, praying, "May God forgive me," his eyes on the bishop. But the bishop, uttering choking sounds, his face purple and one arm dangling useless by his side, fell over in a heap of flesh, clearly dying.

Half-crouching, Robin and Reginald circled each other, spiralling slowly through the dim, shadowy center of the hall, until all at once, at the same moment, they swung, and their swords clashed, sparks flying.

Robin fought fiercely, spinning like a dervish, slicing the air with his scimitar, kicking and somersaulting over benches and tables and dead bodies, his movements quicker than a snake on a rat. But though Robin was faster and lighter, Reginald was bigger and stronger, and he drew his dagger, where Robin had none. Whenever the two foes came close enough together, the Sheriff slashed with his knife, tearing Robin's robe, screeching across the chain mail underneath, gashing open his left arm, gouging at his leg, giving him a dozen wounds, yet Robin was oblivious to them. He scooped up a soldier's fallen helmet from the floor and used that as something of a shield, but then Reginald struck so heavy a blow, it knocked Robin's scimitar from his hand.

The Sheriff lunged, but Robin dropped to all fours and threw himself against Reginald's legs, knocking him to the ground and sending the Sheriff's

blade end over end through the air to land with a clatter in his own wooden throne.

Fallen arrows crunched and splintered beneath them as the two men grappled with each other. Robin's right hand gripped Reginald's wrist, keeping the lethal dagger at bay. But Reginald's own right hand, with a massive grip, wrapped around Robin's throat.

Robin's eyes bulged, his face turned red, then purplish, his hold faltered.

"Robin!" Maerin screamed. She pressed the poppet to her breast and breathed deeply, wishing her lungs could fill Robin's with air.

Robin's arms slipped to the ground. Maerin screamed again, thinking it was his death, but Robin raised a hand, fumbled inside his mail shirt, and after an eternal moment, he drew out a leather thong. On it was tied a narrow gleaming thing like a frozen bolt of lightning. He plunged it into Reginald's right eye. The Sheriff howled as blood spurted out. Robin wrenched the leather thong from his neck, gasping hoarsely for air.

Reginald staggered to his feet, wailing, clutching at his head, his remaining good eye focusing painfully on golden feathers, silver shaft, the silver arrow from the tournament, with the golden point that meant his death.

Robin grabbed the Sheriff's leg and tripped him, then hunched over, panting. The Sheriff lay in the straw shuddering convulsively.

Robin crawled to his sword, gained his feet, stumbled haltingly back to the Sheriff, let out a yell so piercing it made Maerin's bones ache, and cut off the Sheriff's head. He grabbed it by the hair and charged toward the doors with his gory trophy as if he would carry it through the streets of Nottingham in triumph.

Tuck and Maerin both shouted Robin's name. He faltered and turned toward Tuck, his lips twitching. He threw the Sheriff's head down in a shower of blood and made for Tuck, raising his blade as if he would cut his friend down, as if he did not know him, but saw him for another enemy.

Horrified, Maerin shrank back along the stone wall toward the altar. She saw the chalice upon it, took it up and ran toward Robin, dashing the contents in his face. Robin veered toward Maerin, giving John a chance to grab him from behind shaking him, urgently saying his name while Robin struggled to break free, screaming and gasping, his teeth grinding, his muscles flexing uncontrollably, his spine vibrating. A shock of light blinded him; Tuck held a torch before his eyes. At last, Robin became aware of blood mingled with wine drying on his face. The knowledge of his enemy's death, his father's revenge, slowly sank into his heart.

He collapsed backward against John's chest, gasping raggedly.

Maerin forced herself to take a step toward Robin, fearing the terrible look in his eyes. He seemed unnatural, or supernatural, more frenzied beast than man. Yet she made herself put her hand upon his shoulder. He trembled beneath her touch.

"Robin," she said. "Milord."

A red fog seemed to lift from his eyes.

"Goddess," he whispered.

<p style="text-align:center">⌘</p>

Anhold and a dozen of the Sheriff's men marched into the Great Hall to report the retreat of the rebellious peasants. They halted at the entrance in dismay. Stuck in the throne was the Sheriff's sword. On the floor was the Sheriff's head, the silver arrow protruding from one eye. Dead bodies littered the hall in pools of congealing blood.

The canon and the steward crawled out from their hiding places, trembling and half-weeping with fear. "Robin of the Wood!" the steward whispered.

"Christ have mercy on us!" exclaimed one soldier, falling to his knees. The men crossed themselves.

56-tbe ϭaIϭeN aNϭ tbe UNICORN

p the winding stairs the four fugitives ran, for the kitchen off the Great Hall was packed with wounded soldiers, and led to a courtyard of fighting.

Across from her bedchamber, Maerin pulled back the tapestry and revealed the secret stairwell.

Bobbing light from their torches cast distorted shadow-shapes among the cobwebs. They hurried down to the roughhewn corridor above the castle brewery. The caverns were empty of workers due to the battle at the gates. They raced past barrels of ale and pungent brewing vats, out into the piercing daylight, to a copse of beeches not far from the town walls where disguises and horses had been left hidden for them. The men tore off the robes of Templars and quickly donned those of Benedictines.

Maerin did not ask to go with them. She simply swung herself up behind Robin. He dug his heels into the horse's flanks and they galloped to-

ward the wood at top speed, Tuck and John close behind them.

Maerin felt waves of feverish heat pulsing through Robin's body, for he was weakened by the eerie battle frenzy and loss of blood. It seemed his will alone drove him. The moment they were surrounded by the trees of Sherwood, he swayed and would have fallen from the horse if she had not held him fast. She cried out for help, his unconscious weight full upon her.

Tuck rode up and pulled him onto his own horse. Maerin swallowed her fear for him and they raced on through the wood to safety.

When next Robin's eyes flickered open, rough stone walls were whirling around him, partners in a dance without music or rhythm, slowly coming to a standstill. He breathed easier as objects settled into place. Rushlight illuminated his weapons, leaning in their places by the entrance, the shelf holding his cup and bowl, objects familiar and yet strange, as if he could not remember their purpose.

He felt cool liquid on his limbs. Prim was bathing his wounds with the healing waters from Brighid's Well, and a sourful look on her face as she did so. "Ah, good, you rejoin us," she said, "the worse for wear, as usual. Storming a castle with nothing but peasants and archers! Well, I suppose if you listened to reason you wouldn't be called 'Robin.' You'll be a moon and more in mending. Drink this." She shoved a cup to his lips.

"Thank you, Prim," he managed to croak after he drank the nasty brew.

She grunted and dipped lengths of white linen in a cauldron of steaming water. She began wrapping mullein in the cloth for a hot poultice. "And what will your fine lady do here in the greenwood? Fancy needlework stands us little good. I expect she can spin. I would have bid you seek another, trained to the Wiccan Way."

Robin was too tired to reply. Had Maerin truly ridden with him here? He dimly remembered her face in front of him, by the oak doors of Nottingham's Great Hall. Everything after was a blur.

Balor whimpered, gazing at him with a worried expression. His hand dropped off the pallet to fondle the dog's ears. He took a deep breath and forced out words that sapped his strength. "Maerin may do as she pleases. Perhaps she'll leave."

"I think not. I've seen how she looks at you. Like that dog."

"No. Like a Goddess."

"Oh, aye, the folk like to think her your *wudu-maer*, but even if she truly became such—if she were made of such stuff, which I doubt—"

"She found the hunt for us."

"One time. She chanced upon it. She understood nothing. Many people

have the Sight for an instant. Few have the talent or the stomach for developing it. Any road, she need not live here. She is not suited for it."

"I am suited for whatever the Lady wills," Maerin said quietly as she entered the cave. She shot a defiant look at Prim, and held out a steaming bowl of broth taken from the communal cookfire. Robin waved it away, but Prim insisted he eat it. Maerin's eyes met hers; they were in league on this point, at least. Yet Prim did not soften or smile, only looked away and busied herself with her poultices. Maerin offered to assist. Prim curtly bade her get more water as if she were a serving wench.

At Nottingham castle, even at Fontevraud, no peasant would have dared speak to her so, but after a moment's hesitation, Maerin took up the leather buckets on their yoke, swinging the wooden bar awkwardly over her shoulders. It was heavy and bit into her flesh, but she did not complain. She would not be a noblewoman here, but outlawed like the rest, and she must learn to play the part. So the old crone disliked her, Heaven knew why. So be it. She had suffered far worse from Reginald and Coucy.

The buckets dangling at either end of the yoke, she picked her way down the cliff path in the encroaching evening. A cool gust of wind sent a falling leaf drifting about her face like a butterfly's ghost. The sky was a lake of deepening blue. She breathed in the sweet, damp air, that seemed the sweeter because she was free, and all at once she felt she could fly, her heart was so light. She was free of Coucy, of her uncle, of the demands of her dowry and her noble birth, and Robin was alive and would recover, and she was with him. On the valley floor, she almost skipped toward the spring, feeling happy as a child for the first time in many years, and she threw down the buckets, flung her arms wide and spun in a circle, laughing. Tears came to her eyes as she thanked the Lady. Yes, her place *was* in the world. The abbess had been right. Yet the Lady had not denied Maerin's own heart either, but had brought her this Fate at last, to be with Robin. It was worth every trial she had borne along the way.

Dipping the buckets into the pool seemed a sacrament, for knowing the water was for her beloved. Carrying it was an offering. As she climbed up the path, the heavy weight and the strain in her muscles, even Prim's terse manner, seemed not burdens but blessings.

But when she entered the cave, Prim was shaking her head. "No, there is no word of Will."

Robin shut his eyes, his face grey.

Maerin dropped the buckets, spilling their contents. A shudder went through her, of guilt and pity. Ignoring Prim's disapproving scowl, she went

to Robin's side, but then she was afraid to touch him and only stood there, clenching her hands into fists. "Robin, Will Scarlet has fallen."

He opened his eyes.

"I was there. I—I could do nothing. He tried to save me. Reginald's pikemen … they came up behind him, as he fought my uncle. For my sake." She felt responsible for the outlaw's death, though she had not asked for Will's aid, had not struck the blow that killed him. "My uncle would have slain me then and there if not for him. He died bravely."

Robin groaned. His eyes narrowed as if the rushlight were too bright, as if seeing pained him. He closed his eyes again. "He was a boon companion." He felt his heart close around his grief like a heavy fist, even as he thanked his friend's spirit for saving his lady's life.

Maerin turned and picked up the water buckets, to make her way back to the spring. As she left, she heard Robin say, "Let Maerin bide with you tonight, Prim." He was so somber, neither woman would oppose him.

So Maerin spent the first of many uncomfortable nights on a pallet in Prim's cave, surrounded by herbs hanging upside down to dry, dark bottles of tinctures and oils, pouches of powders, baskets of more herbs, mortars, pestles and bowls, and from time to time, a stringy-looking cat, Juniper's stray, prowling amid the complicated odors, not deigning to be petted by the newcomer.

The morning dawned brilliant and clear, a counterpoint to the solemn procession that snaked along the ravine. Robin was carried in a litter, for he insisted on going, against Prim's wishes and counsel. Though they had no body to consign to the flames, a bonfire was lit. Robin stayed by it, wanting to speak, but unable to find the words to bid Will farewell.

Friar Tuck cleared his throat. "Will Scarlok. Known as Will Scarlet, for the color of his hair, for the color of his lady's love token, and for the way he blushed every time he looked at her." That last summoned a faint smile from one or two of the listeners. "Will Scarlok, God's grace be upon him, was a mercenary soldier, a runaway slave and betimes, a deserter. So you might think he was the lowest of men. But he was loyal to those deserving of it, that's it in the end. A stalwart warrior when the cause stirred his heart, and he never left the field while there was fighting to be done. He died with his sword in his hand as he would have wished. We'll meet again in the Apple Isle, Will Scarlok. *In nomine Patris et Fili et Spiritus Sancti*, and may the Lord and Lady guide your spirit."

The others murmured, "Will Scarlet."

"To Will."

"Lord and Lady bless his soul."

Several of the outlaws cast furtive glances Maerin's way. She thought they must blame her for Will's death. She prayed for patience and a forgiving heart, tried not to be hurt by their stares. It was natural; she was a stranger here, and of the nobility, the Sheriff's own niece, no less, the man responsible for much of their suffering. She could not expect them to trust her, let alone like her, at least not yet. Nonetheless, she stepped forward and cast a bouquet of scarlet autumn leaves and late-blooming Michaelmas daisies, asters and marigolds, orange and yellow, magenta and purple, into the fire. Then she turned and walked away to let Will's friends mourn his death in peace. And because she left, she did not see the approval in their eyes for her offering.

At length the flames subsided into smoldering logs and embers. Only then did Robin allow himself to be carried out of sight and hearing of the hissing coals. He lay back and closed his eyes, and it seemed in the days that followed that he healed more slowly for knowing his friend was gone from the earth.

"Someone must go to Anne," Tuck said as they broke their fast after the funeral.

"Anne?" Maerin asked. The name Will had whispered as he died.

"His lady."

"I was there when he died. I should be the one to tell her. But perhaps there is someone else whose lips she'd rather hear it from."

"I shall go. I am still Friar, and with Robin so badly wounded, it falls to me."

They made the journey under cover of night. Anne and her parents were in their main hall, a modest chamber kept cozy with hearthfire, sprigs of rosemary strewn among the fresh rushes on the floor, and bright tapestries worked by Anne, her mother and grandmother warming the walls.

Anne's father sent at once for mulled wine, but Anne saw the looks on Maerin's and Tuck's faces, and stood. "Is Will wounded? Is that why you've come? I'll go to him at once." She dropped her needlework. "What herbs does Prim lack?"

Maerin tried to speak and found she could not.

Anne inhaled sharply. "What is it? Tell me straight."

Tuck was blunt for her sake, but the words cut him. "Will is dead. I am sorry, mistress."

Anne's face went pale. She did not cry out or weep. She whispered, "It cannot be. I would have known." How could she have spent the day in pleasant pastimes, drying herbs, gathering fresh eggs from the henhouse, embroi-

dering a shift for her trousseau, when her lover lay dead? "I would look on his face. I'll not believe it otherwise."

"I regret that cannot be," Maerin said. "By now he is buried in a mass grave at Nottingham."

Anne's father, hating to see his daughter so stricken, sought to break the painful silence. "We heard there was trouble there, not two days' gone. Then we heard the Sheriff is dead, though some say that's a blessing."

"Hush," said his wife, "'tis the man's niece!" She guided her daughter to a bench.

"It was before that," Maerin said, "at the archery contest." Maerin forced herself to frame the words that told of Will's death. Again she felt guilt wrap around her like a shroud. "His last words were of you. He said your name, Anne. I make no myth of it for pity's sake. It's true," she finished, knowing it was small comfort.

The wine was brought, but Tuck and Maerin barely tasted it. Maerin felt too full of sorrow to swallow. As they threw on their cloaks, Anne rose and pointed at Maerin. "It is your fault. I know well enough how Robin has lost his heart to you. And his common sense! It was all done for your sake. You could have stopped them. Why didn't you? Why didn't you keep Robin from the archery contest? Will would have followed him anywhere, the fool! But he was meant for me! Will was meant for me!" Her voice broke into a wail.

"Come away, child. You must rest." Her mother put an arm around the girl's shoulders. To Maerin, she said, "Do not listen to her. She is out of her wits with grief."

Maerin nodded. Anne but spoke the words she had thought herself. She did not say how she had tried to keep Robin away from the tournament. Anne's grief might have been her own. It could have been Robin who lay dead.

She wished she had met Anne in better days. She might have been a kindred spirit and a rare friend. Perhaps, in time, it could still be so.

But word came some weeks later that Anne had left for Ireland, to study at some secret college for women there, and she had sworn never to marry. Prim scowled at the news. Anne had skills in herbcraft that would have served them well. Prim had even toyed with the thought that Anne might make a good match for Robin in time, now that Will was gone, if only Robin's heart weren't so set on the Christian girl.

Yet in that direction, things seemed to be developing slowly or not at all, which suited Prim as much as it surprised her.

The days passed, and Maerin waited for Robin to speak his heart and mind to her. When he said nothing, she made excuses for him, that he was not well, or that they were hardly ever alone. Then she worried he had changed his mind, that he had but sported with her in that ancient grove the day she had come to warn him about the archery contest. But if his flirting had been in jest, whyever would he risk his life and that of his friends to save her? To kill Reginald, of course. Oh, she could not begin to imagine what went on in that trickster's mind! She grew so annoyed with him she avoided him for days after.

Meanwhile, Robin convinced himself he should not press her. She was free at last to do as she willed. He must let her make up her own mind about it. He should watch to see how she fared through a winter in Sherwood. By January, she'd probably be begging for the convent! Besides, had he not killed her own uncle? Not that she seemed to regret it, to be sure, but kin was kin. If she had any living relatives, they would want blood-price and never let her stay with him.

He let her nurse him as much as Prim would allow, spoke of inconsequentials and waited for his strength to return. And the less they chose to say to each other, the more it seemed they could not speak, as if each word unspoken was a brick laid over the well of their desire for each other.

Maerin asked after Elgitha. None had seen her. Worried, she begged to go looking for her maidservant. John promised the men would search for her and ask after her, but the days darkened toward winter and no word came.

Heartsore at the loss, Maerin worked harder than ever she had in her life, even when doing penance at Fontevraud. But though she carried many a load of firewood and pail of water, and skinned many a red squirrel and tawny hare, she was soon banished from the cooking fires, for she had little talent for it. Prim shook her head and muttered to herself that if the girl could not marry the herbs in a stew, she would never be able to marry the herbs in a healing potion. And as for the Mysteries of the Wicca, well, likely the girl would never consent to learn them, let alone be able to master them. Not that Prim was offering, not until Robin demanded it, which so far, he had not.

Frustrated by Prim's unrelenting disregard, Robin's slow healing and her own awkwardness at chores she'd always left to farmwives and servants, Maerin asked to join the men on the hunt.

"A fine idea," Tuck said, having seen her struggles with Prim.

Tom spat on the ground. "No place for a woman."

Tuck objected, "Noblewomen often hunt."

"Aye, a-horse, not on foot, as we do. We're not nobility here."

Aelflin, hugely pregnant, coughed.

"Begging your pardon, mum," Tom ducked his head sheepishly at her.

Allan struck a chord on his dulcimer and sang, "'Oh, the maid she was a hunter, and she preyed upon men's hearts.' No, no, too obvious." He hummed to himself, oblivious to his surroundings in pursuit of a song.

Aelflin smiled and glanced at Maerin with a twinkle in her eyes. Maerin smiled back gratefully. She had two allies now, Tuck and Aelflin.

The next morning Maerin joined the ranks of the hunters with a bow and a sackful of arrows borrowed from Robin without his knowledge, for he might have tried to forbid her, in seeking to protect her.

Though she made no kill that first day, and the bow was that much too tall for her and hard to press, she stoically bore the men's silence, more difficult to bear than jeers and insults would have been, and within a fortnight, she rose to the challenge of a fast-moving target.

Before long, she was learning to fletch her own arrows, John helped her make her own bow, and more days than not, sunrise found her dressed in men's clothes for ease of running, with tightly braided hair stuffed under a hood, bounding through the woods with bow and arrow. Her childhood dreams realized, her muscles hardened, her hands roughened in spite of the leather gloves she wore, her eyes grew clear and her cheeks grew pink with good health. And though she kept her rosary by her always, and often murmured the old prayers, alone in the greenwood, she found herself giving voice to her heart, praising the Lady, thanking the trees for the nuts and fruits they bore and the animals they sheltered, thanking the brooks for their water, seeing altars in slabs of rock. The sky was the dome of the great chapel of the world, the earth itself was where she worshipped, and at times she fancied she heard the voice of the Lady responding to her in the breeze.

So passed the Hunter's Moon and the Cold Moon. Then Aelflin was brought to bed of a baby girl. For once, Prim did not begrudge Maerin's presence, for Aelflin's pelvis was narrow and the birth was hard. Maerin proved she was better with poultices and tisanes than stews and porridge, and even more skilled with a soothing touch. Aelflin, having gripped Maerin's hand so hard during the birth that she practically squeezed the bones out, became her fast friend, though the two were as different as peppers from oranges, Aelflin being fair-haired, delicate and demure, Maerin being dark, stubborn and often outspoken.

The Wolf Moon was near to full and the cold was bearing down hard on them when Robin left his cave on his own two feet and trudged down the

cliff to the communal cave for a meal. The venison in the outlaws' bowls that night Maerin's own arrows had brought them, and Tom jested that, nimble hunter as she was becoming, she should join them on their other exploits as well.

Between large bites of bread sopped in gravy, Tuck said, "Aye, your bright eyes would stand us well in spying out fat flies winging into our web."

"Righteous flies," joked John, thinking of bishops and monks.

Maerin frowned.

"By all means, learn each of our trades, Maerin," Robin said with mischief in his eyes. "Or do you keep a soft spot in your heart for the Church that forswore you?"

"I'll be a huntress, not a thief, thank you," said Maerin. "I'll not help you steal from the Church or anyone else. You should make your way by honest means or not at all."

"Honest means! Like those the bishop used to steal my father's lands?"

"Let it lie, Robin. The man is dead," warned Tuck.

"Guard against becoming that which you despise, Robin!" Maerin said.

Robin retorted, "I would rid the world of those whom I despise, who are truly despicable! And well you know how despicable they are, who would have hung you for a Witch just to take your dowry!"

Maerin reddened.

"And who do you think pays for your bread, my noble lady?"

She paused with a hunk of it halfway to her mouth.

"Or the turnips we roast in the fire? Or the goats that give us milk for our children? Pennies pay for such food, love, and if the greedy churchmen of whom you are so fond, and the law-makers of this land, continue to steal every penny from the people, as well as their souls, why, they'll be stolen back, if not by such as you, then by bolder folk, even by young Harald and Juniper!" At Robin's mention of the two boys, cheers and hoots of laughter went up, and the boys glowed with pride.

Maerin threw her bread down. "Then I'll not eat of it."

All eyes were on her. In the silence, Maerin picked up a strip of venison and daintily nibbled at it. From that night forward, no food passed between her lips that had not been hunted in the forest or traded for fairly in the town. The clothes she wore were deerhide the outlaws had tanned themselves, or linens honestly bought; no stolen silks or jewels would she touch. Unadorned by refined things, she looked wilder and more beautiful than ever, a ripening, reaching vine twining her sturdy place in the woodland. Whenever she and Robin talked of thievery again, there were hard words

spoken, for neither could sway the other, until they learned not to speak of such things for the sake of peace, adding it to the store of things left unsaid.

The Wolf Moon waned. One night Prim and Maerin sat on their pallets preparing for sleep. They did not speak. Prim braided her greying hair, fingers flying with years of practice and no vanity, and she was curled up in her wool blankets and starting to snore before Maerin had even set aside her comb.

Maerin sighed and wondered for the thousandth time how to make the old woman like her. She finished braiding her hair, poked the fire and added one last log, then crawled into her crude bed and lay there restless and fretful, staring at the choppy angles and curves Nature had carved in the cave's granite ceiling.

It had snowed that day, light, enormous flakes soft as a doe's breath. Then the flurries had turned into a real snowstorm, not the fierce, blinding kind, of which there had been plenty already this winter, but a gentle, steady flickering rain of white.

In a glen at the top of the ravine, Robin, foolishly chancing the reopening of his wounds, had been rolling in the falling snow with Balor, Juniper and the other children of the camp as if he himself were a ten-year-old. Maerin watched, hidden behind a hillock, fresh from the hunt with four rabbits in her pouch, and feeling as if she were again a child no longer allowed to play with the boys. Only the boy her eyes fixed upon now was much taller and older, the hard muscles of his thighs flexed visibly through the wool hosen he wore, his shoulders stretched beneath his grey wool tunic, his hood fell back and his dark hair flew tangling about his laughing face, and his blue-grey eyes were sparkling. He was so handsome he took her breath away, and she could not, would not, run to him.

It was not for her to court him. He should come to her! Why did he wait? He had said he loved her. But what would he know of courting? He was too long a brigand, a Pagan who took wenches in the fields. What could be expected of *courteoisie* here in this wilderness? And whom would he ask for her hand in marriage? Now there was a jest. Would he even wed her, or would he only want to bed her like the hundred other hussies he'd assuredly had?

Delighted screams interrupted her tense reverie. The children pounced on Robin in a gang and dragged him to the ground, stuffing snow down his tunic and tickling him. She eased away down the ravine and dumped her prey by the cooking fire, where Aelflin smiled winningly and Prim, of course, ignored her.

Now she lay on her pallet, with the night reaching its zenith, unable to sleep, as happened more and more frequently lately. She burrowed under the blankets, but the heat of her own breath made her think of Robin's breath in her ear, of his arms around her, and then of the words he had spoken to Prim, "Maerin may do as she pleases. Perhaps she'll leave." He had said nothing of wanting her to stay. Yet he never asked her to go, and she never broached the subject.

Well, tonight she would, by all that was holy! She threw off the covers, then halted, fearing to wake Prim, but the elder woman's breathing stayed deep and even. Maerin stripped out of her nightgown, threw on a wool undergown and bliaut, and a fur cloak against the cold.

She picked her way along one of the trails that led from Prim's cave. A faint golden glow bespoke a fire within the cave that was Robin's and Juniper's. As she drew closer, she heard voices: a man's low tones, then a woman's giggling.

Her body went hot and then cold, and her heart seemed to jump out of her chest. What a witling she was! She should have known Robin would already be taking his pleasure with some willing strumpet, as soon as his wounds would let him. She knew his reputation. For all that he had once said he loved Maerin, he had never promised to forsake his old ways. No doubt he spoke of love to every skirt that flounced by him. And here she was running to him, no better than a camp follower!

Thoroughly chagrinned, she was about to turn away when she heard the bell-like pluckings of a harp. Allan-a-dale's mellow voice began a love ballad, then a woman's voice lifted in untrained but easy harmony. Aelflin. Allan's wife, not Robin's. The woman who had become her friend.

Maerin leaned against the cliff and let the granite coldness and the silvery moonlight bathe and soothe her. Ashamed at her own longings and her distrust, she was about to retrace her steps, return to her bed and leave everything as it was, when Robin's voice called out over the music, "Why not enter, Maerin? It is warmer by the fire."

Balor sat on his haunches at her feet, as if he had appeared from nowhere. But it was a dark night, she told herself. The waning moon was just now rising over the ravine. Everything seemed ghostly. Still it unnerved her to see the animal staring up at her, this great beast that had chased her moons ago, and his name, Balor—the name of a demon, some folk said, or one of the Elder Gods, as Robin would have it—and his red tongue hanging out and his white jaws gaping in a caricature of a smile, as if he had spoken with Robin's voice. He licked his jaws and bounded inside the cave.

Maerin steeled herself and followed.

The moonlight streaming through the mouth of the cave mingled with the firelight like a silver ring set with amber. Maerin let the leather hanging fall back behind her, covering the cave's mouth. Smoke eddied up to a natural opening high in one of the walls. Robin was lounging on his pallet with a wolfish grin. The black dog was nowhere to be seen. Juniper sat by the blazing fire, refilling cups with dark red wine. Aelflin, singing and holding her sleeping babe, pushed out a wooden stool with her foot, for Maerin.

Maerin sat and loosened her cloak, for the cave was warm. She tried to listen to the song, but her head was spinning like wisps of smoke from the fire. She was nervous at coming here alone so late at night, embarrassed at what the others must think of her. Then the song was over. Allan and Aelflin made a show of yawning and invited Juniper to come away with them, saying they had a sweet for him, and all at once she was alone with Robin.

"I must be going as well," Maerin said, gathering her cloak about her.

"You've only just arrived."

"It is late."

"It is indeed. And yet I feel strangely wakeful." He grinned.

"You should be sleeping. You are still weak from your wounds."

"Nonsense."

"Shall I prepare you a tisane?"

"I have one." He raised his wine cup.

"Well, then." She rose and refastened the clasp of her cloak, then hesitated, a shiver of unease running through her. "Where is the dog?"

"Balor!" Robin called. The beast unfolded himself from a small recess in the wall where the shadows gathered and came trotting to Robin to have his ears scratched. "Shall I have him see you safely back to your bed?"

"I can find my own way."

"Why did you come?"

"I ... I was afraid you might have taken a chill today. Playing like a child in the snow," she admonished.

He laughed and his cheeks reddened at being discovered. "You sound like Prim! Why didn't you join us?"

She said stiffly, "I only came tonight to see how you fared."

"I fare as well as I might. As well as I fared at supper only a few hours ago, when you saw me." He grinned at her discomfiture. "But really, why did you come? To Sherwood? Why do you stay? It is no fit life for a lady, fetching water like a drudge, poaching voles. Oh, did I forget to mention that your hunting, which you do very well, I'm happy to see, is actually poaching? Do

not the deer belong to King Richard? You know the law, yet you steal from the crown every day. Why not go back to Nottingham and lead an honest life?"

Anger flashed into Maerin's eyes, at the truth of his words, at his taunting tone, at his apparent eagerness to be rid of her. "Very well, you have shamed me! Shall I rush back to Nottingham to let Prince John marry me off to buy the fealty of some earl or other? Is that the future you would have for me, Robin?"

"Would you rather take the veil?"

"Yes! I mean, no! I mean—oh, Robin, why did you not leave me there if you did not want me here?"

He chuckled. "Maerin, you are so highstrung you will snap the bow. Sit down beside me. Have some wine. What makes you think I want you to leave? You must do as you will." He lowered his eyes then, and added, "That is the whole of the law."

"If it harms none." She had heard this saying many times since coming to Brighid's Well.

"Yet I have harmed many, in spite of my vows," he said. "I killed Coucy. I killed your uncle. Perhaps I am forsworn."

"You saved me."

"I have the blood of your kin on my hands."

"Oh, does that trouble you? When did you develop a conscience?" she mocked. He shot her a harsh glance. The look on her face softened immediately and she regretted her teasing tone. "I'm sorry, Robin. You were ever more to me than Sir Reginald was. Or any man since my father died."

Their eyes held.

He reached for the wine and poured her some. She drew the stool closer to him and sat down. They toasted each other's health, and she drank hers off somewhat more quickly than was her habit.

He took her empty cup and set it aside, then reached out and loosened the clasp of her cloak, pushing the folds open slightly. "Are you not warm?" He let his fingers drift up to her forehead. "Yes, your skin feels warm. You have not caught a fever yourself, spying on me in the snow? Or is it the fire burns too hot?" He brushed a stray hair from her face. "Shall I douse it for you?"

She slapped at his hand and said, "Oh, Robin, stop teasing me!"

He let his hand drop to his side, but he smiled rakishly.

She stood, but she did not make for the cave's mouth. Instead she shook off her cloak, letting it fall to the ground. Robin watched in amazement as

she drew off her bliaut, then her undertunic. He could not take his eyes off her, dared not move for thinking she might dart away like a wild creature.

With shaking hands she unlaced and drew off her undergarments until she stood naked before him. The firelight played across her body, strong-limbed yet ripely rounded. She let him gaze at her, though she was nervous. No man had seen her naked in her life since she was a babe. The stark admiration in his glance quickened her blood. She shivered, whether from the chill air or desire, she knew not. She went to him, bent over him and kissed him full sweetly on the mouth. It was like snow melting on the tongue.

He reached up and drew her down on top of him. He felt her shivering and pulled a fur blanket over her, covering her nakedness, marvelling at her shyness changing to boldness and back again. Changeable as the moon, he mused. He cradled her in his arms, kissing her hair, stroking the smooth skin of her cheek, murmuring soothing words, until she raised her head and looked at him. His lips found hers.

Logs snapped in the fire. Maerin thought they sounded very far away, while the heat was so close it was inside her.

Robin explored her mouth with his tongue. He tasted of wine and some other sweetness. He gently bit her lower lip and then licked her upper lip as if he found drops of honey there. Then he leaned back and said, "You are the most beautiful woman I have ever known."

Perhaps he said this to every woman he touched. Perhaps nonetheless in this moment it was true. She could not think. She wanted to believe him. Then she did not care. The throbbing and wetness between her thighs was almost painful, and through his clothes, she felt his hips, hard, and the stiff wand between his legs pressing against her. She felt his heart pounding in unison with her own.

He unlaced his tunic and pulled it over his head. His back and chest no longer boasted the smooth boyishness she remembered from their child-hood. His skin was marked here and there with faint scars, souvenirs of battles. She couldn't bear to think of him suffering. She traced the pale ridges and he gasped, for at her gentle touch, pains he had thought long since mended and gone seemed to lift freshly from him.

The hairs on his chest were coarse and curling. When she drew her fingers across his nipples, they grew taut, and he pressed her fingers harder against them, watching her eyes widen with surprise as she discovered his pleasure. He lifted her hand to his lips, kissed her palms, her wrist, her arm, her breasts. Waves of pleasure rose in her, washing her with warmth and salt sweat.

In between kisses, they both began fumbling with his remaining clothes, their urgency foiling them until they giggled. But when at last he was naked, he saw hesitation in her eyes.

He said, "Proof that the unicorn is no mythic beast! And you are the maiden that draws me to lay my horned head in your lap." She smiled, but she was trembling again. He said, "My love for you is sacred. I will not hurt you. Do not be afraid."

"But it always hurts, so it is said, for a woman. Especially the first time."

"It need not be so." He closed his eyes and saw again the walls hung with colorful carpets, smelled dry desert air scented with oil from flickering brass lamps, smelled and tasted and felt the oiled and perfumed skin of the dark-eyed priestess who taught him, with foreign words, gestures and cries of pleasure, how to make of his own body an offering to the Goddess. Now, truly in love for the first time, he realized how precious a gift that priestess had given him, for he could give the same gift to his beloved. He said, "I am no ignorant youth, lusting only after my own release. And I love you."

She buried her face in his chest. The scent of him filled her. She was shameless! They were not even wed! But she could not resist him. Her shoulders rose and fell with the quick breath of her desire and doubt.

He gently kissed her eyelids and eyebrows until she began to relax again. His light, slow caresses soothed her, then his touch grew more insistent and sensual. She arched against him. He slid his hand between her legs, stroking her in ever-changing swirls and spirals, her juices flowing into his palm like a libation. She moaned and hoarsely called his name. He kissed her soft belly, down to the froth of hair below, and flicked his tongue back and forth among the folds of flesh, light as a butterfly's wing in the nectar. She gasped in astonishment. She had not known men did this. She had not known there could be so much ecstasy in a touch.

He looked into her eyes, reached up and cupped her breast. Firelight shot up through her womb and spun into her heart, bright and hot as the sun.

⌘

Prim woke just before dawn and realized the rustling that had roused her was Maerin taking off her clothes and climbing into the furs on her pallet.

So, thought Prim, they have coupled at last. She had wondered if they would ever get around to it. Still, they should have waited for a more propitious time, for was Maerin not virgin when she went to him? They could have harnessed that power. But what could one expect from a girl convent-raised? Robin, however, should have had more sense. He could have settled

his urges with any lass, and waited for a better time with Maerin. Then again, he had not dallied with anyone since Maerin came to Brighid's Well. Of course, he'd been wounded. Now he was healed and up to his old tricks. Well, if he could not bide until Beltane, at the very least he could have wakened her womanhood at Imbolc, when the womb of the moon lay ripe and waiting, and Gods above and below, not in the dark half of the year and a waning Wolf Moon to boot! It boded ill, for him and for the greenwood.

Prim scowled in the darkness. She had the niggling thought that her forebodings were but the muddy daub over the woven wattle. Sturdy enough, and true enough, to be sure, but not the main structure. Why did she resent Maerin so much? Was it sharing her cave at Robin's behest instead of her own preference? She liked her solitude, and soon she would demand it back. Or was it that his moon-calf infatuation for the girl had led him into dire danger more than once? Ah, but Robin was born to danger the way an otter was born to water.

How distasteful to pluck the lid from her own basket and see the apple spoiling within: she was jealous, that was it. Not jealous of the Maid's youth and beauty, like some petty aging crone longing for younger days and past pleasures. She was not even jealous of the love Robin bore for the girl, as an overanxious mother fears the loss of her child. It was only that no one was good enough for her Robin—no one but a shape-shifted wraith formed of the spirit of a she-owl that she herself could draw down from the Moon!

There, that was rotten enough: Robin had chosen Maerin himself. Rather, the Lord and the Lady had chosen them for each other, and Prim the Busy-Witch had had naught to do with it, and that worried at her hide like a prickly thistle. Why, one might even think the Wheel of the Year might be able to turn without her! She almost snorted out loud with disdain for herself, and rolled over to go back to sleep. But her last waking thought was, "Still, they should have waited for a better tiding."

⌘

The Wolf Moon waned into the new Snow Moon, the one the Druids called the Willow Moon, the time of healing and easing of change. The snowdrifts grew too deep for hunting, even for robbery. Day after day, the sky was a heavy ash-grey, the ravine was a chalice of snow, and the outlaws stayed in their caves before their fires, sewing hides together, repairing weapons, telling stories, playing backgammon and chess, spinning and weaving and making love.

By now Maerin lived openly with Robin, and Juniper came to be like a stepson or nephew to her, so when he developed a sniffle and a cough, she

could no longer put off a visit to Prim, a visit she had been thinking uncomfortably she should make for some time anyway.

A fresh batch of cough syrup bubbled over the fire. The sweet, sharp smells of rosemary and sweet cicely, rue and honey assailed her. While Prim filled a precious flask of her brew, Maerin ventured past the elder's grouchiness, which fortunately had lessened somewhat lately. She pointed at some hanging roots. "What are these?"

"Water lily roots."

"And this?"

"Foxglove."

"I've heard of that."

"For when the heart clenches, like a fist."

Maerin nodded. "And you have the bark of the white willow, of course. What's in here?" She prodded the top of a small covered basket.

"Damiana." Off Maerin's questioning look, Prim added, "A tonic for nerves. And for sex."

Maerin blushed. "I see. And this over here—this is broom, isn't it?"

"Cleanses and strengthens the blood. Makes a poultice for broken bones."

"And carries you all to the greenwood grove for the Sabbat." Maerin tested a jest.

Prim smiled tersely.

Maerin took the flask of cough syrup. "I have need of your advice."

"Pregnant already?" So now the lass came to it, the real reason for her loitering about.

Maerin blushed the color of ripe strawberries. "No, we haven't ... I mean, I ... " She didn't want to discuss what she and Robin did in their lovemaking, and why a child would not be made of it.

"Well, speak up. Do you want to be rid of it or keep it hale and strong?" Prim asked.

"No, it's ... I mean, I ... Robin says we had best wait 'til Beltane."

Prim's brow furrowed. "You say you are still virgin? You lie with him and yet ... Lord and Lady! He is not such a fool for you as I thought! Do you lie with a sword between you?" This last was said half in jest.

Maerin flared, "Why is my maidenhead ever a topic for other people's gossip and designs?"

"Because, my fine lady, there is power in it! Of course men try to claim it, own it, buy it, sell it, while the Church sets a great store by guarding it, leashing its might, for they are afraid of a woman's strength, else they would not forbid women so many things. But a maiden's power is not for men

alone, or even for herself, but for Goddess, for the land, the sun, the sky and the sea. Oh, well done, Robin!" Prim actually beamed at Maerin. "Well, what is it, girl? You are edgy as a spider fallen in water. Speak up."

"It's this." Maerin thrust a hand into her pocket and pulled out her straw poppet.

"The Hooded Man!" Prim gasped, fearing danger to Robin. "Where did you find it?" she snapped.

"I made it."

"What?! To what purpose?"

"I ... I don't know. I only ... I was in the dungeon, accused of Witch-craft, and I made it, or, rather, it seemed to make itself in my hands. And I could not part with it. And then, as they fought, later—Robin and my uncle—I held it, and then, he was close to death—by Our Lady, my uncle was chok-ing the life out of him! I held the poppet and I wished I could breathe into him ... and then he ... " She shuddered, remembering the ghastly sight of the silver arrow in Reginald's eye. "In truth, I don't know why I feel ... I feel its purpose has been served and I don't know what to do with it, or what it has done, or what I have done, but I can't bring myself to throw it in a fire, or take it apart."

"Lord and Lady, no! We must be done with it, but properly."

"Then you will show me what to do?"

Prim gave Maerin a cool, piercing look. "Do you not prefer to keep your hands unsullied with Witchcraft, for all that you have unwittingly toyed with it? I will dispense with it for you and all will be well." She held out her hand imperiously.

"No. It is I who made it. It wouldn't be right. I feel I must do it myself." Maerin felt abashed, for she did not know why she felt as she did.

"You feel you must do it yourself." Prim repeated, crossing her arms. This girl kept surprising her. "Do you truly wish to do this thing, to learn of the old ways? For that is to serve the Elder Gods and Goddesses, and it will not stop with one poppet, once you place a foot on this path a-purpose. Ah, you can walk away, to be sure, but it might follow you!" She gave a sudden cackle like a churchman's worst nightmare of a hag. "Do you know what you say, if you say you will it?"

A tingling ran through Maerin's body. This path was the road to Hell, or so the Church proclaimed. Yet clearly those who practiced the old ways did not worship the Devil. How could the Church be so full of good and yet so wrong about some things? Fontevraud had denied her. The Pope himself had seen her turned out of Nuneaton. Here was a religion that would wel-

come her, and she need not give up her lover for it, or be forced to wed against her will, or be a pawn in anyone's play for money or power, or sheer egotism, or greed.

As if reading her mind, Prim said, "You could become a true consort of Robin, and he yours, if you both will it. But though the rewards and joy of it are great, this is not an easy path, nor even a safe one, in these times. Do you know what you will if you choose it? Do you dare?"

Clasping the poppet, Maerin took a deep breath and said, "I do."

⌘

At the dark of the moon, before the new crescent would appear in the next twilight's sky, three women climbed the path out of the ravine and walked northward under a canopy of bare branches and starlight.

At midnight they stopped. Prim watched and listened as Maerin spoke certain words and drew certain designs upon the air, as Prim had taught her. Then the Crone held up an ancient pick made of a stag's antlers, and Aelflin, the Mother, blessed it and gave it to the Maid Maerin, who knelt and brushed away the snow with her bare hands, dug a hole with the antler pick and buried the Hooded Man with herbs and protective prayers in the safe belly of the earth.

57-Oꞅ a TRICKSTER aNÒ a TRICKSTRESS
wILLOw ꟽOON waNING, 1193

Frozen streams flowed again but icily, the snows melted in the open lowlands, and the first cowslips braved the morning frosts in hopes of blooming, but deep in Sherwood, snow lingered longer under the protection of the trees. Still, the air tasted faintly of spring. That taste, and the knowledge that the roads would be more travelled, wakened the outlaws from their winter hibernation.

One chilly dawn, as great billowing purplish clouds scudded across the crown of the rising sun, Robin and his friends bundled themselves into the white robes of Carmelite monks, which made a lovely camouflage against the snow, and set off along the path that led out of the ravine.

Without even bidding Robin good-bye, Maerin went hunting in another direction. She knew he would be thieving this day, as surely as the bees stole the nectar of blossoms in May. Yet a bee made honey from his plunder,

she thought irritably, and what did Robin make?

Her surly mood lightened as she wandered southward, closer to Derby than Nottingham, and away from the Great North Road where Robin and his men were no doubt pouncing on their first two-legged victims of the season.

She spent the morning luring squirrels to her slingshot, a weapon she was just beginning to master. After saying thanks to the Lord and Lady for their lives, their meat and their pelts, she tied them to her belt, climbed a comfortable oak that overlooked a bend in a track leading to Derby's main road, and pulled from a pouch a hunk of goat cheese and two small apples, their ruddy skins puckered slightly with dryness this long time since the fall harvest. A meagre enough meal, but freedom and hunger made it a feast.

As she ate, she listened contentedly to the wind stirring the creaking branches above her. Her eyes swept the sky. She saw a clump of young mistletoe clinging to the oak, and marked it in her mind for harvest at the right time of year, for mistletoe on oak was the rarest and most sacred, or so Prim and Robin said.

She was perched there, munching, taking deep breaths of fresh air as cold as spring water, when a fluttering on the ground caught her eye. It brought to mind a swan nesting, but there was no pond nearby. Another white fluttering gave a glimpse of a robe disappearing behind a low hill, and then she saw Juniper, in a brown tunic, shimmying up a tree not fifty paces from her, on the opposite side of the track and to her right.

Robin and his men, here? Surely the pickings would be lean on this narrow road. Lady of Mercy, she did not wish to be party to his thieving, or even stay to see it, but she doubted she could slip away unnoticed. She lay motionless against her oak, counting on her own dark clothes to blend in with the bark. She waited, quiet as a lamb, and Juniper quiet as a dove with no love to mourn, and the clouds passing by overhead, and the wind brushing dustings of snow along a branch here or a slope there, and otherwise, the land was still as sleep.

She was stiff and aching from the cold before she heard the cry of the heron calling for its mate. Juniper's warning. She grew more alert. Then came the distant jangle of horses' bridles, the clomping of hooves, and the mutter of men approaching from Derby. When they came into view, she took a sharp breath, for they were sixteen, in the black robes of Benedictines, black cowls hiding their faces.

This would please Robin well, she thought, for he liked nothing better than to play one Order against another, robbing Benedictines while dressed

as a Carmelite, robbing Cistercians while playing the Benedictine, and robbing the Templars whatever way he could, for they were the richest, and formidable warriors besides, and it boosted his pride to best them. So he gleefully added to the strife and confusion that existed already between these Christian factions, for many of them hated one another almost as much as they hated Pagans and Muslims.

Well, here were sixteen Christians who would go safely through Sherwood this day, Maerin vowed. Though she was learning the Way of the Wicca—and taking to it like a spawning salmon to a stream, so Robin said— she had not forsaken the Christ or the face of the Goddess as His Holy Mother Mary. The more she learned, the more she saw the two faiths were alike, perhaps not on the surface, perhaps not in the way some scions of the Church worshipped, but in their profounder Mysteries.

And both deemed it wrong to steal. How Robin could convince himself that his doings were laudable, Maerin simply could not understand. But where His High and Mighty Mischievousness sowed discord like seedlings, and thievery like a weed, she would sow peace and safety.

Giant snowflakes, her lover and two of his thieving companions flickered onto the road around the bend to her left, their faces concealed in their white hoods. When the Black Friars rode around that curve, the hooves of their horses spewing frozen clumps of mud, they halted at the sight of the White Friars who stood blocking the way, their folded hands hidden in their wide white sleeves, ostensibly for warmth.

The Benedictines looked asquint at one another. One who rode in front hailed the strangers, saying, *"Pax vobiscum."*

Robin answered, *"Et tibi, pax."*

"Stand aside and let us pass, Brothers," called a burly Benedictine on a sturdy grey gelding.

"That we may not, Brothers," answered Robin. "We have taken a vow."

"What? A vow to stand in the middle of the road? I have heard of mysterious doings in these woods. Is this some Witch's curse or enchantment?"

By his bearing and the fact that he spoke as the leader, Maerin thought he must be an abbot or a bishop, though his robes were plain. That spoke of humility, and she liked him for it.

"Enchantment it is. We must stand so until someone delivers us," Robin said with a gleam in his eye. "But you may well be the man to do it, Brother."

"That may be," said the Benedictine. The monk beside him murmured something in his ear, but he shook his head. "How may you be aided, our Brothers in Christ? If we can deliver you, we shall."

Robin smiled and drew from his sleeve a long, shining dagger. "You may stand and deliver, Brother," he said. Tuck and John pulled their swords from their robes, and ten more Carmelites appeared from behind tree trunks or hillocks on either side of the road, arrows aimed at the Black Friars.

"What is this? Christian steals from Christian?" the abbot demanded.

"Carmelites are known for their avarice," another black monk said, "but this is beyond the pale!"

"These are not monks, but thieves!" cried another.

"King Richard!" spluttered a third, "I ... King Richard will hear of this!"

Robin laughed. "We do no more or less than Richard himself did on the way to Jerusalem," he said. "I like better to steal from Christian priests than Muslim herdsmen. Their purses are fatter. And priests can grant us absolution after! Pray for our souls, but give us your gold, and get down from your horses or your Devil may take you."

The burly one silenced his companions' objections and was the first to get down from his horse. He reached inside his robe with thick trembling fingers. Robin threatened with his dagger lest the Black Friar thought to pull out a weapon, but the monk only took out a purse and threw it to the ground.

"Many thanks," Robin said, "and now your brothers do likewise."

But Maerin aimed an arrow at Robin's dagger, let it fly, and quickly nocked a second. The first twanged solidly against the long dagger's blade and struck it so it hurtled to the ground. Robin wrung his hand, cursing, and Maerin shouted in as low and manly a voice as she could muster, "Another arrow targets your head, you thieving scoundrel! Let the Black Friar retrieve his purse and pass by in peace. Nay, look not toward the sound of my voice. Call off your robbers!"

Robin swore, but waved to his men to drop their weapons.

The abbot bent down to pick up his purse. As he straightened, he balled his right hand into a fist and delivered a mighty blow to Robin's groin. Robin crumpled, gagging in pain.

To Maerin's shock, the Benedictines spurred their mounts forward to attack, drawing swords, their billowing robes revealing glimpses of chain mail and richly embroidered tunics, hardly the cloth of Benedictines. Soldiers, travelling in disguise! And there was Robin, in the midst of them, rolling in agony on the ground while his friends scrambled to retrieve their weapons.

With a cry of horror, Maerin aimed into the fray, but couldn't get a clear shot. She swung herself down from the tree and rushed into the road, her dagger drawn, but by now the false abbot held the tip of his broadsword

trembling against Robin's throat. She faltered.

The abbot shouted to his monks, "Did I command you to attack?"

The soldiers reined in reluctantly, their horses snorting.

"Let us see our champion!" the abbot called toward Maerin. "Come forth and be rewarded, lad, and know how noble a deed you have done this day!"

Maerin's heart sank. Now that the fighting had ceased, she could have plied her bow against these false Benedictines from the safety of the trees. But it was too late.

As she came closer, a look of disdain crossed the abbot's face. "What trick have we here, a woman dressed as a man?"

She sheathed her dagger and said, "It was my arrow saved you." Robin stared at her, stunned. A sick feeling spread through her stomach, her heart.

"A maid saved us!?" The false abbot laughed heartily. His companions joined in. "Would your aim had been better, wench, for your arrow missed the vermin's heart!" Their guffaws filled the air in crow-like cacophony.

"My arrow hit what I willed it to hit," Maerin said.

"Is it so?" The abbot chuckled, disbelieving, and ordered his men to herd the outlaws together, disarm and bind them. He sheathed his heavy sword as Robin, too, was bound hand and foot.

"I see you are not what you profess to be," Maerin said.

"Travellers must protect themselves, even monks may carry swords, and by God's legs, what do you profess to be?" challenged the abbot.

Maerin hesitated. "That is too long a story for a chill day in the woods."

"Well, perhaps I may warm you by a hearth and hear it." The man looked her up and down as if she were a camp follower. "But I cannot spare myself for such dalliances as yet, my pretty maid. Come to Nottingham in one week's time and you shall receive a reward, for your skill with the bow has served the King well."

"The King? I seek no reward from John Lackland and I'll not set foot in Nottingham. For me, there is only one King of England, and he is in prison, may God have mercy on him!"

At this, the abbot seemed to be considering what to say. Then he threw back his hood with shaking hands to reveal a head of wavy red-gold hair, thick and untonsured. "Richard is free," he declared. "See him before you."

Maerin laughed lightly. "Many men bear the name 'Richard,' men with golden hair such as yours, or brown hair, or black, or balding."

But Robin, forced to his knees in the muddy snow, saw the man's features and recognized him, now knowing the man's trembling came not from

age or fear or weakness, but from the ague that continually plagued the Lion Heart and goaded him to ever-greater feats of strength.

"Richard!" he sang out, as if greeting an old friend. "So you still choose the guise of a monk when you travel in secret. I see this time you hide your royal rings. The Duke of Austria has taught you a lesson."

A black-robed soldier kicked Robin so brutally, he fell backward groaning into the snow. Maerin bit back a cry and forced herself to remain still. She must not run to him, must not show she knew him. If she could not think quickly, it would mean his death, and it would be on her head, and heavy, heavier than a smith's anvil, on her heart.

Richard said, "So, little maid, you have saved your sovereign forty marks today, a bountiful sum now that the Emperor of Austria has bled our country dry. Even the Queen our mother sold her jewels for our ransom."

Maerin managed a curtsey made awkward by the fact that she wore no dress.

"What shall the fate of these rascals be?" he mused. "Shall we gut them here or take them to Nottingham to hang? For we have an appointment there with our brother John, and after that, a bloody hanging of a brace of brigands would suit us very well."

Maerin swallowed and summoned every noble grace taught her at Fontevraud. "If it please you, Your Majesty, I would speak to their fate. But why should you listen to one such as I? I am only Maerin fitz Warin of Derby. My father was Ranulf, once in service to the king your father. I believe my grandmother's cousin was related by marriage to the house of Plantagenet. But distantly, Your Majesty. I cannot claim more than is true."

Richard's lips twitched. "Indeed. Fitz Warin. The name strikes a familiar chord. But what do you here in Sherwood, dressed in such unseemly fashion?"

"As you said, Your Majesty, that is a tale I must reserve for a better time. But I beg you to temper justice with Christian charity and mercy. These ruffians sought only to steal, not to murder. Should their just punishment be death?"

"What, shall we cut off their hands then?" Richard made as if to draw his sword again.

"Oh, no, Your Majesty!" She paled, fearing he would take offense at her boldness. "Then what is left for them, with no hands to work or learn a trade? Shall they be beggars? And the Church and the King bear the weight of their poverty and handicap, and succour them with alms, when as you say, the kingdom is already so much taxed? I pray you, Your Majesty, let them go.

They will be chastened by the brush with death that has befallen them here."

"You are too soft. Woman-soft. With such as you to defend them, they will never forsake their evil ways."

"Forgive my presumption, Your Majesty, but is not Justice ever pictured as a woman? These men have not harmed you, though they tried. Let them swear to you in the name of Our Lady never to rob again, and I warrant they will keep that promise."

Robin, struggling onto his knees again, cursed her silently for her meddling and conniving. Well she knew if he were made to swear in the Lady's name, he would be bound to that oath forever.

"Your arguments are worthy of our best counsellors," Richard said. "You remind us of our mother."

Maerin curtseyed deeply. "I am honored, Your Majesty. If I may be so bold as to speak further?" He nodded somewhat impatiently. "Perhaps some of these outlaws were honest men once. It is well-known that many have been ruined by treachery and the cruelty of Nottingham's former High Sheriff." She bit her lip. Had she said too much?

"The High Sheriff only?" demanded the Lion Heart. "Not the Prince, my brother who has bided with him?"

Maerin dared not speak that truth to the King's face. Besides, she herself had no proof of John's treachery.

"By God's legs, woman! I know well my brother has plotted against me! He will soon eat the fruits of those labors." The King was so incensed, he forgot to use the royal 'we.' "But was not the High Sheriff of Nottingham your uncle and your guardian?"

"Yes, Sire. I fear yours is not the only family that can fall prey to ... "

"Bad counsel?"

She bowed her head.

He addressed the outlaws. "Get to your feet, you bastards. For the sake of this clever woman's tongue, and her beauty, and for that we are newly freed from our imprisonment, we shall set you free also. But never dare to cross swords with us again or we shall have your heads." He did not take seriously, however, the advice to have them swear by the Lady, and this omission the royal family would later have cause to regret.

As soon as his bonds were cut, Robin, bruised and bleeding, got to his feet and remarked, "After all our travail, you never saw Jerusalem, did you, Richard?"

The King lunged toward Robin and gripped his tunic at the throat. "Do we know you, whoreson, that you dare speak to us in this vein?"

"I know you, Angevin, though you have forgotten me. I fought by your side in Acre, may the Lady forgive me, and a dark day it was when three thousand helpless Saracen prisoners were slaughtered at your command."

"Bah! Saracens! What are they to us? Have you not heard Saint Bernard of Clairvaux? He preaches, 'The Christian glories in the death of a Pagan, because thereby Christ Himself is glorified.'"

"And was it Christ's glory you fashioned at Lisbon and Messina, with the rape and murder of Christian women along with Jews and Muslims? The stones are still stained with blood, I'll wager, and echo with screams. And what of Cyprus?"

"The people rejoiced to see me destroy their dictator!" Richard pushed him away, and wiped his hands on his robe as if they had been sullied by the touch. "I shall not lower myself to argue with a peasant. With weaklings such as you, it is no wonder we never took Jerusalem. How is it you came back to England? Wounded? Discharged? More likely you deserted."

Robin said nothing, but his jaw tightened.

"I thought as much. Coward! And now you are a thief as well as a traitor. I should hang you after all."

"Aye, in the name of Christ, do so at once! The men who murdered my father have been trying to kill me ever since I returned to England."

Praying that Robin would shut up, Maerin stepped forward. "Your Majesty, he is Robert of Loxley. He is of noble birth and has been forced into his present state. He has been cheated of his land and name, by my own uncle and the Bishop of York."

"You know this man?" The King turned on her. "What connivance is this?"

Maerin swallowed hard, but stood her ground and returned his gaze.

"These are harsh accusations," he said. "What proof have you?"

"It matters little," Robin said. "Loxley is dead. I am Robin of Sherwood now."

"Robin? Robin Hood? The Devil! I have heard of your exploits! You are marked to be hanged! And you begged for his life?" Richard turned on Maerin.

But she herself was livid with rage. "Why can't you be silent? Why can't you kneel before your King, Robin? Are you determined to die? How many times must I beg for your life?"

"What of you, you poisonous bitch? What game are you playing at? Twice today you've betrayed me!" Bitter anguish clouded the fury in Robin's face. "Make it three times, milady!"

Maerin's heart wrenched. He was right. Her meddling was ruinous. She

was destroying his life, in trying to save his soul. The Church would say the latter was more important, but her own soul told her the two were too close entwined to make such fine distinctions. And feeling her soul entwined with his, for all that he was a scamp, if he were to die this day—she could not bear to think of it. Yet she protested, "Who made you a thief? Not I!"

"Your bloody Church and your bloody uncle!"

"Your bloody pride! I throw you a lifeline and you hang yourself with it!"

"Oh, plying me with arrows is a fine lifeline!"

"I only thought to teach you a lesson."

"And well you've taught it too! And it is not to trust you!"

Richard listened to this exchange in amazement.

Maerin wiped tears from her cheeks. "Oh, Robin, why did you not stay on the Great North Road today?"

"Too many of Prince John's bloody soldiers about. I suppose you had something to do with that," and Robin jerked his head toward the King as if he were nothing more than a swineherd, prompting another soldier to whack Robin in the head with the butt of his sword and tell him to bow to the King.

Tuck chose that moment to observe, "Methinks a draught of wine would stand us in good stead. It's chilly work, this."

Richard's grimace upturned into the trace of a smile. "The villain speaks rightly. Wine!" he commanded, and one of his men quickly handed him a wineskin from which he quenched his thirst. Yet he offered none to anyone else. Then he said to Robin and Maerin, "We waste precious time. We have given our word that you may go free today, but do not tempt our wrath again. We are not our brother, nor are we some hamstrung High Sheriff. We will not suffer a thief and a Witch to live in Sherwood. As for the rest, the matter of Loxley, we will hear your complaints … and your long tale," he added, nodding to Maerin with the ghost of a leer, "in Nottingham, after we have won it. If you have in truth been wronged, Loxley, I shall pardon you and return to you your lands."

Robin shook his head. "It's the land that owns me, not otherwise. You may keep your titles. Lord of the Greenwood is the only one that suits me."

Maerin gritted her teeth at Robin's obstinacy. To her great relief, Richard only said, "Call yourself what you will, you're a fool by any name. By Christ in Heaven, I'll never offer you land or title again. Get out of my sight. It is men we need for England and Aquitaine, not spineless rabbits like you." Richard swung up on his horse and with a harsh kick to its haunches, he

spurred it down the track toward Nottingham. His soldiers galloped after him, spitting and shouting obscenities at the outlaws as they passed.

Maerin and Robin glared at one another, wordless. Their friends, shifting uncomfortably in the silence, gathered up their weapons and began drifting away home.

Robin bent down and retrieved his dagger, wiping the snow off on his robe.

Maerin said, "Do you wish me to return to Nottingham?"

"So Richard's hearth and bed appeal to you!" Robin sneered.

"Of course not!"

"His tastes have not changed," Robin scoffed, waving his dagger. "Noblewomen in distress and pretty boys! And dressed the way you are, no wonder you caught his eye! Do you know how many women he has raped and passed along to his soldiers? Titled women, too. I know, for I saw it happen. But in your case, I suppose it would not be rape, since you are offering yourself."

She flushed with anger. "Though I've made myself your whore, I've offered myself to no one but you! And how dare you make such filthy accusations about our King?"

He swore, spun on his heels and walked away.

More tears sprang to her eyes. What a fool she was! How she had lowered herself, sharing his bed with no marriage vows! And she would do it again, and never regret it, though her angry words seemed to say otherwise. And here he was ready to cast her off, and it was all her fault! Yet the words to beg forgiveness, to say she was sorry, stuck in Maerin's throat.

She called out, "Robin, had you not been thieving … Robin!" She hurried after him, matched him stride for stride, forcing herself to speak. "I—I did not know who they were, or that they were armed. I should not have— I know, and I wish I had not—I rue the day I learned to shoot with bow and arrow! When I thought he would behead you, I would have thrown myself in front of his sword before I would have stood by watching! I would die with you rather than live without you!"

He stopped, his blood still boiling, almost as full of rage as he had been the day he had killed Reginald. He could barely credit her protestations of love. All their silly quarrels and teasing were as nothing to this, her arrogant, stubborn refusal to accept his life, to understand and accept him. "I'm a thief, Maerin, and a deserter, and no doubt every manner of villain you can think of, but I'm no coward and I'm no witling, to steal only when Church and King pretend there's the right of it! I care more for this land than your fine King Richard, who barely sets foot in it before going off to war again,

and takes every speck of wealth in this country to pay for his bloody army. While I take from those who themselves have plenty and I share with those who have need, and I give the people hope and joy in this life, not just pretty promises about the next! So think on who you'd be joining with at Beltane, as we pledged! Imagine your consort: thief, Witch and so-called traitor! Think better of it! Get you to Nottingham or a nunnery or anywhere you need not look on the likes of me!" He turned on his heel, but instead of walking away, he whirled around again and shouted, "I cannot forgive you this! You held my life in your hands and tried to crush it!"

She wept openly now.

His voice caught. He swore again and threw down his dagger. "But I must forgive you, mustn't I? I cannot bear it otherwise. I cannot bear to think of a night in my bed without you, of a morning without waking beside you, looking in your eyes and seeing your soul and your heart there, looking back at me. I cannot think of a meal without you, or a walk in the wood. And certainly not an argument!" He felt his fury giving way to exasperated laughter. He shook his head. "Maerin, I will never ask you to walk my path, but you must leave me be to walk mine."

"Then you want to banish me?" Her voice was strained and broken.

"Banish you? Gods, Maerin!" He looked pained. "Never that. Only do not underestimate my enemies again." He reached out to stroke her cheek. "You mad wench. But if you did not know your own mind so well as you do, for all that I do not think fully the same as you, I would not love you half as much. Well, I'm still alive, so that's enough said about it." Then he grinned. "It would have been a pretty prank, had they really been monks."

She was so relieved at the return of his good humor, more tears stung her eyes. Was he really forgiving her? She reached up tentatively to take hold of his hand against her cheek, then drew it to her lips, kissing his fingertips, his palm. He flung his other arm around her and pulled her to him, and she felt the heat flowing between them, strong as ever, bright and blessed as the morning.

Yet after a moment, she couldn't resist murmuring into the warmth of his neck, "Next time I shall make sure of their Christian vows before I shoot at you."

He threw back his head and laughed.

⌘

58-THE CROWNING
BELTANE, 1194

fever tickled the world sweetly. The nights were cool, the days warm and the rains came often. The morning dew was thick and the fog lay low all night between the hills. Singing, men and women ploughed the fields and sowed the corn, and the flatlands and gentle slopes rose and fell beneath them like a woman waking from sleep, stretching, turning, softening frosts into juices, Her cries of love coming from the red-breasted robin, the nibbling deer, night-calling crickets, buzzing bees and dragonflies. The trees thrilled to green leaf's bud and the smell of damp earth and wild thyme honeyed Her moist breath.

The hawthorn blossomed for gathering into the arms of youths and maidens, for showering the white petals upon each other by the Beltane fires. At dawn on the holy day, they dressed quickly and carelessly, breathless with anticipation, and raced in packs like tousled puppies into the woods to wash with the dew from the May, and gather the flowers, fashioning them into wreaths which they carried singing to their villages, draping the doorways of every home with spring.

They did not spurn the churches either, and if this canon or that priest tore the buds down and threw them cursing away, others among them were not so unfeeling of Nature's glamour. Some clergymen turned aside and pretended not to notice, some were secretly pleased, others openly. Some railed against these Pagan practices, others called the day sacred to this or that saint and so gave sanction to it, but however they tried, they could not stop the people from bringing the summer in.

To them, it was the time of the Sacred Marriage, when the Goddess and Her Consort would bless the land and make it fertile. Many folk believed it unlucky to marry in May. This was no time to think of oneself, but of the greater good, and if a man ploughed the furrowed field with a woman, whether or not they were wed to each other, it was thought they were playing the part of Lord and Lady, and the joy of their love-making would hasten the seeds to sprout. Should a woman bear a child of that night's union, the babe was

honored and said to be a child of the God, not a bastard and scorned, as the Church would have it.

When the time was right, every hearthfire and candle, every flicker of flame in the land was put out, and the people made their way to the local gathering place to see the Need-fire kindled anew. This was the sign of the Lady's promise, that there would be fire in heart and hearth, fire in the loins, fertility, growth and future harvest. From the Need-fire, torches would be lit and every hearth rekindled at dawn the next day.

On a hill crowned with gnarled oak trees, the people from Snaith's keep and Brighid's Well kept their Beltane festival. As the day waxed, they gathered wood for the fires, placed offerings of food on the trestle tables, and danced around the Maypole, ducking in and out of the bright ribbons and the other dancers, slowing their step or darting ahead, or stealing a kiss. The maids spun moonwise and the young men danced sunwise. The ribbons they held wound around the pole, weaving their youth and lightness and strength into the wand of the God standing tall in the waiting earth, until the magic was wound so tight no one could move another step.

A priest and priestess offered prayers, and many people murmured their own, and sent the prayers into the earth and the sky.

At dusk, the last red rays of the sun struck the mountains of wood just as the kindling sticks set them ablaze. They glimmered across the isles, the earth like a mirror of the heavens, as above, so below, with as many sparks shooting up from the ground as there were stars in the sky.

As the fires burned and couples made their eager way into the darkness to bless the fields, the happy daylight piping of tin whistles and jangling of tambourines gave way to the booming staccato of the bodhran. Voices lifted and lowered in waves of song and chanting. Dancing feet and drums pounded hypnotically on and on, while the full moon floated above. Peasants drove grunting herds of goats, cattle and sheep between the bonfires to purify and stimulate the fertility of the beasts.

Men and women alike peeled their clothes away bit by bit as they whirled around the fires. Sweat streamed down arms hardened from working the fields. Garlands of violets, primroses, hyacinths and hawthorn twined through hair unbraided and unbound. From time to time, someone gave a shout and charged the fires, leaping over to purify themselves. Naked thighs flashed under rippling skirts. Couples leaped the flames together to strengthen and purify their love, and chased each other laughing into the darkness.

Seated in state beneath an apple tree, Maerin watched, bedecked with bone jewelry and a deerskin robe. A crescent moon was painted upon her

brow in blue woad, a cardinal cross was painted between her breasts, and on the soles of her feet, a blue sun and a blue moon. She was half in trance from herbal smoke, tisanes and Prim's incantations. Images drifted in and out of her mind, of the elements and elementals, of sylphs and salamanders, ondines and elves, the dances of the stars and the seasons, the sacred trees and their times of budding and flowering, fruiting and planting.

She knew the rhythms of her own body, and of the Goddess reflected in sea and moon, ebb and flow, waxing and waning. She had slept outside under the full moons, and did not go mad as some believed would happen, but weaned her body from the rhythms of the town onto those of the wild, learned to know the moment she was ripe for seed and the moment it passed, knew before it started when her blood would flow from her womb, in the waning or dark of the moon. Prim taught her also the Mysteries of the life-blood, meant not merely to be washed away from rags in the nearest flowing stream, but honored, valued and sometimes, when necessary, used.

Tonight the full moon, the Mother aspect of the Goddess, shone down on the land. Maerin could feel the wetness between her legs that signalled her own fertility. Tonight when she and Robin came together, they might well create a new life, the holiest act. The knowledge sent a throb of excitement through her, yet a part of her shied away, not so much because she did not completely trust his assurances that there would be little or no pain, but because this signalled both a profounder union between them, and a moving forward into magic, and no going back.

The old crone was right; once Maerin had chosen this path, she could not walk away from it, for its power and wisdom would stay with her wherever she went.

The dancers leaped and gyrated, the women shaking their hips and bellies and breasts, or undulating like snakes. Where had she ever seen such reckless dancing, heard such pounding of drums? It was hardly the sedate and ordered hymn-singing and prayer of Mother Church. She was both fascinated by it and slightly repelled. She had truly left her old life behind, yet at this moment, she felt she was not made for such life-loving abandon. A part of her yearned to flee, but she felt rooted to the spot, by her trance, by her love for Robin, by all she had learned.

Tonight, she was a maiden. Tomorrow, she would be a potential mother. She smiled to herself. But where was Robin?

All day she had looked for him. Was he up to some trick, or was he preparing himself for this night? She cast her eyes again over the dancers. Some wore masks of animals or fantastical creatures of myth with leering

grins. Was Robin among them? This man was too stocky, that one too short.

Though she knew it was pointless and even silly, she felt a twinge of jealousy. It was too easy to picture him with some young lass in awe of his name and the half-true legends surrounding it, coupling in some leafy bower. He had as yet made no promises of fidelity to Maerin. She had thought his love promise enough, but now she feared she had misread him, with the dark, unreasoning fears of night.

She started at a warm breath in her ear and arms around her waist. She flushed with eagerness and annoyance at him sneaking up on her, and turned her head only to see Allan's laughing face. He bussed her playfully on the cheek, not seeing her disappointment, and ran off to find Aelflin.

A stranger danced toward her and beckoned, but she shook her head. It was too dark for him to see the crescent moon on her forehead, perhaps, or he would not dare to approach the Queen of the May so casually. Or perhaps he was too drunk to care. He thrust a mug of mead into her hand and danced away.

Ashamed of herself for worrying over Robin, she closed her eyes, tilted the mug to her lips and drank the honeyed stuff down as if it were water, suddenly careless that it might not mix well with Prim's potions. Mead made for a strong water; she felt dizzy before she even finished the draught.

A high, screaming ululation filled the air and she dropped the mug, mead spattering across her hands and her deerskin bodice. The cry was taken up by a score of voices. Her heart pounded as a moon-shadow loomed across the slopes below, the wandering ghost of a giant, with long, massive legs, shoulders wide as a ship's mast, and a spiky crowned head. Her breath caught. Her palms began to sweat.

Then came the source of the shadow, naked but for the furred skin and head of a seven-point buck draping his back from his head to his knees, the antlers forming the crown, the firelight a catapult for shadows, turning his lean body golden-red.

Above the chanting and drumming rose a chorus of shouts. "The Horned One!"

"The God walks among us!"

"The May King! The May Queen!"

People crowded around Robin, their half-naked bodies pressing against him, but he walked steadily toward Maerin and did not turn aside.

She could breathe again. Of course he had not been with some lass in the wood. He had gone away alone, as he often did, to commune with his Gods, to prepare for this rite. She had seen this same tranced look in his eyes

before, after his vigils or the hunt.

Her first thrill of recognition gave way to excitement, tension, even a little fear. He barely seemed human. He had taken on the aspect of the Stag-God, and he stalked her as slowly and majestically as a wild beast. He paused before her.

She rose, shying sideways and back, dancing away from him, unable to take her eyes from him. She moved backwards around the bonfires in a spiral. The people laughed and sang, clapped and danced with her. Her movements found the rhythm of the drums, her bosom lifted and fell, her hips loosened, her pelvis swayed, luring him closer even as she backed away, and her arms raised as if pillows of air lifted them, as if she invoked the Lady. Flames, trees, stars and moon whirled about her like dancers.

Prim put a wreath of fresh hawthorn blossoms into Robin's hand. "The Queen's crown."

"The Queen is the King's crown!" cried someone else, to more laughter and ululations.

Robin held the crown out to Maerin, an offering. The people were looking on, pounding their feet. The heat surged up in her bones, up her spine, her flesh quivered, her head lifted and she held out her hands, her fingers like tendrils of vines, beckoning.

He came close enough for her to smell the sweat on his skin, his breath sweet and pungent with wild grasses, thyme and honeysuckle. He was placing the wreath on her head. The pounding of the drums grew frenzied, irresistible. Her own heart was pounding, and her womb was the ripening Moon, ready. She knew if he reached for her, she would let him take her here and now, in front of everyone, and she trembled with awe at her own desire.

But he only held out his hand to her. She put her hand in his and he smiled, briefly human again, and led her away from the exultant shouts of the dancers in the circle of light.

⌘

Far-off drums sounded the earth's heartbeat. Muffled laughter and moans spoke of other lovers entwined nearby.

Maerin let her clothes fall to the grassy ground. The full moon washed her body with light.

Robin knelt before her. His eyes were the eyes of the Stag, liquid pools flecked with light, but his face was the face of the man she loved.

"Goddess of Night, Goddess of the Moon, Goddess of the Eternal Sea," he said, "behold Thy handmaiden, Maerin. From Thy perfect Wisdom, may she take wisdom. From Thy gracious Mercy, may she draw compassion. With

Thine unending Love, may she also be filled with love. Give Thy Power into her, Lady of the Grove. Be one with her, that our union may serve Thee best." He leaned down and kissed her left foot, then her right, he kissed her left knee, he kissed her right, he kissed her belly, he kissed her breasts, he kissed her lips so lightly, and he ran his fingers along her skin like silver until her heart and veins and bones ran with it, and her blood sailed with the sea.

He threw off his deerskin, spread it on the ground and sat cross-legged, opening his arms to her. His gaze flowed over her naked body like the teasing of a breeze. The tiny hairs on her arms and legs stood on end.

She went to him, knelt and kissed him, lingering on his lips motionless, as if the power of this simple touch was movement enough. Then at last their lips parted and their tongues circled together. They kissed the moon sliding between branches of oaks, kissed the breezes sliding off the moon.

He took her hand and ran his tongue along her fingers, sucking the tips, tasting her skin and the dried mead that had spilled there. He caressed her hips, pulling her toward him. His hands twined in her hair and drew the long tresses over her breasts, down her belly, his face nuzzling the soft curls and the softness beneath. His kisses were hot, his tongue swirling. He heard her gasp and cry out. She tasted salt, sweet and bitter, like a milder version of his own seed. The juices flowed from her; he kissed water from a spring.

She wrapped her legs around his waist, lowered herself down to sit on top of him, his rigid wand between them like a sword. They gazed into each other's eyes, breathed each other's breath. He began rocking from side to side, back and forth, feeling her wetness flowing, the warmth rising, her breasts sweeping against his chest, her kisses on his brow, his ear, in his hair, knowing this time she would open to him completely. The thought made his own juices surge and with a groan, he stopped moving, shuddered and tightened the muscles in his groin, drawing deep breaths, until he was sure he held in his seed. His wand grew softer.

He rocked her gently over onto the ground. It was all he could do to keep himself soft, to use his hand as a guide, easing himself inside her. Her eyes widened, for she felt no sharp pain, only warmth and gentle probing, as if his touch were healing her, piercing the fierce ache of her wanting him.

Almost at once, he felt himself stiffen and grow, but he held himself motionless, not wanting to hurt her, until she began to arch against him, welcoming him deeper.

He began to move inside her. She echoed his groans and his touch, uncoiling beneath him like a pythoness waking from a cold sleep, sunning herself in his heat, and as his wand grew bigger and harder with each passing

pleasure, she was not so much deflowered as unfurled.

⌘

They stayed locked together until dawn, she thought, for the birds were trilling. Then she realized they sang inside her, trilling up and down her spine.

He put his hand on her heart, held hers over his own heart, and began to rock forward and back inside her, side to side, with excruciating, tantalizing slowness. The trilling of the birds rose and fell. She circled her hips against him in a dance and pressed her hand to his brow. The trilling rose and gathered in her heart. She heard herself growling like a lion, and he was thrusting again, harder and deeper. His desire fulfilled her, and when he stopped moving once more, she screamed with frustration and delight. He laughed. With a touch of his thumb to her forehead, the trilling birds burst up through her skull into a fountain of light.

The white stag shone in the light that poured through her, with stars for eyes. He was Robin and not Robin, Lord and not Lord. They were touching and not touching, they were within each other and without. Their joy in each other overflowed the false boundaries of their bodies and together they spilled their love into the Earth, raining down mercy and grace where armies had battered and burned Her, where hunters had hounded Her foxes and sacred hares, mending the mystical ley lines with power surging unstoppable by man-made fences and enclosures, binding the wounds where the holy places had been torn down, caressing the toppled stones and untended groves, the covered wells and hidden springs, melting down and down to the eternal fire in the heart of Her.

⌘

The moon waned and waxed again, and Robin and Maerin often returned to the glade to honor the first crescent and the full, to make love and seal the magic in the place. They would spend the night wrapped in each others' arms on a bed of dried bracken, covered with animal hides. They dug a firepit to cook food they gleaned from the wildwood, and a stream of sweet water nearby was their chalice.

Even in June, the water was icy. The morning sun glittered cold metallic gold upon green leaves and sparkled silver on the river's surface. The water rushed around a large boulder and eddied into a pool among more rocks and silty mud where decades of spring floods had eaten away at the bank and exposed the gnarled tree roots.

Naked, Robin waded in. The cold touched someone else, he thought, for his veins still ran as hot as the Beltane fires, and he knew who blew the

bellows upon those fires. He smiled to himself. He knew she was watching, and he could not help but strive yet again to prove himself to her.

He leaned over, half-crouching, the water lapping at his knees, his hands tickling the water from time to time, but otherwise, motionless for what seemed to Maerin a long time. Then he flipped two fishes out onto the bank as easily as if he were brushing a stray lock of hair out of his eyes. He clambered out of the pool, captured the slithering trout, one in each hand, and held them up smiling.

They wandered back to their private glade. Along the way she picked herbs and wild onions, nasturtiums and violets. She fed him flowers while he gutted the fish. "Some fresh bread and butter would go well with this," he said somewhat mournfully, for they had brought none.

"Shall we go and raid the pantry?" she giggled, reminding him of their exploits as children. "Just think, you were a little thief even then!"

"You were there before me!"

She fed him another flower and he nibbled her fingers. She ran her fingers across his mouth and down his chest, and further down to cup him in her hand.

"Have you no shame left?" he said, grinning. "What would the Church Fathers say? Or your abbess of Fontevraud?"

She smiled back. "Well have I learned that the Church does not make a union sacred. Love is the only power that can do that."

"I love you."

"And I you."

He put aside his knife. "Then wed with me."

"What, in a church? Now you've truly shocked me!"

Surprised at her flippancy, he protested, "No, in a grove, or a circle of stones. A handfasting. For a year and a day, as in the old days."

"A year and a day! Oh, Robin, could you last so long forsaking all others?" She made it into a joke, secretly dreading his answer.

"Who said anything about forsaking others?" he teased back.

Her face fell.

He laughed. "Maerin, you look so downcast!" He chucked her playfully under the chin.

She slapped his hand away. "Your fingers smell of fish!"

"Let me see. Could I last until next May Day with you as my only lover?" he mused.

"Why marry at all, then? If you so desire others, I shall leave you at once." She got to her feet and stalked away toward the tumbled pile of her

442 REYNA THERA LORELE

clothes at the edge of the clearing.

"Wait! Maerin! My love!" Laughing, he chased her and caught her hand.

She pulled away. "Marriage is not a jest or a whim, and it is not for a year and a day! It is 'til death parts us! Our union may be sacred, but marriage is … " She looked suddenly doubtful and confused.

"Maerin my love, why talk of death when we are joining in life? Who can say what the future will bring? In a year and a day you may be sick unto death of me, or of life in the wood. You may welcome the chance to be rid of me!" He chuckled, for he could not resist teasing and arguing with her.

"More likely it is you will be wanting to be rid of me."

His smile left him. There was no denying he had never wished to wed before. There had always been so many lovely lasses. But he had not desired any maid except Maerin for many moons. It was some form of magic, worked by a power beyond him. She bewitched him without even trying. He said, "Right now I feel I will love you and only you forever. But if we judge by the past and not the present, I cannot truly say whether I will never desire another. Nor can you say so, though you desperately want to believe it."

"I will never want another in my bed!"

"No?" He grinned mischievously. "Is it wicked, do you think? Our ancestors had nine different ways of marriage, and not all of them called for lifelong vows."

"I know my heart even if you do not know yours!"

"You do me an injustice," he protested. "Know that I love you, even as I know it! But would you not rather have my love freely given and renewed each day, than bound by law?"

"Then why marry at all, Robin?" she demanded.

"Because I want you for more than a tumble in the hay! And I want everyone to know it!" They glared at each other.

Robin was baffled. Was this not what Maerin also wanted? They seemed to be speaking in different tongues!

Maerin looked down at her pile of clothes, hot tears in her eyes. She would never understand him. How could she love someone so much and be so furious with him at the same time, so at odds with him on some matters? She would not take vows that could change with the seasons! That was no vow at all! She crossed her arms over her chest. "Let us leave things as they are. It is well enough for me."

"Very well, then, as you wish!" he snapped.

Their mood of lighthearted joy was broken and they did not linger in the glade. When they returned to Brighid's Well, the tension between them

was obvious to everyone.

Aelflin took Maerin aside and gently asked what the matter was. Having rarely had a friend she could trust with her secrets, Maerin was slow to reveal her heart, but when at last she did, it was with a torrent of tears. She would have been enraged had she known Aelflin would promptly consult Prim on the matter.

Maerin was gathering herbs with the crone the next day, her mind endlessly on Robin, when her curved knife slipped and she cut her own thumb. She swore, then murmured a blessing, and pressed the wound to her tunic to stop the blood.

Prim sat back on her haunches. "Sometimes I think you are a greater fool than I originally thought."

"Your knife has never slipped?" Maerin retorted.

"I have lost two husbands, one to ill health and one to the gallows. I am twice a widow. Twice I have loved as if I'd love no other, but love proved me wrong. What more would you ask of Robin than for him to love you now? Death comes sooner than you think. Death alone can always be counted upon to fulfill its promise." She shook her head, aware of the irony in her striving to bring Maerin and Robin closer together. "But if a Witch makes a vow, she must stand by it. Falsehood and inconstancy drain her power. Your word must be your law, else your magic will suffer and no God or Goddess will hear you when you say, 'Be it so!'"

"It is ever my intention to honor my vows!" exclaimed Maerin. "It is Robin who would make light of them!"

"Oh? I only say, consider well how you word those vows, little Maid!" Prim smiled with a superior air.

Annoyed, Maerin got to her feet and swept up her basket to move on to the next patch of herbs.

Later, by the great oak, Prim set the second part of her meddling in motion by commenting to Robin, "Lughnassadh is fast upon us, my lad," for this was the holy day when trysts that lasted past Beltane were often sealed with marriage vows. She bobbed her head toward Maerin, who was stacking firewood.

What the two lovers said to one another, Prim never knew, but she savored having a hand in it, for come the first harvest, on the morning of a full moon, a score of men and women gathered in the glade where Prim had once brought Robin to hunt the white stag. Now it was carpeted with flower petals. At the center, tall as a man, loomed the staring-eyed carved head of the ancient Celtic God, sporting garlands of flowers somewhat askew over

the spiralling designs on its sides. A large stone had been laid flat beside the God, and it too was laden with flowers, a bowl of water, a dish of salt, wine in Robin's silver chalice, apples cut in half in a wooden bowl.

Maerin and Robin, crowned with wreaths of flowers, held hands and gave one another nervous smiling glances. Allan played his harp and sang as people formed a circle around the altar. Prim touched the salt with her knife and blessed it. She poured the salt into the water and lowered the knife in, blessing it also. She took up a sprig of fresh rosemary and, dipping it into the holy water, carried it around the circle, sprinkling it behind and on the people, and on the Celtic stone, saying, "By the power of water and earth, our circle is blessed." John followed her, carrying a blazing torch, and Aelflin walked behind him, ringing a bell, while Juniper sang out, "East, South, West, North, here we come to call you forth! Air, Fire, Water and Earth, our bodies bless, our souls rebirth!"

Prim returned to the central altar, raised her arms and said, "Lady and Lord, we humbly ask you to be with us here and witness this rite."

"Be it so," the others murmured.

"Who comes here to seek the bond of handfasting?"

Robin and Maerin stepped forward. "We do."

"Behold Robin and Maerin of Sherwood, who seek union in the sight of the Divine Ones." Prim dipped her thumb into the holy water and anointed them, drawing a crescent moon on Maerin's brow and the symbol of the sun on Robin's. "Blessings be upon you in the name of the Lady and the Lord. What do you vow?"

"I, Maerin, come of my own free will, in love and honor, to seek the hand of Robin." She turned to face him. "Your happiness is my happiness. Your life I will defend with mine. I will be a helpmate to you and a comfort, and I will speak no word against you before others, but keep counsel and seek resolution together, forasmuch as you uphold your honor. These vows I swear in the name of the Lord and the Lady."

Prim nodded and turned to Robin.

"I, Robin, come of my own free will, in love and honor, to seek the hand of Maerin. Your happiness is my happiness. Your life I will defend with mine. I will speak no word against you before others. I will be a help to you, and be true to you, forsaking all others, for as long as our love shall last. This I swear, by land and sea and sky, in the name of our Lord and Lady."

Juniper came forward with a large wreath of flowers, which Prim took, lowering it over the heads of the two lovers until it rested on their shoulders. "Now you are two in one, making a holy trinity, for your union makes a

third being in the sight of God and Goddess. May your bond be felt as lightly as this wreath. Love is the law and love is the bond, and neither chain nor prison is it meant to be. Love the Lady and the Lord. Love each other. Strive to be true to the counsel of the Wise: if you harm none, do as you will. Like the oak, stand strong. Like the willow, bend. Like the apple, bear fruit. Let your vows be a fountain of wisdom, and find within them, within yourselves and within each other, a sacred pool of love to mirror your souls."

She lifted the wreath from their shoulders and stood aside. Behind them, Allan and Aelflin held either end of a broom. Allan said, "Now you shall truly set up housekeeping together!"

Maerin and Robin joined hands, ran and jumped over the broom. The coven cheered and pelted them with flowers and grain, commanding them to kiss, which they did at great length.

John blew a horn and summoned everyone to the east, where he proclaimed, "Behold, Powers of Air! Here are Robin and Maerin, newly and truly joined!"

"Robin and Maerin!" everyone cheered.

"Give her another kiss, Robin!"

He did so, even as he and Maerin were borne along to the south, where John blew the horn and bellowed, "Behold, Powers of Fire! Robin and Maerin, newly and truly joined!"

Someone yelled, "Give him back his kiss, now, Maerin!"

In the west, they were urged to do somewhat more than kiss, and in the north, she was laughing and slapping his teasing hands from her bodice. By the time they reached the center of the circle again, the bawdy jokes were already in full swing, as befit a wedding.

Prim blessed the wine for the Lady and cakes for honoring the God Lugh, and these were passed around the circle as people bid each other, "Never hunger, never thirst."

"For the Lady," Prim said, pouring wine upon the ground.

"For the Lord!" Prim crumbled cakes which later the birds and ants would eat.

Then Maerin held out her hands and the people joined her in singing and dancing in a circle sunwise, their feet weaving a grapevine, a symbol of fertility. She let go Robin's hand and began the dragon dance, weaving inward toward the central altar and out again, the journey into darkness and death, the dancing out of life and rebirth, and as the dancers swung by each other, everyone kissed, or tried to, laughing, for they sang louder and danced faster all the while, until they fairly flew by each other and kissed the air.

Maerin caught hold of Robin's free hand, and with the circle reunited, they swayed to a halt, ended the song and stood silently for a moment. Then John let loose with a howl and everyone cheered. Allan brought out his lute and the feasting began.

The moon rose high in the star-flung sky before John took up his torch. Followed by all the guests who were sober enough to walk, John led the newlyweds out of the circle and into a flower-bedecked bower in the woods where, after much ribald teasing, they were left alone to consummate their own marriage much as they had consummated the sacred one at Beltane.

The harvest was good that year, and the Blood Moon gave in plenty. The wheel of the seasons turned, turning the wheel of life, and time passed as always into the weaving of what is remembered and what is forgotten, what is won and what is lost, what is imagined and what is true, the legend, the lore and the lie, and all that is longed for and hoped for, feared and faced, along the endless winding thread in the eye of the needle that is now.

⌘

epilogue

Some say Robin Hood was a hero who robbed from the rich and gave to the poor, that he was poor himself and wrongly outlawed, or that he was a noble, dispossessed. They say he was a Saxon who fought the Normans, a Crusader who fought the infidels, that he was a yeoman, a forester, a farmer, a shepherd, an earl, a champion of women, a man, a will-o'-the-wisp, a myth.

Some say he was pardonned for his thievery and left the greenwood to take service with the King, whether King Richard or Edward or some other. Yet they say Robin grew so bored and despondent with court life, he left without the King's permission to return to Sherwood, where he spent his remaining days an outlaw once more, until he grew old, though some cannot bear to think of his youthful spirit ever waning.

Some say he fell ill and was betrayed by his cousin at Kirklees, that she killed him through evil scheming when he went to her for healing. They say Maerin died of illness, or that she retired to a convent.

But those who remember Robin as a Sacred King tell the tale in this way.

It was the season of Samhain, the dark half of the year twelve hundred and seven, when Robin dreamed of the white stag. The leaves in the forest had gone from green to gold to shrivelled brown, and had fallen withered to the ground, trampled by boars, skittered by squirrels and blown by the wind into heaps in the folds of the earth.

In Robin's dream, he was chasing the stag through the wood, and the chase went on and on for days, until his limbs weakened and he thought his lungs would explode, and he looked down at his hand that trembling held his dagger, and his hand was old and gnarled like that of a withered old man. In dread, in protest, with one last burst of vigor, he leaped upon the white stag and slit the creature's throat. They fell to earth together, and as the stag rolled his eyes upward and gasped his final breath, Robin choked on air, struggled to gain his feet and failed. As he lay dream-dying in the warm embrace of the stag, he woke gasping. The dream was so real he could barely reckon his wakening, but as he caught his breath, he knew his time had come, even as elusive fragments of his dream evaporated from his awareness like so many dried seedpods before a stiff breeze.

Richard the Lion Heart had died eight years before at Chalus-Chabrol, taking a wound that would not heal, for the sake of a treasure he claimed was his and not his vassal's. John Lackland was King now in England, and strife reigned. His barons connived endlessly against him and each other, and John quarreled with the Church. As always when there was fighting, the land and the people suffered.

Now Robin thought perhaps the Lady would use his sacrifice to stop the conflict, or slow it, or heal it somehow. Any road, it was up to the Lord and the Lady what good might come of the vow he had taken, made real.

But when he told Maerin the dream, she turned pale as the moon, and because she could not bear to think of his death, she argued with him and tried to turn his mind from his goal. She said he had misread the dream. For love of him she sought to delay or forestall the keeping of his word, a sad mistake in any love, but in theirs, a sacrilege.

Yet who can say what love should do?

In the end, she left Brighid's Well, swearing to love him until death and beyond, but unwilling to watch him die. She did indeed retire to a nunnery, as many tales have said. She took with her all the knowledge she had gleaned over the years from Robin and from Prim, who by now walked in the Summerland with the souls of Will Scarlok and Cal of Copmanhurst. It was said in later years that Maerin became an abbess, and passed on her learning to other nuns in her charge, and this was one way the knowledge of the Wiccan Craft survived; but others said she took her knowledge silent to the grave, for many Christians took their religion so seriously they could not hear the wisdom in any other faith, like a hermit who lives on bread alone when the woods abound with berries and roots and game.

With his beloved gone, Robin despaired. Deserted by the woman he loved, he also mourned the lack of a willing priestess for the sacred rites ahead.

He sat alone in his cave in meditation, waiting for a sign. A sleeting rain began to fall and a chill north wind was blowing. For three days and nights the storm battered the land. When it stopped, the earth was soaked and the bare tree trunks dripped wet as black dye against the grey sky, and a memory came to Robin, light as the touch of the grey mist rising from the soil: Constance.

At dawn the next day, Robin left Brighid's Well wearing his black Druid's hood, carrying a leather pack, his bow and a sack of thirteen arrows. Beside him walked Juniper, his adopted son now grown into a man, with a curling black beard, eyes dark and soft as a deer's, and a walk like a cat padding soundless through the underbrush.

They came to the glade where Prim had once sent Robin on the hunt, where

Robin and Maerin had handfasted. Robin stood in the center with his memories, then faced north and shot an arrow through the trees, letting it find its own mark. At east, south and west he did the same, and then at points in between. The last one he stuck into the ground by the ancient Celtic head-stone.

Juniper watched in misery. It was true that Robin's movements were slower and more studied than they had been years ago, but his eyes were bright, his grip strong. Juniper could not believe it was Robin's time to die. He too had argued against it, but to no avail. He wished this day had never dawned, wished his father would change his mind, yet he was powerless to stop him. Yet Juniper said nothing, for he had sworn to himself he would not show any weakness.

They walked on. By midday, they emerged from the wood and followed a track leading to Watling Street. With the Way of the Wyrd when something fateful is to occur, word of Robin's passing had spread, and the road was lined with people. When the women caught sight of Robin, they howled and rent their clothes. The men bellowed like bulls, chanting the name of an ancient God, "Hu, Hu, Hu, Hu."

The people fell in behind him, some weeping, some stoic, some cheering. A troupe of players and Morris dancers leaped out of the crowd, their faces painted black above their gaily colored costumes, bells jingling on their caps and on the toes of their pointed shoes, and they frolicked behind Robin, pulling at their own hair as if to tear it out, mimicking the cries and gestures of the people, shoving one another and playing as if at the May games, while one beat upon a drum, another played a tambourine, a third danced in front of Robin in an endless ecstatic whirl, and a fourth trudged along in Robin's shadow, his black-painted face daubed with white in the outline of a skull.

They came to the river Calder where rushes grew and old fallen leaves sagged against the bank. A crude wooden bridge of planks led across it, and by the bridge an old woman was kneeling, keening and moaning and washing a rag in the water. From it a froth of red liquid floated into the current. As Robin approached, she raised her arms, her fingers dripping rosy water, and she screeched, "Waning, waning! Lack of the moon!"

Juniper stepped forward to move her out of the way, but Robin held him back. "What are you banning, Grandmother?" Robin asked.

Her eyes searched the sky near his voice and he realized she was blind. She said, "Endings and beginnings, vanishing and banishing." She shook her head, muttering to herself.

Robin laid his hand upon her shoulder and she grew silent. Then she said clearly, "Lady keep you."

"And you also," he said, and he made the sign of the five-pointed star on her

brow.

He crossed over the bridge, though many of those who followed him made signs to ward off the evil eye as they passed the hag.

They turned westward on the road, which ran parallel to the river. Ahead loomed the high walls and the peaked roof of the gatehouse of Kirklees Abbey. When they reached it, Robin rang the bell. The crowd grew quiet.

The prioress came to the gate and peered out. Her face was pocked and sagging, lined prematurely from hard work and deprivation, and her nose hooked downward toward her receding chin as if chasing it away. Her eyes narrowed as she surveyed Robin and the crowd. She said, "Cousin. I have not seen you in many a year." She was Sister Gabriel, Robin's Constance, and though she struggled not to show it, her spirit shrank within her at the sight of him.

Why had he come? Had she not long since learned to mourn him less? She was loath to renew old remembrances and griefs. Yet at the same time, she could not keep her heart still; against her will, it fluttered toward joy at seeing his face again, still youthful and handsome despite the years. "Where are you bound?" she asked, her voice breaking, to her embarrassment.

"My path ends here."

"A nunnery?" She managed a wry smile.

He nodded. "I come begging."

At this strange plea, she let him and Juniper in. The crowd watched with a hushed murmur as the heavy iron gate closed.

Sister Gabriel led them toward the refectory, but Robin smiled and said, "It's not for food I'm begging."

"Indeed I thought you stole enough coin to pay for it."

"Indeed I always have," he said, with the old twinkle in his eye. "No, Cousin, I've been ill. I ask only for a favor."

"What illness?"

"I will tell you. But privately. Where is your hospice for the dying?"

With a worried frown, his cousin led them through the abbey, and while they walked, he wondered ruefully at the fate that brought him to Christian ground for this, one of his most sacred acts. The new faith had taken full root and spread, no denying it, but if he had aught to do with it, Goddess would not die.

They came to a small hut attached to the infirmary. She said, "This is where we succour those who are beyond saving. But it is empty for the moment, and clean."

Inside it was also dark and damp and chilly. She lit a candle and built up the fire. Robin sat down on the thin straw-stuffed pallet by the wall. Juniper hunched on his heels before the hearth, holding Robin's bow as well as his own, his

frown half-concealed by his bushy beard.

"And now," Constance said, "what ails you? I have been blessed to learn something of healing, by God's grace."

"So I have heard. My illness is only that life is too long. Too many of my loved ones have gone on before me through the veil." He stared into space for a moment, thinking of Will and Prim, of his father, of Cal and John and others, and then of Maerin, who yet lived, but who was gone from him. The thought of her filled him with longing. "I would stave off old age. Will you grant me the cure?"

"There is no cure for old age but death. Surely you of all people know that."

"For the sake of what you were when you were younger, do not betray my trust."

She peered at him in the flickering light. She could read what he would say next with her second sight, which she had never completely conquered, and which now returned to her unbidden once again. The blood rushed to her face.

He said, "Grant me a life for a life, Cousin. I once gave you yours and now I ask you to take mine."

She shook her head vehemently. "You are not serious! You cannot ask this of me! I am Christian! I cannot follow Pagan ways!"

"It is Christian charity I beg of you. In the name of the Lady. If you love me, Cousin."

She could not trust herself to speak. If she loved him, he said! If he but knew how she loved him, and always had! But she quailed at the thought that he might discover her deepest, worst secret, the yearning of her heart and her flesh for his love, for his body.

He reached into his pack and pulled out several leather-bound books, a flask and his old, battered silver chalice. He handed her the books. "I planned to give these to you for years and never did. I make up for the failing now."

"No doubt you stole them," she said briskly, covering up her emotions as best she could.

He grinned.

She said, "I cannot accept them."

"They are scribed by Christian monks, Cousin, for all that there are Pagan images in some. I but return them to the Church, slightly borrowed."

She opened the cover of one, her fingers lingering on the leather. "It is an herbiary! It is beautiful." Her eyes grew filmy. He had thought to give her gifts, all these years … though he had not thought so much on her that he had brought them sooner. And now they were more of a bribe than a gift. She groaned inwardly at her selfishness, her greed and her self-pity. "I cannot accept these. We are

not allowed to own such things."

"I give them to your abbey, then, for safe-keeping. Surely there is a library here. I would reward you for the service you are about to do me. But first, a cup of wine," he said, proffering the flask.

She shuddered, recognizing the sacrament. Well she knew how the Mystery of Christ's blood had grown out of Pagan customs, Pagan wine.

He took her hand and kissed it. "Help me, Cousin, in the name of all you hold holy."

Sickened as she was by her warring emotions, all her arguments fell away from her. He had trusted her enough to come to her. How could she refuse to do his will, the one time he asked it of her? He would never ask again. If she refused, he would go away and never come again to see her. Either way, it was the last time they would speak in this life.

She took the flask and the chalice and stood. She went to a worktable lined with mortars and pestles, pots of herbs and amber bottles. She poured the wine. But her body hid the movements of her hands, and so he did not see that she deftly opened one of the amber bottles and added a few drops of a tincture to the cup.

She took the wine to him, her hands far steadier than she felt. He drew his dagger and dipped it in the chalice, saying a blessing. Then he drank. "May you never thirst." He offered it to her.

"No, I cannot."

"Today you are a priestess of the Goddess. Drink with me. Do not send me to the shadows without Her blessing."

She took the cup and sipped, then drank a heavy swallow more before handing it to Juniper, who took a mouthful and gave it back to Robin. He drained the cup, then lay back upon the pallet and told her what he willed her to do. With every word he spoke, she wanted to scream against it, but something, perhaps the Devil, she thought, held her tongue.

She looked at Juniper. How could he listen to this without protest? He stared at the hard-packed earthen floor before the fire and did not look up at her, or at Robin, or at anything of this world, it seemed.

She did the deed, with the efficient and practical movements of the experienced healer she had become. Robin thanked her with a nod and a smile, saying Juniper knew what to do for the rest of it. Her stomach twisted. She took up the precious books and swiftly left the hut, leaving Robin's breath slowing and deepening, Robin's blood draining into a bowl and his skin slowly taking on the pallor of the dying.

She stumbled into the quiet darkness of her cell and lay the books on her bed. The potion she had put in the wine had made her dizzy. But Robin had

drunk the lion's share. Even now it would be dulling his pain, dulling his loss of strength, making him fall into a slumber that would ease his way into the death he so desired. She was sure if she had offered the tincture, he would have refused it. So she had succoured him secretly. So much she loved him.

But now he lay dying. At her own hand. She had taken a life! The life of the only man she had ever loved. Betrayed her calling as a healer. Let alone that it was a mortal sin. She was damned for it, as he was damned, for the sin of suicide. Yet she thought she could bear the fires of Hell better than she could live with the grim horror of knowing she was the agent of Robin's death, he whom she had loved in some ways more than Christ, may God forgive her! No comfort was it that he had begged her to do it. He had tricked her into it. "If you love me," he had said.

Of course, he had never said he loved her. Never would.

By God, how dared he return to awaken this torment of desire in her? She was damned, damned!

And where was his Maiden of the Grove, then, who had been his Pagan lover and priestess? She had heard tales of the Maid Maerin, of her courage and her beauty, damn her eyes!

Constance paced her cell, clutching the rosary dangling at her waist. She looked at her perfectly made bed, at the wages of her sin in the form of the books tumbled upon it, the crucifix upon the wall, the washbasin on its stand, with always cold water, never warm, to wash herself. She saw the austerity and precise order of her life, in which her emotions and her bodily desires and her foretelling had always been blasphemy, chaos.

And how much more so now.

By God, if Robin were going to the Devil for his Pagan ways, she would go with him. Why wait? She was doomed any road. Let him thank her in Hell!

Palms sweating, she grabbed the scourge that had failed in beating the lusts out of her body. She climbed onto her bed and tied one end of it to the wooden beam above. The other end she knotted around her throat, threw herself off the edge of the bed and hung strangling, tears choking her, face reddening, limbs jerking, and all the evil liquids of her evil body running out, her hatred for herself running out, and at last, mercifully, the life running out.

Strangely, a peace came upon her, so that only as her spirit fled the hated, ugly, treacherous body she had once inhabited did she begin to pity it, even love it for a fleeting moment, for the first time. She saw, too late, the loss to the world, the true sinfulness of her suicide, for her expert knowledge of healing and skill of foretelling died with her.

Even so, she felt God's forgiveness sooner than she could forgive herself, and

wept tearless grief and joy before dying.

<div align="center">⌘</div>

In the fallow fields that night, women walked under the dark of the moon, sweeping tin cups and wooden bowls left and right, forward and behind, letting drops of Robin's blood spill out and bless the earth. As they walked, they chanted,

> The God is gone, gone into the grain,
> Earth and sun and rain.
> The God is born, the God is born,
> Grow corn, grow corn.

While the fields received his blood, the forest received his body. There were thirteen graves in Sherwood, each one marked with an arrow. Beside the one that held his head, in the glade by the old stone God's-head, blazed a bonfire. Juniper danced around it, naked despite the cold, by turns shouting or silent, weeping or even, now and then, laughing. He danced to forget his loss, to go into a trance. He danced to remember, to celebrate love and duty, honor and wildness, to honor the man who took him in when he was alone, who taught him when he sought to learn, who was a father to him, and a magic-maker, and a friend.

An owl hooted in the darkness. A black mastiff, the bitch granddaughter of Robin's Balor, padded in and out of the firelight and barked at Juniper's frenzied movements.

When Juniper felt the power in him rise up high enough, he threw back his head and flung out his arms, fingers splayed and bones taut, and he sent that power into the night like invisible wings to help carry the spirit of his adopted father to the next life. He felt those wings fly out of him. He thought he heard Robin's spirit laugh in farewell. He dropped to the ground and rubbed at the tears on his face with dirt.

Then he lifted his head and gazed into the fire. He felt drained of all emotion. The dog trotted over and sat beside him, waiting to see what her master would do next.

He reached toward his pile of clothing and pulled forth his dagger. He drew the blade across his left palm, letting the drops of blood fall hissing into the fire. "From the body of the dying God, the earth is renewed. From the womb of the Mother comes the reborn son. From this day forward I put aside anything of my former life that has enslaved my spirit, that the spirit of the Horned One, Lord of the Dance, Lord of the Animals, may move through me, if He so wills it. I put aside my childhood name of Juniper. Henceforth and forever I shall be known and remembered only by my new name, Robin."